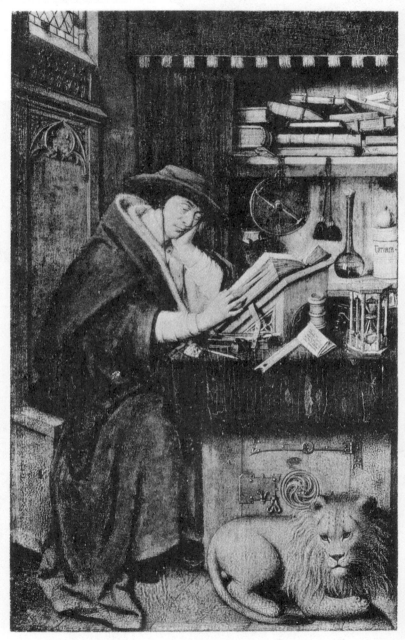

St. Jerome.

BOOKBINDING

ITS BACKGROUND
AND
TECHNIQUE

BY EDITH DIEHL

TWO VOLUMES BOUND AS ONE

VOLUME ONE

DOVER PUBLICATIONS, INC.
NEW YORK

Published in Canada by General Publishing Company, Ltd.,
30 Lesmill Road, Don Mills, Toronto, Ontario.
Published in the United Kingdom by Constable and Com-
pany, Ltd., 10 Orange Street, London WC2H 7EG.

This Dover edition, first published in 1980, is an unabridged
and corrected republication in a single volume of the work
originally published by Rinehart & Company, Inc., in 1946 in
two volumes.

International Standard Book Number: 0-486-24020-7
Library of Congress Catalog Card Number: 80-66958

Manufactured in the United States of America
Dover Publications, Inc.
180 Varick Street
New York, N.Y. 10014

ACKNOWLEDGMENTS

I N my List of Illustrations acknowledgment has been made of the source of each reproduction found in Volume I. To the owners and custodians of the bindings and other objects illustrated I wish to express my thanks and appreciation for their courtesy in allowing these reproductions. I am especially indebted to Mr. Karl Kup, Curator of the Spencer Collection of The New York Public Library, to Miss Belle da Costa Greene, Director of The Pierpont Morgan Library, to Mr. William H. Forsyth, Associate Curator of the Mediæval Department of The Metropolitan Museum of Art, to Dr. M. S. Dimand, Curator of the Department of Near Eastern Art of The Metropolitan Museum of Art, and to Miss Clara L. Penny, Bibliographer of The Hispanic Society of America, for their co-operation in assisting me to locate in this country particular examples of objects of historic and artistic importance which I desired to reproduce. To my critical reader of Volume I, Mr. Karl Kup, I am deeply indebted for constructive suggestions and for his untiring assistance. I am likewise indebted to Mrs. Laurence Prendergast for her assistance in correcting my text, and to Mrs. Edna M. Kaula for her painstaking accuracy in executing the drawings for the illustrations of Volume II.

<div align="right">E. D.</div>

1946

CONTENTS

LIST OF ILLUSTRATIONS

[The illustrations to volume one will be found following the combined text of both volumes.]

BOOKBINDING
ITS BACKGROUND AND TECHNIQUE

CHAPTER I

PRIMITIVE RECORDS AND ANCIENT BOOK FORMS

THE book form has gone through very few changes in physical appearance since its inception, and it is interesting to note that each change of form has been the natural and even the compelling result of a change in the character of the tools and materials used for recording the text.

The printed book is a thing taken for granted in this twentieth century, but one must remember that its origin is of comparatively recent date, and was preceded by centuries of inscribed and written documents, many of which were recorded thousands of years before the Christian Era. The form in which these documents made their appearance varied from age to age with the development of civilization.

Long before an alphabet was conceived and writing developed, men found it necessary to make records and tabulate ideas, and their early pictorial recordings, cut on stone or wood, constitute the first step in the development of an alphabet and the evolution of the printed book. This form of record making was undoubtedly practiced all over the world wherever primitive man existed, and it apparently had its origin in no one place. While these early pictorial records are not directly related to our present form of book, they are interesting in themselves and because of their bearing on the development of our alphabet.

We have the early animal drawings on the walls of caves and tombs, such as the artistic animal delineations in the caves of the

Dordogne in France, which were doubtless full of meaning and told a story to the people of the time, serving as signposts or guides to them in such matters as where they could procure food and the like. Then there are the cryptic cup and ring markings found on rocks from Western Europe to the Far East, all with a certain similarity in form, suggesting a common idea among widely separated tribes of men. There are other records of similar character, numerous and suggestive of varying degrees of civilization, in addition to the Egyptian and Assyrian inscriptions that scholars have been deciphering and interpreting for many years. But it was at quite a late period that all these records were sufficiently analyzed to supply evidence that it was through them that the art of writing was evolved. The carvings by men of the early Stone Age represent prehistoric picture books, and there is reason to consider them the earliest ancestors of all our later art and literature.

As letters of the alphabet now in use were derived from hieroglyphics, so hieroglyphics were copies from the animal and vegetable forms familiar to primitive man, and there gradually evolved three great pictorial systems of writing in the old world — the Assyrian-Babylonian, the Egyptian, and the Chinese. These systems, however, in their symbolic form were by degrees lost as complex ideas of civilization progressed. For while concrete happenings could be expressed in picture writing, the portrayal of abstract notions demanded a less primitive system.

In addition to the inaccessible Egyptian and Babylonian monuments, there are in our museums examples of pictographic and ideographic types of record keeping in the form of Chinese leaves of jade, carved amulets, notched sticks of primitive tribes, runic calendars, and the very much later clog almanacs. The wampum belts of our North American Indian are not without interest in this connection, and the knotted quipus of Peru represents an amazing system of a sign language.

We find that the uncivilized peoples, such as the North American Indians, continued symbol writing and found it equal to their needs, while the development of civilization in Egypt and China made it necessary to find a form of writing better adapted to the expression of finer shades of meaning, and these nations converted symbol writing into a syllabary, or character writing. As men emerged from a simple life to a more complex manner of living, incidents and thoughts became more involved, and their transference through records became more difficult to achieve. A sketched picture outline served well to portray a concrete message or to record incidents among primitive peoples, but was found inadequate for expressing intricate ideas and involved incidents. So we find the hieroglyphic modernized to meet the demands of civilized life. This change from the symbolic to the syllabic as a mode of expression marks the actual beginning of our alphabet. It may be noted here that the Egyptians never developed an alphabet as did the Western Europeans. They continued to retain traces of a vivid art and imagination in their form of writing.

For centuries little was known about the origin of the five great early alphabets—the hieratic, Phoenician, Hebrew, Greek, and Latin, for the key to their interpretation was lost from the fifth or sixth century until the end of the eighteenth century when the Rosetta stone, now in the British Museum, was discovered (1799). This stone contains a trilingual inscription, namely, an inscription in hieroglyphic, demotic and Greek. Since the Greek was understood, the stone proved to be the key to the mystery of the hieroglyphic, and from it a common origin of these five early alphabets was established. The Latin alphabet was found to have been derived from the Greek, the Greek from the Phoenician or Semitic, the Semitic from the hieratic, or cursive, Egyptian, and the hieratic from the hieroglyphic. And thus our twenty-six letter alphabet, which was inherited from the Latins, has been traced back to the hieroglyphic monuments of Egypt.

One of the most interesting records of the Assyrians and Babylonians is the *foundation cylinder* (see Plate 1). These cylinders are barrel shaped, hexagonal, or round. They are flat at each end, with a hole pierced through them lengthwise. They were made of clay, and upon their sides are inscribed accounts of historical events, in consequence of which they have proved a valuable source for establishing facts and data concerning this ancient period of Babylonian and Assyrian history. Stone cylinders and other records on stone constitute the first books, if we accept the dictionary definition of a book as a written or printed document.

The Egyptian inscriptions on stone were followed by *clay tablets* (see Plate 2), originating in Babylonia at the time of the Semitic invasion, about 2400 B.C. It was found by the scribes that the complicated picture characters, or hieroglyphics, incised on stone were difficult to impress on clay, and gradually the old picture writing seems to have been transformed into conventional signs of greater simplicity, and the wedge-shaped cuneiform writing came into being. This form was a modification of the hieroglyphic.

The invaders of Babylonia, who first discovered the use of clay as a material for writing purposes, made their tablets quadrangular in shape, wrote upon them while still moist, and then baked them in the sun or in an oven. Writing was impressed on them by means of a stylus, a pointed instrument usually of wood, bone or metal; and these tablets proved very durable for record keeping. They were first used for recording business transactions, such as the sale of a parcel of land or the loan of money, and later they were used for literary purposes. On the tablets representing business transactions, seals of mud were affixed in order to attest the presence of witnesses.

We have reason to believe that these early documents were stored on shelves in libraries in a manner similar to the fashion prevalent in our libraries today. They too had their covers and

their labels, as have our present-day books, the difference in kind obviously due to the difference in the substance of the material used for the text. The covers of these tablets were sometimes earthen jars, and they were labeled with clay markers secured by straws. Frequently the text continued from tablet to tablet, like the leaves of a modern book. In the seventh century B.C. a large library of clay tablets existed in Nineveh. It is said to have been established about 3800 B.C. by Sargon I, founder of the Semitic empire in Chaldea, and it was the first great library of which we have any record. It was destroyed by fire on the fall of Nineveh.

In the Oriental countries the early books were made from narrow strips of palm leaves as well as from strips of bark. The writin on these strips, or sheets, was scratched in and then blackened with lampblack in order to make the text stand out more distinctly. The leaves followed each other in sequence and were covered on the top and bottom with wooden boards, which were fastened on by means of cord run through holes at each end. Sometimes these covers were of gold or silver and were often elaborately decorated with carvings or with intricate inlaid designs.

The *papyrus roll* (see Plate 3) made its appearance at a very early period. Each roll was made of sheets of papyrus leaves pasted together. The text was written in ink by a scribe who used a sort of reed brush-pen. One of the earliest literary examples of a papyrus roll, called the *Prisse Papyrus*, is now in the Louvre, and dates before 2500 B.C. Many papyrus rolls have been found buried in the ground in earthenware jars, which served to protect them from the ravages of dampness, insects, and other injurious agents. In forming the rolls, one papyrus sheet was pasted to another lengthwise, and after the text was completed, the manuscript was rolled up tightly and placed in a cylindrical box called a *scrinium*. Some of the more valuable rolls were protected with a wrapper before being put in their boxes, and there was fre-

quently more than one roll in a box, each usually with a tag or label affixed to it.

Papyrus as a writing material has probably been in use since about 3500 B.C. It continued to be employed almost exclusively for this purpose until the early part of the Christian Era, when vellum began to supplant it as a substance better adapted to the work of the scribe and less vulnerable to injurious agencies. However, it continued to be used in Western Europe far into the tenth century, and it is used in Egypt even at the present time for recording certain documents.

When the scribe began to write on papyrus, he was forced to change his writing implement from the hard stylus employed on clay and wax to a tool less incisive, and he developed the brush-pen. It was made out of a reed and had a fibrous pointed end. Both black and red inks were used on papyrus documents, and these were made by the scribe as he needed them — the black ink being a mixture of lampblack, gum, and water; and the red ink, a sort of metallic infusion. A sponge was kept at hand by the scribe while laboring over a papyrus text for the purpose of erasing writing when in need of correction, since the surface of papyrus does not admit of scraping with a knife for erasures as does the surface of vellum.

The papyrus plant was widely cultivated in Egypt along the Nile and is still found in the upper Nile region and in Abyssinia and Sicily. It is a very decorative plant that grows in bush form, with many stalks coming up from a single root, each stalk ending in a tufted head. It resembles quite closely, and is related to, some of our common North American sedges.

We learn from Theophrastus that many useful articles were fabricated from the papyrus plant. He tells us in his history of plants that the tufted heads were used for making garlands for the shrines of the gods and that the roots were made into different utensils and were utilized for fuel. According to Theophrastus,

boats, sails, cloth, cord, and writing material were all made from the stems of this plant.

Papyrus was made in Egypt by slitting the plant stems and cutting them into fibrous strips, which were laid side by side on a board until the desired width had been reached. Then at right angles across this layer of strips another layer was laid. These two layers of split stems, supported by the board, were then immersed in the water of the Nile, and after being thoroughly soaked, were left to dry in the sun. They were later hammered into flat sheets and finally polished with pieces of ivory or with a shell.

There was an early superstition that attributed certain chemical properties to the waters of the Nile, which were thought to make the strips of papyrus adhere to each other, but since papyrus was made on the Euphrates and in other places as well as upon the Nile, another explanation for this mysterious cementing together of these strips must be sought for. A theory has been advanced that inherent in the reed stems was a glutinous substance which exuded from the strips after being wet and served to bind them together. But a simpler and more probable explanation is that the early papyrus makers used some sort of adhesive which they applied to the strips. The papyrus produced by the Romans was remade from imported papyrus, and the brittle condition of the Latin papyri is evidence that the Roman papyrus was of inferior quality as compared to the Egyptian.

So long as papyrus remained the chief writing material, the roll form of book was inevitable. Papyrus could be cut into sheets and written upon, but its texture is more or less brittle and it does not admit of being folded without injury. Hence the roll form was continued for papyrus manuscripts.

The Greeks modified the Phoenician alphabet for their use probably before 700 B.C. and later both Greeks and Romans adopted the roll form of book. One of the earliest examples extant of a Greek papyrus roll dates back to about 280 B.C.

Skins of animals were used as a writing material at a very early date, though we know nothing about the earliest method of preparing them for manuscripts. It is probable that the character of the skins first used for writing purposes was rather heavy and more like a tanned leather than the thinner and better prepared ones found in the skin rolls of a later period. In the second century B.C., a great improvement took place in the preparation of skins used for writing on. This finer substance was called parchment or vellum, and was not tanned like leather but was prepared quite differently.

The invention of vellum has been attributed to Eumenes II of Pergamum, though it is known that prepared animal skins were used for MSS. before this time. It appears, however, that a new method was employed for preparing skins during the reign of Eumenes II, and a finer material was fabricated, which was smoothly finished on both sides instead of upon one side as previously.

According to a popular story, Eumenes, who was interested in accumulating books for his library, found papyrus difficult to procure, since the Ptolemies forbade its export from Egypt, hoping to check the growth of a rival library. Hence he was forced to substitute skins for his books. Be that as it may, we know that during the second century B.C., when Eumenes II was in power, Pergamum was the chief center of the vellum trade, and the term "parchment" doubtless derives its name from Pergamum, the early seat of parchment and vellum making. The term "vellum" is in general use at the present time to denote both parchment and vellum, though among manufacturers of these products parchment connotes a material made from the skins of sheep or goats, while a finer material made from the skins of calves or of stillborn lambs is called vellum.

The making of parchment and vellum is not a complicated process, though it is a very messy procedure. One of our Ameri-

can nuns, a scribe and illuminator, made her vellum skins for years, and she also produced the rare purple vellum, the making of which is an art thought to have been lost since the Middle Ages.

To make vellum, the skins are first washed, and the under-surfaces scraped and cleaned. Then they are put into a vat of caustic lime and are left to soak for many days until the hair is sufficiently loosened to be easily removed. To remove this hair, the skins are placed on a wooden block and are flayed vigorously. A second scraping and many washings follow, after which the skins are stretched tightly and evenly on a frame and are fastened there to dry. During the drying process more scraping has to be done, and the inequalities of the surface are pared down with a sharp knife. The drying often takes weeks, and the skins are kept evenly stretched during this time. When finally dry, they are rubbed down with powdered pumice and then given a dusting with finely powdered chalk. It is probable that a method similar to this was employed in preparing the fine vellum used on early MSS.

Rolls made of vellum were comparatively rare in Egypt, where papyrus continued to be the chief writing material. But their use was widespread in western Asia at an early period, and the vellum roll was the prescribed form for books used by the Jews in their synagogues.

Vellum rolls were written upon in various ways. The writing was on one side of the material only, and that was the so-called recto of the skin, which had been polished to a smooth surface. The earliest ones were written with the lines running across the width of the roll, and the manuscript was held upright as it was read, and unrolled from top to bottom.

The Buddhist prayer wheel contains a roll written with the lines running along its length, and the roll has to be unrolled side-wise in order to be read. It is a curious fact that these rolls were

never really read, but with each revolution of the wheel, the suppliant is given credit for having read the text. The best-known prayer wheels are the small hand ones seen in Tibet.

There is another form of rolled manuscript, which is a modification of the Tibetan form, found in the Jewish scrolls. On these, the writing runs as in the Tibetan roll, but instead of running the whole length of the roll it is written in page form with the lines following under each other within a prescribed space. The roll is unrolled sidewise (see Plate 4).

This page form of roll suggests a type of written text found in the East among primitive nations. The writing is on a continuous sheet of vellum, paper, bark, or other writing material, and is written the length of the sheet with spaces left between all pages of writing. It is then folded or pleated like an accordion, and usually the folded text is placed between two boards in order to keep it flat, but it is not fastened in any way.

A book of this type is akin to the Oriental *Orihon*, or stabbed binding, which has been in use in China and Japan for centuries. The *Orihon* is written in the manner just described and is likewise folded in accordion pleats, but instead of being left unfastened, the text is placed between thin boards made of pasted paper and is laced into its covers through holes stabbed along the back edge. Its covers are made so that they form a sort of hinge, which allows the book to be opened and read more easily.

Following the roll came the Roman *diptych* which was made of two wax tablets, or *pugillares*, joined together at the back with rings. The pugillares were rectangular pieces of ebony or boxwood, having one side slightly hollowed out so as to receive a filling of blackened wax on which the text was written. Sometimes these tablets were hinged together in threes, called *triptychs*, or occasionally in greater numbers. The writing was impressed on the wax surface by means of a stylus, which was made of wood, bone, brass, or some other hard material. It had one end pointed

for writing, and the other flat for erasing. On the text side of the diptych, spaces were often left on the outer edge, and the wood was cut out to form a receptacle for holding the stylus.

Diptychs were also made of ivory and were elaborately carved, the earlier examples of which are the finest. The ivory diptychs, which were sent by the Roman consuls in order to announce their election to office, were called consular diptychs, and they were usually larger than the pugillares. Besides the consular diptychs there were also ecclestical diptychs, which bore writing pertaining to the ecclesiastical world, such as lists of martyrs. The Roman diptychs, like the Oriental stabbed bindings, were a near approach to the later flat form of book. They are a sort of link between the roll and the *codex*, or flat book of the Christian Era.

CHAPTER II

THE BOOK OF THE MIDDLE AGES

THE roll form of book used by the ancient Babylonians and Assyrians changed for the Greek and Roman literature when vellum began to supplant papyrus as a writing material. It was then that the roll was superseded by the *codex*, the manuscript in flat book form composed of separate folded sheets of vellum, stitched together in quires, or sections, and containing writing on both sides of the sheet, or of unfolded sheets of papyrus held together by a cord passed through holes pierced along the back margins of the sheets.

It was found that vellum, unlike papyrus, could be folded without injury, and for the codex the vellum was cut into sheets which, after being ruled by the scribe with a blunt tool, were written on and were then folded and arranged in proper sequence. These folded sheets were gathered together in units of four, each gathering or section constituting a *quaternion*, from which name our word "quire" is derived. The gathered quires were at first just stitched through the folds singly by the *bibliopegus*, or binder, but soon groups of quires began to be stitched one to another by winding the sewing threads around a strong strip of leather or vellum placed at right angles to the folds at the back of the book. They were then usually encased between two wooden boards, which were afterwards covered with roughly cured skins. These sturdy covers served as a protection to the ancient MSS., which doubtless owe their preservation in large measure to this simple strong binding.

The codex in appearance and construction is surprisingly like our present-day hand-bound book. It was really a development of the Greek and Roman diptych, which we might call the primitive codex. This flat book marked the beginning of the binder's craft. M. Paul Lacroix writes: "As soon as the ancients had

made square books more convenient to read than the rolls, book-binding was invented."[1] The only sort of real binding in use before the appearance of the codex was the stabbed binding, which was not suitable as a device for protecting the refractory vellum codex texts.

The vellum flat book had numerous advantages over the book-roll. It was more convenient to handle, and since the text was written on both sides of the sheet, a codex manuscript occupied far less space on the shelf than the rolled book. Hence a single codex could hold the contents of a work which must be distributed through many volumes in roll form. Being more compact, it was much easier to read, and its convenience quickly recommended it to favor.

In the early centuries, after the flat book form had become more or less usual, papyrus as well as vellum was made up into leaved books. In fact, the greater number of papyri of the third century A.D. containing Christian writings are in the flat book form, while on the other hand, the non-Christian writings of that period kept to the roll form. So it is that the codex form of book becomes identified with the Christian Era.

In the fourth century the competition between roll and codex in the literary field was finished. From then on the roll remained in use only for records and legal documents and for the sacred books of the Jews. It is interesting to note that the Jews have continued to use the vellum rolls even to the present time, requiring that their synagogue books be written on vellum and in roll form.

The shape of the codex book was square, resembling what we think of as a quarto, though it was made up in folio format. The title was usually written at the end of the text. Even down to the fifteenth century, the practice of writing the title of a manuscript at the end of the text was prevalent, and after the title there were added such items as the date, the name of the scribe, and other details concerning the manuscript. This matter was all in a sort

of final paragraph called the *colophon*. The early Christian manuscript is replete with interest for both artist and craftsman. It beggars description because of its illusive qualities and unadorned simplicity — a product of the silent monastery, written in the beautiful, clear hand of the early scribe.

In the monasteries of Europe, the monkish scribes collated and copied both religious and classical literature and thus made them available to us by producing the copy for the later printing press. Chief among the earliest monasteries was that at Monte Cassino, which was instituted in the year A.D. 529, by the order of St. Benedict. These monasteries were in a measure asylums of safety in the Middle Ages when ruthless warriors sacked the towns and destroyed and pillaged, though they did not always escape the ravages of war. It seems a pity that during our supposedly enlightened time this early Benedictine monastery at Monte Cassino, which had been rebuilt after previous ravages, should have fared no better than in the so-called Dark Ages at the hands of the warring Lombards and Saracens. For here it was that under the inspiration of Cassiodorus, St. Benedict organized a *scriptorium* that was a model for future ones. Here the monks worked tirelessly according to their Rule, transcribing books, binding them, and distributing them to the world.

The scriptorium of a monastery was usually a large room situated over the chapter house. The monastic scribes worked under rigorous discipline, and the rules of the scriptorium were very definite. Artificial light was forbidden for fear of possible injury to the manuscripts. Absolute silence was insisted upon, and no one was allowed in the scriptorium except dignitaries of the monastery. The monk, called the *armarius* or *librarius*, was the one who presided over the scriptorium, attending to all the details of providing desks, pen and ink, parchment, erasing knives and other necessities for the work of the scribes. When no special room was set apart for this work, the scribes worked in small cells

bordering the cloister of the abbey. If the monastic scribes were not capable of finishing a manuscript by rubrication, the work was turned over to secular scribes to be completed.

The reason for binding books is primarily to preserve them intact. Unless the sections were held together and bound between covers, they would soon be separated from one another and texts would rarely survive in their entirety. The early bindings produced in the monasteries served this purpose well. After sewing the sections together, the monastic binder laced them between two wooden board covers with the ends of the cords or strips around which the sections were sewn. Then a piece of leather was pasted over the back of the book and was drawn over onto the sides of the boards far enough to cover the joint where the boards were hinged to the back, leaving the front part of the boards without a leather covering. Thus we have the mediæval "half binding." Later, the leather was made to cover the boards entirely, developing the "whole binding." And when it was realized that these flat surfaces of leather offered an excellent opportunity for decorative designs, the art of binding books with decoration on their covers began to be practiced.

That wooden boards were used as covers on the early MSS. was doubtless due to the fact that the vellum on which they were written had a strong tendency to curl, and could not be made to lie flat without some pressure. Even the weight of the heavy wooden boards had to be augmented, and the added pressure produced by placing metal clasps over the edges of the books was resorted to in order to keep these texts from yawning. I might add that metal bosses were fastened to the sides of these early books probably for the twofold purpose of decoration and keeping the leather from being scratched or harmed as the book lay on its side.

There were monasteries in great numbers in all the European countries, and these religious institutions were the chief source of book production in early times, but the origin of most of the

monastic bindings extant is Germany, Austria, and the Low Countries[2]— southern Germany, and especially Austria, contributing the greatest number of written books and of bindings. One of the reasons for this rarity of French and English fifteenth century monastic bindings is that many books were systematically destroyed during religious wars in these two countries, and then, too, there were possibly fewer bindings produced in England and France than in the other countries of Europe and many of the original bindings are lost to us also through the process of rebinding. The Italian monasteries were prolific producers of written manuscripts, but their monks do not appear to have had much zeal for decorating their bindings.

Outside the monasteries no regular practice of bookbinding seems to have been established in the early Middle Ages, probably because of the great scarcity of books. The monks bound practically all the manuscripts they wrote, and the few that were bound outside the walls of these monasteries were not so numerous as to keep a lay binder continually occupied and become the means of a livelihood to him. It must be remembered too that owing to royal decrees no one outside the monasteries, except men of noble birth, was allowed to practice more than one art and craft, and therefore it was only the monks who were skillful in many crafts. For this reason it can be readily understood why bookbinding made such progress in early times in monasteries while it was being neglected in the towns. Later, in several countries of Europe, some of these noblemen who shared with the monks the right to practice many arts established workshops in their households, where they employed scribes, illuminators, and bookbinders and kept them busy producing books for their libraries.

If books were as scarce in the Middle Ages as Dr. Goldschmidt believes, it can be readily understood why the services of lay binders were not required to keep pace with the output. However, there appears to be a wide divergence of opinion concern-

ing the number of books produced during this early period. Goldschmidt is of the opinion that the number was very limited, and he quotes M. R. James's catalogue of the library of Christ Church, Canterbury, in substantiating his belief that "even the richest and most famous libraries before the year 1200 did not contain more than 500-700 books all told."[3] On the other hand, Henry Thomas, in his book on early Spanish bookbinding, points out that Moorish Spain was far ahead of Christian Europe in the matter of libraries. Describing the splendor of the Moorish capital of Spain in the tenth century he quotes a Spanish author who cites a royal library of four hundred thousand books existing not later than the beginning of the eleventh century.[4]

Influence of the Church manifested itself in art in the early part of the Christian Era and may be noted in the type of decoration found on bound copies of the Gospels and other service books which were placed upon the high altars all through the Middle Ages. These books were bound sumptuously with precious metal covers inlaid with jewels, and many of them had carved ivory or Limoges enamel plaques containing religious subjects set into their covers. Massive books bound in colored leathers are said to have been carried in public processions of the Byzantine emperor during the middle of the fifth century, and bindings with Byzantine covers of gold, silver, and copper gilt, inset with jewels, have been identified with the sixth century.

Fine and genuine examples of Byzantine bindings are quite rare. Most of the known specimens are no longer attached to the MSS. they originally covered, but many are preserved as loose covers, and others have been used to cover books for which they were evidently not originally designed. Imitations of Byzantine bindings are not uncommon, and collectors of such bindings have been frequently victimized, for they are evidently not too difficult to imitate, and in order to judge them expertly, one should have technical knowledge of many crafts such as that of

the gem cutter, the gold and silversmith, enameler, and bookbinder, and should be something of an antiquarian as well.

Sumptuously bound books of various types continued to be made even after mediæval times. For the most part they are not examples of the binder's craft, but represent rather the work of goldsmiths and probably independent artists. Examples may be found in public libraries, in museums, and in private collections, though a great number have been destroyed because of religious prejudices or by predatory minions of conquering warriors, who have appropriated their costly covers without regard to their historic or artistic value.

Celebrated Christian artists came from Italy to Byzantium during the reign of Constantine and brought with them a decadent form of classic art prevailing in Rome at the time. These artists were apparently unable to create for themselves a new technique and worked along the old lines which they adapted to express the new Christian ideas. Later, in the sixth century, Persian art began to affect the Byzantine style, and a strong Oriental influence may be noted. By the tenth century, the school of Constantinople was well established, and its artists were sought after by both Italy and Germany. These men carried their art throughout the greater part of Europe, where the Byzantine style became apparent in bookbinding decoration.

Arabic art was doubtless introduced into Europe by the crusaders, and its influence may be observed in the forms of winged birds and beasts appearing on decorated bindings of the Middle Ages. Ornamented sunken panels also were of Arab origin, which fashion apparently came to Europe through the Venetian binders.

The art of enameling was known in very early times and reached perfection in Constantinople in the ninth century. This art was introduced into Constantinople from Asia, and hence the Byzantine enamels were executed in cloisonné, following the

Oriental method. The cloisonné method, which is still practiced to perfection in the Orient, is a sort of filigreed enamel. The design is outlined by soldering fine wires of metal onto a metal undersurface, and then the empty spaces are filled in with a colored paste which is vitrified by heat, producing a glassy appearance. The Germans and the French practiced the so-called champlevé method of enameling, in which the surface of a metal plate is hollowed out to form the design, and the colored substance is placed in these hollows (see Plate 5). In identifying enamel book covers it is important to be able to distinguish between these two methods. The Italians practiced still another manner of enameling in the thirteenth century and produced the translucent enamels on bindings which, though very brilliant, were fragile, and there are few specimens extant.

The monastic leather bindings were for the most part undecorated until later in the Middle Ages. As to when and where the first decorated leather bindings were made cannot be stated with certainty. There are various opinions concerning the origin of these bindings. Evidence seemed to point to England as their country of origin, and place them in the twelfth century. However, decorated leather bindings dating from the twelfth century have been accredited to Spain.[5] And some twelfth century Romanesque bindings appear to have been produced in Germany. Romanesque bindings which belonged to the Clairvaux monastery in France have been found to be the work of French craftsmen. So it is, Mr. Hobson has come to the conclusion that the art of decorating bindings with engraved stamps was not English, but international,[6] though he points out that all the finest specimens surviving are either French or English.

We know of at least one very early decorated leather binding predating the twelfth century, to which I shall refer later, but it is an isolated example, and there is no indication that this art was in general practice at that time.

The Romanesque bindings were not decorated by means of drawing designs on their covers with a knife or graver, but by impressing figured metal stamps on the leather in "repeat patterns." These remarkable bindings are especially noteworthy because of the great number of finely cut different stamps which appear on them. The stamps represent both Biblical subjects such as Samson and the lion, David with a harp, the Virgin and Child, and subjects of mythical origin like centaurs and mermaids. These incongruous mythical figures appear side by side with the Biblical ones.

Romanesque bindings were produced in England principally at Winchester, London, and Durham, and they were also produced in some monasteries in France. There is scant evidence that any Romanesque bindings of great merit were created outside of these two countries, though a single German example has been discovered, which is characterized by inferior workmanship and tool design.[7] The decoration of all these bindings was doubtless entirely done by hand without the aid of a press, which came into use later for stamped bindings.

A distinguished characteristic of the Romanesque bindings may be noted in the scheme of decoration used. They usually had entirely different designs on their upper and lower covers, in contrast with the later stamped bindings on which the designs were similar on both covers. In this respect the twelfth century binders probably imitated the sumptuous service books then in use in the churches. On these precious metal bindings, the lower covers were flat, to allow the book to rest securely on the altar when not in use, while the upper covers were more elaborately decorated with insets of jewels and embossed designs.

In discussing Romanesque bindings Mr. Hobson protests against foreign critics of England and thinks them prejudiced for two reasons. First, he points out that bibliographers have studied principally the fifteenth century, and he acknowledges

that at that time England was a backward country, "impoverished and brutalized by the long barbarism of foreign and domestic warfare." Secondly, he refers to the fact that fewer mediæval works of art have survived in England than in France and Germany, owing to their systematic destruction in the seventeenth century. For these two reasons, he believes the general impression prevails that England was always backward and inartistic —"a reluctant scholar sitting at the feet of France." But while he admits that this evaluation of England may be just, as far as the fifteenth and sixteenth centuries are concerned, he unequivocally denies that England failed to keep pace with the Continent in artistic initiative outside of this period. He cites the fact that Alquin of York, the English Benedictine monk, was sent for by Charlemagne to direct his imperial school at Tours as early as the eighth century, and gives later instances of English influence on Continental art, concluding with the statement that in the last part of the twelfth century "England was a home of art and letters, no less likely to lead the mainland than to follow it."[8]

In collections of mediæval books found in museums as well as in private libraries, it will be noted that there is a strange absence of examples of decorative stamped bindings identified with the thirteenth and fourteenth centuries. The cause of this is problematical, and will be discussed in a later chapter.

The custom of chaining books to shelves and reading desks was common all over Western Europe in mediæval times and continued down through the seventeenth century (see Plate 6). This practice was no doubt due to the fact that books were difficult to replace and could not be left too accessible to the careless reader or a possible thief. Small books such as Bibles and prayer books were chained to the backs of the pews in private chapels in England, and books chained in churches were quite common in the Reformation days. Whole collections were chained in the large cathedral libraries, each volume being fastened to the shelf in its

assigned place. The chains were of iron, averaging about three feet in length. One end of the chain was fastened to the volume with a ring and the other end was either clamped to a shelf or fastened by means of another ring to a locked iron bar extending along the shelf. The books could be taken from the shelf and rested on a near-by desk provided for the purpose.

The chained libraries at Hereford Cathedral and Wimborne Minster are the two largest and most interesting ones in England. But the largest collection of chained books now extant is that in the Laurentian Library in Florence (see Plate 7). In this library the books are chained to desklike carved wooden stalls. This method of storing chained books differs from that employed generally in England, where the books were placed on shelves one over the other (see Plate 8). The Italian method must have been far more convenient for the reader, since the books were more accessible and their chains were not easily entangled as they were bound to be in the English libraries where they hung from shelf to shelf.

Chained books, or *catenati*, were normally placed on the shelf with their fore-edges outward, and on these edges the titles were written. There are several examples of chained libraries still left in England, in addition to the larger ones just mentioned. A complete list of these libraries is given in William Blades's *Books in Chains*. In the same book may be found excellent photographs of a number of interesting chained libraries.

Although not primarily connected with bookbinding, the introduction of papermaking into Western Europe had a direct influence on the craft of binding, and for this reason I feel bound to mention it. The opinion long held by most authorities on the subject is that papermaking had its origin in China in the early part of the first century A.D. According to Dr. Carter, this early paper was made from the bark of the mulberry tree, from hemp, and from various plant fibers taken from rags.[9] Paper was introduced

into Spain about the tenth century and began to be manufactured in that country sometime during the twelfth century. By the fifteenth century it was made in all the principal countries of Western Europe.

The manufacture by hand of this new writing material was well understood in Western Europe by the middle of the fifteenth century when the invention of movable type set the first printing press in motion. It was a happy coincidence for the first printers that this Oriental discovery had come to the West and had been converted into a European industry, for vellum was found very difficult to print on, and paper, which proved to be a most satisfactory medium for this purpose, soon began to be utilized in sufficient quantity to keep the paper mills busy.

As a result of the revolutionary method of printing books with movable type, their multiplication increased enormously and the printing press was made to do quickly and easily the work that the scribes had been doing for many centuries slowly and laboriously. In consequence, the binder's craft took on a new lease of life and developed from a monastery occupation into an organized craft in the world of book production.

Although the history of block books is not within the scope of this survey, it is a subject germane to printing and binding, and I would remind the reader that these beautiful pictorial books that in the Middle Ages made graphic the teachings of both the Bible and other subjects were printed before the invention of movable type. The art of xylography, or printing from wood blocks on which illustrations and texts were cut, was practiced in a primitive fashion by placing a sheet of dampened paper over the surface of an engraved block after it had been coated with a sort of distemper and then by rubbing the back of the paper carefully with some sort of burnisher until the raised outline of the pattern was transferred to the paper. Even from this sketchy description of block printing, it can be readily understood why most block

books have printing on only one side of the sheet, though some block books were made up of two sheets of paper pasted together, bearing printing on both sides of the book leaf.

These block books were the first books printed in Europe, but the oldest printed book of which we have any record is an Oriental block book in the form of a roll, called the "Diamond Sutra," printed in 868. It was discovered by Sir Aurel Stein in 1907 in the sealed "Caves of the Thousand Buddhas" in Turkestan.[10] This book was in perfect condition when found, owing to the climate in Turkestan, which like that of Egypt preserved intact the books that were buried there.

A picture of the Middle Ages would be very faulty without some reference to the movement, or school of thought, called Humanism, which had a direct connection with the activities in the period following the so-called Middle Ages. Humanism broke through the traditions of scholasticism and devoted itself to a firsthand study of the classics, in order to get a picture of life itself instead of a philosophy about life. The movement began with Petrarch (1304-1374), who has been called the "father of Humanism." In their study of the classics, the Humanists set themselves to clearing away errors in the imperfect texts that had been copied by the monastic scribes, so that when printing came into being, the classics were carefully collated and ready for the printers' use. The Humanists also established what has been termed a "lower criticism" in their endeavor to recover the Latin way of life, stressing man as a free being and demolishing the orthodoxy of the Middle Ages.

The Middle Ages cannot be thought of as a period existing between fixed dates. Our old schoolbooks taught us to place it between the fall of the Roman Empire (A.D. 476) and the fall of Constantinople in 1453, but neither the mediæval period nor the Renaissance can be confined within strict chronological limits, as they overlap and scholars differ both as to the significance of

these periods and as to placing them within definite confines of time. This is understandable, since in Italy we find the spirit of the Renaissance manifesting itself as early as the thirteenth century, whereas in England this spirit was not captured until nearly two hundred years later. Roughly speaking, the mediæval period might be considered as covering about a thousand years, extending from the middle of the fifth century to the middle of the fifteenth. There was a time in the Middle Ages that is usually referred to as the Dark Ages, but certainly this cannot be said to characterize the whole period. Recent mediævalists draw a picture of the Middle Ages which is not unlike what we think of as the Renaissance, and it seems to me that one must construct an idea of mediæval times as representing a period connecting the fifth century with the Renaissance, whenever that may have begun, and overlapping it. I have a conviction that the latter part of the period which has been termed the Middle Ages should be thought of as a period of new birth, or renascence. Whether it is considered a sort of transition period, or a part of either the Middle Ages or the Renaissance, depends upon the accepted meaning of these two periods.

However, for a treatise of this kind, it is necessary to limit periods arbitrarily when there are no exact dates set for them, and for convenience I am reluctantly basing the mediæval period on the popularly accepted opinion that it ends about the middle of the fifteenth century, placing the advent of printing on the borderline, though I am inclined to believe that I am trespassing on the Renaissance in extending the time of the Middle Ages to this late date.

CHAPTER III

RENAISSANCE AND MODERN TIMES

THE revolutionary ideas of the Humanists pervaded the early Renaissance and found expression in the free creative spirit that manifested itself in art. The flowering of this period certainly appears to have sprung from the seeds planted in the preceding period. In book decoration there was a notable quickening of energy and originality in expression, as well as a new enthusiasm for producing beautiful bindings. Printing, without doubt, served to stimulate the craft of binding, and it was in the fifteenth century that stamped bindings under this influence began to be made again after a strangely quiescent period of some two hundred years. The binding of books extended beyond the monasteries as books were produced in greater numbers, and from the first part of the fifteenth century bookbinding began to be developed into a regular craft and trade, keeping pace with the printing press. Bindings of this period, generally in calf and pigskin, were decorated in blind, with ornamental stamps or dies representing flowers, animals, and various stylized decorative subjects. These pictorial designs were enclosed in round, square, lozenge-shaped and other forms, usually bounded by lines.

In addition to ornamental stamps, rolls with a continuous ornamental pattern began to be used at the end of the fifteenth century[11] And later, in Germany, rolls with a pattern divided into segments came into vogue.[12] On these were frequently engraved the initials of the bookbinder, interrupting the pattern of the design. Both individual stamps and rolls were used on the covers of books according to the taste of the binder, the ornamental designs having no bearing whatever on the contents of the book. In fact, the designs were often most incongruous with the subject of the text.

The monasteries used heraldic stamps and images of patron

saints as well as stamps indicating their individual binderies, and they even stamped their full names on the sides of some of their bindings. It is to be remembered that at this time there were book-binders among priests outside the monasteries as well as among cloistered monks. One of the most famous of these binder-priests was Johannes Rychenbach, chaplain at Geislingen in Württemberg, who bound books during the fifteenth century. He is said to be the first binder who signed his bindings with his name.

The two foundations of Gerard Groot the Hollander, who formed the Windesheim Congregation and the Brotherhood of the Common Life in the last part of the fourteenth century, were very active in the production of books. These two brotherhoods made book production their chief activity and they bound books commercially as a regular professon. More books appear to have stemmed from these binderies at this period than from any other single source.[18] The revival of bookbinding in the fifteenth century is undoubtedly in large measure connected with the monastic movement of reform which began in the monasteries after the decay of the Church in the fourteenth century and was continued during the Reformation.

Two very different types of design characterized these blind-stamped books. In one type, the surface of the leather was divided up into compartments and borders by means of lines, and then impressions of small engraved stamps were arranged in the empty spaces. A distinctive style of space division and arrangement of stamps was developed in the various European countries (see Plate 9).

The second type of decoration was marked by a totally different scheme of space division. The design was bolder and less stiff and formal. Instead of dividing up the whole side of the book into a number of parts, the surface was so divided as to form a large central panel set off by a framework of lines. The panel was decorated with a freely drawn design which was impressed on

the leather by means of an engraved die (see Plate 10). Frequently the designs were pictorial and rather imaginative and original. These panel-stamped books are among the most interesting and beautiful of the period. They show a freedom of expression and a creative quality that are lacking in the compartment arrangement of decoration, which by its very structure seems to have been intended for a purely conventional treatment. The Low Countries produced some of the finest specimens of early panel bindings extant, though many of the pictorial examples of French, English and German origin are interesting and delightful.

The fifteenth century binders apparently copied some of their tool forms from the twelfth century bindings, as various motifs characteristic of the earlier bindings reappeared in this later period. Reproductions of the stamps used in both these periods may be found in Weale's *Early Stamped Bookbindings in the British Museum*. In this book Weale gives a minute description of 385 early stamped bindings, from which the reader will be able to gain detailed information concerning the kinds of boards and leather used and the manner in which designs were broken up into compartments or panels. In this connection, Goldschmidt's work on Gothic and Renaissance bindings, Hobson's later book on English bindings before 1500, and other books noted in the appended list of books should be consulted by the student desiring authoritative information about leather stamped bindings.

Blind stamping on leather bindings with small cold tools was first done entirely by hand. The small stamps were cut, as were the panels, so that the impressions stood out in relief, which gives the opposite effect from that made by the heated tools used after the development of hand tooling, which impressed the design into the leather. This seallike cutting left the design depressed in the die, and when it was pressed upon leather previously dampened, the hollows forming the design were squeezed full of moist

leather, leaving the pattern standing out against a flattened background. After the leather had dried, the raised design became hardened and was solidly outlined.

The small stamps in the Gothic bindings of this period were usually arranged in vertical or horizontal rows. Hobson offers a very interesting and ingenious hypothesis to explain the smaller number of stamps used at this time than were used on the Romanesque bindings of the twelfth century. He attributes it to what he calls "the higgling of the market." In other words, it represents an economic situation existing between the stamp cutter and the binder. The stamp cutter naturally wanted to sell as many stamps as possible and succeeded in getting the twelfth century binder to buy stamps in great quantity, whereas the fifteenth century craftsman appears to have been less lavish in his purchases. Mr. Hobson explains this on the ground that the monks, who were the early binders, had the funds of their monasteries back of them, while the later lay binders had no such subsidy and had to pay for their equipment out of their personal earnings.[14]

The technique of stamping the large engraved panel stamps on the sides of a book introduces a sort of mechanized method into binding for the first time, for although the presses that were used for this purpose were operated by hand, they were really machines. They not merely held the book, like the sewing bench and other small presses then in use, but they actually performed the operation of stamping.

This process of impressing the large stamps on the sides of a book is thought to have been achieved by first dampening the leather and then tying the panel stamps on both sides of the book. After this was done, the book was put into a screw press and left under heavy pressure until the dampened leather had taken the impression of the stamp, or die, which had been engraved with the design cut intaglio, like a seal.

The panel stamps were used frequently on the small octavo books, which were produced in quantity soon after the printing press took over the work of the scribes. The panels covered almost the entire surface of the leather on these small books, and probably the binders resorted to their use because the work of decoration was more quickly done by stamping the whole side of a book with a single large stamp in this manner than by decorating the sides of a book by hand with many small stamps (see Plate 11). However, their use cannot be attributed entirely to their laborsaving advantage, for doubtless the spirit of the times impelled the artists and binders to produce these beautiful little books with their free, original designs.

The size of a book is no small factor in the matter of design. It will be remembered that most of the early mediæval books were fairly large, either quarto or folio format (except books of hours and other prayer books), and the smaller octavo books were not frequently met with until after paper was used as a material for the text. Here again we may note the influence of material on the book form, for stiff vellum did not lend itself as did paper to being folded several times and made up into small books. The octavo book was popularized through Aldus, the Venetian printer, about the end of the fifteenth century, and this size was still further reduced as time went on. In the sixteenth century the French printers at Paris and Lyons issued books half the size of the octavo, and in the following century the printing house of the Elzevirs in Holland put out 32mo books, which were printed on thin paper and sold very cheaply.

Covers made of pasteboard were put on books in Western Europe at the end of the fifteenth and beginning of the sixteenth centuries. They were made by pasting several pieces of paper together until the desired thickness was attained. After these covers were fastened to the book, a woodcut design printed on paper in black and white was pasted over both the covers and the back of

the book.[15] Because of their perishable character few of these bindings have come down to us. By identifying the engraver who designed the woodcuts, a number of paper bindings have been ascribed to Ferrara and others to Venice. Some are of German origin, but they differ from the Italian bindings in that the woodcuts were evidently taken from publishers' wrappers, whereas the Italian woodcuts were designed especially for book covers. These paper bindings are exceedingly rare.

A unique style of book decoration was developed during the Gothic period on the Continent by means of cutting the leather and fashioning it so that it stood out in relief. The Germans appear to have excelled in this art, which is generally designated as *cuir-ciselé*, and which according to some authorities was practiced only during the fifteenth century (see Plate 12).

There seems to be some confusion in nomenclature concerning this manner of decorating leather. It is described as *cuirbouilli* by M. de Laborde.[16] Another authority also speaks of Nuremberg and Bruges bindings of this type as cuirbouilli.[17] Two styles of cuirbouilli are described, one cut with a knife and raised in relief (apparently identical with the so-called cuir-ciselé technique), which de Laborde dates back to the middle of the ninth century, and another style which was punched and worked with a stamp or ornamental die used cold, attributed to the fourteenth century.[18]

However, all the authorities describe the cut process in the same way, and as I find cuir-ciselé more accurately descriptive of the method used in producing this kind of leather decoration, I will refer to it by that name. The tools used for these cuir-ciselé bindings were very simple, in contrast to the engraved stamps used for impressing repeat designs on stamped bindings, but the technique employed in executing the designs required much greater skill than that demanded for executing stamped bindings. Each one of these cuir-ciselé bindings represents a different,

original design wrought by hand directly on the leather without any patterned tools. First the leather was dampened, and then the design was outlined on the book cover with a sharp tool or knife and afterwards made to stand out in relief by punching and deepening the leather around the outlined pattern. Sometimes the design was hammered from the back, causing it to appear embossed on the deepened background that was usually worked over by a stippling process similar to the later gold *pointillé* designs.

The outstanding masterpieces of this type of binding are to be found in the Nuremberg specimens, which exhibit great beauty in design and richness in effect. Almost all the cuir-ciselé bindings now extant are of German origin. The French and other Europeans, while practicing this art on various leather objects, apparently did not apply it to bindings. The famous Spanish cut-leather work of Cordova is well known and was apparently imitated in other countries, but as applied to bindings the Germans are the outstanding craftsmen who worked in cuir-ciselé.

Professor Jean Loubier has made an exhaustive study of "lederschnitt," or cuir-ciselé bindings, and in his work *Der Bucheinband* will be found much interesting data on this subject.

Sarre mentions bindings found in Chinese Turkestan dating back to the sixth century which are done in cut leather with solid geometrical ornamentation. He also speaks of blind-tooled embossed bindings found in Turkestan and identified with this early period.[19]

A new method of decorating leather bindings appeared in Europe shortly after the middle of the fifteenth century, with the introduction of gold tooling. Until a comparatively recent date it was the accepted theory that gold tooling "à petits fers" originated in the East and was introduced into Western Europe at Venice, where Eastern workmen practiced this art in the bindery of the Aldus printing house. Most of the authorities on binding

advanced this opinion, but the theory has been attacked in recent years, and a controversy has developed which bids fair to rival that over the European invention of movable type. There are protagonists for various theories as to the origin of this method of book decoration.

The legend about Venice being the "foster mother" of gold tooling has been uprooted in a most convincing manner,[20] and it is fairly well established that the Venetian bookbinders who were thought to have practiced this art, actually used the Oriental technique of gilding their designs by painting in the blinded impressions, instead of gold-tooling them. The Italians are no longer credited with using the Western technique of working through gold leaf with a hot tool until later, probably not before 1480 at the earliest.[21] It seems likely that the art of gold tooling "à petits fers" was a Moorish invention, innovated by the leatherworkers of Cordova, and that it possibly came to Naples (not Venice) from Spain and later spread over the rest of Western Europe from Italy. It has even been suggested that this art was practiced by the Moors as early as the middle of the thirteenth century.[22] However, none of the scholarly authorities on the subject appear willing to commit themselves decisively as to the actual time and place of the invention of gold tooling, though it would seem as though the theory that this art originated in Venice must be added to the other bookbinding myths such as that about Mearne bindings, the identity of Le Gascon, and the Venetian bindings on books bound for Grolier. That it is of Moorish origin appears to be the consensus of opinion.

Gold tooling was not practiced very extensively in Western Europe, except in Italy and France, until the middle of the sixteenth century. Blind stamping continued to be the prevalent mode of book decoration in all the other countries, and the Germans did not take to gold tooling as did the bookbinders in France and England until a later period.

The gold-tooled bindings produced in the sixteenth century and the early part of the seventeenth mark the crest of the craft. The most talented binders of this period commanded large prices for their work and their designs were original, elaborate, and, for the most part, skillfully executed. The French bindings of this period are outstanding examples of richness and beauty, though some of the Italian, English, Scotch and Irish bindings are worthy of great esteem. Spain was not backward in this art of gold tooling, but unfortunately specimens of Spanish gold-tooled bindings are very scarce. Of course Italy has been associated with the new art of book decoration almost since its first appearance in Western Europe.

The method used in tooling book covers with designs in gold as practiced from the fifteenth century on is merely an extension of the process of blind tooling. The design is first drawn or outlined by a disposition of tool forms on a piece of strong thin paper. The size of the book cover is carefully measured, and in making the design these dimensions must be taken into consideration and the pattern worked out in minute detail so that it exactly fits the cover to be tooled. Then the binder selects curved line tools to suit the outlines drawn on the design, assembles his engraved tool forms that compose the design, and proceeds to work out the design with impressions of these tools and curves in dark outline on his paper pattern. The paper on which the design is made is then "tipped," or lightly pasted, in place on the side of the book cover, and the outline of the design is impressed on the leather through the paper by means of heated tools. After this, the paper pattern is removed, the leather is slightly dampened, and the outline is worked over again with heated tools so as to make a clear and crisp impression of the design. This operation is called "blinding-in." After blinding-in, the impressions are carefully painted with a solution of white of egg and vinegar called "glaire." Then a slight amount of almond oil or some other vola-

tile oil is applied over the design by means of a cotton "tampon" so that the gold leaf will lie flat in place when "laid on." Gold leaf is next laid over the whole pattern to be tooled, and finally the various tools and curves are heated and impressed again through the gold in their respective places. Once this is accomplished, the surplus gold is wiped off the surface of the leather, and the outline of the design appears in gold. All straight lines are tooled in the same manner, with a wheellike tool called a fillet or roll, which has a line or lines engraved on it. Both fillets and engraved tool forms are made of metal, usually brass, and are fitted into wooden handles.

The art of gold tooling requires a great deal of skill and can be mastered only after long experience at the workbench. Every piece of leather is an entity in itself and differs from every other leather, so that it takes much practice before a workman is able to determine what heat to use in order to secure a clear, solid outline. If a tool is too hot, the impression is burned in on the leather; if too cool, the gold does not stick. Just the right amount of heat must be used in order to coagulate the albumen in the glaire, for otherwise it does not act as an adhesive agent. Great skill is also needed to be able to "strike" the tools through the layer of gold without doubling the impression.

Morocco leather began to be used extensively for binding books about the time gold tooling appeared in Europe. This leather is the finest of all leathers and the most suitable for elaborately gold-tooled books, just as smooth thick calf and pigskin were suitable for stamped and embossed bindings, and as the skins of stags and does, killed and roughly dressed by the monks themselves, were for the undecorated and rather crudely finished bindings made in the early centuries in the monasteries.

Before the middle of the sixteenth century, after the art of gold tooling began to be practiced, panel bindings, tooled and stamped with gold leaf, made their appearance in Europe. An outstand-

ing example of this type of book decoration is the "pot cassé" binding, designed by Geoffroy Tory. In order to cut the cost of bindings, and probably also to speed up output, covers partly decorated with large panel stamps and partly tooled by hand were supplied to the trade. On some of the small books the entire work was done with a single panel stamp, and many of these little bindings are very attractive. Large center and corner stamps were also used on this type of trade binding, which was often decorated in a rather elegant manner with a design adapted from hand-tooled books of the period. Though originality is lacking in these bindings, many of them display much taste and an honest effort on the part of the trade binders to render an inexpensive binding as attractive as possible. The style is said to have originated in Italy about 1540[23] (see Plate 13).

As learning extended beyond the confines of the monasteries and spread from the clerics to the laymen, European culture developed and produced bibliophiles among the leisure classes. Since a history of famous libraries and noted book collectors is outside the province of this treatise, I cannot dwell upon the subject, though it is tempting to make mention of such libraries as that of King Corvinus of Hungary, who was an ardent patron of bookbinding, who furthered this art and craft greatly by the establishment of a bindery within his own domain, and who imported binders and provided them with every means for developing their craft. Then, too, the libraries created by the Medici are subjects of great interest, especially since the famous Laurentian Library was named after one of this family of book collectors. As for discriminating bibliophiles, they are astonishingly numerous during this period, and such names as Grolier, Maioli, Canevarius, and others, even though they be pseudonyms, are names perpetuated in designating institutions and movements connected with the world of books. The New York Grolier Club is one of the most familiar instances of this practice in America.

Under styles of binding I shall have occasion to refer in more detail to a few great collectors whose names are linked with certain period bindings, as well as to some of the royal patrons and patronesses of the binding art and craft.

During the latter part of the eighteenth century the art in bookbinding deteriorated notably, though the craft of binding attained greater perfection. Very little originality was shown in book decoration after A. M. Padeloup, and from the middle of the eighteenth century until the very end of the nineteenth. I can name no binders who I think showed creative ability of great merit except Roger Payne, and a few binders in France. Excluding the binders decorating their books in the romantic style, they all appear to be adapters and imitators of previous styles of binding, producing bindings decorated too often in bad taste, though tooled with great mechanical skill. The perfectly tooled books of this period suffer greatly in comparison artistically with the masterpieces of design produced on book covers in the sixteenth and seventeenth centuries, when binders created designs devoid of sentimentality, and with impeccable taste. Even though the technique of these bindings was often faulty, they exhibit an inspiration and a creative quality almost entirely lacking in the later period just mentioned.

About the middle of the eighteenth century, the vicious practice of "sawing in" the backs of books became prevalent among hand binders. As to where this method originated, no one seems to have offered conclusive proof, but numerous books appeared without raised bands on their backs, and the style became fashionable, though it had been practiced, particularly in France, before this time.

I refer to this practice as "vicious" because it meant that the actual paper text was sawn into, making cutout grooves along the back of the sections into which the bands were sunk, in order that the book when covered with leather might have a smooth-

surfaced back uninterrupted by raised bands. Along with this practice appeared another equally vicious one, which was that of marbling and sprinkling the sides of books by applying acids to their leather surfaces. Calf was the leather mostly in use for this type of binding, and it lent itself admirably to the "secret" process of producing marbled and other patterns on book covers. The leather covers were considered suitably decorated when bearing marbled patterns, and no other designs were placed on them, but the smooth backs of the books were lavishly tooled in gold. These "full gilt" books had a colored piece of leather set in to receive the title, and they presented a very rich appearance on a bookshelf, but it seems a pity that informed collectors should have countenanced the use of sunken bands and the practice of marbling the leather sides of books, since it must have been apparent to them that by these practices the functional qualities of the bindings were being sacrificed.

At the beginning of the nineteenth century great changes were destined to take place in hand bookbinding because of the development of machines. Although this book is not concerned primarily with machine binding, I shall sketch in a later chapter the process of machine-made edition bindings, or casings, in order to bring out clearly the fundamental differences in the structure of a hand-bound book and a cased book. And now, without dwelling on the history of the edition binding, I should like to refer to its development and point out the influence it had on hand bookbinding.

During the nineteenth century large publishing houses were established all over the Western world. As these large firms put out editions running into thousands, there was necessity for a cheap and serviceable type of binding in which to issue these editions. That sort of binding could not be made by hand after traditional methods because of slowness of production and prohibitive cost. Though for some time the hand binder tried to keep

pace with the new printing machine, by degrees bookbinding machines were developed for this new type of so-called binding, and the hand binder was eventually supplanted by the machine, or edition, binder.

As these changes in binding construction were developing, a change in covering material served to alter the appearance of publisher's bindings. In the year 1821 books covered with cloth began to appear in England. This was indeed a departure from the paper covered publisher's editions then generally in vogue. The credit for originating cloth covered books has been ascribed to Mr. Archibald Leighton, the English binder of the Pickering Classics, but doubt has been cast on this contention.[24] Nevertheless, Mr. Leighton was an ingenious and progressive binder, who later introduced the first stamping on cloth bindings.

From this time on, the mechanization of binding, or casing, of books made rapid strides. The French were slow to adopt the new cloth-covered casings and continued for some time to cling to their paper covers, but the American publishers embraced the idea of cloth-covered books with enthusiasm and proceeded soon to flood the market with cloth casings decorated with flamboyant ornamentation that was confused in design and meaningless. Gold stamping on book covers was introduced in England about 1832, with the publication of Lord Byron's *Life and Works* in many volumes. Embossing machines run by power later speeded up the decoration of publishers' bindings and replaced the small hand-operated arming presses which were first used for stamping these books. In fact, at the crossroads of the nineteenth and twentieth centuries the mechanization of bookbinding was in full swing.

One can imagine the abhorrence with which William Morris regarded these machines when he began to turn his attention to book decoration. He who detested speed and who worshiped the hand product revolted against the tide that was tending to drive

man away from the quiet life where the muses had their sway. He rose up in wrath and anathematized the makers of shoddy products. In his wake followed a few craftsmen who strove to revolutionize the standards of the arts and crafts; and thus began a new movement which projected itself into the craft of binding books. It reclaimed the art of hand bookbinding from its declining level and gave it an impetus that it had lacked for at least a century.

Since the turn of the present century great strides have been made in retrieving the publishers' casings from a state of meaningless decoration. No longer can it be said that these book covers are tawdry or that they are for the most part badly constructed. In the first quarter of this century the protective covering of an ordinary book was anything that a shop foreman chose to suggest for it. In other words, there was little art or science in the matter of providing these books with suitable and well-constructed covers. But as printing felt the influence of the back-to-the-mediæval movement, so did binding, and machine-made books actually began to be designed from the title page to the cover, with excellent results.

As for hand binding in this century, the strides made have been neither so long nor so strong as in machine binding, though the sentimental jumble of decorative forms inherited from the Victorian period no longer appears upon our bound books. We have made progress in eliminating a type of so-called "decoration" that was lacking in art, but little progress has been made in creating anything new in book decoration that might be termed original. Some binders in recent years have been attempting to be "modern." They have succeeded in being different, and often pleasingly different, but on the whole they have failed to be creatively different to the extent of evolving a style that merits the distinction of a name like "fanfare" or "pointillé."

This failure is certainly not due to a lack of incentive supplied

by appreciative book collectors who are continually searching for able binders in order to add worthy specimens to their collections. It is due, in my opinion, to a single cause — that of economics. There is a dearth of artists in the craft of binding, since there is not sufficient remuneration to attract artistic individuals to become professional hand binders, and I think this economic factor is responsible for the lack of artist-craftsmen in the binding profession.

The scarcity of artistic craftsmen may be due in part to the fact that so many talented men were eliminated in World War I. At that time France was certainly the mecca of hand bookbinding and had more able binder-craftsmen than any other country. After the war it was shocking to see how thinned the ranks of the binders had become in the Paris ateliers. Almost none of the veteran craftsmen remained, and in the workshops were raw and untrained workmen with scarcely anyone to teach them the craft. The binding craft in France had to be rebuilt almost from the foundation up, and I fear that, after having made a creditable new start, the craft is destined now to suffer again by the loss of much talent.

The economic influence militating against the development of able hand bookbinders I see no possibility of counteracting. The truth is the profession is poorly paid, and adopting it means an economic sacrifice, because it does not permit one to gain an adequate livelihood. It takes at least five to seven years of training at the bench and another two years of art training to enable a man to become a master binder. And when he has finished his professional training he is not able to earn the remuneration suitable for a well-trained artist-craftsman.

The work of binding a book and tooling it by hand with an elaborate design takes even the most efficient craftsman an unbelievable amount of time to perform, and to this must be added the hours of work spent in creating the design and drawing it

with meticulous care. The master binder's work cannot be measured in time, and it is not paid on a remunerative time basis. So it is that the binding craft loses many potentially able and talented men. If this condition continues to prevail, I doubt very much whether the twentieth century will produce more than a few really expert hand binders who have mastered the technique of binding, who show by their work that they have captured the spirit of this mechanical age, and who express that spirit in the creation of truly artistic, original designs on the covers of handbound books.

CHAPTER IV

EARLY METHODS OF PRODUCTION AND DISTRIBUTION OF BOOKS

ONE of the most absorbing subjects to the bibliophile is the history of early book production and distribution. It is fascinating to follow the manner of producing manuscripts in the monasteries, then in the universities, and finally, when reading was no longer the special privilege of the cleric or the scholar, to find that book production was taken over by the townspeople and became a real industry.

The Greek classics have not come down to us through the efforts of their authors. These writers were evidently not concerned with preserving their writing for future generations, but were content to have their compositions recited or dramatically presented to their immediate public and to receive the approbation of their fellow citizens and gain the laurel crown as their reward. Only a few copies of the Greek classics were produced during the lifetime of the man who wrote them, and these few were for the most part the property of the Crown or of the state, and seldom belonged to individuals. There was no zealous or systematic effort in book production until it was developed in Alexandria under the Ptolemies, when the classics began to be transcribed and distributed.

Later in Rome, during the Augustan period, Greek manuscripts were imported along with Greek scribes, and the production of books took on great importance. Active trade in books was carried on with other Italian cities, as well as with Spain and Gaul, and even with the distant Roman towns of Britain. It was during this Augustan period that, for the first time, the works of contemporary writers were copied and distributed extensively to a reading public in distant parts of the world. This appears to be the beginning of an efficient system of production and distri-

bution of books. But it was destined not to last for long, for with the fall of the Roman Empire the well-organized book trade came to an end. The wealthy patrons of the publishers disappeared, literary production almost ceased, and the system of transportation broke down so that communication even within the Empire was difficult. Thus it was that the auspicious beginning of the publishing of books as a business was interrupted and failed to be revived systematically until it was taken up by the universities of Bologna and Paris seven centuries later.

Meanwhile, the scribes of the monasteries were rendering a great service in rescuing the classics for posterity. It was through their efforts that these writings were transcribed and preserved. Protected as they were in their fastnesses of quiet during these times of social and political upheaval, they worked assiduously, laboriously copying texts which, though doubtless intended for use in their own times, proved to be for the benefit of future generations. The scriptoria in the Western monasteries were chiefly concerned with copying service books and the Scriptures, and had no interest in the classics. St. Martin of Tours impressed upon the monks the importance of copying the Scriptures, but apparently was not concerned with matters of secular learning. It was Cassiodorus, the scholar-monk, who in the sixth century established the first mediæval scriptorium in the south of Italy and who introduced the practice of copying not only the Scriptures, but works of classical literature, geography, and rhetoric, for he felt that these subjects were not necessarily in discord with Christianity. He emphasized the importance of accurate copying, and in his *Institutiones* prescribed in detail technical practices for the scriptoria. The scriptorium established by Cassiodorus at Viviers became a model for the Benedictine monasteries.

While at first the art of writing was introduced into the monasteries to keep the idle monks busy or to supply religious books for the use of the religious community, it became later an im-

portant and systematized monastic practice, and the most intelligent monks were chosen for the work. On the Continent, the monastic schools of scribes at Tours, Corbie, St. Gall, Fleury, Bobbio, and Corvey were among the most famous at an early date. And in England the scriptoria of St. Albans and St. Augustine of Canterbury, and the Benedictine school at York, were noted for their copyists.

The Benedictines produced more scribes than any of the other religious orders on the Continent, and to these were added scribes brought over from Ireland and England by missionary monks. Cloisters were founded by the Irish monk St. Columban, who came to Gaul and set up religious houses and scriptoria, the one at Bobbio being especially famous. During the first half of the eighth century St. Boniface arrived on the Continent, bringing with him Saxon scribes and founding monasteries in Germany, among them that at Fulda, which became a great German center of learning in mediæval times. The most noted scribe to come to the Continent was the scholarly Benedictine English monk Alquin, who had been master of the cathedral school at York. Charlemagne, seeking to raise the standard of learning, had to search for his teachers among the monks, as it was only in the monasteries that scholarship could be found, and he induced Alquin to come to Tours in 782, putting him in charge of organizing the imperial school there. Alquin also instituted a school in Aachen and, later, one in Milan, which were placed in charge of Benedictine monks. The script developed in these Benedictine scriptoria under Alquin stands out as one of the most beautiful "hands," if not the most beautiful, produced in the history of writing, and its origin was undoubtedly English. It served later as a model for the type-founders of Italy and France.

Some of the theological texts were *palimpsests*, manuscripts copied on vellum sheets taken from texts of Latin classics which had been erased. This practice was evidently due to the scarcity

of vellum. Happily, many of these important erased texts have since been deciphered by photographic processes and by the use of certain chemical reagents, so that they have been reclaimed. The transcribing of all these texts was done in large rooms, or in small individual cells, and sometimes even in the open cloisters, where the monk had little protection from the elements.[25] In a former chapter I have given some particulars about the organization of the work in the mediæval scriptoria.

So it is we find that the production of books was entirely in the hands of the monks, with some lay assistance, from the fall of Rome until the thirteenth century. Toward the end of the century the activities in the monastic scriptoria began to decline, first on the Continent and then in England. The demoralization of the monks and the laxity of the monastic life at this time are well known, and because of this, the decline in production of books may be readily understood. At about the same time, with the development of the universities of Paris and Bologna, the demand for textbooks became pressing. Lay scribes were called in and were employed by the universities for manifolding these texts. This soon brought about changes in the control of book production and distribution. It was at this time that the first guild of writers was established. For the previous six or seven hundred years the monks had been the distributors of books as well as the producers of them, though individual wealthy collectors often had their own scribes housed in their palaces to produce the items for their libraries, the texts sometimes being borrowed for the purpose of copying. But the "trade," such as it was, was largely a monastery activity.

The passing of entire control of education from the monasteries to the universities was a gradual process. Even after the universities came into being, the monks continued to exercise control over theological teaching and turned this control to account as members of the staffs in the universities. However, learning

was broadened. Four divisions of university instruction were established — Theology, Philosophy (which included Art), Law, and Medicine. While the monasteries still directed the teaching of theology, and the Church strove to keep under its direction the teaching of philosophy, the branches of law and medicine were entirely free from ecclesiastical influence, and the lay scholars made their influence felt. The fact that the Church was no longer entirely directing matters of education had an important effect not only on learning, but on the making and distributing of books, though for some time after the universities of Bologna and Paris began to employ lay scribes for producing books, the monasteries continued their work of copying texts and aided considerably in the preservation of literature.

The universities of Bologna, Paris, Padua, Oxford, and Cambridge grew out of the ecclesiastical schools already in existence and were not new "foundations," as were the later universities such as Prague. But we are not concerned here with this development, except as it relates to the making and distributing of books. There was no selling of books in the universities at first, in the sense that an individual might buy a book to keep as his personal possession. Books were rented to students and to instructors at rates that were prescribed by university regulation, and they were not allowed to be taken out of the university town. Only the use of books could be bought for the duration of time the purchaser remained in the town, and a heavy fine was imposed for any infraction of this regulation. *Stationarii* were appointed to see that the books recommended for use in connection with various courses were manifolded and made available. In the hands of these stationarii, under university regulation, rested all matters pertaining to production and distribution, but originally the output was specialized and merely augmented the production in the monasteries. No general distribution of books was undertaken in the universities during this first period of their existence, though

later it became the practice actually to sell instead of to let out the texts, as was the custom in Paris and Bologna during the thirteenth century and the first part of the fourteenth. The stationarii, who were commissioned first in the University of Bologna, were men who had some scholarly knowledge, and after certain preliminary examinations as to their suitability for this office, they were appointed by representatives of the university.[26]

Book dealers came into existence in the city of Paris, but they were organized in a guild within the university, and the guild was directly controlled by university authorities. Scribes were working in the Latin Quarter of Paris supplying textbooks for the university as well as literary productions for the scholars of Europe. This book trade included not only scribes, but illuminators, bookbinders, sellers of parchment and later of paper. The trade was encouraged by Charles V, who issued letters patent in 1369 declaring that all dealers and makers of books required for the use of scholars should be exempt from all taxes. This exemption included all members of the book trade, such as bookbinders, illuminators, et cetera, and the encouragement of the production of books by release from paying taxes continued even after books began to be printed. No such policy prevailed in Italy or England.

Although the university exercised the strictest supervision and control over the bookdealers, a monopoly was granted them, and no one but a *librarius*, or a licensed bookdealer, was allowed to engage in the trade in a regular shop or place of business. Penalties for infringement of this law were severe. However, the privilege of trade in the selling of small manuscripts, such as broadsides or single sheets on which a Credo or a Pater was written, was allowed to peddlers, who sold their little written texts from a cart. This privilege was regulated by the value of the manuscript, and the peddler was permitted to sell only manuscripts limited in price to ten sous, which amount, considering the relatively high

price for manuscripts in the Middle Ages, could buy little of commercial value. In spite of the fact that the book trade of Paris was conducted under severe restrictions, it flourished, and in the thirteenth and fourteenth centuries Paris became one of the chief centers of the manuscript trade in Europe. Florence was at that time also established as a great center of the book trade.

In the German universities the work of book production was carried on by stationarii in a manner similar to that originating in Bologna, but the importance of their work was not as great as it was in the universities of Italy and France. It has been suggested that the German students were better informed and more industrious than those of other countries and that consequently they did much of their own transcribing. All the Continental universities followed much the same procedure in producing and distributing books at this early time. However, the production of books in the universities did not affect the work of the scribes in the monasteries, where work in the scriptoria continued active for several centuries.

In the English universities the "stationers" were not strictly regulated[27] and the book trade in England did not develop in the universities as it did on the Continent. London, instead of the universities, was the center of the trade, and it was there that the bookdealers plied their trade in manuscripts from bookstalls outside of St. Paul's Cathedral. A stationers' guild was formed in 1403, and the first English stationers' guildhall was built near the cathedral. Later, the activities of the London book trade were moved to Paternoster Row, which became the publishing center of England.

In mediæval times manuscripts were usually sold from stalls found in the vicinity of the universities, but on the Continent, as well as in England, bookstalls were frequently clustered about cathedrals and churches or in the open market squares. In time, manuscripts were offered for sale at annual markets and fairs.

During the first half of the fifteenth century many of the manuscripts produced might be classed as works of art, because of the beauty of the script and of the illustrations. Centers for selling these products of the scribes and illuminators were chiefly in the Low Countries and in Germany. They could be found in such towns as Bruges, Ghent, Antwerp, Aix-la-Chapelle, Cologne, Augsburg, Strassburg, Ulm, and Vienna.[28] Of all these centers Bruges probably had the most highly developed art, and the dukes in the wealthy domain of Burgundy manifested great interest in art and literature. They were avid collectors of literary productions, and in many instances they maintained staffs of skilled illuminators, scribes, and binders to produce books for their libraries.

Just what effect the guilds of the scribes and the bookbinders had upon the production of books in the Middle Ages is open to question. They certainly served to preserve the integrity of the workman and appear to have protected him to some extent from interference in his work. The restrictions imposed by royal decree on binding could not have had much effect on the art or craft of book decoration, since these restrictions were concerned mostly with matters such as the quantitative limitations of jewels that were permitted to be used in adorning book covers. The number of jewels allowed to be used on a binding was commensurate with the rank of the individual nobleman for whom the binding was to be made. This limitation could not have materially curbed the imagination of the artist who designed the book cover nor have interfered with the work of the craftsmen who executed the technique of the binding.

In mediæval England, as in Greece in the early centuries, literary productions were read aloud to the masses. At a time when reading and writing were not common and when books were rare, the English reciters and minstrels made known to the populace much of the English poetry and other literary productions.

Thus it was that popular literature was passed on to the public, though perhaps not accurately, before printing could record it.

There were undoubtedly trained scribes in England outside of the monastic scriptoria before the advent of printing. The romantic Canterbury Tales of Geoffrey Chaucer were copied by the scribes, and Caxton included them among his first publications. Books in manuscript were sold at fairs such as those at Stourbridge, St. Giles (near Cambridge and Oxford), and St. Bartholomew in London, but the manuscript dealers do not appear to have been allowed to carry on their trade within the cathedrals as was the practice in Germany and France.[29]

In Holland, the "Brothers of the Common Life" made one of their chief occupations the production of books, and they conducted a lively industry in the selling of their manuscripts. Unlike the monastic scribes, this religious order established a book trade expressly for the purpose of supporting the activities of their organization, and they used the profits of this trade in their missionary work. In 1383 Gerhard Groote founded a Brotherhood house in Deventer, Holland, and he was instrumental in establishing other houses, such as the Windesheim Congregation, in the Low Countries and in Germany. The full importance of the work of the foundations of Groote has rarely been stressed in appraising the influence of various sources on the production and distribution of books. But aside from the fact that through these foundations texts were multiplied enormously in the Middle Ages, these brotherhoods initiated and organized commercial manufacture of books in their religious houses. Moreover, instead of issuing their books in Latin, which had been the distinctive language for literary productions, they issued them in the language of the country where they were produced and distributed. This, of course, provoked the opposition of the Church, which relegated to itself the privilege of interpreting for the masses all written documents.

While this progressive brotherhood issued their texts with careful editing, they wasted no expense on decoration and embellishment. These were cheap texts for the people. In keeping with their independent and practical outlook in all matters, they immediately seized upon the advantages of the printing press and utilized this new invention by setting up printing presses in connection with their houses in the Low Countries and in Germany. In addition to the output of these establishments, the production of manuscripts continued active in Germany, especially in the monasteries of St. Peter at Erfurt and of St. Ulrich and Afra in Augsburg, some time after books had begun to be printed.[30]

The activities of the scribes did not cease immediately after the introduction of printing, but were still carried on in the sixteenth century. Many scholars continued to prefer written texts to printed ones, in spite of their greater cost, and there was evidently a feeling among some scholars that these cheaper books coming from the printing presses were not worthy of being used by the learned.

After movable type was implemented to increase the production of books, and the machine was used to augment the limited output of the scribes, book production took on a distinctly businesslike aspect. There was then need to set up some sort of organized effort to dispose of the products of the printing press. We find that Fust and Schoeffer went to Paris in connection with disposing of their books soon after they were printed and that they kept there a permanent agent.[31] Schoeffer, together with other printers of his time, maintained traveling agencies for the sale of books, and these firms suggested on their announcements that their agents could be found at certain places. Thus the first evidences of book advertising appeared soon after books began to be multiplied by mechanical methods.

However, owing to the difficulties of transportation and to the dangers of travel in the Middle Ages, it was not a simple matter

to reach a buying public for the sale of books. So it was that the various sacred festivals were utilized as a commercial opportunity for disposing of books. These festivals occurred at regular intervals, and great crowds assembled, as at the earlier festivals of Delos and at the Olympic games, where advantage was taken of the huge gatherings for purposes of trade. The Church turned the mediæval fairs to her profit by exacting payment from merchants for the privilege of selling goods at these festival gatherings. In Rome great license was taken in conducting trade in the precincts of the churches during the feasts of the saints, though in England such desecrations of the church or the church-yard were forbidden during the reign of Edward I. Most of the festivals held in mediæval England and on the Continent were held through grants from the ruling monarchs to the abbots or bishops, and the tolls exacted for the privilege of trade were often considerable. The Germans designated these religious celebrations by the term "Messen," while in Flanders such a festival was called a "Kerk-misse," and in France, a "Kermesse." The Kermess, as it is termed in English, was originally a mass held at the dedication of a church, though it degenerated into a public orgy in time, finally coming under the regulation of the law.

Aside from these religious festivals, there were trade fairs held which the populace, and especially merchants and prospective buyers, were encouraged to attend. Safe-conduct was granted to all people visiting these fairs, and the ruling kings sought to induce the merchants to frequent them by offering them special privileges as a reward for their participation. In Germany the three great fairs were in Frankfort on the Main, in Frankfort on the Oder, and in Leipzig. The greatest of these book fairs was at Leipzig, where the fair continued for three weeks. Until the recent war disrupted trade, the Leipzig fair was held three times yearly, and it attracted merchants from all over the world. The most important Leipzig fairs were those held at Easter and

Michaelmas, which are said to date back as early as 1170. The New Year's fair, which was first established in 1548, is of lesser importance. In mediæval times these Leipzig fairs were held to be so important to the book trade that for fear of encroaching on their attendance no other fairs were allowed to be held in the vicinity so long as the Leipzig fair was in session.

Charles IV, in the fourteenth century, held out inducements to traders visiting the great fair at Frankfort on the Main. In the charter given for this fair, it was specified that during the continuance of the fair and for eighteen consecutive days before and after it "merchants would be exempt from imperial taxation, from arrest, from debts or civil processes of any sort, except such as might arise from the transactions of the market itself." It is evident from the inducements offered the booksellers to attend these book fairs that the rulers of the various countries were interested in furthering an active trade in books. The Frankfort fair is said to have attained great activity as early as 1485.

But it was not alone the booksellers who made excursions to the Frankfort fair. It became a rendezvous of scholars, printers and publishers, booksellers, and purveyors of paper, parchment, and other articles used in the book industry. This fair, in mediæval times, exerted a powerful influence on scholarly endeavor in the literary field. It was not just a book mart where the products of the printing press were sold. It had something of the significance of a club where men interested in books from various angles congregated, discussed, and planned. One can visualize the learned printer-publisher Henri Estienne sitting in conference with Venetian printers and with bookmen and printers from all over the Continent. He might even have chatted with Sir Thomas Wotton, who is said to have stopped at the Frankfort fair in 1589 to arrange for the publication of his edition of Aristotle.

Although the Frankfort book fair, held as it was in a com-

mercially important town, was of international importance, the publishers of England, of some of the Scandinavian countries, and of Spain and Portugal were not so well represented there as were the publishers of other European countries. The Leipzig fairs manifested less of the fraternal spirit to be found in the Frankfort fairs. They were more like business institutions, though they have produced a very stimulating influence in the book world. This influence of the Leipzig fairs has been felt through the opportunity offered to view and compare examples of book production on a scale equaled in no other one place.

One of the oldest fairs in France is that of St. Denis, the charter for which was given to the monks by Dagobert, King of the Franks, in A.D. 642 "for the glory of God and the honour of St. Denys at his festival." The ancient fair at Lyons had been celebrated as a book fair up to the end of the sixteenth century. Lyons vied with Leipzig and Frankfort as a mart for carrying on the book trade. In England, it was only after the Norman Conquest that fairs took on any importance. The first grant recorded was that of William the Conqueror to the Bishop of Winchester "for leave to hold an annual free fair at St. Giles hill."

Fairs began to be of less importance to trade when better means of communication developed. In England, they were abolished "because of the evil effect on public morals" — whatever that may mean — and the London fairs were done away with as "public nuisances" after the last fair of the famous St. Bartholomew. Most of the French fairs were swallowed up in the Revolution, but the greatest of all the book fairs, that at Leipzig, continued to be an important event in the book world.

It should be noted that the first German printers of books marketed their own productions, and they reached their buying public through direct contact, and through both resident agents in large towns and traveling salesmen, as well as through fairs. All the Continental printers at that time appear to have followed

this same procedure, but the German printers doubtless had the best organized book trade in the early days of printing, as may be judged by the fact that they issued regular announcements of publications about to be put upon the market and took care to make known where their agents might be found. This custom was not exclusively German, but seems to have been more systematically practiced by the German printers than by those of other nations.[32] Toward the close of the fifteenth century, books began to be sold through firms of organized booksellers, and the trade in marketing books gradually went out of the hands of the printers. In other words, at the end of the fifteenth century books were no longer sold direct to the customer by the printer, but were marketed through other business firms.

The achievements of the great printer-publishers of the fifteenth and sixteenth centuries are well known, and while it is not my purpose to discuss the matter in detail, I should like to point out that, in view of the fact that so many of these men were scholars and editors of their own publications, their success as businessmen is all the more phenomenal. It was no simple matter to develop a book trade such as Aldus established in Venice, the Kobergers built up in Nuremburg, and the Elzevirs developed in Leyden and Amsterdam. I am not selecting these particular printers because they are worthy of mention above others, but because they represent the heads of printing and publishing concerns doing business from Italy to the Netherlands under the same conditions of trade. When one considers the restrictions imposed through crude means of communication and the operation of guilds, of monopolies, and of censorship of the Church, the accomplishment of these early printer-publishers looms large in the history of the book trade.

CHAPTER V

BOOKBINDING PRACTICES

ALTHOUGH the basic principles involved in binding a book by hand have not changed all through the centuries from the very beginning up to the present time, practices peculiar to certain countries have served to modify the superficial characteristics of hand-bound books. These practices often merely set a new style in binding and may even have been due to the taste of the collector who ordered the binding. Then, again, they were dictated by practical considerations in handling new materials and in meeting new conditions arising from the changed formats of books. Rarely have they been so revolutionary as to threaten the fundamental structure of bindings. The technique of binding a book and encasing it between covers has been marked by no such national differences as may be found in the decoration of bindings.

Methods of flattening the folded sections of books have ranged from beating them by hand with a heavy hammer (see beating stone, Vol. II, Fig. 49) to compressing them by means of a screw press. The manner of sewing the sections together universally followed that which was used by monastic binders until smooth back books, with sawn-in bands, were introduced by French binders in the seventeenth or eighteenth century, when the sewing thread was merely passed over the "cords." Since that time this less strong method of sewing has continued to be employed by many hand binders throughout the Western world, but "extra" binders have adhered to the ancient practice of sewing their books by wrapping the thread completely around cord or some strong material, as they fasten one section to another.

Leather thongs, flat or twisted strips of vellum, and actual cords were used for holding sections together all through the Middle Ages and continued to be used in the early part of the

Renaissance. Vellum strips were used by hand binders even through the nineteenth century for account books and the like, but cords began to be the favored material for this purpose after the octavo format was made popular by Aldus, the Venetian printer. Cords were then used for both large and small books; the large books being sewn on double cords and the smaller ones on single cords.

These cords represent so-called "bands" after the books are covered. Bands of books have varied in number, as well as in width, but there appears to have been no marked national characteristic in respect to the number and disposition of bands except in Italy, where in the sixteenth century the use of alternate double and single bands was a practice peculiar to that country. Broad or double bands were mostly used in Western Europe in early times, and their number varied generally from three to six or more, with three or four bands predominating on the earlier books and increasing in number on the later ones. They were disposed at more or less regular intervals down the back of the book. Smooth backs, made possible by sewing the sections of books on flat strips of parchment or leather and concealing them, were characteristic of the Maioli, or Mahieu, bindings, and the absence of raised bands may be noted on bindings of the Eve school of binding toward the end of the sixteenth century. The material used for sewing around these cords or flat strips was usually linen thread, though silk thread was used at a later date, and both linen and silk thread continue to be used by hand binders. It was Mr. Cobden-Sanderson who, at the end of the nineteenth century, made silk thread popular for the sewing of books, but happily its popularity has waned, for most books cannot be as firmly sewed with silk thread as with linen.

The sewer in mediæval times made the headbands of a book while sewing the book. The linen sewing thread passed continuously through the sections, around the cords on the back of the

book, and over the headbands at head and tail, without interrup-
tion. When the sewing was finished and the book was ready to be
laced to its boards the two ends of the headband material were
led through grooves on the sides of the boards, were laced
through them to the inside at an angle sloping toward the head
or tail of the book, and were securely fastened (see Fig. 95, Vol.
II). This practice of headbanding was discontinued after medi-
æval methods gave way to the less crude practices of the Renais-
sance, and when head and tailbands became a more decorative
feature of a hand-bound book. They were then woven onto the
back at the head and tail with colored threads, instead of linen
thread, after the sewing was completed and were made with a
finish which formed a line of beads across the head and tail edges
of the book.

The material used for the basis of these headbands varied. It
was of cord, round gut, or of narrow pieces of vellum pasted or
glued together. The French binders introduced the use of round
windings of paper for their headbands. They employed them in
tiers of two, a small one on top of a larger one, and introduced
what is known as the "tranchfille chapiteau." These double
rounded strips were wound round with variegated colored silks
forming beads across the head and tail edges. They are perhaps
the most decorative of all styles of headbands, and they have been
copied down to the present day. Double headbands have also
been made over glued cord or cello string without a bead finish.
These were usually made with linen thread. A very distinctive
type of headband is found on bindings of Greek MSS. It is a
double-tiered headband which protrudes beyond the line of the
book boards (see Plate 35). Though very decorative, it is not prac-
tical for books that are to be placed upright on shelves, since the
leather covering it would be quickly worn out in removing the
book from the shelf.

The use of end papers has been marked by some changes due

mostly to the introduction of new materials. The form of end papers from the time they were first used continued to be simply folded sheets of paper or vellum up to the present century, when Mr. Cockerell introduced an inventive folding of end papers with what he terms a "zigzag," which reduced the strain at the joint of a book where the end paper hinges on to the cover (see End Papers, Vol. II).

It was customary in mediæval times to reinforce an end paper over the joint with a piece of vellum or strong paper. This strip was sewed with the book and was pasted down on the board over the joint before the end paper was lined down. The Italian binders left this reinforced material with a jagged edge where it rested on the board, while in France the binders trimmed off the edge neatly. This difference in finish has often been an aid in determining the source of a binding. The practice of reinforcing an end paper in this manner is still continued by hand binders when binding heavy books of reference. The material now used is a piece of strong cambric, and it is sewed with the book by "extra" binders, though "job" binders frequently merely paste it over the joint of the book.

Many of the texts of manuscripts and early printed books were not protected by end papers, and consequently the first and last pages of these texts came directly next to the covers. When any protection was used it was in the form of a vellum flyleaf, or one-half of a sheet of folded vellum, often cut out of some earlier manuscript, was let to fold over the text and the other half was pasted down on the cover board. The technical difference between an end paper and a flyleaf is that an end paper consists of a folded sheet one half of which lies over the text at the beginning and end of a book and the other half is pasted down on the opposite cover board, whereas a flyleaf is a single unfolded sheet that covers the text at the front and back of a book.

In the sixteenth century a combination of vellum and paper

was used for end papers. Some of the Grolier bindings and French bindings of the same period had one vellum end paper and three or four white papers at the beginning and end of the text, but the number and arrangement of end papers in bindings of the sixteenth and seventeenth centuries varied. Frequently a greater number are found in the back of a book than in the front. Variation in number has continued down through the centuries and exists at the present time, though most extra binders show a preference for three leaves preceding and following the text. A fourth leaf of an end-paper section is usually pasted down on the inside of the cover board.

The materials used for end papers also have varied. Marbled papers were introduced into Western Europe and were used as end papers along the end of the sixteenth or beginning of the seventeenth century. Printed block papers, lithograph papers, paste papers, and various decorated papers of different types have all been used for the end papers of books. Vellum, paper, silk, and leather have had their vogue as flyleaves, and doublures of leather, silk, and other materials have been used on cover boards opposite these flyleaves for several centuries. Leather doublures, which were first introduced in France at the time of Le Gascon, are found in his bindings with marbled papers facing them. The origin of decorated papers used in bookbinding will be found in the following chapter under "Materials."

Wooden boards were used for the sides of books throughout Western Europe until after the middle of the fifteenth century, when pasteboard began to be substituted for wood for this purpose. The substitution of thinner boards for the thick cumbersome wooden boards represents a practice in binding that followed logically when books began to be made in a more convenient size, as learning extended their use. Pasteboard was used for book covers in the East long before this time, and appears to have been first fabricated by pasting sheets of paper together. The

mediæval binders, following this method, frequently employed the wastepaper from the early printing establishments to make up their book boards, which practice has often served as a clue to the origin of a binding. No longer, however, are book boards made up by the binders themselves, but are now manufactured for the use of binders out of a pulp with a paper or rope base.

In mediæval times wooden book boards were often beveled where they rested next to the back of a book, and the heavy cords or thongs on which the book was sewed were laced through the boards from the outside and were fastened on the inside by means of a wedge, or the cords were pegged from the outside of the boards. In Greece and the southern Slavic countries grooves were put on the edges of the book boards and this style of grooving boards was copied in Venice, Lyons, and Paris during the sixteenth century on bindings of Greek manuscripts, and occasionally on books printed in Greek. Until the beginning of the fifteenth century the boards were made flush with the text of the book, and then after books began to be placed in an upright position on shelves, the board covers were made to project beyond the leaves of the book.

Originally, books were laid on shelves on their sides, and their leather coverings were protected by metal bosses and metal corners. Titles were written on the fore-edges, which were placed outward, and they were also written on pieces of vellum which were usually fastened above the center bosses on the obverse sides of books, and were covered with horn or some other material. In Germany, during the fifteenth century, titles were not infrequently painted in gold on the sides of books. This custom appears to be peculiar to South German binders.

The usual practice in early times of leaving the backs of books plain and placing the titles on the fore-edges or sides is undoubtedly due to the fact that backs of books were merely glued up by the early binders and were not rounded. They consequently had

a tendency to sink in and did not offer a suitable surface for a title. Books were not rounded and backed until pasteboard began to supplant the use of wooden boards for the sides of books, but while this rounding of backs made a smooth-convex surface on which a title could be placed to advantage, it served to constrict the back and made for a less supple opening of the book. It was not until the second quarter of the sixteenth century that books were lettered on the back, and the practice did not become a universal one until much later. The introduction of this new manner of placing titles on books is attributed to Italian binders.[33] Before this time, however, the backs of stamped bindings were sometimes decorated with impressions of tool forms like rosettes, as shown in the Nuremberg type of binding, though the backs of the majority of the early stamped bindings were left plain.

The covers of books were frequently held together with metal clasps. Two clasps placed on the fore-edge were characteristic of books bound in the western part of Europe — in western Germany, France, and England. In Italy, Spain, and the eastern part of Europe four clasps were used; one being added at the head and one at the tail of the binding. Mediæval bindings often had flat strips of brass bound around the edges of the covers, and rings were fastened by rivets through the board edges so that books might be chained. The rings on books bound in Italy were fastened at the tail of the books, those bound in France, Germany, and the Netherlands had their rings attached to the boards at the head, while the English binders riveted rings on the boards at the fore-edges.

Not only did the number of clasps vary in different countries, but the manner of placing clasps varied as well. The English, French, Italian, and Spanish binders usually put the clasp on the upper cover and the catch on the lower one, whereas the binders in Germany and the Netherlands reversed this method, and placed the clasp on the lower and the catch on the upper cover.

Mr. Oldham, in his *Shrewsbury School Library Bindings*, points out that the position of the clasp and catch on a binding constitutes very telling evidence in determining the nationality of a binding.

As early as the fourth century, when book covers were laden with gold and jewels, book-edges are said to have been stained with purple. While the edges of books were at first plainly tinted, the practices of gilding, marbling, gauffering, and painting on book-edges followed, and were used, with variations, in all European countries (see Decoration of Edges, Chapter VII).

The leather used for binding purposes was made from the hides of both domestic and wild animals. The hides of oxen, asses, calves, sheep, pigs, and even horses, as well as skins of stags, does, goats, seals and other animals, were all prepared and used for covering books during the Middle Ages. Calfskin was the leather most usually employed for bindings in France, England, and the Netherlands during the fifteenth century; morocco was mostly used in Italy and Spain, and pigskin in Germany. Asses' skins are said to be found almost exclusively on bindings produced in south Germany, Venice and Lombardy,[34] while the skins of seals and sharks were frequently used in countries which border the seas in the north of Europe. Calfskin was especially suitable for stamped bindings on account of its smooth pliable surface, and this doubtless explains why the panel-stamped books of the Low Countries, which was the birthplace of this art, are mostly of calfskin. A leather called chevrotain, or cheveril, as it is known in England, was made use of in that country in early times for the covers of books. It was fabricated from the hides of the small guinea deer and, like that made from the skins of does, lambs, and sheep, was very soft and supple.

Practices in the craft of hand bookbinding were for the most part similar in all European countries up to modern times, though, as we have noted, minor innovations made their appear-

ance in the technique of forwarding, and certain materials were more favored by the hand binders in one country than in another. Characteristics peculiar to the various countries will be pointed out in the following chapter with reference to the art and technique of decorating book covers, and there appears to have been greater originality shown in the art than in the craft of binding. Considerable inventiveness of craftsmen is apparent in connection with the mastering of new techniques necessitated, for example, by the introduction of panel stamps, by the change from tooling in blind outline to an outline in gold, or in the inlaying of colored leathers into a tooled design. Each of these inventive practices originated in some particular country, but except perhaps that of gold tooling and a few minor practices expressive of the taste of the binder, they were dictated by necessity and were not the outcome of some imaginative conception. They became universal practices without marked alteration in technique, and very few differences in the manner of forwarding a book serve to indicate the origin of a binding, though the use of particular materials often betrays its source.

After the Middle Ages, the craft of bookbinding was constantly tending toward greater refinements and finish, and the art of book decoration reached its zenith, at least temporarily, before the end of the Renaissance, when both the art and the craft of binding appear to have descended from their lofty planes. This decline seems to have foreshadowed the oncoming of a new period, and may have been entirely due to the social and industrial changes then taking place, for the patrons of bookbinding were not left untouched by these changes.

The nineteenth century might be termed a transition period. Before the end of this period demand for all manufactured articles, including books, was incessant and importunate, inventions were revolutionizing all crafts, transportation and communication services were perfected which served to jolt book-

binders and other craftsmen out of their accustomed placidity, and gave them no pause. The demand was for rapid production, and these men, trained to use their hands to bind books, found themselves pitted against new conditions and efficient machines which were utilized for the purpose of increasing production. Increased production became a necessity if the public demand for books was to be satisfied. As a consequence, the craft of binding developed a new technique — that of "casing" a book by machine.

And thus it was that hand binders were faced with a sort of competition that was new to them, and that took away from them a monopoly in the field of bookbinding that they had held undisputed for so many centuries. The stormy petrel of ill omen to hand bookbinders was speed, and the slow method of binding a book by hand was seriously challenged for the first time.

Before the end of the nineteenth century the craft of binding began to be carried on in binderies specializing in different methods of performing the operations of fastening the sections of texts together, putting them into covers, and decorating them. Bookbinding establishments were classified into what are known as "extra" binderies, "job" binderies, and "commercial" binderies, depending upon the methods used in the work. From this time on the extra binders' work has been almost entirely confined to the binding and rebinding of single books demanding special treatment and originally designed covers. The job binders take on books in large quantities which they bind or rebind in quantity lots, and the so-called commerical binders do not "bind" books in the technical sense of the word, but "case" them. The "casing" of the commercial binder serves as a temporary protection to the text of a book, whereas the "binding" of the extra and job binder is so constructed that it performs the function of protecting a text with a degree of permanency limited only by abuse and the quality of materials used in the work.

The work of the modern extra binder is done entirely by hand, except in the matter of cutting and pressing, for which he employs cutting and pressing machines, and his practices conform closely to those which have come down to him from mediæval binders. The various processes of hand binding are explained in Vol. II. The extra binder's shop is a one- or two-man shop with the possible addition of a woman for mending and sewing books. The numerous operations of binding a book by hand fall under the two main classifications of "forwarding" and "finishing," and the workmen who perform these two different kinds of work are called "forwarders" and "finishers." The forwarder constructs the binding, and the finisher titles and decorates it. In "one-man" extra binderies the same individual is both forwarder and finisher, and he often sews his books.

The job binder does most of his work by hand, though he uses some laborsaving devices and some short cuts in method. Each "job" is made up of assorted sizes of books, instead of one individual book, as is the case with the extra binder. Some books he cases, and others he binds, using a technique similar to that of the extra binder. His prices are moderate, and he spends no time on special design in decorating his bindings, but uses a stereotyped decoration that is usually pleasing in effect. In these days of specialization, the forwarder of a book in a job bindery is not usually the finisher. In fact, in the very large job binderies even the processes of forwarding and finishing are divided into several branches. For example, one man does nothing but pare leather, another confines his activities to covering or to backing a book, and a woman does the folding, mending, and sewing. (The only jobs for which women are ever employed in unionized binderies.) Likewise in the department of finishing, one workman will do nothing but titling, while another does the designing for the decoration on the book, and still another does the tooling of the designs. Thus there are nearly as many special workmen in a

large job bindery as there are operations, the book passing from one workman to another in its successive stages. It can be readily understood that when this method of binding is used, the processes have a tendency to become mechanical, and even if a master craftsman has planned the binding, the finished product invariably lacks the master workmanship that characterizes a binding planned and executed by the same individual.

The third classification of binderies which is usually designated as a "commercial" bindery should, it seems to me, more logically be termed an "edition" bindery or a "machine" bindery, since all the work produced in this type of bindery is done by machinery on publishers' editions. "Commercial" bindery is certainly a misnomer, for a job bindery or an extra bindery is quite as much a commercial bindery as any other bindery.

The processes of machine binding are quite different from those employed in binding a book by hand, and I will describe briefly the stages through which a book is taken in a machine bindery and will point out the main structural differences between a casing and a hand-bound book.

Books coming to the machine binder are publishers' editions. They arrive in sheets direct from the printer. Each sheet represents a "section," or "signature," and the first operation is that of folding. Large power folding machines are used for this purpose, and the folding operator takes some time before he is able to "set" his machine accurately for the job in hand. The edition which he is about to fold runs into thousands of books, all printed exactly alike, and one "setting" of this folding machine suffices to fold this large edition mechanically perfect. The machine is so set that each sheet passing through it will be folded into a complete section like every other sheet, with the "register" in truth. (The pages of a book are said to be "registered in truth" when the line of printing and page number on one page come exactly over the line of printing and page number on each following page.)

These folding machines, run by power, are superhuman in performance. After the operator has adjusted the machine for the particular job he is about to perform, he presses a button and the machine is set in motion, working with lightning rapidity and folding one section after another in perfect register. The sheets are fed automatically from a large pile placed on the top of the machine. Through an electrical device, they are separated one from another and are delivered to the mechanism of the folder, coming out in perfectly folded sections at an astounding rate of speed (hundreds of sections per hour).

After having been folded, the sections are "gathered," or brought together in proper sequence, by another machine. They are turned out of the gathering machine as so many complete texts, and are then sent on to a smashing machine where each book is compressed in thickness and is made solid by this power-driven monster that prepares it for the next operation of sewing.

A book sewing machine is a fascinating machine to operate and to see in operation. Usually women are employed for this purpose. After receiving the folded and gathered edition, the operator sets her machine and then begins running the books through it. There are three or four large spools of thread resting on top of the machine, and needles and "loopers" are held in place below the thread, which is fed to each section as it is brought up on top of an iron "saddle" to a position directly under the line of needles and loopers. This operation is performed by putting out a clutch with the foot, exactly as one puts out a clutch in a motorcar for the purpose of meshing the gears. As the section is brought up in this manner, it is pierced with the needles and "looped," or fastened, to each succeeding section in three or four places along the back or fold. In machine sewing, the thread runs perpendicularly through the folds of the sections, whereas in hand sewing it runs vertically, or along the length of the sec-

tions. This accounts for the sewing pattern to which I will refer later.

These sewing machines operate with great speed, and consequently much spoilage ensues, even with careful and skilled operators. This matter of spoilage is of considerable importance when books which have been printed on expensive hand-made paper are being sewed, and when I once ran a small machine bindery where I planned and superintended the casing of limited editions of specially designed books, I experimented with a sewing machine in order to solve the problem of reducing spoilage. With the aid of a master mechanic I had the machine rearranged by changing over the "pulleys" which control the speed, so as to slow down the tempo in operation materially. The result was that spoilage was reduced to a minimum, and we were able to turn out these limited editions with a great saving of expense. This goes to show that machines are sometimes hindered by speed from delivering their best performance and that there is a limit to which a machine may be speeded up in the interest of both technical accuracy and material profit.

The book having been sewn, it goes to the workbench where a folded sheet of paper is pasted on to the first and last sections to form "end papers." Then it has its edges trimmed in a cutting machine and is sent to the "gilder" to have its "head" gilded. The head of a book is the topmost part of the book when it is standing as on a shelf, with the title correctly placed. The "tail" of a book is the end opposite to the head, and the "fore-edge" is the edge opposite to the backbone, or spine, of a book.

Books are usually sent out to a gilder to have their edges gilded. Gilders do nothing but edge gilding, and sometimes when there are large jobs to be done they come into a machine bindery and do the edge gilding on the spot.

After being edge-gilt, books are glued up along the back (this gluing is sometimes done before gilding) and a strip of meshed

cotton material called "super" is glued over their backs. The super extends about three-quarters of an inch over each side of the back and forms a reinforcement at the joint of the book. The term "joint" is self-explanatory, as it represents the space along the back of the text where the book joins the cover boards.

Some cased books are left with flat backs, and others have rounded backs. If the back is to be rounded, the book is put through a backing machine before being lined up with super. The groove produced by this operation is slightly different from that for a flat-backed casing. When a book is rounded and backed, a groove, which is of a depth sufficient to receive the thickness of the cover boards, is formed along the back of the text, and the end papers with reinforced super serve as the hinges in this joint.

When headbands are specified, they are glued on at head and tail. These are machine-made pieces of fabric with a beaded finish that are glued across the back of the book at head and tail. They extend beyond the length of the text so as to fill up the space that would otherwise be left between the head and tail book-edges and the ends of the bookboards which protrude beyond the text. Then a piece of strong paper is glued along the length of the back of the book to strengthen it and to make it more even. Now the book is ready for its cover.

The covers, or casings, are machine made. The boards are cut for them in large rotary cutters, and the covering cloth is cut by machine. Full cloth casings are made in a case-making machine, which is amazing to watch when in operation. It receives the cut boards and cloth and automatically glues them in place, transforming them into a cover, or finished casing, for the book. When casings are made with paper sides, they cannot be made by machine, but must be "bench made" — that is, covered by hand.

The casings when finished are sent to a stamping or blocking machine, where the spaces for the titles and decoration are sized and "laid" with gold leaf by hand. They are then placed in a

stamping machine, one by one, to have the titles and decoration stamped on their surfaces.

Once these casings are finished, they go again to the work-bench or to the casing-in machine, and the completed gatherings are pasted into them. This process is called "casing-in." It merely consists in pasting the end papers at the front and back of the book down onto the inside of the cover boards and then putting the cased book into a large standing press, leaving it under heavy pressure until the end papers have dried thoroughly. Thus it may be noted that the cover of a cased book is held on solely by means of paste, and is not bound on by cords, as in hand binding.

This is the product of the machine bindery where large editions are cased. Machine casing represents a method suitable only for quantity production, and the large machines employed could not be advantageously used for casing a batch of books differing in size, or even for casing a small number of books of identical size and format, as the setting of the various machines requires too great an amount of time.

Well-made cased books sewed by machine resemble very closely hand-bound books, especially if they have leather backs. In order to distinguish a book bound by hand from a machine-made book, one should first look along the outside cover where it joins the back. If the book is bound by hand, there is likely to be, opposite the usual five bands on the spine or backbone of the book, a slight indication of the cords which are laced into the boards. Even if there are no raised bands on the spine, these lac-ings are generally recognizable, though in overrefined binding, whether with or without raised bands, the lacings may be difficult to detect. But one may be quite sure whether or not a book is bound by hand by consulting the sewing along the center fold of each section. The hand binding will show a sewing thread run-ning continuously from the first needle hole to the last one, only interrupted where the section is pierced for the thread to go

through to the back of the section, whereas, the cased book will show a different pattern of sewing. The thread will not run continuously, but will be interrupted by from two to four empty spaces. This type of interrupted thread pattern identifies the book as being machine sewed, and a casing job is almost certainly indicated. I say "almost certainly," because occasionally a hand binder sews a book by hand and then puts it into a handmade casing, but these instances are rare.

Like the word "format," "binding" has almost lost its original meaning. It has become a generic term, and no distinction is usually made by the layman between bound books and cased books. This general use of the term "binding" is probably a survival from early times, when all books were bound. Unless the cover boards of a book are laced onto the back of the book with the ends of the cords over which the sections are sewed together, the book is not a bound book. The usual publishers' editions with cloth covers appearing in all our bookshops are examples of cased books.

Cased books open more freely than bound books, since their sections are merely stitched together, their backs are not moulded into a solid convex surface with a deep joint projecting on each side, and their covers are not laced tightly onto them.

When books were first printed in Western Europe, a very superior quality of paper was used for the text. It was a rather thin handmade paper, manufactured out of rag stock and unladen with clay or other heavy filler material. In consequence it had great suppleness. The mediæval books were issued mostly in folio or quarto format. In the folio book each sheet of paper was folded once, with the grain of the paper running with the fold. A single section, or signature, was usually composed of two folded sheets, one inserted into the other, making a total of eight pages. Today most of our books are printed on machine-made paper, frequently of inferior, clay-filled stock. The paper is often heavy

and stiffened with sizing, and the sheets are many times the size of the early rag paper sheets. They are folded at least three times, often against the grain, making sections of sixteen pages or more. As a result, the sections are thick and stiff and a book issued with its sections made up in this way presents a problem to the hand binder, because it is extremely difficult, and frequently impossible, to bind such a book and ensure its free opening. Hollow backs and other expedients are not a solution.

I am well aware of the fact that the publisher often cannot afford to issue books in a format suitable to the quality and thickness of the paper available for use. The increase in cost would frequently be prohibitive. But I think he could exercise more judgment in selecting his paper for a given project. To change the usual octavo format of a book would involve considerable expense in the manufacturing cost both in printing and in binding, and I am not condemning the publisher for seeking to make a fair profit. I wish merely to support my contention that a book with a faulty format cannot be hand bound and still open freely. When flexibility is desired, certain books should not be bound, but should be cased in a strongly and carefully made casing, which will admit of a free opening of the book. The life of such a cased book, considerately handled, will doubtless last as long as the leather now available for use by the hand binder.

Toward the end of the eighteenth century, when hand binding suffered a decline in craftsmanship, hollow backs came into constant use, leather covers were pared very thin, sections were "sawn in," false bands were resorted to, and for the sake of "finish," slips, or frayed band cords, were pared down to such a degree that their strength was greatly impaired. All these pseudo methods were introduced under the guise of refinements, and consequently soundness of construction was sacrificed. The dignified craft of binding was at a low ebb for a time.

It was during this period that sprinkled, marbled, and tree

calf came into vogue. Happily this practice is no longer in style, though even now one is sometimes asked to admire a tree calf binding, the proud owner not realizing that the treelike pattern formed on its polished sides was produced by treating the calf with a bath of acid.

At the end of the nineteenth century, with the revival of hand-work, the craft of binding improved along with the other hand-crafts. There was a return to what is called the "mediæval spirit" among craftsmen, and the craze for novelty subsided. In England, William Morris led and inspired a small group of craftsmen to seek higher standards of workmanship. These men sought also to improve the quality of materials used in the crafts. Under the Morris influence great stress was put upon both utility and beauty. Morris, who felt that "life was uglier every day," sought to create beauty and durability in the things he designed and made, and he cried out against speed, which he felt was responsible for so much ugliness. He stressed balance and appropriateness in design and discouraged competitive production. I think he might be considered to have been the archenemy of the modern machine. This same attitude was characteristic of all the Pre-Raphaelites, to which group Morris belonged. Among this little coterie of men was Mr. T. J. Cobden-Sanderson, who gave up the legal profession, for which he was trained, and became a printer and a hand bookbinder. It was he who brought fresh impetus to the craft of binding, retrieving it from many vicious practices in construction and leading the way to greater simplicity and taste in design.

The influence of these men still lingers with craftsmen, and the sound mediæval practices which were revived in bookbinding by Mr. Cobden-Sanderson have become the standard practices of the extra binder of today. The machines which invaded the field of bookbinding have not destroyed the old craft, but have developed a new one. While the machines turn out cased

books for transient use, hand binders are producing bindings for the shelves of scholars and collectors. Each of these distinctly different techniques has found its niche, and there is no longer any attempt by the hand binder to compete with the machine. He is supreme in his own field, and at the present time, at least, he has nothing to fear from the machine.

CHAPTER VI

NATIONAL STYLES OF BOOK DECORATION

The Near East, Italy, Spain, France, England, Scotland, Ireland,
Low Countries, Germany, Hungary, Poland, Scandinavia,
North America

IDENTIFYING a binder's work and tracing a style of binding
to its source are matters of arduous study. Even when bind-
ings are signed, it is a task to identify the craftsmen who did the
work, as initials and names mean little in themselves. A name
found on a binding might refer to the owner or to the bookseller,
and does not necessarily indicate the workman who bound the
book. When bindings are not signed, as is too often the case, the
investigator must depend upon circumstantial evidence and must
build up this evidence by tireless comparisons and constant re-
search before he can establish a well-founded opinion concerning
the origin of a binding.

As for classifying bindings and determining in what country
the style of decoration originated or where some sort of tech-
nique was first practiced, only long and wide familiarity with
specimens of the craft and scholarly investigation of every minor
characteristic of the specimen under consideration will make
possible an authoritative conclusion. In order to establish the
origin of a binding and connect it with some particular town the
matter of research becomes more and more complicated, for
binders in widely separated towns in the same country are known
to have used stamps almost identical in design, and we have al-
ready observed that on bindings produced in Germany during
the fifteenth century are found impressions of stamps hardly
distinguishable from those used in England in the twelfth
century.

These facts are confusing to one setting out to establish the
source of a binding, and the work of the binding specialist is

often further complicated by other conditions that tend to obscure the facts. As we know, Europe was overrun with wars for centuries, and during the Middle Ages, after invaders failed in their conquests and had been driven out of a country, there would be left some of their number who had been professional artists or craftsmen in their native land and who continued to practice their professions in their adopted country. Many of these foreigners, after being freed as prisoners, were kept as slaves and were made to practice their crafts for their masters' benefit. Slaves were also imported into countries and they brought with them a knowledge of some foreign art or craft which was promptly utilized. Owing to all these confusing data, which render identification so difficult, even experts often fail to agree upon the source of certain technical characteristics of a binding or upon the origin of particular styles of decoration.

As an example of the danger of coming to a conclusion regarding the origin of a binding without exhaustive study and comparisons covering a very wide field, I would point to the recently upset theories about Grolier, Canevari, and Maioli bindings. That scholarly authorities should have left unchallenged the opinions of Guglielmo Libri, the alleged forger, for so long a time is unbelievable. Libri evidently attached celebrated names to bindings without thorough research and he built up a romance about them in his auction catalogues, surrounding them with a glamour that was fictitious. His statements were generally accepted at face value by collectors and book specialists for many years. Though Libri undoubtedly possessed much knowledge about the art of binding, he appears often to have substituted imagination for research, and in view of the revelations as to his lack of integrity, it seems probable that his misstatements were not wholly accidental.[35]

In this chapter I propose to discuss styles of binding under na-

tional characteristics rather than in chronological order, though I am aware of the fact that European national boundary lines were not stationary and that what constituted France or the Netherlands or some other country at one time often did no represent the domains of these nations at another time. However, since I am not attempting more than a very general classification of styles of binding, and though I realize that frontiers continued to be changed and Continental Europe did not assume anything like its present national divisions until after the Congress of Vienna (1815), I am designating countries as we conceive of them today, in the belief that this will be most helpful to the layman in gaining a rough idea of binding styles, and I trust that geographical changes in the past will not confuse the subject. I have already outlined the general development of the book through successive centuries, and now by identifying styles of book decoration with their countries of origin I hope to give the reader a fairly clear picture of the contribution to the art of binding by each individual country and to render it possible for him to piece together the mosaic of successive periods without losing sight of the influences which affected the decoration of books.

Civilization and culture traveled from the East to the West and the East had a developed art when the West was still too occupied with surviving to have the leisure for cultural pursuits. As the Eastern art gradually infiltrated into the West, it stamped its imprint on almost all forms of art created in Western countries. So it is that in the European art of book decoration we frequently find traces of Eastern influence. This influence on Western European bookbinding has been too little emphasized. It is usually referred to in general terms without specifically stating that certain forms of decoration were taken over in detail from Eastern art. We read of adapting Persian figures or arranging designs in the Oriental manner, but seldom are we told that this or that

motif was virtually copied from some Eastern design, or that an Oriental workman was actually the artist who created the design.

EASTERN BINDINGS

Islamic bookbinding has been little written about, and I do not propose to attempt even a cursory survey of the Islamic art and craft of binding, but I should like to emphasize that there are certain unmistakable forms of Islamic design that found their way into Western Europe book decoration and that this influence lent variety to European tool forms and served to influence creative design.

The fancifully decorated lacquered Persian bindings with their graphically drawn animal forms have no counterpart in Western bindings, but we find geometrical designs on the fifteenth century Italian and French decorated books, knotted borders and patterns, oval center medallions and arabesques, all very suggestive of Islamic influence (see Plate 14); and the French trade bindings with center panels and decorated corners, to which I have previously referred, are very like some Egyptian bindings of about the same period. The custom of using triangular-shaped flaps hinged to the cover to protect the book, which was a distinguishing feature of Islamic bindings, was rarely adopted in Western Europe. These flaps were elaborately decorated in the style used on the exterior of the binding (see Plate 15).

ITALY

As Italy was quick to take up the making of paper and adopt printing as a method of multiplying texts of books soon after their introduction into Europe, so was she ardent in her efforts to produce decorated bookbindings at an early period. If we accept the theory that Grolier, Maioli, and Canevari bindings were not for the most part the work of Italian binders, as seems now well authenticated, we rob Italy of considerable glamour in the

world of binding. However, Italy has made a notable contribution to the binding of books, though her binders have produced fewer original styles than we have been led to suppose and she has been far less creative in the art of book decoration than in painting or sculpture. But her bindings have a certain intriguing quality that is characteristic of most Italian handmade things and they often exhibit a deftness without cohesion and a charm without the unexpected.

The monastic bindings produced in Italy are still numerous, but they are usually undecorated and are lacking in interest. The large Italian libraries are stacked full of these monotonously bound books. Some are in full vellum covers, others are in unpolished half leather bindings of sheepskin or doeskin, encased between beech boards; and a very few are decorated full leather bindings. Toward the end of the fifteenth century a distinctive style of binding attributed to Florentine binders appeared in Italy. It may be found on books bearing a blind-tooled panel and border design in which an interlaced cable pattern is used, with the introduction of small roundels filled with a sort of gesso mixed with varnish. An excellent reproduction of this type of binding is represented in Fletcher's *Foreign Bookbinding in the British Museum*, Plate VIII. The cable pattern was of course borrowed from the East, but the Italians adapted the Eastern motifs in a distinctive manner. We find this exemplified in the Venetian bindings decorated with Saracenic rope patterns which were sprinkled with small gold circles. This was an innovation in decoration which produced a transition type of binding, linking the blind- with the gold-tooled design (see Plate 16).

Extant examples of panel-stamped bindings of Italian origin, similar to those produced in Northern Europe, are rare. One reason that has been assigned for this is that calf leather, on which these panels were most successfully stamped, was not generally available in Italy at this time. Calf was cheaper and more plenti-

ful in the north, whereas morocco was doubtless cheaper and more easily obtainable in the south.[36]

Before discussing Italian gold-tooled bindings I must refer to the origin of the Grolier, Maioli, and Canevari bindings. For generations the opinion has been generally held and disseminated by distinguished authorities on binding that a great many of the books in these collections were bound in Venice on the order of these noted bibliophiles. But this contention has been attacked in recent years, and much scholarly investigation, centering principally on the Grolier bindings, has served to demolish this long-held theory.

Jean Grolier, the distinguished collector, was descended from the Italian Groliers, originally from Verona, who came to France and settled at Lyons during the early part of the thirteenth century. Grolier was born at Lyons in 1479. For many years he spent much time in Italy in the capacity of Civil Servant for the French Government. He has been regarded as one of the most eminent bibliophiles of all time and is believed to have numbered among his friends Aldus the Venetian printer, Erasmus the scholar, Geoffroy Tory the artist, and many other men celebrated for their learning and artistic achievements. Until recently it was thought that the books bearing Grolier's name and motto were bound for him in Venice under his personal supervision and that the books which he accumulated after about 1540 were bound for him in France. But the origin of his bindings and the length of his sojourn in Italy became moot points after Dr. Gottlieb cast doubt on the previously held theories on the subject.[37] Since then, scholars have been extending their researches and have come to the conclusion that all the Grolier bindings with simple interlacings and solid tools, bearing his name and ET AMICORUM, were bound in France, probably Paris, not much earlier than 1535.[38] Furthermore, it is contended that these bindings were not executed by workmen

brought by Grolier from Italy, but represent the work of French binders.

That there were two main types of bindings owned by Grolier which were supposed to have been of Italian origin must not be lost sight of. Those belonging to one classification have his name and motto on the covers, and those without the name and motto fall into another category. The first-mentioned group are those which have now been identified as the work of French binders, and are thought to be not earlier than 1530-1535. The second group, among which are the "plaquette" bindings, have been attributed to Italian binders working in the early part of the sixteenth century, and are believed to have been ordered by Grolier before he conceived the idea of having his name and motto tooled on his bindings. Former binding specialists, basing their conclusions on Libri and Le Roux de Lincy, seem to have been quite wrong, for they all believed the books stamped with Grolier's name to have been of Italian workmanship.[39] They furthermore held that the early Grolier bindings without distinctive marks were bought by him in Italy already bound, though the more recent investigators find this theory untenable and believe that Grolier probably ordered these bindings made for him, as well as most of his later ones.

Thus in the light of critical analysis we must reconstruct our ideas about the origin of the Grolier bindings and must deny Italy the prestige she has so long held in the world of bookbinding for having produced such matchless specimens of binding for Grolier. At the same time, there must be added to the already great fame of French artists and craftsmen the distinction of being the creators of these bindings for their illustrious bibliophile.

Among other evidence that served to establish the fact that certain Grolier bindings were of French origin was that found in the strips of parchment containing French handwriting on which one of these books was sewn, and in the French waste

used to line the back of another book. The opportunity to examine books so critically is not often afforded the book collector, as it means either tearing a binding apart or finding a specimen already partly demolished, but there are certain surface characteristics of books that offer distinguishing indications of the origin of bindings, and collectors will find them helpful in appraising the authenticity of some dealer's claim. Among them are the kind of leather used and the character of the bands appearing on the back of a book.

The kind of leather used on the Grolier bindings proved to be a telling point in establishing their origin, for during the period in which the Grolier bindings were produced the French binders covered their books in smooth calf and the Italian binders used a fine-grained morocco leather. Hence these calf bindings of Grolier's seem to point to the workshops of the French binders. This matter of leather should always be one of the first things to observe in a binding when attempting to identify it, for, as in this case, it might be quite conclusive evidence. Different kinds of leather may be characteristic of bindings produced in certain countries, and individual binders in the same country have a tendency to use distinctive leathers.

The other surface feature helpful in the identification of bindings, which is found on the backs of books, is not so distinctive always as is the kind of leather used, though both physical and decorative characteristics of backs often assist in building up evidence.

A third surface indication of the source of a binding, that of decorative style, is fraught with difficulties, owing to the fact that styles of decoration were so frequently imitated. French bindings were often imitated in Italy, and Italian bindings in France. Likewise, French bindings were imitated rather freely in other countries, especially in England and the Low Countries during the time when the Le Gascon style of decoration was at its height.

However, most tooling can be distinguished from the French, regardless of the design, owing to the inimitable French technique.

The earliest gold tooling in Italy is thought to have come from the binderies of the Neapolitan workmen about 1480. Until then the Italian binders were gilding their designs after the Oriental fashion and not gold-tooling them. Oriental bookbinders are known to have been working in Venice during this period and the Italians continued the Oriental technique of polychrome decoration of books well into the sixteenth century, even though the Oriental workmen in Italy appear to have practiced the Western art of gold tooling as early as the last part of the fifteenth century. That many foreign binders were working in Italy in the fifteenth century is quite certain. Saracenic workmen from Sicily, Greek and Oriental workmen, a few French binders, and, later, German and Netherlandish printers and booksellers who came to Italy and settled there, all introduced different styles of ornamentation which appeared on Italian bindings.[40]

Mr. Fumagalli, the well-known bibliographer, has written a monograph on the bindings at the Court of the Este at Ferrara and Modena (see Selected List of Books), in which he gives a description of the Este bindings and mentions several of the Este binders. He describes the books bound in leather, silk and damask, and it has been pointed out that on one of the bindings, bound by a Ferrarese binder, appears a leaf exactly like that always attributed especially to the bindery of Aldus Manutius,[41] which, as I have already mentioned, Goldschmidt believes never to have existed.

Though Aldus may not have had a bindery in Venice, there is abundant evidence pointing to the fact that much beautiful work was done in Venetian binderies (see Plate 17). The Ducali in the Museo Civico Correr in Venice are among the finest examples of Venetian bindings, exhibiting a combination of Oriental and Western techniques in decoration. These Ducali bindings ac-

quired their name from the fact that they covered manuscripts on which were written the decrees of the Doges. They were written on vellum and were elaborately illuminated and beautifully bound, often with the Lion of St. Mark on their covers.[42]

A style of binding originating in Italy about the end of the fifteenth century is the so-called cameo binding. This style spread to France and England, but has not been identified with Germany. These bindings were first produced in northern Italy, dating between 1490 and 1530, and they are known also as "plaquette bindings." I quote in part an elucidation of plaquettes appended to the British Museum collection: "Plaquettes are small metal tablets in relief, usually produced by casting in a mould from a wax model. The finest plaquettes are of the Italian school of the end of the fifteenth and beginning of the sixteenth centuries. Some of them reproduce motives by the famous sculptor Donatello though none can be attributed to his hand. Briosco of Padua called Riccio (1470-1532) is however, well represented in the art. Two of the most charming plaquette modellers are Fra Antonio da Brescia and the artist who signs I.O.F.F. The non-Italian schools are of less artistic importance, though mention should be made of Peter Flötner of Nüremberg (died 1546)."

These cameo, or plaquette, bindings have a center medallion stamped with an intaglio-cut die producing an embossed design, the background of which is painted in gold and colors. The earlier plaquette bindings were stamped with dies copied from antique cameos. Later, plaquettes portraying mythological and allegorical scenes were used on bindings (see Plate 18), and we also find plaquettes especially designed for bibliophiles, which appear on their books as emblems indicating their ownership. One of the most famous of these emblematic plaquettes is that representing Apollo driving his chariot over the waves toward Pegasus standing on a rock in the sea (see Plate 19). The medallion is surrounded by a Greek inscription. Bindings bearing this

Apollo plaquette have long been associated with Demetrio Canevari (born 1559), a physician and book collector who was appointed chief physician to Pope Urban VII. Hobson, who calls these bindings the "masterless bindings," has now identified them as the work of Roman binders, and he has also established the fact that the original owner was Pier Luigi Farnese, and not Canevari. The identity of this Pier Luigi and a sketch of his life will be found in Hobson's book on Canevari [43] (see Plate 20).

The Roman binder who is thought to have made the "masterless bindings" worked for several popes, Pier Luigi, Filareto, and a number of cardinals, though almost all the bindings attributed to this binder have heretofore been described in book catalogues as "Venetian bindings." A very beautiful example of a Farnese binding and one bound in similar style for Apollonio Filareto, his confidential secretary, are given in Goldschmidt's *Gothic & Renaissance Bookbinding*, Vol. II, Nos. 204 and 205.

In the early Renaissance many beautiful bindings were produced in Italy. The tools used were gracefully and originally designed and are expressive of a new spirit in book decoration (see Plate 21).

Bookbinding in Italy after the seventeenth century, like that in other countries, suffered a decline; but to this day it has a certain appeal to the uninitiated. The Italian binders have a knack for turning out trim-looking bindings lavishly decorated with gold at an amazingly cheap price. However, present-day Italian binding is not taken seriously by professional binders or collectors. The Italian tooling is not done in the manner of the French "à petits fers." It is surface tooling with engraved fillets, and now that calf is easily procurable in Italy, the Italian binders have become master makers of boxes and portfolios in highly polished calf, fashioned with extraordinary skill, but they no longer produce decorated hand-bound books comparable to those produced in Italy in the fifteenth and sixteenth centuries.

SPAIN

The study of Spanish bindings seems to have been neglected by most authorities writing on the subject of bookbinding. The turbulent history of Spain makes it difficult to follow the development of book production in that country and to differentiate between the purely native bindings and those executed by foreigners whose work shows the influence of the craft of the country from which they emigrated.

There are only a few specimens of artistically decorated Spanish bindings predating the twelfth century. This may be due to the destruction wrought by the early invaders of this country, for it is thought that a greater number of these early bindings probably existed. Two single book covers of this rarely represented period are now in the Metropolitan Museum of New York. They are undoubtedly from Gospel books, and each consists of a wooden board overlaid with silver gilt and with ivory figures in a central panel. They are both studded with cabochon jewels and pieces of enamel, and date from the second half of the eleventh century (see Plates 22, 23).

Beginning with the twelfth century, the Spanish binders bound books with uncovered wooden boards. There are examples extant of these bindings with the covers carved in high relief. Then we find books of this period with wooden board sides overlaid with silver and gilt plating, frequently adorned with gems. Large decorated center panels with surrounding borders characterize this type of binding. These Gospel and missal books, written on vellum, have bindings of rare beauty and originality in design. Like the other European metal and jeweled bindings, they are for the most part creations of the metalworker, possibly in conjunction with some independent artist. Also, in this century books were bound in Spain in full leather and were decorated with blind designs in the monastic or

Gothic style and under the French influence. This decoration was done by hand with blunt tools and stamps.

Their mudéjar bindings showing the Arab influence, were characterized by interlaced strapwork patterns (see Plate 24). The small stamps used in these designs were merely supplementary to the interlacements. Some were Arabic in character and others purely Christian Dots and rings and various forms of knots were freely used. The roundels were often stamped over gesso, giving the stamped impression a metallic luster similar to the Italian bindings of the fifteenth century, though these mudéjar bindings were produced a century earlier.

It has been asserted that the technique of cuir-ciselé was employed on the Mauresque bindings,[44] but this theory has been controverted by an eminent authority who holds that the technique employed in decorating these bindings was the same as that used in the Gothic stamped bindings, namely, by lines drawn with a blunt tool, and by impressions of stamps; and that the difference between the Gothic and mudéjar bindings is a matter purely of art, and not of technique.[45] The mudéjar style of binding flourished in Spain from the thirteenth to the fifteenth century. There are many examples of these Hispanio-Arabic bindings to be found in Spain and a few in England (see Plates 25, 26).

In comparing the Gothic with the mudéjar style of book decoration there appears to be a fundamental difference. In the Gothic style, the cover of the binding is ruled off with lines forming compartments, and the stamps play an important part in the decoration and were arranged so as more or less to fill the compartments. In the mudéjar style, the lines forming interlacing patterns express the basic motif of the design, and the tools are merely accessory to the strapwork interlacement. The Gothic stamps were greatly varied, representing grotesque forms of animals, flowers, and conventional ornaments of various kinds,

whereas the mudéjar stamps were for the most part forms of knots, and these binders followed the Arabic tradition of using no representations of living objects in their art. To relieve the monotonous effect of these constantly repeated knot forms, the binders interspersed dots, rings, and roundels in the background of the designs.

Panel stamps, a development of the late fifteenth century, are rarely found in Spanish bindings. They are even rarer in Spain than in Italy. I have already pointed out that the attractive panel-stamped bindings were identified chiefly with England, France, the Low Countries, and Germany.

Though the art of gold tooling is thought to have been first practiced in Spain, surprisingly few specimens of early Spanish gold-tooled bindings have survived (see Plate 27). A splendid example is represented in Mr. Thomas's *Early Spanish Bookbindings*, Plate LXXXVIII. This book is bound in brown goatskin with wooden board covers. The decoration is in the mudéjar style, showing a large cross on a sort of pedestal, which is blind tooled in a cable pattern, parts of which are set off with gold tooling. The large cross motif, outlined with a narrow cable border, covers the entire surface of the cover except for a narrow margin outlined by a triple fillet. This rare binding formed part of Sir Sydney Cockerell's collection. The binding is of the late fifteenth or early sixteenth century.

A Cordova binding of the seventeenth century is shown in Quaritch's *Facsimiles of Bookbindings*, No. 66. It is clearly an imitation of the Eve style of decoration with a strong Spanish feeling. The design is confused, showing no originality and little purpose, though the dotting of small stars throughout the background is arresting.

In the fifteenth century, bindings were made in Spain in full vellum with the vellum extending over the fore-edge of the cover and nearly half across it on the upper side, with an envelope like

flap. The cover was decorated with lacings of thongs by which it was fastened with a sort of elongated button, and the book was laced into its cover with the thongs over which it was sewed. While this binding is not of great interest as an example of the art of binding, it has been often imitated, and is an item of historical interest to the collector, since it illustrates a type of binding used in Spain on account books and registers (see Plate 28).

Not only are there exceedingly few specimens of Spanish book decorations available for inspection, but scarcely any reference is made to Spanish bookbinding in the books written on the history of binding. Nothing of interest can be added with reference to the recent development of bookbinding in Spain, as there is little available information on modern Spanish binding.

FRANCE

Few specimens of early French monastic bindings have survived the destruction of the Revolution, when raids were made on everything related to the Church and anything mediæval was connected with superstition and consigned to the flames. Another fact which accounts for the disappearance of early stamped calf bindings in France is the seventeenth and eighteenth century custom of needlessly rebinding old manuscripts and incunabula in order to dress up books and make them fit into the elegant libraries of the luxurious baroque period. This was an age when the exterior of a book was often of more importance than its contents.

The specimens that remain, however, have a style of decoration distinctly French. Those decorated with an arrangement of small stamps have their covers divided by a series of vertical lines; the ones in the center are quite close together and form a sort of panel, which is not nearly so prominent a feature as is found in the German stamped bindings. Between the lines, the spaces are decorated by repeating the same small stamp their entire length,

although different stamps are used for the various spaces. The whole effect is a mass of vertical lines and stamps and is not broken up into prominent compartments. It is very rich and homogeneous, and the stamps themselves are often charming in design. There is nothing crude or heavy about these bindings, most of which have been traced to Paris binderies; and they have a style that is as Parisian as most styles emanating from that French capital.

The French blind panel-stamped bindings also have grace and imagination. They were not produced in France until the last quarter of the fifteenth century, but from extant examples it would appear that binders from various parts of France adopted this method of book decoration. Except for panel bindings identified with the region north of Paris, which resemble some of the Flemish panel-stamped books, there seems to be no particular style characteristic of localities. Most of the subjects represented are of a religious nature, the Annunciation occurring frequently. Intermingled with figures of saints and religious motifs are found hounds, stags, huntsmen, and other secular subjects fancifully interwoven to depict some suggestive idea. No other stamped bindings represent such distinctive art as the panel bindings, the peculiar technique of which I have already noted.

About the year 1500 engraved rolls appeared in France to replace the small stamps. At first these rolls contained patterns which were merely repeats of two alternating motifs, and then rolls were developed having on their surface continuous designs composed of flowers, foliage, fruit, and animals, interwoven in the style of the Renaissance. During the reign of Louis XII, ermine and fleurs-de-lys crept into the roll pattern, and they began to be commonly used in borders on books of this period.

The first binder of the University of Paris, Guillaume Eustace, was probably binder to Louis XII along with Giles Hannequin, a priest from Blois.[46] There is nothing outstanding in the bind-

ings made for this French monarch, apart from certain identifying characteristics. His symbol, a hedgehog, appears on his bindings together with his arms and the arms of his queen, Ann de Bretagne. Fleurs-de-lys and ermine often dotted the center field of the design and this was enclosed by borders in the Italian style.

The history of bookbinding in France is closely connected with the great collectors of that country, for it was the patrons of this art and craft who served to develop it. There are several prominent figures in the Renaissance period connected not only with careers but with scholarship and art, and among them were a few bibliophiles such as Jean Grolier — a man who has come down to posterity chiefly as a collector of books and beautiful bindings, though he held high rank as a statesman (see Plate 29).

Heading the list of famous French collectors in importance are Grolier and Thomas Mahieu, for many years known as Thomas Maioli. The bindings on which THOMAE MAIOLI ET AMICORUM is inscribed are well known to all bibliophiles, but the owner of these bindings had been unidentified for several centuries until Mr. Seymour de Ricci discovered that Thomas Maiolus was none other than Thomas Mahieu. It has been established that this mysterious book collector was a Frenchman who was principal secretary to Catherine de Medici from 1549 to 1560. Little more is known about him, except that he was alive in 1572, though he is thought to have been a friend of Grolier's. Mahieu was believed by some authorities to have been an Italian, and his name has been given an Italian flavor by some writers who have referred to him as Tommasso Maioli. His bindings, like some of Grolier's, had always been considered the work of Venetian workmen until scholars recently discovered that they came from Paris workshops.

Grolier, Mahieu, a Belgian collector by the name of Marc Louwryn, Sir Thomas Wotton, René Thévenin, and a few other collectors had the words ET AMICORUM tooled on their bindings in

a center cartouche, or interwoven in the design (see Plate 30). This seems to be a peculiarly French practice, and all the bindings on which this inscription appears are now considered to have been made in France. In addition to their names with this dedication to their friends on the upper covers of their books, both Grolier and Mahieu often had the lower covers marked with a distinctive motto. Among the mottoes employed by Grolier are the well-known ones PORTIO MEA DOMINE SIT IN TERRA VIVENTUM (O Lord, be Thou my portion in the land of the living) and TANQUAM VENTUS EST VITA MEA (Nevertheless, O remember that my life is wind), apparently adopted from the Psalms and Job. There are various other mottoes which are listed and explained by Miss Prideaux in *Bookbinders and Their Craft*, pp. 248-249. Mahieu used among others the mottoes INGRATIS SERVIRE NEPHAS (It is useless to help the ungrateful) and INIMICI MEI MEA MIHI (or MICHI) NON ME MIHI (or MICHI) ("My enemies may rob (or have robbed) me of my lands, but not of my soul").[47] Although something of a cynic, Mahieu was not discouraged from following ardently the quest of collecting books and beautiful bindings (see Plate 31).

The French bindings of these contemporary collectors, along with others of this time, are regarded by many connoisseurs as exhibiting the highest attainment of book decoration in gold-tooled designs. This is all the more remarkable since gold tooling had been practiced a very short time in France when these bindings were produced (about 1535). The Italian gold-tooled books of earlier and contemporary dates lack the creative quality displayed in the designs of these early French bindings. The French designs were produced by the use of straight lines, a variety of curves, and a very few flowered tools which were woven into a pattern created by an artist. On the other hand, the Italian binders of this period employed a greater number of tools than the French, and many of their designs seem often to have been

built up by an arrangement of these tool forms rather than to have been originally created and developed with the use of tools only as accessory to the central pattern. There are, however, numerous examples of Italian gold-tooled bindings which exhibit originality and great taste and simplicity, such as the Venetian binding shown by Hobson in *Maioli, Canevari and Others*, Plate 18. The designs on many of the early Grolier and Mahieu bindings consisted of simple flowing interlaced double lines and curves, with a few small tools worked into the pattern. The artist who conceived them had great taste and inspiration, and the hand that tooled them made them alive.

Many of the designs on Grolier and Mahieu's bindings are very similar, as might be expected, since some of them probably represent the work of the same binder, though his identity is unknown. A few of the Mahieu bindings are somewhat more elaborate than those of Grolier, and there is a type of Mahieu binding with dotted background that is rarely found on Grolier books. The tools on Mahieu's bindings, instead of being solid as they generally were on Grolier's, are either azured or merely outlined. Another distinctive characteristic of some Mahieu bindings is the effect produced on the background of the design, which Miss Prideaux attributes to rubbing gold into the grain of the leather. These bindings have been described as "the powdered bindings." I have already pointed out the smooth backs characteristic of the bindings of this collector.

The simple geometric Grolier bindings are well known, as are those colored by some sort of painting process. But a less known type of binding and one not so popularly associated with either Grolier or Mahieu, though bearing their mottoes, is that on which classical temples or porticoes appear in three-dimensional representations (see Plate 32).[48] Examples of sixteenth century portico bindings are comparatively few in number. Their origin appears to be both Italian and French. It may be of interest to

note that the same manner of portraying a portico in perspective which is tooled on these bindings is likewise found printed in books by Simon de Colines.

Almost all writers on this subject have arbitrarily divided the Grolier and Mahieu bindings into groups, analyzing each group in detail, but I have not attempted to make an exhaustive classification of all the types of bindings represented in these two famous collections, as they have already been amply described and analyzed by many authorities. I have merely pointed out some outstanding types with a description of their main characteristics. There are quite a number of reproductions of Grolier and Mahieu bindings easily accessible, and a goodly number of specimens may be found in both private and public libraries in this country.

Geoffroy Tory in his *Champfleury* states that he was employed by Grolier to design some letters for him, and it is thought that these letters may have been used on Grolier's bindings and that Tory might have been connected with the designing of some of the Grolier bindings, as he is said to have been a bookbinder as well as a writer, engraver, printer, and artist. The famous "pot cassé" bindings of Tory are outstanding examples of Renaissance gold-stamped bindings. The center panel design in which the pot cassé is introduced is composed of flowing curves and small leaves. The border is in the Italian style with a running repeat of a single motif. Tory explains the pot cassé device in his *Champfleury*. He interprets the broken vase as signifying our body, which is a vessel of clay (pot de terre), and the toret, or wimble, as Fate, which pierces both the weak and the strong. The toret, which is in the form of a T, doubtless represents a verbal quibble on his name. In this style of binding Tory achieved an entirely new and original manner of artistic decoration in bookbinding. There is an example of a pot cassé binding in the British Museum collection without the wimble, a facsimile of which is produced

by Fletcher, and another binding in the Bibliothèque Nationale which has the vase pierced by the wimble. There are, however, few examples extant.

This new type of panel stamping in which the design was purely ornamental and was executed in a manner that gave an effect very like gold tooling by hand was in marked contrast to the fifteenth century panel stamping representing pictorial subjects and impressed on leather covers in relief. It was used by Tory both in blind and in gold, and later, gold-stamped bindings after the Tory method were produced in several countries. Mention has been made of these as trade bindings. The French examples, especially the small Lyons bindings, have considerable artistic merit, though the designs are obviously adaptations from hand-tooled books. Not only trade binders but extra binders were designing and tooling books by hand in Lyons early in the sixteenth century. In fact the extra Lyons binders are celebrated for the artistic bindings they are thought to have executed (see Plate 33).

François I, the luxury-loving Renaissance king, was a generous patron of the fine arts, and he indulged himself in collecting beautiful bindings. His binders are known to be Etienne Roffet, called Le Faucheur, and Philippe Le Noir. They created a number of distinguished bindings for their royal patron. Some of these bindings are decorated with semis patterns of fleur-de-lys and the King's initial in gold or silver. Others are in the style of Grolier bindings, but almost always this king's device, together with his arms, will be found on his books (see Plate 34). The device usually depicts a salamander surrounded by flames of fire with the motto NUTRISCO ET EXTINGUO. The books bound for the Dauphin during the life of François I have a dolphin in addition to the salamander. It is thought likely that one of the binders to François I also worked for Grolier.[49]

During the reign of Henri II (1547-1559) a great variety of

beautiful bindings was produced. Grolier and Mahieu were still collecting, and "the unknown binder of the King" was executing exceptionally graceful designs on the covers of books. Two of the most famous *femme bibliophiles* were Catherine de Medici, the Queen, and Diane de Poitiers, the mistress of Henri II, created by him Duchesse de Valentinois. These two ambitious women vied with each other to secure the most distinctive bindings obtainable, and by their patronage fostered the art of fine binding. Diane is said to have influenced Henri II to issue an edict which obliged every publisher to deliver three copies of each publication to the Crown, and one of each of these books was placed in Diane's library at Anet. This edict constitutes a forerunner of the copyright law which was later established[50] (see Plate 35).

The ciphers on the bindings of Henri II and Diane are perplexing. These bindings are adorned with the royal arms and the crowned initials of the King as well as the interlaced crescents and the bows and arrows supposed to represent the devices of Diane. They are also stamped with a monogram composed of what is thought to be the initial of Diane and that of Henri (see Plate 36). There are some who doubt that the King would have permitted his initial to be so openly entwined with that of his mistress, and it is suggested that these letters are not HD but HC, representing Henri and Catherine, his queen. However, this same monogram with both the arms of the King and those of his mistress appear on the Château of Anet built by Diane, which contained her famous library, and there are various evidences to confirm the opinion that the letters in the cipher represent those of the King and Diane, though this same cipher is found on a necklace of Queen Catherine. MM. Marius Michel support the opinion that the ciphers are those of Henri and his mistress.[51]

Catherine's bindings are richly tooled and were evidently designed by the most able artists of the time. They bear the arms of France with a crown, under which is a monogram formed by an

H and two C's. Catherine de Medici had a large library in her Château of Chenonceaux near Paris, but few of her bindings survive, as she died deeply in debt and her library suffered many vicissitudes. It would have been seized by her creditors had it not been for the efforts of her chaplain, Abbé de Bellebranche, and others, who finally rescued it, and it afterwards became the property of the royal library. Later most of the books were rebound with the royal arms placed upon their covers to indicate that they were the property of the Crown, and consequently there are few of Queen Catherine's bindings extant. The King's books, which he kept in his library at Fontainebleau, are now in the Bibliothèque Nationale, and those of Diane were sold at auction in 1724.

Few of the early French binders have been identified. We know the names of a number of binders connected with panel-stamped books, such as Jehan Moulin, Johan Dupin, Julian des Jardins and others, and I have mentioned Guillaume Eustace, the first binder of the University of Paris, the Roffets (Pierre and Stephen), and Philippe Le Noir, all of whom have been associated with the binding of books for sixteenth century collectors. But there is a long list of binders' names known to us, taken from records of various kinds, whose work cannot be definitely connected with particular bindings.

Claude de Picque, bookbinder and bookseller, is known to have been binder to Charles IX. Charles had two interwoven C's for his monogram, and this cipher was crowned and appeared on the sides of his books, usually with the arms of France. During his reign, the Eve family came into prominence as bookbinders with the introduction of what is known as the "fanfare" style of decoration (see Plate 37). Both Nicholas and Clovis Eve were binders during the reign of Charles IX and continued binding while Henri III, Henri IV, and Louis XIII were on the throne of France. Whether Clovis Eve was the brother or the son of Nich-

olas is apparently not certain. The style "à la fanfare" consisted of a geometrical scrollwork design formed by interlaced double lines and single curves, with the introduction of small flower and leaf forms and with the larger spaces filled with branching foliage (see Plate 38). Several excellent examples of Eve bindings are reproduced in Quaritch's *Facsimiles of Bookbindings*.

During the reign of Henri IV, bindings "powdered" with monograms and fleurs-de-lys were in vogue, and dots began to be used more generously. Jacques-Auguste de Thou (1553-1617) was the famous bibliophile of this period (see Plate 39). His bindings were usually quite plain, with his armorial bearings in the center, though a few of his bindings were in the fanfare style. Even his plainer books often had their spines quite elaborately decorated in accordance with the style of the period. A reproduction of a very beautiful example of one of de Thou's late bindings in the simple style will be found in Fletcher's *Bookbinding in France*, p. 39. This binding shows the charming use of the dotted fillet which came in with Le Gascon.

Clovis Eve was succeeded by Macé Ruette (1606-1638) as binder to Louis XIII. Ruette, in addition to being a bookbinder, was a printer and bookseller. He is said to have invented the art of marbling paper, though this is probably not true. However, he evidently found out how marbling was done and produced some very attractive comb patterns, which he used as end papers.

The greatest French binder of the seventeenth century was the mysterious Le Gascon, who produced pointillé bindings unexcelled in delicacy and workmanship (see Plate 40). He had countless imitators in his own country and in foreign lands as well, but there is something inimitable in Le Gascon's bindings that to the trained eye makes them distinguishable from even the most meticulously executed copies. There is also something that excites one's delight and wonder, and in my opinion Le Gascon should rank with the greatest masters of book decoration, for

not only is his style entirely original and apparently untrammeled by conventions but his "all-over" designs are very delicate and beautiful, his tooling is extraordinarily precise, and he showed unrivaled taste in his simple designs, if the de Thou binding found in Fletcher, which I have already pointed out, is a veritable binding of Le Gascon's. What appears to be Le Gascon's early work was characterized by an outlined framework, but in his later designs the pointillé ornament carried the motif without distinctive outline. In this manner he achieved a most brilliant and delicate tracery effect. He used red morocco almost exclusively for his bindings and frequently inlaid them with various colored leathers. He had all his ornamental tools cut in dotted, instead of solid, outline (see Plate 41). His bad habit of cropping the edges of the text does not appear somehow to be consistent with his fine feeling in the matter of design, though probably his forwarding was done by someone other than himself.

For a time it was doubted whether Le Gascon ever existed, but it has been established through an entry in the register of the Guild of St. Jean that he bound a missal for the Guild, and in the letters of correspondence between certain well-known men Le Gascon's name has been found. His identity, however, has been debated by several authorities on binding. M. Gruel in his *Manuel Historique* leans toward the opinion that Le Gascon is identical with Florimond Badier MM. Marius Michel in *La Reliure Française* insist that Badier cannot have been Le Gascon, judging from a signed binding of Badier's which exhibits a kind of workmanship they deem unworthy of Le Gascon, and M. Thoinan, in *Les Relieurs Français* expresses the opinion that Badier is an entirely different person from Le Gascon, and he believed that the "couped head" which appears on these pointillé bindings and has been considered a sort of binders' mark is the signature of Badier. If this be so, then all the so-called Le Gascon bindings are the work of Florimond Badier, and the mystery about this Le Gas-

con, who evidently worked in 1622 as a binder, still remains unsolved. The most successful imitators of Le Gascon were Magnus of Amsterdam and Badier, if one considers him not Le Gascon himself.

Inlays of colored leather are not uncommon on French bindings of the sixteenth century. An unidentified Parisian binder, working between 1560 and 1570, is thought to be the first to practice to any extent the art of inlaying bindings with different colors.[52] This method of introducing several colors into the decoration of binding is much more durable than the polychromatic effect achieved by painting.

Heading the list of the eighteenth century French binders are Boyet, or Boyer, the Padeloups, the Deromes, Le Monnier, and Duseuil. The surnames of Padeloup and Derome without a prefix mean little, for there were many bookbinders in both of these families, as there were in the Eve family before them. The most celebrated of the Padeloups were Nicholas and Antoine-Michel. Of the Deromes, Derome le jeune is best known.

The Boyet family, which began binding in the seventeenth century, was celebrated for its excellent work. One of the Boyets is said to have introduced elaborately decorated doublures. Luc-Antoine, who was appointed binder to the King in 1698, is perhaps the best known. The Boyets tooled the backs of their books more elaborately than the sides, which were left fairly plain except for gold lines and corners tooled in a delicate dentelle pattern. Augustin Duseuil is thought to have been a pupil of the Boyets. He used wide dentelle borders and doublures decorated even more lavishly than those of the Boyets. His work was excellent, and his bindings elegant in style though delicate in design. Le Monnier was a popular binder of his time, who came to fame for his skill in inlaid designs. A. M. Padeloup is known chiefly by his "mosaic" decoration of bindings which were inlaid in colored leathers (see Plate 42), though he produced bindings in many

styles, some often quite simple. His work is technically almost faultless (see Plate 43), but his taste is often florid and his art is not always above criticism. Among many collectors, he worked for Mme. de Pompadour. The Deromes' work is similar to that of Padeloup. Derome le jeune won great renown for his dentelle bindings (see Plate 44). His designs are very lacelike in effect and one loses consciousness of forms of tools, which seem to be lost in the design. In Thoinan's *Les Relieurs Français* will be found a full account of all these binders and their work, and under "Etude sur les Styles de Reliure," Thoinan illustrates his text with line cuts showing various French styles of design. The second volume of this valuable work is entirely devoted to a critical biography of French binders up to the nineteenth century, and constitutes a veritable dictionary on the subject.

After these binders ceased working, bookbinding in France lost most of its claim to fame until Thouvenin appeared, binding books in the late romantic style, and Vogel and Simmier in the style "à la cathédrale" (see Plate 45). Then followed Trautz, a man born in the Grand Duchy of Baden, who came to Paris, worked in the bindery of Bauzonnet, married his daughter, and succeeded him in the middle of the nineteenth century (see Plate 46). Meanwhile there were other binders such as Bozérian, and Capé, all excellent workmen, but of the plodding type who were not great artists. Trautz's workmanship was of the highest order. He used excellent leathers and other materials and did not copy too slavishly the designs of his predecessors, but he showed little creative ability, though his work has been much sought after by collectors.

Later came Cuzin, Duru, Lortic, Chambolle, Mercier, Gruel, and others — all honest and able craftsmen living in an age that was past but making a valiant effort to keep French binding on a high plane. These men were often inventive and always painstaking, but they were not creative. Some of their designs were

pitifully sentimental and trite, all the more so because they were executed with such perfect mastery of technique and exhibited superlative skill and finish. We unquestionably owe much to them for their forthright integrity as craftsmen and for the standards they set and maintained.

The master binders of France were not young when the war broke out in 1914, and their places had soon to be taken by the apprentices being trained in their workshops. But most of the young apprentices never returned from the war, and consequently the perfect French technique of binding was in danger of being lost. This is not an exaggeration, for the empty workshops in Paris after the First World War were obvious and French binding establishments were concerned about being able to carry on worthily the craft of binding in France. There was a great effort made to staff the technical schools with competent instructors, and the best of the remaining craftsmen were sought for and were made attractive offers to teach their craft in these schools. Excellent "modern artists" were put in charge of the art departments of the technical schools, and students of binding were encouraged to attend their classes as well as those of the older craftsmen teaching the technique of the craft.

As a result, nearly twenty years later, Paris was having continuous exhibitions of "modern bookbinding" in its salons, and the periodicals such as *L'Illustration* and *Mobilier et Décoration* were filled with reproductions of contemporary French bindings. M. Silvan Savage, the talented French designer, was made Director of the Ecole Estienne, which devoted itself entirely to the art and craft of the book. This institution is a municipal school very elaborately equipped to teach printing, design, type cutting, bookbinding, and all other book arts, but takes in only male pupils. The Arts Décoratif, however, recently under the direction of Mlle. Langrand was open to both male and female pupils and gave excellent courses in bookbinding. In the summer of 1938 at

the closing exhibition of the binding work done by the pupils in this school during the year, the character of the designs made by the pupils and the quality of their work were amazing. The old conventional type of book decoration was absent, and the pupils were actually creating new designs.

Before this time, Pierre Legrain had brought a collection of his bindings to America for exhibition and many of them were sold for very high prices. It was this modern binder who did much to make the bibliophiles in this country conscious of the advent of a new art in book decoration, and from then on our collectors were eager and waiting to secure superior specimens of modern book-binding (see Plate 47).

A long list of modern French binders could be named, among them both men and women, who were active in binding books just before World War II. There is Rose Adler, who paced the women binders and who insisted, from the time she began to bind books, on a new formula for book design. She worked ceaselessly to proclaim a new era in the decoration of books, and captured public attention soon after World War I by her original designs. Among French women binders deserving of mention are Marguerite Fray, Antoinette Ceruti, Suzanne Regnoul, Mme. Weill, Geneviève de Léotard as well as others who have produced creditable bindings decorated with a refreshing disregard for traditional line and form.

A binder by the name of Creuzevault introduced a style of decoration that is architectural in effect which is not achieved by a design drawn in perspective, as in the case of the portico bindings made in the sixteenth century for Grolier and others, but by raised panels and other raised forms that gave a structural appearance to his covers and took the decoration of binding out of the two-dimensional. He uses very thick boards, which are beveled at the fore-edge, and his designs are mostly tooled "à froid." Georges Cretté, a former head workman in the Marius

Michel bindery, does all his own designing and tooling and even some of his forwarding. He has produced simple line designs, some semis patterns with a modern interpretation, and some quite original, fanciful designs of great merit. His tooling is extremely brilliant and perfect, and his forwarding painstaking and substantial. Paul Bonet does his designing in his apartment on the Rive Gauche and in 1938 had an atelier where workmen carried out his designs under his supervision. It is this last-named binder who evolved an entirely new style of book decoration — totally original, amazingly clever, and really "modern" in spirit, with a *mouvement radiant* (see Plate 48). His great swirling designs are so ingeniously drawn that, although they are carried out on a flat surface, they represent a third dimension purely through an illusion created by the drawing, and not by means of an alteration in the surface of the cover as was practiced by Creuzevault. The tooling on his bindings is faultless and brilliant. It has a machinelike precision with a quality that can only be achieved by "striking" each tool separately by hand. Paul Bonet, in my opinion, is without a rival today.

As for the celebrated ateliers of Gruel and Mercier, they have been practically closed. Just before World War II Gruel's workshop was in operation only between the hours of nine and eleven in the morning and M. and Mme. Gruel were spending their time as "patrons" of a very elaborately appointed bookshop in Paris. Mercier, installed in a tiny workroom, complained of having had nothing to do for three years. He insisted sadly that he had no feeling for the modern, and he continued to bind his books usually in the fifteenth century fashion, using impeccable technique. It is truly sad that such accomplished craftsmen should have failed to live in the present.

Modern French binders show no paucity of imagination, nor any lack of present-timed consciousness. They are not bound by conventions nor are they lacking in inspiration and verve. On

the eve of World War II there was in France an amazing vivacity, a veritable *vita nuova* among the rank and file of bookbinders, and it was evident that the talent for creating styles, so singularly peculiar to the French, could not fail to make itself manifest in a new art of book decoration. In no other country at that time was there to be found such creative art in the decoration of books as in France, and it made one feel that de Laborde's statement "La relieure est un art tout français" was an excusable exaggeration.

ENGLAND

A very tiny volume, bound between two thin lime-wood boards which are covered with red leather and decorated with an interlaced design, was found in the tomb of St. Cuthbert at Durham when his shrine was opened in 1104. St. Cuthbert died in the year 687 on an island of Farne off the north coast of England. He was buried at Lindisfarne, and a few years later his body was taken to Durham. The book found in his coffin is a manuscript of the Gospel of St. John, unornamented and written in uncial letters. The binding on the obverse cover is decorated with interlacements and a leaf ornament in relief, the incised lines still showing traces of color. The reverse cover has just a simple decoration of lines. The binding has been pronounced by English experts on Anglo-Saxon art to be not later than the ninth or tenth century, and it is thought possibly to be an example of seventh century Northumbrian binding.[53] In either case, it is the earliest English binding extant. It is now in the Jesuit College at Stonyhurst, England, and not easily accessible for inspection, as it is closely guarded, but a reproduction of both covers is shown by Mr. G. D. Hobson.[54]

On the St. Cuthbert book we have an example of a binding decorated freehand with a sharp instrument like an engraving tool, and not stamped by the use of cut dies. This little binding seems to be an isolated specimen, and a gap of several centuries occurs

before decorated bindings were produced in the monasteries of England. I have already referred to the twelfth century Romanesque English stamped bindings in a previous chapter, and have indicated their general characteristics. Mr. Hobson has made a special study of these brown leather bindings, produced principally at Winchester, London, and Durham, and he describes them in detail in his book *English Bindings Before 1500*, giving many excellent reproductions of them. Some of his facsimiles of the curious dies used on them afford an opportunity for a fascinating study of the imaginative conceptions of the artists who drew the designs for the stamps.

A Romanesque binding now owned by the Society of Antiquaries, London, is a superb example of one of these twelfth century English bindings. It is bound in dark-brown goatskin and ornamented in blind with intaglio-cut stamps.[55] In a rectangular panel on the obverse cover are two large circles, one above the other, both the circles and the outline of the panel formed by repeating small stamps. These circular patterns are characteristic of early English designs and are found later in some of Berthelet's work and, still later, in English seventeenth century book decoration.

England is often represented as lacking in originality and initiative in producing decorated leather bindings, but this group of twelfth century English work should retrieve her reputation, for while a few decorated bindings were produced in France and possibly some in Germany during this period, England probably produced the greatest number and seems to have justified a reputation for decorating books in an original manner at a time when binders on the Continent, except in France, were doing little or nothing. It has been hinted, but not conclusively proved, that the stamps used on English bindings were cut, and possibly designed on the Continent. In view of the fact that England today is so expert in the cutting of dies for designs that require perfect

register for reproduction in colors, this suggestion does not, in my opinion, merit consideration without further proof.

The production of Romanesque bindings, on which most beautifully cut stamps were used, appears to have ceased very suddenly, and few examples are known of either English or Continental stamped bindings representing the period between about 1250 and the fifteenth century. It should be noted that with the reappearance of stamped bindings in England there is a very apparent difference in the stamps used. The later stamps are far less imaginative and are more commonplace in design; they are also less numerous and not so expertly cut. The sudden cessation of binding activities in the thirteenth century may conceivably be explained by the demoralization of monastic life which was taking place at that time; and the vigorous revival of the art and craft of binding in the fifteenth century is doubtless due to two factors — the regeneration of the monasteries, with the consequent return of the monks to their former pursuits, and the tremendous development of the book trade after the invention of printing.

The monks at Canterbury are thought to have been among the first to revive the art and craft of binding in England, and several of their late Gothic bindings are now in the Bodleian Library. Like other English bindings of this period, the decoration on them shows unmistakable evidence of foreign influence. After Canterbury, the abbey at Salisbury and numerous binders at Oxford became active in binding. In some of their work the use of the French manner of arranging stamps in vertical rows is apparent. The London binders, on the other hand, show the influence of the Low Countries. The first London binder has not been identified, but he is referred to as the "Scales binder," since one of his most frequently used stamps represents a pair of scales. This binder not only used decorative stamps on his bindings but is the only English binder to have used both the stamped- and the cut-

leather method of decoration.[56] G. D. Hobson has a fondness for naming things, and he calls one of the Cambridge binders of this period the Demon binder, another the Unicorn binder, and still another the Greyhound binder, giving them these appellations because of their use of certain stamps bearing a reproduction of a demon, a unicorn, and a greyhound, respectively.

Caxton returned to England from Bruges in 1476, and evidently brought with him not only the necessary equipment to set up the first English printing establishment, but bookbinding tools as well, and possibly Continental workmen. The few specimens of his bindings that have survived show a distinct Continental influence, and the stamps he used are totally different from those cut in England. Richard Pynson, a Frenchman by birth and one of Caxton's successors, often used a large rose in the center of his panel-stamped bindings, and smaller roses with foliage and clusters of grapes will be found interwoven in his borders. John Reynes (see Plate 49), bookseller and binder to Henry VII and Henry VIII, employed the Tudor rose frequently, as did other English binders of the time. He used scrolls enclosing mottoes and placed the sun and the moon in his panels, in addition to shields and coats of arms. He also employed a distinctive roll stamp on which were engraved his trademark: a bird, a flower, a bee, and a dog. A book ornamented with this roll is now in the Gloucester Cathedral library.[57] There were numerous binders working in England at this time, and they all used engraved rolls and panel stamps, producing more or less the same type of bindings. They did not use pictorial panels very extensively, but were fond of employing instead panel stamps with heraldic devices cut on them.

This period is not marked in England by any great contribution to the art of binding. No national style was developed, and almost all the decoration appears to be imitative of the styles of book decoration on the Continent. Undoubtedly this is due to the

fact that, after foreign books were allowed to be imported into England in 1484, booksellers from the Continent opened establishments in London and in the university towns of Oxford and Cambridge, where they not only sold books but bound them; and they probably brought both stamps and workmen with them when they emigrated to England. It was not until the following century that English binders began to display once again any signs of a distinctive style of their own.

There were in England no bibliophiles quite like the inimitable Jean Grolier, nor was England distinguished by so many or such discriminating *femmes bibliophiles* as was France, but it is a mistake to think of France with its Grolier, de Thou, and royal collectors as totally eclipsing England in this respect. In addition to the royal bibliophiles there is a long list of English collectors who merit recognition, beginning with Archbishop Cramner, the Earl of Arundel, the Earl of Leicester, Lord Lumley, and others in the sixteenth century (see Plate 50) and continuing in increasing numbers down to the present century. The books in English collections attest the fact that these bibliophiles were not only book lovers but ardent patrons of binding as well. In the British Museum alone, we find among others such noted collections as those of Lord Harley and the Rev. Mr. Cracherode, and bindings which belonged to Thomas Wotton, called the English Grolier. Some of the eighteenth century collectors, like the Duke of Devonshire and the earls of Oxford and Sunderland, are said to have been bibliophiles embued with a great passion for acquiring books, and they apparently spent much of their time searching in obscure bookshops for some item to add to their libraries.[58]

Among the English kings who had an interest in collecting books, Henry VII was the first to form a library. All the bindings still existing that once belonged to this king are thought to have been originally bound in velvet.[59] Some of these are now in the

Westminster Abbey Library, but the finest specimens are in the British Museum.

Velvet, silk, and satin were used for book covers in various countries at an early date, but England has no rival in the production of embroidered bindings (see Plate 51). A Psalter belonging to Anne Felbrigge, an English nun, and probably embroidered by her during the latter part of the fourteenth century is the earliest known example of an embroidered binding. On the upper cover of this manuscript is a graceful design depicting the Annunciation, and on the lower cover is a representation of the Crucifixion, embroidered in colors and having a groundwork in gold thread. This binding is now in the British Museum. Most of these embroidered covers represent the handiwork of the English nuns, but the Tudor princesses were fond of making embroidered book covers in gold and silver studded with pearls; and in the reign of the Stuarts many covers for Bibles and prayer books were made by noblewomen outside the convents, and the books were bound in velvet and embroidered with Bible scenes or floral designs, and even with portraits of the King. The little prayer books were often decorated with engraved gold and silver ornaments and fastened with elaborately chased precious metal clasps. These English bindings are not without charm, and I think they are worthy of mention, though I have made no attempt to do more than that, since the subject has been amply covered by Mr. Cyril Davenport (see Plate 52).

The art of gold tooling was not introduced into England until about 1540, or over fifty years after it had been practiced in Continental countries. Thomas Berthelet, or Bartlet, printer and binder to the King, was the first English binder to tool his books in gold (see Plate 53). His tools were cut "solid" like those used in Italy at the time, and it is generally recognized that his designs were inspired by foreign models of that period. In fact, he even described them in his bills as "being bound after the Italian

"fascion." It is not known whether Berthelet was actually taught the art of gold tooling by an Italian workman or whether he acquired his knowledge through his own trial-and-error efforts to learn this art from foreign examples. However that may be, he quickly gained a mastery of gold tooling and some individuality in design, for the tooling on most of his books is excellent, and his designs became less Italianesque as he continued to bind. The best examples of his work are his royal bindings.

None of the bindings attributed to Berthelet were signed, so that it has proved difficult to identify his bindings with certainty. English binders rarely signed their work on the outside of the binding, but, with the passing of time, they used the method of pasting tickets on the inside of the book or of placing initials on the lower edge of the inside of the cover.

Before printing was introduced into England, the leathers most frequently used for binding books were sheepskin and goatskin, and Berthelet is thought to have been the first English binder to use calfskin almost exclusively for his bindings.[60] He also used a white leather, probably deerskin or doeskin prepared with lime, which has proved very durable. That his calf bindings are still in a marvelous state of preservation after all these years bears witness to the fact that tanners and dyers of leather in Berthelet's time understood their craft far better than those of the present, as the calf prepared today for binding lasts barely fifteen or twenty years and is not suitable for the binding of valuable books.

Berthelet succeeded Richard Pynson in 1530 as printer and binder to King Henry VIII and was the first binder to be honored by patent in England, receiving the magnificent allowance of four pounds a year for life.

The influx of foreign booksellers and binders into England in the sixteenth century grew so serious that measures were taken to control it. Among other expedients an "Acte" was passed in

1533, which restricted the importation of bound books into England in order to encourage the home production of books and bookbinding. However, this act did not prevent foreign bookbinders from entering the country and setting up their workshops, and since these workmen were evidently superior to those of England, they captured a great deal of the binding trade. As a consequence, there were grievances presented to the Lord Mayor of London, where the greatest number of foreign binders seem to have settled, and a decree was enacted in 1597 which limited the number of foreign workmen "who intrudded into the trade and workers of the bookbinders." This seems to have effectively controlled the situation, as there is apparently no mention of further grievances recorded in the "Stationers' Company."

After the middle of the sixteenth century, bindings decorated with a stamped center and corners, with either plain or tooled border, replaced the geometrical compartment designs used previously. The binders of Archbishop Parker, a noted collector, who is said to have established a printing shop and bindery in his residence of Lambeth Palace, have been credited with having introduced this style, though I have failed to find any conclusive evidence in support of this theory.

During the reign of Queen Elizabeth the bindings made for Thomas Wotton are the most noteworthy. This well-known collector has been called the English Grolier, owing to the fact that some of his books were bound in the Grolier style with the inscription THOMAE WOTTONI ET AMICORUM. His bindings were decorated in several different styles, and those similar to the Grolier bindings with Wotton's name and the inscription on them are believed to have been bound by French workmen, either in France or in England (see Plate 54). A distinctive characteristic of the Wotton bindings is that of the color combination, for Wotton used brown leather for his bindings with the decoration tooled on black. Some of his bindings are very plain, with merely

an elaborate armorial stamp in the center. The bindings of this noted bibliophile probably exhibit the best work done in England in the sixteenth century, much of which was of a high standard.[61]

Though the Little Gidding's bindings represent for the most part the work of amateurs, they are not without merit, and certainly the story of their production is not lacking in interest. It was during the reign of Charles I (1625-1649) that Nicholas Ferrar, an English theologian, organized a small religious community composed of his relatives at the manor of Little Gidding in Huntingdonshire. These pious people, mostly women, occupied themselves with a variety of useful pursuits, among them bookbinding, and a teacher was employed to instruct them in the craft. The Little Gidding's nuns, as they were called, were thought to have produced embroidered as well as gold-tooled bindings, but no embroidered bindings have ever been identified as their work. They bound several "Harmonies" of Biblical books in leather, very elaborately tooled, and their velvet bindings were decorated with gold ornaments. These were the first Englishwomen to bind books. A niece of this learned Mr. Ferrar, by the name of Mary Collet, is known to be one of the Little Gidding binders. She produced some excellently tooled books.[62]

Beginning with the seventeenth century, English technique in binding improved, and a less heavy style of decoration came into vogue (see Plate 55). The tools used were smaller and more expertly cut, but there is every evidence of the influence of Parisian designers on the English binders of this period. The English work is not so perfect as the French in technique, but a large variety of designs is found on the English bindings, and the so-called "Mearne bindings," which were produced toward the end of the century, display an effect of great richness, though perhaps they are less delicate than their French models.

All the finest binding produced in England in the latter part of

the seventeenth century had been attributed to Samuel Mearne, bookbinder to Charles II, until 1917 when "The Great Mearne Myth" was uprooted by Mr. Gordon Duff, who read a paper before the Edinburgh Bibliographical Society exposing the fallacy of regarding Mearne as a great binder.[63] That Mearne was an important bookseller and publisher is not questioned, and like most publishers of his time he must have had a shop in connection with his publishing business where workmen were employed to bind his publications — hence his appointment as the royal binder of the Restoration, but Mr. Duff expresses doubt whether Mearne himself ever bound a book, and cites convincing proof that Mearne's son Charles could not have bound certain books attributed to him.

Probably only the plainer royal bindings were made in Mearne's small workshop, and the more elaborate ones were executed for him by other binders. Bagford and Dunton, who appear to be the first English writers on the subject of binding, mention several noted binders who worked for Mearne, among them a workman from Holland by the name of Zuckerman, or Suckerman. It is this binder who is thought by some authorities to have produced the most elaborate of the bindings formerly accredited to Mearne. But this theory has been attacked as a mere conjecture, and who the Mearne binder really was does not seem to have been conclusively established.

It is certain that Mearne was mentioned in state papers and elsewhere as a royal binder, and he is thought to have been bookbinder to Charles II and James II from 1660 to 1674.[64]

The so-called Mearne bindings have been fully described by Mr. Cyril Davenport in his book on Samuel Mearne, and extraordinarily good reproductions are given of these bindings, but for those to whom this book is not accessible I will briefly describe the work of this "binder to the King." In referring to the book on Mearne by Mr. Davenport, it should be borne in mind that the

book was written before Mr. Gordon Duff's evidence about the Mearne bindings had been established.

It is generally conceded that the binder of these books was influenced by the mysterious French pointillé binder Le Gascon, or Badier, as some authorities believe the pointillé binder to have been, but if the Mearne binder imitated Le Gascon in his designs and in the form of some of his tools, he certainly evolved a style of his own, and many of his tools are distinctly original.

There is great variety displayed in the decoration of the Mearne bindings. They have been classified into three main groups — the "rectangular," the "cottage," and the "all-over." In the rectangular style the lines, most often thin double ones, are usually placed some distance from the edges of the book, forming a rectangular panel, the four corners of which are ornamented, often with a crowned cipher or with a spray of flowers. This is one of the plainest types, but it is a style that has great distinction, owing to the artistic sense displayed in the proportions of the design. The backs of this style of binding are richly tooled with a mass of delicate tool forms — a fashion that is characteristic of all Mearne bindings.

The cottage style is the one for which this binder is most celebrated (see Plate 56). In these designs the large center panel is a broken rectangle with a peaked top and bottom resembling a cottage roof. The broken outline of the panel is often inlaid in black leather in strong contrast to the leather of the binding. The whole center is elaborately decorated with leaf forms and an intermingling of small delicate tools, and is filled in with dots, rings, and frequently with small curves piled one on the other in the form of waves, likened to fish scales in some descriptions of Mearne bindings. I find no convincing evidence for doubting that this broken-gable design was invented by the Mearne binder, though it is contended that it originated in France.[65]

The all-over designs are very suggestive of the Le Gascon style,

although quite different in treatment. The Mearne all-over designs are bolder and more imposing, if less delicate, than Le Gascon's, and they have larger spaces left undecorated. In these designs the Mearne binder outlined large rectangular forms often made up of a double-horned curve, inlaid with colored leather or painted, and he used silver and black paint frequently to fill the outline of small tools and flower petals. These repeat forms occupy the whole side of the book, merging into the book edges in a variety of ways most expertly managed. This style does not suggest Le Gascon to me, except in a very general way, and it is certainly uniquely distinctive (see Plate 57).

The Mearne binder used a great variety of original flower forms in both dotted and unbroken outline, and his pineapple tool, cut in several sizes, seems to have been a favorite with him. His double-horned curve, which he often employed to form his motifs and frequently used in other ingenious ways, was cut in several sizes and in different outlines. His tulip and tulip-bud tools, of which there are also many sizes and various "cuttings," are very simple outline tools, the petals of which are often colored with paint, in his designs. Then there are in the Mearne designs stars, rings, and dots, roses and other flower forms, and leaf sprays suggesting the fanfare style of Clovis Eve. All these tools are used lavishly but not promiscuously. There is always purpose as well as restraint in this binder's use of his great variety of tools (see Plate 58).

The Mearne binder usually used black, blue, or olive morocco, less frequently red morocco, and occasionally calf. He is celebrated for his decorated book-edges and is said to have discovered the process of decorating his fore-edges with hidden paintings.

The Mearne bindings seem to me to be the work of a creator, not an imitator, though a binder unconsciously absorbing the influence of some particular style of binding is certain to show

traces of that influence in his work. This influence, in the case of the Mearne binder, is manifest, but that it was absorbed and utilized in a creative manner seems equally manifest.

In the eighteenth century there were several good English binders, such as Eliot and Chapman, trade binders, who are said to have been employed by Lord Harley; James Edwards of Halifax, the inventor of transparent vellum bindings; John Whitaker, who bound in the classical Etruscan style late in the century; and Roger Payne, the genius who infused originality into the decoration of English bindings after nearly a century of rather uninspired performance.

Roger Payne was a most versatile individual, and a veritable artist. He has been much written about and his peculiarities have been emphasized, along with his reputed fondness for strong drink. There is no doubt that the man was eccentric, but that he "died a drunkard" has only been surmised. Mr. Cyril Davenport, who was probably the greatest Roger Payne expert, doubted this alleged fact and offered an interesting refutation.[66] He pointed out that if Payne had been an habitual drunkard he could never have cut his beautifully delicate small tools nor could he have used them with such precision, for both tool cutting and gold tooling require the most amazing steadiness of head and hand. It is known that Richard Weir, who was Payne's assistant for about eighteen years, was given to intemperance, and it is possible that Payne may have been led astray by his associate on occasions, but if he had been an habitual user of "barley-wine" or other intoxicants, he certainly could not have continued to turn out work that exhibits such a sure and steady hand. Dibdin, who describes Payne as an habitual drunkard in his *Bibliographical Decameron*, offers no conclusive proof of his contention. It is possible that Payne's own humor may have fanned the flame which injured his reputation, for he was given to writ-

ing observations on his bills or on notes which he tucked in with his bindings. He bound a copy of Barry's *Wines of the Ancients*, and on it he wrote:

> *Falernian gave Horace, Virgil fire*
> *And barley-wine my British muse inspire.*

This little jest might well have set tongues wagging. Although Roger Payne was apparently a weak and possibly a slovenly man (a reputation that seems to have been overemphasized), in all probability he does not merit the representation of his personality that has been bestowed upon him. In the reproduction of an etching of Payne, the broken wall of his workshop and his tattered clothes could easily have been due to the artistic license of the etcher seeking to depict such an eccentric individual as Payne was known to be. Since the etching was made after Payne's death, it cannot be considered a portrait (see Plate 59).

Roger Payne not only designed and cut his own tools and created the designs for his bindings, but unlike Berthelet and Mearne in the previous centuries, he did most of his own work. He was set up in a small workshop in London about 1768 by his friend Thomas Payne, a prosperous bookseller, who, though no relation, befriended him all his life and cared for him when his health began to fail after about twenty years of hard work.

Payne employed his own brother Thomas to assist him with the "forwarding" of his books during the first six years of his career as a binder, and in 1774 he took a binder named Weir (either Richard or David) into partnership. Weir was a very skillful workman who, besides being a competent "forwarder" and "finisher," was noted for his ability in repairing and restoring old books. Mrs. Weir also had a reputation for her dexterity in book restoration, and she worked with her husband for Payne. The Weirs, while in his employ, are thought to have bound several books which have been attributed to Payne, but the master's

hand probably put many touches on the work, and he may well have planned and designed all the bindings produced in his workshop. His output was necessarily very limited, but he worked for a few noted collectors, such as Lord Spencer, the Rev. C. M. Cracherode, and the Hon. Thomas Grenville. The greatest number of specimens of Payne's binding are in the Cracherode collection in the British Museum and in the Ryland Library in Manchester, which contains the Lord Spencer collection. In this latter collection are many bindings by Charles Kalthoeber, who was an imitator of Payne and who bound for George III. Curiously enough, Payne was never made a royal binder.

Payne was most careful and precise in all matters connected with his work. He chose his leathers with great care and was the first to use straight-grain morocco, which he originated and produced by dampening the leather and then "boarding" it in one direction (rolling it one way). This is a process that was afterward copied by the leather manufacturers. He used morocco in various colors, among which was a greenish gray, sometimes described as olive, that is peculiar to him and is evidently a color he managed to make himself. Payne used mostly straight-grain morocco and russia leather. The russia leather he always "diced" by ruling it with diagonal lines. His headbands were made over flat vellum strips with green silk thread and his lining papers were the sole features of his work in questionable taste. They were usually mat-surfaced purple papers and rather thick, though he used several other colors equally unattractive. His books were heavily lined up in the back and therefore did not open easily. This was a natural consequence of the sound binding method used by Payne, though one would expect a binder of his inventiveness to have overcome this difficulty if it could be done without sacrifice to structure.

Payne's tooling, which was almost impeccable and very brilliant, makes it easier to detect the work of his imitators, for few

English finishers attained his skill in tooling. All his tools were small, except his heraldic devices. Many of them were cut in dotted outline, or pointillé, which Le Gascon originated, but the designs were drawn by him and most of them are entirely original. Even the compound pointillé curve, which is very like a Le Gascon curve, has an unmistakable Paynesque quality.[67]

Roger Payne's greatness as a designer of book decoration lies not only in his creative ability but in his eclectic selection and artistic arrangement of his tools in making up a design. It was he who like Derome, first used small single tools so successfully and with such delicate charm in making elaborate borders, instead of using an engraved roll for the purpose as had been the previous custom in England (see Plate 60). His rectangular and square corners, which were later imitated by Cobden-Sanderson, are purely original, and the manner in which he edged his triangular corners with wavy outlines is refreshingly distinctive (see Plate 61). When he left the sides of his book quite plain, he tooled the spine with a solid effect, using very small tools, and he tooled not only the panels between the bands, but the bands themselves. On the leather covering the fore-edges of his boards, he often tooled diagonal lines for a space of an inch or two from the corners. In his elaborate designs he left undecorated even larger spaces than did the Mearne and most other binders, so that his beautiful leathers were utilized to give a certain éclat to the book cover. He always showed consummate taste and much reserve and finesse in his designs, and his versatility seems to me to exceed that of any other English binder.[68] There appear to be many figments of imagination in regard to noted bookbinders, but none more lacking in proof than those about this physically frail binder, poor in material possessions, talented and rich in artistic endowment, and withal a painstaking, honest workman who created many beautiful bindings.

After Roger Payne's death there were a number of German

binders who settled in London and worked after the manner and style of Payne, among whom were Baumgarten, Staggemeier, and Kalthoeber. This last-named binder revived the art of hidden paintings on fore-edges and appears to have been a talented workman. Then there were Lewis and Herring, both imitators of Payne's style, who did excellent work technically but who lacked the genius inherent in Payne.

I have already referred to the universal waning of originality and the perversion of sound structural methods prevalent in the art and craft of binding in the nineteenth century, but there were some excellent "trade binders" in England during this time, such as Bedford, Revière, and Zaensdorf, who, though they sometimes indulged in bad practices in construction, were all binders of technical skill. They bound books in the Edwardian style with great care and finish, and their work exhibited a certain conventional elegance that is pleasing, if not too inspired. Later Sangorski and Sutcliff became the popular trade binders of London.

It was Mr. T. J. Cobden-Sanderson who exposed the faulty work of English binders of his time. He set an example of sound workmanship and inspired his followers with high ideals, encouraging them to attempt to express themselves in an original manner. This binder's work is too well known to need detailed description. His few simple flower tools were designed by him directly from nature, and he used them with good taste and in a manner which, if not altogether original, was at least very distinctive (see Plate 62).

Both Mr. Cobden-Sanderson's work as a binder and his virile and interesting personality attracted to him many followers and devotees. Among them was his pupil of greatest distinction, Mr. Douglas Cockerell. Mr. Cockerell continued his master's practices in forwarding, adding many innovations of his own, for he has always been an extremely inventive craftsman. This was

shown not only in his forwarding but in his decoration as well, since he developed a manner of ornamenting his books quite as distinctive as that of his teacher (see Plate 63). Since his semiretirement as a binder, he has shown his urge for experimenting by evolving a new style of marbled end papers and by having white leather prepared with lime, somewhat after the fashion of Berthelet. The work of the firm of Douglas Cockerell & Son was carried on before the war by Mr. Cockerell's son, Sydney Cockerell, and Roger Powell, a partner.*

Mention should be made of several English women binders, among them the late Miss Sarah Prideaux, one of the pioneer Englishwomen in the craft in recent years and an able scholar and writer on the history of binding. Then Miss MacColl deserves recognition for her ingenious invention of using a very small wheel for tooling small curves. Miss Woolrich is another woman who has turned out very creditable work in the past, and Miss Katharine Adams (Mrs. Webb) has recently scored considerable success in the binding world. One of the English women binders to break away from the convention in design is Miss Madeleine Kohn, who has exhibited some bindings designed in a manner departing from the traditions of the past.

It has been frequently affirmed that the English have been unoriginal in their decoration of bindings — that they are not creative but imitative. I think it is undoubtedly true that they created few styles in binding that were totally original, but they certainly have had a way of putting a truly English stamp on their designs, even on those where traces of foreign influence are quite obvious. If there were space I could illustrate my contention by pointing out the distinguishing differences between a Berthelet design and one of some Italian or French binder whom Berthelet is said to have imitated. A comparison of the designs of the Mearne binder with those of Le Gascon would be equally

* Since this book was written word has come of Mr. Cockerell's death.

fruitful in proof of this point. Almost every binding of English origin is recognizable by something about it that is thoroughly and peculiarly English, and I think that the English have rarely been slavish imitators in any period of bookbinding. It would be strange indeed if foreign influences had not crept into English art, as they have done in Italian, French, and German.

We hear it said that Mearne copied or imitated Le Gascon. But one wonders whom Le Gascon imitated. The saying that there is nothing new under the sun appears to be so. Le Gascon got his idea for his curves and his little flowerlike forms from somewhere, and certainly not from nowhere. Then he dotted these curves and the flower petals instead of using them in continuous line. So it is, Le Gascon adapted the curve and the flower form to his use and modified them by breaking up the solid outline. Or geometrically speaking, the line of continuous dots became a line of interrupted dots, and a new style of tool was created. Then the Mearne binder appropriated these modified, or dotted, curved tools and flowers of Le Gascon's and used them in his designs, changing the outlines in some instances and using the tools not as Le Gascon had used them, but in a Mearne manner. And so goes the story of borrowed ideas. In the last analysis, all ideas seem to be borrowed, and often stem from an unknown source, but creation takes place in using these ideas and forms in a different and a new manner.

It is difficult to say what is "original" in design. It is equally difficult to define "creative," and yet we use both these adjectives with a great deal of gusto and authority with reference to design. When one pauses to analyze the designs created by Le Gascon, the Mearne binder, Nicholas Eve, Roger Payne, and others, I think it is evident that each one is in some way entirely different from the others. There may be actual borrowing of tool forms, and even similarity of arrangement, but what constitutes originality is the question. If everything about a design must be created in order

to be stamped or labeled "original," then there are no original designs, for everything starts from something and that something must have existed before it could be used.

I do not mean to be academic in discussing this subject, but it would seem as though there has been a great deal of blithe labeling of "unoriginal" and "uncreative" in the field of appraising art in book decoration. In consequence, considerable injustice has been done, in my opinion, and because of these arbitrary taboo labels much beautiful work has been passed up as unworthy and has not been appreciated or impartially evaluated.

The question is: Must a thing be entirely new in order to be beautiful? If so, there is no beauty, for, again in the last analysis, there is nothing absolutely and entirely new. I take it that beauty does not reside wholly in newness. There is a law outside of time which governs form, and I believe that beauty resides largely in form.

SCOTLAND

There is not a great deal known about Scottish binders prior to the last part of the seventeenth century. In the time of James VI, John Gibson of Edinburgh was the royal binder, but no particular bindings can be definitely attributed to him, though in records of his bills he describes his books bound for the King as "gylt," "in vellum," and "in parchement." There was a binder by the name of John Norton, who bound books for the King "with velvet coverings," and one named Robert Barker, who bound "in Turkie leather" and "vellum." But which books they bound is not known.

The style of decoration used on bindings for James VI was characterized by "semis designs" made up of small stamps, such as thistles, fleurs-de-lys, small tridents, surrounding a center royal escutcheon, and with narrow decorated borders. Among the best examples of these bindings is the Pontifical of 1595. It is tooled with a large semis design of alternate thistles and fleurs-

de-lys interspersed with a smaller tool. The narrow border consists of flowing decorative curves, and the back is smooth and is decorated the full length with small tools, except for the title space. In the center, almost buried in the semis, is the royal escutcheon with the arms of Scotland and Ireland. It is probable that John and Abraham Bateman were the binders of this imposing folio binding.[69] This Scottish style of binding is apparently in imitation of the Louis XIII semi designs.

Some of the ordinary bindings are decorated with oval centers of strap and scrollwork in a semis field of small floral sprays. Many of them have rather banal corners of overbearing proportions which add to the heavy elaborateness of the design and mark them as trade bindings. They represent a showy but unimaginative type of decoration.

During the eighteenth century the Scottish designs were lighter, suggestive of the Mearne and Payne styles. One recognizes the Payne small tools and rosettes and the Mearne mounds of curves and branching leaves. Four excellent examples of this style will be found in Quaritch's *Facsimiles of Book-bindings*. The small dots and tools used produce an effect of great brilliance in these designs, but they are rather stiff and overelaborate.

Since James VI of Scotland was likewise James I of England, I think there has been a tendency to class much of the Scottish work of his time with the English. It may be possible that, after further research, many so-called English bindings will be found to be the work of Scottish binders.

IRELAND

The Irish had a custom of keeping their early manuscripts in book boxes called *cumdachs*, or *book shrines*, and instead of decorating the covers of their bindings, they usually left them plain and lavished all their imaginative art on the boxes in which the books were kept, merely bestowing upon these written religious

books a limp leather cover. I shall discuss cumdachs and book satchels later under Miscellanea.

There were noteworthy exceptions to the Irish plain bindings, but there have been identified only a very few Celtic bookbinders who ornamented their bindings in something of the styles they used in decorating their cumdachs. Dagaeus, a monk living in Ireland during the sixth century, is said to have been not only a skillful scribe but a bookbinder as well. And in the ninth century an Irish monk by the name of Ultan was made mention of in a letter written by one Ethelwolf, of Lindisfarne, to Bishop Egbert.[70] Ultan was praised in this letter for his accomplishment in producing beautiful bindings. These early Irish bindings were covered with gold and silver, studded with jewels. There are few intact examples of them extant, though fragments of early Celtic bindings are preserved, the largest number of which are found in Irish museums.

An example of a Celtic book cover is found on a MS. of *The Four Gospels* frequently referred to as "The Gospels of Lindau." This MS. was discovered in the Abbey of Lindau on Lake Constance, and after having been bought by the Earl of Ashburnham and taken to England, it was later added to The Pierpont Morgan Collection, where it is now known as MS. No. 1. The upper cover of the binding is thought to be of ninth century workmanship (*ca.* 875) and is considered one of the finest specimens of Carolingian work in existence (see Plate 64). The Celtic decoration on the lower cover represents a beautiful example of artistic workmanship, also of the ninth century (*ca.* 825-850), possibly executed at St. Gall, Switzerland, by an Irish emigrant to the Continent[71] (see Plate 65). This cover is an example of the art of the jeweler and metalworker, containing a large beautifully designed gold patée cross covering almost the entire side of the book, which is studded with garnets and enamels in colors. In this connection it may be noted that Ireland had native jewelers

and enamelers of great repute at an early period, and it is not improbable that their services were in demand beyond the borders of their own country.

Celtic interlacings are found on extant Irish *polaires*, or book covers, which were ornamented with designs executed by means of hard styles or by impressing ornamental stamps on their surfaces.[72] These bindings were of course later than the metal jeweled cover of the Lindau Gospels.

In the eighteenth century some handsome and gracefully designed bindings were produced in Dublin, usually in red morocco inlaid with large diamond-shaped centers of white or cream-colored leather, richly tooled in gold. Irish binders continued to produce very creditable work in binding, under the English influence, from the time they began to practice the art of gold tooling. They have always shown much taste and skill in their work (see Plate 66).

LOW COUNTRIES

The Low Countries occupy the same position in regard to originality and beauty of stamped bindings as the French do in gold-tooled decoration of books. The panel-stamped bindings produced in the towns of Flanders are incomparable. They exhibit an imagination and beauty in design, a style, and a skillfully developed technical excellence that is unsurpassed.

The creative conceptions shown in the imagery of the early art of the Netherlands has a peculiar storytelling quality that evokes delight. It is apparent in all the art emanating from these foggy, mist-enshrouded countries — in paintings, choir stalls, silver boxes, and even in the small trinkets that were made. That this vividly imaginative quality which was shown by these artists repeatedly in their designs for book covers should have left its imprint on bookbinding design throughout most of Western Europe is not surprising.

Panel-stamped bindings which originated in Flanders some-
time after the middle of the fifteenth century and continued to
be made there until the latter half of the sixteenth century offered
an ideal opportunity for the play of imagination. The idea of panel
stamps was appropriated by binders outside the Low Countries,
and we find stamped bindings with panel designs coming from
Holland, several parts of France, England, and Germany, as well
as from Flanders. Most of the Flemish panels were too small to
cover the whole side of a large quarto or folio volume, and they
were therefore repeated on the cover as many times as was
necessary to complete a full design sufficiently large in scale to be
appropriate to the size of the book (see Plate 67). These designs
had to be registered just as the designs of the goldsmiths were
registered, and the facsimiles of them were kept in the guild
archives, as were the trademarks of merchants, in order to protect
them by law from being reproduced. They could not be used
by anyone but the designer unless they were changed in some
way.[73]

There were probably few professional bookbinders in the
towns of the Low Countries before the fifteenth century. All the
binding was done in the monasteries, and by the lay clergy. The
principal binders of Flanders were in the abbeys of the Augustin-
ians at Bruges, Ghent, Louvain, and Utrecht, in the houses of the
Crutched Friars at Namur, and in those of the Brothers of the
Common Life at Ghent, Brussels, Wesel, and elsewhere. The
binderies in the university town of Louvain produced some inter-
esting bindings as early as the last quarter of the fifteenth cen-
tury, but owing to the large-scale destruction of the Louvain
archives in World War I, there will be, unfortunately, no further
possibility of identifying bindings from this source. One of the
panel stamps often found is attributed to a Louvain binder who
signed his bindings IP[74] (see Plate 68).

The earliest Bruges binder appears to be James van Gavere

(1454-1465), probably of the family of the same name which migrated to England. Several of his bindings are described in detail by Weale in his *Bookbindings and Rubbings*, pp. 158-206, as are those of other Low Country binders, of which there were many. The earliest dated panel (1488) is one owned by Jacques Moerart, a native of Flanders who became a bookseller and printer in Paris.[75]

A great variety of spiral panel stamps, horizontally placed, were used in designs. These designs contained foliage, fruits, birds, beasts, and many other subjects, which were often enclosed in circles and were surrounded by a border containing some legend. In a single Bruges design are found a stag, a hound, a lion, a unicorn, a monster, an angel, two Tritons, and a monkey and the Holy Lamb with cross and banner. This seems a weird combination, but the Bruges artists were equal to resolving such diverse and incongruous subjects into most entrancing designs. The people of the Low Countries possessed a talent for expressing their fantasies in pictures that were alive with meaning and harmonious in effect, no less in art than in literature. Of all the Flemish panels those of Bruges and Ghent are the most beautiful.

There were three noted Bruges collectors, Philip, Duke of Burgundy, Louis Grunthuuse, and Mark Lauweryn. The Duke of Burgundy's books were usually bound in velvet. Those of Louis Grunthuuse, who was a friend of Edward IV of England and a patron of the Bruges printer Colard Mansion, are said to have been mostly rebound. Mark Lauweryn, of Watervliet, was the most famous of the three collectors. His binder has not been identified, but many of his books were bound in the style of Grolier and bore the ET AMICORUM label, together with his Latinized name Marcus Laurinus, and one of his mottoes. His collection passed to his nephew Mark, who was a collector of coins and medals and who was banished from his estate just outside of Bruges in 1578, when his palatial Renaissance residence

was destroyed by order of the Bruges magistrates because of anti-Catholic prejudices.

I have already remarked that many of the tools used in England were brought over from Holland and Flanders by workmen who emigrated to that country and settled there. The van Gavere family from Ghent and the van der Lendes of Bruges were among the number who introduced Low Country designs on English bindings, though there were other Dutch and Flemish binders working in England in the late fifteenth and early sixteenth centuries.

It has been said that during the period between 1400 and 1550 "in all matters pertaining to books, England, Belgium, Holland, North-western France, and the German provinces of the Lower Rhine and Westphalia formed one region of more or less uniform or at least closely related character," [76] but certainly very strong local characteristics in bookbinding may be discovered in the various countries just mentioned. However, bindings produced in England at that time were often in the style of the Low Countries, and the Flemish influence is strongly evident in the panel-stamped bindings of Cologne, which resemble closely those produced in Bruges, Ghent, and Louvain. It would seem as though the influence of the closely related countries of France and the Low Countries was the most dominant in the matter of book decoration in the fifteenth and the early part of the sixteenth century.

Panel bindings were likewise produced in Holland, but they were less attractive than those made by Flemish binders. However, the Dutch appear to have had excellent binders, and one, Magnus of Amsterdam, working in the seventeenth century, was a very skillful gold tooler. He was probably the most successful imitator of Le Gascon. This talented binder evidently had many clients, among whom were the Elzevirs, the Dutch family of

celebrated printers, whose workshops in Leyden and Amsterdam had a tremendous output.

Belgium has continued to foster the craft of binding down to the present time, but there are few binders there who do work of exceptional excellence. Professor Henry van de Velde, who was Director of the Institut Supérieur des Arts Décoratif in Brussels, made a great effort to stimulate the Belgian binders to forsake conventional decoration of books and follow in the footsteps of the more recent French binders, but without marked success. René Laurent was one of the best Brussels binders who did modern work before World War II, and de Doucker was another Brussels binder who specialized in binding books in the antique style, similar to Mercier of Paris.

In Holland at the end of the nineteenth century there was a small group of excellent binders like John B. Smits of Haarlem, S. H. de Roos in Amsterdam, and J. G. Loebèr who decorated their books in an unconventional manner. Later followed a number of young binders who went to Paris and London for further training. And after the war, in 1921, a movement was started in Holland to stimulate interest in modern hand binding, resulting in the formation of a society called the "Boekband en Bindkunst." A. M. Oosterbaan, P. d'Huy and Jan Wansik were among the well-known binders at that time. Craft schools put in courses of bookbinding, and J. H. J. de Vries, A. M. Kupers, and D. N. Esveld taught in the Amsterdam school, while Professor Oosterbaan was an instructor in Utrecht, and F. Mesman in Rotterdam. These schools turned out pupils who produced some very creditable work, among them several women whose bindings have been in a number of exhibitions in Holland where one might find represented the work of Geertruid de Graaff, Annie Abresch, Elizabeth Mendalda, and of several other women. Doubtless, if Holland continues to stimulate interest in the craft

of bookbinding and gives that craft an important place in the curricula of its craft schools, we may hope to see developed a national type of modern book decoration in that country. A comprehensive survey of modern bookbinding in the Netherlands, written by Elizabeth Mendalda of Amsterdam, will be found in the *Jahrbuch der Einbandkunst* of 1928, pp. 187-192.

GERMANY

Germany is especially distinguished for the great variety and excellence of decorated bindings produced by her binders in the fifteenth century, and fortunately there are a large number of specimens of this work extant. In fact, the greater proportion of monastic bindings still surviving are of German origin.

It has already been noted that in France many old bindings were deliberately destroyed at the time of the Revolution, and it is a matter of record that England suffered a like fate during the reign of Henry VIII and through the fanaticism of the Puritans. On the other hand, only in the center and the north of Germany was there any great destruction of monastic bindings during the Reformation. Along the Rhineland, in Bavaria, Austria and Westphalia, the monasteries escaped the wrath of the reformers, though later, at the beginning of the nineteenth century, the wealthy Bavarian abbeys were suppressed, and the valuable old bound manuscripts reposing in their libraries were dispersed. Then, too, in Germany as in France, a factor which reduced the number of examples of early bindings in their original condition was the disregard of their artistic and historical value by those who did not hesitate to mutilate them in order to fit them into their baroque libraries (see Plate 69).

Nevertheless, the partial escape from wholesale destruction is one reason why German fifteenth century bindings are so numerous, and an added reason is that in the fifteenth century probably more bindings were produced in German monasteries

than in any other monasteries of Europe. Among the surviving specimens, south Germany is represented with a greater number than north Germany, and this is probably due to the fact that fewer south German monasteries were despoiled, though it is quite possible that the southern monastic binders were more numerous and more productive.

As Dr. Goldschmidt's work *Gothic & Renaissance Bookbindings* is the most comprehensive treatise on the subject written in English, I shall make it the chief basis of my observations on German bindings of this period, linking the Austrian and Bavarian. It is both because of its scholarly approach and because of its convenience as a source of information for augmenting the following brief summary that I have chosen it as the main nucleus of reference on this period of German book decoration.

German bindings of the fifteenth century were of two distinct types — the one stamped and the other cut leather or cuir-ciselé. Because of the peculiar excellence and profusion of stamped bindings produced in Germany, I shall outline the distinctive characteristics of the various types of decoration representative of certain bookbinding centers in that country (see Plate 70).

In common with all other stamped bindings, those produced by the Germans have wooden board sides covered with leather, and the earliest specimens are decorated with blind lines which divide the whole cover up into compartments. To decorate these compartments a variety of stamps was used, ranging from simple floral subjects to animals and grotesque figures. It is by means of identifying these tools with a certain region or a particular binder, if possible, and by noting peculiar characteristics and the general plan of dividing up the design into spaces that the origin of bindings can often be established. For example, many of the bindings made either in the monasteries or by binders working in the towns near Cologne and in the vicinity of the Lower Rhine may be recognized by their boards, which are beveled.

This is a singularly distinguishing characteristic, since it seems to have been confined almost entirely to this particular region (see Plates 71, 72).

The Erfurt bindings may be recognized by the scheme of decoration used, which follows the plan of dividing up the whole of the book cover by a double border which encloses a long narrow panel. The outer border is narrow, with a broader inner border separated from it by several parallel lines. Parallel lines also outline a center panel. All the lines, horizontal and vertical, cross near their extreme ends and form squares at the corners of the cover. The central panel is usually decorated with a pattern composed of small, almost touching tools, and both borders are likewise decorated with a succession of tools, those of the broad inner one often being interrupted with a scroll bearing the binder's name.[77]

Augsburg bindings are characterized by certain stamps, such as the heart-shaped palmette, and by large square or diamond-shaped stamps used in the spaces formed by a framework, the crossing lines of which also form square corners.

The Nuremberg type of binding is easily distinguishable by a central diaper pattern on the obverse cover made up of a floriated "ogee" tool. The panel containing this pattern is outlined by a border composed of rather large foliage designs, and in the border running across the top, the title is often lettered in large gilt Gothic letters. The reverse cover of the binding does not usually contain the diaper pattern, but is decorated in both the center panel and borders with characteristic lozenge or square tools containing grotesquely drawn animal forms.

Bavarian monastic bindings are not so easily recognizable, since they exhibit a less rigidly followed manner of decoration and more varying characteristics, but on most of these bindings a peculiar decorative motif is used, like that employed by binders from south Germany, Austria, and the Upper Rhine and Mo-

selle regions. This type of decoration is achieved by the use of a "cusped-edge stamp," or "headed-outline tool." It was adroitly used to form a leaf effect, making for great richness in the decoration.[78] Line sketches of all these distinguishable types of stamped bindings will be found in Dr. Goldschmidt's *Gothic and Renaissance Bookbindings*, pp. 18-23.

The first binder to sign his bindings with his name was Johannes Rychenbach of Geislingen. Rychenbach was the famous binder-priest who was chaplain of a church in Württemberg. He was the best known of the German clerics who bound books commercially, and he began using rolls before 1500[79] (see Plate 73). There were many binders in the university town of Erfurt, at least twelve of whom signed their names, a practice which at that time was not too common. Johannes Fogel (1455-1460) was one of these, and he is among the most celebrated of the German binders and is often referred to as having bound several copies of the Gutenberg Bible. One of these bindings, which is on a 42-line edition and which was signed by Fogel with his name in a scroll, is now in the Eton College Library. Fogel used a rope knot and a lute player stamp, and he is described by Schwenke as "Der Buchbinder mit dem Lauten spieler und dem Knoten" (the bookbinder with the lute player and the knots).[80] All of Fogel's bindings are decorated in the manner just described as being characteristic of Erfurt bindings, having the long narrow center panel enclosed in a broad border, which is surrounded by a narrow outer border, with all lines crossing at the ends to form squares in the corners (see Plate 74). Johannes Hagmayr of Ulm was a talented German binder who used a large number of beautiful small stamps and two very well-cut panel stamps. One of these panels contained figures of animals, such as apes and dragons, and the other one was engraved with fourteen birds and a dragon, enclosed within curves of foliage. The animals are copied from playing cards engraved in 1466[81] (see Plate 75).

Ambrose Keller was an Augsburg binder of some repute, whose stamps were well designed and well cut.

It was at Augsburg that the first gold tooling was done in Germany, though the German binders usually decorated their books in blind until about 1540. The gold titles on their stamped books were first stamped in blind and then gilded with a brush, after the Eastern manner. The celebrated Fugger family of "baron bankers and merchants" living in Augsburg established the first important bindery in Germany where gold tooling was done. This patriarchal family had wide connections outside of Germany, and the Fuggers doubtless imported workmen from Italy to bind their large collection of books, since many of them are gold tooled after the Italian fashion of the time. Jacob Krause, binder to the Elector of Saxony, learned his craft in the Fugger bindery, and his gold tooling is considered the best produced in Germany and it is thought by some experts to rival the work of the French binders in technical perfection. Krause not only bound books in calf and morocco which he decorated with gold-tooled designs, but also bound in pigskin and he blind-stamped his designs, using both panels and rolls. While his technique was excellent, his taste was not always above reproach, for many of his designs were overelaborate and lacking in artistic balance and finesse.[82]

Erhard Ratdolt, the celebrated fifteenth century German printer, employed several binders, and a number of liturgical books printed by him, which retain their original bindings in both calf and pigskin, still exist. They are decorated with interlacing strapwork, rosettes, dots, foliage, and birds; even a hunting scene adorns one of them. Though this may be considered a strange sort of decoration for religious books, it appears that liturgical books were frequently decorated with hunting scenes, especially by south German binders, and a twelfth century authority writes in explanation of this curious custom[83] (see

Plate 76). From this ancient source we learn that an allegory was built up in Germany around the Christians' efforts to convert sinners. This religious pursuit after the unrighteous is likened to the worldly sport of hunting hares, kids, wild boars and stags; and these animals are personified in this metaphorical conception by identifying the hares with the incontinent, the kids with the proud, the wild boars with the rich, and the stags with the worldly-wise. Continuing the allegory, these personified sinners are struck with the arrows of good example in an endeavor to convert them from their evil ways and are chased by the dogs of preachers' voices in order to frighten them. Thus they finally become caught in the "nets of faith" and are led to the "practice of Holy Religion."[84] This mode of allegorical expression was not confined to the graphic arts at this time but was used as well by contemporary writers.

Bindings coming from the prosperous Baltic town of Lübeck have considerable merit, but are less purely German than bindings hitherto mentioned, as their designs exhibit an admixture of influences due to the proximity of this "free city" to northern countries. The saints of the Netherlands and the floral ogee-shaped motifs of Nuremberg, as well as the winged gryphon of Scandinavian art, are all used by the Lübeck binders in book decoration.

The towns and monasteries in Germany that produced fifteenth century bindings are too numerous to mention in this slight sketch. The subject, if dealt with at all comprehensively, even using the incomplete available data, would require at least a full volume or more, and I have merely attempted to mention a few of the most celebrated binders and to refer to several outstanding types of stamped book decoration coming from some of the chief sources of German stamped bookbindings of the period.

It should be noted that the regional types of bindings just described are representative of the production of binding both by

the monks in the monasteries and by the lay binders in the towns. The two towns conspicuous for the quality and quantity of their bindings are Nuremberg and Augsburg. Many of the monasteries had their own special stamps of identification, bearing religious emblems and names of their patron saints, some of which were elaborate and interesting. Reproductions of these stamps are shown in several books listed in the appended Selected List of Books.

The Germans were doubtless the greatest masters of the art of cuir-ciselé as applied to book decoration. This technique was probably not practiced for more than one hundred and fifty years (about 1350-1500) and was confined to certain localities. Most of the extant examples come either from the southeast of Germany or the adjacent countries eastward, that is, from Franconia, Bavaria, Lower Austria, Bohemia, and Hungary.[85] The finest work of this kind produced in Germany comes from Nuremberg and apparently, for the most part, from the workshop of a single artist, who has been identified as a Jew from Ulm by the name of Mair Jaffe, or Meyerlein (little Jew).[86] According to a Nuremberg decree of 1468, permission was given a certain "Meyerlein, Jew from Ulm" to remain in Nuremberg for a specified time, and Mair Jaffe has been identified with this Meyerlein mentioned in the decree. This talented Jewish artist-binder bound a Hebrew Pentateuch manuscript, now in the Munich State Library, which was decorated with beautifully designed animal figures; and he also bound books for wealthy Nuremberg patricians. The Jewish cuir-ciselé binders excelled all others in this particular art of book decoration, and in spite of the known restrictions imposed on the Jews at this time, they were evidently not prevented from competing with Gentile binders in practicing this art in Germany, for a large proportion of the earlier cuir-ciselé bindings were the work of Jewish artists. It is notable that none of Jaffe's bindings contain any Christian symbols, but they

were decorated with heraldic and ornamental designs composed of unicorns, flowers, hounds, and other motifs of like nature.

Panel stamps were rarely used in Germany until after 1550. The earlier panel-stamped work coming from the Ulm binder Johannes Hagmayr, to whom I have referred as having copied his animal figures from playing cards, is an exception. However, after 1550, panel stamps came into general use in Germany, but many of the designs are not especially inspiring. They exhibit a sameness of character, and frequent use was made of such subjects as allegorical figures and portraits of famous men. The panel bindings coming from Cologne are the most imaginative, showing somewhat the influence of the Flemish binders, though few of the designs on these German bindings compare in imagination and artistic treatment with those of the Low Countries and France. While panel stamps made it possible to achieve almost the entire decoration of a book cover with one single impression, thus saving much time and labor, I imagine they were not mere laborsaving devices, as they seem to represent in great measure an attempt on the part of the artist-binder to express greater freedom and originality in the decoration of books than could be arrived at by merely repeating set tool forms. The designs of German artists were frequently copied by the makers of panel stamps, but it is interesting to note that a reproduction of a Dürer design appears only once on a German binding. It is on a sixteenth century binding in pigskin with a panel reproducing the woodcut title page of the 1511 edition of the Little Passion, and it is dated 1577.[87]

German sixteenth century unidentified bindings often display beautiful workmanship and designs, and those with coats of arms in the center are frequently of historical interest (see Plate 77). Others, even though they may not be unique in design, exhibit great perfection in technique (see Plate 78). When the German binders began to practice the art of gold tooling, they pro-

duced some bindings decorated in a simple and charming manner (see Plate 79).

About the middle of the sixteenth century the Germans developed a new kind of engraved roll for decorating their books. Instead of having an uninterrupted design on the entire cylinder which they used for impressing the leather with decorative motifs, they divided the surface of this circular wheel, or roll, into segments, and engraved a separate motif on each segment. This lent an entirely new character to the designs, and in consequence, they became less flowing and more compartmented. Some of these rolls bore the signature of the artist or of the bookbinder.

After the sixteenth century, when Jacob Krause produced gold-tooled bindings of great technical excellence, there were no outstanding German binders until of a very recent date. However, some German bindings were produced in the seventeenth century that compare favorably in technique with those of other European countries (see Plate 80). The Germans evidently neglected the craft of bookbinding for a long period of time. They were of course occupied with one war after another, and both internal dissensions and strife with neighboring countries kept Germany in such turmoil that peaceful arts and crafts had little opportunity to develop. The art and craft of bookbinding ceased to flourish, and a strange indifference about reclaiming her position in the world of bookbinding persisted in Germany longer than in either France or England. Even at the beginning of the twentieth century there were no binderies in Germany turning out such creditable work as was being done in these other two countries. The German craftsmen were clumsy in their forwarding, and they exhibited the most wretched taste in decorating their bindings. It was not until the technical schools in Germany turned their attention to the craft of binding that bookbinding began once again to exhibit some of the talent inherent in the Germans. This movement started shortly before World

War I and was accelerated after the collapse of the monarchy. Technical schools were financially supported by the government with liberal allowances, and binders were sent to England, France, and Switzerland to perfect their craft in order to teach in these schools. Rigorous rules regarding the length of apprenticeship were enforced, and no binder was allowed to practice his craft until he had qualified under stipulated regulations and had received his diploma, which entitled him to set up an establishment as a bookbinder or to teach his craft.

Eight years of training were prescribed in Germany in order to become a bookbinder. First, there were four years spent in a workshop as a pupil, during which time the learner received a very small stipend. Then, after the four years were completed, the worker came up for an examination in one of the technical schools, and if he qualified, he was made an apprentice and was given a certificate entitling him to finish his training. This training had to be completed partly in a workshop as an apprentice and partly in a technical school. After another four years he was allowed to come up for a second examination before a commission of the so-called "Handwork Chamber," and if he passed this test successfully he was made a master binder, received his diploma, and was allowed to practice the craft of binding. This system of apprenticeship is similar to that used in both France and England, though the term of training has recently been only seven years in these two countries, and there is less regimentation.

It is very evident that the thoroughness with which the Germans attacked the situation with regard to the craft of binding in their country during the first quarter of this century has been most fruitful of results. Once again German binders' names have come into prominence, and German bindings of great merit may now be found in international exhibitions. In regard to both forwarding and finishing, as well as to design, the modern German binders are turning out excellent work. Not only with

reference to the extra hand binding, but in the job and trade bindings as well, standards in construction and design have been noticeably raised.

Probably the two best-known German hand binders of the present time are Otto Dorfner and Ignatz Wiemler, both professors in craft schools and binders of repute (see Plate 81). Then there is Professor Weisse, who was formerly director of the Hamburg Craft School, and Professor Joseph Hoffman, in the principal technical school of Vienna, both of whom have contributed greatly to the furthering of better binding methods in Germany and Austria. Paul Adam is another German binder who merits distinction, not only as a binder but as a teacher, scholar, and author, and Bruno Wagner of Breslau has exhibited some interesting bindings, as has Otto Pfaff of Halle, who has broken away from the traditional in his designs.

The craft of binding has quite a large following among women in Germany, several of whom have been partially trained in England. Among the women binders of southern Germany who have exhibited some interesting and distinctive bindings are Frieda Tiersch, Frau von Guaita, Frl. Lederhose, and Frl. Jacob. Frl. Ascoff and Frau Frieda Schoy, who have their workshop in the vicinity of the Rhine, are talented professional binders who have gained a reputation for expert work. Without question, the German binders have recently been asserting their ability to take a distinguished place in the art and craft of bookbinding.

HUNGARY

Hungary is especially noted in the world of books because of its famous royal bibliophile, King Matthias Corvinus, who reigned from 1458 to 1490. This collector was a learned man and a patron not only of the art of bookbinding but of other arts as well. He brought together an extensive library of manuscripts and had books transcribed and illuminated especially for him

by Italian artists, such as Attavante degli Attavanti and other cel-
ebrated Florentine miniaturists. The Italian Renaissance master-
pieces which he collected rivaled in beauty and magnificence the
famous collections of the Medici and the Urbino dukes, and
Corvinus built a library fitting in elegance to hold his treasures,
which were placed on elaborately carved shelves of the finest
workmanship and protected by gold-embroidered velvet cur-
tains. After a time, this bibliophile king brought to Hungary the
most skillful scribes and talented miniature painters from Italy
and created a scriptorium in his own palace at Buda for them
to work in.[88] Such was his enthusiasm and love for the art of
bookmaking and binding that he also established a bindery
workshop in his palace.

In 1526 the famous Corvinus library was pillaged, many books
were burned and others were carried away to Constantinople.
Most of those still existing are now in Vienna, though a few are
to be found principally in Germany, Paris, and Venice. A small
number were returned from Constantinople to Budapest and are
now in the National Hungarian Museum. There is at the present
time a movement on foot to have some of the Corviniana MSS.
returned to Budapest.

Since the discoveries about the origin of gold tooling resulting
from the scholarly researches of Dr. Gottlieb and Baron Rud-
beck, which have been passed on to the English-speaking world
by Dr. Goldschmidt with valuable deductions, King Corvinus
has grown in stature and importance to the student of bookbind-
ing. It has been substantiated that this royal bibliophile had the
knowledge and the sagacity which prompted him to import
from Italy binders who understood an art of book decoration
that had hitherto not been in general use anywhere in the world.
These workmen, in all probability from Naples, understood this
new art of tooling book covers in a manner that is generally char-
acterized by the French term "à petits fers," namely, by the use of

heated tools impressed by hand over gold leaf. Most informed authorities have concluded that the art of gold tooling à petits fers as distinct from gilding with a brush in the Oriental fashion was introduced from Spain into Italy at Naples. So it appears that this connoisseur of art discovered that a superior kind of book decoration was being practiced in Naples and therefore imported workmen from that town to decorate the bindings of his priceless manuscripts in the new manner, before the method was generally practiced elsewhere. Since King Corvinus had married Beatrix, the daughter of Ferdinand of Aragon, King of Naples, it is not surprising that he should have discovered the new art of gold tooling in Naples, for he certainly must have visited that city frequently, on account of his connection by marriage with the King, who was also a scholar and a book collector. The whole story woven about this Hungarian king forms a romance of significance in the history of bookbinding and certainly adds prestige to Hungary.

The Corvinus books were bound in velvet or morocco leather. They were often decorated with colored leather inlays, inset cameos, or colored enamels. Some are rather Oriental in character and others are in the Italian style of the period. All exhibit the most expert workmanship.[89]

It seems probable that the Italian workmen in the Corvinus bindery trained native helpers to assist them, and thus gold tooling was learned and practiced at an early date by Hungarian binders. There was apparently a generally high level of workmanship in Hungary, and the intermixture of gold tooling with the added color and luster introduced by the Oriental enamel technique made for a splendor peculiar to book decoration in Hungary at this time. But it must be remembered that this art was imported and that it was chiefly practiced by foreign workmen at this early period. The native Hungarian workmen who learned from Italian binders to tool books in gold continued to

follow foreign models, and no national style was evolved. Apparently the Hungarian binders have never succeeded, certainly up to recent times, in developing a style of book decoration entirely free from foreign influence.

POLAND

The Jagellonic Library in the University of Cracow and the Czartoryski Museum, also of Cracow, contain many bindings of Polish origin that exhibit some excellent fifteenth century work and a variety of artistic designs. These bindings are similar to the German bindings of the period. Both the stamps used and the character of the designs display rather generally the influence of German binders, though Italian influence also is apparent. This latter influence is shown in the use of gold tooling at a time when blind stamping was prevalent in that part of Europe, and in the use of certain Italian tool forms.

The early penetration of the art and technique of gold tooling into Poland, before they were practiced to any extent outside of Spain and Italy, is doubtless due to the proximity of Poland to Hungary. Following the reign of Corvinus, Poland, Hungary, and Bohemia were united under one king (1490-1516). Budapest was the political center of these three countries, and Cracow was the center of learning and book production. With this in mind, it does not seem strange that the technique being practiced in Budapest in the Corvinus bindery should have found its way into Cracow, where the art of binding was well advanced. The Poles not only practiced the arts of blind stamping and gold tooling on their bindings, but evidently also used the cuir-ciselé technique, which they probably learned from the Jewish Bavarian and Austrian workmen.

Judging from the Wislocki catalogue of incunabula in the Jagellonic Library, which ascribes many bindings to Polish workmen, there must have been a number of talented binders

connected with the University of Cracow in the fifteenth century.

That the Poles felt both the German and the French influence in their art and craft of binding may be partly explained by the fact that Henri of Valois, or Henri III of France, was King of Poland in the sixteenth century, as was Augustus the Strong, the Elector of Saxony, in the eighteenth century. It seems doubtful that Henri of Valois should have exercised much influence on the art of book decoration during his brief reign as monarch of Poland (1573-1574), except through his mother, Catherine de Medici, who, being an ardent lover of beautiful bindings, might well have extended her live interest in binding to Poland through her son, whom she put upon the throne. The German influence is more readily understood, since the proximity of Germany to Poland and the continual effort of Germany to take a hand in Polish affairs are well known.

The later Polish binders appear to have copied the German schools of binding in their technique, and in design they have leaned toward the traditional eighteenth century or the modern French schools until recently, when Polish binders began to design the covers of their books in a manner suggesting a national consciousness.

SCANDINAVIA

The fifteenth century Scandinavian bindings were decorated with stamps similar to those used in Germany, though some of the animal forms used show the influence of Byzantine art. Later work is after the French fashion, and the French models of tools were doubtless either copied by native tool cutters or were possibly engraved in Paris. It is reported in the catalogue of the National Library of Stockholm that Christina of Sweden, who is known to have been a book lover, imported French and Italian binders into Sweden. In all the Scandinavian countries there has been for many centuries a persistent effort to produce well-bound books.

During the middle of the eighteenth century the art and craft of binding in Sweden was flourishing, but Swedish bookbinding languished soon afterward, until toward the end of the nineteenth century. It was at about this time that Gustaf Hedberg went to Paris and London to study and work in these foreign binderies, and upon his return to Sweden he evidently stimulated the Swedish binders to work along less conventional lines. His designs exhibit no more marked originality than is shown by other binders of his time but he displayed ingenuity in making a few tools carry out his designs. Countess Eva Sparre is a noted Swedish binder who has shown originality and independence of traditional styles. Her decoration is usually simple and always in excellent taste. Miss Greta Morssing is another well-known Swedish binder who has generally bound and designed books after the English fashion.

The Danish binders Petersen and Petersen, Oscar Jacobsen, and Anker Kyster have exhibited extensively. These men have all produced bindings decorated in a conventional manner, but they have also departed from the conventional and have decorated their books with freely drawn line designs that are peculiarly Danish in feeling. Among the several women binders in Denmark producing interestingly designed bindings is Ingeborg Borjeson of Copenhagen who is noted as a maker of charming decorated end papers.

Hand bookbinding in Norway has developed as great activity as in the other Scandinavian countries. Among the most versatile Norwegian binders are Rander Naess, Signe Bjerke, and Ruth Arnes.

Just after the beginning of the twentieth century the binders in all the Scandinavian countries began decorating their bindings with simple lines, showing the influence of a modern trend in their treatment of book-cover designs. In these North European countries functionalism was stressed in architecture soon

after its conception and, in keeping with this influence, the book-binders evidently sought to break away from the traditions of the past in decorating their books. In many instances they have become ultramodern in their free treatment of unconventional line motifs.

One often hears the term "functional design" applied to this sort of book decoration, but since functional design, as it is usually understood, must be adapted to structure, it is difficult to see how it can possibly be applied to book decoration without stretching the term illogically. Decorative art and functionalism would appear to be almost entirely divorced from each other by their very natures; the one belonging to the realm of aesthetics and the other basically bound up with utilitarianism. I fail to see how decorative art, as such, can possibly serve a utilitarian purpose in the generally accepted use of the term, and therefore how it can be construed to be functional, though it is apparent that through the manner in which structure is adapted to function an aesthetic result may be produced.

NORTH AMERICA

The field of hand bookbinding in America has been neglected by writers presenting the history of the craft of binding, and our information about the work of the early American binders is spotty and incomplete, though recently some interesting data have come to light.

As our earliest settlers came mostly from English stock, we find immigrant binders in the seventeenth century practicing the art and craft of hand bookbinding in colonial America after the fashion of their English ancestors, with modifications imposed by limitations due to scarcity of materials. However, immigrant binders came not only from England in the colonial period, but also from other foreign countries, particularly Scotland, France, and Germany. These skilled workmen influenced styles

and technique in this country, and the early work of our binders exemplifies the traditions of Western Europe, though at length American binders developed a style of binding marked by characteristics of some independence as to both technique and design.

The colonial binders had no direct legacy from monastic binderies, for they began practicing their craft after that craft had been in secular hands for nearly two centuries, but mediæval practices in general continued to be used in binding in colonial America until mechanization quickened the pace of bookbinding and made hand binders resort to various expedients in order to compete with the machine.

Most of the early American bindings were blind tooled on sheep and calf covers over wooden boards. Wood such as oak, maple, and birch was used for book covers instead of pasteboard, because pasteboard was not easily obtainable in America during the colonial period, while wood was plentiful. But these American wooden board covers were different from those used abroad on the thick folio fifteenth century volumes. Of necessity, they had to be much thinner in order to be suitable for use on the thin books first published in this country. They were scarcely thicker than pasteboard and were called "scaleboard" or "scabboard." It is obvious that these thin wooden boards were considerably more durable than the pasteboard then in general use for book covers on the Continent and in the British Isles. Not until the eighteenth century was wood superseded by pasteboard in this country for the sides of books, as pasteboard had to be imported, at least until after the first paper mill was established in Philadelphia in 1690.

The colonial binders sewed their books after the soundest method, over raised cords which were laced into the covers, but they also followed the less sound practice of sewing over rawhide thongs and sinking them into grooves sawed out in the back of the sections, in order to produce a smooth back uninterrupted by bands. When head and tailbands were used, they were usually

made of linen thread, and book-edges were colored instead of being gilded. But books were not at first rounded and backed, though this highly desirable feature of book construction came into practice somewhat later, obviating the tendency of backs to cave in.

One of the Grolier Club catalogues mentions a bookbinder by the name of John Sanders,[90] who opened a shop in Boston in 1637, though nothing further is known about him or his work.

We have no record of the fact, but it is probable that the American colonial binders were connected with printing and bookselling shops, and that books came to the booksellers of New England in sheets, as they did to the booksellers abroad, and were bound in these establishments, where tools and materials for the work were provided. Sanders may well have been absorbed by one of these firms, who employed him to bind their books.

The two early American binders most frequently mentioned are Edmund Ranger and John Ratcliff. It is known that Ranger was a bookseller as well as a binder, and that Ratcliff worked in Boston for about twenty years (1663-1682) and came from England to bind the Indian Bible of John Eliot. Ranger was the more conservative binder of the two, eschewing the use of sawn-in bands and other questionable practices that Ratcliff indulged in to the detriment of his work. Both Ratcliff and Ranger did what is termed "plain" binding as well as extra binding. In common with other American binders of their time, they used domestic sheep and calf for their plain bindings, which they decorated with blind tooling after the fashion then in vogue in this country. But they are especially distinguished for their departure from many of the usual practices. Instead of wooden boards, we find on their books pasteboard covers, which were doubtless imported, and their use of imported morocco leather, marbled end papers, and gold tooling, at a time when plain end papers, blind tooling, and domestic leather were used by other binders, serves to

entitle them to a place of pre-eminence among colonial binders. Not only did they use gold leaf for tooling their morocco bindings, but it was used by them for gilding the edges of their books, and Ranger added head and tailbands made of silk instead of linen thread, thus inaugurating new colonial practices.[91]

In comparison with the technique of European binders of this period, the native American binders' work was somewhat crude, though their methods of construction were for the most part sound and their bindings were characterized by qualities of solidity and a simple style of decoration that is very pleasing. Considering that many of these binders lacked long experience and had often to rely upon homemade materials that were less expertly fabricated than those manufactured abroad, their work is amazingly creditable.

An adaptation of the English panel style of decoration, known as the "Cambridge style," was used by colonial binders throughout the seventeenth century and part of the eighteenth. The tooling was in blind, and the board edges were often bounded by double lines, sometimes with a flowered roll running next to the lines, and generally with some sort of flower tool at the four corners of a central panel. This style of decoration is characteristic of bindings of this period and is to be found on bindings made by Boston, Philadelphia, and even some southern colonial binders. A colonial binding on the Bay Psalm book is shown in Plate 82.

The "backbone," or "spine," of a colonial binding was not titled or ornamented except for lines on each side of the bands, which were tooled either in blind or gold. Or when bands were absent, lines were tooled across the spine at intervals corresponding with the position of the sunken cords on which the sections were sewed. An attractive feature of these early bindings, which was almost always present, was the decoration in blind or gold on the edges of the covered boards, and the custom of decorating

the inside leather margins with blind tooling served to make the bindings less plain.

Sprinkled calf was in vogue at this time in England, and American binders used this method of achieving what was considered a decorative effect. But since acids had to be applied to the leather in the process of "sprinkling," the effect was got at the expense of the durability of the binding.

Toward the end of the eighteenth century there were bindings produced in the American colonies by workmen who had been trained in England and Scotland. These bindings display a style of decoration less simple than those produced in the earliest period. The sides and backs of the bindings were often decorated with elaborate gold-tooled designs in a manner then current in the countries where the workmen served their apprenticeship. However, the German-trained colonial binders who worked in the last part of the eighteenth century produced bindings often mediæval in character, with brass clasps and bosses and with scant decoration in blind tooling.

After the Revolution, when America had become politically independent of England, a new consciousness was manifest in American pursuits and new influences infiltrated into the activities of the Republic. France had been bound to America by close ties, and the American horizon was broadened by new contacts. Though the Republic continued to be dependent on Great Britain for much of its inspiration, as in colonial days, there was evidence in American enterprises of a wider perspective and a more virile independence. A new era came into being.

Thus we find the art and craft of bookbinding reflecting the less provincial and more independent outlook of the American mind. Hand binding began to be practiced in independent shops not connected with printing or bookselling establishments. By the end of the eighteenth century all materials necessary for binding purposes were made in the new United States, and binders

were no longer dependent upon foreign sources for their supplies. Pasteboard covers, marbled end papers, and imitation morocco leather came into general use as the rapid development of new industries produced these articles.

However, although the industrialized United States produced a flourishing craft in bookbinding, it did not improve the technique of the craft. The printing houses were turning out books in great numbers after the close of the eighteenth century, and speed became the necessity of the binder in order to meet the demands of industrialized book production. Therefore every possible means of increasing production was put into practice, often with little regard for the lasting qualities of the binding. Sawn-in backs with false glued-on raised bands were the usual order of the day. Pasted-on head and tailbands made of cloth or leather began to be substituted for those woven onto the book with silk or linen thread. Books were sewed on fewer cords, often not more than two, and even these were finally not laced into the covers but were frayed out and pasted down onto them. Nevertheless, one important improvement occurred in the disappearance of concave, or sunken, backs, for the binders began to round the backs of their books and force them into a convex shape, a technique which was necessary if a title were to be put on them successfully. While short cuts in construction were characteristic of the general run of bindings produced in America at this time, it was still possible to get a sound binding done by the extra binder, if one were willing to give him time and pay him for a substantial job.

In the matter of decoration, bindings took on a greater elaborateness after the colonies became a republic. Gold-tooled designs were substituted for blind-tooled ones, and decorative rolls became increasingly employed for a massed effect of gold tooling. These engraved rolls were often an inch wide and were used to produce a floral border running around the outer edge of the

cover (see Plate 83). But the most attractive bindings of this period, though less frequently met with, are the ones on which a center design is built up of small tools, with the book-edges bounded by a narrow roll pattern and with a small fleuron emerging from the four corners of the border. This style smacks of English and French influence, but the proportions of the designs and the general effect of unpretentiousness suggest immediately that they must be the products of less sophisticated craftsmen than those binding abroad at that time. There is no dash about the small books tooled in this manner, but there is a delightful naïveté about the designs, and the craftsmanship is excellent. In my judgment these charming, simple bindings represent more taste than any other bindings produced after the American colonies were united in a republic.

Small tools were occasionally used to make a repeat border design, and very rarely an all-over design was produced, in which both small tools and engraved floral rolls were utilized. Leather inlays appear on some bindings of this period, but that technique was practiced neither extensively nor too successfully by these binders, though colored leather labels were put on the backs of books, enhancing the attractiveness of the binding in an intriguing manner. The labels containing the title and the volume number were often quite charmingly decorated with gold tooling even on otherwise plain bindings.

Undoubtedly the immigrant binders in the colonial period brought with them tools for decorating their books, and tools were probably imported for use in colonial times. Just when they were first engraved in this country, is uncertain, though records bear testimony to the fact that they were being made in the United States early in the nineteenth century.[92] Since type was cut in America as early as the last quarter of the eighteenth century, it seems probable that bookbinding tools were cut in this country not much later.

It appears that tanneries were established in Virginia and Massachusetts as early as 1630, and the American leather manufacturers apparently supplied colonial bookbinders with sheep, calf, doeskin, and possibly some vellum and parchment. As parchment and vellum covers are rarely found on early colonial books, it would seem as though only a small quantity of these materials was manufactured here at that time, and it is doubtful if these products were imported to any extent. From account books kept by Benjamin Franklin we learn that binders were supplied with gold leaf from Pennsylvania as early as 1820.

The great centers of printing in the United States were Boston, Philadelphia, and New York, and the craft of bookbinding flourished particularly in these cities, but there were hand binders working in various other parts of the country. I quote from Hannah Dustin French in *Bookbinding in America:* "There were bookbinders in Worcester and Salem, Massachusetts; Albany and Hudson, New York; Newark, New Jersey; Baltimore, Maryland; and Charleston, South Carolina. However, information about them is scarce, except possibly for those in Worcester and Salem."

In the eighteenth century, a Scotsman by the name of Robert Aitken was printing and selling books in Philadelphia, and though no bindings have been discovered which were signed by him, he is thought to have bound several copies of the Bibles he printed. He must have been trained in Scotland, and if the bindings attributed to him are authentic, he should be credited with extremely careful workmanship and much taste (see Plate 84). In the nineteenth century one of the outstanding binders was John Roulstone, of Boston, whose bindings are signed. I have mentioned Ranger, Ratcliff, and Aitken as binders representative of some of the best work done in the three first centuries of bookbinding in America, but there were scores of other binders working in America at this time. There is an extensive list of early

American binders given by Hannah Dustin French in *Bookbinding in America*, pp. 99-116. Much other valuable information may be gleaned from this able and painstaking presentation of the subject of early American hand bookbinding.

Though many gold-overloaded and stereotyped designs were produced on hand-bound books in America during the nineteenth century, as was the case in European countries, occasional examples of this period are found which display restraint and a certain Victorian self-consciousness that is not unpleasing; but the craft of hand binding was less and less able to keep pace with the speed brought about by the industrialization of this country. Competition with the machines, which were capable of producing covers quickly and cheaply for publishers' editions, was too great, and finally the machine "stole the show" from the hand binders. They were no longer supreme, and their craft ceased to be a thriving one.

This condition obtained in America to a greater extent than in any other country, and I think was entirely due to economic causes. Labor was cheaper abroad than in America, and therefore the economic differential between handwork and machine work was most pronounced in this country and made competition sharper here than elsewhere. Furthermore, high tariffs, which were designed to "protect" American industries, were imposed upon materials coming into the United States from abroad and made them just as expensive as those produced here with higher labor costs. This prevented American binders from taking advantage of the cheaper prices paid by European binders for materials. With this double economic handicap, it is not surprising that our hand binders not only were unable to compete with machines, but lost business in competition with foreign hand binders. A large number of American bibliophiles had their books bound in England and France at this time, and our booksellers in great numbers sent their books abroad to be bound, as

they were able to get the work done more cheaply than in the United States, notwithstanding the tariff imposed on imported bindings. These conditions produced a declining craft of hand bookbinding in America at the end of the nineteenth century, when binders in England and France were doing a thriving business, chiefly because they were able to turn out bindings at a price the public could afford to pay. The foreign competition, together with the lack of an apprenticeship system, has militated against the development of hand bookbinding in America, and it is no wonder that superior craftsmen are produced abroad. The few job binders that have been able to survive in this country are doing creditable plain binding, but there is no incentive for them to strive for art in binding, for it is "a losing game" financially and they cannot afford such an adventure.

Nevertheless, the revived interest in handwork that began to be shown toward the end of the nineteenth century extended to all the crafts, both in this country and abroad, and finally pervaded the field of bookbinding. Collectors not only were willing to pay high prices for specimens of rare bindings produced in the past, but sought out contemporary hand binders who were able to take commissions for artistically decorated books, and became their patrons. In 1895 Mr. Robert Hoe, whose extraordinary collection of bindings is well known, together with several Grolier Club members, established a hand bindery in the city of New York, known as the Club Bindery, where imported foreign binders carried on the work. Several large and prosperous bookbinding firms in this country which had previously devoted their efforts to machine binding established departments which were solely devoted to extra binding, and the most talented workmen procurable were employed. Printing firms, such as the Lakeside Press in Chicago and Doubleday, Page & Company of Garden City, organized hand binderies in connection with their establishments and manned them with competent hand binders. The

school for teaching the craft of binding which was instituted and underwritten by the Lakeside Press is evidence of the increasing interest in the United States in furthering the craft of hand bookbinding. The tide was so strong that bookish people at the beginning of the present century became bookbinding conscious, as they had become printing conscious, and hand bookbinding in American was on trial.

As a result of this stimulated interest in binding, a number of would-be bookbinders, mostly women, set sail for Europe to learn the art and craft of binding. Whether this quest by women for training in the craft was inspired by the feminist movement then in progress in this country or whether it was mostly influenced by the fact that women had a lesser economic value than men and could afford to train professionally and practice a poorly paid craft, is a question. In any case, a few of these women worked almost religiously, and after serving a voluntary apprenticeship of several years, returned to America to practice and teach their craft. One of the first American women to study abroad was Miss Evelyn Nordhoff, who worked in England with Mr. Cobden-Sanderson for some time and then returned to New York, where she set up a bindery known as the Evelyn Nordhoff Bindery. Among the women pioneers of the craft in this country is Miss Marguerite Duprez Lahey, whose work is of high standard. She is thoroughly trained, and has made frequent pilgrimages to Paris since her first apprenticeship there, seeking to perfect her technique. For many years she has worked only for The Pierpont Morgan Library. In America at the present time there are other hand binders, both men and women, deserving of mention, but I shall not attempt to present a list of them, for the total number is comparatively large, and it would be difficult to single out a few for special mention without overlooking others.

If hand bookbinding is to develop in America as it has de-

veloped in European countries, first of all, provision must be made for making it possible to get a well-founded training in both the art and the technique of the craft. In European countries standards are set in hand bookbinding, craft schools are inaugurated, and apprenticeship systems are in force which offer opportunities for thorough training in the craft of binding, while in America these organized opportunities are lacking.

In this country, where formerly a system of apprenticeship was abused and hardships were inflicted on apprentices by their masters (as they were also in Europe), instead of stopping these abuses and regulating the system, we, in my opinion, very unwisely abolished it. As a result, we have had to recruit our most expert hand binders from the ranks of foreign workmen. Had we established good technical schools, manned by practical and well-qualified teachers, and had we coincidentally put the whole system of bookbinding apprenticeship on a sound basis, with proper regulation and prescribed standards, we would have been creating our own able bookbinders instead of importing them from abroad.

The course of training for bookbinders in Europe embraces not only the technical and mechanical processes of the craft, but includes sound instruction, by noted masters of art, in the rudiments of drawing and design. This is why the foreign binders are equipped to become creative designers if they possess the talent of originality. If opportunities were offered in America to gain a thorough basic training in the technique of the craft of binding, and if a fundamental, practical knowledge of drawing and design were insisted upon as a part of a hand bookbinder's training, there is no doubt in my mind that we should be producing master binders and really creative work in bookbinding design. The necessity of thorough training applies to every craft, and a well-organized and properly regulated apprenticeship system with standards of proficiency must be adopted in this country,

not only in bookbinding but in many other crafts, if a high standard of workmanship is to be attained.

It is much easier to abolish an apprenticeship system that has been abused than to regulate and enforce that system; but I believe that when we in America learn to substitute the difficult practice of regulating an apprenticeship system for the expedient of summary abolishment of it in our crafts, we shall improve standards of workmanship, and at the same time achieve a greater degree of justice in our social order.

I stated that hand bookbinding was "on trial" in the United States at the beginning of this century, and I think it is still on trial, for the challenge of bookbinders in Europe is at the present time strong.

CHAPTER VII

MISCELLANEA

*Format, Signatures, Decoration of Book-edges, Shrines, Satchels,
Book Covers, and Girdle Books, Forgeries, Some Materials
and their Manufacture, Deterioration of Bindings,
and the Care of Books*

FORMAT

THE early codex is generally referred to as a square quarto
book, but as a matter of fact it is made up in folio format.
Though most bibliophiles are conversant with the "make-up" of
a book, some confusion seems to exist concerning the use of the
term "format." However, the etymology of the word, as stated in
Littré's dictionary of the French language, points to the conclu-
sion that the term comes to us through the French word *formé,*
from the Latin participle *formatus,* meaning "formed."

The word is, at the present time, indiscriminately used by the
"trade" with comprehensive significance to describe the size and
the entire general make-up of a book, whereas by the bibliogra-
pher it is used in a restrictive sense to refer only to the way in
which a book has been printed or written on the sheets used for
the text and to the consequent folding of those sheets which com-
pose the sections, or gatherings, of the book. To the bibliogra-
pher, nothing with reference to size is comprehended in the
word "format." A book made up in octavo format may be the
same size as one in folio format, depending upon the size of the
sheet used for the text.

A folio format, in bibliographical parlance, is made up of
sheets folded only once, forming two leaves and four pages. In a
quarto format the sheet is folded twice, making double the
number of leaves and pages. By folding the sheet a third time one
has eight leaves or sixteen pages making an octavo format, which

has been the usual format since about 1700. By additional foldings the 12mo, or duodecimo, format, the 16mo format, and the 32mo formats are arrived at.

The number of leaves to a section does not always identify the format of a book, however, as each sheet does not always constitute a section. For example, folios are usually composed of two or more folded sheets, and the bibliographer looks to the grain of the paper and to other characteristics of a book in determining the format. For more detailed information on the subject, the reader is advised to consult one of the many books on bibliography.

This connotation of the bibliographer is technically precise, and should be adhered to when referring to books printed or written in the early period when the term meant really nothing but the manner in which the sheet was folded.

In the early days of printing the term carried a fairly definite significance with reference to size, because the hand made paper then used varied much less in size than paper used at a later period, and for this reason the term suggested very definitely the shape and size of the book. A folio was then a large oblong book from twelve to sixteen inches in height. A quarto was a square book measuring from nine to twelve inches, and an octavo, a small oblong book about seven to nine inches in height. It was some time after the invention of printing, however, before formats of books became standardized.

The loose use of the term "format" by our publishers seems a bit extravagant to the bibliographer, but it is helpful in visualizing the size and shape of books, and if applied only to books published after the beginning of the nineteenth century, when machine-made paper in larger sizes came into use, it should cause no confusion. In my opinion there is considerable justification for this popular use of "format," for, after all, "formed" seems to permit a broader use of the word than that of merely "folded." In

the final analysis, usage can change the meaning of words, and in this instance I think the bibliographer should not quarrel with the publisher's and the layman's wide meaning of the word, so long as its technical meaning is not lost sight of.

SIGNATURES

The letters or numerals printed or written on the first page of a sheet, which when folded forms a section of a book, are called signatures. The book sections, or gatherings, were marked in this manner in order that their sequence might be easily identified. William Blades has written a monograph on signatures which is illuminating to anyone seeking further information on the subject. In it he sums up the matter interestingly: "The chief use of signatures was and is for the binder. Binding is certainly as old as books. Signatures are certainly as old as binders. It is conceivable that the early monastic scribe, who made his own parchment, concocted his own writing-ink, copied leisurely, with his own hand, the Bible or Psalter, and, lastly bound them *propriâ manu*, might complete his work without wanting any signatures to help him; or, at any rate, might be satisfied with placing a catchword at the end of each section as a guide to their sequence. But the manufacture of books passed from the monk's scriptorium into the hands of trade guilds, and the increased demand for books caused a great sub-division of labour; and when, instead of one, a manuscript would pass through a dozen workmen's hands before completion; then signatures became a necessity, as much for the scribe as for the binder, as necessary for the collation of the early MS as for the steam-printed novel of today." [93]

Signatures were purposely placed by scribes on the outer edges of manuscripts at the foot of the page so that they would be cut off during the process of binding. This was also the practice in early printed books, and it accounts for the fact that often no sig-

natures are found on them or, when found, are sometimes partially cut off.

The form and system of signatures varies with different scribes and printers, but usually either a capital letter followed by a numeral or one followed by a small letter was put on the first leaf of a gathering. The same capital letter was followed by another numeral or a small letter on the second leaf, and so on: viz. A or A1, A2, or Ai, Aij, etc. Neither the letters *i* and *j* nor *u* and *v* were differentiated in early times, and the letter *w* was never used in signatures. This same system continues to be used in printing books at the present time with slight variations, though the signatures are now placed close up to the last line of type.

DECORATION OF BOOK-EDGES

The storing of books in mediæval times flat on shelves, one upon another, with their edges exposed undoubtedly gave rise to the adorning of book-edges, and in the sixteenth century much attention was given to decorating the edges of books by coloring, gilding, gauffering, and painting, though the decoration of book-edges dates to the tenth century.[94] Titles, legends, floral designs, and devices of various sorts were painted upon book-edges, either purely for their decorative effect or to denote ownership. In Mexico at the beginning of the seventeenth century the edges of books were branded to designate the ownership of a book.

The gilding of edges was practiced soon after gold tooling appeared on book covers, and it was not long thereafter that edges began to be decorated by gauffering. This was done by impressing designs on the edges already gilded, either with a small pointed tool or with binders' tools slightly heated, and these designs were sometimes picked out in color. After the pattern was stamped on the gilded edge, the surface was burnished. The gauffering was done with the book closed and with the edges

tightly compressd. The earliest examples of gauffered edges were produced at Venice and Augsburg.

The German binders were fond of painting their edges, and they used figure subjects from about the middle of the sixteenth century. They excelled in the use of color on their gauffered edges, though the effect was less delicate than florid.

A variety of pleasing effects was obtained in edge decoration by using gold of different shades and combining these varied tones with silver. The Italians, at an early age, employed pale gold in decorating their edges, and by means of its use produced a very dainty effect. The Venetians in particular, as early as the first part of the sixteenth century, gauffered their edges, using a rope pattern similar to that produced on the covers of their books.

The French binders throughout the sixteenth century gilded their edges and gauffered them in elaborate patterns, which they outlined with pointed tools. These designs were usually of a floral or arabesque nature. They also stamped designs on gilded edges of books and then scraped the pattern out, leaving it in white. This gauffering of edges was at its height of perfection in the sixteenth century (see Plate 85).

Le Gascon is said to be the first binder to introduce marbling on edges under gilt. The marbling was done by placing the book-edges on a marbled pattern, which was prepared in a vat. Colors were floated onto a layer of size in the vat, and the patterns were made by stirring and arranging the colors with combs or with other implements. The book-edges were then lightly rested on the marbled pattern, which was transferred to them in its varie-gated design. When dry, the edges were gilded over the marbl-ing. The gold on edges treated in this manner has a deep luster, but when the book is opened, the gilding is not visible, and the edges appear merely to be marbled. This is caused by the fact that the colors in the marbling run very slightly into the paper, so that they show when the leaves are not compressed, whereas the

gold leaf rests solidly upon the surface of the edge and is not visible from a side view when the book is opened.

It was the "Mearne binder" who introduced an entirely new manner of decorating the fore-edges of books by putting a "hidden painting" on them. This was effected by "fanning out" the edges, painting on them a design, a coat of arms, or a portrait when they were in this position, and then gilding over the painting. As a result of this procedure the edges appear merely gilt when the book is closed, as is the case with the Le Gascon edges that were gilded over a marbled pattern. In order to see the painting, the book must be laid flat with its upper cover opened and on a line with the lower cover. In this position the fore-edge assumes a beveled contour, slanting from the front page to the last page, and thus the painting is exposed to view (see Plate 86). These fore-edge paintings are usually found with the colors still quite strong, doubtless because of their having been protected by a coat of gold leaf.

Later, in the eighteenth century, James Edwards of Halifax, who is noted for his transparent vellum bindings, and John Whitaker, the binder who bound strained calf books in the Etruscan style, revived the art of painting book fore-edges after the Mearne fashion. This use of concealed paintings on the fore-edges of books was practiced by other binders as well. Kalthoeber used the art of gilding over a painted design, though his designs showed under the gold when the book was closed.

The technique used for book-edge paintings is not difficult, though the painting of the designs requires the talent of an artist. The artisan and the artist, though they may be one and the same individual, have distinctly different functions to perform. To produce a painting under gold, the fore-edge of the book is first "cut in boards" with a plough, so that the edge will offer a perfectly smooth surface to work on. The leaves of the book are then "fanned out," and they are held in this position clamped

tightly between wooden boards. The design is painted on the edge with a brush held at right angles to it so that the paint will remain on the surface, and the paint is used not too much thinned in order to prevent the colors from running. When the painting is finished and is thoroughly dry, the clamps are removed, the book is put in a gilding press between gilding boards, and after burnishing the painted edge, it is gilded like any ordinary book-edge, though the press must be screwed up as tightly as possible to prevent the glaire, or size, from penetrating the painting.

This elaborate decoration on book-edges is appealing to many, though it often appears like "gilding the lily." It seems to me most appropriate on embroidered books but very often out of place on leather-covered bindings (see Plates 87, 88).

The branding of book-edges in Mexico, which began in the seventeenth century, was first done by monks in charge of convent libraries in order to mark their property as a precaution against theft. Brands of red-hot iron or bronze were used for this purpose in a manner similar to that used for branding cattle. Usually this branding was done only on the edges at the head of the book, though sometimes it is found on fore-edges of books, and occasionally on both head and tail. Unfortunately, the process often injured the covers, title pages and flyleaves by burning into them. This owner's mark was very effective as a protection against thievery, for a branded insignia on a book-edge is almost impossible to efface without resorting to trimming deep enough into the edges to cut the marks entirely away[95] (see Plate 89).

SHRINES, SATCHELS, BOOK COVERS, AND GIRDLE BOOKS

SHRINES. It was an early custom to make covers for bound books, and in many instances these covers were more elaborately decorated that the bindings themselves. Books, as well as ecclesi-

astical sacred vessels and prized personal ornaments, were protected by coverings of various sorts, and in the early days of Christianity shrines were made as repositories for sacred books, as they were for other sacred objects.

The boxes, or *book shrines,* made in Ireland for holding their simply bound leather manuscripts are called *cumdachs.* They were overlaid with precious metals inset with jewels, but there are few specimens extant (see Plate 90). One of the finest examples of the Irish cumdachs still in existence is that of the Stowe Missal (eleventh century), which is now in the Museum of the Royal Irish Academy. The lid of this book is ornamented with a metal cross, at the ends of which large jewels are set. The silver-gilt background of the cross is decorated with engraved figures of saints, and around the edge of the cover are Irish inscriptions. On the base of the box the jewels and enamels have been destroyed, but the ornamentation of silver openwork design over gilt still remains. This openwork ornamentation is characteristic of other Irish cumdachs extant.[96] The earliest cumdach of which there is any record was that for the Book of Durrow (*ca.* 877). This, however, has been lost, but there are several later cumdachs to be found in the Museum of the Royal Irish Academy. The cumdachs are usually quite small, ranging from 5½ to 9½ inches in length, and they are made of wood, gold, silver, or bronze and almost always have a large cross in the center, with the background filled with various decorative forms. It was the custom in Ireland to put their sacred books placed in shrines under the care of certain families, and their guardianship was inherited by successive generations. The original use of these shrines was in later days perverted, and they were sometimes appropriated as talismans for warriors. A large cumdach is said to have been used as a breastplate by a warrior, who carried it into battle, possibly for his protection.

Book shrines were not only of Irish usage, though they seem to

have been peculiarly endowed with veneration by this Celtic race. Byzantine book shrines are still extant and are preserved in some of the Continental ancient churches. Mention of a book shrine under the name of *capsa* is to be found in very early records on the Continent. The celebrated gold capsa of Monza in Italy is decorated in a style very like that found on the Irish cumdachs. A few examples of Irish shrines may be seen in the royal library of Munich. I have already called attention to the emigration of Irish and English monks to the Continent and have noted their influence on the production of books. It should likewise be remembered that missionaries came from the Continent to the British Isles. While the Celtic influence of Irish art affected art on the Continent, and while the English scribes infused into Continental book art a perfection of performance and a delicacy of feeling, especially under the influence of Alquin of York, the Continent in turn put its stamp upon the art of England and Ireland. It impressed on the art of the British Isles both its forms borrowed from the East and its own peculiarly created or adapted forms. St. Patrick, when he came from the Continent to Ireland (*ca.* 1440), is said to have been followed not only by evangelists, but also by religious associates who were skillful art and craft workers. Through these and other foreign emigrants, Continental influence may be noted on extant book coverings of Irish origin.

BOOK SATCHELS. The very early books were of a religious nature, and all over the Christian world they were treasured and kept carefully protected by coverings such as *book satchels*. The Irish ecclesiastics usually kept their books in satchels, called *polaires*. These cases were made of leather, with straps on them for the purpose of hanging them over the shoulder when traveling or of hanging them up on pegs when they were not in use.[97] Book satchels were a necessity to the bishop who had to go on

foot to visit the various distant parishes under his jurisdiction, and the priests likewise had to make use of book satchels when they toured their parishes on their various missions. This custom of using book satchels is said to have been brought from Gaul to Ireland, and it probably came to Gaul from the East. Even in modern times, books were carried in satchels by the monks from the monasteries of Egypt and the Levant,[98] but they were not elsewhere in general use after the eleventh century.

The Irish leather satchels were probably decorated by means of using a blunt point to trace the design, and a flattened hard surface to outline it. Mr. Alfred de Burgh, one of the librarians of Trinity College, Dublin, and an authority on Irish book satchels, came to the conclusion that the cowhide leather used for the Irish polaires was first soaked, after the pattern had been traced on it with a pointed or flat bone instrument, and that the background was then pressed down by wooden or bone implements so that the design was left in relief. He suggests that pressure was also probably applied from the underside of the leather.[99] Aside from this manner of decorating Irish book satchels, the technique of *cuirbouilli* is said to have been used by Italian workmen in the fifteenth and sixteenth centuries for decorating leather book coverings.

BOOK COVERS AND GIRDLE BOOKS. Several types of leather book covers have been in use since the first flat book began to be bound in leather. The usual leather binding, which is pasted over the sides and back of a book and is then turned over the edges of the boards and pasted down on the inside of the covers, is the well-known type that continues to be made today.

During the Middle Ages and early Renaissance a protective cover of soft leather, like doeskin, was often sewed fast to a leather-covered book. It entirely covered the sides and back of the book and usually extended several inches over all the book-

edges at head, tail, and fore-edge. When the book was not in use the projecting edges of leather were folded over the edges of the book, and thus the covering not only protected the leather binding on the sides and back, but the edges of the book leaves as well. Some sort of covering was necessary for keeping book covers from being badly worn and unstained by inclement weather when books were carried about in the Middle Ages as they were so frequently by scholars and clerics.

It is possible that this manner of covering bound books suggested a second type of extra-covered book — the girdle book (see Plate 91) — which was peculiarly adapted for the use of the monks and clergy who needed not only to carry books from one place to another, but to have them conveniently near for the purpose of reciting their offices. Magistrates have been pictured carrying girdle books, but scholars who have made a study of the history of these books have come to the conclusion that they were probably used only by the clergy or by someone connected with the Church.[100]

The uniquely fashioned extra cover of the girdle book folded over at head and tail of the binding, served not only for the convenience of the cleric, but as a very excellent protection from soil and wear when carrying the book about. The leather folded over at the head of the book is left about two inches long; that at the tail extends for nearly a foot beyond the book, and is gathered together at the end into a braided buttonlike knob, effecting a sort of hooded gossamer bag convenient both for carrying the book by hand or fastening it to a girdle. Hence the name "girdle book." Monks walking about on their various missions, in the holy processions when they were wont to read from their books of prayer and suggested meditations, or in the monastery gardens between the offices of Lauds and Vespers, must have been consoled by the ever-presence of their breviaries, made possible by the girdle book.

The use of girdle books, beginning in the second half of the fourteenth century, appears to have been confined to a period of not more than 150 years, and to the limited region which extends from the Netherlands to the valley of the Upper Rhine. Though these books were evidently not uncommon during that time, since they were frequently depicted in prints, paintings, and sculpture, there are few examples of them extant. Most of the few remaining girdle books now known to be in existence are in European libraries and institutions. The example illustrated in Plate 91 is available for inspection in the Spencer Collection at The New York Public Library.

Mr. Kup, in his brochure A *Fifteenth-Century Girdle Book*, suggests that the mysterious disappearance of girdle books may be due not only to "wear, negligence, fire or warfare," but to the fact that possibly the long ends of girdle books were cut off, after they ceased to be popularly used, in order that they might be more conveniently placed on library shelves.[101]

FORGERIES

Forgeries in bindings have been quite common in the past. When the price of an article reaches fabulous heights, there are always crafty and talented workmen who spend their expert workmanship imitating the objects of art in demand and offer them for sale as originals.

I have already referred to the imitation of early enamel bindings, which only the well-versed specialists are able to tell from veritable old bindings. As articles become scarce, they are more ardently sought after by the collector, and then the imitator sets out to take advantage of the market.

Mr. G. D. Hobson, in his book *Thirty Bindings*, referring to the London exhibition held at the Burlington Fine Arts Club in 1891, writes of "the increasing struggle between the wiliness of forgers and the wariness of collectors," and he mentions several

books in that exhibition that were found to be forgeries. Among them was a Grolier binding in Lord Amherst's library which was discovered by Mr. Seymour de Rici to be an imitation. In this same exhibition there were several elaborate bindings belonging to the Huth library that were found to be forgeries.

Many early Italian cameo bindings which bore impressions taken from antique originals have been imitated and passed off as originals. This type of forgery was practiced to a great extent in producing imitations of Italian bindings with figures painted on their wooden covers.

Super-ex libris bindings, like the association bindings containing the coats of arms of Madame Pompadour or some other book collector, have been often imitated, and modern dies have been cut with surprising faithfulness to the originals for impressing upon the sides of books purporting to have original bindings. The fake bindings can only be told by a study of the cutting of the dies, the color and quality of the gold used in tooling, or by some other technical characteristics. As a matter of fact, the list of discovered forgeries in bindings is a long one.

There have been quite a number of Grolier, Roger Payne, and other bindings cherished by collectors "floating about," as it were, and I have introduced this topic merely to cite the frequency of forgeries in bookbindings. Since it requires the knowledge of an astute binding specialist to discover an imitation of a master binder's work, the average collector should expect to be doomed to possible disappointment if he purchases bindings without first submitting them to the inspection of some authority specializing in the history of bookbinding styles and workmanship.

SOME MATERIALS AND THEIR MANUFACTURE

LEATHER. Much experimenting has been done, since the beginning of the nineteenth century, to perfect methods of prepar-

ing leather suitable for use in covering books. This material has undergone changes in manufacture since it was first used as a protective covering for books, when it was tanned and dyed by binders for their own use, instead of being manufactured as a commercial product.

There has been a practice among some manufacturers of impressing on sheepskin an artificial grain like that of morocco or levant. Other cheap skins are marketed which have imprinted on their surface the grain of some skin that is foreign to them. They are thus made to resemble skins which are commercially considerably more valuable than these inferior skins would be if finished without the disguise of having a spurious grain put upon them. The grains which are achieved by artificial methods are often so skillfully put upon the surface of leathers that it is difficult to identify the true nature of the skin. Leathers can be identified only by studying the disposition of the pores of the skin under a high-powered magnifying glass, for every animal has a skin with pores of such a character and particular distribution that they form a pattern peculiar to each different breed. An artificial grain cannot conceal this pattern and the character of the pores if the skin is examined under a powerful lens, though it requires an expert in this field to read the pattern and identify the kind of skin on which the grain has been impressed.

In 1900, by special request of the Library Association of London, the Society of Arts began a scientific investigation into the cause of the deterioration of leather, and a committee was appointed to inquire into leather manufacturing methods. This committee was composed of representative librarians, bookbinders, leather manufacturers, and scientists of England, who after intensive investigation and study of the deleterious effects upon leather, formulated a report which was published by the Society.[102] The conclusion was reached by this committee that old bindings of the fifteenth and sixteenth centuries were generally

in a better state of preservation than books bound during and after about the middle of the nineteenth century. They found that morocco bindings earlier than 1869 were in a fair state of preservation, while morocco bindings after that date showed much deterioration, and in many cases the leather on them was almost entirely rotted away. It was also reported that hardly any sound calfskin appeared to have been used on books since about 1830. And russia leather, which is of the nature of ordinary calf, was found to have been especially vulnerable to deteriorating influences. This leather, so favored by Roger Payne, was first produced in Russia and later imitated in other countries. Its process of manufacture differs from that of other leathers, in that it is tanned with willow bark, dyed with sandalwood, and is soaked in birch oil, which accounts for its pleasing odor. Possibly this special treatment is responsible for its susceptibility to rotting.

The committee expressed the opinion that the premature decay of leather is due chiefly to improper tanning and dyeing materials and methods. It was pointed out that before 1860, leathers were generally tanned with oak bark or sumac and were dyed without the aid of acids, whereas leather manufactured since that date has been tanned with inferior tanning agents and is usually cleared of grease by the use of sulphuric acid. The work of clearing skins with acids is a quick process, requiring far less time than when skins are cleared in vats with water revolving over them for six weeks or more. Thus methods in tanning and dyeing and the use of inferior tanning and dying materials appear to have been the chief factors responsible for the inferiority of leather recently manufactured. However, the committee came to the conclusion that the deterioration of calf on bindings produced in the latter part of the nineteenth century was probably due as much to the fact that the leather had been unduly thinned by the binder as to the poor quality of the leather itself.

Since the publication of this report some manufacturers have

been preparing leather in accordance with the recommendations of the committee, and as a result we are now able to procure leathers guaranteed "acid free," but these leathers have not been found altogether satisfactory. They, too, appear to be subject to decay, though not as quickly as leathers prepared with acid. More light on the subject must be sought, and experimentation directed toward producing sounder leathers is continually going on here by the United States Department of Agriculture and by large libraries, as well as in Europe. The bookbinder is eagerly awaiting the time when these investigations and experiments will result in producing leathers as durable as those made in the Middle Ages, but I have a suspicion that if books bound in mediæval times had been subjected from the first to the fumes of gas, the intensity of heat in houses, and other deteriorating conditions which prevail in modern times, they would not be found to be so well preserved as they have been.

PAPER. The history of paper manufacture has been covered by various authorities and, without going into great detail, I propose to give a brief sketch of how a sheet of paper is usually made, both by hand and by machine, in order to bring out the main differences in the manner of fabricating these two types of paper.

To make paper by hand, the rags are put into a vat in which there are revolving knives. A large metal block is next to the shaft on which the knives are fixed, and the rags are shredded by being caught between this block and the revolving knives. In order to retain a long fiber, it is necessary to have the knives quite dull and to do the cutting slowly. It requires about a week to grind up the rags for the best paper, if done in this way.

Having been cut up, the rags are washed and are colored, if colored paper is to be made. If colored stock has been used for making white paper, the rags are bleached with a bleaching chemical, though this process is obviously not desirable. Water is

added to the rags, and they are then put in a vat and are mixed to a pulp. When "digested" and ready to be used, the pulp is taken from the vat on a *form*, or *mould*. A mould is a sort of frame with a fine screen bottom and with four raised edges to hold in the pulp as it is being moulded into a sheet of paper. A flat frame, or cover, is placed on top of the mould and the covered mould is shaken until the material in it is level. The pulp is then turned out, or *couched*, on a felt pad which absorbs the water and imparts to the sheet of paper its surface. The felt pads used are rough or smooth according to the finish desired on the paper, and the sheets of paper are piled between them one over another.

The process of dipping the mould into the vat to take up just the amount of pulp needed and that of shaking the mould require much experience before a workman is able to produce sheets of paper uniform in thickness.

After being couched and let to dry somewhat, the paper is dipped by hand into a gelatin size. It is dipped several times if a hard finish is desired. Papers may also be "vat sized," in which case the size is put in the vat of pulp before the pulp is used to form a sheet. After being dipped in size, the sheet is hung up to dry on wires that have little pins, similar to pinching clothes pins. The sheets of paper are left about a week and are then put in a press, sometimes between metal plates if a "plate finish" is called for. All four sides of the sheets have a *deckle*, or an irregular edge, made when the pulp touches the sides of the mould as it is being shaken. On the screen is a raised design of some sort serving as a mark to denote the papermaker. The mark made on the paper by this design is known as a *watermark*. The paper is made thinner where the pulp touches this raised design, and when the paper is dry, the design becomes distinguishable when being held up to the light. The lines of the heavy wires running from side to side of the mould are also impressed on the paper

and are known as *chain lines*, or *wire marks*. These wire marks indicate the "grain" of the paper.

Machine-made paper is made in one long continuous piece on a mould that is kept in motion from end to end. These paper-making machines are enormously long. The pulp is fed to the bed of the mould from one end of the machine, and it comes out as paper at the other end, where it is rolled up into large rolls. Machine-made paper can have only two deckles, which are produced during the process of manufacture by playing a stream of water on the edges of the pulp.

When a new sheet of paper has only two deckles it is certain to be machine made. This is one of the ways of distinguishing it from handmade paper. The deckles on machine-made paper differ from those on a handmade sheet and can be easily recognized, as the surface of the edges is more regular and is somewhat flattened on one side.

Instead of using gelatin for a size, the cheaper machine-made paper is sized with resin, which has to be mixed with sulphur or sulphuric acid. On this account the paper is likely to turn yellow rather quickly.

According to paper experts, a machine-made paper should have as lasting qualities as a handmade paper if the same stock is used in both instances, except for the fact that the fibers in the stock of a machine-made paper tend to run in one direction, since they are shaken only crosswise. In the case of a handmade paper, the fibers are shaken four ways and thus the sheet is made equally resistant to being torn crosswise or lengthwise. This is not true of the machine-made paper.[103] The great variety in the methods and designs used in making decorated papers represents both the inventiveness and the taste of their makers. The earliest decorated papers used in Western Europe for the end papers of books were marbled.[104]

When and where the first marbled papers were made is veiled

in considerable obscurity. Lord Bacon, who in his *Sylva Sylvarum* called the process "chamoletting," believed this invention to be a Turkish one;[105] a theory which E. P. Horne apparently shared. J. de la Caille attributed it to the French binder Macé Ruette,[106] whereas C. W. Woolnough was persuaded that the art probably had its origin in Holland or in that vicinity.[107] In his book *The Whole Art of Marbling* he appears to base his opinion on the fact that at the beginning of the seventeenth century small packages of Dutch toys sent into England were wrapped with marbled papers, for the obvious purpose of avoiding the English duty, and that these papers were smoothed out and sold to bookbinders for use as end papers. Although the Dutch are credited with having been the first to marble book-edges, this evidence presented by Woolnough seems rather flimsy proof that they were the first to marble papers. It is well known that Holland at that time was a thriving center for the importation and exportation of manufactured articles. It is furthermore known that bookbinding papers were imported from Germany and Italy and were exported to England and even back to the countries of their origin, via Holland. The so-called "Dutch" toys were not even always of Dutch manufacture, but were likely to have been made in Nuremberg.

Mr. W. H. James Weale, in reviewing the various theories about the origin of marbled papers, ascribed the invention to the Germans, though in a later note he mentions having found marbled papers of Turkish origin in an album dated 1616, and he refers to still another Oriental binding of the end of the sixteenth century containing marbled end papers. He does not state categorically that his later discoveries changed his opinion about the origin of marbled paper, though this might be inferred.[108]

It is quite possible that the Turks, Germans, and Dutch discovered this method of decorating papers independently of each other, and that Macé Ruette may have worked out the process

through his own initiative, irrespective of whether or not it had been discovered previously.

The exporting and importing of papers has caused much confusion and difficulty in the matter of identifying the origin of bindings. Papers made on the Continent are found in English bindings, and papers made in a certain Continental country are found in bindings the origin of which are unmistakably that of a different country. Foreign papers were imported into America as early as 1679 and were used by American binders before and after paper began to be made in this country.

The French are credited with having made "drawn" patterned and fine "comb" patterned marbled paper probably along the end of the sixteenth or the beginning of the seventeenth century.[109] These papers were certainly used in France in the early part of the seventeenth century for various purposes. Marbled papers began to be made in Spain, as well as in Holland, and in almost all other Continental countries during the seventeenth century. Though some of the patterns, such as the "French shell," were not made until late in the eighteenth century. The French patterns most used at first were the "drawn" and "comb" patterns, each of these patterns having been formed by means of drawing them or combing them on a sized and colored surface which was floated on water in a marbling tub, and afterward transferred to sheets of paper by laying them over this surface. The process of marbling paper is described in books recommended in Selected List of Books at the end of this volume. Rosamond B. Loring in her book *Decorated Book Papers*, describes not only various processes of making decorated papers, but reviews their history.

Some of the early wood and metal block papers were printed in small repeat patterns. The eighteenth century French ones are not so decorative as the scenic patterns made in France in the early seventeenth century, the designs of which were too large to

use for end papers. The large-patterned printed papers were used on walls to cheer up particular spaces cut up around cupboards and fireplaces by the French people who could not afford the expensive hangings that adorned the walls of the wealthy people of that country. Many types of so-called "block papers" were made in most of the Western European countries in the seventeenth and eighteenth centuries, and they were used for many purposes besides end papers, for books, such as that of covering small objects of many kinds. Papers were also printed by the lithographic process.

The early block papers of Italian origin are less stereotyped in pattern than those made in the countries farther north, and they display a merging of colors which tends to make one less conscious of the repeated forms. Probably somewhat earlier than the eighteenth century gold was introduced into wood- and metal-block papers in the south of Germany and in Italy. Many papers of this type are signed by papermakers of Augsburg and Nuremberg. They have bright colored backgrounds, and the stamping in gold leaf over color imparts to them a rich effect. In some of these papers the pattern is printed solidly in gold and is slightly raised.

Frequently gold-printed papers had freely drawn arabesque designs into which figures of birds, beasts, and other subjects were introduced in a fanciful manner. Others, such as those depicting religious subjects or the various trades, display an equal amount of imagination, though they are printed in rigid panel forms. In each panel appears a figure of a saint holding some emblem, and often identified by name at the bottom of the panel, or a figurative conception of some craft or trade will form the motif of the panel. Panel papers were rarely used for end papers or on book covers, as they do not lend themselves to such use. When they have been found in books, the designs are mutilated by being interrupted or cut into.

Block papers of alphabets were also printed in gold over colored backgrounds in panel form. The alphabets were arranged like those found on hornbooks, with a row of digits at the bottom, and they were probably used for hornbooks. Many of the "gilt" papers were made during the eighteenth century in England as well as in Germany and Italy.

There is a type of decorated papers called "paste papers," which have been used extensively for both end papers and for covering the sides of books and portfolios. The art of making paste papers is not an intricate one, and it is taught to children in many of our progressive schools. In Europe the processes of making all types of decorated papers are taught in most of the trade schools, along with the designing and making of wood and linoleum blocks.

Paste papers were used for end papers as early as the late sixteenth century,[110] and continue to be used both for end papers and for book covers. They are made in a number of different ways. The simplest technique used is that of covering the surface of a sheet of paper with colored paste and drawing a design on it through the paste with a blunt tool, with a comb or some other object, or even simply with the finger or thumb. In this way striped patterns may be made, or plaids, diamonds and various forms may be impressed through the colored paste, which show a paler tone than that of the surface color. Engraved rolls, like binders' fillets, when run over the colored paste will leave their definite patterns. A simple paste paper can be made by merely applying a sponge with a patting motion over the pasted surface and leaving a mottled effect in two or more tones.

Another simple way of making paste papers consists in applying colored paste to two sheets of paper, pressing the two papers together and then pulling them apart. This leaves a not unattractive irregular effect of color on the papers, and if some objects like pieces of string, coins, or flat articles of any sort are laid down in a

pattern on one pasted paper before the other one is put down over it and pulled away, a considerable amount of variety may be attained by this simple process. This type of paper is called a "pulled" paste paper. The paste is colored for all these papers with "show card colors," inks or any sort of dissolved pigment.

"Sprinkled" end papers have been made by binders both with and without paste for a long time, by using the same technique that they use on the edges of books. A color, in liquid form, is brushed through a fine sieve onto the paper with a stiff brush, resulting in a stippled effect. Frequently more than one color is applied, one after the other.

End papers were used by nineteenth century publishers by way of advertisement which were printed with designs intermingled with lists of books for sale, and frequently with insignia or a monogram of the publishing house. Our present-day publishers often employ celebrated artists for designing end papers that are descriptive of the subject matter in the text. Jessie Willcox Smith, Maxfield Parish, Arthur Rackham, Boutet de Monvel and others have designed end papers especially for children's books. Walter Crane and Aubrey Beardsley in England, and Joseph Pennell and Howard Pyle in America, besides numerous other artists both here and abroad, have produced designs for printed end papers that have lent much interest to publishers' editions. Contemporary artists, such as Rockwell Kent, W. A. Dwiggins and Boris Artzybasheff have been using their talent in making designs for the printed end papers used by publishers.

In the nineteenth century, William Morris gave attention to making patterns for end papers which were printed from wood and zinc blocks. Principally in Germany, France, and Italy old block-paper designs have been revived and new ones designed for the making of end papers. Old marbled patterns have also been reproduced in European countries and new ones invented. Those made by Douglas Cockerell and Son are among the most

original in design and pleasing in color. In the United States there are many makers of attractive marbled and paste papers of original design. While a number of American binders make end papers for their own use, there is a long list of makers of decorated end papers who sell their papers, among whom are Mrs. Henry F. James, a pioneer in the field, Rosamond B. Loring (Mrs. Augustus B., Jr.), Peter Frank, Oscar H. de Boyedon, Dorothy B. Moulton, Janet E. Bullock (Mrs. George), Jane E. Cox (Mrs. Irving), Mrs. Thomas H. Shipman and Veronica Ruzicka. This list does not pretend to be complete.

GOLD LEAF. The process of beating solid, thick pieces of gold into thin sheets, called gold leaf, is a very specialized one, and there are few workmen who understand the art of gold beating.

A standard size of gold leaf was formerly three and one-half inches square, and in order to make the finest sheets of gold this size 22-carat gold is cast into a bar measuring approximately eight inches long, one inch wide, and one-half inch thick, and weighing about thirty-five ounces. The bar is then rolled out into a sheet of about the thickness of a visiting card, and the sheet is cut into pieces called "ribbons," which are made up into packages, or "beatings," weighing about two and one-half ounces each. These go to the goldbeaters' bench, and the beater first cuts one of the "beatings" into 181 inch-square pieces and places them into a *kutch* two and one-half inches square, which is made of specially prepared so-called "paper." As he lays these pieces of gold into the kutch the workman interleaves them with "paper," and then he proceeds to beat on the kutch with an iron hammer weighing about eighteen pounds until the gold squares are thinned out to the size of the kutch, or to two and one-half square inches. Next these squares are cut in quarters and are placed into a four-inch-square goldbeater's skin called a *shoder*, and they are beaten out with a hammer until they are the size of the shoder. This shoder is made from the intestines of an ox, and the

prepared "paper" is made from calfskin and is really a sort of parchment.

The "shoder leaves" are then cut into quarters, making them two inches square, and they are fitted into moulds which are made of the same material as the shoder. Next the gold is beaten out in the moulds with a lighter hammer until it is about the size of the mould, and the gold beating is completed. The moulds are passed on to girls who take out one leaf of gold at a time, trim it, and then "book" it, or place the leaves between papers into a book which holds twenty-five sheets. These "books of gold" are then ready for sale to the binder.

Thus an eight-inch bar of gold one-half inch thick and one inch wide, after being rolled, cut into thin sheets, and cut into one-inch-square pieces, is transformed into 2,080 sheets of gold of almost transparent thinness by successively confining its pieces into increasingly larger "beaters' skins" and beating them until they reach the thinness and size desired.

This process of gold beating was described to me in detail and demonstrated by an aged English goldbeater, who had plied his craft for over fifty years and who was considered one of the most expert goldbeaters in England.

DETERIORATION OF BINDINGS AND THE CARE OF BOOKS

The deterioration of bindings is due to a variety of causes, chief among which are poor materials used for binding books, faulty workmanship in their construction, bad conditions in storing bound books, and improper handling of them.

Most extra binders use the best materials procurable, but these are not wholly satisfactory and are subject to impairment of strength even under the most favorable conditions. When these materials are used on a faultily constructed book, there is an unnecessary strain put upon them, and a premature wearing out

takes place. This is also the case when the materials themselves are used in a manner not consistent with strength. The most flagrant example of this is found in bindings the leather covers of which have been unduly pared and thinned in such a manner that the very life of the leather is vitiated. The strength of leather resides for the most part in its fibers, and these cannot be cut into without injury to the material. At the present time we are tending toward such "finish" in hand bookbinding that strength and lasting qualities are being sacrificed. It would be unnecessary to thin a leather too drastically if the size of the skin used for covering were suited to the size of the book to be covered. Small skins of fine grain are quite thin, and these should be chosen for covering small, slender books, for then practically the whole strength of the skin may be left intact. This practice adds to the expense of a binding, for small skins do not cut to advantage economically, but I think most book lovers would be glad to pay for the extra expense involved in order to secure a more lasting binding.

Another practice that shortens the life of a leather-covered book is that of wetting and stretching the leather when covering. When leather is pasted it has a tendency to stretch, and if its natural stretching characteristic is increased by profuse wetting when it is being fashioned to the shape of a book, its fibers are pulled out to unnatural length. As a result, a strain is put upon them, and after the leather has dried, it is far more likely to crack than when put in place without being stretched to its utmost in this manner.

One of the commonest faults of construction is the use of a hollow back (see Vol. II). This type of back is a false back, and therein lies its weakness. The same weakness is inherent in false headbands, which, like hollow backs, are merely pasted or glued on. The only type of headband that will withstand the wear and tear of usage is one sewed through the sections of the book and thus made an integral part of it.

There are numerous minor features of construction in book-binding, too technical to discuss here, which are important to the life of a binding. A collector of bindings would do well to acquaint himself with them and insist upon having them incorporated in his bindings.

The matter of storing books has been the subject of scientific study, and though experts differ about certain conditions most favorable for preserving the life of bindings, they are unanimous in their opinion about the action of some agents that have a deteriorating effect upon bindings. It is agreed that ventilation and freedom from dampness are necessary to prevent premature decay of leather. We know that dampness produces mould, or mildew, and that excessive dryness produces cracking and rotting of leather. The partial answer to this has been air conditioning. Light has been found to be a deteriorating agent, as well as dust, gas fumes, and smoke. Tobacco smoke is extremely deleterious, and gas fumes not only conduce to the deterioration of leather bindings, but have a dulling effect on gold tooling. To exclude the direct rays of light in glassed-in bookcases, colored glass has been found effective. A pale-yellow or yellowish-green tint has been found to be most successful for this purpose.

Books should be placed on shelves sufficiently tight together to keep them from yawning, in order that the boards will not warp. To this end, an inconspicuous metal prop can be used to hold the last book upright when a shelf is not filled. But if books are too tightly packed, no circulation of air can reach their sides, and mildew is liable to be the consequence. If mildew has attacked a binding, it can often be removed by wiping it off with diluted alcohol or vinegar, but its occurrence could be prevented by keeping the books in a dry atmosphere and removing them from the shelves periodically to rub their sides with a dry, soft cloth.

One of the moot points about housing books is the question of glass-covered cases or uncovered shelves. Glass cases certainly

keep out dust and fumes of gas and smoke to a great extent, but if leather bindings are left in closed-in cases in a room not air conditioned and are not handled frequently, they are liable to be attacked by mould. If they are kept on open shelves and not frequently dusted and oiled, they are vulnerable to many deteriorating conditions. So it is that, whether kept behind glass or on open shelves, books should be frequently handled, cleaned, and oiled if the life of their bindings is to be prolonged.

There are numerous formulae for the preservation of leather bindings. Different leathers demand different treatment if maximum preservation is to be attained. For example, leathers with many small pores are best fed and dressed with a more fluid mixture than those with larger pores, or the pores will be clogged. But it requires some expert knowledge to be able to determine just the dressing which would be most efficacious in preserving a leather binding, and a general-use dressing is best employed by one not expert in this field. Such a dressing must be composed of an oil, to serve as a food, and a penetrating fluid. There is a simple formula developed by The New York Public Library which serves this purpose well. It is composed of four parts of lanolin (procured at any pharmacy) to six parts of neat's-foot oil. The lanolin should be warmed slowly until it runs freely, and then the pure, filtered neat's-foot oil mixed thoroughly with it. A book taken from the shelf should be freed from dust by first lightly slapping its covers together and then wiping off the head and sides of the volume with a dry cloth. The dressing mixture, after being cooled, may next be applied with a tampon. To make the tampon, a small amount of absorbent cotton is formed into a fair-sized ball, and around it is wrapped a piece of clean white cotton cloth which is screwed together at the top like a cornucopia. It is then tied at the neck with a piece of string. With this tampon, the dressing is applied to the leather sides and back of the book, and the book is left to stand for a few hours until the oil

in the dressing has been absorbed. When dry, the sides of the book are rubbed with a soft cloth and are finished off with a clean sheep's-wool shoe polisher if a high polish is desired.

When the skin of an animal is parted from its fatty body to be used on a binding, it loses its source of food and the natural animal oils. This loss must be supplied if the skin is to retain its life to any great extent. The feeding of oils from the surface of the skin cannot wholly compensate for the loss the skin has sustained by being cut off from the natural oils of the animal body, but this artificial feeding has been found to be beneficial and even necessary, for prolonging the life of leather that has been stripped from animals for the purpose of covering books. Subject as it is to foreign conditions, unless some artificial means are employed, the skin very soon becomes dried out, and disintegration sets in.

Just a word about bookworms — those pests that defy the wit of man. These so-called worms are not confined to their attack on books, for they infest wood as well. Something can be done about their ravages by putting camphor or alum in bookshelves as a repellent. But glue and paste seem to attract them. A book infested with them if put in a closed box with ether is effective against the live worms, but this treatment will not destroy the eggs, and a book containing them must be treated frequently. Turpentine, camphor, and tobacco infusions seem to help, but only by persistent effort can bookworms be exterminated. Though the live worms can easily be killed with ether, the larvæ must be coped with. A weak solution of formaldehyde can be sprayed on the book with good results, but care must be taken, and no discoloring insecticide should be used on books. Usually it is only old books that are attacked, and these must be isolated.

Many helpful suggestions on the preservation of bindings will be found in the United States Leaflet No. 69, and in *The Care and Repair of Books* by Harry Miller Lydenburg and John Archer, second edition.

In the foregoing remarks I have had especially in mind real bindings, but publishers' casings likewise suffer from being exposed to dampness, excessive heat, and fumes of gas and smoke. Faulty planning and inferior workmanship are contributing factors in shortening the life of a casing as well as a binding, and because of their very temporary character, casings are too often looked upon with indifference, and less care is taken in their handling and housing than they merit.

I feel sure that a large part of the general public would use more care in the handling of books if it were better informed about book structure. The carelessness with which books are pulled off the shelf by tugging at their headcaps, the manner in which they are thrown with open pages face down on the table, thus straining their backs, and the habit of stuffing their pages with extraneous matter inserted for bookmarks, all militate against the life of a casing or binding, however well constructed. Then, too, much harm is done to a new book that is quickly and sometimes roughly opened by an avid reader. A newly cased or bound book should be opened with care, lest its back be broken, for then a binding has been started on its way to an untimely disintegration. To open a newly bound book, it should be laid on a table, and a few leaves at the front and at the back should be pressed open on the book boards. Then several more leaves, at both front and back of the book, should be pressed down gently in the same manner, and this should be continued until the center is reached, using care to take approximately the same number of leaves at the front and back. After this is done, the book will probably have a tendency to yawn, but this can be overcome by putting it under a few heavy volumes and leaving it under pressure for a short time.

Books serve us as silent friends and they should be treated by their owners with consideration.

LIST OF REFERENCES

1. M. Paul Lacroix, *The Arts of the Middle Ages*, p. 471.
2. E. PH. Goldschmidt, *Gothic & Renaissance Bookbindings*, Vol. I, p. 13.
3. *Ibid.*, pp. 2-3.
4. Henry Thomas, *Early Spanish Bookbindings XI-XV Centuries*, p. xiv.
5. *Ibid.*, p. xx.
6. G. D. Hobson, *English Binding Before 1500*, p. 2.
7. *Ibid.*, p. 12.
8. *Ibid.*, pp. 43-45.
9. Thomas F. Carter, *The Invention of Printing in China*, p. 4.
10. *Ibid.*, pp. 39-46.
11. E. PH. Goldschmidt, *Gothic & Renaissance Bookbindings*, Vol. I, p. 64.
12. *Ibid.*, p. 65.
13. *Ibid.*, p. 8.
14. G. D. Hobson, *English Bindings before 1500*, p. 14.
15. E. PH. Goldschmidt, *Gothic & Renaissance Bookbindings*, Vol. I, pp. 74-75.
16. W. Salt Brassington, *A History of the Art of Bookbinding*, p. 99.
17. Joseph Cundall, *On Bookbindings Ancient and Modern*, p. 49.
18. W. Salt Brassington, *A History of the Art of Bookbinding*, p. 99.
19. F. Sarre, *Islamic Bookbindings*, p. 11.
20. Th. Gottlieb, *Venezianer Einbände des XV Jahrhunderts nach Persischen Mustern, in Kunst und Kunsthandwerk*, pp. 153-176.
21. E. PH. Goldschmidt, *Gothic & Renaissance Bookbindings*, Vol. I, pp. 87-93.
22. Henry Thomas, *Early Spanish Bookbindings XI-XV Centuries*, p. xxxi.
23. Bernard Quaritch, *Facsimiles of Bookbindings*, p. 17.
24. Michael Sadlier, *The Evolution of Publishers' Binding Styles*, pp. 40-43.
25. James Westfall Thompson, *The Medieval Library*, pp. 594-621.
26. For a detailed account of the regulations governing book production in the early universities, see George Haven Putnam, *Books and Their Makers During the Middle Ages*, Vol. I, pp. 178-224.

27. James Westfall Thompson, *The Medieval Library*, p. 643.
28. George Haven Putnam, *Books and Their Makers During the Middle Ages*, Vol. I, p. 293.
29. *Ibid.*, p. 306.
30. For further information on this subject see:
 1. W. Wattenbach, *Das Schriftwesen im Mittlealter*.
 2. E. PH. Goldschmidt, *Gothic & Renaissance Bookbindings*, Vol. I.
 3. George Haven Putnam, *Books and Their Makers During the Middle Ages*, Vol. I.
31. Konrad Haebler, *The Study of Incunabula*, translated by Lucy Eugenia Osborne, p. 176.
32. See K. Burger, *Buchhändleranzeigen des XV Jahrhunderts*, for a full discussion of the book trade in the fifteenth century.
33. H. P. Horne, *The Binding of Books*, p. 36.
34. W. H. James Weale, *Bookbindings and Rubbings*, p. xv.
35. See Prof. A. de Morgan, *The Case of Libri*.
36. E. PH. Goldschmidt, *Gothic & Renaissance Bookbindings*, Vol. I, p. 68.
37. Th. Gottlieb, *Bucheinbände K K Hofbibliothek*, Einleitung Colums 12-18.
38. See: 1. Johannes Rudbeck, *Entstehungsgeschichte der Grolier-Einbände*. Bücherfreude N F IV, 2 (1913), pp. 319-324.
 2. J. Loubier, *Festschrift* (1933), pp. 183-190.
 3. E. PH. Goldschmidt, *Gothic & Renaissance Bookbindings*, Vol. I, pp. 99-103.
 4. G. D. Hobson, *Maioli, Canevari and Others*. A summary of the findings of Dr. Gottlieb and Baron Rudbeck on Grolier Bindings, pp. 171-172.
39. See: 1. M. Le Roux de Lincy, *Recherches sur Jean Grolier*, pp. 61-73.
 2. W. Salt Brassington, *A History of the Art of Bookbinding*, p. 182.
 3. Joseph Cundall, *On Bookbindings Ancient and Modern*, pp. 31-32.
 4. W. J. Fletcher, *Foreign Bookbindings in the British Museum*. See description on Plate XI.
40. W. H. James Weale, *Bookbindings and Rubbings*, p. cxxiv.
41. E. PH. Goldschmidt, *Gothic & Renaissance Bookbindings*, Vol. I, p. 92.

42. *Ibid.* See note Vol. I, p. 53, for interesting date on Ducali bindings.
43. G. D. Hobson, *Maioli, Canevari and Others*, p. 129.
44. E. PH. Goldschmidt, *Gothic & Renaissance Bookbindings*, Vol. I, p. 138.
45. Henry Thomas, *Early Spanish Bookbindings XI-XV Centuries*, p. xxiii.
46. W. H. James Weale, *Bookbindings and Rubbings*, p. lxxvii and p. lxx note.
47. This translation is that of G. D. Hobson in *Maioli, Canevari and Others*, p. 58.
48. Several reproductions will be found in *Maioli, Canevari and Others*, Plates 19-24, and the result of Mr. Hobson's research on these bindings is given in the same volume pp. 18-36.
49. W. H. James Weale, *Bookbindings and Rubbings*, p. lxxviii.
50. Grace Hart Seely, *Diane the Huntress*, The Life and Times of Diane de Poitiers, pp. 211 ff.
51. MM. Marius Michel, *La Reliure Française*, p. 63.
52. G. B. Hobson, *Thirty Bindings*, p. 34.
53. G. B. Hobson, *English Binding Before 1500*, p. 2.
54. *Ibid.* See Plate I.
55. *Ibid.* See Plates 4 and 5.
56. *Ibid.*, p. 17.
57. J. Salt Brassington, *A History of the Art of Bookbinding*, pp. 157-158.
58. W. Y. Fletcher, *English Book Collectors*, Preface p. ix.
59. Cyril Davenport, *Thomas Berthelet*, p. 24.
60. *Ibid.*, p. 64.
61. See *English Book Collectors* by William Younger Fletcher, pp. 43-45, for information about Sir Thomas Wotton.
62. See William Younger Fletcher, *English Bookbindings in the British Museum*, Plate XLVIII, for a very remarkable example of a Little Giddings binding by Mary Collet.
63. See *The Edinburgh Bibliographical Society Transactions*, 1918.
64. G. D. Hobson, *Thirty Bindings*, p. 56.
65. See Cyril Davenport, *Samuel Mearne*, p. 90.
66. Cyril Davenport, *Roger Payne*, pp. 30-31.
67. See Cyril Davenport, *Roger Payne*, for a full page of reproductions of Roger Payne tools, p. 61.
68. *Ibid.* Note many excellent reproductions of Roger Payne bindings.

69. William Younger Fletcher, *English Bookbindings in the British Museum*, Plate XXXII.

70. Charles O'Conor, *Rerum hibernicarum scriptores vesteres* CLXXVII.

71. The date of these two covers has been taken from the files of The Pierpont Morgan Library, and according to Miss Belle da Costa Greene, Director of The Pierpont Morgan Library, has been confirmed by all the leading scholars in this field of art.

72. Cyril Davenport, *The Book*, p. 182.

73. W. H. James Weale, *Bookbindings and Rubbings*, p. liii.

74. *Ibid.*, p. lxiv.

75. See E. PH. Goldschmidt, *Gothic & Renaissance Bookbindings*, Vol. I, Opp. p. 56, for a rubbing of this Gothic panel.

76. *Ibid.*, Vol. I, p. 24.

77. *Ibid.*, Vol. II, Plate I.

78. *Ibid.* Line sketches of all these distinguishable types of stamped bindings will be found in Vol. I, pp. 18-23.

79. Konrad Haebler, *Rollen und Plattenstempel des XVI Jahrhunderts*, Leipzig, 1928, pp. 1, 377.

80. E. PH. Goldschmidt, *Gothic & Renaissance Bookbindings*, Vol. I, p. 133.

81. W. H. James Weale, *Bookbindings and Rubbings*, p. cxvii.

82. See Dr. P. Christel Schmidt, *Jacob Krause*, for information about this binder.

83. W. H. James Weale, *Bookbindings and Rubbings*, p. cxviii.

84. MS. of Herrade quoted by Martin, *Mélanges d'Archéologie*.

85. E. PH. Goldschmidt, *Gothic & Renaissance Bookbindings*, Vol. I, p. 76.

86. *Ibid.*, Vol. I, pp. 78-82.

87. G. D. Hobson, *Thirty Bindings*, Remarks p. 36. Note reproduction of this binding facing p. 36.

88. See A. de Hevesy, *La Bibliothèque du Roi Mathias Corvin*, for further information.

89. For colored reproductions see Th. Gottlieb, *Bucheinbände der K K Hofbibliothek*, and A. de Hevesy, *La Bibliotheque du Roi Mathias Corvin*.

90. *Catalogue of Ornamental Leather Bookbindings prior to 1850*. Exhibited at the Grolier Club, Nov. 7 to 30, 1907, p. 93.

91. Hannah Dustin French, *Bookbinding in America*, p. 17.

92. *Ibid.,* p. 67.
93. William Blades, *Bibliographical Miscellanies,* No. 1, p. 5.
94. Cyril Davenport, *Samuel Mearne,* p. 16.
95. Lewis Stark, *Branded Books for Mexican Libraries.* New York Public Library Bulletin, August, 1942, pp. 738-741.
96. See Margaret Stokes, *Early Christian Art in Ireland,* for a detailed account of Irish cumdachs, pp. 76-83.
97. J. Salt Brassington, *A History of the Art of Bookbinding,* p. 76.
98. See Robert Curson (known as Zouche), *Visits to the Ancient Monasteries,* for further details.
99. G. D. Hobson, *English Bindings Before 1500,* p. 27.
100. Karl Küp, *A Fifteenth Century Girdle Book,* p. 13.
101. Karl Küp, *A Fifteenth Century Girdle Book.* The New York Public Library, 1939.
102. *Report of the Committee on Leather for Bookbinding* by the Society of Arts and the Worshipful Company of Leathersellers by the *Rt. Hon. Viscount Cobham* and *Sir Henry Trueman Wood,* London, George Bell & Sons, 1905.
103. Dard Hunter, *The Dolphin,* Vol. I, p. 122.
104. Rosamond B. Loring, *Decorated Book Papers,* p. 12.
105. Francis Bacon, *Sylva Sylvarum.*
106. J. de la Caille, *Histoire de L'Imprimerie et de la Librairie,* p. 213.
107. C. W. Woolnough, *The Whole Art of Marbling,* p. 14.
108. W. H. James Weale, *Bookbindings and Rubbings, Introduction,* p. xx.
109. Rosamond B. Loring, *Decorated Book Papers,* p. 23.
110. *Ibid.,* p. 65.

A SELECTED LIST OF BOOKS

Primitive Records and Prehistoric Times

BUDGE, E. A. WALLIS. *The Dwellers on the Nile*, or Chapters on the Life, Literature, History, and Customs of the Ancient Egyptians. London, 1888.

CHIERA, EDWARD. *They Wrote on Clay*. Chicago: University of Chicago Press, 1938 (235 pp., illus.).

CLODD, EDWARD. *The Story of Primitive Man*. New York, London: Appleton, 1905 (190 pp., 88 illus., bibliog, index) (later ed.).

KENYON, FREDERIC G. *Ancient Books and Modern Discoveries*. Chicago: The Caxton Club, 1927 (83 pp., 30 facs.).

——— *The Palaeography of Greek Papyri*. Oxford: The Clarendon Press, 1899 (160 pp., 20 facs., index, table of alphabets).

ILIN, M. *Black on White: The Story of Books*. Philadelphia: Lippincott, 1932 (135 pp., illus.).

McMURTRIE, DOUGLAS C. *The Book*. The Story of Printing and Bookmaking. New York: Covici-Friede, 1937 (675 pp., illus., bibliogs., index).

SAYCE, A. M. *Fresh Light from the Ancient Monuments*. London, 1884. New York: F. H. Revell, 1895 (160 pp.).

——— *Records of the Past*. Being an English translation of the Ancient Monuments of Egypt and western Asia. London: Bagster, 1889-1893 (6 vols.).

SPINDEN, HERBERT J. *Ancient Civilizations of Mexico and Central America*. New York: Museum of Natural History, 1914 (238 pp., illus., maps, bibliog., index).

THOMPSON, EDWARD MAUNDE. *Handbook of Greek and Latin Palaeography*. London: Kegan Paul, Trench, Trübner, 1894 (343 pp., illus., bibliog., index).

THOMPSON, E. M., and E. A. WALLIS BUDGE. *A Series of Plates Illustrating Biblical Versions and Antiquities*. An Appendix to Helps to the Study of the Bible. Oxford: The University Press, 1900 (83 pp., 124 illus.).

PALÆOGRAPHY AND CALLIGRAPHY

CHIERA, EDWARD. *They Wrote on Clay*.

CLODD, EDWARD. *The Story of the Alphabet*. New York: Appleton, 1905 (illus.).

(203–205)

KENYON, FREDERIC G. *Ancient Books and Modern Discoveries.*
────── *Books and Readers in Ancient Greece and Rome.* Oxford: The
Clarendon Press, 1932 (136 pp., illus., plates, facs.).
────── *The Palaeography of Greek Papyri.*
MCMURTRIE, DOUGLAS C. *The Book.*
MADAN, FALCONER. *Books in Manuscript.* London: Kegan Paul,
Trench, Trübner, 1893 (188 pp., plates, bibliog., index).
MASON, WILLIAM A. *A History of the Art of Writing.* New York:
Macmillan, 1920 (502 pp., illus., bibliog., index).
TAYLOR, ISAAC. *The Alphabet.* An Account of the Origin and Develop-
ment of Letters. New York, 1899 (2 vols.) (tables and lists, index).
THOMPSON, SIR EDWARD M. *An Introduction to Greek and Latin
Palaeography.* Oxford: The Clarendon Press, 1912 (600 pp., 250 facs.).
THOMPSON, E. M., and E. A. WALLIS BUDGE. *A Series of Plates Il-
lustrating Biblical Versions and Antiquities.*
ULLMAN, B. L. *Ancient Writing and Its Influence.* New York: Long-
mans Green, 1932 (234 pp., 16 plates, illus.).
WADDELL, L. A. *The Aryan Origin of the Alphabet.* London: Lucas &
Company, 1927 (plates and illus.).

EARLY BOOK FORMS

BRASSINGTON, W. SALT. *A History of the Art of Bookbinding.* With
Some Account of the Books of the Ancients. London: Elliot Stock, 1894
(277 pp., 10 colored plates, 112 illus., index).
CUNDALL, JOSEPH. *On Bookbindings Ancient and Modern.* London:
George Bell & Sons, 1881 (132 pp., 28 plates, list of binders and patrons of
binding, index).
DAVENPORT, CYRIL. *The Book.* Its History and Development. New
York: Van Nostrand, 1908 (258 pp., 7 plates, 126 figs., bibliog., index).
KENYON, FREDERIC G. *Ancient Books and Modern Discoveries.*
────── *Books and Readers in Ancient Greece and Rome.*
MCMURTRIE, DOUGLAS C. *The Book.*
PUTNAM, GEORGE HAVEN. *Books and Their Makers During the Mid-
dle Ages.* New York, London: G. P. Putnam's Sons, 1896 (Vol. I, 476-
1600, 460 pp.; Vol. II, 1500-1709; 538 pp., index).
THOMPSON, EDWARD MAUNDE. *Handbook of Greek and Latin Pa-
laeography.*

THOMPSON, JAMES WESTFALL. *The Medieval Library*. Chicago: University of Chicago Press, 1939 (682 pp., index).

THE EARLY BOOK TRADE

BURGER, K. *Buchhändleranzeigen des XV Jahrhunderts*. Leipzig: Hiersemann, 1907 (15 pp., many plates).

CURWEN, HENRY. *A History of Booksellers the Old and the New*. London: Chatto and Windus, 1873 (483 pp.).

THE ENCYCLOPAEDIA BRITANNICA. *Bookselling*, Vol. IV.

────── *Publishing*, Vol. XXII.

GOLDSCHMIDT, E. PH. *Gothic & Renaissance Bookbindings*. London: Benn. New York, Boston: Houghton Mifflin, 1928 (Vol. I).

HAEBLER, KONRAD. *The Study of Incunabula*. Translated from the German. Foreword by Alfred W. Pollard. New York: The Grolier Club, 1933 (241 pp. Index).

HASE, OSCAR. *Die Koberger*. Eine Darstellung des buchhändlerischen Geschäftsbetriebs in der Zeit des Überganges vom Mittelalter zur Neuzeit. Leipzig: 1885 (2nd ed.) (462 pp., 154 illus.).

KOCH, THEODORE WESLEY. *The Florentine Book Fair*. Evanston, Ill.: Printed for subscribers, 1925. The German Book Exhibit at Columbia University (121 pp., 29 illus.).

MUMBY, FRANK A. *The Romance of Bookselling*. A History from the Earliest Times to the Twentieth Century. London: Chapman & Hall, 1910 (492 pp., bibliog.).

MUMBY, FRANK ARTHUR. *Publishing and Bookselling*. A History from the Earliest Times to the Present Day. New York: R. R. Bowker, 1931 (480 pp., 13 plates, line cuts, bibliog. by W. H. Peet).

PUTNAM, GEORGE HAVEN. *Books and Their Makers During the Middle Ages*. New York, London: G. P. Putnam's Sons, 1896 (Vol. I).

THOMPSON, JAMES WESTFALL. *The Frankfort Book Fair*. Chicago: The Caxton Club, 1911 (204 pp., illus., bibliog., index).

────── *The Medieval Library*. Chicago: University of Chicago Press, 1939 (682 pp., historical index).

WATTENBACH, W. *Das Schriftwesen im Mittlealter*. Leipzig: S. Hirzel, 1875 (569 pp.).

HISTORY OF THE ART AND CRAFT OF BOOKBINDING

ADAM, PAUL. *Der Bucheinband Seine Technik and seine Geschichte.* Leipzig: Seemann, 1890 (268 pp., 194 illus., bibliog., index).

——— *Der Einfluss der Klosterarbeit auf die Einbandkunst.* In Buch und Bucheinband. Festschrift zu Hans Loubiers 60 Geburtstag. 1923.

——— *Polnische Einbandkunst im XII Jahrhundert.* In Anzeiger für Buchbindereien. Stuttgart, 1925, No. 30.

ANDREWS, WILLIAM LORING. *Roger Payne and His Art.* New York: De Vinne Press, 1892 (36 pp., 11 plates).

ARNOLD, SIR THOMAS W., and PROFESSOR ADOLF GROHMANN. *The Islamic Book.* Leipzig: Pegasus Press, 1929 (131 pp., 30 plates, 19 figs., list of refs., index).

ARNETT, JOHN ANDREWS. *An Enquiry Into the Nature and Form of the Books of the Ancients.* With a History of the Art of Bookbinding from the Times of the Greeks and Romans to the Present Day. London: Groombridge, 1837 (212 pp., 14 plates).

BRASSINGTON, W. SALT. *A History of the Art of Bookbinding.* With Some Account of the Books of the Ancients.

BRUNET, GUSTAVE. *La Reliure Ancienne et Moderne.* Paris: Paul Daffis, 1878 (116 plates).

CARTER, JOHN. *Binding Variants in English Publishing 1820-1900.* London: Constable. New York: Long & Smith (172 pp., 15 plates, index).

COCKERELL, DOUGLAS. *The Development of Bookbinding Methods —Coptic Influence.* London: The Library, 1933 (Vol. XIII) (19 pp.).

CUNDALL, JOSEPH. *On Bookbindings Ancient and Modern.*

DAVENPORT, CYRIL. *Bagford's Notes on Bookbinding.* London: Transactions of the Bibliographical Society, 1902-1904.

——— *The Book.* Its History and Development.

——— *English Embroidered Bindings.* London: Kegan Paul, Trench, Trübner, 1899 (113 pp., 52 plates, 13 line cuts, index).

——— "Little Giddings Bindings." In *Bibliographica*, Vol. II, 1896.

——— "Three Recently Discovered Bindings with Little Giddings Stamps." London, 1900. In *The Library*, Ser. 2, Vol. I.

——— *Roger Payne.* Chicago: The Caxton Club, 1929 (88 pp., 32 plates, bibliog., index).

——— "Roger Payne and His Predecessors," *The Art Journal.* London, August, October, November, 1911 (12 pp., 13 illus., facs. of tools).

DAVENPORT, CYRIL. *Royal English Bookbindings.* London: Seeley. New York: Macmillan, 1896 (95 pp., 8 plates + 29 illus., bibliog.).

———— *Samuel Mearne.* Binder to King Charles II. Chicago: The Caxton Club, 1906 (118 pp., 24 plates in color, 22 illus., index).

———— *Thomas Berthelet.* Royal Printer and Bookbinder to Henry VIII King of England. Chicago: The Caxton Club, 1901 (102 pp., 18 plates, index).

DUFF, E. GORDON. *The Bindings of Thomas Wotton.* London: The Library, 1910, 3, Ser. 1, Vol. III.

———— "Early Stamped Bindings." In *An Historical Sketch of Bookbinding,* by S. T. Prideaux (*see* Prideaux).

———— *The English Provincial Printers, Stationers and Bookbinders.* Cambridge: The University Press, 1912 (153 pp., bibliog., index).

———— *The Great Mearne Myth.* The Edinburgh Bibliographical Society, Vol. XI, Part II, September, 1918 (20 pp.).

———— *Scottish Bookbinding Armorial and Artistic.* London: The Bibliographical Society Transactions, 1920.

FLETCHER, WILLIAM YOUNGER. *Bookbinding in France.* London: Seeley, 1905 (80 pp., 8 colored plates, 31 illus.).

———— *English Bookbindings in the British Museum.* London: Kegan Paul, Trench, Trübner, 1895 (63 illus., descriptions).

———— *Foreign Bookbindings in the British Museum.* London: Kegan Paul, Trench, Trübner, 1896 (63 illus., descriptions).

FRENCH, HANNAH DUSTIN. "Early American Bookbinding by Hand." In *Bookbinding in America.* Portland, Maine: The Southworth-Anthoensen Press, 1941 (pp. 3-127).

FUMAGALLI, G. *L'arte della legatura alla corte degli Estensi, a Ferrara e a Modena dal Sec. XV al XIX.* Florenz: De Marinis, 1913 (104 pp., 29 plates).

GOLDSCHMIDT, E. PH. *Gothic & Renaissance Bookbindings.*

GOTTLIEB, THEODOR. *K. K. Hofbibliothek Bucheinbände.* Wien, 1910, 1911 (84 pp., 100 plates, bibliog., index). See discussion about the origin of Grolier bindings, *Einleitung,* pp. 12-18.

———— "Venezianer Einbände des 15 Jahrhundert nach Persischen Mustern." In *Kunst and Kunsthandwerk.* Wien, 1913.

GRARZL, EMIL. *Islamische Bucheinbände des 14. bis 19. Jahrhunderts.* Leipzig: Hiersemann, 1924 (33 pp., 24 plates, bibliog.).

GRAUZAT, ERNEST DE. *La Reliure Française de 1900-1925.* Paris: Kieffer, 1932 (2 vols.).

GRAY, GEORGE J. *The Earlier Cambridge Stationers & Bookbinders and the First Cambridge Printer.* Oxford: The University Press, 1904 (73 pp., 28 plates, index).

GRUEL, LEON. *Manuel Historique et Bibliographique de L'Amateur de Reliure.* Paris: Gruel & Engelmann, 1887 (186 pp., 65 plates + illus., bibliog.).

HAEBLER, KONRAD. *Rollen and Plattenstempel des XVI Jahrhunderts.* Leipzig: Otto Harrassowitz, 1928-1929 (Vol. I, 518 pp., 2 plates; Vol. II, 479 pp., 8 plates, index).

HOBSON, G. D. *Bindings in Cambridge Libraries.* Cambridge: The University Press, 1929 (179 pp., 72 plates, indexes).

—— *English Binding Before 1500.* Cambridge: The University Press, 1929 (58 pp., 55 plates).

—— *Further Notes on Romanesque Bindings.* London: The Bibliographical Society, September, 1934.

—— *Les Reliures à la Fanfare.* Le Problème de L's Fermé. London: Chiswick Press, 1935 (151 pp., 37 colored plates, other illus. and figs.).

—— *Maioli, Canevari and Others.* Boston: Little, Brown, 1926 (178 pp., 64 plates, indexes).

—— *Thirty Bindings.* London: The First Editions Club, 1926 (68 pp., 30 plates with descriptions).

HOLMES, THOMAS JAMES. *The Bookbindings of John Ratcliff and Edmund Ranger.* Proceedings of the American Antiquarian Society, 1928 and 1929.

HORNE, HERBERT P. *The Binding of Books.* London: Kegan Paul, Trench, Trübner, 1894 (224 pp., 12 plates, index).

Jahrbuch der Einbandkunst. 1927 Leipzig: Haessel. 1928 Leipzig: Einbandkunst.

LEIGHTON, DOUGLAS. *Modern Bookbinding.* A Survey and a Prospect. New York: Oxford University Press. London: Dent & Sons, 1935 (63 pp.).

LOUBIER, HANS. *Der Bucheinband von seinem Anfang bis zum Ende des 18 Jahrhunderts.* Leipzig: Klinkhardt and Biermann, 1926 (272 pp., 232 illus.).

LOUBIER, JEAN. *Der Bucheinband in Alter und Neuer Zeit.* Berlin, Leipzig: Herman Seemann, 1926 (184 pp., 197 illus.).

McMurtrie, Douglas C. *The Book*.

Matthews, Brander. *Bookbindings Old and New*. With an Account of the Grolier Club of New York. New York: Macmillan, 1895 (252 pp., illus., index).

Michel, MM. Marius. *La Reliure Française*. Depuis L'Invention de L'Imprimerie Jusqu'a la Fin du XVIII Siècle. Paris, 1880 (144 pp., 22 plates + illus.).

Oldham, J. Basil. *Shrewsbury School Library Bindings*. Oxford: The University Press, 1943 (183 pp., gloss., indexes).

Prideaux, S. T. *An Historical Sketch of Bookbinding*. With a chapter on early stamped bindings by E. Gordon Duff. London: Archibald Constable, 1906.

—— *Modern Bookbindings*. Their Design and Decoration. London: Archibald Constable, 1906 (131 pp., 58 illus.).

—— *Bookbinders and Their Craft*. New York: Scribner's, 1903 (299 pp., 96 illus., index).

Planas, Ramón Miguel y. *Restauración del Arte hispano-arabe en la decoración exterior de los libros*. Barcelona, 1913 (23 pp., 21 illus.).

Rogers, Joseph W. "The Rise of American Edition Binding." In *Bookbinding In America*. Portland, Maine: The Southworth-Anthoensen Press, 1941.

Rudbeck, Johannes. *Entstehungsgeschichte der Grolier-Einbände*. Büherfreude N.F. 4, 1913, pp. 319-324.

—— "Ueber die Herkunft der Grolier-Einbände." In *Buch und Bucheindband, Festschrift*, 1923, pp. 183-190.

Sadlier, Michael. *The Evolution of Publishers' Binding Styles, 1770-1900*. London: Constable and Company. New York: Richard R. Smith, 1930 (96 pp., 12 plates).

Sarre, F. *Islamic Bookbindings*. London: Kegan Paul, Trench, Trübner, 1923 (167 pp., 36 plates).

Schmidt, Adolf. *Lederschnittbände des XV Jahrhunderts*. In Bücherfreude, 1909-1910.

Schmidt, P. Christel. *Jacob Krause*. Ein Kursaechsischer Hofbuchbinder des 16 Jahrhunderts. Leipzig: Hiersemann, 1923 (83 pp., 76 illus.).

Schwenke, Paul. *Zur Erforschung der Bucheinbaende des 15 und 16 Jahrhunderts*. Leipzig: Spirgatis, 1898 (167 pp., 36 plates).

SULLIVAN, EDWARD. *The Bookbinders of the Irish House of Parliament 1613-1800.* London: Quaritch, 1905 (50 illus.).

THOINAN, ERNEST. *Les Relieurs Français (1500-1800).* Paris: Paul, Huard, Guillemin, 1893 (416 pp., 31 plates + illus.).

UZANNE, OCTAVE. *The French Bookbinders of the Eighteenth Century.* Chicago: The Caxton Club, 1904 (133 pp., 20 illus., bibliog.).

WEAD, EUNICE. "Early Binding Stamps of Religious Significance in Certain American Libraries." In *The Colophon,* Part 20 (20 pp., plates).

WEALE, W. H. JAMES. *Bookbindings and Rubbings of Bindings.* London: Eyre and Spottiswoode, 1898, 1894 (329 pp., lists of libraries, binders, binderies, ciphers, mottoes, symbols, illus., index).

WILMERDING, LUCIUS. *Renaissance Bookbindings.* New York: Grolier Club Catalogue, 1937-1938 (68 pp., 8 illus., index).

WROTH, L. C. *The Colonial Printer.* Portland, Maine: The Southworth-Anthoensen Press, 1938 (368 pp., illus., facs., diagrams).

TECHNIQUE OF BOOKBINDING

ADAM, PAUL. *Der Bucheinband-Seine Technik und seine Geschichte.* Leipzig: Seemann, 1890 (268 pp., 194 illus., bibliog., index).

───── *Practical Bookbinding.* London: Scott, 1903 (193 pp., illus.).

ARNETT, JOHN ANDREWS. *Bibliopegia; or, The Art of Bookbinding.* London: Groombridge. Edinburgh: Oliver and Boyd. Dublin: Wakeman. New York: Jackson, 1835 (312 pp., glos., illus., index).

Bookbinder, The, 1887-1890. From 1890 to 1894 called *The British Bookmaker,* London (illus., index).

BUCK, MITCHELL S. *Book Repair and Restoration.* Philadelphia: Nicholas Brown, 1918 (126 pp., plates, index).

COBDEN-SANDERSON, T. J. *Bookbinding.* In Arts and Crafts Essays. London: Longmans Green, 1903 (15 pp.).

COCKERELL, DOUGLAS. *Bookbinding, And the Care of Books.* London: John Hogg, 1901. New York: Appleton, 1912 (342 pp., illus., glos., index).

───── *A Note on Bookbinding.* London: W. H. Smith and Son, 1904 (26 pp., + binding specifications, 1 plate).

───── *Some Notes on Bookbinding.* London: Oxford University Press, 1925 (105 pp.).

COCKERELL, S. M. *Marbling Paper as a School Subject.* Hitchin, England: G. W. Russell & Son, 1934.

CRANE, W. J. E. *Bookbinding for Amateurs*. London: L. Upcott Gill, 1885 (184 pp., illus., index).

DANA, JOHN COTTON. *Notes on Bookbinding for Libraries*. Chicago: Library Bureau, 1906 (114 pp., illus., glos., index).

FORSYTH, K. MARJORIE. *Bookbinding for Teachers, Students, and Amateurs*. London: Black. New York: Macmillan, 1932 (116 pp., illus., index).

HEWITT-BATES, J. S. *Bookbinding for Schools*. Peoria, Ill.: The Manual Arts Press. Leicester, England: Dryad Handicrafts, 1927 (142 pp., illus., index).

KINDER, LOUIS H. *Formulas for Bookbinders*. East Aurora, N. Y.: The Roycrofters, 1905 (115 pp., 1 plate).

MATTHEWS, WILLIAM F. *Bookbinding*. New York: Dutton (252 pp., plates and line cuts, glos., index).

NICHOLSON, JAMES B. *A Manual of the Art of Bookbinding*. Philadelphia: H. C. Baird, 1856 (318 pp., illus., glos., index).

PALMER, E. W. *A Course in Bookbinding for Vocational Training*. New York: Employing Bookbinders of America, 1927 (452 pp., illus., glos.).

PLEGER, JOHN J. *Bookbinding*. Chicago: The Inland Printer, 1924 (425 pp., 186 illus., glos.).

United States Government Printing Office Technical Bulletin. Washington, D. C., 1925 + .

VAUGHAN, ALEX. J. *Modern Bookbinding*. Leicester, England: Rathby, Lawrence, 1929 (218 pp., illus., glos., index).

WIEMLER, IGNATZ. "Bookbinding Old and New." In *The Dolphin*. New York: Limited Editions Club, 1933 (14 pp., illus.).

ZAEHNSDORF, JOSEPH W. *The Art of Bookbinding*. London: George Bell and Sons, 1900 (2nd ed.) (190 pp., illus., glos., index).

MATERIALS

CLOTH

CARTER, JOHN. *Binding Variants in English Publishing 1820-1900*. London, New York, 1932.

—— "The Origin of Publishers' Cloth Binding." In *The Colophon*, Part 8.

—— *Publisher's Cloth*. London: Constable & Company. New York: Bowker, 1935 (48 pp.).

DANA, JOHN COTTON. *Notes on Bookbinding for Libraries.*

LEIGHTON, DOUGLAS. *Modern Bookbinding.*

ROGER, JOSEPH W. *The Rise of American Edition Binding.*

GLUE

Flexible Glues for Bookbinding. United States Government Printing Office, 1941, Technical Bulletin No. 24.

HUNT, GEORGE M., and W. L. JONES. *The Selection and Testing of Animal Glue for High-Grade Joint Work.* Madison, Wis.: Forest Products Laboratory, L26, 506.

LYDENBERG, HARRY MILLER, and JOHN ARCHER. *The Care and Repair of Books.*

LEATHER

DAVENPORT, CYRIL. "Leather as Used in Libraries." In *The Library,* Vol. X, 1898.

FISKE, ROBERT F. *Bookbinding Leather — In Harvard Library.* Notes No. 30, March, 1940 (6 pp.).

Hide and Leathers' Blue Book. Chicago, 1906-1936-1937.

HULME, E. W., J. G. PARKER, A. SEYMOUR-JONES, CYRIL DAVENPORT, and F. J. WILLIAMSON. *Leather for Libraries.* London, 1905 (57 pp., index).

KENYON, FREDERIC G. *Ancient Books and Modern Discoveries.*

PROCTOR, HENRY R. *The Making of Leather.* Cambridge: University Press. New York, Putnam's, 1914 (153 pp., illus., index).

COBHAM, THE RT. HON. VISCOUNT, and SIR HENRY TRUEMAN WOOD. *Leather for Bookbinding,* Report of the Committee on. London: George Bell & Sons, 1905 (93 pp., 11 plates, diags., leather samples, index).

PARKER, JAMES GORDON. *Leather.* The Encyclopædia Britannica, 11th ed. Vol. XVI.

PAPER

BRIQUET, C. M. *Les Filigranes.* Paris, London, Leipzig, 1907 (4 vols.) (16, 112 facs., 39 figs.).

CARTER, THOMAS FRANCIS. *The Invention of Printing in China, and Its Spread Westward.* New York: Columbia University Press, 1925 (282 pp., 37 plates, maps, bibliog., index).

CLAPPERTON, R. H. *Paper.* An Historical Account of Its Making by Hand from the Earliest Times Down to the Present Day. Oxford: Shakespeare Head Press, 1934 (158 pp., illus., plates).

HUNTER, DARD. "Hand-made Paper and Its Relation to Modern Printing." In *The Dolphin*, No. 1. New York: Limited Editions Club, 1933 (12 pp.).

—— *Old Papermaking*. Chillicothe, Ohio, 1923 (114 illus.).

—— *Papermaking Through Eighteen Centuries*. New York: W. E. Rudge, 1930 (354 pp., 214 illus., index).

INGPEN, ROGER. "Decorated Papers." In *The Fleuron*, No. 2. London: Office of *The Fleuron*, 1924 (8 pp., paper samples).

KENYON, FREDERIC G. *Ancient Books and Modern Discoveries*.

LAUFER, BERTHOLD. *Paper and Printing in Ancient China*. Chicago: The Caxton Club, 1931 (33 pp.).

McKERROW, RONALD B. *An Introduction to Bibliography*. Oxford: Clarendon Press, 1927-1928 (358 pp., 23 illus., bibliog., index).

LORING, ROSAMOND B. *Decorated Book Papers*. Cambridge: Harvard College Library, 1942 (171 pp., illus., index).

STEIN, SIR M. AUREL. *Serindia*. Oxford: Clarendon Press, 1921 (*see* Vol. II, pp. 807-830).

VON HAGEN, VICTOR WOLFGANG. *Aztec and Mayan Paper Makers*. New York: J. J. Augustin, Limited Edition, 1943 (115 pp., 32 plates). Trade Edition, 1944.

PAPYRUS

DAVENPORT, CYRIL. *The Book*.

KENYON, FREDERIC G. *Ancient Books and Modern Discoveries*.

Papyrus, The Encyclopædia Britannica, Vol. XX.

PARCHMENT AND VELLUM

DAVENPORT, CYRIL. *The Book*.

KENYON, FREDERIC G. *Ancient Books and Modern Discoveries*.

MADAN, FALCONER. *Books in Manuscript*.

PUTNAM, GEORGE HAVEN. *Books and Their Makers During the Middle Ages*.

THOMPSON, SIR EDWARD M. *An Introduction to Greek and Latin Palaeography*.

—— *Parchment*. The Encyclopædia Britannica, Vol. XX.

MISCELLANEOUS MATERIALS

The Bookbinder and *The British Bookmaker*.

Bookbinder's Manual. London, 1832.

United States Printing Office, *Technical Bulletin*, 1925 + .

MISCELLANEOUS

BACON, FRANCIS. *Sylva Sylvarum.* London, 1627 (9th ed.) (322 pp., index).

BAUCHART, M. QUENTIN. *Les Femmes Bibliophiles de France. XVI, XVII, et XVIII Siècles.* Paris: Morgand, 1886 (2 vols.).

BLADES, WILLIAM. *Bibliographical Miscellanies.* London: Blades, East & Blades, 1890. Issued in 3 parts (93 pp., illus.).

———— *The Enemies of Books.* London: Trübner & Co., 1880 (114 pp., 7 plates).

BOGENG, G. A. E. *Die Grossen Bibliophilen.* Leipzig: Seemann, 1922 (3 vols.). Vol. I, Die Geschichte (512 pp.); Vol. II, Die Bilder (309 reproductions); Vol. III, Die Biographie (248 pp.).

BURTON, MARGARET, and ARUNDEL ESDAILE. *World's Great Libraries.* London: Grafton and Company, 1937 (458 pp., 32 illus., index).

CAILLÉ, DE LA. *Histoire de l'Imprimerie et de la Librairie.* Paris, 1889.

CARTER, THOMAS FRANCIS. *The Invention of Printing in China.* New York: Columbia University Press, 1925 (282 pp., 37 plates, maps, bibliog., index).

CHRISTIE, ARCHIBALD H. *Traditional Methods of Pattern Designing.* Oxford: Clarendon Press, 1910, 1929 (313 pp., illus., index).

CLARK, JOHN WILLIS. *The Care of Books.* Cambridge: The University Press, 1901 (330 pp., 156 illus., index).

COBDEN-SANDERSON, T. J. *The Arts and Crafts Movement.* Hammersmith: The Hammersmith Publishing Society, 1905 (39 pp.).

COMPAYRÉ, GABRIEL. *Abelard and the Origin and Early History of Universities.* New York: Scribner's, 1893 (315 pp., bibliog., index).

CRANE, WALTER. *The Bases of Design.* London: George Bell & Sons, 1904 (184 pp., illus., index).

CRUMP, C. G., and E. F. JACOB. *The Legacy of the Middle Ages.* Oxford: The Clarendon Press, 1943 (549 pp., 41 illus., index).

CURSON, HON. ROBERT, JUN. (known as Zouche). *Visits to the Ancient Monasteries.* New York: Barnes & Company, 1856 (390 pp., illus.).

CUST, A. M. *The Ivory Workers of the Middle Ages.* London: George Bell & Sons, 1906 (170 pp., 37 illus., bibliog., lists, index).

DAVENPORT, CYRIL. *Cameo Book-Stamps.* London: Edward Arnold, 1911(208 pp., 15 plates, index).

———— "The Decoration of Book-Edges." In *Bibliographica,* Vol. II. London: Kegan Paul, Trench, Trübner, 1896 (pp. 385-407).

DAY, LEWIS F. *Nature and Ornament*. London: B. T. Batsford, 1909 (2 vols.) (illus., indexes).

―――― *Ornament and Its Application*. London: Batsford. New York: Scribner's, 1904 (319 pp., illus., index).

―――― *Pattern Design*. London: Batsford. New York: Scribner's, 1903 (276 pp., illus., index).

DE LINCY, A. J. V. LE ROUX. *Researches Concerning Jean Grolier. His Life and His Library*. New York: The Grolier Club, 1907 (386 pp., plates, lists, bibliog., index).

DE RICCI, SEYMOUR. *English Collectors of Books and Manuscripts (1500-1930) and Their Marks of Ownership*. Cambridge: The University Press. New York: Macmillan, 1930 (203 pp., 8 plates, 24 figs., index).

DIBDIN, THOMAS F. *The Bibliographical Decameron*. London, 1817 (3 vols.).

DUFF, E. G. "The Bindings of Thomas Wotton." In *The Library*, Ser. I, 1910.

ESDAILE, ARUNDEL. *A Student's Manual of Bibliography*. London: Allen & Unwin, 1931 (384 pp., facs., index).

FLETCHER, WILLIAM YOUNGER. *English Book Collectors*. London: Kegan Paul, Trench, Trübner & Co., 1902 (448 pp., 46 plates, lists).

FOLMSBEE, BEULAH. *A Little History of the Horn-book*. Boston: The Horn Book, Inc., 1942 (57 pp., 22 illus., bibliog.).

GIBSON, STRICKLAND. *The Localization of Books by Their Bindings*. In Transactions of the Bibliographical Society, 1906-1907.

GLAUNNING, OTTO. "Der Buchbeutel in der bildenen Kunst." In *Archiv für Buchgewerbe und Gebrauchsgraphic*, Jahrgang 1926, Band 63.

GRANNIS, RUTH. "Colophons." In *The Colophon*, Part I, February, 1930.

"Gauffered Edges 16 Century. Method or Technique." In *Stone's Impressions*, 1934-1935, Vol. IV (2 pp., 9 illus.).

HAEBLER, KONRAD. *The Study of Incunabula*.

HATTON, RICHARD G. *The Craftsman's Plant Book*. London: Chapman and Hall, 1909 (539 pp., illus., index).

HENRY, FRANÇOISE. *Irish Art in the Early Christian Period*. London: Methuen & Company, 1940 (220 pp., 80 plates, illus., bibliog., index).

DE HEVESY, A. *La Bibliothèque du Roi Mathias Corvin*. Paris, 1923 (52 plates).

HOE, ROBERT. *Historic and Artistic Book-Bindings.* Dating From the Fifteenth Century to the Present Time. New York: Dodd, Mead, 1895 (176 plates).

IIAMS, THOMAS M. "Preservation of Rare Manuscripts in the Huntington Library." In *The Library Quarterly*, October, 1932, Vol. II, No. 4.

IVINS, W. M. JR. *The Arts of the Book.* New York: The Metropolitan Museum of Art, 1924 (96 pp., 56 illus., list of important dates).

JACKSON, HOLBROOK. *The Anatomy of Bibliomania.* London, 1930-1931 (2 vols.) (830 pp., index).

KOCH, THEODORE WESLEY. *The Florentine Fair.* Evanston, Ill., 1926. Printed for Subscribers (121 pp., 29 illus.).

KÜP, KARL. *A Fifteenth Century Girdle Book.* New York: The New York Public Library, 1939 (15 pp., 4 plates, bibliog.).

LABARTE, J. *Histoire des Arts Industrielles au Moyen Age.* Paris, 1864-1866.

LACROIX, PAUL. *Les Arts au Moyen Age et à l'époque de la renaissance.* Paris, 1880 (7th ed.).

DE MORGAN, PROF. A. *The Case of Libri.* London: Richard Bentley, 1852 (12 pp.).

LANG, ANDREW. *The Library.* London: Macmillan, 1881 (184 pp., index).

LOCKE, LELAND. *The Ancient Quipu or Peruvian Knot Record.* New York: The American Museum of Natural History, 1923 (84 pp., 59 plates, 17 text figs.).

LYDENBERG, HARRY MILLER, and JOHN ARCHER. *The Care and Repair of Books.* New York: R. R. Bowker, 1945 (2nd ed.) (127 pp., bibliog., index).

MACKAIL, J. W. *William Morris.* An address delivered before the Hammersmith Socialist Society. Hammersmith: Hammersmith Publication Society, 1905.

McKERROW, RONALD B. *An Introduction to Bibliography.*

MASKELL, ALFRED. *Ivories.* London: Methuen, 1905 (444 pp., 85 plates).

MASKELL, WILLIAM. *Ivories Ancient and Mediæval.* London. Chapman & Hall, 1875 (124 pp., numerous woodcuts, index).

MEJER, WOLFGANG. *Bibliographie der Buchbinderei-Literatur.* Leipzig: Hiersemann, 1925 (208 pp., 2,691 items).

MEYER, FRANZ SALES. *Handbook of Ornament.* Leipzig: Oswald Mutze, 1892 (4th ed.) (300 plates).

MORRIS, WILLIAM. *Some Hints on Pattern Designing.* A Lecture. London: Longmans, 1899 (45 pp.).

—— *The Arts and Crafts of To-day.* A Lecture. London: Longmans, 1889 (47 pp.).

NESBITT, A. *Memoir on 'Evangelia Quatuor' of Lindau. Vetusta Monumenta.* Society of Antiquaries, 1885.

O'CONNOR, REV. J. F. X. *Facts About Bookworms.* Their History in Literature and Work in Libraries. London: Suckling & Company, 1898.

O'CONOR, CHARLES. *Rerum hibernicarum scriptores vesteres Buckinghamie.* Excudebat J. Seely veneunt apud T. Payne. London, 1814-1826.

O'NEILL, HENRY. *The Fine Arts and Civilization of Ancient Ireland.* London: Smith-Elder. Dublin: George Herbert, 1863 (118 pp., 20 plates, illus.).

POLLARD, ALFRED W. *An Essay on Colophons.* Chicago: The Caxton Club, 1905 (198 pp., illus.).

—— *Early Illustrated Books.* London: Kegan Paul, Trench, Trübner, 1893, 1912 (236 pp., illus., index).

—— *Fine Books.* London: Methuen, 1912 (331 pp., 40 plates).

PLIMPTON, GEORGE A. *The Hornbook and Its Use in America.* Boston: Ginn & Company, 1916 (10 pp., 19 plates).

Preservation of Leather Bindings. United States Department of Agriculture, November, 1930. Leaflet No. 69 (8 pp., 3 plates).

RASHDALL, HASTINGS. *The Universities of the Middle Ages.*

ROUVEYRE, ÉDOUARD. *Connaissances nécessaires à un Bibliophile.* Paris: Édouard Rouveyre (several editions) (illus., lexicon).

SEELY, GRACE HART. *Diane the Huntress, The Life and Times of Diane de Poitiers.* New York: Appleton, 1936 (211 pp.).

SPELTZ, ALEXANDER. *Styles of Ornament.* Leipzig, 1910 (647 pp., illus., index).

STARK, LEWIS. *Branded Books from Mexico.* New York: The New York Public Library Bulletin, August, 1942 (3 pp. + bibliog.).

STOKES, MARGARET MCNAIR. *Early Christian Art in Ireland.* London: Chapman & Hall, 1887. Dublin: The Stationers' Office, 1932 (82 pp., 52 illus., bibliog.).

THOMPSON, JAMES WESTFALL. *The Medieval Library.*

WEISS, HARRY BISCHOFF, and R. H. CARRUTHERS. *Insect Enemies of Books.* New York: The New York Public Library, 1937 (63 pp.).

GLOSSARY

À froid. The French term for blind tooling.

Alae. A term of Arabic derivation meaning wings. Used to describe a motif in book decoration.

à la Cathédrale. A style of book decoration featuring a center design suggestive of a cathedral window.

à la fanfare. See Fanfare.

All-over design. A design planned as a decoration to cover an entire side of a binding, in distinction to a corner, center or border design, whether made up of a single motif, different motifs or a repeated motif.

Antique. Term used with reference to book decoration to designate blind tooling.

À petits fers. A French term used to describe tooling a design with small individual tools.

Arabesque. A kind of fanciful decoration combining foliage, fruits, flowers, curves and figures, which was perfected by Arabian artists.

Armaria. Cupboards for keeping books. A term used in the first centuries of the Christian Era.

Armarius. A monk who presided over a scriptorium.

Azured tool. A finishing tool with close parallel lines running diagonally across its surface.

Backbone. Same as Spine.

Bands. The covered cords or other material across the spine of a book which divide it into segments.

Bead. The twisted stitch formed in headbanding.

Bench-made. Any work done on the workbench by hand.

Bibliophegus. The name used in early Christian times for bookbinder.

Bibliophegy. The term for bookbinding used in early Christian times.

Blinded-in. A design is said to be blinded-in, when it has been impressed on a book cover with heated tools.

Blind tooling. Impressing heated tools on leather by hand, without the use of gold. Sometimes referred to as antique.

Block book. A book printed from blocks of wood having the letters or figures cut on them in relief.

Block papers. Papers printed from blocks of wood or metal on which a design has been cut or engraved.

Boards.

 1. Wooden or composition pasteboard covers used on the sides of books.
 2. A general term used by binders for various stiff lining and mounting materials.

Boarding leather. Dampening leather and then rolling it with the hand or a piece of cork in such a manner as to make the natural grain more prominent or to induce a straight or pebble grain.

Book covers.

 1. A term applied to the covered sides of a book.
 2. Protective covers of soft leather, like doeskin, sewed fast to a leather-covered book. A custom in use during the Middle Ages and early Renaissance.

Book satchel. A bag used in mediæval times for carrying books. It was frequently hung on a cleric's habit cord or on a warrior's belt.

Book shrine. A box or casket used in mediæval times to hold sacred books.

Bosses. Brass or other metal pieces fastened on the covers of books for the purpose of preventing the leather from being scratched or for an ornamental value.

Bound book. A covered book the sections of which have been sewn around cords or some other material, the ends of which are laced through the cover boards.

Bradel binding. A type of temporary binding said to have originated in Germany, and first adopted in France by a binder named Bradel. Known in France as "cartonnage à la Bradel."

Brochure. A sewed book with a paper cover.

Brush-pen. A pen, with a fibrous point, made of a reed, used for writing on papyrus.

Cambridge style. An English style of book decoration characterized by double panels with a flower tool at each of the outer four corners.

Cameo binding. A binding decorated with a cameo stamp. Also called a "plaquette binding."

Cameo stamp. A stamp cut intaglio like a seal.

Capsa. A term used on the Continent in early times to denote a book box or book shrine.

Cased book. A book which is held to its covers, or casing, only by means of pasted-down end papers, which are sometimes reinforced.

Casing. Cover of a book made separately and pasted to the book by means of end papers.

Catenati. Chained books.

Chain lines. The narrow numerous lines in a sheet of paper made by wires in the "mould."

Chain marks. Same as chain lines.

Champlevé. A method of enameling in which the enamel is embedded in cavities hollowed out of metal plates.

Chevrotain. A term used in England for a kind of leather fabricated from the hides of the small guinea deer. Also called "cheveril."

Clog almanac. An early kind of calendar made usually of a four-sided piece of wood with notches cut on it to denote the days of each month of the year.

Cloisonné. A kind of enamel inlay work set between metal strips on a metal or porcelain ground.

Codex. A manuscript written on papyrus or vellum, square in shape, and bound in flat form, originating in the early Christian Era.

Colophon. A paragraph put at the end of a written or printed book, containing information as to the identity of the scribe or printer, place of origin, date of printing, and sometimes other related matter. In extensive use until after about 1570. Sometimes referred to as an imprint.

Comb pattern. A pattern produced on marbled papers or other surfaces from a vat in which colors have been combed to form a pattern.

Commercial binder. A term used to denote a binder who turns out publishers' editions in "casings," using machinery for the work. Better termed a machine binder.

Cords. The material around which the sections of a book are sewed.

Cottage style. A style of book decoration associated with the "Mearne binder," in which a cottage gable is outlined.

Couch. To turn a sheet of paper from a mould onto a felt pad, during the process of making paper by hand.

Cover boards. Same as "boards": 1.

Cropped. A book is said to be cropped when its margins have been injured in cutting.

Cropping. Cutting the edges of a book beyond the shortest, or proof, sheet.

Cuirbouilli. A word used to describe a kind of book decoration in which the leather cover is modeled and hammered to raise the design in relief.

Cuir-ciselé binding. A binding with a design cut into the leather cover instead of being stamped or tooled on it.

Cumdach. A casketlike book box, sometimes called a book shrine, used in Ireland in early times.

Cusped-edged stamp. A stamp used by Bavarian, Austrian and South German binders employed in a manner to form a leaf effect. Sometimes described as "a headed-outline tool."

Deckle edge. The rough or irregular edge produced on a sheet of paper when in process of being made. Especially characteristic of handmade paper.

Dentelle. A type of border decoration in gold leaf composed of small tool forms that touch each other near the edges of a book cover and end in a delicate lacelike pattern pointing toward the center of the cover.

Dentelle à l'oiseau. A dentelle design in which birds are introduced.

Diaper design. A design in which a motif is frequently repeated at regular intervals, usually in lozenge forms.

Diced leather. Leather, usually calf, ruled with crossing diagonal lines which form a diamond pattern.

Diptych. A two-leaved hinged tablet made of wood, ivory or metal, with inner surfaces of wax, on which writing is impressed with a stylus.

Doublure. The lining of silk, leather or other material on the inside of book covers.

Drawn pattern. A term used to define a type of marbled paper the pattern on which was transferred to it from a pattern drawn on the surface of a marbling vat.

Ducali bindings. A term applied to the Venetian bindings of the decrees of the Doges which are decorated with a combination of Oriental and Western techniques.

Embossed. A design is said to be embossed when it is raised in relief.

End papers. The extra unprinted papers placed at the beginning and the end of a text, a sheet of which is pasted down on the inside of the front and the back book covers.

Etruscan style. A style of binding, originating in the 18th century, characterized by a calfskin cover which is stained with acid and decorated with classical ornaments.

Extra binder. A hand binder who uses the best materials and employs the soundest methods of construction and who usually decorates each binding with a design especially made for it.

Extra binding. A term used to denote a binding done by hand with especial care.

Fanfare. A style of book decoration said to have been initiated by the Eve binders of France, in which the book cover is divided into geometrically formed compartments bounded by fillets, and is profusely decorated with small tools and branching foliage.

Fanning out. Manipulating a pile of book sections, sheets of paper or boards so that each unit is exposed under the other a short distance along one edge.

Fanning over. Same as fanning out.

Fillet. A cylindrical revolving metal finishing tool mounted in a wooden handle and used for running lines or designs on a book cover. Sometimes called a roulette or a roll.

Finishing. All the work done on a binding after it has been covered in leather. The workman who does this work is called a "finisher."

Fleuron. A conventional flower or an anomalous type of ornament floral in character.

Flyleaves. All the free leaves of an end-paper section, but when used in the singular, the term denotes the uppermost free leaf of the section next to the cover board.

Folio. A book made up of sheets folded only once.

Fore-edge. The edge of a book opposite the folds of the sections.

Format. In bibliographical parlance, a term used to indicate the number of times the original sheets have been folded to form the sections of a book.

Forwarding. The branch of bookbinding that takes the book after it is sewed, and completes the binding through the covering process. The workman is called a "forwarder."

French shell. A term applied to marbled surfaces with a shell-like pattern on them. Made on paper in France in the late 18th century.

Full-bound. When the entire back and sides of a book are covered with leather the book is said to be full-bound.

Full-gilt. A term applied to books with all edges gilded.

Functionalism. The adaptation of structure to the use of an object.

Gathering.

1. A section or signature of a book.

2. Collecting the sheets when folded and placing the sections in sequence.

Gauffered edge. A book-edge decorated with a design tooled in over the gilded edge, and frequently colored.

Gesso. A prepared coating material applied to a surface as a groundwork for color.

Gilder. The workman who gilds the edges of books.

Gilding. The process of burnishing gold leaf on the edges of books.

Gilding boards. Boards similar to cutting boards which are used when gilding the edges of books.

Gilding press. A screw press used for holding a book when in the process of gilding.

Girdle book. A type of book used in the Middle Ages and early Renaissance which had secured to it an extra protective cover of soft leather fashioned in such a manner that the book could be hung from a girdle or from the habit cord of a cleric.

Glaire. A liquid deposited from the beating up of white of egg and vinegar or water used to size tooled impressions before laying on gold leaf for gold tooling, and for sizing book edges before gilding.

Gold leaf. A thin leaf of gold beaten out of a block of gold.

Grain of paper. The grain of paper is constituted by the main direction taken by its fibers.

Grooved boards.

 1. Cover boards with grooved edges, peculiar to Greek bindings.

 2. Cover boards that are cut out to receive the slips of a book.

Guild or Gild. A fraternal organization of free craftsmen for the purpose of protecting their rights.

Half binding. A book covered over the back and partly on the sides with leather, and with some other material on the sides, is said to be a half binding.

Harleian style. An English style of book decoration with a center motif composed of small tool forms usually arranged in a lozenge-shaped design, and having a border decorated by means of an engraved roll. This style was named after Lord Harley, whose bindings were decorated in this manner.

Head. The head of a written or printed book is that part above the first line of writing or printing.

Headband. A silk-, linen- or cotton-covered band stretching across the head edge of a book and resting along the contour of the back of the book.

Headcap. The shaped folded piece of leather that covers the headband.

Head-outline tool. Same as cusped-edged stamp.

Hinge. The material which is used to fasten the text of a book to its board covers.

Hollow back. A type of false back of hollow construction affixed to the back of an uncovered book.

Imprint. The subject matter on the lower part of a title page, concerning the place and date of publication, the publisher's name, and sometimes the name and address of the printer. The term is also applied to a colophon.

Inlays. Pieces of colored leather or other material set into a figured pattern, a border or panel. Now used interchangeably with "onlays."

Intaglio. If a design is cut on a tool in such a manner that when stamped on a surface it appears raised above a sunken background, it is said to be cut intaglio.

Jansenist binding. A French style of binding the covers of which are decorated only with blind lines. From the severity of its style, it was named after the Roman Catholic Jansenists.

Job binder. A binder who does mostly hand binding for the trade.

Joint. The groove formed along the back of a book to hold the cover board.

Kermess. Originally the feast of dedication of a church. Later, an annual festival or fair held in the Low Countries, French Flanders, and in France.

Kutch. A receptacle for holding a thick piece of gold when it is being beaten into thin leaves.

Laid lines. The broad lines seen through a sheet of paper running across its width, made by the heavy wires in the bottom of the "mould."

Laid on. Gold leaf is said to be "laid on" when it has been applied over a surface to be tooled.

Laid paper. Paper made in a mould in the bottom of which heavy lines of wire are fastened.

Librarii. A word used in mediæval times signifying scribes.

Lithograph papers. Papers decorated by means of being printed from lithographic stones on which designs have been drawn.

Looper. A special kind of needle used on a book sewing machine.

Lozenge. A diamond-shaped figure, or a square figure placed from one of its points; usually decorated.

Lyonnaise. A name given to a style of binding with broad interlaced strapwork usually painted, or a style in which the binding is decorated with large corner ornaments and with a prominent center design, the all-over

background being filled in with dots. These styles are, however, not peculiar to Lyons bindings.

Marbled paper. Paper that has had a colored pattern put on one surface by the process of marbling.

Marbler. The workman who marbles paper, leather, and the edges of books.

Marbling. The art of veining a surface by floating colors on size in a design and transferring the colored design to leather, paper, or book-edges.

Marbling comb. An instrument with teeth like those in a comb used in forming patterns for marbled papers and other surfaces.

Marbling vat. A vat in which colored patterns are floated on a sized surface of water for the purpose of transferring them to paper or to some other surface.

Margins.

1. The unprinted spaces around the written or printed text of a book.

2. The turned-over leather or other covering material on the inside of book boards.

Monopolies. Exclusive privileges granted by the crown or state to individuals or groups of men, for their pecuniary advantage.

Mosaic. A term applied in bookbinding to inlaid designs; especially to bindings of A. M. Padeloup.

Mould. A frame for making paper. Also, a receptacle used in gold beating.

Mudéjar binding. A type of Spanish strapwork binding made by Moorish binders.

Ogee tool. A double-curved finishing tool sometimes in floral outline.

Onlays. Pieces of thin colored leather or other material pasted over an outlined tool form, border or panel. Usually referred to as "inlays."

Orihon. A book composed of a continuous, folded, uncut sheet that is stabbed along one side and held together by cords laced through the stabbed holds. A "stabbed binding" of oriental origin.

Palimpsest. A book composed of sheets of parchment or vellum on which a new writing is done over writing that has been scraped off or erased.

Panel. The space on the back or side of a book bounded by joined lines.

Panel-stamped. Stamped with one or more decorative panels by means of heavy pressure.

Papyri. Ancient scrolls, books or fragments of the same, written on papyrus.

Papyrus. A kind of writing material made from the stems of a reedlike plant which grows along the river banks of Abyssinia, Egypt, and Sicily.

Parchment. Sheepskin prepared with lime, like vellum.

Paste papers. Decorated papers made by imposing designs on their colored pasted surfaces.

Patté, or Patée. Spreading toward the extremity. In the case of a cross, having each of its arms narrow at the center and spreading toward the extreme ends.

Personal binding. A binding bearing the owner's initials.

Plaquette binding. See Cameo binding.

Plough. The wooden implement equipped with a knife used by hand binders for cutting edges of books in a lying press.

Pointillé. A style used in decorating books initiated by Le Gascon in the 17th century characterized by the use of tool forms in dotted outline. The term is used also to denote a background covered with dots.

Polaires. Early Irish book satchels in which books were carried about.

Polychrome decoration. A style in book decoration characterized by the introduction of gold and various colors painted over the design.

Pounce. An adhesive preparative compound used under gold or colors.

Pugillares. Small wax writing tablets.

Quarto. A book made up of groups of four leaves, or eight pages.

Quaternion. A term used in the early Christian Era to denote a gathering of folded sheets of vellum in units of four leaves.

Quipus. A Peruvian name for a primitive method of record keeping and conveying messages used in Peru, for which colored knotted strings attached to a long cord were employed. A species of sign language.

Quire. A word formerly used in bookbinding to denote a "gathering" or a "section."

Repeat Design. A design made up of a repeated motif.

Roll. Same as fillet. Called by French binders "roulette."

Romantic style. In bookbinding decoration, an informal, nonclassical style in which fancy predominates.

Roundel. A double ring, usually with a center dot.

Russia leather. A leather tanned with willow bark, dyed with sandalwood, and soaked in birch oil.

Saddle. A part of a book sewing machine on which the sections of a book are placed when they are brought up under the sewing needles and loopers.

Saracenic. A name used in designating a style of decorative design originating among Mohammedan peoples such as the Arabic, Moorish, Alhambric, and Indo-Saracenic.

Sawn-in. A book is sawn-in when the back of the sections are sawed through for sinking the cords for sewing.

Scriptorium. A room set apart in a monastery, or abbey, for the copying of manuscripts.

Section. A term applied to each unit of folded leaves comprising a book.

Semis, or Semée. A term meaning sprinkled, borrowed from heraldry by the bookbinder to denote a type of design in which small tool forms are placed over a surface at regular intervals.

Shoder. A skin used by a goldbeater to hold the gold as it is being beaten.

Signature. The letters or figures placed under the foot line of the first page of each section of a book to indicate the sequence of the sections. The word is also used synonymously with section.

Spine. A term used to designate the covered back of a book on which the title is usually lettered. Sometimes called the backbone.

Sprinkled calf. Calfskin book covers that have speckled surfaces, produced by the application of acid, are said to be "sprinkled."

Sprinkled edge. A book-edge that has been covered with a sprinkling of color or colors.

Stabbed binding. A binding that is held together by cord laced through holes stabbed along its back edge.

Stamp. In mediæval times, a piece of metal engraved intaglio, used cold, for impressing a design on a surface either by hand or by means of a press. At the present time, a piece of metal with a design cut either intaglio or in surface outline, and impressed heated, by means of an arming or blocking press.

Stamping. In mediæval times, impressing an unheated, engraved stamp on a surface either by hand or by means of a press. In modern times, impressing a heated engraved stamp on a surface by means of an arming or blocking press.

Stationarii. Men commissioned by mediæval universities to attend to the production and distribution of books.

Straight-grain leather. A leather that has been dampened and rolled, or "boarded," to make the grain run in straight lines. An innovation accredited to Roger Payne.

Strapwork. Interlaced double lines, usually forming a pattern geometrical in character.

Stylus, or Style. A writing instrument pointed at one end, which was used in ancient and mediæval times.

Tail. The tail of a book is the end opposite the head.

Tailband. A band on the tail edge of a book woven over with silk or linen thread by which it is fastened to the book.

Title piece. A colored leather label, usually pasted on the back of a binding, on which the lettering of a book is done.

Tooling. The art of impressing a design on leather or some other material by hand, with heated tools.

Tools. The name applied in a specific sense to the engraved metal bookbinder's tools with wooden handles which are used by hand, heated, to impress a design on a surface.

Tree-calf binding. A calf binding the sides of which have been stained with acid in such a manner as to form a treelike pattern over the entire cover.

Triptych. A hinged tablet like a dyptych, composed of three sections instead of two.

Vat-sized. Paper is said to be "vat-sized" when the size is put in the pulp before the pulp is used to form a sheet.

Vellum. A calfskin prepared with lime, and not tanned like leather.

Volumen. A Latin term used to signify a rolled form of book, or a scroll. The word from which "volume" is derived.

Waste.

1. Fragments of old books or spoiled and excess sheets of new books, frequently utilized by binders for lining purposes.

2. The extra sheets supplied to a binder to substitute in the event of spoilage.

3. Excess pieces of paper cut off by a binder.

Watermark. A device, or design, in a sheet of paper, which is made during the process of forming the sheet, representing a sort of trademark of the maker.

Whole binding. A binding with spine and sides entirely covered with leather.

Wire marks. The lines made in a sheet of paper, while it is being formed, by the wires in the bottom of the "mould."

Wove paper. Paper made in a mould which has a bottom of woven wire screening similar to woven cloth fabric.

Yawning boards. Cover boards that curl away from the text of a book.

INDEX

BOOKBINDING
ITS BACKGROUND AND TECHNIQUE

VOLUME TWO

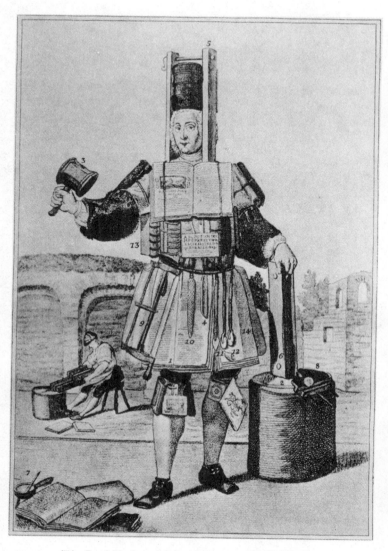

The Bookbinder with Instruments of his Profession

Instead of presenting the tools of the profession in a textbook manner, the artist Martin Engelbrecht makes them a part of an imaginary portrait—showing the craftsman "in action."

1. A folio book "planed," made even by previous hammering. 2. The stone anvil or beating stone (the loose sheets are put on this device to be evened out). 3. The hammer. 4. The folding bone used to fold the printed sheets. 5. Bookbinder's press used to keep the signatures together during the process of binding. 6. The sewing frame on which the folded sections of a book are sewn to upright cords or tapes. 7. The glue pan. 8. The planer. 9. The saw necessary to prepare wooden boards, basis of all binding till the late 17th century. 10. The file. 11 & 12. Rollers for the making of ornamental designs on book covers. 13. Some bound and unbound books. 14. Blue end paper and marbled paper.

BOOKBINDING

ITS BACKGROUND
AND
TECHNIQUE

BY EDITH DIEHL

VOLUME TWO

DOVER PUBLICATIONS, INC.
NEW YORK

BOOKBINDING

ITS BACKGROUND
AND
TECHNIQUE

BY EDITH DIEHL

VOLUME TWO

DOVER PUBLICATIONS, INC.
NEW YORK

CONTENTS

vi CONTENTS

CHAPTER I

CRAFTSMANSHIP

Tool handling. Organization of the workbench

CRAFTSMANSHIP is not an academic subject, and no craft can be mastered by learning about it from a book. It is empirical knowledge that counts in producing a skilled craftsman, since a craft is a practical matter. Long hours of work at the bench are necessary, repeating operation after operation, before the eye can be trained, the hand made skillful, and the mind, eye, and hand co-ordinated. So it is that a textbook on a craft like hand bookbinding can be at best nothing more than a guide to learning how to bind books. The would-be binder must expect to get his real knowledge from benchwork practice.

It is axiomatic that a practical performance or demonstration of how to do a thing is more vivid than a mere verbal explanation of how a thing should be done. And when a demonstration is not possible, I think the next best way of learning to perform a manual task is to have before one a picture or graph which illustrates the process contemplated, since most people are visual-minded. For this reason I have built this manual around illustrations.

TOOL HANDLING

The importance of correct tool handling in craftwork cannot be too greatly stressed. Without question, a good tool is most desirable, but the manner in which a tool is used counts for as much as, and often more than, the perfection of the tool itself. Many a poor workman blames his failure on his tool, whereas a master craftsman seldom grumbles about a tool, but makes it serve him.

There are certain cardinal principles with reference to the handling of tools which any craftsman should integrate into his manner of working. First, there is the matter of the position of a tool in the hand. A tool should be held, for every operation, so

that it is a natural extension of the arm and hand. This makes for directness, accuracy, and dexterity in working, and incidentally, a certain gracefulness in performance. When a workman holds his tool awkwardly, using it as a sort of appendage instead of as a component part of his hand, he is working against an unnecessary handicap, and the quality of his work is bound to suffer in consequence. Then, too, it is essential that a craftsman should be relaxed when working. He must assume a comfortable position, with his muscles uncramped and free. This will allow him the highest degree of efficiency, and will make it possible for him to work with a minimum amount of fatigue.

A tool should be held lightly but firmly, and it must never be forced to do its work. Every sportsman knows the advantage of this light, firm holding of his tool, whether golf club, gun, or billiard cue, for in the course of his practice he has sliced his ball on the golf links, has missed his shot in the woodland, or has failed to carom his balls on the billiard table, simply because he was grasping his tool for dear life and was performing with muscles taut and constricted. The whole body must be relaxed, with muscles co-ordinated and not tied up in knots, when any member of it is used for a given physical activity. The hand should never work with concentrated force, cut off, as it were, from the rest of the body. The muscles of the hand should be in coextension with the arm, shoulder, and body muscles, whenever the hand is being used to perform a task, for when working in this manner it is able to function with the greatest ease and efficiency, since it has a continuous line of power back of it.

To sum up, the position of a tool in the hand when working, the matter of relaxed and co-ordinated muscles, and the position of the body are of utmost importance in any craftwork. Above all, one must be comfortable and unhampered if one is to work efficiently. This matter of comfort in performance of a task cannot be too greatly stressed. Fatigue is the archenemy of skillful per-

formance, and discomfort is a great promoter of fatigue. It is obvious that all tools must be kept clean and effectively conditioned. Knives especially should be reconditioned frequently, for the using of a dull knife often results in ruined materials.

ORGANIZATION OF THE WORKBENCH

Another important aid to easy and deft performance in binding a book is organization of the workbench. All tools and materials necessary for use should be at hand and should be assembled in such a manner as to be quickly grasped. For example, when glue or paste is being used, a certain degree of speed in working is necessary, and a missing or misplaced tool or piece of material is often the cause of a badly done job. Order is equally important in many other bookbinding operations.

At an efficiently organized workbench, one is able to work with maximum speed and without any confusion or hurry. A worker must never hurry, no matter how speedily he works. It is the calm and well-poised craftsman who is able to marshal his faculties and handle his tools to the greatest advantage. Every craftsman should bear in mind that the element of hurry is vitiating and destructive of efficient performance; whereas speed is the very product of efficiency and can be attained in craftwork only by controlled effort.

As I proceed to describe the various processes of bookbinding, I shall remind the reader from time to time of these fundamental principles of good craftsmanship as applied to specific operations.

CHAPTER II

WORKSHOP APPOINTMENTS, EQUIP-MENT, AND RECORD KEEPING

UNTIL recent years, no actual machines were used by hand binders, unless one were to consider the large standing press a machine. Boards were roughly cut out by means of large bench shears and then were cut to size by hand; the edges of books were trimmed by hand at the workbench or were cut by hand in a press with a plough. Now, however, in every well-equipped hand bindery there will be found small hand-operated machines for cutting both bookboards and book-edges. They make it possible to do the work more accurately and quickly, and only prejudice or lack of means would cause them to be excluded from the equipment of a hand bindery.

There is something to be said for the contention of the hand binder who refuses to use any sort of machine, for it is certain that machinery has a tendency to destroy sound craftwork and too frequently turns real craftsmen into mere workmen, but it is apparent that nothing is gained by plodding along with any work by hand that can be done equally well by machine. Thus far, machines have not been invented capable of performing all the operations that are peculiar to hand bookbinding, and I think it improbable that science will succeed in mechanizing the craft; but if this ever comes to pass, it will not necessarily constitute a tragedy. Mechanization of hand binding should be welcomed for its laborsaving value, providing it can be applied to the craft of binding without destroying the soundness of construction and the distinctive qualities that are inherent in the hand-bound book.

BINDERY APPOINTMENTS

In addition to several small machines, hand tools, and other equipment, there are certain appointments desirable in a bindery workshop. I propose to list the equipment and discuss the features of a well-appointed small hand bindery suitable for professional work. The room for this purpose should be of generous size, with ample storage space. It should have the convenience of running water close at hand and must be well lighted, having preferably a northern and eastern exposure. It would be possible to bind books in a smaller room with much less elaborate equipment than I am about to describe. Even a corner of some room which is provided with good light and affords sufficient space for storing a skeleton outfit will be found to offer the amateur binder a possible place in which to work, but would not be found very satisfactory at best.

BINDERY EQUIPMENT

The first matter of importance in equipping a bindery workroom is to provide a minimum of two good workbenches and two extra tables. Each workbench should be placed against an outside wall in front of at least two large windows in order to ensure adequate light for the worker. The benches should be strongly built and of a height convenient for a standing workman. The height, of course, will vary with each individual. An ideal workbench is about seven feet long, by thirty inches wide, by from thirty-four to thirty-six inches high. It is desirable to have two shelves built in under the bench for storage space, and the shelves should be recessed about six inches so as not to interfere with the feet of the worker when he is sitting. For the binder obliged to work in a room not set apart exclusively for his use, a very excellent workbench may be improvised by having an adjustable cover made for the top of the lying or cutting press. This

cover can be made to fit on top of the press when the flat side is uppermost, and should extend well over at the sides.

The lying press (Figs. 1A and B) is one of the most useful implements in a binder's equipment, and, in a simplified form, it dates back to very early times. It consists of two blocks of wood the tops of which are held together by two large screws. These

Fig. 1 A.

are operated by means of an iron bar called a "pin." The blocks of wood are flat on one side, making the press available for "backing" and other operations, while the opposite side is arranged for cutting purposes. On the cutting side, two runners are screwed onto the left block to serve as guides for the cutting "plough." The plough also has two solid wooden sides which are brought closer or farther apart by means of manipulating a screw which

Fig. 1 B.

Fig. 2.

connects them. In the base of the right side of the plough there is a metal device for fastening a cutting knife (Fig. 2). The lying press is mounted on a wooden frame called a "tub," which has a solid bottom well up from the floor, for the purpose of catching any waste resulting from a cutting operation. The wooden screws of all presses should occasionally have a little soap applied sparingly to them in order to effect their smooth operation. If the

Fig. 3.

screws are metal, they should be treated with graphite. When not in use, presses must not be left with their jaws open, but should be kept screwed up, though not too tightly, for wood is liable to swell, especially in warm weather, and if the cheeks are left too tightly screwed together, even the strongest arm finds difficulty in budging them.

A small iron nipping press (Fig. 3) is a necessary part of a

binder's outfit. It should be firmly fastened to the top of a low, sturdy table or chest of drawers specially reserved for the pur-

Fig. 4.

pose. An old-fashioned letterpress could be utilized for this small auxiliary screw press.

Then a more powerful standing press is needed. The most commonly used type is made of iron and is operated with a lever bar (Fig. 4). There is an American-made wooden standing press

of the lever type which has the advantage of being much lighter for use on a floor supported by wooden beams, but it has not so much power as the iron press. The French standing press (Fig.

Fig. 5.

5) is the most satisfactory of them all for a small bindery. It has a heavy wooden frame with an iron screw and an ingenious device for "wringing down" the top platen by a hammering action

of two metal parts. It requires little strength to operate and has the advantage of being light in weight, though it is capable of as great pressure as an iron lever press of the same size. Wooden standing presses, after being perfectly leveled, should be anchored to a wall with bolts and to the floor with angle irons.

Fig. 6.

Graphite should be used on the screw occasionally to keep it from rusting and to facilitate easy operation.

Pressing boards are required for use in both the nipping and the standing press. They are made of solid or laminated wood and are about four-eighths of an inch thick. I recommend the solid wooden ones, as the laminated boards, even though kept

under pressure most of the time, are liable to become unglued. These boards are needed in the following sizes: 8 x 12 inches for octavo work; 10 x 16 inches for quarto and small folio; and 12 x 16 or 18 x 23½ inches for large folio and portfolio work. They should always be kept flat, under pressure. For use with these boards, there should be a stock of pressing tins corresponding in size with each size of board. In addition to ordinary pressing boards, a few brassbound boards of two or three sizes should be added to the equipment for use in casing work.

Fig. 7.

One of the most convenient timesaving devices in a bindery is a good lever cutting machine (Fig. 6). Small ones that are efficient are not manufactured in this country for binding purposes, and the efficient ones take up a great amount of space. However, space must be allotted to this machine in a well-equipped bindery, and it should be of all-metal construction. For the amateur, a large-sized table cutter like those used by photographers (Fig. 7) might suffice for any cutting of paper stock to be done, but in the absence of an efficient cutting machine, boards will have to

be cut out roughly by the use of bench shears (Fig. 8) and then cut to size with the plough. Single large cutting blades with a

Fig. 8.

foot-pedal attachment for holding the work are procurable (Fig. 9), and a fairly satisfactory cheap board cutter can be rigged up by mounting a pair of these shears on the edge of a smooth-

Fig. 9.

topped table and affixing a strap of metal at right angles to the blade at its handle end. A sliding metal guide can be put in the table back of the shears, to serve as a measure for the work. If one cares to take the time and trouble, the table top can be marked off in inches and its segments.

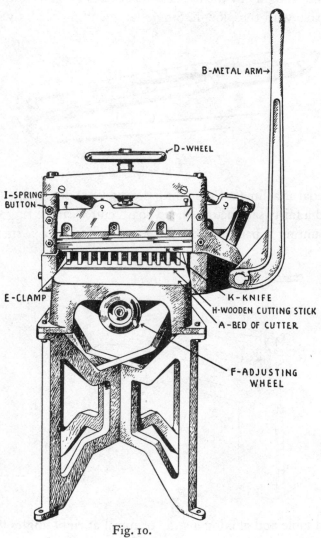

B-METAL ARM→

D-WHEEL

I-SPRING
BUTTON

E-CLAMP

K-KNIFE
H-WOODEN CUTTING STICK
A-BED OF CUTTER

F-ADJUSTING
WHEEL

Fig. 10.

Another type of cutting machine, which, though not absolutely requisite, is desirable and saves considerable time in cutting book-edges, is the guillotine cutter (Fig. 10). Small machines of this kind are to be had, but they are comparatively expensive. If space and purse allow, this machine should be added to the bindery equipment.

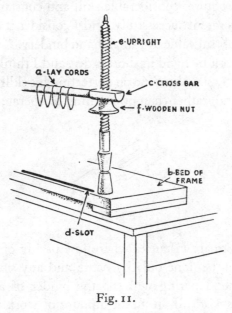

Fig. 11.

A wooden sewing frame (Figs. 11, 70) is an indispensable adjunct to a hand bindery. The type in general use at present is very like that shown in illustrations of binders working in the early sixteenth century, and a similar sort of device for sewing books was used even before that time. A sewing frame consists of a flat bed, in the front of which are two uprights, one at each end. These are connected by a bar that is lowered or raised by screwing it up or down on threads of the uprights. In the bottom of the frame there is a slot which is utilized for holding the brass keys (Fig. 12) that are necessary to secure the cords over which the

sections of a book are sewed. Another type of sewing frame, called a blankbook frame, is made for use when tapes are substituted for cords, but the sewing frame shown in Fig. 11 can be utilized for sewing over both tapes and cords.

There is an electrically driven "Fortuna" paring machine of German manufacture that might be added to a bindery equipment, but it requires considerable skill and constant practice to be able to operate it successfully, and I consider it an expensive luxury of doubtful value to a small hand bindery. A skillful parer can do the work by hand in short order, and I think it far better for a binder to spend his time on perfecting his skill and speed at paring by hand, rather than on learning to operate a tricky ma-

Fig. 12.

chine, for there are instances where fine paring of both leather and paper can be done only by hand, and any sidestepping of practice in hand paring will rob the binder of a skill sorely needed in his work. If an undue amount of work piles up, one can have paring done by professional operators, who make a specialty of machine paring and who do it expertly.

Two or three small wooden presses, called "finishing presses," are necessary for various operations in binding. One with beveled cheeks (Fig. 13) will be found especially useful for holding a book in the process of having its spine decorated or lettered. Another, with square cheeks (Fig. 14), may be utilized to advantage for other work such as headbanding and marking up for sewing.

A tooling stove is a necessary part of a finisher's equipment. Gas stoves have proved the most satisfactory for this purpose.

Some few years ago many job binderies in this country aban-
doned their gas tooling stoves and substituted electric ones, but

Fig. 13.

gradually electric tooling stoves have been cast aside and gas
stoves have returned to the tooling bench. The reason for this is

Fig. 14.

that the electric stove is slower to come to a desired degree of heat,
and even when it is set for a low, medium, or high temperature,
there seems to be a cumulative piling up of heat that is very

dangerous in tooling. In other words, it is not as flexible nor as dependable a heating unit for tooling purposes as a gas stove and consequently slows up the work of a tooler very measurably.

Fig. 15.

There are two kinds of gas stoves most desirable for a small bindery: one, an English or American model, very similar in construction (Fig. 15); the other, a French model (Fig. 16).

Fig. 16.

Each has its advantages, though for general use I think the model pictured in Fig. 15 preferable. For work requiring a greater number of tools than can be accommodated on either of these bench stoves, there is a large standing stove, which is

placed on the floor by the side of the worker. This stove differs from that shown in Fig. 15 only in that it is taller and accommodates more tools. It is necessary to have a small ordinary heating stove for general purposes, in addition to a tooling stove.

To complete the list of larger, and for the most part stationary, equipment for a bindery, one should have some sort of apparatus for grinding knives. Knives and shears can be sent out to be ground to advantage when they require a great amount of time to recondition, but there are occasions when a timely grinding of a knife will rescue it from becoming unusable. A small old-fashioned foot-treadle grindstone will answer the purpose, but a

Fig. 17.

much more efficient implement can be assembled at little extra cost, by mounting a one-quarter horsepower motor on one end of a block of wood and mounting two small grindstones on the other end (Fig. 17). The original block of wood should be about ten inches wide, by twenty-one inches long, by two inches thick, and to one end of this block should be added a piece of wood two inches thick, by ten inches long, by ten inches wide (see Fig. 17) (A). On the four-inch-thick end of the block, the motor, which has a "pulley" on one side (B), should be securely bolted down. On the opposite end, a mounted shaft, which has two arms (C), should be rigidly fastened with bolts. Then on one arm of the mounted shaft a medium-coarse sharpening stone is affixed

(D), and on the other end of the shaft a fine finishing stone is likewise fastened (E). Lastly, a narrow belt (F), about one and one-half inches wide, is arranged to connect the shaft of the mounted stones with the pulley of the motor. There is an insulated lead cord (G) on the motor opposite to the pulley, and by plugging the end of this cord into any base plug or other electric outlet, the motor is set in motion and the operator can proceed to his task of grinding his knives on the spinning stones. Such an instrument is a joy forever to the craftsman who takes pride in keeping his cutting tools in order, and all the parts necessary for constructing this gadget can be bought at slight expense at a mail-order store such as Sears, Roebuck and can be quickly assembled by any small-town electrician or even by a novice who possesses a flair for this sort of work. The underside of the belt must have a coating of belting graphite applied to it periodically to keep it from slipping.

In addition to this equipment, there are a number of small hand tools and other items necessary for binding a book, which I shall list and illustrate as I proceed with the explanation of the various processes of bookbinding. There are also a few pieces of furniture and storage devices that cannot be dispensed with, such as a type cabinet, boxes for alphabets, tool cases for brass finishing tools, racks for holding fillets or roulettes, and several stools of at least three different heights. I have already suggested the necessity of ample storage space for materials as well as for various small tools that are needed in a bindery.

RECORD KEEPING

Books come to the binder in sheets, in sound or badly worn casings, or bindings, and in dilapidated bindings. In the first two instances, the books are taken through the usual processes of binding. In the case of a dilapidated binding, it is often advisable to repair rather than rebind it, and the matter of repairing,

except for torn leaves, I shall take up in a later chapter. In any case, when a book is received from a client for binding, a record should be kept concerning it. In a book set apart for such records, all details concerning the book received should be entered, such as the date when received, the name and address of the owner, the title, and full particulars specified by the owner about the binding. The price given for the work, and the time set for its completion, if specified, should also be jotted down in the entry. The book to be bound should be carefully looked over at once and collated before being put aside or pulled apart, and if any imperfections are found in the text, the owner should be notified immediately. This is a very necessary precaution for a binder to take, for a surprising number of books have imperfections that their owners are not aware of, such as missing leaves, and these imperfections might be attributed later to the fault of the binder. It is a useful practice to leave space under each entry for a record of time spent on binding the book and the cost of materials used, as well as detailed specifications of the binding. Accumulated records of this sort serve as a guide in giving estimates for binding.

CHAPTER III

FLEXIBLE BINDING

Operations in binding.
Collating and paging. Pulling and removing glue.
Sharpening a utility knife. Knocking out joints

THERE are two main branches of hand bookbinding, one known as "forwarding" and the other as "finishing." Technically speaking, forwarding consists in taking the book, which is already mended and sewed, through various processes until it is encased between boards and finally covered with some protective material. In other words, the term comprises all the operations performed by the man called a "forwarder," who constructs the binding after certain preliminary operations have been done. The word, however, has come to have a wider meaning, and it has been a growing custom to include under the term "forwarding" all the operations in binding through covering. The preparation of a book for the forwarder is usually carried out by women who are employed for this purpose only and are not allowed to do any forwarding except the one operation of headbanding. This division of work obtains in all hand binderies both in this country and abroad, except in the so-called "one-man shops" where all the work is done by one or two persons, either male or female.

A book may be bound by hand in several different ways, and the various types of binding will be discussed separately. The type which I am describing first is that in general practice by "extra" binders, and its construction is based upon the principles used for binding books in mediæval times. This type of binding is known as a "flexible binding" for some strange reason, as it is the most unflexible binding produced. A book is said to be "bound

flexible" when the sections are sewed around cords which are laced through the bookboards and the leather is attached directly to the back of the sections. Although this sort of binding is not suitable for all books, it is the strongest of all types of binding, and I shall first describe the procedure of binding a book in full leather after this fashion and later indicate modifications that are desirable in certain instances.

OPERATIONS IN BINDING

In order that the various operations in binding a book may be more easily comprehended, I have arbitrarily divided them into a total of thirty in number, and shall explain them in their successive order. The first four operations indicated do not apply to books received from the printer in sheets, and I shall not consider this type of book until I get to the explanation of Operation 5.

Following is the order in which I shall discuss both the preliminary work in binding a book "flexible" and the actual processes of forwarding. If the beginner will refer to this outline as he proceeds with binding, he will find himself less likely to get the cart before the horse and will probably save himself embarrassing moments.

1. Collate and Page
2. Pull and Remove Glue
3. Knock Out Joints
4. Guard and Mend
5. Fold Sheets and Gather
6. Make End Papers
7. Press Book
8. Cut Head of Book. Trim Tail and Fore-edge (if necessary)
9. Gild or Color Edges (when rough edges are desired; omit when smooth edges are called for)

10. Cut Out and Line Up Boards
11. Mark Book for Sewing and Saw Kettle
12. Collate
13. Sew
14. Fray Out Slips
15. Knock Up Book and Glue Back
16. Round Book and Back
17. Cut Boards to Book
18. File Boards to Joint (if necessary) and Mark for Holing
19. Hole Boards. Cut Out for Lacing-in
20. Lace-in Slips
21. Cut Book "In Boards" (when smooth edges are desired)
22. Gild, Color, or Marble Edges (when finished smooth)
23. Headband
24. Line Up Back
25. Case Text in Protective Cover
26. Cut Out Leather and Pare
27. Trim Cords (if necessary). Clean Up Boards. Look to Squares
28. Cover
29. Cut Inside Margins and Fill In
30. Paste Back End Papers and Leather Hinges

COLLATING AND PAGING

Collating and paging consist in examining a text to verify that each page is in its proper sequence and supplying lacking numbers on all pages. This operation is a most important one, as collating represents an insurance to the binder against any mistakes due to imperfect texts, and paging ensures him against failing to bind the text in proper sequence. Each sheet of a book is usually numbered, and each section bears a number or a letter called a "signature" at the bottom of the first page, to indicate its relative position in the text. In assigning signature letters to the

sections, if there are more sections than letters in the alphabet, the printer continues to identify the sections by doubling the letters, as AA, BB, etc., or by prefixing a numeral to the letter, as 2A, 2B, etc. The letters J, V and W are usually omitted in lettering sections. Various systems are used for signatures, which in early times were indicated in the colophon, but colophons are no longer in vogue, and in any event, the system used is apparent. Pagination is self-evident, as it continues numerically.

To collate and page a book while it is still in its covers requires much more time than when the sections are unbound. Often the speediest manner of collating is to take about forty or fifty pages at a time, grasping them with the right hand at the foot of the page at the fore-edge, and then turning the hand so that the pages roll over to the left and are fanned out in such a way that the page numbers are visible and each page can be picked off one by one with the thumb of the left hand (Fig. 18). But when the book is small and is printed on heavy, stiff paper, this is extremely difficult to do, and I think it saves time to collate and page in one operation by turning over one page at a time, noting the numbers, and supplying any that are lacking.

As there are usually no numbers on title pages and frontispiece illustrations, and as the first printed page, or the half title, must often be numbered 3 instead of 1, the section containing it is best paged by beginning at its last page and counting back to the first unnumbered page. Numbers should be lightly penciled at the top of the page as near as possible to the fore-edge. It is not necessary to have a number on both sides of a leaf. For a first section which contains Roman numerals any supplied numbers should be characterized in a way to indicate that the page is a part of the preface or first section. A simple scheme for this purpose is to affix an "a" to each number, as 1a, 2a, etc. Otherwise, the page might be confused with a page of the second section, which likewise begins with page 1. The remaining sections may be collated

and paged by proceeding from the front to the back of the text, not failing to supply a number to the back of every illustration and to one side of every leaf that is not numbered. All plates should be numbered on the verso with the same number as the pages facing them.

When folded, loose, or unbound sections are collated, it is sufficient to observe merely the signature letters or numbers, for, since the pages are not cut, they will not be disturbed and misplaced in the process of binding.

To collate loose, folded sections, the book is grasped in the

Fig. 18.

left hand at the top corner with the fore-edge toward the right, and the right hand is held under the leaves at the left bottom corner with the thumb lightly holding the sections at their fore-edges. Then the right wrist is twisted around so as to turn over the top section and cause it to fall toward the right, face down, as it is released by the left thumb (Fig. 18). This exposes the first page of the section underneath it, which is held in place by the thumb of the left hand. Then with another twist each section is disengaged, one at a time, from the pressure of the left thumb and is forced to fall over to the right by a slight twisting of the wrist. This permits a view of the signature mark on each section before it is released by the left thumb and is made to spring up over to

the right. With a very little practice, collating can be rapidly done in this manner.

PULLING AND REMOVING GLUE

After the operation of collating and paging, a book must be "pulled" and the glue must be removed from the backs of the sec-

Fig. 19.

tions. Pulling consists in separating the cover from the text, detaching each section from the one next to it, and removing all plates that are pasted onto the text. First, the book is placed on the

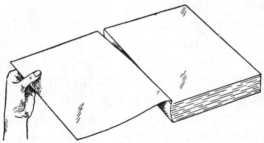

Fig. 20.

workbench, with the two covers turned back to the left (Fig. 19); then, with a sharp utility knife, the text is cut from the cover along the joints (Fig. 20), first on one side and then on the other, thus freeing the cover from the text. This necessitates cutting the cords or tapes which bind the cover to the text and also cutting

any material, like "super" or cloth, that serves to reinforce the end papers at the joints. Care should be used in this operation not to cut the text. The end papers are the blank sheets at the beginning and end of a text, one leaf of which is pasted down on the inside of each cover board.

With the text freed from the covers, the workman first removes any lining or other material from the back of the book and then proceeds to separate the sections one from the other. This may be done in one of two ways. If the book has been cased and not bound, the center of the first section must be found by counting off the pages until the sewing thread is visible along the inside of the fold. With a pair of small curved scissors, the threads are cut. This having been done, the worker removes all glue along the back on top of the section, either with a knife or with his left thumb, and then he runs the forefinger of his left hand up to the top of the section and separates it from the one below. Next, he grasps the section at about the center with his left hand and gently eases it away from the section below, beginning to pull at the head of the book (Fig. 21). The "head" of a book is the part uppermost when it is in a standing position with the title reading properly. The "tail" is the opposite end from the head, and the "fore-edge" is the front edge of the leaves of the book, or that which is opposite to the "spine," or "backbone." The freed section should now have the cut threads removed from the inside, not only because they are unsightly, but because, if left, they would mark the leaves of the book after it is put under pressure. Finally, with a sharp knife, all glue should be cleaned off along the folded edge on both sides of each section. Figure 22 illustrates the manner of holding a knife for this operation which permits lifting the glue off without damage to the paper. The point of the knife is first inserted under the glue and is then flipped up toward the worker with a light, quick motion. The section is now placed face downward on the left of the worker.

Each section is pulled and cleaned in this manner and placed face downward on top of the preceding one, so that when the pulling is finished, the sections will be in proper sequence, with

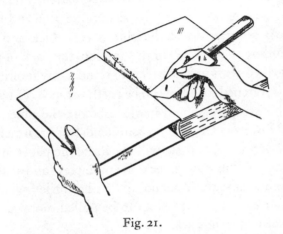

Fig. 21.

the last section uppermost. If there are any plates pasted onto the text, these should be removed and put in their proper places, care being taken that each plate bears a number on its blank side, so

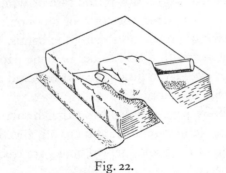

Fig. 22.

that its place may be identified. All the work of removing glue from the sections should be done upon a small slab of plate glass, which has a hard surface but not so hard that it dulls the knife quickly.

Some books have a great amount of glue on their backs and are difficult to clean without tearing. It is often advisable to pound the back of the book lightly with a backing hammer while it is in a position on the bench with the back flattened out after the cover has been removed. This breaks up the glue and facilitates pulling. As a last resort, if the glue is very thick and will not permit pulling the sections in this fashion, the back of the book may be soaked with paste and left to stand a few moments until the glue is softened so that it can be partly scraped off with a dull knife. This scraping should be done before the glue begins to harden. However, I do not recommend this treatment unless positively necessary, as paste will penetrate the paper and soften it so that great damage may be done to the text and will necessitate an undue amount of mending. With a little ingenuity and some practice, almost any book can be pulled more successfully without softening the back.

If the book has been bound, instead of cased, with the sewing thread wrapped around cords or tapes, pulling will differ from the way just described, but only in the manner in which the sections are separated. To do this in the case of wrapped bands, a sharp knife is drawn across the cords or tapes on the back, thus cutting the sewing thread and freeing the bands. Then the sections are separated with a thin folder or bone paper cutter, the threads are removed from inside the sections, and the glue is removed as already described.

When the book pages are held together by wire staples, the free ends of the staples are lifted and cut off, and the staples are then pulled out of the book. Stapled books are frequently made up of single sheets.

SHARPENING A UTILITY KNIFE

Before a binder completes the operation of pulling a book, he will find it necessary to learn how to sharpen his utility knife.

For this purpose, a flat, not too fine carborundum stone is required. All knives used in bookbinding, except some mat-cutting knives, are ground and sharpened on one side only. This is the side which is beveled, and the opposite side must be kept flat. There is a definite distinction between grinding and sharpening, which must be understood. Grinding, which requires some sort of revolving stone, is the operation of putting a rather deep, evenly graduated bevel on a knife, whereas sharpening consists in keeping that bevel unthickened at the cutting edge.

Fig. 23.

To sharpen a knife, its beveled side is placed down on the stone, and the knife is run straight along back and forth with some pressure, the bevel of the knife being kept parallel with the stone (see Fig. 23). The outward pressure should be the heavier. A circular motion should never be used in sharpening a knife, for this produces an uneven bevel which can be avoided only by the parallel position of the bevel to the stone. If the pressure is too great, a burr, or turned-over edge, will be produced on the side of the knife opposite the bevel. This must be removed by drawing the flat side of the knife lightly over the stone. Then the knife edge will have to be "touched up" a bit by sharpening it again, as

the edge will be thickened and dulled after the burr is removed. No oil or water is required on the stone when it is used for sharpening a utility knife, though water should be applied to a stone when the knife is being ground.

KNOCKING OUT JOINTS

The "joint" of a book is formed in "backing" by turning the folded edges of the sections over at right angles to the text so that a groove will be formed on the upper and lower sides of the book. The function of a joint is to hold the cover boards so that they will not slip over the back of the sections. After the book is

Fig. 24.

pulled, this small turned-over edge must be flattened out before the work can be proceeded with. To accomplish this, two or three sections are taken at a time with their folded edges placed evenly on each other and away from the worker, who holds them with the left hand at the fore-edge on the surface of a knocking-down block. Then they are tapped with a few strokes of the backing hammer until the grooves are straightened out. If the grooves fail to yield to this treatment, each section is taken separately, is held in the right hand with folded edge away from the worker, and is grasped at the back right corner. Then it is placed bottom up on the workbench or block, the left thumb is pressed along the folded edge near the right hand, and the right

wrist is twisted so as to bring the back of the section over toward the worker and against the left thumb (see Fig. 24). As the back edge of the section continues to be twisted in this manner against the left thumb and is progressively worked to the left end of the section, the groove will be forced to unbend and become flattened. Any hammer blows on the sections should be made with the face of the hammer hitting squarely, for a glancing blow may cut the paper.

CHAPTER IV

GUARDING, MENDING, AND MOUNTING

GUARDING

IF a book has been skillfully pulled, there should be little mending to do, except in cases of badly worn books. I consider pulling one of the most important operations in bookbinding, for if the text is much injured in this operation, the binder is forced to guard the sections to such an extent that an undue amount of swelling is produced in the back. This causes difficulty in backing the book and makes the book so round that it will not open easily.

It requires some experience to determine just how much mending is advisable. If the sections are thick, they will admit of being mended to a greater extent than when they are thin, for the increased swelling at the back of a book caused by guarding or mending can be more easily compensated for. To avoid an overamount of swelling, it is often preferable to leave the sheets of sections slightly damaged rather than to mend them, but the worker will not be able to exercise judgment in this matter until after he has had experience in sewing and backing a book.

It is a question what is the best practice in dealing with books that have the backs of their sections split down to the "kettle stitch." If short pieces of paper are pasted over the slit sheets at head and tail, the back of the book will be thickened at head and tail beyond the thickness of the rest of the back. If the split ends are left unmended and are held together with glue which is applied when backing, the back will be somewhat stiffened. I am inclined to favor this latter treatment as the lesser of two evils, for if the glue is applied sparingly, most of it can be removed after backing, and after the book is backed, the joint and the "lining-

up" material will prevent the leaves from "starting," or pushing forward, at this point.

GUARDING FOLDED SHEETS

Any sheet really badly damaged along its fold must be guarded. I do not approve of setting in pieces of paper along the fold to mend any holes or tears, for these make lumps in the back. If the back of a sheet must be mended, it is best to paste a guard down its entire length. A guard is a narrow strip of paper used to strengthen or repair the fold of a sheet that is damaged, or to attach a plate or a single leaf to another leaf. It should be of strong, thin paper and of a color similar to the text. It is usually cut about three-eighths of an inch wide and slightly longer than the sheet to be guarded. The best guarding papers are some Japanese tissues and an English paper made by the Whatman Company and known as "bank-note paper." Both of these papers are at the moment unprocurable in America, and some sort of domestic "linen-bond" paper appears to be the best substitute.

ARRANGING SHEETS FOR GUARDING. Before beginning to mend and guard, the sections are examined one by one, and it is determined what guarding is necessary. This is an operation in which system will save much time. An efficient way to organize the work is first to look the book over superficially to determine whether much or little guarding is necessary. If little, then the worker can afford to guard more sections than he otherwise would, and this preliminary survey will assist him in deciding just what sections to put aside for guarding. Then, beginning with the first section, the outside folded sheet is examined. If it is much damaged — and the first and last sections are usually the ones to suffer most in pulling — then it must be guarded. This sheet is abstracted from the rest of the sections and is laid down open on the table with the printing running parallel to the

worker. Its counterpart is laid next to it, with the printing running likewise. If the next section needs no guarding, it is placed in a separate pile. Then the following sections are examined, and the sound sections are placed with those not to be guarded. The sheets of those sections that need guarding are placed in a pile one on top of the other with the printing running alternately perpendicular and parallel to the worker, and their counterparts are placed likewise. This procedure is continued through the book, and when finished, there will be three piles of sheets or sections — first, a pile of sheets to be mended, then a pile of folded sheets which complement these, and lastly a pile of folded sections that need no mending. The sheets in the first two piles are placed with the line of type running alternately one way and then the opposite way because this enables the worker to distinguish each unit quickly and unmistakably. If there are any pasted-on plates, these should be loosened and placed with the sheets to which they are to be guarded. If any sheets are torn completely apart, they are laid down with each half next the other half, in proper position for guarding.

In case there is damage to the corners of pages or if there are parts of a page torn, these page numbers should be jotted down on a list when they are found, and the mending of the pages would best be attended to after the whole book has been guarded and "gathered." It is better to make a second operation of this mending in order to avoid confusion by interrupting the guarding process. There is no operation in binding that demands so much orderly arrangement of the work as that of guarding and mending. If a definite plan is adhered to in arranging the pages and sections of the book necessarily separated for the work, they can be folded and gathered without difficulty and with maximum efficiency. Unless some rigid plan is followed, there will be hopeless confusion in getting the text together in proper se-

quence, and a tremendous amount of needless time will be consumed.

CUTTING GUARDS. Now the worker is ready to cut his guards. To save time in cutting when there is much guarding to be done, a sheet of guarding paper, somewhat longer than the height of the book page, should be folded lengthwise twice to make four sheets. Then the folds on one end of these sheets are left uncut, and on the other end they are cut off. This folded paper is placed on a cutting tin or zinc, and a clean edge along the length of it is cut. The spring dividers (Fig. 25) are set to about three-eighths

Fig. 25.

of an inch, and from the clean-cut edge, this distance is marked off near the top and the bottom of the paper with the dividers, by impressing the point of them into the paper. This width is marked off as many times as is necessary to cut the approximate number of guards needed. If wider guards are needed, the dividers may be set to the width desired, but three-eighths of an inch will be found about the right width for octavo books, unless a page has to be set out by using a wider guard to extend the page from the back so that it is even with the fore-edge. Then, starting at about one-half inch from the folded end of the paper, strips of guards are cut through the four thicknesses of paper on the marks

indicated. The line to be cut should be placed perpendicular to the worker, who should always cut toward him (Fig. 26).

Cutting paper must be done with care. Good guarding paper is well sized, so that a ragged edge is not liable to result from cut-

Fig. 26.

ting, as in the case of soft-finished paper. But in order to cut a clean edge on any paper, certain principles must be observed. In the first place, it is essential to hold the knife so that the cutting motion will be free and deft. The knife should be held as one

Fig. 27.

holds a pencil in writing (Fig. 27), and there should be only the lightest pressure used with the knife. A "straightedge," or metal rule, is placed on the two marks made by the dividers. To do this expeditiously, the point of the knife is placed exactly on the lower mark, and the straightedge is brought up to it from the left. Then with the knife still held in this position, the straight-

edge is revolved against the knife until the straightedge coincides with the top mark. In this way only one mark has to be found with the straightedge, for the knife keeps the straightedge on the other mark. The worker then spreads his left hand out on the straightedge and puts very firm pressure on it, to prevent the paper from slipping (Fig. 28). Then at a distance of about one-half inch from the top folded edge of the paper he lightly runs the point of his knife down along the straightedge several times, if necessary, until the four guards are cut away. This will leave the guards held together at one end after they are all cut, and they may be pulled off one at a time as needed.

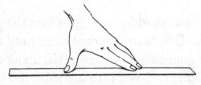

Fig. 28.

Very little pressure should be used with the cutting hand and extremely firm pressure with the holding hand, if a clean edge is to be attained. And one must beware of ruffling the edges especially in cutting soft paper. The best method is to cut lightly several times, rather than heavily once, and if this method in cutting is used, the thinnest blotting paper, delicate silk, and other fragile material can be cut to a perfect edge.

TOOLS FOR GUARDING. Now the necessary tools and materials should be gotten together on the workbench preliminary to pasting and guarding. A piece of plate glass will be needed to work on. One about 10 x 15 inches will be found convenient for octavo books, though a larger glass is required for books of larger format. Several pieces of "unprinted news," cut to about 8 x 12 inches are necessary, and a bowl of well-beaten, smooth paste must be at hand. For ordinary guarding, ready-made commer-

cial brands of paste will be found suitable, though for mending tears a paste made of cornstarch or rice flour will be needed, as ready-made paste contains chemical preservatives and is liable to leave a stain (see "Paste," Chapter XXI).

A small quantity of commercial paste is put in a bowl and is beaten smooth with a paste brush (Fig. 29). Then a sufficient

Fig. 29.

amount of cold water is added slowly to thin the paste to the desired thickness, and the beating is continued until the paste is free from lumps. For guarding, paste should be about the consistency of thick cream. The tendency is to use paste too thick, in which case the brush drags when applying the paste and stretches the work. This causes the paper to be wrinkled after it dries and shrinks.

Fig. 30.

As for the tools necessary for guarding, they are few in number. A well-shaped bone folder (Fig. 30), a paste brush, and a pair of eight-inch shears will be required. The brush must be of generous size. A large brush is necessary to gain speed and efficiency in any pasting work, and very fine work can be accomplished with a large brush in competent hands. Paste dries quickly and must be applied fast enough so that no part of the pasted material will have time to dry before being used. A copper-set round brush made of strong hairs, with bristles measuring about two

and one-half inches long by one and one-quarter inches thick, will be found most efficient for general work.

Holding Paste Brush. At this point, the correct manner of holding a paste brush must be stressed. The brush should be grasped in the fist and not held with the fingers (Fig. 31). The reason for this is that the wrist has a "strap joint" and can be moved in only two directions without changing the position of the arm. If a brush is held in the hand with the fingers, it is dependent upon the wrist for its guidance and can therefore be ma-

Fig. 31.

nipulated only up and down or back and forth. But if it is held in the fist, it can call upon the joint of the shoulder for direction, and this shoulder joint is of the "ball-and-socket" type, which admits of a rotary motion. Thus, by holding it so as to utilize the shoulder joint a brush can be made to operate freely in any direction without change of bodily stance or position of the arm. This holding of a brush applies as well to working with glue as with paste. In fact it is even more important, since glue dries faster than paste, and for large work such as making of portfolios it is imperative to use a sizable brush, grasped in the fist.

It is sometimes difficult to convince a novice that a quicker and better job can generally be accomplished with a large brush held in this manner than with a small brush held by the fingers. But

if one were to watch seasoned bookbinders in the large shops, it would be found that they use large brushes and hold them as I have described. Possibly they have not analyzed the reason for this, but experience has taught them how to work most efficiently.

Where to Guard. It is probably the best practice to guard the outside sheets of a section on the inside of the sheet, and the inside sheets on the outside. Certainly the inside sheets should have their guards put on the outside, for otherwise the needle in sewing, as it comes through from the back of the section, has a tendency to force the guard inward and start it to peel off. Any loose plates should be guarded around the section next them, or if in the middle of a section, they should be guarded down on the opposite page. Any section consisting of only two leaves should be treated like a single sheet and be guarded around the next section, for otherwise the thread is likely to cut through when the book is being sewed.

Pasting. When a worker is ready for pasting, a clean piece of unprinted news is laid on a piece of glass. The top sheet is taken off from the pile to be guarded and is placed on the covered glass with the fold parallel to the worker and with the side to be guarded uppermost. Then all the paste that has been previously thinned down should be confined to one side of the bowl, leaving the other side free from paste so that the brush, when not in use, may be placed in the bowl with the handle resting against the clean side. All the paste is worked out of the brush on the side of the bowl, leaving the brush clean and not "groggy," or befouled with paste. A guard is laid parallel to the worker, on a piece of clean unprinted news. The brush is grasped as previously described, a very sparing amount of paste is taken on the brush from the edge of the bowl, and the guard is pasted. The pasting is begun at the right end of the guard and the brush is worked in

short, light strokes from left to right, progressing toward the left end. The guard is first held near the right end by the fingers of the left hand, which is moved toward the left as the pasting proceeds. Finally, when the pasting comes to within about one-half inch from the left end of the guard, the fingers are removed, and a final light stroke of the brush is given toward the end of the guard to complete the pasting.

PLACING GUARDS. Next, the left forefinger is placed on the left end of the pasted guard, and the guard is lifted from the pasting paper. Then it is grasped with the fingers of both hands and is laid over the fold and placed as evenly as possible. It should be placed without stretching, for otherwise the sheet will curl. Finally, a small piece of unprinted newspaper is laid over the guard and is rubbed down lightly with the folder. Then the sheet is picked up and the guard is cut off even with both ends of the sheet. Both sides of the sheet are rubbed down through the protection paper with the folder until the guard is securely adhered. The sheet is put under the glass with a narrow strip of unprinted news over the freshly pasted guard to prevent it from sticking. All the other sheets are guarded likewise and are put on top of one another under the glass, with narrow strips of clean paper between them. Working in this manner on the glass with the freshly pasted sheets underneath gives continuous pressure on the sheets.

GUARDING TWO SINGLE SHEETS. If two half sheets are to be guarded together, the procedure does not differ from that just outlined except in the matter of placing the guard. The two sheets to be guarded should be placed about an inch apart on the covered glass with their length parallel to the worker and with the sides to be guarded face down. After the guard is pasted, it is lifted and placed between the two sheets, and first one sheet and then the other is brought up to the middle of the guard, leaving

just enough clearance so that the sheets can be folded without interference. Then rubbing down and finishing are proceeded with as for double leaves. All single sheets that are guarded together must be folded and guarded around a folded sheet, for otherwise they will tear when being sewed.

Guarding Half Sheets and Illustrations. When a single leaf or an illustration is to be guarded around a folded sheet, the same method of guarding is used as in guarding two single sheets, that is, placing the illustration or single sheet up to the middle of the pasted guard and then bringing up the folded sheet in place on the other side of the guard. Illustrations are sometimes printed crookedly on the sheet, and they should then be squared before guarding. It is usually better first to trim the head of the illustration sheet so that the margin beyond the print is even, and then square the fore-edge to the head, leaving the trimming of the back edge and tail until last. If the back edge has to be trimmed so that the sheet is much narrower than the text, the sheet can be mounted on a wide guard and set out to align with the fore-edge. If the trimming makes the sheet shorter than the text, the sheet should be guarded around the section with the head even with that of the section and should be left short at the tail. Care must be taken when guarding illustrations printed on "art-mat" paper, for any paste gotten on a sheet will leave a stain.

Squaring Plates. Trimming and squaring illustrations or plates is usually done by hand with a knife, on a tin or zinc. With a pair of dividers, an equal distance is measured and marked off at two points above the line of printing, and with the straight-edge as a guide, the head of the sheet is trimmed through these points. This margin should be left as large as possible, but it must be even with the top line of printing. Then the fore-edge is squared to this edge by means of a carpenter's square (Fig. 42).

Next the back edge of the sheet is squared to the head in the same manner, and lastly the tail is squared either to the back edge or to the fore-edge.

Some discrimination should be used in the trimming and squaring of plates to ensure their centering nicely, and it may be necessary to trim one edge rather generously in order to achieve this end. But much consideration should be given to the matter before altering the printer's margins. Many margins are left by the printer in accordance with the plan prescribed by the typographer, and these margins should not be cut if cutting can possibly be avoided.

GUARDING SINGLE PLATES. When plates are tipped on, they should be freed from the text and should be guarded round the sections next to them. When a text consists of a large number of plates, so much guarding would cause the back to swell to such a degree that difficulty in sewing and backing would result. Hence, some measure must be taken to reduce the swelling produced by a great amount of guarding. It is usual in such instance to pare the back of each plate from the line on which the guard is to be pasted, so that when the guard is added, the thickness will be the same along this edge as it is throughout the whole sheet. The guards for plates should be wide enough to be folded around the next sheet or section, and they need not be pasted to the section, but may be left loose, in which case they are folded around the sheet or section and are sewed through. When a plate comes in the middle of a section, it is best to paste it down onto the opposite sheet to avoid difficulty in sewing.

The guarding may be proceeded with as for half sheets, or when there are a number of plates to be guarded, the plates may be pasted instead of the guards, and several may be pasted in one operation. This saves considerable time but requires the ability to work quickly lest the paste be dried before the guard is ap-

plied. When this method is followed, a number of plates are placed on a clean pasting paper, with the back edge of each plate drawn back about one-eighth of an inch from the edge of the plate beneath it. The top plate is covered with a piece of un-printed news folded on the bias and is placed about one-eighth of an inch from the edge of the plate. A bias-folded paper will hug the paper beneath it and obviate the danger of having paste get under it (Fig. 32). Now the exposed edges of the plates are pasted from the top of the pile toward the bottom to avoid letting the paste penetrate beyond the one-eighth-inch line. After the plate is pasted it is laid up to the middle of the guard and is

Fig. 32.

rubbed down thoroughly. The work is then proceeded with as for guarding half sheets.

When plates are thick, they must be hinged, or they will not lie flat as the book is opened. To hinge a plate, a strip is cut off the back edge about one-quarter or three-eighths of an inch wide, depending on the size of the book and the thickness of the plate. Then the newly cut edge of the plate is pared slightly (see "Paper Paring") to a width of about one-eighth of an inch. The cutoff strip is pared likewise, or a thinner piece of paper is used in its stead. A piece of fine muslin or cambric is cut a little longer than the length of the plate and wide enough to reach from the pared edge of the plate over the cut strip and extend around the

next section for about one-quarter of an inch if it be guarded to it, or three-eighths of an inch or more if it is to be left free. This strip of muslin is pasted, the pared edge of the plate is laid on it, and the pared strip is laid next to the plate, leaving a small space between the strip and the plate so as to form a hinge. The linen guard is rubbed down, and the plate is kept under pressure until dry. The guard may simply be left free and folded around the section to which the plate belongs, or it may be pasted around the section.

GUARDING DOUBLE PLATES. When books are made up entirely of plates, all the leaves are cut as described above, and they must be guarded one to the other and made up into sections, each leaf being hinged along the back edge. It must first be determined whether to make up the sections into "fours" or "sixes," for rarely should they be made into a greater number of sheets to a section if the plates are at all thick. Then the back of each plate is carefully numbered so there can be no mistake about making up the text in proper sequence. After pulling the book, if the format is to be "sixes," that is, six single sheets or twelve pages to a section, six sheets at a time are counted off and are placed in correct order on the workbench. This counting off of six sheets at a time is continued, and each group of six sheets is placed at right angles to the previously counted sheets, one group over another, until the pages are all counted off and are separated. If there should be only two pages left at the end, these are included with the previous section.

Now the binder proceeds to cut off the strips at the back of each plate, section by section; and after the necessary paring, the pages are laid out in the order in which they are to be guarded. That is, for the first section, pages 2, 4, and 6 will lie opposite pages 11, 9, and 7, respectively, and these pages, when guarded, will form this section. Then at right angles across this first sec-

tion, pages 14, 16, and 18 are placed opposite to pages 19, 21, and 23, respectively, and the second section is complete. Sections are cut and grouped in this way throughout the book.

When the whole text is thus arranged, the operation of guarding is begun. Page 2 is guarded to page 11, page 4 to page 9, and page 6 to page 7, thus completing the guarding of the first section. The other sections are guarded likewise. The sheets are guarded as described, with a strip of muslin reaching from the

Fig. 33.

back edge of the first page over the cutoff piece, then over the second cutoff piece and onto the back edge of the complementary page. A small space is left between the cut strips and the edges of the adjoining sheets, and between the cut strips themselves, so that a fold can be made between them (Fig. 33). After the sheets are guarded, they should be well pressed in order to prevent too much swelling along the back of the book. If the book is large and the plates are on very heavy paper, it is better to paste a muslin guard over both sides of the plates.

This work takes much time, though if a definite system is adhered to while working, considerable speed can be attained in making up a book of plates after this fashion. It is the only way to bind this type of book so that the pages of plates will lie flat when open. A far quicker job can be done by making up the sections by

"whipstitching," or overcasting, the plates together at the back, but the pages of a book bound in this manner stand up stiffly when opened, and the book is rendered almost useless.

GUARDING MAPS OR FOLDED INSERTS

Folded maps or folded sheets containing any reference matter should be mounted on linen or fine strong muslin and "thrown out," or guarded so that they may be opened clear of the book (Fig. 34). It is usual to place such sheets at the end of the text since they may then be unfolded and referred to easily while the book is being read.

Fig. 34.

The mounting material should be cut somewhat larger than the map or sheet to be mounted, with a generous extra piece allowed for attaching the guard at the edge nearest the book. Then it must be seen that the back edge of the folded sheet has an even margin and a straight edge, and if necessary, the other edges should be trimmed and squared.

Now the mounting material is laid on a large drawing board and is pinned down taut with thumbtacks. The sheet is unfolded, and the back of it is pasted evenly with thin paste. Then immediately the pasted sheet is "skinned" by placing over it a piece of unprinted newspaper large enough to cover the sheet. This

paper is let to rest lightly in place for a bare second and is then pulled off. This will equalize the paste and prevent any brush marks from showing through the mounting material.

The pasted sheet is then placed on the mounting material and, with a large piece of unprinted "news" over it, is rubbed down thoroughly with a folder. The newspaper is changed if it appears damp. The mounted sheet is left to dry with a weight over it before handling. When dry, the mounting material projecting over the edges of the sheet should be trimmed even with the sheet on all sides except that next the back of the book. At this side the material should be left long enough so that a guard may be

Fig. 35.

pasted along its edge. The sheet may then be folded to a size somewhat smaller than the text.

A guard of strong paper is cut the width of the back, plus about one-half inch, and it is cut the length of the mounted sheet. This guard is then pasted onto the mounting material projecting over the inside edge of the folded sheet, and at the back a piece is folded over. Into this folded piece are placed folded guards, sufficient in number to make the back as thick as the folded sheet (Fig. 35). If there were not the same thickness at the back of the section as that of the folded sheet, the book would spring open at the fore-edge.

If a folded sheet is printed on very heavy paper, the sheet has to

be cut up into as many pieces are there are folds. These separate pieces are then mounted on linen in their respective positions, small spaces being left between the cut pieces so that they will fold over easily.

MENDING

MENDING A TORN PAGE. When a page is torn, it will usually be found that on each side of the tear the edges of the paper are not cleanly cut, but are slightly beveled and have an uneven, furry contour, produced by the torn fibers of the paper. Though this bevel may not be easily discernible, it is likely to be there and should be utilized in the following manner when the tear is being mended. With a very small brush, white paste made of cornstarch or rice flour is carefully and thoroughly applied to each side of the lip of the tear. Then with the edges of the tear brought close together, the sheet is placed down on a slab of plate glass, over a small piece of the thinnest transparent Japanese tissue large enough to cover the tear. On top of the tear, another piece of tissue is placed. The tear is covered with a clean piece of "rubbing down" paper, such as unprinted news, and it is gently rubbed with a folder. This will fix the beveled lips in place and will press the fine fibers of the tissue into the tear. Then the mended page is placed under the plate glass or a board, with a light weight on it, and is left until it is thoroughly dry.

The edges of the tissue will be loose, and when the paste has dried, the tissue may be torn off. If the operation has been carefully done, the tissue will tear off cleanly, leaving only a few fibers in the tear, which serve to reinforce the mending and hold the edges of the tear firmly. Should any of the tissue stick beyond the line of the tear, it can be removed by lightly scraping with a knife which has a slightly burred edge and then rubbing down gently with a piece of very fine emery paper. In this way, most tears can be mended without showing, unless they are in-

spected minutely. Commercial paste must not be used for this work, for it will stain and produce an unsightly job.

If the tear to be mended is on thick paper of poor quality, it may be necessary to pare the edges slightly and "set on" a pared piece of mending paper (see "Paper Paring"). This is to be avoided if possible, for the repairing is bound to be noticeable, and the former method should be tried first.

MENDING A MISSING CORNER. When a piece is torn away from a corner completely, another one must be "set in." All binders save pieces of old paper and paper of peculiar color and texture. From the stock on hand, a piece is selected that matches as nearly as possible, in both color and texture, that of the paper to be mended. If the right color cannot be found, a piece of paper can be stained or toned to match the text.

The torn page is placed on the mending paper selected, care being taken that the "wire marks," if any, correspond with those of the page to be mended. Then the torn edge is outlined on the mending paper by drawing a line along it with either a bone point or a pointed finishing folder. The mending paper is cut off about one-eighth of an inch beyond the indented outline of the tear and is left projecting beyond the corner of the page on the opposite side. The edge of the mending paper is now pared carefully up to the indented line, and likewise the edge of the tear is pared about one-eighth of an inch back all along, so that when the two edges are placed together they will not be thicker than the sheet of the text. Both pared edges should then be carefully pasted with white paste and be put together and rubbed down between two pieces of unprinted news. The projecting mending paper may now be squared to the corner. If it is necessary to reduce the thickness of the beveled edges this may be done after they are dry in the manner suggested for thinning the edges of a mended tear.

In all paper mending, meticulous care must be taken not to soil the work. Even the touch of a finger, which has a certain amount of oil on it natural to all human skin, may cause a grayish tone along the mend, and a particle of dust of any sort will cause the work to look soiled. So if a clean job is to be expected, the fingers should not be allowed to touch the work along the pasted edges, and the workbench and tools should be kept spotlessly clean and free from dust while working.

MOUNTING A PAGE

Not infrequently, when old books are to be rebound, very badly damaged pages will be found, and these cannot be made strong unless they are mounted between some thin material. Either a Japanese tissue or chiffon may be used for this purpose. The chiffon is preferable, as it is more transparent. Pasting any material on only one side of a sheet of paper causes it to curl, and therefore a sheet to be strengthened by applying chiffon or Japanese tissue to its surface must be covered with the material on both sides. The page must, of course, be separated from the text in order to mount it.

When the paste is beaten to the desired consistency, a thin coating of it is spread over a glass slab, which must be larger than the page to be mounted. Then on the pasted glass is laid a piece of chiffon that has been cut to a size about one inch larger all round than the size of the page. After another coat of paste is spread over the upper surface of the chiffon and is smoothed out with the paste brush until the chiffon is quite flat, the page is laid on the pasted chiffon. Next, the surface of the page is pasted, over it a second piece of chiffon is laid and again the paste is smoothed out until the chiffon lies flat over the surface of the page. Then the three layers of material must be stripped off the glass in one piece. This is a rather difficult procedure and necessitates some

practice, but with a little ingenuity it can be accomplished if the worker is determined and does not allow himself to get flustered. The three pasted layers will be sticky and moist and will require care in handling. They must now be hung over a clothesline or over a spreading clothesbar with wooden arms. The mounted page must be left until partly dry, when it should be taken down, placed between waxed boards, and put in a press for a half hour or so. Then the boards are removed from the press and the page is peeled from them. It is placed between freshly waxed boards and left under some pressure until it is thoroughly dry. Frequently it is advisable to change the waxed boards and increase the pressure while the page is drying. When the work is entirely dry, the projecting edges of the chiffon are cut off even with the line of the page, and after this is done, a sparing amount of paste should be run along the edges of the page with the finger to seal the chiffon with the page and prevent any fraying. The page should then be put between waxed boards and kept in the press for at least twenty-four hours.

The procedure when using Japanese tissue is practically the same as for chiffon, except that the mounted page is not put between waxed boards but is hung up at once to dry. The page should be pressed as when using chiffon, and it will make a smoother job if the final pressing is done between heated metal pressing plates.

INLAYING A PLATE

When an illustration or plate has to be incorporated with a text, if the plate is smaller than the pages of the text, it must be inlaid on a sheet the size of the text. To inlay a plate, a piece of paper of about the same thickness should be found. Then the plate must be squared and placed in position on the paper. It should be placed with fore-edge and tail margins wider than head and back margins, or, in technical language, it should be

"top centered." When the plate is in proper position, the four corners should be marked with an impression made by a folder. Then, about one-eighth of an inch within the corners of these marks, four points are made opposite the four corners, and the paper is cut out on the four lines which join the four inner points (Fig. 36). Thus there will be a cutout space one-eighth of an inch smaller all round than the plate to be mounted.

Fig. 36.

The upper edge of the mounting sheet and the under edge of the plate should then be pared in the same way as has been out-lined for paring an inlaid cornerpiece. Both the pared edges of the plate and those of the sheet should now be pasted with rice-flour or cornstarch paste. The sheet is laid on a glass covered with unprinted news and the plate put in place with its four corners coinciding with the corners marked by the folder. Another piece of unprinted news is placed under and over it, and it is rubbed down gently with a folder. The plate is turned over, a fresh piece of unprinted news is put under and over it, and it is rubbed down again. The unprinted news is frequently changed and the plate is rubbed down with increasing pressure until it is securely fastened in place. Then, after drying thoroughly under light pressure, the mounted plate is put between tins covered with unprinted news

and given a thorough pressing in the standing press. The same precautions must be taken to keep the work clean when mounting a plate as when mending paper. If the paring has not been done perfectly and there is an undue thickness left around the edges of the plate, the edges may be scraped with a burr-edged knife and finished as suggested for finishing inset corners. This should, of course, be done before the plate is pressed.

Rarely is a binder called upon to wash, tone, or size the pages of a book. Only when rebinding very old books of great value is it advisable to spend time on such work. For this reason I will not now interrupt the sequence of the usual processes of binding by a consideration of this special work but will take the matter up in a later chapter, though this work must be done before the operation next described.

CHAPTER V

FOLDING AND GATHERING

FOLDING MENDED SHEETS

AFTER the sheets of a book have been guarded and mended and have been left to dry, they should be folded. First, a sheet of clean binder's board is laid on the workbench to work on. To fold a single sheet, it is placed on the covered workbench with the inside page numbers uppermost, and is held with the left hand. Then, with a folder grasped in the right hand, the right side of the sheet is brought over onto the left side, and the page number and first line of print of the right side are placed directly over the page number and first line of the opposite side (Fig. 37). The sheet is held in this position with the left hand, and the folder is run from about the middle of the sheet upward away from the worker, creasing a fold sharply (Fig. 38), and then it is run downward toward the worker to finish the creasing of the fold. This completes the folding, and the sheet should be placed on the bench at the left with the last page number uppermost, that is, with the fold to the right. All the sheets are folded after this manner, and each sheet, when folded, is placed on top of the preceding one.

GATHERING

Gathering consists in collecting from piles all the folded sheets of a book, putting them in place in their respective sections, and then gathering the sections together so that they will follow one after another in correct sequence. If directions for guarding and folding were carefully followed as described under "Arranging Sheets for Guarding" in the previous chapter, there should now be three piles of sheets: one pile consisting of the guarded and folded sheets; a second pile composed of the counterparts of

Pile 1; and a third pile made up of the complete sections that needed no guarding or mending. The folded sheets of Pile 1 will be the other part of the incomplete sections of Pile 2, and since the sheets in Piles 2 and 3 were placed with their first pages down-

Fig. 37.

ward, these two piles must be turned over, so that the page numbers will follow in sequence from the first to the last.

Complete sections are formed from Piles 1 and 2 by inserting each part into its counterpart. As each section is completed, it is placed on the bench with the first page downward and is piled on top of the last completed section. When finished, the pile is

Fig. 38.

turned over so that the first collected section will be uppermost. There will then be two piles of completed sections. From these two piles one section is added to another in sequence until all the sections are gathered to form the complete text.

Although at first glance this process may appear complicated, it is actually very simple, and this system makes for the least con-

fusion and the greatest speed in gathering. Amateur binders are prone to "lose" a page when taking a book through the mending and folding processes, and they often spend an endless amount of time searching for it. But invariably it will be found not lost, but misplaced in the text by guarding or folding wrongly. So it is of great importance to use care in guarding and folding sheets in proper order and then to have a cut-and-dried system for keeping all the sheets and sections in such order that the final gathering may be accomplished automatically and without loss of time.

FOLDING BOOKS IN SHEETS

Books usually come from the printer or publisher to the hand binder already folded and gathered. When books come to the binder in sheets unfolded, it is necessary to fold and to gather them, that is, place them in their respective order according to the page numbers or signature letters or numbers. Some books lack signatures (letters or numbers at the foot of the first page of each sheet or section), and then the page numbers must be followed in gathering the sections.

Plates and maps are in their proper places when books are received folded and gathered, but when the text reaches the binder in sheets, they are in separate piles like the sections of the text.

The binder proceeds to fold the individual text, taking one signature or sheet after another from the various piles. He begins with the last signature and continues until he has folded one each of all the signatures up to the first, placing each one on top of the other. When he has completed the folding of one sheet in each pile, he has completed a single text. He then places any plates in their proper places in the text, after referring to a printer's list supplied by the publishers.

Folding requires much care, for unless the printer's sheets are carefully folded so that the line of print of each page coincides with the printed line of every other page, the register will not be

"in truth" and the margins of the text will not be uniform. The typographer will then have cause for complaint. (When the line of print of the recto corresponds to the line of the print on the verso, the page is said to be "in register.")

Books are issued in various formats, termed folio, quarto, octavo, duodecimo, 12mo, etc. (see "Format," Chapter VI, Vol. I).

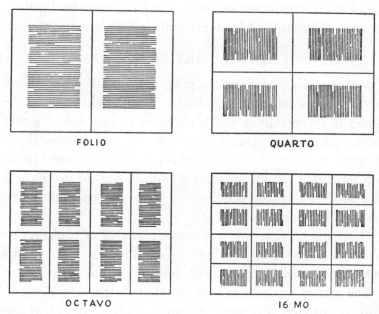

FOLIO　QUARTO

OCTAVO　16 MO

Fig. 39.

To the binder these formats indicate the number of times a printer's sheet, or book section, has to be folded. A folio sheet is folded once, a quarto twice, an octavo three times, and a 16mo four times. A 12mo is a combination of an octavo and an extra quarto folding which is cut off and inserted. All books are printed on both sides of a large sheet of paper, each sheet representing a section (see Fig. 39 for an illustration of the page divisions of formats referred to above).

Both the inner and outer sides of an octavo sheet are shown in Fig. 40 with signature letter and page numbers indicated. As an example of the procedure in folding, I shall describe how Sheet

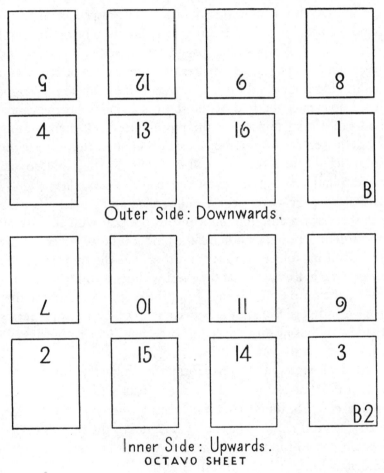

Fig. 40.

B should be folded. Section B or 2 is always the first section of the text proper, as the section containing the title and other matter constitutes Section A or 1. Before beginning to fold, the operator

places the first page of the section with the signature number or letter at the bottom face downward on the table and to the left. He then holds the left side of the sheet a little up from the table, with his left thumb and forefinger placed at about the center of the sheet. With a folder or folding stick, grasped in his right hand, he uses his right forefinger and thumb to bring the right side of the sheet over so that page 6 falls exactly on page 7, and page 3 falls on page 2. He secures the sheet in this position with his left forefinger and thumb, and with the folder in his right hand he creases the fold of the sheet, starting from the center and proceeding upward to the top of the sheet, then coming from the center down to the bottom of the sheet to complete the fold. Next he turns the sheet halfway around to the right, so that pages 4 and 5 are at the top, and he then raises the sheet slightly and places page 5 over page 4 and page 12 over page 13. Letting the sheet down and holding it in this position with the thumb and forefinger of the left hand, the binder proceeds to crease the fold with his folder as before and then cuts the fold up a little more than halfway, so that the sheet will not wrinkle when it is folded the third time. He then turns the sheet to the right so that page 9 and page 8 are at the bottom, places 8 over 9, and creases the last fold as he creased the previous one. This completes the folding of the section.

All book sheets, of whatever format, are folded in this manner, except those of a 12mo or duodecimo, format (see Fig. 41). On this sheet will be found a mark indicating where the line of pages 10, 15, 14, and 11 are to be cut off. The rest of the sheet is folded like an octavo format, and the part which has been cut off is folded and inserted into the center of the octavo part.

When there are plates to be inserted, it is often necessary to trim them to size. Sometimes there is a guide mark for trimming plates, but when none exists, the plates should be trimmed so that they have as nearly as possible the same respective margins as the

text of the book, and they should be put in their proper places when the text is gathered. When plates are not numbered, the printer's instructions will supply information as to where they are to be placed.

The first section, which contains the half-title and full-title pages, and usually some other matter, does not always follow the make-up of the rest of the sections, and then it has to be folded

12 MO

Fig. 41.

differently. Most of the pages are numbered with Roman numerals, except the half-title and full-title pages, and the proper folding is obvious, though care must be taken to see that the half title precedes the full title.

CANCELING PAGES

It sometimes happens that when books are delivered in sheets direct from the printer or publisher there are some pages that are incorrectly printed and that must be cut out and substituted with correct pages, or "cancels." Usually pages to be cut out, or "canceled," are indicated by an asterisk, and correct pages are supplied by the printer. It is best to make this substitution after the sheet has been folded. Before cutting out the incorrect page, the new page is tipped onto the incorrect page and is set well up at the back after it has been pasted along its back edge for a depth of about one-eighth of an inch. It is rubbed in place and left to

dry thoroughly. When dry, the page is turned upside down, the new page is let to fall to the right, and then the old page is creased sharply along the one-eighth inch line of the newly tipped-in page. With the section in this position, the old page is torn off against itself with the right hand. The leaf should tear easily along the creased edge, but if it tears with difficulty, a thin canceling tin is put along the line and the page is torn off against the tin.

CHAPTER VI

END PAPERS

Simple folded end papers. Tipping on colored end papers.
Lining down end papers. Accordion-pleated end papers.
Leather hinges with end papers

END papers are the blank sheets preceding and following the text of a book. They serve the double purpose of protecting the first and last sheets of the text and of forming a finish to the inside of the covers, on which one of them is pasted down at both front and back of the book.

In exceptionally well-planned de luxe books, two or three blank sheets often form a part of the first and last sections. In this case these sheets may be used as end papers, and since they constitute a part of the folded sections, they will be sewed with the book. If these blank sheets do not exist, a section should be made up for both the front and back of the book to serve as end papers. Each section should be composed of at least two folded sheets, with the grain of the paper running parallel to the fold of the sheet, for otherwise the sheet will be folded against the grain of the paper and will impede the free opening of the book (see "Paper," Chapter XXI). All end-paper sections should be sewed with the book, and under no circumstance is it good practice to "tip on" to the half- or full-title page a sheet to be used as an end paper.

There are only two types of end-paper construction used in hand bookbinding that can be recommended as sound. One, which is that in general use, is composed of sheets of paper with a simple fold down the middle. The other, an ingenious invention of Mr. Douglas Cockerell, has one sheet folded in the form of an accordion pleat.

There is always a strain on the first and last sections of a book

when the covers are opened and bent back. To reinforce these sections, some binders overcast them, but this prevents the free opening of the pages of the book and fails to keep the strain from the end papers. Another method for overcoming this difficulty is to fold a piece of linen cloth around the end-paper section and sew it with the section. The cloth is cut wide enough to project about one-half inch over the upper side of the end-paper section and about one-quarter inch over the underside. The piece on the upper side is pasted down with the end papers. This method is similar to the practice of the mediæval binders, who used strips of vellum for this purpose. But while the end papers are effectively strengthened at the joint in this way, it is a clumsy method at best. A far more effective and neater method of preventing end papers from breaking away from the covers is to make them up with an accordion pleat, which functions as a hinge and relieves all strain at the "joint" of the book when the paper is pasted down onto the inside cover. This type of end paper is especially recommended for large and heavy books, though it is equally suitable for very small books.

I will first describe the making of the simple folded end papers and then the more complicated accordion-pleated ones, indicating the various ways of constructing them with colored or marbled paper.

SIMPLE FOLDED END PAPERS

With All White Sheets. To make a pair of simple folded end papers of all white sheets, four sheets are cut out of handmade white paper (with the grain running up and down the paper and not across it) to a size which, when folded, will be slightly larger than a page of the text. These sheets are folded down the middle and are made up into two sections by inserting one folded sheet into another. Then two pieces of ordinary wrapping paper are cut to the same size and are folded, and one is

"tipped on" to each section with the folds placed so that they align evenly. This forms a "protection sheet," and because it must later be pulled off, it should not be too firmly pasted onto the white end paper. It is best to put just a daub of paste in about three spots on the underside of the protection sheet before putting it in place. It can then later be removed without injury to the surface of the white end paper. As soon as the protection sheets are tipped on, the two end papers should be kept under a board or glass with a light weight until the sheets are securely affixed.

The end papers are first squared at the head, either in the cutting machine, if there is one, or on the workbench. A carpenter's

Fig. 42.

square is used for this purpose, and the end paper is cut with a tin under it (Fig. 42). Next, the end papers are cut the exact length of the book sections with a knife and a square or with the cutting machine. Then the width of the text is measured and the fore-edges are squared to this measure. This completes the making of the simple folded end-paper sections, each composed of two folded plain white sheets. For measuring the width and length of the book sections, a pair of wing dividers, set to size, will be found convenient (Fig. 43).

WITH WHITE AND COLORED SHEETS. The first, or outside, sheet of an end-paper section is the one which is pasted down onto the inside of the book cover board. This may be of plain

white paper, toned or marbled paper, figured block paper, or of silk.

Plain-toned end papers may simply be tipped on without being lined down, because both sides of the sheet are clean and not disfigured by the process of marbling or printing. When block papers or marbled papers are undamaged on the wrong side, they too may be folded and tipped on. But when the underside of this type of paper is stained or unsightly, it must be lined down onto the first white end paper. Lining down always makes a

Fig. 43.

paper stiff, with a tendency to curl, though a colored end paper tipped on along the fold of a white sheet is not as strong as one lined down. It is not advisable to tip on end papers used in large books.

To make up a pair of end-paper sections with plain colored papers, cut out four sheets of white paper as for end papers made of all white sheets; two colored papers of the same size; and two protection sheets. Fold the white sheets and insert them within each other according to directions for making up sections of all white paper. Add to each of these sections a folded colored paper by "tipping it all along," as described later in this chapter under

"Tipping on Colored Ends." Then add the protection sheets and trim to size.

End-paper sections with lined-down colored or marbled paper are made up in the same manner as those with unlined paper. Under "Lining Down Half or Whole Colored End Papers" directions are given for the lining-down process. If only half the sheet is to be lined down, the colored paper is folded with the right side inward, and then half of it is pasted onto the upper white sheet of the section. When dry, it is put in place, the protection sheet is added, and the end-paper section is squared and cut to size. If a whole sheet is to be lined down, the construction is less strong, as the sheet is usually tipped on along the fold of the upper white end paper after it has been lined down (see "Tipping on Colored Ends"). When both the colored paper and the lining paper are very thin, the paper may be lined down onto the white sheet instead of being tipped on, but this will result in a very much curled end paper. To both these end papers are added protection sheets, and the end-paper section is squared and cut to size after being assembled.

WITH LEATHER HINGE. Leather hinges may be used with simple folded end papers in two different ways. They may be sewed in with the end paper while the book is being sewed, or pasted down on top of the end paper after the book has been covered. The former method is preferable, and when it is employed, the leather must be pared and made a part of the end-paper section. The paring of leather hinges and the manner in which they are pasted down are described under "Paring," p. 204, and we are now concerned only with how to incorporate them into an end-paper section. When they are used in this way, it is customary to have the end papers made up with a single colored or marbled sheet, as outlined under "End Papers with White and Colored Sheets," p. 69. Before the protection sheets are

added, the pared leather hinge is tipped along the under, or white, side of the sheet, on top of which the colored paper has been lined.

After its thinner edge is trimmed off to a straight line, each pared leather hinge is cut the length of the untrimmed folded

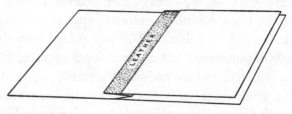

Fig. 44 A.

sheets on which it is to be pasted. The width to which it is trimmed is the distance of the depth of the joint of the book, plus one-quarter of an inch. This hinge is to be tipped along the fold of the underside of the white sheet on the top of which the colored sheet has been lined down. A pair of spring dividers is set to a quarter inch opening, and two dots are made near each

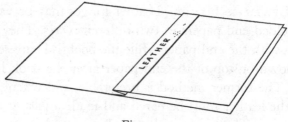

Fig. 44 B.

end of the white paper to indicate this distance. The dots are made with a point of the dividers next to the fold of the paper. Then a folded piece of wastepaper is laid over the sheet just up to the two dots, and the exposed quarter of an inch is pasted along the fold of the sheet. The wastepaper is removed, and the cut thin edge of the leather, with its grained side down, is laid up to the

edge of the pasted line. The leather will then extend beyond the fold, as shown in Fig. 44 A. It is rubbed in place, and the sheet is put under a weight to dry. When dry, the unpasted part of the leather is folded around the sheet. It will then lie with its right side downward on the colored lined-down sheet of the end paper (Fig. 44 B). A piece of wrapping paper is folded around this sheet to serve as a protection paper, and the extra folded white sheet is inserted into the sheet on which the leather hinge is attached. The assembled end paper is then squared and cut to size as previously outlined. Since one edge of the leather is pasted around the back of the section, the hinge will be sewed through and held securely.

When the leather hinges are to be pasted on top of the end papers and are not sewed through with the section, they are not put in place until after the book is covered. This method will be discussed under "Pasting Back End Papers and Leather Hinges" in a later chapter.

TIPPING ON COLORED ENDS

To tip on toned or figured folded sheets, the colored folded sheets are laid on a piece of clean unprinted news, one over the other, with the folds away from the worker. The top fold is placed about three-sixteenths of an inch back of the underfold. Then the top folded paper is covered with a piece of printed news folded on the bias, and its folded edge is placed about three-sixteenths of an inch back of the folded edge of the top paper, so that the paste will not be spread beyond this line. Now the two exposed folded edges of the colored sheets are pasted. The two white end-paper sections, with folded edges placed away from the worker, must be ready on the bench, and the pasted edge of each colored sheet is placed down on the top sheet of each white paper section, with care taken that the two folded edges are in exact alignment. With a clean paper over the sheets, they are

rubbed down along the back with a folder and are then placed under a glass slab or board and left to dry. The protection sheets are then added, and the end-paper section is cut to size.

LINING DOWN END PAPERS

HALF-COLORED END PAPERS. If the quality of the paper used for colored end papers is strong, only that half of it which comes next to the text need be lined down. First the colored end papers are cut a little larger than the white end papers and are folded with the right side inward. Then a bowl of commercial paste is prepared by thinning it down to the consistency of thin cream, as described in Chapter IV. Two pressing boards of a size sufficiently large to cover the folded sheets are got ready, and two covered tins to fit the boards are chosen. The standing press should be open and ready for use. Then one folded colored sheet is placed on a piece of clean unprinted news, with the fold away from the worker. A piece of newspaper is slipped between the folds of the sheet. The newspaper should be large enough to cover the underpart of the sheet and should be placed well up into the fold. Now the exposed part of the folded sheet is pasted with light, quick strokes with care to overlap each successive stroke; and care must also be taken to see that the paste penetrates the grain of the paper. It is best to work from right to left in pasting, and to paste from the folded edge toward the cut edge, after first giving one stroke along the folded edge. This prevents the paper from stretching unevenly. Pasting in more than one direction raises havoc with a job, as it causes the paper to stretch in pockets instead of evenly. In pasting a paper thoroughly, a residue of paste is sometimes left when the paper has a pronounced grain; then the pasted sheet is "skinned." To skin paste off a sheet, a piece of printed news is laid over the sheet, rubbed very lightly, and pulled off almost instantly. The paste on the sheet will then be even and not too thick.

Next the pasted colored sheet is placed on the top white end paper, great care being taken to see that the two folded edges coincide exactly. Then the colored sheet is rubbed down quickly with the hand. The folds of both white and colored sheets are opened, the part that has been pasted is put in the press between boards and two covered tins, and the press is wrung down sharply. After a few minutes the newly pasted sheet is removed from the press and is left on a table to dry without any weight until it begins to curl slightly. Then it is put in the press again between freshly covered tins, with fairly heavy pressure, and is let stay there for about half an hour. Again it is removed from the press and is put on a table to dry until it begins to curl considerably, when it is finally put in the press between freshly covered tins and left for at least twenty-four hours. When the end paper is dry, both the white and colored sheets are folded back in place, and the end paper should be made up as outlined under the last paragraph of instructions for making end papers ("With White and Colored Sheets"). As I have already suggested, a lined-down end paper is bound to curl, and there is no way of preventing this curling entirely, though the tendency to curl can be discouraged if the paper is allowed to "season" under pressure for some time.

It requires considerable experience to handle papers that are pasted. Many of them curl as soon as they have received a coat of paste, and a binder must use his fingers deftly in order to prevent the edges of the paper from curling so far over as to touch and soil the sheet. The trick of getting a pasted paper in place without soiling it necessitates learning to spread the fingers in such a manner over the surface of the paper as to prevent the rolling edges from touching the upper surface. This calls for calm nerves, some practice, and a good deal of assurance.

FOLDED COLORED END PAPERS. When end papers are made with an entire colored end sheet lined down, three full white

sheets are required for each end-paper section. The whole colored paper is pasted onto a full white sheet, and the same procedure is used as that for lining down a half sheet, except that neither the colored nor the white paper should be folded before pasting. After the two sheets have been pasted together and have been left in the press to dry, they are folded with the colored side inward. Then this sheet should be tipped onto a folded white sheet all along the back edge, as described under "Tipping on Colored Ends." The remaining white sheet is then folded and inserted into the first one on which the colored end is tipped because a single folded sheet would be split through in the sewing. Finally, a protection sheet is added, and the end papers are cut to size.

Silk, vellum, and leather flyleaves, as well as pasted-in leather joints, will be discussed in a later chapter.

ACCORDION-PLEATED END PAPERS

With All White Sheets. To make a pair of end papers of all white sheets with an accordion, or "concertina," fold, four sheets of a good quality handmade white paper are cut out to a size, which, when folded, will be about one-half inch larger all round than the page size of the text, and care must be taken that the "chain marks" run with the fold of the paper. Two more sheets of the same kind of paper are cut, with about one-half inch added to their width. All six sheets are folded down the middle and creased sharply. Then, with the spring dividers, two points are marked about three-sixteenths of an inch from the fold on the two larger folded sheets. Two of the smaller folded sheets are laid one over the other and are pasted along the folded edges, about three-sixteenths of an inch in from the folds, as described under "Tipping on Colored Ends." Each of these pasted edges is placed on each of the two larger folded papers up to the marked dots, as in Fig. 45 A. They are rubbed down and are put aside to dry under a light weight. When the end papers are dry, the larger

folded paper A1 is folded back over the smaller folded paper B1, and A2 is folded back over B2. Then between A2 and B2 one of the remaining small folded papers is inserted at Fold C (see Fig. 45 B). This completes the end-paper section. A1 represents the protection sheet, which is later torn off, B1 is the paper that is pasted back onto the cover board, and the end-paper section is sewed through the folded sheet at Fold C.

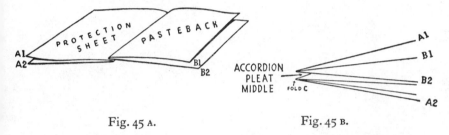

Fig. 45 A. Fig. 45 B.

WITH WHITE AND UNLINED COLORED SHEETS. Plain-toned papers and marbled or block papers, if perfectly clean on the wrong side, need not be lined down but may be folded and tipped. To make up a pair of end papers with folded tipped-on colored sheets, four sheets of white paper are cut out as for end papers with all white sheets, and two colored papers the size of the smaller two sheets are also cut out. All these sheets are folded down the middle. Along the back fold of the larger white sheets, the colored folded sheets are tipped on up to a line indicated by divider marks, as explained for tipping on the folded white papers in end papers with all white sheets (Fig. 45 A). The A1 is folded over onto B1, A2 over B2, and the smaller folded white sheet is inserted into Fold C (Fig. 45 B). When finished, the end papers are squared to size. They are sewed at Fold C.

WITH LINED-DOWN COLORED SHEETS. When lined-down colored sheets are to be used, the end-paper sections are made up in the same way as for unlined sheets. After being lined down,

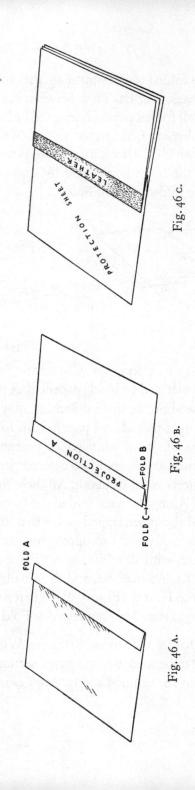

PROTECTION SHEET

LEATHER

Fig. 46 c.

PROJECTION A

FOLD B

FOLD C

Fig. 46 b.

FOLD A

Fig. 46 a.

according to previous directions, each colored sheet is folded and put in place as for an unlined folded colored sheet. The end-paper section is completed as outlined in the preceding paragraph.

LEATHER HINGES WITH END PAPERS

LEATHER HINGE AND UNLINED SHEETS. A slightly different procedure is followed when a leather hinge is to be made up with the end papers. For each end paper one white sheet is cut so that, when folded, it is about one-quarter inch larger all round than a page of the text. A colored sheet is cut the same size, and both sheets are folded and creased sharply. Then a smaller white sheet is cut the same length as these, and about an inch wider than a single page of the book, and a protection sheet is cut the same size from a piece of wrapping paper. On the smaller or half sheet, dots are marked with the dividers about one-quarter of an inch in from the long edge of the sheet. A steel straightedge is placed on these dots, and with a folder the paper is creased up against the straightedge and is turned over onto the face of the paper (Fig. 46 A). Then a distance of one-quarter of an inch is marked on the side of the paper opposite the folded-over piece, and the half sheet is folded over in the opposite direction from the first fold (Fig. 46 B). A gusset, or accordion pleat, will then be formed on one side of the half sheet. On top of Projection A, the folded colored paper is pasted. The thinner edge of the leather hinge is pasted on the underside of Projection A, with its finished side uppermost, and the single protection sheet is pasted on the inside of Fold B opposite to where the leather hinge is pasted (see Fig. 46 C). When they are dry, the leather hinge is folded over the colored paper that has been pasted on top of Projection A, and the protection sheet is folded over the leather hinge. Now a white folded sheet is inserted into Fold C. The end paper is sewed through this folded sheet.

In order to avoid having the leather hinge mark or stain the end paper, there should be a piece of some absorbent paper between it and the upper end-paper sheet. Thin blotting paper is ideal for this purpose, but it is not obtainable in this country, and some sort of unsized paper may be substituted for it. To cover the hinge in this way, a piece of unsized paper is cut the size of the protection sheet, the protection sheet is bent back, and the leather hinge is laid straight out over it. Then the unsized paper is tipped onto the inside of the protection sheet by putting a few generous daubs of paste toward the outer edge of the paper, where they will not come in contact with the leather, and the

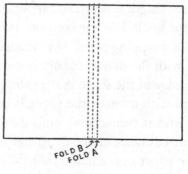

FOLD B
FOLD A

Fig. 47.

protection sheet and hinge are folded back in place. This completes the making of the end-paper section, which should be squared to the book.

WITH LEATHER HINGE AND LINED-DOWN COLORED FLYLEAF. If a lined-down single colored or marbled flyleaf is to be used with a leather hinge, one full sheet of white handmade paper should be provided for each end paper for making the accordion-pleated hinge. The sheet is folded down the middle, and a concertina fold is made as for the previous end papers. After being folded and sharply creased, the whole sheet is spread out

flat, and a single colored sheet is lined down onto it up to the middle of the accordion pleat at Fold B (see Fig. 47). When dry, the sheet is refolded, and the colored paper which is fastened to the sheet should be sharply creased at A. The leather hinge is then pasted in, the protection sheet is added and the end paper is completed as outlined for "Leather Hinge and Unlined Sheets."

WITH LEATHER HINGE AND VELLUM FLYLEAF. Vellum flyleaves are not very satisfactory even when made and kept in a moist climate. There is a mulish quality about vellum that renders it difficult to cope with while being worked on and causes it to buckle and curl after it has finally been straightened out and put in place. Heat and dryness are persistent enemies of vellum, and for this reason the climate of the United States, with its extremes of heat and cold, is not propitious for the use of vellum. However, single vellum flyleaves may be used in a book even in this climate if they are properly embodied in an end paper, and if the book, after being bound, is kept on a tightly stacked book shelf or elsewhere under some pressure.

When vellum is used for a flyleaf, it should be fairly thin and should be made up with a leather hinge and an accordion pleat, so that it will be sewed through. It is a mistake to attempt to paste back vellum over a cover board. Even if the vellum is lined, the result will not be satisfactory. Hence, only a single sheet should be used when made up with end papers. This sheet will constitute a flyleaf (the blank leaf uppermost when a book is opened).

To make up an end paper with a vellum flyleaf, the vellum is cut about one-half inch longer than a page of the text and about seven-eighths of an inch wider. This extra width is necessary so as to allow enough material to form an accordion pleat along the length of the flyleaf at the back of the sheet. A sheet of hand-made white paper also is cut, which, when folded, will be about

one-half inch longer and one-quarter inch wider than the text page; and a single sheet of wrapping paper is cut the same length and one-half the width of this sheet, for a protection sheet. Then a piece of thin Japanese vellum is cut the length of the vellum sheet and three-quarters of an inch wide. This piece is for lining

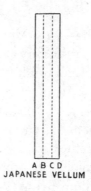

A B C D
JAPANESE VELLUM

Fig. 48 A.

down onto the real vellum sheet at the hinge. On the back edge of the vellum sheet three-quarters of an inch is measured off, and the vellum is scraped quite thin with a knife. With the dividers, the three-quarter-inch Japanese vellum strip is divided into three parts, each part one-quarter inch wide (Fig. 48 A). Part A-B is

Fig. 48 B.

folded over at B toward C. Part C-D is folded in the opposite direction. This will form an accordion pleat. The folded strip is pasted thoroughly and is lined down over the scraped part of the vellum sheet. When dry, the vellum is creased and is folded with the strip into an accordion pleat (see Fig. 48 B). The leather hinge and the protection sheet are pasted in, in the same relative

position as shown in Fig. 46 B, and the end paper is finished in the same way as for "Leather Hinge and Unlined Sheet." An extra folded white paper is inserted into the underfold of the vellum, and the end paper is sewed through this sheet and fold.

A leather hinge adds no strength to the joint of a book, because it has to be pared very thin. The object of having a leather hinge is to give a rather elegant appearance to the inside of the covers, for it makes possible the use of silk and leather "doublures" to decorate the inside covers more profusely than otherwise could be done.

LEATHER HINGE WITH LINED-DOWN FABRIC FLY-LEAVES. Lined-down silk flyleaves may be made up as outlined under "Leather Hinge and Lined-down Colored Flyleaf," substituting the silk for the colored half sheet, though the lining-down process is entirely different from that used in lining down paper. Some binders use thin glue for this purpose, but glue is very likely to strike through the silk, and I prefer using paste made of starch.

A most satisfactory way of lining silk, which requires two people to do the work, is as follows: A piece of good white hand-made paper is cut a little larger than a page of the text, with the grain running with the width of the paper. Then a piece of thin silk is cut with the grain running up and down, or in the opposite direction from the grain of the paper. The size of the silk should be enough larger than the paper to overlap it one-half inch on all four sides. All wrinkles are pressed out of the silk from the underside. A bowl of rather thin starch paste is got ready, and a full-size sheet of cover board is placed flat on a table to which access may be had from two sides. The white lining paper is laid on the board at a place convenient for the worker. The silk is carefully pasted and is then picked up at one end by the worker, with his two forefingers and thumbs. He turns it so that the pasted side is downward, and the assistant takes hold of

the other end of the silk with both hands. The silk is brought over to the table on which the lining paper lies spread on the board, and the assistant raises his end of the silk and holds it above the worker's end. With the silk held in this position, the worker's end of the silk is let to fall onto the lining paper so that it projects about one-half inch beyond the paper. Then the worker smooths out the silk over the paper with his bare hand, to a depth of about an inch, and rubs it firmly. The assistant now gradually lowers his end of the pasted silk, to fall onto the lining paper, guiding it straight as it falls, and as it falls, the worker smooths it into place with his hand. If any small wrinkles appear, they can usually be sponged out with a small slightly dampened sponge, but after the knack of placing the silk has been mastered, the silk can be laid down without any wrinkles.

After the silk has been carefully smoothed out with the hand and rubbed firmly in place, the board is stood up on one edge so that the work may dry. In the course of a few hours, the lined silk will begin to peel off the board, and it frequently falls completely off. After the silk is dry, if it fails to peel off of itself, one end is loosened by using a knife blade to start it, and the whole lined-down silk is pulled off the board. The silk may then be squared to size, and before it is pasted in place on the end paper, a little medium-thick paste is taken on the forefinger and applied carefully along the cut edges. This prevents the silk from raveling. Glaire, or size, may be used for this purpose instead of paste, but they are more liable to stain.

The best silk to use for this sort of lined-down end is a thin China silk. Heavier silks cannot be made up with the end papers and are made after the book is in leather. Directions for these end papers will be given with silk doublures in a later chapter.

This type of silk-lined end may be used in a whole folded sheet without a leather hinge. It is then treated like a folded colored sheet that is pasted over the joint of the book, and in making it

the binder must see that the paper is cut so that it will be folded with the grain.

Airplane linen and other fabrics may be used for flyleaves. For lining down airplane linen and most other fabrics, either a thin bond or a Japanese tissue paper will be found best. The paper and cloth are cut with the grain running in the same direction. The paper is slightly dampened with a soft sponge and is then pasted with a fairly thin starch paste. It is placed on the linen or other fabric, and after being covered with a piece of clean unprinted news, it is rubbed down thoroughly with a folder. It is then put between boards and is left to dry under a heavy weight such as a lithographic block.

CHAPTER VII

FORWARDING

Pressing, Cutting and Trimming before Sewing.
Gilding and Coloring Edges

PRESSING

IN order to expel the air from between the pages of a book and to crease the folds of the sheets sharply, thus making the text solid, considerable pressure must be applied to them.

There are several ways to attain this result. The oldest method is that of "beating." The book was divided into parts and placed upon a stone or iron embedded in sand, and it was then beaten with a heavy bell-shaped hammer (Fig. 49). This method of making a book solid requires considerable skill to prevent the edges of the pages from being compressed thinner than the center, and it is a slower *modus operandi* than that of any of the later devised ways of achieving this solidness of a text.

In the early part of the nineteenth century, books began to be rolled instead of beaten. A few sections at a time, put between thin sheets of metal, are pressed between the rollers of a machine until they are sufficiently compressed. This is a quick method of making a book solid, and this method is still in use in large binderies. A later machine, called a "smasher," was developed, in which whole books can be smashed between the jaws of iron platens. Under no circumstances should this machine be used on a hand-printed book, for it completely eradicates the "punch," or indentation of the type, which is such a desirable characteristic of hand printing. Neither of these machines forms a part of an extra binder's equipment, and on newly printed books they are both liable to cause a "setoff" — that is, an impression of the ink from a page to the one opposite it.

The modern standing press gives sufficient pressure to make a

book solid for binding, and it is generally used for this purpose in all extra binderies. Care must be taken, however, even in the use of this press, in pressing very old books. The early printing presses gave a "punch" to the type which left a thickness of paper around its outline. These thick edges should not be unduly flattened, or the form of the type will be blurred. When hand-printed books are pressed, precaution should be taken not to destroy the punch of the type. Before a newly printed book is pressed, the printing

Fig. 49.

should be examined to make sure that it is thoroughly dry. Properly prepared printing inks dry quickly, but occasionally a book comes to the binder that is printed with badly made ink, and the oils employed in making the ink leave a stain. This is more liable to be the case with books printed in the last century, before the science of making printing inks was mastered. The binder cannot do anything about already oil-blurred printing, but he should not put such a book under severe pressure, for fear of increasing the old setoff.

To press a book in a standing press, the press should be opened up fully and some of the pressing boards should be withdrawn. The boards should be a little larger than the book. A tin the size of the pressing boards to be used is covered with unprinted news and is laid on the top board left in the press. The book is divided into two or three parts. One part is "knocked up" at head and back until all the sections align perfectly and are squared to the head. It is centered on the covered tin, with the back of the sections facing outward. On this group of sections another covered

Fig. 50.

tin is placed; a second lot of sections is knocked up and put on the tin over the first ones with the fore-edges facing out, and so on. All the groups of sections should be centered between two covered tins with their fore-edges and back folds placed alternately outward, and with care that each group is exactly over the group below it. Then the last tin is covered with enough pressing boards to fill the press nearly up to the top platen. All boards should be evenly aligned. The press is "wrung down," and the book is left under pressure for twenty-four hours (see Fig. 50).

A fairly thin book need be divided into only two parts, whereas an exceptionally thick book should sometimes be divided into as many as four or five parts, depending upon the quality of the paper. Highly sized paper usually requires less pressing than

porous paper. Newly printed plates should have a piece of thin tissue put over them before being pressed. Folded maps or plates should usually not be pressed with the book, but if pressed, they should have thin tins put on each side so that they will not mark the text.

If a book is very thick and in need of heavy pressure, it is advisable to insert a pressing board after every two sections are built up between tins. It is far easier to arrange the sections in this manner in the press than to make them up between tins on the

Fig. 51 A. · Fig. 51 B.

bench and then try to put them into the press afterward, for there is danger of their slipping when handled. How much pressure to put on the text of a book must be determined by the character of the printing and by the absence or presence of colored plates. For ordinary books without plates, the pressure should be as great as the press is capable of.

KNOCKING UP. To "knock up" the sections of a book, the head is placed on the bench parallel to the worker, with the back to the right. The book is held at the right-hand upper corner and the left-hand lower corner with the thumbs and fingers (Fig. 51 A). In this position the sections are firmly struck *en block* on the benchtop until all sections are even at the head. Then with the

book held lightly the sections are swiveled over to the right so that they stand on the "back" (Fig. 51 B) and are knocked firmly on the bench. They are swiveled back again and knocked. This swiveling is continued from one position to the other until all sections align evenly at the back and the head. If sections are knocked up without leaning them, the head will be square with the back.

CUTTING AND TRIMMING BOOKS
BEFORE SEWING

Books may be trimmed before sewing or may be "cut in boards" before covering. The latter method results in solid edges. When marbled edges were in vogue, a solid finish to the edges was necessary. It is also necessary when edges are to be decorated with a "gauffered" pattern or a painting. I think it is often desirable to have a solid gilt edge on books decorated with modern designs, as they demand a greater austerity of edge contour to harmonize with the streamlined effect of their decoration. The cutting of book-edges "in boards" will be explained later when it comes in the regular sequence of binding operations.

The edges of most books printed on machine-made paper are fairly uniform if the printing is well planned and the pages are "imposed" with care. These books usually require no trimming, and it is only necessary to "square" the head of the text so that it may be gilded. A book printed on handmade paper, having deckle edges at fore-edge and tail, is frequently characterized by a very uneven surface. This is due to abnormally irregular deckles, to faulty imposing of the book on the sheet by the printer, or to imperfect folding. Such edges soil easily, are unsightly, and are difficult to turn over when reading a book. On the tail of the book, they present a problem to the binder when he makes his tailbands. There has been an exaggerated respect for deckled edges in recent years, simply because they indicate to the

uninitiated that the paper is handmade. But such an edge on handmade paper is really due to what might be termed a fault in manufacture. Handmade paper cannot be produced with a perfectly true straight edge (see "Paper"), and now that machine-made paper is being manufactured with a spurious deckle, the glorified deckle has lost some of its allure. It is true that a "real" deckle can easily be distinguished from a manufactured one, but, nevertheless, I am of the opinion that even real deckled edges have been held too sacred.

A matter that cannot be held too sacred, however, is cutting the edges of a book so that plenty of "proof" is left. The proof of edges should be sacrosanct to a binder, and if he fails to regard the edges of a book with respect, he is sure to justify William Blades's estimate of him as one of the "enemies of books."

When a book has been pressed, it is ready to cut at the head and have its edges trimmed before sewing, if the fore-edge and tail are to be left somewhat irregular and not cut smooth. A book should never be cut smooth if it is a valuable one. "Cropping," that is, cutting edges beyond the shortest "proof" sheet of a book, should never be done. In fact, as many proof sheets as possible should be left in a book as evidence that the binder has respected the margins planned by the typographer. When the sheets are very irregular and possibly soiled, even though the edges are deckled, it is best to trim them slightly in order to clean them up and make them less ragged and unkempt in appearance. This should be done at both fore-edge and tail.

CUTTING THE HEAD BEFORE SEWING. The least possible amount should be cut off the head of a book in order to square it to the folds of the sections and produce an even edge that can be gilded successfully. In a well-equipped modern bindery, this cutting is done in a guillotine cutter. If no such cutter is available, the head may be cut by hand with a carpenter's square, as for

squaring end papers (Fig. 42), or it may be cut with the plough. To operate a guillotine cutter like that shown in Fig. 10, the book is placed on the iron bed A of the cutter, with the back folds resting against the left-hand metal side of the cutter and with the tail of the book up to the guide slide in the back of the cutter bed. Then the wheel D is turned until the head of the book projects beyond clamp E the least possible distance, so that the book will be cut when the knife G is brought down. Underneath the book a piece of bookboard is put in order to protect the wooden cutting stick H, and on top of the book another piece of bookboard is placed to hold the book solid and protect it from being injured by the iron teeth back of clamp E. Then the wheel D is turned so as to bring clamp E down as firmly as possible on top of the book. The spring button I is released, and the knife is brought down over the edge of the book and cuts its way through. As the metal side of the cutter is mechanically squared to the clamp E, which is in line with the cutting knife, the head of the book will be cut square to the folds of the sections. Cutting a head with the plough will be explained later under "Cutting a Book in Boards."

Trimming Book Before Sewing. The texts of incunabula should never be cut or even trimmed but must be rebound without putting a knife to the pages of the books, even though the heads are not square and the edges are very uneven. The edges of all books, if valuable editions, should be left untrimmed.

Frequently just a tiny sliver cut off of a few sheets on the tail and fore-edge will be sufficient to straighten up the edges of a book and make them look neat and tidy. But when the edges are exaggeratedly uneven, I advise sacrificing some of the deckle if necessary, except on first editions or books whose value as fine printing specimens would be destroyed by trimming. It is always best to consult the owner of the book before trimming edges. He often prizes the volume as a collector's item and desires its origi-

nal condition preserved. On the other hand, the value of the book to him may lie entirely in its contents, and he may then prefer to have it bound in such a manner as to be most easily readable. The owner should always be the final arbiter in the matter.

If it seems advisable to trim the fore-edge and tail of a book before sewing, the trimming should be done after the head has been squared. First, the book is knocked up at head and back, in order to line up the edges. Then the longest sheet possible to trim to is selected on both the tail and the fore-edge, with care taken that several shorter sheets will be left untrimmed. When the book is to be trimmed in a lever cutting machine, the machine gauge is set to the size of the sheet chosen, and all sections, including the end papers, are trimmed to this size at both tail and fore-edge.

TRIMMING BOARD. If the trimming must be done by hand with a knife, a homemade trimming board may be improvised and kept for this purpose. For making a trimming board on which to trim octavo and smaller books, a wooden board of any thickness is selected and is cut perfectly square to about 9 x 12 inches in size. Then a sheet of zinc is cut squarely to the same size, and is fastened down on the wooden board securely with screws that are countersunk, with care to line it evenly with the squared board. Now four small "angle irons" are bought, and two of them are screwed on the underside of the wooden board at one end. One angle iron is placed about two inches from the left corner, and the other one about five and one-half inches from that corner. They are sunk flat into the wood, and the unfastened part is allowed to extend up over the top edge of the wooden board. Then the other two angle irons are fastened on the long side of the board. The first one is secured about three inches from the corner, and the second one six inches (see Fig. 52). If the board and zinc are accurately squared and the angle irons are fastened properly, this device will serve admirably for

edge trimming. Very small angle irons made of thin steel, such as those used in fine cabinetwork, are obtainable. The zinc must be changed from time to time as it becomes too damaged for accurate cutting, but this may be done easily, since the zinc is secured to the board with screws. In changing the zinc, it is advisable to change the placing of the screws. For trimming folio editions a larger board may be constructed.

To use this contraption for trimming, a piece of thin bookboard (preferably English millboard) is squared to the size of the sheet selected to trim to, and this board is used as a trimming guide. After the head of the section to be trimmed is squared, it

Fig. 52.

is placed up to angle irons A and B, and the back fold is placed against C and D. Then the trimming-guide board is put up to these four points over the section and is held firmly in place while cutting. With a sharp knife, the fore-edge and tail of the section are trimmed to the trimming-guide board. The position of the trimming board should be changed so that the worker will always have the edge to be cut at right angles to him.

If a trimming board of this sort cannot be constructed and no cutting machine is available, the trimming may be done by squaring a thin bookboard to the size decided on for cutting the sections, and using it as a trimming guide, care being taken to knock it up with the section at head and back before trimming. This trimming should be done on a cutting tin or zinc.

GILDING AND COLORING EDGES

When book-edges are to be "rough-gilt," they are gilded before sewing. In a rough-gilt job, the surface of the edges has a pleasing texture due to a quality imparted to it by the leaves of the book. If carefully sewed, the pages line up with almost imperceptible unevenness. When books are "smooth-gilt," they are cut to a smooth edge and gilded after being laced into boards. As a result, the surface of the edges has a hard, metallic appearance devoid of any suggestion that it represents an aggregation of the leaves of the book.

Except possibly in special instances, such as when it is desirable to utilize the book-edges as bold masses of gilt to harmonize with or augment the scheme of decoration on the book covers, I think soft, rough-gilt edges are preferable to hard, metallic ones. I, for one, dislike having the individuality of the leaves of my books destroyed. The purpose of gilding or coloring edges is primarily protective, as the sized finish prevents the dust from penetrating the pages. Rough edge-gilding achieves this end, if the work is properly done, and moreover it does not change the physical appearance of the book leaves.

There are a variety of ways in which the edges of a book may be gilded. Colors of different hues or painted scenes can be put on before gilding, or marbling may be done on the edges either before or after gilding. Some treatments of edges before laying on the gold leaf lend a pleasing undertone to the gilded edge, and the extra binder would do well to experiment along this line and seek to add to the discoveries made in the past by master binders, from whom we have inherited the art and science of gilding edges in several different ways. There are books written on this subject listed in the Selected List of Books at the end of Vol. I, which may be consulted by the binder bent upon embellishing his edges in some special manner, and I purpose here to describe merely the process of plain edge-gilding.

The fore-edge and tail of most books are usually left ungilded. This is probably due to the fact that there is no need, for a utilitarian purpose, to gild other than the edges on the head of a book. Table books, such as guest books, have all their edges exposed and are therefore better "gilt all round" or "full gilt." Likewise, very sumptuously bound books with all-over gold tooling, silk doublures, and other elegant features seem to call for "full-gilt" edges.

OUTFIT FOR EDGE-GILDING. The outfit and materials necessary for edge-gilding consist of a heavy lying press (Fig. 1); a pair of gilding boards (Fig. 53); a steel scraper, such as is used by

Fig. 53.

cabinetmakers, or a few pieces of broken heavy glass; a flat bloodstone or agate burnisher and a "tooth" burnisher (Fig. 54 A and B); a fairly stiff ordinary nailbrush; and a gold cushion and knife (Fig. 55 A), with a shield (Fig. 55 B) placed around the cushion. The shield is made of corrugated paper, cut and bent into shape and bound with artist's tape. A gilder's tip (Fig. 56), a book of gold leaf, a jar of glaire, a sizable camel's-hair glaire brush, a pot of "Armenian bole," a small sponge, some French chalk, a piece of beeswax, a few pieces of very fine sandpaper, and some unprinted newspaper will all be necessary for the worker.

Fig. 54 A.

Fig. 54 B.

Fig. 55 A. Fig. 55 B.

Fig. 56.

Gilding boards are best made of beechwood. They are of various lengths, according to the size of the book on which they are to be used, and they are beveled from a thickness of about three-eighths or one-half inch to one-eighth of an inch.

Almost every edge-gilder has his own special formula for making glaire, and any formula is good if it can be "wormed out" of the gilder. I have found the following one satisfactory: Break a fresh egg, separating the white from the yolk. Measure the white, and to it add four times as much water as there is egg white. Beat this mixture up with an egg beater and let it stand overnight. Then strain it through a piece of fine muslin, and it is ready for use, but when not in use it should always be kept tightly covered. Glaire acts as an adhesive and makes the gold stick to the edge.

A gold cushion and knife can be bought at any binder's supply house, likewise a gilder's tip. "Armenian bole" is procured from a chemist and is a kind of powdered red chalk. To prepare it for gilding, it is mixed with water until it becomes a rather thick paste. Some gilders use black lead with the bole, but I have not found this necessary.

Edge-gilding should be done in a room free from dust and drafts of air. Dust spoils the gilding, and even a slight breeze makes the handling of gold leaf troublesome. Before the edges of a book are gilded, the type of paper used for the text should be noted. If it is clay-filled glazed paper such as that known to the trade as "art mat," it will need to be French chalked in order to prevent the edges from sticking together by the penetration of the glaire. Books printed on thin India paper should also be chalked. Chalking is done by fanning out the edges slightly and dusting on the powdered chalk.

EDGE-GILDING BEFORE SEWING. To gild the head of a book before sewing, the book is knocked up at the head between two gilding boards until all the sections are even with the edges of the

boards. Then it is lowered into the lying press until the gilding boards are almost flush with the cheeks of the press (Fig. 57), and the press is screwed up evenly and as tightly as possible.

Next, the edge is scraped either with a steel scraper having a slight burr on it or with a piece of heavy glass. The scraping of the head should be done from the back toward the fore-edge, for otherwise the sections may be broken at the fold. When scraped evenly, the edge is rubbed off with a very fine sandpaper in order to remove any chance stains. The scraper must be sharpened on a piece of steel harder than itself. To do this, the scraper is laid on

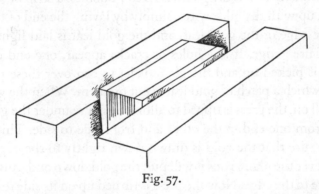

Fig. 57.

an edge of a table, with the end to be sharpened projecting beyond the table. The sharpening steel is rubbed vigorously over one side of the scraper with a downward motion. Then the scraper is turned over, and the other side of it is rubbed against the sharpener. To put a burr on the scraper, the hard steel is held against a table, and the blade edge of the scraper is rubbed over it while the scraper is held at right angles to the sharpening steel.

A thin coat of bole is applied with a small sponge to the book-edge in order to seal it, and the edge, after it is dry, is brushed vigorously with a nail brush until it has a high polish. The bole must not be used so thin that it will penetrate the leaves of the book. If the book paper is soft-finished, it should have a coat of

size made of vellum scrapings or gelatin before the bole is applied (See Chapter XX for making size). Any preparation applied to the edge must be allowed to dry thoroughly before glairing for the laying of gold leaf.

On the gold cushion, a sheet of gold leaf is laid out (see instructions under "Gold Tooling") and is cut into strips sufficiently wide to cover the width of the edge to be gilded. Then, with the large glaire brush, a generous coating of glaire is applied to the edge. The glaire is floated on with strokes of the brush from one end of the edge to the other, and any bubbles that appear are brushed out. When the glaire is free of bubbles, a strip of gold is taken up with the gilders' tip, simply by laying the end of the tip on the edge of the gold leaf, and the gold leaf is laid lightly on the glaired edge. If any holes or cracks appear, one end of the press is picked up and the glaire is let to run over these places, after which a patch of gold leaf is put on them. When the gold is all laid on, the press is tipped to allow the glaire under the gold to run from one end to the other and from side to side. This is to make sure that the gold is drawn down tightly to the edge, for wherever the glaire runs it will pull the gold down and cause it to adhere to the edge. Now the press is turned up on its side to drain off any excess glaire (Fig. 58), and after the glaire ceases running off from under the gold, the press is laid flat and the edge is let to stay in this position until it is dry. The amount of time necessary for drying varies from a half hour to an hour, depending upon the quality of the paper and the temperature of the room. It is best to do edge-gilding in a warm room.

Just when an edge is ready to burnish can be determined accurately only after some experience. When a bright gilt edge is desired, a useful way of testing for dryness is to breathe on the edge. If the vaporous cloudiness produced on the gold by breathing on it disappears quickly, the edge is ready for burnishing. The edge must not be too dry, for then it will not polish bril-

liantly. If the edge is too damp, the gold will rub off. When it seems to be ready, some beeswax is rubbed on a piece of thin paper, and with the waxed side up, the paper is laid on the edge and a burnisher is gently run crosswise over the paper. This sets the gold if it is ready for burnishing, but if the gold seems to smear or rub, the gilder must stop burnishing and wait for the

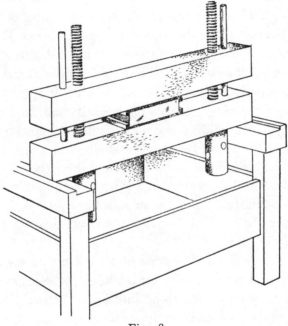

Fig. 58.

work to dry. When finally ready to be burnished, the edge is lightly rubbed lengthwise with a soft pad that has been well rubbed over with beeswax. Then the burnisher is gently rubbed across the edge, and the pressure is gradually increased until finally, with the burnisher handle in the pit of the arm and both hands on the handle, as much pressure as possible is used. The burnisher must be held squarely or it will leave marks on the edge. After the burnishing is done across the edge from one di-

rection, it is done from the opposite direction. The edge must never be burnished lengthwise directly on the gold. Occasionally in burnishing, the edge is waxed in order to permit the burnisher to work easily.

After the edge is burnished, if there should be a break in the gold on a spot that is not well covered, spirits of wine is applied to the place with a brush, and a piece of gold is laid over the imperfect edge. Then almost immediately a thin piece of paper is put over the patch, and the edge is lightly burnished. The paper is removed, and the spot or crack is burnished so that it merges with the rest of the gilded edge. If the patching is unsatisfactory, spirits of wine is applied to the whole edge, it is then glaired again, and the gilding process is repeated. If chalk has been used on the edge before gilding, the edge should be tapped lightly on the cheek of the press to remove the chalk. Edges may be either bright gilt or dull gilt. If a dull finish is desired, the edge should be let to dry for a longer time than when a bright gilt is to be produced. For this dull finish, the edge is burnished with a paper over it, and the burnisher should not be used directly on the surface of the gold leaf.

To gild the tail and fore-edge of a book before sewing, the same procedure is followed as for the head. If the edges are very irregular, they may need to be interleaved before gilding, in order to produce a firm enough surface to take the gold evenly. In such case, the pages must be carefully interleaved with a fairly hard-sized paper, so that when the edge is knocked up for gilding, it will be as solid as possible. This sort of edge-gilding requires much patience and experience and should not be attempted by an amateur worker on a book of any value until he has practiced on dummies or on worthless books.

COLORING HEAD BEFORE SEWING. A simple way to finish the edge on the head of a book is to color it. This is not suitable

for books bound in full leather or for books of much value, but the head of a current novel or of some reference book or pamphlet may be finished in this manner.

Higgins' inks, "show card colors" mixed with water with a little size in it, or powdered colors mixed with a thin size or with thin paste may be used for coloring edges. The color is mixed in a shallow dish, and the book is put in the lying press as for gilding. The edge is scraped smooth and is finished off with fine sandpaper. The color is applied sparingly from the back to the foreedge with a large soft brush or a small sponge. When dry, the edge is burnished vigorously with a stiff nailbrush. Then a waxed cloth is rubbed over it, and it is burnished with the agate or bloodstone burnisher crosswise as for gilding.

The head of a book and the other edges cut with the plough may be sprinkled instead of being finished with an even color. This is done by brushing a color through a wire screen. Another color may be brushed on after the first color. When dry, the edges are burnished like other colored edges.

CHAPTER VIII

FORWARDING

*Cover Boards. Cutting Boards and Lining Up.
Marking Book for Sewing*

COVER BOARDS

IN Vol. I, p. 63, will be found some information about the early use of coverboards. In recent years various kinds of composition boards have been manufactured for the use of the hand binder. At the present time there are three varieties of this type of board suitable for using as book covers. The most superior bookboard is the English "millboard," which is made of rope or old cordage. It does not warp easily and will stand a great deal of abuse. It is manufactured in several thicknesses and is usually used by the hand binder in sheets 19 x 24 inches in size. A French bookboard called "carton bleu" is also a very sturdy board. Like millboard, it is manufactured in a number of thicknesses but usually in somewhat larger sheets than millboard. Both of these boards have been unprocurable in this country for several years, and the hand binder whose stock of them is exhausted has had to use an inferior American-made board as a substitute. The American bookboard is manufactured out of wastepaper pulp and other fibrous materials. It is made in various sizes and thicknesses and is sold under trade names. In "the trade" it is sometimes referred to as "cloth board." Boards of American manufacture are liable to warp unduly and to bend or break more easily at the corners than those of English or French make, though recently a board of better quality has been produced in America than those made in the past.

CUTTING OUT BOARDS

The size and thickness of a book should be taken into consid-

eration in selecting the thickness of the board to be used. Thin boards are less clumsy than thick ones, and I think they should be used more frequently than is the present custom. The domestic board, of a size 20 x 30 inches, is most economical to use for octavo books. For a single volume, two boards are cut out about three-quarters of an inch wider and one inch longer than the book, to allow for trimming in the cutter. The length of the boards should run along the width of the board sheet. If no cutter is at hand, a pair of bench shears as shown in Fig. 8 may be used for getting out the boards roughly. In this case the boards should be cut amply large, for they will not be square. However, any bindery should be equipped with some sort of cutting machine, for otherwise cutting cannot be done efficiently and without great waste of time. It is the practice in even the smallest binderies to cut up at least one whole board at a time. The board is cut into eight parts for octavo books, and after these are lined up, they are kept under a weight to "season." A stock of well-seasoned boards should always be kept on hand, and not less than a few weeks should be allowed for the seasoning process. If freshly lined-up boards are used on books, they are sure to warp badly unless the book is kept constantly under pressure. Since most books are not likely to be kept under pressure, it is safer to season the boards some time before they are needed.

LINING UP BOARDS

It is customary on all extra work to line up both sides of the cover boards with paper before attaching them to the book in order to prevent the color of the boards from showing through the end papers and also to give the boards a surface which will take the paste evenly in covering and in pasting back the end papers.

When any material is pasted on only one side of a board, the board will warp and curl over toward the side on which the ma-

terial has been pasted. Hence, when a leather cover is pasted over the boards on the outside, it will warp them outward. To counteract this warping which will take place after covering, boards are always lined up with an extra piece of paper on the inside. Therefore two pieces of paper are pasted on the inside, and one piece on the outside, when they are being lined up.

A suitable kind of lining paper for boards is unprinted newspaper. This is the sort of paper used for newspaper printing. It is almost entirely unsized and is hence quite porous. A medium quality is strong enough for lining-up work, and it may be purchased by the bundle from paper houses specializing in the cheaper grades of paper.

To line up a batch of boards after they have been cut, three pieces of paper are cut for each board one-quarter of an inch larger than the board all round. To do this efficiently three full sheets of newspaper are counted out and each is laid evenly on top of the other. The cutter is set to the width or length desired, and the three sheets at a time are cut through until their whole length is cut up. These cut sheets are piled evenly on each other, the cutter is set to the second measurement desired, and all the sheets are cut to this measure.

Now the cut boards and the lining papers are placed on the workbench in piles. A bowl of commercial paste is mixed up and beaten free of lumps, and it is thinned down with water until it is the thickness of thin milk. Paste for lining up boards is used thinner than for any other job in bookbinding, because the thinner the paste the less drag there will be when it is applied, and drag tends to stretch the paper and warp the boards. After the paste is mixed, two wooden pressing boards and four covered tins of the same size are laid out. These should be large enough to cover the cut bookboards. They are put on the table next to the nipping press. Then to paste on, a supply of printed newspaper is cut generously larger than the cut lining paper, and this is put in

a pile on the workbench. Three pieces of cut lining paper are counted out and are placed one on top of the other on the pasting paper, and then the worker is ready to line up the first board. Simple as pasting appears, it requires a little practice before one is able to do it expeditiously and neatly, and a good thing to practice on is lining-up boards, for an occasional lining paper spoiled by a wrong stroke of the brush is not too serious a matter.

The paste brush is grasped in the hand as described for guarding. A small amount of paste at a time is taken up, and the worker begins spreading the paste at the right end of the paper with quick, light, overlapping strokes directed from left to right, while holding the paper with the left hand so that it will not slip. The holding hand should be kept fairly close to where the paste is being spread, and it is gradually moved along to the left as the pasting progresses. When the left end of the paper is nearly reached, the holding hand is removed and the pasting is finished with a few light strokes toward the left end of the paper. (These directions should be reversed for a left-handed person.) The paper is lightly folded over, without creasing, so that the pasted sides are inward, and it is placed on the left side of the work. Without changing the pasting paper, first one and then the other of the three pieces of paper are pasted in like manner and are folded over, one being placed on top of the other. The used pasting paper is discarded, and one of the cut boards is placed on a clean pasting paper. The pile of folded pasted papers is turned over so that the first one pasted will be on top. The top one is unfolded, is spread over the board, and is smoothed out with the palm of the hand. A second pasted paper is unfolded, is spread over the first one, and is smoothed out with the hand. It is marked lightly in the center with a cross or a letter to indicate the side with two lining papers. The board is turned over; the third paper is spread on it and is smoothed out with the hand. The papers must not be smoothed with a folder, as there is danger of

tearing an unsized paper. Now the overhanging edges of the papers are trimmed off with the shears, and the lined-up board is taken over to the nipping press. It is placed between two tins and two pressing boards and is nipped for an instant in the press. It is then stood up to dry in some place where it can rest against the wall or some other surface perpendicular to the standing surface, and the marked side is placed outward. This process is repeated with the next board, the used covered tins being changed for fresh ones in pressing. This board is stood up beside the first one with its marked side out, and the first board is turned around in order to expose the unmarked side. After they are pasted and nipped in the press, one board after another is stood up in this manner, and the standing boards are turned as the new one is added so that both sides of the boards will be exposed to the air while drying and will dry evenly. The boards should be stood up as straight as possible and as they begin to curl and seem almost dry, they are piled on a workbench or table with a paring block as a weight. They should be left under this heavy weight for at least twenty-four hours, when they may be put aside with a lighter weight on them until they are needed.

If there are no lined boards in stock, boards should be lined up at an early stage in binding a book so that they will be dry when the book is ready to have its boards laced on, but if they are used soon after lining up, it must be remembered that they are not seasoned, and the book on which they are used must be kept under pressure while in work.

I have described this system of lining up boards in detail because much time may be needlessly consumed in this simple operation unless an efficient system is followed. Boards can be cut out and lined up for a dozen books in an hour or less, though I have known amateur binders who take twice that time to line up boards for two or three books, because of lack of system.

MARKING BOOK FOR SEWING

Before being sewed, books must be marked up on the back to indicate the position of the cords or tapes around which the sections are to be sewed. When a book is sewed on cords, it should be sewed flexibly, that is, with the thread wrapped around each cord. If the book is sewed on tapes, this cannot be done, and hence a book sewed on cords is stronger and less slippery than one sewed on tapes.

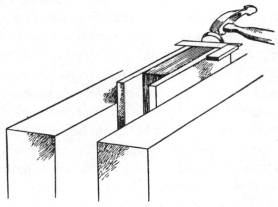

Fig. 59.

MARKING UP FOR CORDS. To mark up for cords, the book is knocked up at head and back between two old squared cover boards. The folds of the sections should align evenly and the head should be squared to the back. Then with the boards on each side the book is lowered into the finishing press. It is placed at right angles to the worker and with the head away from him. The press is tightened, and the head is tested for squareness by means of a small try square. If the head is not perfectly square, the press is unscrewed slightly, and a large-faced backing hammer is used to tap the head of the book gently up to the try square until all the pages align with it (see Fig. 59). Then the press is screwed up, and with a pair of spring dividers the back of the book is measured

off into segments. The usual number of bands on a book is five, though on a thin large book six bands are sometimes used, and four bands are often used on small thick books. Each cord constitutes a band after the book is covered.

In marking up for five cords, the back is divided into six portions. Measuring from head to tail, the first five portions are equal, and the last one at the tail is somewhat longer than the other five. This is customary because if all six divisions were equal, the tail division, due to an optical illusion, would look shorter than the others when the book is standing on a shelf. How much longer the tail division should be than the others is a matter of taste, but in my opinion it should not be exaggerately long — only just enough longer to overcome the appearance of being shorter. Something between one-eighth and one-quarter of an inch longer, depending upon the size and thickness of the book, should suffice. When a book is to be cut in boards, allowance must be made for the amount to be cut off, for otherwise the head and tail divisions, after being cut off, will be too short.

After the position of the cords has been decided on, their places are indicated with the point of the dividers all down the back. Then, using a small try square as a guide for marking, in the manner it is used in Fig. 59, a pencil mark is drawn through each point, making lines at right angles across the back of the book, so that the sewer may know where to place her cords when "stringing up." Two additional lines are now marked across the back with the aid of the try square, one about one-half inch down from the head and the other one-half inch up from the tail. These lines serve to indicate where the kettle or catch stitches are to go, and they must be sawed in across the back so as to sink the sewing thread as it catches or fastens one section to the other at each end of the book. But before the sawing-in, the end papers are removed or pulled forward so that they will not be sawed through, for if they were sawed the holes would show at the

joint of the book after the end papers are pasted down on the boards. To saw in the kettle stitch marks, a moulding saw is used, and a groove is sawed across the back only deep enough to sink the thread to be used for sewing (Fig. 60).

MARKING UP FOR TAPES. To mark up for tapes or for double bands, the procedure is the same as for marking up for cords, except that two marks are made for each band. To do this without

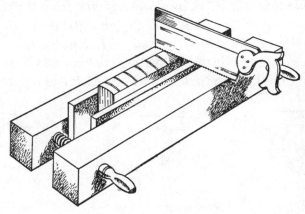

Fig. 60.

loss of time, the back is divided up into six equal parts for five bands. Then lines are marked across the back on the division points. The small dividers are set to the width of the tape or to the two cords to be sewed over, and this distance is marked above each division line. Lines are drawn through these marks and through the two kettle-stitch marks, and the latter are sawed. The back will then be divided into five equal portions, with the tail portion as much longer than the others as the width of the tape or the double cord.

CHAPTER IX

SEWING

STRINGING UP FOR SEWING

AFTER a book has been marked up for sewing, it should be collated before the sewing operation is begun. Then the sewing frame must be "strung up." On every sewing frame in all hand binderies, there are five loops hanging from the cross bar. These are called "lay cords" (see Fig. 70), and the cords around which the sections are to be sewed are fastened to the lay cords with a knot, so made that by pulling the loose end it will untie. To make this knot, the index finger of the left had is put through

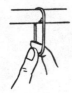

Fig. 61 i.

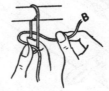

Fig. 61 ii.

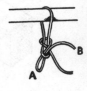

Fig. 61 iii.

the lay cord from the back, pointing toward the sewer when she is sitting in the position shown in Fig. 70, and the left thumb is brought up to meet the finger (Fig. 61 I). Then with the right hand the end of the cord is brought up in front of the lay cord, is held between the finger and thumb, and is wrapped around the back of the lay cord (Fig. 61 II). With the forefinger of the right hand, the cord is stuffed under the left forefinger and thumb through the bottom loop of the lay cord (Fig. 61 III), thus forming loop A of it, and with the free end B sticking up. Loop A is pulled until the knot is tight. If properly made, this knot can be untied simply by pulling end B.

After the sewing cord has been thus fastened to the lay cord, it is secured under the bed of the sewing frame (Fig. 62). A brass

key (Fig. 63) serves for this purpose, and it is fastened to the sewing frame as follows. In order to determine the length of the cord necessary to reach from the lay cord to the bed of the sewing frame, the key is held in the right hand and the cord in the left

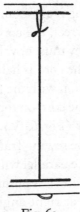

Fig. 62.

hand. The right side of the neck of the key (A) is placed against the cord and is brought along the cord until it reaches the bed of the sewing frame. Then, with the cord held firmly, the key is pushed under the bed of the sewing frame from the front

Fig. 63.

(Fig. 64 I). In this manner the distance from the lay-cord loop to the underside of the sewing frame is measured so that the sewer may know where to fasten the key on the sewing cord. The fore-finger of the right hand is then held under the key in order to se-cure the cord in place, and with the thumb on top of the key, the

key is brought out from under the sewing frame (Fig. 64 II), with the left hand the cord is wrapped across the top of the key on the side toward the sewing frame (Fig. 64 III), and then the key is flopped toward the sewer so that it will pass between the two prongs of the key (Fig. 64 IV). Before the cord is cut off, it is tested for length by pushing it again under the bed of the sewing frame. If the length is correct, the cord is cut, with an end left about an inch long. The key must now be fastened under the bed of the frame. To do this, the cord is held taut with the left hand, and the key is kept in position with the first and second fingers of the right hand astride of the cord on top of the key, and with the thumb underneath the key (Fig. 64 V). The key is let down into the slot along the bed of the sewing frame and is held there with the left hand. It will then be parallel with the slot, and in order to make it hold the cord in place, it is pushed down with the fingers or a folder, and is turned at right angles to the slot so that the prongs will be under the bed of the frame and the head and neck of the key will be under the outside bar of the slot (Fig. 64 VI). This is repeated for fastening all the cords to be used.

The cords are then adjusted so that they correspond with the marks on the back of the book. To do this, the book is first knocked up at head and back to get it squared. It is then placed on the sewing frame with the head to the right and the back against the cords, and one cord after another is brought up so that all the cords line with the marks on the back of the book. The first cord should be set well up toward the right, with not more than four or five inches of space left between it and the right up-right of the frame, so that the sewer, while working, may have space beyond the tail of the book to rest her arm comfortably on the bed of the frame.

All the cords should be strung up with the same tautness. They may be tightened by screwing up the two wooden nuts on the up-rights so as to lift the crossbar. If any seems looser than the others,

a piece of folded paper or cardboard is stuffed under the lay cord on top of the crossbar to tighten it, but if tested before being fastened, the cords should all be evenly taut.

If there is no blankbook sewing frame in the bindery equipment, tapes may be strung up in a manner similar to that used for cords. The tapes are fastened to the keys as for cords, but instead of being attached to the lay cords by means of a knot, they are pulled through the lay-cord loops and are held in place by pins (see Fig. 65). In order to be economical with tape, it is not cut, but is strung up in one continuous piece. This can be done by

Fig. 65.

leaving enough extra length between the keys and between the lay cords when they are strung up, so that it will be possible for the worker to move the tapes to conform with the positions for them marked on the back of the book.

CORDS VERSUS TAPES

Flexible sewing around cords is the strongest type of sewing in use by hand binders, and hand-bound books should be flexibly sewed unless there is good reason for sewing them over tapes. In my opinion, there are only two valid reasons for sewing books over tapes instead of around cords. The first is due to the format of the book, and the second is to allow the binder to have a

smooth back or an irregular grouping of bands in order to serve some artistic effect in his scheme of decoration.

The first reason, that of format, can be defended on the ground of utility. Books which are printed on thick, heavily sized paper and are made up with thick sections will never open freely if they are flexibly sewn. It seems a pity to bind these thick, stiff sections rigidly together by wrapping the sewing thread around cords. So it is, the binder seeks a way out, and he frequently decides to sew the book over tapes in order to make for greater suppleness. But even this manner of sewing will not entirely correct the stiff opening of a book if it has been printed on very heavy paper and is made up into thick sections. The only way to escape the dire result of a faulty format is to cut each section apart and make it up into several sections by guarding the pages together. This, of course, a binder hesitates to do and should never do without the consent of the owner. If he fails to do it, however, he is often blamed unjustly for being unable to bind books that open freely, and the real culprit, the printer, goes scot free.

The second reason for sewing over tapes instead of around cords is less defensible than the first one, as it is dictated purely by a consideration of aesthetics. However, I think it should be conceded as a proper practice under these circumstances so long as the binder takes care in sewing and uses strong materials for the work.

MATERIALS FOR SEWING

The size of the book should determine the size of the cord used in sewing, for the larger the book the thicker the cord must be, both for strength and for appearance. Since the cords will represent the bands on the back of the book after it is covered, their size has a bearing on the appearance of the finished binding. Sewing cord should be made of hemp with strands containing long fibers so that they may be frayed out and still retain their strength. When extra-heavy books seem to require especially

heavy cords, the book should be sewed on double cords. This method is stronger and produces a less clumsy appearance than would result if an excessively thick single cord were used.

All sewing tape should be unbleached, especially for use on heavy books, as bleaching chemicals serve to induce a rotting of the fiber of any material to which they are applied. The French, however, make a very finely woven tape that is bleached but exceedingly strong, and I have found it superior to some unbleached tapes, though the best quality unbleached tape is doubtless superior to it.

Thread for sewing should be made of unbleached linen. Linen thread is the most satisfactory for sewing, except when a very thin thread is called for, and then a surgeon's ligature silk may be used instead of thread. Any thread thinner than No. 30 is not suitable to use for sewing books, for it is liable to break when being tightened. Surgeon's silk will be found much stronger, and may be had in several thicknesses. I do not advocate using silk for sewing if it can be avoided, for it makes for a "slippery" book, that is, a book with sections that are liable to sag.

Hayes or Barbour's Irish linen thread will be found to be of excellent quality. It is sold by the pound and is numbered according to its thickness. Numbers 12, 16, 18, 20, 25, and 30 should be in stock to choose from, No. 12 being the thickest.

KINDS OF SEWING

There are three different types of sewing used by the hand binder. Flexible sewing around single or double cords is undoubtedly the strongest type and is that which is in general use in hand binderies. Its disadvantage, as I have already explained, lies in the fact that it tends to make for a stiff opening of a book when the text is printed on heavy paper, as the thread is wound completely around each cord so that the sections are held rigidly in place. Sewing over tapes induces an easier opening, and if

done with great care is quite strong and serviceable. Sewing "two-on" is by no means as strong as the other two types, but it is sometimes necessary to resort to it in order to reduce the swelling on the back of a book. Under no circumstances should sewing over sawn-in bands be practiced, as the book is weakened by being sawed into, and the holes produced are unsightly. This questionable method of sewing is used by some job binders, as it makes for speed. In Figs. 69 the thread pattern is shown for each type of sewing recommended above.

After the sewing frame has been strung up and the cords or tapes have been adjusted to the markings for the bands on the

JOINT

Fig. 66.

back of the book, the sewer should first determine the size of thread to be used.

The sewing thread runs all along the inside fold of each section, and it produces an added thickness, or swelling, at the back of the book. Some extra thickness is necessary if the book, after being backed, is to have a "joint" large enough to equal the thickness of the cover boards, for it is this increase in thickness along the folds of the book that permits the binder to turn over this joint into which the cover boards hinge (see Fig. 66). Too much or too little joint will cause a ridge on the leather cover along the back of the book. Hence a nice calculation must be made in selecting the proper thickness of thread.

Only experience will develop judgment in making this decision, but there are certain characteristics of the book format that play a part in it, and some general rules may be laid down to aid

the sewer in arriving at the right thickness of thread to use. Three things must be taken into consideration: the number of sections making up the text, the thickness of the sections, and the quality of the paper. If the sections are few and thick, a thickish thread is required. If they are numerous and thin, then a thinner thread is called for. If the paper is soft-finished and not heavily sized, the thread will sink into it and its swelling value will be diminished. Conversely, the thread will stand out on a sized paper and notably increase the swelling of the sections. Summing up roughly, we may say that fewness of sections and unsized or slightly sized

Fig. 67.

paper tend to call for a heavier thread than numerousness of sections and heavily sized paper.

Having made the choice of thread to be used, the binder fastens the skein around the right-hand upright of the sewing frame, convenient for use, and selects a darning needle with an eye that will receive the thread easily. A darning needle is used for sewing thread because it has an egg-shaped eye that allows the thread to go through without too much bulking. For silk, a milliner's needle with a round eye is used, and after the needle has been threaded, the silk is spliced with the point of the needle about an inch from one end. This splicing will fasten the needle and keep it from slipping off while working.

A pair of shears, a folder, a sewing stick (see Fig. 67), and a

low stool are needed for the sewing operation. It is necessary to use a low stool so that the sewer may rest her left arm comfortably on the bed of the frame and will be in a position to sew efficiently and to use both hands in the operation.

The book having been collated and made ready for sewing, it is placed on the workbench back of the bed of the sewing frame with the head to the right and the fore-edge toward the worker. Then a pressing board is laid on the bed of the frame up to the cords so as to elevate the book while sewing, because it is difficult

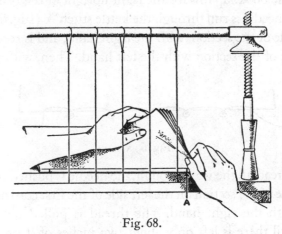

Fig. 68.

to insert the needle through the sections unless they are raised above the bed of the frame.

When beginning the sewing operation, the worker takes the top section off the book with the left hand and turns it over so that the fold faces her and is brought forward onto the bed of the frame. The section is grasped with the right hand at the fold as shown in Fig. 68, and with the left hand half the pages are counted off until the middle of the section is reached. The left forefinger is held in the middle of the section, and the section is knocked up at the head. It is placed against the sewing cords, with the head to the right and with the marks on the back of it

adjusted to the position of the cords. Holding it in this position, with the left hand inside the middle of the section, the sewer is ready to begin sewing the section around the cords (see Fig. 70).

FLEXIBLE SEWING ON SINGLE CORDS. From the thread pattern for flexible sewing on single cords shown in Fig. 69 A, it will be seen that the sewing thread is wrapped entirely around each cord as the section is being sewed. Assuming the position indicated in Fig. 70, the sewer begins sewing the first section at the head of the book, up toward the right upright of the frame. The threaded needle is run through the kettle stitch A (Fig. 68) from the outside of the section, with the right hand, and is received on the inside of the section with the left hand. Then, without pull-

Fig. 69 A.

ing the thread all the way through, the needle is pushed out from the middle of the section on the left side of the first cord and is received with the right hand. The thread is pulled toward the sewer until there is left only about two inches of it protruding from the kettle stitch. The needle is now inserted on the right side of the first cord, is received by the left hand inside the section, and is pushed out on the left side of the second cord. It is pulled tightly and inserted on the right side of the second cord. This manner of sewing is continued around all five bands, when finally the needle is passed out of the kettle stitch at the tail of the section. The next section is then put in place on top of the first one, after the center is found as previously directed, and it is lined up squarely at the head with the first section. A folder will be found convenient for this purpose. Next, the needle is inserted through the tail kettle stitch from the outside of the section and is

pushed out on the right side of the fifth cord. The thread is now
pulled tightly and the needle is inserted from the outside on the

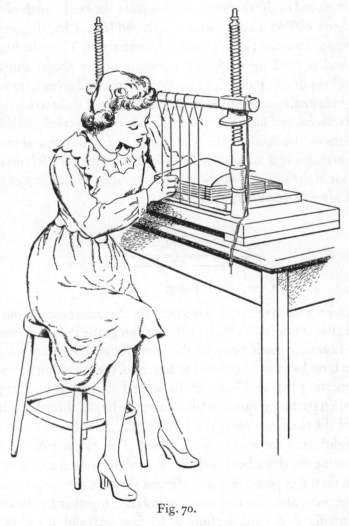

Fig. 70.

left of the fifth cord, thus completing the wrapping of the cord.
It is brought out again on the right side of the fourth cord, and
the sewing is continued in this manner until the head kettle stitch

of the second section is reached. When the thread is brought through this kettle stitch to the outside of the section, it is tied to the loose end of the thread projecting from the kettle stitch of the first section. To make this knot, the thread fastened to the needle is wrapped around the left hand to form a noose. Then the hanging end is stuck up through the bottom of the noose, and the thread is pulled up tightly. This knot is repeated so as to ensure a tight fastening, and the loose end of the thread is cut to a length of about one-half inch and is placed between the second and third sections on the inside of the text. It may be frayed out and made soft so that it will not mark the book. It should not be left on the outside of the sections, as it would form a ridge on the back of the book after the book is covered.

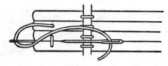

Fig. 71.

After the third section is sewed and the thread is brought out of the kettle stitch on the back of the section at the tail, there must be a fastening made between the second and third sections. As there is no loose end of thread to fasten to, the fastening is made by inserting the needle under the second section, as in Fig. 71, and then putting it through the loop made by the thread coming out of the third section at the kettle stitch. The thread is pulled up tightly and the sewing is continued. This manner of sewing by pulling the thread out of the far side of the section and returning it on the opposite side is continued through the whole book. All sections, after the first two, are fastened together by sticking the needle under the section to be fastened and drawing it through the loop formed. Care must be taken to pull the thread tightly at each band after it comes from the inside of the section, and it must be pulled straight along the sewing frame and in the

direction in which the sewing is proceeding, for otherwise there is danger of splitting the paper. When the final section, or end paper, is sewed, it is fastened off like all the others, except that two fastenings are made instead of one. In other words, after fastening the last section to the first one below it, the worker repeats the fastening under the second one below, draws the thread through into the inside of the back between the sections and cuts it off, leaving about one-half inch. The thread is then frayed out and left between the sections.

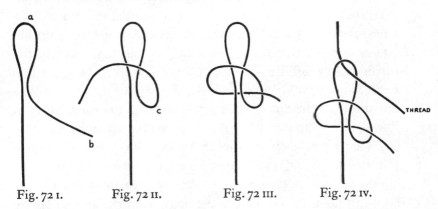

Fig. 72 I. Fig. 72 II. Fig. 72 III. Fig. 72 IV.

When one strand of sewing thread is used up, another strand must be tied on with a weaver's knot. To make this knot, first an ordinary slipknot is made on the end of the new thread. This is done by holding the thread with the left hand and forming the Loop a as shown in Fig. 72 I. Then the free end of Thread b is passed over in front of Loop a, thus forming a second Loop c at right angles to Loop a and passing over it (see Fig. 72 II). Next the free end of Thread b is brought around the back of Loop a while Loop c is kept flat in place by holding the left thumb on it, and the end is stuck up through Loop c from the underside (Fig. 72 III). The end is pulled down, and the knot pictured in Fig. 72 IV results. This knot is pulled up from both End b and the other long end of the thread, with the left thumb kept on top of the

knot as the pulling is done. The thread coming out of the book is then inserted into Loop a from the underside, and with the right hand it is grasped together with End b. The two threads are simultaneously pulled against the long end of the thread. If directions are followed carefully, this knot will hold. The only trick in making it is being sure that Loop c is kept in position as shown in Fig. 72 IV. If the top of this loop is allowed to fall over, the knot will not hold. After the knot is made, it must be pulled into the inside of the section and left there.

During the operation of sewing, it is essential to keep an even tension of the thread all through the book. The sewing must not be too loose, so that the sections sag, nor too tight, so that the thread is strained. Especial care must be taken to keep the two kettle stitches evenly tightened, else the head of the book will be broader than the tail, or vice versa. In order to ensure an even line all along the sections, it is well to use the sewing stick (Fig. 67) during the process of sewing. By inserting this stick (which is loaded at the end with lead) between the cords, and using it to tap the sections on the top, the book may be made solid and kept even in thickness. To remove the book from the sewing frame after the sewing is finished, first the cords are freed from the lay cords by pulling their ends. This unties the knot. Then the keys are freed.

If this ambidextrous method of sewing is adhered to, the tension of the thread is sure to be more even than in any other manner of sewing, because the left hand is held against the inside of the fold and serves to keep the sections close up against the cords. At first it may be somewhat awkward for a beginner to make the left hand do its allotted work, but after a little practice, this method becomes a mechanical matter, and both speed and ease in sewing are facilitated, for the sewer has no need to interrupt the rhythm of the operation by having to stop and inspect the sewing on the inside of the fold.

FLEXIBLE SEWING ON DOUBLE CORDS. Books were usually sewed on double cords in mediæval times, and this type of sewing is very desirable for large, heavy books, as the double wrapping of the thread around the cords makes for great strength. This wrapping forms a figure eight (see Fig. 69 B) so that the thread if broken on one cord will be held by the other; thus a section is prevented from being entirely loosened. Flexible sewing over double cords follows the same procedure in general as that for single cords, the only difference being that the wrapping operation is repeated each time. Starting at the kettle stitch near the head of the book, the needle is inserted and then, after being received by the left hand on the inside of the section, it is pushed out between the two cords, is wrapped around the first of the two,

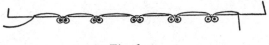

Fig. 69 B.

and is inserted on the right side of it. The needle is next brought out on the left side of the second cord and is pushed in again between the two cords.

SEWING ON TAPES. When stringing up with tapes, the operator must be sure to keep the tapes flat. A book sewed over tapes is not as firmly held together as one flexibly sewed, and in order to avoid too great looseness, it is best to catch every four or five sections together with a stitch called a "catch stitch." The thread for sewing on tapes does not encircle the tapes but merely passes over them. It comes out on one side of the tape, goes over it, and then returns to the inside of the section, and so on. After three or four sections are sewed, the catch stitch is made. To make this stitch, the needle, after it comes out of the right side of the tape and before it goes across the tape, is pushed eye-end down under the three or four threads below it and is then inserted into the

loop formed by this procedure. The thread is pulled up tight, forming a knot in the center of the tape, and it is afterward drawn back into the middle of the section. The catch stitch is made on all the tapes to the end of the section, as shown in Fig. 69 C. To unfasten the book from the frame, the tapes are all unpinned. Then the first tape is pulled through the sewing at the back of the book, an end of about one and one-half inches being left, and the opposite side of the tape is cut to the same length. Each tape is pulled through in this manner and is cut off. Thus all the tape not needed for the job is left in one continuous piece and may be used again.

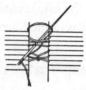

Fig. 69 c.

SEWING TWO-ON. Sewing two sections on at a time is obviously not as strong as sewing "all-along" and is done only when it is necessary to reduce the swelling in the back of the book that would be caused by sewing a large number of very thin sections together.

When sewing a book "two-on," the first and last two sections should be sewed all-along. After the first two sections are sewed, the next section is put in place and is lined up at the head with the one under it. The thread is then inserted at the kettle stitch of this section and is brought out at the left of the first cord. Then a folder is put in the middle of this section to keep the place easily, and the following section is put in place. Now the needle is inserted into the upper section on the right side of the first cord and is brought out on the left side of the next cord. Then a folder is put inside this uppermost section to keep the place, and the thread is inserted on the right side of the section below, and so on

along the length of the book. Finally, the last two sections are sewed all-along. This will form a thread pattern such as is shown in Fig. 69 D. With this sewing, there will be only three stitches of thread inside of each section, in a book sewed on five bands,

Fig. 69 D.

whereas there would be six stitches if the book were sewed all-along. Hence the swelling in the back of the book will be reduced by half. The work is strung up and removed from the frame as for flexible sewing on single cords.

CHAPTER X

FORWARDING (Continued)

Fraying out Slips, Gluing Up and Rounding, Backing

FRAYING OUT SLIPS

AFTER the book has been sewed, the ends of the cords should be cut off, about two inches on each side of the book being left. These ends are called "slips," and they must be frayed out soft enough so that they can be laced flat through the boards.

To fray out the slips, the book is placed on the workbench with the back toward the worker, and a carpenter's awl or a binder's bodkin is inserted into the cord in order to separate the strands (see Fig. 73). Most English cord is made of two strands, but

Fig. 73.

cord of other manufacture often has three or four strands. After the strands are separated their fibers are then made into a soft mass by fraying them out with an awl which has the point flattened on two sides (see Fig. 74). This flattened point makes it possible to fray the slips without curling them if it is inserted into them from the back, with the thumb held against them at the front, as shown in Fig. 75. It does not do to simply pass the awl over the surface of the slip. The point must be made to actually pierce the strands in order to separate the fibers.

It is well to hold the opposite end of the slip while it is being

frayed out, or the whole cord may be pulled through the thread loops. If this should happen, it probably means that the sewing is too loose, but the damage may be remedied by threading the slip through a large-eyed darning needle and working it again through the thread loops. However, rarely is it possible to work

Fig. 74.

the slip back in its entirety, and it is wise to avoid such an accident by keeping firm hold of the lower end of the slip.

GLUING BOOK AND ROUNDING

GLUING UP. The next operation after fraying the slips is gluing up the back of the book and rounding it, preparatory to backing. The gluing-up process is necessary in order to hold the sections together while they are being formed into the shape they are to assume permanently.

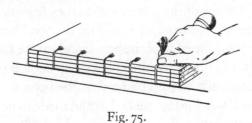

Fig. 75.

There are many kinds of glue, each of which varies in quality. Only the best quality glue should be used in bookbinding (see Chapter XXI, p. 314). After the glue is heated, it should be thinned down with water for the gluing-up operation to a consistency which is neither too thick nor too thin. If too thick, it will make too heavy a coating on the back of the book which tends to stiffen it and hinders its easy opening. If too thin, it will penetrate

too far between the sections and will damage the pages of the book. There is a tendency to use the glue too thick rather than too thin.

Glue should never be used in front of an open window unless the outside temperature is quite warm, for the least draft tends to congeal it. Glue should be hot enough to run freely from the brush when tested in the gluepot and if further testing is needed, it may be spread on a piece of wastepaper to be sure that it does not drag when being applied. A certain amount of speed is necessary in spreading glue, for it dries quickly, and for this reason, before beginning to apply glue, it is necessary to have everything in readiness for a straightforward job. All tools and materials used in the work must be conveniently placed. Delays caused by the necessity of shifting the position of the work, with the glue brush poised in mid-air, are likely to be fatal.

To glue up the back of a book, it is knocked up at head and back until all the sections line up evenly and are square at the head. It is very important to have a book knocked up evenly and squared perfectly before gluing, for it is almost impossible to change the position of the sections after they are once glued. A single thickness of wastepaper is laid on the workbench so that it projects beyond the edge of the bench and can be folded down over the edge. On the paper, the knocked-up book is placed even with the workbench edge. The head of the book is kept to the right, and the lower slips are tucked in and made to lie flat underneath the book so that they will not be glued. Then the upper slips are spread flat over the top surface of the book, and an old cover board is laid on top of them and is brought up even with the back edge of the book. The cover board is held very firmly in this position, with the left hand pressing down with considerable force to prevent the glue from oozing through onto the outside surface of the end papers. A rather sparse coating of glue is then applied to the back of the sections. (A thin coating of good glue

will perform its function far better than a thick coating of inferior glue.) The glue should be well brushed on so that it will slightly penetrate between the sections, and it should be applied with a stroke toward the head and tail edges of the book, in order that these edges will not be stained by it. A large, rather short-bristled, copper-set brush is used for gluing, and it should be held as for spreading paste, in order to give the worker proper control of it (see p. 43).

Many English hand binders screw the book up in the press for the gluing-up process, but this method takes more time than the one just explained, the slips are more likely to get daubed with

Fig. 76.

glue, and, if the book is screwed up too tightly, no glue will penetrate between the sections. It is desirable that an infinitesimal amount of it should penetrate, first in order to make the book less likely to separate inside between the sections, and also to hold the book sufficiently rigid so that it will remain solid after most of the glue is cleaned off.

After the gluing is finished, the book is taken between the two hands and is knocked up at back and head firmly on a piece of wastepaper. It is then set aside on the edge of a table or bench to dry, with the slips brought out at right angles to the side of the book (see Fig. 76). If there is any glue on the frayed slips near the book, it should now be cleaned off with a knife before it has time to harden.

An ordinary gluepot like that used by cabinetmakers answers the binder's purpose. The glue is heated in it over a gas stove. But a more convenient gluepot is an automatic electric one with a pilot light. A gluepot should be fitted with some device so that all surplus glue can be taken out of the brush before it is used. Some binders fasten a heavy wire or a braided cord from one ring of the pot handle to the other ring so that the wire or cord stretches tightly across the middle of the pot. The surplus glue may then be taken out of the brush by stroking it over this rigid line. Other binders keep a small wooden paddle in the gluepot

Fig. 77 A. Fig. 77 B.

and stroke the brush against it in order to remove the glue. (Consult p. 315 for information about preparing glue.)

ROUNDING. The back of every book must be made convex in shape, or the very weight of the sections will force it into a concave form (see Fig. 77 A). We have examples of sunken backs in some of the mediæval books now extant.

The object of rounding the backs of books is to produce a smooth evenly curved surface that can be successfully titled; to prevent sinking in; and to utilize the swelling value of the sewing thread so that a "joint" may be formed to support the thickness of the cover boards and keep them from slipping over the

back of the book. If there is too great an amount of swelling, due to miscalculation about the thickness of thread used in sewing, the back will have an exaggerated roundness that is not attractive and that hinders the free opening of the book (see Fig. 77 B). If not enough swelling has been achieved in sewing, it will be difficult to induce a sufficient amount of joint to hold the boards, and the back will be dangerously flat. The flatter the back of a book the easier the opening — all things being equal — and a good rule to follow is to produce only enough swelling to ensure a sufficiently large joint and to leave the back as flat as possible consistent with utility.

After the back has been glued and has been left until the glue ceases to be "tacky," the book is ready to be rounded. It should not be left so long that the glue becomes hardened. Preliminary to the actual rounding, the book is placed on the workbench with the fore-edge toward the worker, and the sections are "started" from the center outward. To do this, the back is brought over toward the worker by placing the fingers of the right hand under the book and the palm of the hand on top of it and forcing the sections over until the back lies almost flat and is inclined toward the worker (see Fig. 77 C). Then the backing hammer is grasped in the right hand, and the sections are stroked from the center upward with a light tapping all along the back and with the hammer held so that the handle is at right angles to the length of the book (see Fig. 77 D). The book is then turned over and the same operation is repeated on the opposite side. This starting of the sections in the proper direction makes for an easier and more symmetrical rounding.

Next the book is knocked up at the head and back and is placed upon the bench again with the fore-edge toward the worker. With the thumb of the left hand in the middle of the fore-edge and the fingers spread out over the upper part of the book, it is held firmly while, with the fingers of the right hand under the

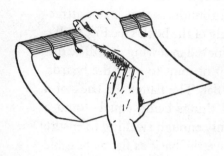

Fig. 77 C.

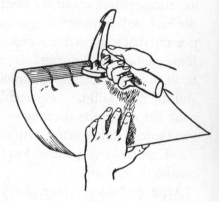

Fig. 77 D.

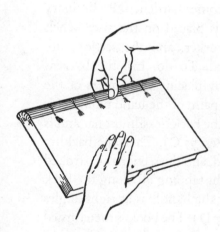

Fig. 77 E.

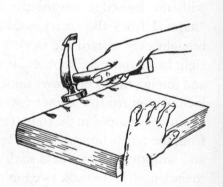

Fig. 77 F.

book at the back, the palm of the hand draws the back over evenly all along the length of the book (see Fig. 77 E). Held in this position, the back of the book is lightly stroked with the hammer from the center upward all along, and then on top of the book all along the back edge, the book is hammered smartly with a few evenly directed perpendicular strokes. This clinches the sections in the position they have assumed (see Fig. 77 F). Now, with the book held very firmly to keep the upper half in this position, it is turned over, and the same operation is performed on the second half of the book.

If adroitly done, the rounding will be perfect. If it is not perfect, the book should be tapped and brought into a symmetrical shape. This completes the rounding.

If the glue has been left too long and is hardened, it may be softened by moistening the back with a dampened sponge several times and then left to stand until it becomes pliable. If necessary, it may be freshened by applying an excessively thin coating of glue.

BACKING

The object of backing a book is to solidify and make permanent the round shape already given the back and to make the groove, called a "joint," on each side of the back for the boards to lie in. This is accomplished by fanning one section over the other on each side of the center of the back, thus making the sections with their thread stuffings incline toward the edges and away from the center, and then by turning over at right angles the first and last sections, to produce the "joint." If the sections were not thus fanned over, it would be impossible to form a joint that would hold, for the bulk of the sections with their added thread must be induced to incline their weight toward the side edges of the back in order to make a reinforcement to hold the joint firmly.

In a book composed of ten sections, there are ten strands of thread, running all along the inside folds, which make the back that much thicker than the fore-edge of the book. This extra thickness, or swelling, must be properly disposed of, for unless it is utilized to make the back evenly round in shape and to form a joint, after the boards are laced onto the book and the book is pressed, it will cause the back to cave in and will produce a wavy fore-edge line. If there is too much swelling in the book, so that the back becomes exaggeratedly round, the sections are almost

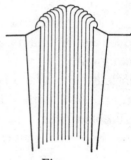

Fig. 79 c.

sure to split in the center when the book is being backed (see Fig. 79 C).

The sections must be fanned over evenly with a sidelike stroke of the hammer that follows a curved line like that bounding the sides of an ellipse (see Fig. 78), rather than with a direct, straight stroke. A direct blow of the hammer will crush the sections, as shown in Fig. 79 A, and a creased line will result on the inside of the book along the back. An uneven fanning over of the sections will produce a deformed back (see Fig. 79 B), which, though it may be corrected to some extent and be forced into a fairly symmetrical shape, will almost certainly tend to return to its crippled contour after a little use of the book.

To back a book after it has been glued up, it is placed between backing boards and is lowered into the lying press. First, with a

pair of spring dividers, the thickness of the cover boards to be used is measured, and this distance is marked on each outside section near the head and the tail. To indicate the measure on the

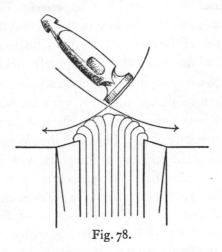

Fig. 78.

book, one prong of the dividers is placed at the back edge of the sections, and dots are made with the other prong on the sides of the sections. The dots are marked with a pencil point. This dis-

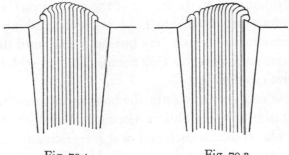

Fig. 79 A. Fig. 79 B.

tance represents the width of the joint to be turned over. The press is then opened evenly to a distance approximating the thickness of the book, plus the thickness of the backing boards. Each side of the book and each backing board is lightly chalked

with a piece of white chalk to keep the book from slipping. One backing board, an inch or two longer than the book, is now placed across one end of the press, with the beveled edge away from the worker and the steel face uppermost. The book is laid upon this board, and the flat face of the second board is placed on the upper side of the book exactly up to the dots made to indicate the width of the joint, with the slips left sticking out.

Since the book is lying in a position straddling the press opening, it may then be picked up easily with the boards, and it is turned over without disturbing the position of the backing board that has been correctly placed. The book should now be placed as before, straddling the opening of the press, with the back away from the worker. The first backing board, on which the book was laid without exact placing, is put in position on the dots, with the slips of the book out, and it is pressed down firmly until the edges of the two backing boards are in line with each other. With the left hand, the book and boards are picked up and placed between the opening of the press while the right hand screws up the press sufficiently to hold the book lightly. Then the operator steps to the side of the press, adjusts the book so that it is exactly the same distance from the screws of the press at each end, and gradually lowers the book into the press jaws by pushing it down and unscrewing the press a very little at a time until the lower edges of the bevel of the backing boards rest even with the jaws of the press (see Fig. 80).

It is now necessary to tighten the book in the press evenly to prevent it from slipping while it is being backed. If the book has not been placed so that each end of it is equidistant from each screw, it cannot be tightened evenly. Hence, the distance between the screws is measured at each end and is kept even while the book is being screwed up. To screw up the press, an iron pin is placed in the holes of the screw operating ends (see Fig. 1), and the screws are thus revolved and tightened.

Standing either at one end or on one side of the press while backing, the worker holds the hammer close up to its iron head, with the handle parallel to the length of the book. Beginning at the center of the back, all the sections are fanned over on each side from the middle toward the edge, using the stroke pictured in Fig. 78. The first strokes should be light all the way across the back in order to effect an even, smooth contour. Then the back should be gone over again with increasingly heavy strokes until all the fullness has been brought over to the line where the joint is to be formed. When this is accomplished, the hammer is tapped

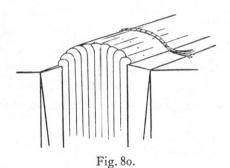

Fig. 80.

along each joint until the joint has been turned over sharply at right angles to the back. This stroke is more direct than the stroke for fanning over the sections, but it must not be too heavy, for fear of splitting the end papers.

When a book has too much swelling, it is often difficult to get it into the press for backing and keep the backing boards from slipping below the marks indicating the joint. This difficulty can be overcome by inserting into the sheets of the text a few pieces of newsboard fully as large as the pages of the book. These boards should not extend up to the back of the sections but should be placed about three-eighths of an inch forward of the back folds. The book may then be lowered successfully into the press without slipping below the joint marks. The sections are first fanned

over up to the line of the joint, but the joint must not yet be turned. The book is taken out of the press after this first fanning over, and the cardboards are removed. It is then put back into the press and will be found to hold in place without the cardboard

Fig. 81.

stuffing after it has been given this rounded shape. The backing is then proceeded with, and the hinge is turned over.

When the backing is finished, it is good practice to remove some of the glue and rub over the back with a piece of wood with a curved end, called by the French a "frottoir" (Fig. 81). To remove the glue, some thin paste is put over the back and is left to stand a few moments. The glue will then be found to be softened

Fig. 82.

and will yield to the action of the frottoir, which may be used to smooth out any irregularities in the shape of the back. Before removing the book from the press, it is well to check the cords for distance and straightness. If they need to be moved, they may be dampened slightly with a sponge; then a straight, thinnish piece of boxwood, like a modeler's flat stick (Fig. 82) is put against each cord, and the end of the stick is tapped with a hammer until the cord is straightened and brought to the position desired. After the book has been taken from the press, it should be kept between boards large enough to protect the joint, and when laid down without boards while in work, the joint should protrude beyond the bench so that it will not be injured.

A backing hammer, in my opinion, should be fairly heavy and should have a large, almost flat face and a short handle (Fig. 83 A). It should be so weighted that when held close up near the iron head, as it should be held in backing, it almost balances in

Fig. 83 A.

the hand without grasping it around the handle. Some binders prefer a small, light backing hammer with a square head (Fig. 83 B), and they contend that it is easier to turn the sections over evenly near the bands with such a hammer than with a large,

Fig. 83 B.

round-faced one. However, I believe better backing can be done with a large, heavy hammer than with a light, small one, for the very weight of this hammer makes it unnecessary to force it, and as the hammer covers a larger space, it is less likely to leave little indentations on the back of the book. As for being able to reach the sections close up to the bands with a large hammer, that is

purely a matter of knowing how and of having a hammer with the face not too rounded, for if the hammer is tipped so that only the forward edge is allowed to come in contact with the sections

Fig. 83 c.

next to the bands while the stroke is being made, the sections may be turned over at this point, very neatly and evenly. A smaller model of hammer is sketched in Fig. 83 C.

Fig. 84 A.

Backing boards are usually made of wood, beveled on the upper edge and faced with steel. Several pairs of these boards, suitable for different-sized books, will be needed. The bevel should be fairly long, to avoid the possibility of cutting the book along the joint (see Fig. 84 A). All-steel backing boards are preferred by some binders. They are long so that they may be used

for a book of any size, and they are put in the press separately from the book with their projecting flanges resting on the cheek of the press (see Fig. 84 B). Then the book is placed between them on the line of the joint. When a book is perfectly rounded

Fig. 84 B.

and has not too much swelling, it may be more quickly placed in the press for backing between the all-steel stationary boards than between adjustable boards, but because of the fact that the steel-faced boards are adjustable, they permit of manipulation in the placement of a book that is often very desirable and sometimes even necessary.

CHAPTER XI

FORWARDING

Cutting Boards to Book. Holing-out and Grooving Boards for Lacing. Lacing-in

CUTTING BOARDS TO BOOK

A DIFFERENT calculation must be made for cutting boards to size for a book which has the head already cut and the other edges trimmed or left rough, than for a book the edges of which are to be cut "in-boards." I shall explain how to estimate the size of boards in both cases.

CUTTING BOARDS IN A LEVER CUTTER. Cutting and trimming book-edges are two distinctly different operations, and most hand binders cut only the head of a book and leave the other edges untouched or merely trimmed. To cut boards for both these types of books, the lever cutting machine is generally used, although boards can be cut with the plough when there is no cutting machine in the equipment. Boards may even be cut by hand on the bench, but this is not practical for a binder whose time is a consideration. The hand method of cutting would never be used except by the amateur binder who had to work without much equipment. The rules to follow in measuring for the size of the boards are the same in any instance.

When cutting boards in a lever cutter, first a straight edge is cut along the length of the board. This is called "backing" the board. The board is then squared at one end, is next cut for length, and is finally cut for width.

One board is placed with the long edge under the knife anywhere in the middle of the cutter, and the least possible amount is cut off it in order to produce a straight edge. The second board is likewise cut. One board is then held at the near end of the cutter against the metal edge used for squaring, and one end of it

is squared to the straight edge just cut. This is repeated on the second board. Then one of the boards is placed on the side of the book, and calculation is made for cutting the length. The board should extend in length over the over-all length of the book about one-eighth of an inch at both head and tail. This extension of the board beyond the text is called the "book-square." When this length has been determined, it is marked on the board at the cut edge. The board is now put in the cutter up against the squaring line, and when it is placed so that the knife will cut through the mark, the guide on the top of the cutter is set so that it touches the back edge of the board. The length is then squared on this board, and the second board is placed in position and squared to the same length. The width of the board is cut in like manner.

To measure the length of the boards for a book the fore-edge and tail of which are to remain uncut, a board is placed on the book so that its squared end extends about one-eighth of an inch beyond the cut head of the book. It is then marked at the other end so as to allow it to extend one-eighth of an inch over the tail of the book.

To measure the length of the boards for a book to be cut in-boards, the amount to be cut off the head and tail of the book should be determined and marked on the front end paper of the book. Then one-eighth of an inch is allowed for the book-squares at head and tail, by adding one-quarter of an inch to the final length indicated for the book.

The manner of measuring for the width of the boards will also differ for the book with trimmed edges and the one cut in-boards. In both cases, however, the two end-paper sections are first cut to the longest width of the text, as they are usually pushed forward in backing. To measure for cutting the end papers, the point of one prong of a pair of wing dividers (see Fig. 43) is placed close up into the joint on the outside protection

sheets, and the end papers are slightly raised at the fore-edge so that the width of the first and last sections of the text may be seen. The points of the second pair of dividers are opened and set to an average measure. This distance is marked on the fore-edges of the two end papers, and they are cut to it with a knife and straightedge, after a cutting tin has been put under the end-paper sections. For a trimmed-edge book, an eighth of an inch is added to this measure for the width of the boards, in order to have the same book-square on all three sides. For the book to be cut in-boards the amount to be cut off the book is determined and marked on the book. Then the dividers are set to one-eighth of an inch beyond this mark, measuring from the joint. It is wise to allow a generous measure for the boards of books cut in-boards, because if the squares are too large after the boards have been laced on, it is a simple matter to cut them down, and if the squares prove to be too small, a new pair of boards will have to be gotten out. However, small squares look trimmer than large ones on a book, and at the fore-edge they enable the reader to open the book with greater ease. An experienced workman can calculate to a nicety for these measures.

By using the back guide in cutting and the metal side for squaring, the two boards will be cut of an exact size, and both of them will be square. Boards must be square, or the squares of the book will not be even. A good cutting machine, if kept with the knife frequently sharpened, will cut boards to a very smooth edge.

CUTTING WITH A PLOUGH. To cut the boards of a book with a plough, the lying press is turned over so that the cutting side is uppermost. The two boards are then lowered into the press with two thick cover boards or a wooden cutting board back of them, that is, on the side next to the runners, and the press is screwed up tightly. A straight edge should be cut off the long side and as

little as possible taken off the board. A cutting board (Fig. 91) is like a gilding board except that it is not quite so wide, and it is used to "back" the boards that are being cut, in order to prevent the knife from cutting into the cheek of the press.

To do this cutting, the operator stands at the end of the press, with the plough knife on his right, and he pushes the plough forward and screws it up until it touches the board. Then holding the plough with his right hand on the handle and his left hand on the end of the screw, he runs it forward and backward and makes the knife cut into the board by slightly screwing it up

Fig. 85 A.

with the handle as it goes forward and releasing it a little as it comes back. The plough must be kept firm on the cheeks of the press as it runs through the guides and is made to cut (see Figs. 85 A and 85 B).

After a straight edge is cut along the length of the two boards, they are taken out of the press, and one end of each board is marked for squaring. A carpenter's square is placed along the straight edge of one of the boards near one end. Then dots are marked at each end of the blade of the square to indicate where the next cutting is to be done. The boards are then knocked up together on their straight edges, and with the marked board facing toward the knife, the two boards are lowered into the press as

before and placed so that the plough knife will cut through the two dots. To test whether the boards are accurately placed, the plough knife is run along and made to touch the marked board very lightly near the dots. If it does not hit the dots, the position of the boards must be corrected.

After this, the length of the boards is cut. The length is determined as described for cutting by machine, and the square is used to mark the length in two places, as for the first squared end. The boards are knocked up and cut as before. Finally, the

Fig. 85 B.

width is marked on the boards, from the square placed at the edge, and this last edge is then cut.

In order to test a pair of boards for squareness after they have been cut, the position of the boards is reversed and after they have been knocked up, any deviation will be shown. The inequality will be doubled by this reversing, and the boards should not be used but should be put aside for a smaller book.

The English plough is made with a knife that fits into the bottom of the plough with a square bolt, whereas the French plough has a knife that runs through a metal slide in the bottom. Both

knives are fastened in a similar manner, by screwing down a nut at the top of the plough. The English press is of all wood and is operated by screwing up the jaws with an iron pin. The French press has iron screws which are operated by a metal wheel placed at the center on one side of the press. The guides for holding the plough are of metal, and the jaws of the press are topped with metal. Both styles of presses are shown in Fig. 1, A and B.

Plough knives must be ground frequently and the bevels kept thinned, or the knives will not go through the boards easily. When used for cutting boards, these knives should not have too fine a point, as a fine point is liable to be broken off in board cutting. A slight rounding of the point is advisable for this work.

HOLING-OUT AND
CUTTING BOARDS FOR LACING

HOLING-OUT. After the boards have been cut to size, they are holed-out and laced onto the book. To hole-out the boards for cords, one board is put in place with its double lining inward, close up to the joint and is adjusted so that it extends the same distance over the text at the head and tail of the book. In case of a book to be cut in-boards the board is placed with reference to the margins on the end paper which indicate the cut size of the book. The book is then laid on the bench with the top board in place and the back toward the worker. The frayed slips are brought over the back of the book so that the center of each one may be found and its place marked on the board near the joint. Then the board is removed from the book and placed on the bench. A pair of spring dividers is set to about three-eighths of an inch. One point of the dividers is held against the back edge of the board, and a line is made with the other point along the length of the board on its outer side.

A small try square (Fig. 86) is then placed against the back edge of the board at each point that has been marked to indicate

the center of the slips, and a line guided by the square is drawn
with a pencil through these points at right angles to and crossing
the three-eighths-inch line drawn by the dividers. Where these

Fig. 86.

lines cross indicates the points at which a hole is to be made
through the board (see Fig. 87).

To make these holes (five in number, if there are five slips) the

Fig. 87.

board is placed on a block of lead with a piece of cover board
over it to prevent the bookboard from being damaged by the
lead. A round-pointed awl is then used to punch the holes
through the board. The awl should be struck firmly with the

backing hammer, making holes through the board large enough so that the slips may be passed through them. The board is then turned over and placed on the edge of the bench, with the holed-out side toward the worker, and with a sharp utility knife the material that has been punched through the board is cut off flat with the surface of the inside of the board.

Then the dividers are opened about one full turn, and a line is drawn with them on the inside of the board near the previously made holes. Now another row of holes is punched through the board from the inside outward. Starting from the head, a hole is punched on the line made by the dividers about three-eighths of an inch from the first hole and down toward the tail. A hole is likewise punched the same distance below each of the holes in the first row. This second line of holes will be a trifle beyond the first line, so that when the slips are laced through, they will come through on a slight angle. This serves to hold them more firmly than would be the case if they were pulled through on a straight line with the first holes. The board is then turned over, and the surplus material on the upper side is cut off. The second board is holed-out in the same manner.

Grooving Boards for Lacing. When the boards have been holed-out, grooves are cut along the back edge, into which the slips are sunk. Before this work is done, the boards should be put in place on the book to test the depth of the joint with relation to them. If the joint is too deep, so that it is higher than the boards, the fault cannot be entirely remedied at this time, but by tapping the back of the book over toward the board along the joint, the fullness is forced toward the middle of the back of the book, and the joint is made somewhat smaller. This increases the roundness of the back and is to be avoided if possible. It is usually better to wait until after the boards have been laced onto the book and then glue a piece of newsboard over the outside of the board.

Newsboard may be had in several thicknesses, and a thickness is chosen which, when added to the board of the book, will compensate for the discrepancy. This newsboard is glued, not pasted, for gluing warps less than pasting, and it is not desirable to warp the cover boards.

If a joint is not deep enough to equal the thickness of the board, a sandpaper block is run over the back edge of the board until it is made to conform in thickness with the joint. Care must be used not to make a sharp bevel along the board by this sandpapering. The bevel should extend far enough over the board so that it slopes very gradually toward the joint in order to avoid its being noticeable after the book is covered. Sandpapering blocks of various sizes covered with sandpaper of different degrees of harshness are needed by the bookbinder. It is useful to have a wooden stick, about eight inches long by three-quarters of an inch thick by one inch wide, covered on one side with a fine grade of sandpaper and on the other with a coarser grade. One or two blocks five inches by three inches by one-half inch, covered with different grades of sandpaper, are also useful. The sandpaper should be glued in place.

Now the grooving of the boards is proceeded with. This is done in the following manner. The slips are first freed of all glue and are thinned out, if necessary, to avoid their showing appreciably on the sides of the book after it is covered. This thinning-out process requires some judgment. The slips should not be thinned so as to vitiate their necessary strength. It is desirable to have them show as little as possible on the outside of the covered book, but strength should never be sacrificed to appearance. It is safe to thin down English cord somewhat, but with other cord one must beware, as the fibers are not too long.

I think the lacing-in method followed by mediæval binders is unnecessarily crude. If the sewing cord is made of hemp in long continuous strands, very few strands are necessary to hold the

boards firmly and permanently in place. Therefore, when a really fine English cord is used, it is safe to reduce it somewhat as it laces into the boards, and exaggerated lumps in the leather on the outside of the cover will be avoided, thus facilitating the tooling near the joint and achieving a more "finished" cover. However, I confess that I belong to the school of binders and bookmen that rather likes to have the structural features of a binding not altogether obliterated for the sake of making a surface for the designer of the cover to utilize for purely decorative purposes. To my mind, the structural features of a binding, if not too obtrusive, are as significant as the decorative features and would better be turned to account in carrying out the decorative design than sacrificed to it.

Once the slips have been freed of glue and are reduced in size according to the dictates of the binder, the cover board is put in place and the slips are brought over on it, one by one, in a line with the first punched holes. Marks are then made on the board to indicate the width of each slip where it comes over the back of the book. These marks should be made close up to each side of the slip at the edge of the board, so that the grooves to be cut will not be wider than the slips. Then the cover board is removed from the book and is placed on the extreme front edge of the workbench with the slip marks toward the worker. A utility knife is placed on each slip mark, and the point is projected up to the outer side of the hole. In this position, the knife is drawn sharply from each side of the hole to the edge of the board, and a groove is cut, of a depth sufficient to sink the slip as it is laced into the hole. The lines forming the groove should not converge at the hole and form a V, but should be the width of the hole at its extreme end, so that the thickness of the slip will not pile up into a lump as it goes through the board. It is obviously not possible to draw the slip through the hole without bunching it, unless the groove leading to it is as wide as the hole where the slip is pulled

through. Yet many hand binders persist in making this V-shaped groove for their lacing-in, and in consequence they are obliged to pare the slip down severely where it leads into the cover.

LACING-IN

LACING-IN SLIPS. When these grooves have been cut, the book is placed on the bench with the back toward the worker, and a quantity of medium-thick paste is worked thoroughly into the slips. After they are saturated with paste, they are flattened next to the back for the distance of about a half inch, and the ends are

Fig. 88

screwed up as tightly as possible above the flattened part. The very tips of the ends are cut off on an angle to produce points that will permit the ends to be led through the holes easily. Then the book is turned so that the tail is toward the worker and the back is at the right, in order that the slips may be pushed through the board with the right hand and received inside with the left hand, which rests upon the book. The book is now turned around to enable the worker to lead the slips back through the second holes, using both hands for the operation. And then with the back toward the worker, all the slips are pulled up evenly and tightly, with the board resting next the joint at right angles to the side of

the book (see Fig. 88). This is in order to get the tension even on all the slips. The board is let down onto the side of the book, and it will probably yawn at the front. To correct this yawning, the board is held half open and it is forced up into the joint. It should then lie flat on the side of the book when it is let down. This process should be repeated on the opposite side of the book.

The slips must next be cut off on the outside of the board close to the hole with a knife, and they are hammered flat on both the inside and the outside of the board. For this hammering, the board must lie open on a flat knocking-down iron or a paring

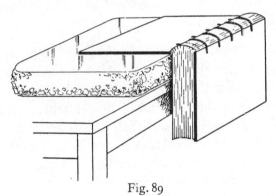

Fig. 89

stone (see Fig. 89). Now the boards are closed and are pushed well up into the joints. With the fore-edge of the book held on the palm of one hand, the back of the book is pushed with the other hand until its contour is made symmetrical and the two joints are on a line with each other. With the book kept in this position, it is placed on the bench, and a covered tin is carefully inserted under each board and made to go close up into the joint, without disturbing the position of the boards. Then the book is put in the standing press between covered tins and pressing boards, with the back facing out and with the boards on a line with the pressing boards and tins at the front of the press. This will ensure strong pressure on the back line of the boards and

force them down even with the joints. The book is left under pressure until the slips are dry.

To lace slips into wooden boards, holes are bored through the boards with a brace and fine bit. It is sufficient to make only one line of holes. After grooves have been cut out on the outside of the boards for the slips to lie in, the slips are led through the holes, and then wooden pegs are driven into the holes from the outside until the slips are thoroughly pegged in. The pegs are cut off on both outside and inside of the board, and any thin ends of the slips left inside are spread out, pasted and hammered flat. It is well to put some paste in the grooves and on the slips, as they may then be made to lie flatter.

LACING-IN TAPES. The principle of lacing-in tapes is the same as that for lacing-in slips, or cords. After the board is properly placed on the side of the book, with its double lining next to the text, a line of about three-eighths of an inch wide is made along the outside of the board, next the joint, with the point of the dividers. The tapes are then led across from the back of the book to this line, and their position is marked on each side of the tapes. Pencil lines are made to denote the width of the tapes as they run up to the line marked by the dividers along the length of the board. These lines must be at right angles to the book-edge, and therefore, to make them, a try square is used across the back edge of the board.

Slits are made through the board the width of the tapes, on the line marked by the dividers. To make these slits a utility knife is used. The board is placed on a holing-out block, the point of the knife is placed on the line to be pierced, and the end of the knife handle is struck with a hammer so that the board is cut through between the marks defining the width of the tapes. After the slits have all been made, the knife is pushed through them, and the ridges made on the inside of the board are cut off with a knife.

The board is then turned over, a second line is made along the back of the inside of the board about three-quarters of an inch from the edge of the board, and lines are drawn from each edge of all the slits to the line marked by the dividers. These lines are all marked at right angles from the back of the board by using a try square.

There will then be segments marked on the outside of the board running from the slits in the board to the back edge of the board. On the inside of the board there will be segments outlined in pencil running from the slits about three-fourths of an inch in from the back edge of the board. These segments on both sides of the board are cut out with the point of a knife to a depth equal to the thickness of the tape. This will make little troughs formed to receive the tape when it is laced-in.

To lace-in the tapes, a little paste is put in each trough on the outside of the board, the underside of each tape is pasted where it will fall into the trough, and the tapes are then inserted into their respective slits by pushing them through with the point of a knife. They are pulled through the board tightly, and the board is then stood up on the book at right angles as for lacing-in cords, or slips (see Fig. 88). Paste is put into the inside cutout troughs and the tapes are drawn across these troughs, and are pressed into them. With the board opened at right angles to the book, the tapes are cut off even with the ends of the troughs with a pair of shears, and they are pressed into place. Then, without disturbing the position of the tapes, the board is laid on the knocking-down iron or on a lithographic block with its inside upward, and all the tapes are gently tapped with a hammer. The board is turned, and the outside tapes are tapped gently. The book is then ready to be put in the standing press where it is left until the tapes are dry. For pressing, directions should be followed as outlined for pressing a book laced-in with cords, as described on p. 157.

CHAPTER XII

FORWARDING

Cutting Edges In-boards. Headbanding. Bookmarkers

CUTTING EDGES IN-BOARDS

BOOKS are best cut in-boards with the plough, and the head is cut first. Before the book is put in the press for cutting, the plough knife should be sharpened to a fine point. The bevels on the upper side should be quite thin for book-edge cutting (see Fig. 90). The knife is sharpened on one side only, and the underside must be kept absolutely flat. The knife should be checked after being fastened into the plough, to make sure that it is running level. To test it, the cheeks of the press are slightly opened,

Fig. 90.

and the plough is screwed up until the knife comes over to the left cheek of the press. It must then just clear the top of the left cheek, in order to cut a square edge. If it hits too far above the cheek, pieces of thin cardboard should be stuffed above the knife where it is held in the slot of the plough. If it hits below the press cheek, the cardboard stuffing must be inserted below the knife to raise it.

To cut the head, the two boards of the book are set in correct position, and then the front board is dropped down to the marks made on the end paper to indicate the place to be cut (see p. 147). The boards are pushed up tightly into the joint, and a piece of binder's board is inserted between the end paper and the back board of the book so that the book will not be cut. A cutting board (Fig. 91) is put on the back and on the front of the book even with the bookboards. The book is now lowered carefully

into the lying press with its back toward the worker as he stands at the end of the press, and it is adjusted to bring the edge of the front board, which is on a line with the cutting marks, perfectly even with the right cheek of the press. Then, if the book is held level as it is being put in the press, the top of the back board will

Fig. 91.

be the same distance up from the left cheek of the press as the top of the book is up from the right cheek. When the book is thus placed, the press is screwed up tightly, and after the knife is run up to the front marks in order to make sure that it will cut through them, the book-edge is cut as for cover boards (see p. 149).

Fig. 92.

The tail of the book is cut in the same manner as the head, but the marks for cutting the length should be put on the back end paper, as the book must be cut with the back toward the worker, to prevent the sections from being crushed and chipped off at the joint. This makes it necessary to place the book in the press with the back board to the right of the worker.

Since the fore-edge is a curved edge, it is more difficult to put the book in the press for this cutting. First the protection sheets on each side of the book are cut off even with the edge of the boards. Then the spring dividers are set to the size of the square, and dots are made with a pencil on the end papers in from the

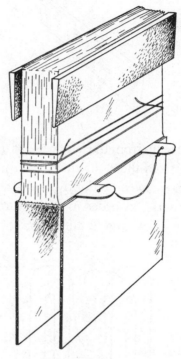

Fig. 93.

fore-edge, to indicate this distance. These marks signify the amount to be cut off. The same distance is marked on the back of one of the cutting boards.

The curved fore-edge will have to be made flat in order to be cut, so the book is knocked up flat at the back between its boards, and a pair of steel "trindles" (Fig. 92) are inserted so that they straddle the cords between the book and the back edge of the

boards (Fig. 93). If the book is very large and heavy, a piece of tape should be tied around the text near the back to prevent it from reverting to its rounded shape. A cutting board is then put on each side of the book. The back one, on which the dots are marked, is placed level with the edge of the protection sheet, and the front one is placed on the dots marked in from the fore-edge to indicate the amount to be cut off. The book is held firmly by the cutting boards, and the trindles are removed. Then the book is put into the press and is placed so that the edge of the lowered

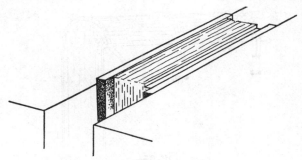

Fig. 94.

cutting board is even with the right cheek of the press and the top of the opposite cutting board is above the press, with the dots on it even with the cheek of the press (see Fig. 94).

After the placement of the book is checked and before the cutting is begun, the back of the book should be inspected to see that it has remained flat. If it is not perfectly flat, the book must be taken out and put in again correctly. When the book is satisfactorily placed, the press is screwed up tight and the fore-edge is cut in the same manner as the head and tail edges.

HEADBANDING

"Headband" is a term used to designate the strip of material at both the head and tail of a book which has threads, usually of silk or linen, woven over it. The headbands are made to fill the

space on the back of a book that is lower than the board edges. If it were not for filling in this space, the leather at the back would be crushed when the book is pulled from the shelf. There are various types of headbands made on books. In mediæval times these bands were worked onto the book over strips of leather or vellum as the sewing was done, and their ends were left long and laced into the boards on each side of the book (see Fig. 95). This is a clumsy method of headbanding and does not admit of converting this structural feature into a decorative one. The modern

Fig. 95.

headband performs its function quite as well and allows the binder the opportunity of introducing color and a pleasingly woven band at head and tail.

HEADBANDING MATERIAL. Most binders use cord, catgut, or pieces of leather or vellum strips for headband material. When cord is used, it is prepared by sticking a length of cord into the gluepot and then hanging it up with a heavy weight on the end to allow the surplus glue to run off and the glue remaining on the cord to dry. Weighting the cord stretches it so that it will not buckle up during the drying process. After it has dried, it is sandpapered down so that it is of even surface and uniform thickness. Cords of different thicknesses are prepared in this way, and when needed, pieces are cut off for the headbanding. Leather or vellum is used in cut strips, sometimes pasted to-

gether. A material that I consider superior to any, if a flat headband is desired, is made up by pasting a piece of newsboard between two pieces of postcard board. After being pasted, it is left under a weight to dry. Pieces may be made of various thicknesses by adding extra newsboard or by increasing the weight of all the boards. This material is made up in large pieces, and strips are cut off it for the headbands. The advantage of this kind of material is that it is more pliable than catgut or vellum and is firmer than leather. After strips have been cut for use, the layers composing them should be pulled apart and be freshly pasted together again in order to allow them to be shaped to the contour of the back of the book without cracking. This shaping is done by curling the strip over a folder edge. Glue must not be used in making up this material, for if used the pieces would peel apart and the material when made up would be less supple. The French binders use pieces of rolled paper in various thicknesses. These should be moistened with a little thin paste and then left until nearly dry before being shaped, as otherwise they are liable to crack in the shaping process. Colored silk or linen thread is usually used for weaving over the strips.

The extra binder always fastens his headbands to the back of a book by running the thread down through the sections as he weaves it around the band material. Job binders use headbands that are previously fabricated, and merely glue them onto the back of the book. These have very little functional value.

TWO-COLORED DOUBLE-WRAPPED HEADBANDS. The two-colored double-wrapped headband may be made quickly, and it presents the most attractive decorative effect of any headband made in so short a time.

Before the work of headbanding is begun, a strip of headbanding material is cut for the head and tail of the book the width of the book-squares if the banding is flat, or if it is round, a size is

chosen which will fill up the distance between the edge of the book and the length of the boards. These strips should be about one-half inch longer than enough to encircle the back of the book, and they must be shaped to the contour of the back of the book.

Fig. 96.

The book is then put in a finishing press forward of the first screw, with the fore-edge placed toward the worker and slightly tilted downward, in order to keep the head from riding up as the headband is being made (see Fig. 96). Then two strands of silk,

Fig. 97.

or other thread, of different colors are cut and tied together at one end. Each color is threaded through a milliner's needle (which is long) at the opposite end of the knot, and the two threads are spliced in order to hold them in the needles while the headband is being made (see p. 120 for splicing).

One threaded needle is now inserted from the front of the book toward the back (see Fig. 97) through the inside of the end-paper section at the left of the book, and is passed between the second and third leaves of the section, counted from the outside. It is pulled out through the back of the book just under the kettle stitch, and the thread is pulled through the back of the book its full length, with the knot left inside the section. It is now brought back to the front of the book, and the needle is pushed through the book again in the same place, thus forming a loop. The

Fig. 98.

headbanding strip is inserted into the loop, about a quarter of an inch is allowed to extend beyond the back on each side, and both threads are then pulled up tightly (see Fig. 98). The strip must be held from slipping over the back of the book by placing a needle back of it, sticking vertically into the book. The first thread, which we will call white, is brought up over the back of the book, and the second thread, which will be called blue, is crossed over it from left to right, forming a bead on the top of the book. It is then brought down under the headband strip to the back of the book and up over the strip to the front. It is led down again under the strip and brought up again to the front, thus en-

circling the strip twice. The white thread is crossed over the blue thread, forming another bead (see Fig. 99), and this procedure is repeated all the way across the back of the book. The beads should be kept evenly tightened, and they should be made to rest along the top of the book-edge.

At intervals during the headbanding process, the thread must be tied down, or "anchored." It is necessary to anchor it only where the back curves or when the bandstrip is not easily held in

Fig. 99.

place — about four or five times for a mediumly thick book. Mediæval headbands, which were sewed with the book, were anchored with each section, but this is unnecessary, for a headband is sufficiently strong if anchored every three or four sections. To anchor the headband, the thread is not wrapped around the bandstrip, but after it is brought up from the back, it is merely brought over the strip, and the needle is pushed from the front down through the inside of the section on a line with the last stitch and then pushed out at the back under the kettle stitch.

The thread is pulled up tightly and is brought again over to the front, where the other thread is made to cross it and form a bead. The headbanding is continued as before. When finally the right side of the book is reached, the two threads must be anchored twice, as they were at the beginning. The thread at the back is brought to the front over the bandstrip and is pushed down through the last end paper between the second and third sheets and under the kettle stitch. It is brought up again over to the front and pushed down again, so that it comes out at the back, where it will remain. The second thread is then crossed over it to form the last bead, and is brought under the band and down the back, where it is tied with a secure double knot to the first thread under the kettle stitch. Both threads are then cut off and frayed out. A little paste is put on them and on the knot, and the knot is pushed in between the sections at the back of the book. The ends are smoothed out with a folder and made to lie flat.

When the headband is finished, the ends of the bandstrips are cut off close to the silk. Each end is tinted with a water-color paint which matches the colored silk next to it, so that the headband will not have an unfinished appearance. The beads on this headband will be of alternating color, a white bead over the blue thread and a blue bead over the white thread. These beads should rest evenly across the edge of the book, and if any are inclined to ride up, they should be pushed down with a folder until they all align.

In making the headband, the two hands holding the thread should be drawn away from the book as the thread comes over the back and then they should be worked back up toward the book as the crossing thread is led under the band. During this operation the left first finger should be placed where the bead is being formed. A certain rhythm must be maintained in the working, in order to keep the tension of the threads even while the beads are being made. The left and right hands are alternately

drawn forward and backward on the thread as the banding proceeds, so as to control the tension.

The headbanding must not be carried too far over to the right, for then the band will be too long, and when the book is covered, the headband will not have sufficient space in which to lie evenly and will push out at the back. A good way to test the length is to press the boards on the sides of the book together firmly at the headband and then note how far the thread should come when the book is in this position, for this is the position the back of the book will take after the book is covered.

Headbands of one color may be made in this same way, if desired, though it is not necessary to knot the thread as for two-colored bands. This method produces a large bead, and the solid-colored headbands have a more attractive appearance if made without wrapping, since then the bead will be smaller.

Single-wrapped Headbands. To make headbands of one solid color or of two colors, with a single wrapping, the same procedure is followed as for double-wrapped headbands except that the beads are made after the back thread is brought over to the front, without wrapping it around the bandstrip. The beads, if two colors are used, will be first of one color and then of the other. For example, if blue and green threads are used, a blue bead will be made over the green thread, and a green bead over the blue alternately to the end of the headband.

Multicolored Headband. A headband may be made of several colors, and there may be stretches of one color after another, either equal or unequal in length. For instance, if a headband is to be made of a light-green, a blue, and a dark-green thread in stretches of five threads of the light green and blue at the beginning and end and a longer stretch of dark green in the center, the worker proceeds as follows: The light-green and blue threads are threaded through milliner's needles, and they are

tied together at the other end. The needle with the light-green thread is inserted from the front of the book through the back and is brought up over the bandslip, which has been previously shaped to the book, and inserted again in the same place, thus forming a loop, as described for making two-colored double-wrapped headbands. The light-green thread is brought over the slip to the front, and the blue thread is wrapped around it completely from left to right to form a blue bead. Then the green thread is led under the slip and is brought up over it again, and the blue thread is wrapped around as before. This is continued until five strands of the light-green thread are laid over the top of the slip, with beads of blue thread made along the top of the book. When this is done, the blue thread is wrapped around the slip five times, and beads of green are formed. The two threads will then both be in front of the slip. A strand of dark green is threaded into a needle and is tied onto the light-green thread about one-half inch from where the last blue thread bead was made, and the ends of the two threads are cut off. (This severs the remaining strand of light-green thread.) The blue thread is then wrapped entirely around the dark-green thread from left to right; the needle of the dark-green thread is inserted through the front of the section on a line with the last wrapping; and after coming out at the back of the book, it is brought up over to the front, and the blue thread is crossed over it as before. This is continued for as great a distance as has been planned for the stretch of dark-green thread. The light-green thread is then attached to the blue thread in the manner before described for attaching the dark-green thread, and the five blue and five light-green wrappings are made to correspond to the first five ones, up to the end of the book, when they are anchored and finished off as were the previously described headbands. The headband should be anchored at intervals as it is being made (see "Two-colored Double-wrapped Headbands" for anchoring). Any number of colors

may be used in this manner, and the color spacings may be varied or kept even, as desired. Calculation must be made, after the first segments of the band are finished, in order to determine how long to make the center segment.

HEADBANDS OVER DOUBLE STRIPS. Headbands may be made over double bandstrips, cut either from round or flat material. I will describe two kinds of double headbands — the first an English type, and the second a double headband called "tranchfille chapiteau," made by the French extra binders.

The English type is made over either round or flat strips, and the pattern of thread, as it winds over the strips, forms a figure eight. The thread is of a single color. The lower strip, which is the larger, rests on the leaves of the book, and the second strip is placed on top of it toward the back of the book. If the strips are round, the lower one is generally made of glued cord, which is covered with leather. (This leather is pared very thin and is either glued or pasted around the cord.) Small cello string is used for the upper cord. The strips are cut long enough to reach across the back of the book, with about one-half inch added. They are shaped to the book and are tied together at the left end, the smaller one resting on top of the larger. The thread is doubly knotted at one end, so that it will not pull through the sections, and it is threaded at the other end. The needle is inserted through the leaves of the end-paper section from the front to the back of the book, and the thread is pulled through the book until the knot rests in a fold of the section. The two tied cords are then placed on top of the book and are held in front by the square of the board and in back by a needle which is pushed down back of them vertically into the back of the book on the left side. Now the thread is brought up from the back between the two cords and is inserted through the back of the book again from the front, forming a loop which ties down the larger cord. It is

brought up from the back again between the two cords, is led over the upper cord from the front, and is brought out between the cords to the front again, thus completing a figure eight. Then it is passed under the lower cord, brought out from the back between the cords, and wrapped around the upper cord as before, forming another figure eight. The thread continues to be formed around the cords in figure eights across the edge of the book. The headband is tied down at the right end by securing the larger cord in the usual way and then the smaller one. The end of the thread is cut off after it comes out of the back of the book and is pasted down. It may be noticed that no beads are formed in this type of headband.

The two cords are tied down, or anchored, alternately and frequently as the work progresses. The large cord is tied down by bringing the thread up over it and then inserting the thread from the front to the back of the book before it is wrapped around the smaller cord. The smaller cord is tied down by bringing the thread up from the back between the two cords, then around the smaller cord, and down in front of the larger cord, when the thread is inserted from the front of the sections. The thread, when it comes from the back, is always brought over the larger cord, and never under it, in making this headband. The English also make a double headband, with a bead finish similar to the French one.

The French double headband is more complicated than the English one without beads. It is made of two colors of silk thread, over cords of rolled paper of different sizes. After the cords are cut to size and shaped, the larger cord is anchored with the first thread, as for other headbands. Then the second cord is placed on top of it and is tied to the larger cord. The first silk is brought up from the back under the top cord, is wrapped around it, and is brought out to the front between the two cords. The second thread is then crossed over the first one to form a bead. This pat-

tern of weaving the thread around and between the cords is continued across the book. The headband is tied down frequently, like the double headband previously described, and it is finished off at the end in the same way as the other double headband.

BOOKMARKERS

Prayer books and books of devotion usually have one or two silk ribbons, called "markers," put in them to assist the reader to mark special places in the book. These markers must be attached to the book after the headbands are made and before they are "set." The French manufacture thin silk ribbons, called "signets," for this special purpose, and they may be had in many and variegated colors. In order to fasten them into a book, lengths are cut off one and one-half times the height of the book and are pushed under the headband from the front, with a short end left at the back. This short end is pasted or glued to the back of the book, and the long portion of the marker is led between the sections opposite to where its end is affixed to the back of the book. It is folded over inside the section so that none of the marker extends beyond the tail of the book.

CHAPTER XIII

FORWARDING

Lining Up Back. Hollow Backs. Casing Text in Protective Cover

LINING UP BACK

IF the back of the book has not had the surplus glue cleaned off
and the bands straightened and made equidistant, this work
should now be done (see p. 142) before the lining up. The head-
bands should also be "set" by inserting a little hot glue between
them and the back, in order to make them a firm extension of
the back. After the glue has been inserted, each headband is
shaped to the book and is held firmly in this position while the
glue is drying. Both the setting of the headbands and the clean-
ing of the back are done with the book in a finishing press.

Preliminary to lining up, it may be necessary to attend to cor-
recting some irregularities on the back. If the binder has been un-
able to back a book without splitting the sections from one an-
other, the cavities between the sections should be filled before the
back is lined. For this purpose, lengths of frayed-out cord perme-
ated with paste may be put in the crevices of the back and
smoothed out. When the tail edges are left very rough, there will
be open spaces under the headbands, and these must be filled in.
A very satisfactory material to use for filling in these holes is a
filler made up of coverboard scrapings. To make this, a piece of
board is scraped with a knife until some powdery material is col-
lected. These scrapings are then mixed with paste until they form
a smooth compound. This is then put into the holes with a pointed
folder and is smoothed off even with the back. Another useful
stuffing for inequalities on the back of a book is made by snip-
ping very fine particles off a piece of cord and making a pulp by
mixing them with paste. This is the better compound to use in
the finer patching.

After these preliminary things have been done, a small piece of thin kraft paper or other thin stout paper is glued over the back of the book to cap the headbands and the headband threads lying on the back. This paper is cut the exact width of the back from board to board and cut long enough to extend over the threads and beyond the edge of the headband. It is first dampened with a small sponge on both sides, then glued, and put in place. After it is well rubbed down with a folder, the book is taken out of the press and turned over so that its back rests on the workbench. In this position, the headband may be pressed down firmly against the paper, from the front. Then with the shears the paper is cut off even with the top of the headbands. It can be more easily and accurately cut before the glue is hardened by drying, and the cutting is best done with the fore-edge facing the worker. After it has thoroughly dried, the paper is sandpapered down. All the high spots produced by the thread are leveled by this sandpapering, and they should be sandpapered off entirely even, down to the thread, if necessary. Dampening the paper and gluing it instead of the book causes the paper to stretch, and after it is dry, it shrinks and makes a tight union with the back.

It is a general practice to line up the backs of books before covering. Lining up produces a back devoid of irregularities and makes it more solid for tooling. Binders vary in both the methods and the materials they use for this process. The French binders are prone to line a back up heavily so that they may lavish their expert tooling on its surface after it is covered in leather. They use split leather or paper for this purpose and often glue on several thicknesses of either, or both, of these materials. This heavy lining up results in making not only a solid back for tooling, but unfortunately, a stiff back, which prevents an easy opening of the book. While some lining up is advisable, both for the sake of appearance and for making a surface suitable for titling and decorating, it is certain that lining up does not contribute to the prac-

tical functioning of a binding. This should be borne in mind by the binder and should influence him to line up as little as possible.

One lining paper hardly suffices to make an even and sufficiently solid back for tooling, for most of it has to be sandpapered off in order to take down the high spots. It will be found that if a lining of meshed cloth, called "super," is glued over the back, it will be unnecessary to use so many thicknesses of paper. This makes for a more supple back, and the meshes of the cloth serve to conceal the irregularities of the back, so that little sandpapering has to be done after the paper is added. Super, in my opinion, is superior to muslin or the English jaconet for lining up backs, because the meshes of the super clinch the glue to the back, whereas the muslin, being a solidly woven material, is stiffer and cannot be made to conform to the back and make as close a union with it as the super. This "clinching" is very important in joining materials, as is demonstrated in cement work, where a meshed wire is placed over one layer of cement to clinch it to the next layer.

The lining for a back is cut the exact width of the back. This measure is best taken by using the straight edge of a small piece of paper and marking the width on it, as the surface is round and cannot be measured with dividers. The length of the back lining for a book sewed over cords is cut to go between the cords except at head and tail. The material which goes over the headbands is cut to project beyond them. Super is cut on one of the threads of the squares, and the length should be cut to line with the selvage on the width of the material. When books are sewed on tapes, the first lining is cut in this way, but the upper linings are cut the width of the book and a little more than the full length of the back.

If a book is to be lined up with super and then with paper, a thin strong paper is used for the upper linings. After the linings are cut, the book is taken in the left hand and the back is glued

over its entire length with thin, hot glue, with care taken at head and tail to spread the glue toward the ends, so as not to soil the headbands. If there are cords, care must also be taken to avoid spreading glue over them. The book is put in the press, and without delay the pieces of cut super, which should be laid out on the side of the press in proper order, are placed and are rubbed down with a folder. Attention must be given at the headbands to make sure the super is adhering to them. Then the book is removed from the press, and the super extending beyond the head and tail is cut off even with the headbands. Next the paper linings are glued on. First the paper is moistened with a sponge on both sides. It is then glued, put in place while the book is in the press, and rubbed down firmly. At head and tail it is cut off to line with the headbands, as was the super. The lined-up book is then left to dry for perhaps a half hour, when any irregularities on the back are sandpapered off with a sandpaper block (see p. 154). If the surface of the book is irregular after being lined up once with paper and sandpapered, another lining paper may be added, though it is well to bear in mind that each extra lining paper adds to the stiffness of the back.

HOLLOW BACKS

When the backs of books first began to be elaborately gold tooled, a solid surface was found to be necessary under the tooling in order to prevent its being cracked when the book was opened and closed. In consequence, backs of books were lined up many times and were made solid and stiff. Binders at that time were apparently more concerned about the perfection of their tooling than about the practical features of their book construction.

As increasing complaints came from the bibliophiles because their books would not open freely, binders were finally forced to seek a way to correct the fault. Still bent on not sacrificing the

appearance of the book, they resorted to sawing through the back to sink the cords around which the sections were sewed, and they devised a change in the structure of the back. This change represents the invention of the hollow back.

Hollow backs are a debated subject among binders. They certainly have their use and offer a solution for overcoming a stiff opening of a book caused by the fault of the printer or the typographer. When a book is printed on stiff, thick paper, if it is ex-

Fig. 100 A.

Fig. 100 B.

Fig. 100 C.

pected to open properly, the sections should not be made up in a format that necessitates folding the printed sheets too many times, thus producing thick, stiff sections. No binder can bind this type of book so as to prevent entirely the leaves from fighting back when the book is opened, without sacrificing the book structure. The leaves will persist in standing up in the air and will not lie flat if the sections are sewed flexibly around cords. So it is that the binder has to do his best to bind such books in a manner that will overcome the gross fault in the "make-up" of the book, and he employs a hollow back for the purpose. Figure 100 A illustrates the manner in which the leaves of a book are allowed to

open freely and lie flat when a hollow back is used. Figure 100 B illustrates a book printed on stiff paper and sewed flexibly over cords. Figure 100 C shows a book made up in a format suitable to the paper and sewed flexibly .

Bindings with hollow backs forfeit the soundness of construction of bindings in which the leather is pasted directly to the actual back of the book. A hollow back is a false back. It is made of layers of paper formed like a tube with a hollow center and is glued onto the real back of the book. The leather is attached to it, and not to the book sections. Hence, if the leather is broken at the joint or is disintegrated through rotting, the false back falls off the book. If the leather is broken at the joint on a binding in which it is pasted directly to the back, the back is in no way injured.

Nevertheless, when a free opening is expected, the binder is compelled to use a hollow back if he is called upon to bind a book made up with a faulty format inconsistent with the useful functioning of a binding. This does not mean that binders should blindly espouse the cause of hollow backs and use them indiscriminately and habitually, for no matter how they are affixed to the back of a book, hollow backs still remain false backs.

When hollow backs are used, the back of the book should first be lined with super, and usually a strong thin paper is glued over the super. If the book is very small, this paper may not be needed. If it is large and heavy, it may need two lining papers over the super to give the back solidity and strength. Even a piece of split leather might be required for lining a very heavy book bound with a hollow back. Blankbook and account-book binders, called in England "vellum binders," employ the hollow back in their work, and the best "vellum binders" line up the backs of their books with leather. Hollow-backed books are customarily sewed on tapes or on sunken cords, in order to attain a smooth back, though sewing on sunken cords is not a good practice. Some of

the German binders are attaching hollow backs, made after the English model, to books sewed over raised cords. The construction is identical in both instances. The French hollow back differs from the English one, very materially.

ENGLISH HOLLOW BACK. To make a hollow back after the English model, the hollow is usually made directly on the back of the book. A piece of heavy wrapping paper is cut with the grain running with the width of the paper. It should be cut a

Fig. 101 A. Fig. 101 B.

little longer than the book and wider than enough to extend over the back three times. One straight edge of the width is placed on the back at one joint, and the distance across the back is marked from joint to joint. The full length of the paper is folded to this distance. The same distance is marked again on the paper, and it is folded a second time. This distance is marked off the third time, and the paper is cut on the marks.

The back of the book is glued, and the center part of the folded paper is placed on the back and is rubbed down thoroughly (see Fig. 101 A). Then a piece of wastepaper is placed under one of the free parts and that part is glued. The third part is folded over the glued paper and is well rubbed down. One thickness of the

paper will be glued to the book and two other thicknesses will be glued together, to form a hollow (see Fig. 101 B). When finished, the hollow back is cut even with the headbands at head and tail. For most books it is desirable to add one or two layers of paper over the hollow. This makes the hollow stiffer and does not add to the stiffness of the opening. A hollow back should not be put on a very thin book, for there is too little to glue to, and it does not make for a substantial construction.

French Hollow Back. There is a type of hollow back much used in France that is peculiar to that country. It has the advantage of greater strength than the hollow back just described, because it is carried over beyond the back and is attached to the end papers of the book; but since the cover boards cannot be laced onto the book, this advantage is nullified. It is not suitable for extra bindings, as the paper that is covered over the back makes a ridge under the pasted-down end papers on the inside of the book unless double boards are used.

A book with this hollow back is sewed on tapes, and super or cambric, which is cut even with the headbands, is glued over the book and is allowed to extend beyond the back for about an inch on each side. A paper the width of the back is lined over the super and is cut at head and tail even with the headbands. Then a piece of chipboard is cut the exact width of the back and the length of the bookboards, and a piece of wrapping paper is got out somewhat larger than the chipboard and wide enough to go over the back of the book and extend onto the sides for about an inch. The chipboard is glued to this paper and is centered when put in place. If single boards are to be used, the super and the tapes extending over onto the sides of the book are pasted down onto the end papers and are shaped into the joint. In this case, the chip board is put in place on the back, and the paper extending over it is pasted down on the end papers and is worked well into the

joint. The book is then put in the press until the paste is dry. If double boards are used, the lower, or thinner, board is cut to size and is put in place on the book. The paper, together with the tapes and super, are lined down on it, after which the upper board is glued onto the lower one.

This type of hollow back is especially suitable for books with double boards, and it is used for limp-covered books, such as prayer books. The French use it for books bound in "Bradel" fashion, with a French joint.

Before the covering is done, all hollow backs are slit up at the joint for about three-quarters of an inch at head and tail on each side of the book, so as to allow the leather turn-ins coming over the back to be tucked in under the hollow. It is best to slit the back just before the covering operation, as it is likely to curl if exposed to the air too long after being slit.

Casing Text in Protective Cover. To protect the edges of a book from being soiled with paste when covering, the text is cased in paper. A piece of wrapping paper is cut large enough to wrap the length of the text completely, with a small overlap. The width is about twice that of the book. The book is laid on the workbench with the fore-edge toward the worker, the under-board closed, and the upper board lying open. The paper is placed between the lower board and the text, well up to the joint. It is folded over and creased sharply on all three upper book-edges. The book is turned over and the other three edges are creased likewise. Then the creased paper is taken from the book and is cut as shown in Fig. 102 A. In this diagram the dotted lines indicate the folds; the solid lines indicate the boundary lines of the cover and all lines on which the paper is to be cut. Figure 102 B shows the protective cover after it has been cut. In this diagram the dotted lines represent where the paper is to be folded as it is put in place on the book. As the book lies flat on the work-

Fig. 102 A.

Fig. 102 B.

bench, one side, D, of the protective cover is inserted between the lower book cover and the last end-paper sheet until it reaches the joint of the book. Pieces A and B, which are cut to reach not quite half across the book, are then folded over onto the upperside of the book and are firmly creased in place. The tabs E and F are folded over the fore-edge and creased, and piece C is brought over on the upperside of the book and is well creased along the

FRONT FOLDED OVER

Fig. 102 C.

fore-edge. One or two daubs of paste are put under piece C, which is then made to adhere to the folded-over pieces A and B. This paper casing must be put on neatly so that the squares of the book will be visible when the book is being covered, and all creasings must be very definitely made, both when the casing is being put on the book and when the pattern is being blocked out. The manner in which the tabs are folded over at the fore-edge corners is shown in Fig. 102 C. For a half binding this type of protective

case is not necessary. The covering does not need to extend over the fore-edge of the book, hence a strip of paper is cut the width of the book and long enough to encircle it completely. It is joined on one side of the book.

CHAPTER XIV

FORWARDING

Patterns for Leather Covers. Cutting Leather Covers.
Facts Related to Paring. Paring Leather. Paring Paper

PATTERNS FOR LEATHER COVERS

BEFORE leather is cut for a book, a paper pattern is made for the size needed. Good leather is expensive, and a full skin can be utilized most economically if cover patterns are laid over it. Calculation can then be made accurately as to where to cut a cover to the best advantage, and the time used for cutting these patterns is more than paid for by the saving of leather.

Fig. 103.

PATTERN FOR FULL LEATHER COVER. To cut a pattern for a full leather cover, a piece of wrapping paper is cut with one edge squared to another. The closed book is laid at the squared corner of this paper, and allowance is made for about an inch projection of the paper beyond the book board at the fore-edge and at the two ends of the book. A line is drawn around the board at head, tail, and fore-edge, as the book lies in this position (see Fig. 103). Marks are made to indicate the back line of the board, the book is removed from the paper, and a straight line is drawn through the marks. This gives the boundary lines of one board. A measure of the width of the back is then taken from cover to cover with the straight edge of a piece of paper, and the distance

187

is marked from the back line of the board. A line is drawn through these marks, and the back board of the book is placed on it, so that the fore-edge board line may be drawn. An inch is allowed beyond this line of the fore-edge, and the paper is squared through the line in order to get the length of the leather needed to go round the book. An inch is added beyond the marked length of the board, and the paper is squared through this measure to get the required height. This completes the paper pattern.

PATTERN FOR HALF LEATHER. "Half leather" is a term used in a generic sense to denote both half and three-quarter bindings, though the professional bookbinder technically refers to these two types of book in specific terms, calling a half binding one on which the leather at the corners and over the sides of the book is not so expansive as that used on a three-quarter binding. There is a convention observed among binders in respect to both half and three-quarter bindings about the proportion of the leather on the sides to the over-all width of the boards, as also about the size of the corners in relation to the width of the leather next the back.

For a half binding, the side of the board is divided into four parts with the dividers, with the last division left about one-half inch short of the others. This width is marked on the side of the board next the back. A piece of wrapping paper is squared as for whole leather patterns, and about five-eighths of an inch over the length of the board measure at both head and tail is allowed, and the length of the leather is indicated. The paper is squared to this length. The distance decided upon for the width of the leather covering the sides is doubled and marked on the paper. Then the width of the back is added. About one-quarter of an inch also is added, and the paper pattern is cut for width. This finishes the pattern for the back and sides of the book.

To measure for a three-quarter binding, the side of the board

is divided into three parts, with the last division left one-third smaller than the others. This distance is marked on the board near the back, and the leather pattern is made as for half bindings.

It will be found that if these rules are followed, there will always be a pleasing proportion of leather on the book sides. Amateur binders who are anxious to make the binding as elegant as possible and who are not informed about these conventional proportions often turn out half bindings with an overheavy amount of leather on their sides. However, these proportions may be altered with impunity if a large-figured paper is to be used on the sides of the book. The width of the leather strip on

Fig. 104.

the sides and also that on the corners should then be reduced, or the large figures in the paper will look grotesque.

Every binder has a set of corners cut out from millboard if possible, or if this is not available, then of any binders cover board. These corners are cut in the form of an isosceles triangle, with the sides of even length squared to the corner. They range in size from very small ones to large ones, and each one is about one-eighth of an inch larger than the other. These triangles are usually numbered, and they represent the measuring instruments for determining the size of the leather corners to be put on the book. There must be a counterpart, which is used as a leather pattern, for each triangle. The counterparts are cut with about five-eighths of an inch allowance on the two squared edges, and they have the end of the triangle cut off (see Fig. 104). They are numbered to accord with the numbers on their respective triangles. There is a corner measurer made of metal which saves

the trouble of making all these patterns, but so far as I know, it is not found except in France.

CUTTING LEATHER COVERS

The best part of a skin is near the backbone. The part bordering the side edges, which is that part over the flank and belly of the animal, is considerably softer and is usually not as clear and even in color. It does not matter whether the leather for a book is cut running up and down or from the center to the side of the

Fig. 105.

skin, except from the viewpoint of economy. If the backbone is used, it will be less conspicuous if it runs down the middle of the back of the book, though with very small, thin books this is not advisable, as the leather on or near the backbone is very stiff. The larger the skin, the thicker it is, and if a large thick skin is used for small books, it will have to be pared down so much that its strength is injured. Hence, it is desirable to use small skins for covers of small books. Many binders always buy large skins because they are more economical than small ones, but this is a doubtful practice. A few small skins of different colors should be on hand for use for small books.

After the pattern for a full binding has been made, it should be laid on the skin, and with due consideration to the usefulness of the smaller parts of the skin for half bindings, the pattern is cut against a straightedge with a knife, on a tin or zinc.

Half-binding corners are cut out of any part of the skin left after cutting full-binding and half-binding covers. The corners

Fig. 106 A.

of a half binding are usually cut from the edges of the skin, with the corner-cutting patterns used for a measure. In order to determine the proper corner pattern to use, a measuring corner is placed on the side of the board with one squared edge up to the joint (see Fig. 105). When a corner is found the squared side of which measures about one-quarter of an inch beyond the meas-

Fig. 106 B.

ure marked for the width of the leather on the side of the book, it is the proper-sized corner for the book. When the counterpart of this corner, which is numbered, is found it is used as a pattern for cutting the leather corners.

FACTS RELATED TO PARING

PARING KNIVES. There are two types of knives used for paring, one known as the French paring knife, which is usually slightly rounded at the cutting end (see Fig. 106 A), and the other, a knife with the end cut on an angle (see Fig. 106 B). The

so-called French paring knife originated in France, though it has been adopted for use by most extra hand binders. It is generally used with a scraping stroke, and the other knife is used with a direct cutting stroke. Both of these knives are ground with a rather deep bevel on the upper side, and the underside is left flat. The knife with its cutting edge on an angle has the point squared off to prevent its slitting the leather. It is the quicker of the two in taking down the thickness of leather, but when paring leather very thin, as for inlays, the French knife is perhaps the safer one to use. In 106 A and B note the wrapping of leather on the blade of the knives which is to protect the worker's hand when paring.

The most valuable and profound "secret" about paring lies in the sharpness of the paring knife. The stroke itself is simple, but conditioning a knife for paring is by no means simple for a novice. Most beginners fail to realize how greatly success in paring depends upon the condition of the knife, and they continue to force a dull knife, hoping to make it cut. A dull knife will not pare leather, and a forced knife may cause much damage. When a knife fails to cut, it is simply dull and must be sharpened. The inexperienced parer is inclined to blame his lack of proficiency in making the stroke, when the paring isn't going well, and can hardly be persuaded that nine times out of ten his knife needs sharpening and perhaps even grinding.

I have already pointed out in a previous chapter the difference between grinding and sharpening a knife (see p. 33). When the bevel of the paring knife is worn down so that it is too thick at the cutting edge to be readily sharpened, it must be reground. The binder can do this work on his own grindstone, or he can send the knife out to get it ground at little expense. If he sends it out to be ground, he should paste a paper pattern on the end of it to show the grinder both the angle and the depth to which the bevel is to be ground. The French paring knife is usually not ground on an angle, but is merely rounded at the cutting end. A

convenient shape is shown in Fig. 106 A. The bevel is about one-half to five-eighths of an inch deep. If the edge of the other knife is ground at an angle about half that of a right angle, it will be found that the stroke may be well controlled. A more acute angle will allow of more speed in paring, but neither so fine nor sure paring can be done with it. The bevel for this knife should be about three-quarters of an inch deep and should graduate evenly to a thin edge.

Fig. 107 A.

As for sharpening, a considerable amount of intuitive comprehension is called for if the operator is to succeed. The ability to sharpen a paring knife is attained only after considerable experience, but there are a few general rules that may be laid down.

SHARPENING A FRENCH PARING KNIFE. Sharpening a French paring knife is not an involved process. The edge, in order to do its work, must have a slight burr on it, that is, the edge must be turned over from the beveled side to the underside. Before the burr is turned over, the knife is drawn back and forth

over a fine oilstone until the edge is thinned. It is stropped to get a smoother and finer edge, and then, with the beveled side down, it is lightly rubbed on the surface of a lithographic stone, or paring block, until the edge is turned over (see Fig. 107 A). If too much burr has been turned over, it may be taken off by rubbing the knife on the stone with the flat side down.

SHARPENING AN ANGLE-EDGED PARING KNIFE. An angle-edged paring knife is universally used for paring, especially by job binders, but I am unable to give it a national designation, though it is to be presumed that it originated in England or

Fig. 107 B.

Germany. In order to be able to refer to this knife without confusion, I shall hereafter call it the "edging knife," since in this country it is in general use for edging leather. To sharpen the edging knife, the edge must first be examined to see where it needs thinning. Thick spots are indicated by a sort of highlight showing along the beveled edge. To thin the edge of the knife, it is held with the beveled side down, with the handle resting in the palm of the hand, and with the first and second fingers on top of the blade. The blade is placed on the stone, parallel with the length of the stone, and is tilted at a slight angle as it is drawn back and forth (see Fig. 107 B). The angle at which it is held depends upon how much sharpening the knife needs. The knife should never be sharpened with a circular motion, for this will leave low and

high spots on the bevel instead of leaving it of even thickness. After the edge has been thinned in this manner with whatever pressure is needed, the knife is tilted at a much greater angle and is very lightly drawn back and forth over the stone, in order to produce a "secondary bevel," suitable for cutting. A secondary bevel is an almost infinitesimal bevel made on the cutting edge of the deep bevel ground on the knife. Producing and keeping this bevel are tricks that must be learned.

After being sharpened on the stone, the knife is well stropped. With bevel down, the whole blade is drawn with considerable pressure over the strop from left to right, with the thumb on top of it. When the right end of the strop is reached, the knife is flopped over in the hand so that the two first fingers are on top of the blade, and it is lightly drawn back on the strop with the beveled side uppermost. Care must be taken to keep the whole blade of the knife on the strop, to prevent its being worn down more at the "toe" than at the "heel." The toe of a knife is at the point of the blade; the heel is at the opposite end of the blade. If the whole blade is not kept on the strop, it will develop such a curved shape that its efficiency will be impaired, and it will have to be reground frequently. Always, in stropping, a knife must be kept absolutely flat or the edge will be thickened instead of thinned. The expert parer strops after every few strokes of the knife and thus keeps his cutting blade in perfect condition.

Paring knives are tempered to different degrees of hardness. A mediumly hard-tempered knife will be found the most satisfactory for paring. If the knife is too soft, the edge will wear down quickly and continual sharpening will be necessary. If it is too hard, it is very difficult to sharpen.

SHARPENING STONES. Oilstones with different degrees of coarseness are needed for paring. One knife may require a finer or a coarser stone in order to be sharpened. But these stones

should all be of fairly fine quality, and little oil should be used on them. Too much oil on a stone interferes with the "biting" action of the stone.

MARKING UP LEATHER. Before paring is begun, the leather must be marked up to indicate the margins for turning over the board edges, and lines are drawn to mark the width of the back. To mark up for a full binding, the leather is folded from outside inward, with fore-edges even, so that the center of it may be found. The center is marked at head and tail on the "flesher" side of the leather — the side next the animal. Then the width of the back of the book is measured from board to board with the straight edge of a piece of a paper and this width is marked on the paper. The paper is folded over, mark on mark, to find the center of the back measure, and this is indicated on the paper. Then this back center mark is placed on the center mark of the leather, the width of the back is marked at head and tail from the measure on the paper and lines are drawn through these marks to outline the position of the back. The book is placed on the leather with the back edge of one board on one of these lines, and it is centered on the width of the leather, with the same amount left beyond the board at head and tail. The boundary lines of this board are then drawn, and the lines for the second board are drawn in the same way (Figs. 103, 108). This may seem to be somewhat complicated, but the operation is very simple, and marking up leather in this way is far more quickly accomplished than measuring with the dividers. The dotted lines in Fig. 108 indicate where the leather is to be cut off before paring.

The leather will stretch from back to fore-edge in the process of covering. To allow for this stretching the two fore-edge lines must be re-marked a little back from the edge of the board. Leathers differ in the amount they will stretch, but this can be closely estimated. To determine the amount of stretch likely, one

side of the book is placed on the leather with the back edge of the board on one of the lines marked for the back. The fore-edge of the book is brought slightly over the front of the workbench, and with pressure on the cover of the book at the back edge to hold the book in place, the leather underneath the book is pulled to its extreme length. In this way the amount of probable stretch there is in the leather may be seen and a mark is made on the leather, back of the front edge of the board, to indicate where to draw the

Fig. 108.

final fore-edge line for paring. No allowance is made for stretching from head to tail of the book.

The leather for a half binding is marked in the same way as for a whole binding except that no fore-edge marks are necessary.

PARING LEATHER

The technique of paring leather is illusive, and learning to pare is very much like learning to play golf. There is, first of all, a knack that has to be mastered, and then various conditions play their part in contributing to success or failure. The worker must learn to recognize these conditions, and either utilize them or overcome them. It is utterly impossible to teach paring verbally.

The best that can be done, when practical demonstration is impossible, is to outline where and why leather must be thinned by paring and make some helpful suggestions about the process. The learner must then proceed by the trial-and-error method to master the technique.

Fig. 109 A.

The margins of leather extending beyond the cover boards must be pared, or thinned down, in order that they may be neatly turned over onto the inside of the covers. If the leather along the lines marking the width of the back is thick or stiff, it must also be pared or it will wrinkle on the outside of the book

Fig. 109 B.

along the joint and will make the opening of the book more difficult. There is a tendency to pare margins too thin for the sake of achieving a very finished appearance. Margins should not be pared more than enough to allow the leather to be turned over neatly. Too thin paring is to be condemned because the pores of

a skin run through it from the upper to the lower surface, and cutting through them deeply impairs the strength of leather and shortens its life materially as a book covering.

The best surface on which to pare leather is a lithographic stone. It may be bought new at a binder's supply place, or used ones, which are quite as good when they are cleaned off, may be had from a lithographic printer. Leather can also be pared on a slab of marble or of glass.

As some pressure must be used in paring, the stone, even when heavy, is liable to keep pushing back on the bench. In order

Fig. 110.

to steady it and keep it in place, a device made of wood serves well (see Figs. 109 A and B). This is made by taking a piece of wood about 9 x 12 x ⅜ inches and securing to it, with small angle irons, two wooden rims about 1⅜ inches wide by ⅜ of an inch thick — one going down to hold the wooden frame to the table and the other going up to hold the lithographic block in place. The angle irons are placed around the four corners of the board.

A leather strop, a sharpening stone, and an oilcan will be needed in paring. In order to keep these things together conveniently, the following device will be found useful (see Fig. 110): This is made up of plyboard or other material about ¼ of an inch

thick, 12 inches long, and 8 inches wide. Instead of plyboard, binder's board may be squared to this size and glued together. The top surface is varnished to keep the oil from penetrating and making a messy board. Then a piece of leather belting, 3 inches wide and the length of the board, is sewed firmly onto the board at each end with heavy linen thread. The belting should be even with the front edge of the board. To sew it on, holes must be pierced through the leather and board with an awl. The underside of the board is then lined up with split leather to keep it from slipping. On the free part of the board back of the strop, the sharpening stone and oilcan are placed for the work of paring, and the whole board is conveniently placed to the right of the paring stone.

PARING FULL LEATHER COVERS. Edges may be pared to a line, or they may be pared well back of a line and beveled gradually. In paring so that the bevel begins far back of the line marked to indicate the boundaries of the boards, the French paring knife will be found the better one to use. In paring to the board lines, it is advisable to use both paring knives. The edging knife is used for thinning down the edges from the line, and the French knife is used to take down abrupt bevels.

In beginning to pare the margins, the edges are first beveled all round the cover. Either of the two paring knives may be used for this and should be held at quite an angle. The leather is placed on the paring stone with the grain side down and is held against the side of the block with the left thumb. The bevel is started at the right end of the edge by drawing the knife sharply to the right to produce a small cut. Then, with the edge of the leather almost parallel to the worker, the knife is placed in this cut and is pressed to the left along the edge, taking off the leather somewhat less than an eighth of an inch, on an abrupt bevel. The leather is placed at a slight angle to the front of the paring stone,

and with the thumb still holding it as before, the wrist is turned so that the fingers may point toward the left as they lie on top of the leather, in order to keep the leather held flat as the paring strokes are made (see Fig. 111). If the fingers are not pressing toward the left as the stroke is being made, the leather will bunch up and prevent the parer from finishing the stroke. When any part of the leather is being pared, it should be held on the stone, close to the front. If it is placed any distance back on the stone, the knife cannot be held flat.

A paring knife with the beveled side up is held with the handle resting in the palm of the right hand and with the first and sec-

Fig. 111.

ond fingers on top of the knife. To pare the margins to a line, the edging knife is used. The blade is placed just back of the marked line and is pressed forward, being directed toward the left at an angle of about twenty-five degrees instead of being pressed straight out at right angles to the line. The beginning of the cut is made with the point of the knife, and as the stroke proceeds, most of the blade comes into use. The knife must be held very flat for this cutting stroke, and as the stroke is made, there must be a constant, steady pressure downward as well as forward. The angles for holding the leather and for the stroke of the knife are indicated in Fig. 111. Too much leather must not be cut off with

a single stroke — only as much is cut at a time as can be taken off evenly and without forcing the knife. The edges usually require going over two or three times, a little thickness being taken off at a time, before they are thinned sufficiently. The worker should always be seated when using this knife.

After the edge has been gone over with the edging knife, there will be a "shoulder," or ridge, left on the leather where the edge began to be pared at the line. This ridge should be smoothed off with the French paring knife after each time the other knife is used. If this ridge is not leveled, paring down again with the edging knife will be difficult, and there will be danger of cutting in. Whenever the marked lines are cut off in paring, they should be put in again.

The French paring knife is not difficult to learn to use. It may be used with both a cutting and a scraping stroke, but except for edging work, it is mostly used with a scraping stroke. It will be found that this knife is more easily used if the parer is standing. He can do the work more quickly in this position, as the knife may be held at a greater angle with safety, and thus he can put more force into the stroke and take off a greater amount of leather at a time. The knife is held in the same manner as the edging knife, and the stroke is made at the same angle also. When paring with this knife, the handle is tilted slightly upward, and the knife is drawn forward and backward in short, quick strokes. The amount to tilt the knife varies with the leather — the softer the leather, the greater the angle at which it may be used with safety, and consequently the quicker the paring.

As the edges are being pared, they should be tested for thickness and evenness from time to time. To test them, the leather is folded over with the grain inside, and the fingers and thumb are run over the fold. The thickness, as well as any unevenness, can be judged in this way. This same test should be made along the middle of the margin. The margins are pared so that they gradu-

ate from the thickest part, which is along the line, to a fairly thin edge.

Usually a little paring has to be done along the edges which outline the position of the back. This is done with the French knife unless the leather is very heavy, when both knives may be brought into use. With small books, the paring often has to extend over the leather covering the back itself. By folding over the leather with the flesher side out and rolling it between the fingers and thumb, the worker can readily judge whether or not it is too thick to work over the bands of the book. The leather over the joint should not be pared more than enough to allow a free opening of the book.

After the back and margins are pared evenly, the two leather margins within the marks for the back must be pared still further. The part of the leather which turns over to form the headcap should be thinned only slightly — just enough so that after the headcap has been formed it will be on a line with the boards. But the remaining part of the leather, beyond that used to make the headcap, is graduated down until at the edge it is quite thin. This is to prevent this doubled-over leather from making a ridge on the back.

PARING HALF LEATHER COVERS. The leather for half bindings, which reaches over the back and end margins, is pared the same as for whole bindings. Where the leather ends on the sides, it is beveled off and thinned down to a thickness equal to the "filling-in" boards, which are glued up to it (see p. 247).

To pare the corners, the measuring corner pattern (see Fig. 104) is placed on the leather corner with its long, or diagonal, side even with the long side of the leather. The outline of the corner pattern is marked on the leather with a pencil to indicate the margins to be turned over the board, and these are pared like the margins of a full leather binding. The leather projecting be-

yond the point of the corner outline is cut off so that it is just long enough to be folded over the corner and to overlap slightly on the inside of the cover. This small space of leather at the tip of the triangle is thinned down somewhat more than the other margins to enable it to be folded over the board neatly.

PARING LEATHER HINGES. Leather hinges are cut to a width that allows the leather to go over the joint of the book and be pasted on an end paper, plus the width of the turn-ins, or margins, of the cover. The length of the hinges is cut about a half inch longer than the bookboard, to allow for a possible accident in paring. When the measure of the depth of the joint has been taken, a liberal one-quarter inch should be added to it, and this distance is marked on the long side of the leather hinge after the length has been cut. The remaining width represents the part of the leather that is to lie on the inside of the book cover.

The margin of the hinge which is to rest on the inside of the book cover is pared the same thickness as the other inside margins. That part of the hinge which is to be pasted over the joint and onto the end paper is pared quite thin, increasingly thin toward the edge.

It has already been indicated (see Fig. 46 C) that leather hinges are attached to the end paper when they are to be sewed with it, and they must therefore be pared before the book is sewed. The procedure for attaching leather hinges to be put in after the book has been covered will be explained in proper sequence.

PARING INLAYS, LEATHER FLYLEAVES, AND DOUBLURES. Leather for inlaying or onlaying a design must be pared very thin. The edges are pared to paper thinness, though the center may be left somewhat thicker if the inlay is large, in order to allow the inlaid pattern to stand out. This is purely a matter of judgment and taste, dependent upon the type of inlay. If control of the edging paring knife has been mastered, this knife is best

used for small inlays. An inlay must be pared absolutely even, or bumps will appear on its surface.

Leather flyleaves and doublures are the most difficult to pare. They too must be pared to an even thickness. The leather, if thick, should be sent out to be thinned down, unless a leather-paring machine is in the binder's equipment. When received from the professional parer, the flyleaves must be still further pared down to the thinness desired. They must be of the same thickness throughout. The doublures may be slightly thicker in the center, but the edges must be of a thickness equal to the thickness of the leather margins. Either the French knife or the edging knife may be used for the paring. Very likely both should be employed to attain the greatest efficiency.

PARING PAPER

Paper paring is quite tricky. It is done with a very sharp knife on which a slight burr has been put. To get a burr on a knife for paring paper, the cutting edge is drawn several times across a lithographic stone, with the blade tilted to just less than ninety degrees and with the bevel down toward the stone. This should turn the edge over to form the burr that is needed. The edge to be pared should be placed away from the worker and almost parallel to him. Then with the burr downward and the knife held at a slight angle, the edge of the paper can be pared off from right to left in a long curl, with slight pressure of the knife. The amount of burr needed, as well as the amount of pressure to be used and the angle at which the knife is to be held, will vary with different papers, and it requires considerable practice to learn to pare paper with an evenly beveled edge. The greater the angle of the knife, the shorter and sharper the bevel will be.

CHAPTER XV

FORWARDING

Covering. Cutting Inside Margins and Filling In.
Pasting Back End Papers

COVERING

BEFORE a book is covered, the boards must be cleaned up. If there are any spots of glue or paste on them, they should be removed, and the edges should be rubbed down with a folder to take off any burr. If the slips on the outside are too thick, they are trimmed down so that they will not show too prominently. Then a piece of wrapping paper, cut a little larger than the boards, is glued and is lined down on the outside of each board. It is placed with one straight edge just barely up to the edge of the board next the joint and is rubbed down. A tin is put under the board, and with a knife, the paper is cut even with the board edges. Wrapping paper is likewise lined down on the inside of the boards to counteract any warping. After the boards are lined, the book is put aside under a weight until the paper has dried. After it has dried, it is sandpapered down just over the slips on both the inside and the outside of the boards until the bumps produced by the slips have disappeared. These lining papers prevent the slips from showing through.

The squares of the book should be looked to, for although they were "set" when the boards were laced on, they may have been disturbed. To reset them, some paste is put on the underside of each slip; after the boards are adjusted so that the squares are even all round, the slips are tapped with a hammer on the outside of the board, as when lacing in; and the book is put in the press with covered tins outside and inside of the boards and is left for about fifteen minutes.

If the cords have not been straightened and made equidistant,

this should be done before covering, and they should be nipped up tightly with a pair of nickel-plated band nippers (see Fig. 112). Presumably the cover was marked after paring; if not, the

Fig. 112.

marking should be done before beginning to cover. The lines should be distinct and should run all the way to the edges of the leather, as this makes the placement of the book on the leather easier and quicker.

Fig. 113.

Before the covering, there must be ready on the workbench: a bowl of well-beaten-up starch paste; a clean paste brush; a jar of commercial paste; two shaped covering folders, one for pulling over the leather and smoothing it down (Fig. 30) and the other

Fig. 114.

for use in shaping the headcaps (see Fig. 113); a small bowl of water with a sponge; a utility knife; a corner knife (see Fig. 114); a pair of shears; a band stick (a piece of wood about eight inches long by half an inch thick and three-quarters of an inch wide covered with split skin); a pair of band nippers; a headcap-

setting block (see Fig. 115); a utility sharpening stone; a clean lithographic block; several pieces of unprinted news; several thicknesses of paper towels; two celluloid sheets; a piece of strong sewing thread; and a cloth for wiping off the hands or the lithographic block. After these things are assembled, the binder is ready for covering.

The novice has a tendency to feel hurried and flustered when covering, but if the leather is pasted properly and the whole operation of covering has been analyzed and resolved into successive steps, there is no need of hurrying. I have found that if the begin-

Fig. 115.

ner has these steps outlined before him as he works, he gains confidence and poise. An outline serves to dispel his nervousness from the fear of forgetting to do something at the proper time. After covering has been done a few times in this way, the progressive order of working becomes automatic. Following is an outline suggested for this purpose:

1. Paste leather and fold over.
2. Nick corners of boards.
3. Paste spine with commercial paste.
4. Repaste leather.
5. Place book on leather and pull up left side.
6. Dampen leather on spine—pull it over back.
7. Nip up bands slightly.
8. Use band stick until leather begins to stick.
9. Nip up.
10. Set sides and rub them down.

11. Nip up.
12. Band-stick again.
13. Tailor back.
14. Cut corners of leather.
15. Nip up and rub down sides with special attention to joint.
16. Paste turn-ins at head or tail.
17. Turn over pasted turn-ins.
18. Paste opposite turn-ins.
19. Turn over opposite turn-ins.
20. Paste fore-edge turn-ins one at a time and turn over.
21. Set and shape headcaps.
22. Give a general tailoring of leather.
23. Set boards to joints.
24. Nip up and rub down.
25. Tie thread around book and through nicks at headcaps.
26. Set headcaps and shape.
27. Nip up and rub down.

We shall now proceed with instructions based on this synopsis of covering. The first thing to be done is to paste the leather cover. The cover is placed on newspaper cut amply large so that the worker is not hampered by fearing to go beyond the edges of it and the leather is pasted from center to fore-edge in order that any stretching will take place on the book-width and not on the book-height of the leather. The brush is held as for other pasting. If the leather is delicate in color, unprinted news should be used to paste on, but for dark leathers printed newspaper is suitable. There should be a generous amount of paste used in this first pasting of the leather, as the pores of the skin are thirsty for it, and this thirst must be satisfied; otherwise the pores will steal the paste put on later to make the leather adhere to the book. In other words, this first coat of paste acts as a filler, or size, and nothing more. It must be evenly applied, and no surplus paste should be

left. The entire success in making a leather adhere firmly to a book, providing it is properly rubbed into place, lies in filling up these pores before paste is applied for the purpose of affixing the leather to the book. When pasted smoothly the leather is folded over "to mellow," with the pasted side in.

It may be noted here that a smooth leather, such as calf or seal-skin, should be pasted with thinner paste than that used for morocco, levant, or pigskin. The reason is that calf and sealskin

Fig. 116.

have many small pores, and a heavy paste would clog them and not penetrate so far as a thinner paste.

While the pasted leather is left folded so that the paste will penetrate the pores of the skin, the four corners of the boards next to the joint are nicked. That is, they are cut off at an angle from the upper side, so that the ends of the headbands may have a place to lodge and will not protrude on the sides of the book after it is covered. A tin or headcap setting block is placed under the board at the joint, and the board is cut with the utility knife on an angle slanting toward the joint (see Fig. 116). After this, the spine of the book is pasted thoroughly with a commercial paste in

order to size it, and care must be taken not to leave an excess of paste next the cords.

The leather is then unfolded and is given a second pasting. The more perfect side is chosen for the front of the book, and the leather is laid out flat. With the covers of the book held closed, the back of the book is placed down on the leather between the two lines marked for it and between the head and tail margin lines (see Fig. 117). The left side of the leather is brought up on the cover board, the book is turned over on the bench with the foreedge down, and the other side of the leather is let to fall over its board. The leather on the sides should not yet be put in place, but

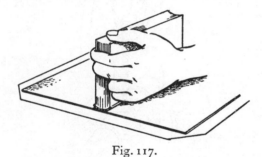

Fig. 117.

should be allowed to take its approximate position without being pressed down until the leather on the back has been worked over and fixed in place.

With the book in this same position, the leather along the back is slightly dampened with a small sponge (except when calf or delicate leathers are used). Then, beginning with the center cord, or, as it will be called hereafter, "band," the worker pulls the leather downward from the end of the book toward the bands, using the palms of the hands on each side of the back. The book is reversed, and the leather is pulled toward the bands from its opposite end. This pulling toward the bands from opposite directions is to ensure a sufficient amount of leather over the bands. Then the leather is pulled straight down on each side of the back

with a good deal of force. The bands are now nipped up with the band nippers (see Fig. 118) just enough to see if sufficient leather has been pulled over them so that they may be later nipped up tightly without having the leather pull away from them. Too much time must not be spent on them just yet, for they will lend themselves to being more firmly nipped up after the paste has taken hold, whereas it is important at this point to work the leather down between the bands and to get the rest of the cover put in its proper place before the paste has had time to dry.

Fig. 118.

After the leather on the back of the book has been pulled over tightly, the band stick is used between the bands to induce the leather to stick. With the book parallel to the worker, the stick is pressed, not rubbed, on the leather with a rocking motion. Then when the paste appears to be taking hold on the back, the bands are nipped up again, as they are after almost every operation of covering, and the sides are looked to and set. To set the sides, the book is placed flat on the lithographic stone with the back toward the worker, and the leather is pressed with a folder very firmly over the joint from the back of the book toward the side. This fixes the leather at the joint and brings over any surplus leather. Now the fore-edge of the book is turned toward the

worker, and the leather is raised on a side of the book and pulled over from the joint until the lines marked on it coincide with the edges of the board. If it is necessary to pull the leather in to conform to the marks, it will of course be wrinkled, and then the grain must be "made." To "make" the grain, that is, to form it in a natural pattern, the leather is slightly dampened, and with the ends of the fingers it is worked over with a rotary pushing motion. The grain is arranged in this way to correspond with that on the rest of the leather. This process is repeated on the other side of the book. After the leather on the sides has been placed and the grain has been adjusted, paper is put over the sides, and they are rubbed down thoroughly, with particular attention to the board edges and the joints.

All this manipulation of the book has a tendency to interfere with the sticking of the leather on the back, and therefore the back is looked to again. It is nipped up, band-sticked, and "tailored," or finished to a nicety. Almost any amount of time may now be spent on the refinements of the covering, for the leather has been put in place, and it should be sticking firmly. At this point it is well to test the leather over the back to see whether it is adhering. To test the sticking of the leather, the back is placed upward and one board at a time is lifted. If the leather is not stuck down tightly to the back, it will pull away from the board when the board is opened in this way. In that event, the leather over the back must be slightly dampened and then worked over until it is made to stick.

The next step is to turn over the margins and miter the corners on the inside. There are several ways of mitering the corners of the leather on the inside of a book, and one of the strongest corners, which will now be described, is mitered before the margins are turned over. For this purpose a corner knife is used (see Fig. 114). The knife has a long flexible blade, which is beveled on one side and tapers from the handle toward the end. It

must be kept sharpened to an acute cutting edge. The book is placed near the right corner of the covering stone with its covers closed and with its fore-edge to the right. The left hand is put between the book and the bottom board, and the back edge of the knife is drawn at right angles to the corner of the board and a little more than one-eighth of an inch from the corner, to make a line on which the leather is to be cut. The leather is then cut on this line by inserting the long-bladed knife under the board at the corner and drawing it sharply across the corner (see Fig. 119). On the inside of the board, a line bisecting the corner is drawn

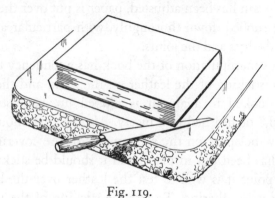

Fig. 119.

with a pencil, and the leather is brought over onto the inside and tested for length. It should be long enough so that the two sides just lap over each other on the line bisecting the corner. If too long, it should be trimmed in the same manner it was cut. It is then thinned down all along the edge back to where it is to turn over onto the board so that the corner can be neatly mitered. The cut edge on the fore-edge margin will be turned over the other edge, and it must therefore be thinned carefully and be cleanly cut. The leather on all four corners is cut and mitered in this way, and the coverer is then ready for turning over the margins. If the book to be covered has a hollow back, the paper forming the hollow should be slit up along the joint for about three-quarters of

an inch at head and tail on both sides of the book, so that the leather turn-in, as it comes over the back of the book, may be tucked under the hollow when the turn-in is being turned over.

Beginning with either the head or the tail margin, the leather is pasted thoroughly with starch paste on the inside of the turn-over, and a little paste is put with the finger on the outside of the leather which is to be turned in over the back. Several thicknesses of soft paper toweling are put along the edge of the lithographic stone to prevent the back of the book from being marked. The book is placed back down on the stone and over the edge, and the boards are let to fall open on the stone (see Fig. 120). Then,

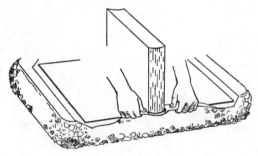

Fig. 120.

with one thumb on each of the boards just next to the back of the book and with the index fingers under the turn-ins, the boards are pressed down quickly, and the turn-ins are simultaneously brought over the boards at this point and are tucked in next to the back of the book. The left board is then brought up into place to prevent the leather from being pulled away at the joint; and on the underboard, which is on the block, the turn-in leather is pulled over with the covering folder and is smoothed out (see Fig. 121 A). At the corner, the leather turned over is made to come just over the bisecting mark on the inside of the board, and the leather on the edge of the book at the corner is folded over onto the edge of the board at the fore-edge (see Fig. 121 B) and

, is creased firmly so that when the fore-edge turn-in is brought over the edge of the board, the corner will be neatly covered (see Fig. 121 C . The projection beyond the corner should not be over

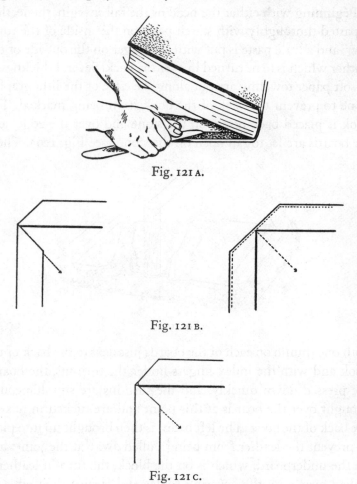

Fig. 121 A.

Fig. 121 B.

Fig. 121 C.

a sixteenth of an inch. If too long, there will be an unsightly pleat at the corner. The leather all along the edge should be squared up on the board. Then the book is turned over and the opposite turn-in is brought over and smoothed down.

The boards of the book are closed, and the headcaps are looked to. The leather forming the headcaps should just cover the headband. After a little practice, the coverer will be able to leave out just the right amount, but if too little has been left out, the book is placed back down on the stone and the leather is pulled out from the back with the point of a folder until the right amount protrudes evenly. If too much has been left out, the excess leather can usually be worked down on the back of the book toward the band. This is better than trying to get rid of the leather by pushing it in under the back, for the lining paper is liable to be disturbed through this manipulation, and a bump under the leather on the back of the book will result. After the amount of leather left for the headcap has been adjusted it is turned over and patted down with the folder; then the margins on the opposite end of the book are pasted and turned in, and the second headcap is formed. Finally the two fore-edge margins are pasted and turned over, and the leather on all the edges of the book is squared up with the folder and made sharp and trim-looking.

The book is now covered, and it is best to give the leather a general tailoring at this point. The bands are nipped up, the back and sides rubbed down, and the board edges sharpened. Then the boards of the book are squared with the joint. Just here it may be well to remind the reader that there is a technical difference between "a hinge" and "a joint." A joint is that part of the bound book which has been turned over during the backing operation for the board to rest in. A hinge is any material that is fastened over the joint to connect the book with the board. A close analogy will be found in the jamb and hinge of a door; the jamb represents the space provided for hinging the door to the frame, as the joint of a book represents the space for hinging the cover to the book. It is important to make this distinction clear, and this analogy is suggested in order to bring out the necessity of having a joint square if it is to function properly, for we are all acquainted

with doors that swing open when they are unlatched and will not stay closed, because the doorjambs are not square.

If a board has dragged away from the joint (see Fig. 122 A), one cover is opened at right angles to the back of the book, and with a folder in the right hand held up in the joint, the board is forced toward the book and against the folder until it lines with the edge of the joint (see Figs. 122 B and 122 C). Then the cover

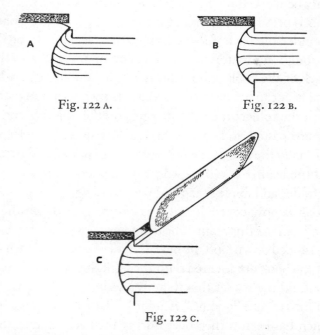

Fig. 122 A. Fig. 122 B.

Fig. 122 C.

is carefully closed without disturbing the position of the board, and the other joint is set likewise.

After this is done, the bands are again nipped up, the sides and back are rubbed down, and a thread is tied around the book at the back, passing through the nicks on the back edges of the boards. To tie the book up easily it is placed on the stone with the back toward the worker. A piece of linen sewing thread is wound around the index finger of the left hand to hold it firmly and is

then brought twice around the book through the nicks. The book is stood up on end, and the thread is pulled firmly, tied in the center of the edge, and then cut off. If tied too near the boards, the ends are liable to mark the leather on the back.

The two headcaps are then shaped and set. The thread running through the nicks defines the ends of the headcaps and enables the worker to curl the ends over with the headcap folder (see Fig. 113) and give them a trig shape (see Fig. 123). The book is placed down on the headcap setting block (see Fig. 115), and a folder is dipped in water and made to smooth the leather

Fig. 123.

down lightly on the back toward the block. Then the leather is sharply tapped at right angles to the back as the book is pressed down on the setting block. This is done at both head and tail of the book. Since the block is wedge-shaped, the greatest pressure on the book comes on the headcap at the thicker end of the block, so that a sharp outline of the headcap may be made. Again, the meticulous binder nips up, rubs down, and tailors his book carefully. Before the book is put away to dry, the leather cover should be wiped off with a dampened sponge to remove any paste stains. Care must be taken during the covering operation to keep the book from hitting metal tools, for if metal touches damp leather, it will leave a dark stain.

When the book is ready to be put aside to dry, celluloid sheets are slipped between the book and the cover board on each side without raising the boards and disturbing the joints. The book is put away between several thicknesses of printed newspaper with a sheet of unprinted news next the leather, and a lithographic block is placed over it. It is left for about three-quarters of an hour, or until the paste has had time to take hold. At the end of this time the book is taken from under the weight, the thread is cut, and the joints are looked to. This is merely a matter of insurance, for the boards are probably set in place, but, should they

Fig. 124.

need forcing up a bit toward the joint, this can now be done effectually before the paste has thoroughly dried. After the setting of joints has been done, the covers of the book are closed, and the headcaps, which have been disturbed by opening of the book, are set and tailored again. The book is then put under the stone, after being placed between fresh papers, and is left to dry overnight. It is very necessary to change the papers, for the first papers absorb a great deal of dampness from the leather cover and are likely to be marked in wavy lines, which would be imprinted on the leather cover if the paper were left on the book.

Should there be trouble in making the leather stick on the back, as is not unlikely to happen in the case of very thin books, it is best to tie the book up after it is covered, instead of putting it

under a lithographic stone. A pair of tying-up boards, which have a small ledge on the bottom to hold the book, are used (see Fig. 124). Before the book is tied up, celluloid sheets are put in between the text and the bookboards. After the book is placed between the tying-up boards, the heaviest sewing thread or fine string is first wrapped around the length of the boards two or three times and fastened with a knot, and then it is brought up from underneath the boards over the underside of the first right band, is run around the book, and is brought up on the opposite side of the same band. This is continued around all the bands, as shown in Fig. 124. The thread must be laid close up to the bands, is pulled as tightly as possible, and is finally fastened by drawing it through a slit in the end of the tying-up board. A strip of paper folded over several times is drawn up under the threads near the back on each side of the book to prevent the book from being marked. After the book has been left tied up for about three-quarters of an hour, it may be untied, and if the back is sticking, the book is put away under a stone as previously described.

The day after a book has been covered, its boards should be opened, but if the leather binds over the joints, the opening must not be proceeded with until the leather has been loosened. The book is placed on the bench with one cover pulled back as far as it will go without straining the leather, and a supporting board of the same thickness as the book is put under it. The leather near the joint is then dampened with a sable brush, and the water is spread over the whole margin, so that a watermark rim will not be left on the leather. As soon as the leather is sufficiently dampened, it may be lifted from the board near the joint with the point of a small bone folder. This stretches the leather somewhat, and the board is then pushed toward the back of the book until it is squared to the joint. After the board is squared up at both ends, a little paste is put under the freed leather, and with a piece of paper over it, the leather is rubbed down in place. The board is

left in this position without disturbing the joint, and the book is turned over. If the second board opens stiffly, the leather is freed at the joint and is set as for the first one. The book must be left in this position, with both boards turned back at right angles to the book and with a board between them, until the freshly pasted leather is dry. This usually takes about a half hour. The boards are then closed, and the book is put away under a heavy weight until needed. It may be well to point out that if the leather had not been pulled away unduly from the joint when it was being turned over the boards, it would not be necessary to loosen it after covering.

Fig. 125.

CUTTING INSIDE MARGINS AND FILLING IN

After a book has been covered, the leather margins on the inside of the cover are uneven and must be trimmed. To prevent a depression from showing under the end papers after they are pasted back, the cover is lined with a piece of board equal in thickness to the leather turn-ins. The book is placed on the bench with both of the covers turned back, and a board is put between them to keep them level so that they will not be pulled away from the joint (see Fig. 125). If the book has leather hinges, this process is deferred until after the leather hinges have been pasted down.

A very satisfactory kind of board to use for filling in is newsboard or chipboard. A thickness is chosen equal to the thickness of the leather margins, and a piece is cut for each side of the book a trifle smaller than the bookboard, with one straight edge along its length. A width is decided on for the margin and the dividers are set to this measure. The straight edge of the filling-in board is set just a hairbreadth back of the cover board at the joint, and the underside of the filling-in board is marked at the joint to correspond with a mark put on the cover board opposite it. A weight is then put on the board to keep it from slipping, and the width decided on for the margin is marked on the filling-in board with the dividers. At each of the two corners of the board, intersecting lines are drawn with the dividers to define the corner accurately, and the point of the cutting knife is punched into each of the lines where they cross at the corner, marking it deeply to make a stopping place that prevents cutting beyond the corner. With a straightedge placed on the marks indicated for the width of the margins, the leather and filling-in paper are cut with a sharp utility knife. During the cutting process, the book should be turned so that the line to be cut will be perpendicular to the worker. When the cutting is finished, the leather cut off beyond the width of the margins is removed from the board, and even margins of leather will be left on three sides of the board. The filling-in board, which was cut with the leather, is bound to fit exactly into the center space.

The filling-in board must now be pasted in place. A very small shaving is cut off the length of the board, as it will stretch after being pasted. The board is then pasted from length to length and is put in place, with attention given to the marks which identify its position, and it is rubbed down thoroughly. If it has stretched beyond the leather margins it must be cut off, in order that it may sink down level with the leather. When the pasting is finished, the book is stood up to dry, with its boards held open by a piece

of cardboard cut out to fit over the board edges (see Fig. 126). When dry, it is put away lying on one side with a weight over it, and it should be kept always weighted when it is not being worked on.

PASTING BACK END PAPERS

Most binders prefer to leave the pasting back of end papers until after the book is titled and decorated, but since this is essentially a job for the forwarder, it will be described at this point, as it may be done any time after the boards have been filled in.

Fig. 126.

Before the end papers are pasted back, they are cut so that they come just over the leather on the inside margins. The book is placed on the bench with both covers turned back, and enough boards are built up between the covers so that they will not pull away at the joint. The protection sheet is pulled off, and with a knife, the joint is cleared of any particles of glue or other foreign substance. The dividers are then set to a distance a little narrower than the leather margins, and the outside end paper is drawn over onto the board, is rubbed down all along the joint, and is firmly creased. With the paper drawn tightly over the board, two points are made on the end paper by the set dividers on all three sides of the cover. The measure is taken with one point of the

dividers resting on the edge of the cover. A cutting tin is placed on the book, and the end paper is let down over it and is trimmed off with a knife and straightedge, through the divider points at head and tail. Little tabs are left to cover the joint at each end of the paper. These should be cut in width to the depth of the joint (see Fig. 127). Instead of cutting through the points on the fore-edge, the cut is made just inside of the points so that the end paper will be a trifle shorter on this edge. The reason for cutting this edge of the paper short of the points is that, after being pasted, the paper will stretch in this direction. The book should be turned so that the line to be cut is perpendicular to and on the

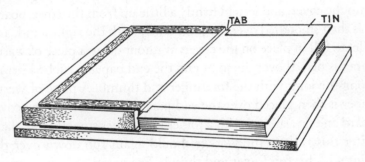

Fig. 127.

right side of the worker, while cutting. At this point it must not be forgotten that in order to produce a clean edge, heavy pressure must be put on the straightedge with the left hand and the very slightest pressure must be used with the knife. After both end papers are cut, they are ready to be pasted back.

To paste back the end papers of a book, the two boards are turned back as for filling in (see Fig. 125), and a piece of waste-paper is laid under the cut end paper which is to be pasted. Some commercial paste is beaten up to a smooth consistency and is thinned down only just enough so that, when being applied, the brush will not drag and stretch the end paper more than neces-

sary. A little thick paste is first well rubbed into the joint of the book with a finger, and then the thinned-down paste is applied to the surface of the end paper. When applying the paste the worker takes a very small amount of paste into his brush and directs a few strokes of the brush along the length of the end paper at the joint of the book. He then applies the paste over the rest of the end paper with all strokes of the brush directed from the joint toward the fore-edge, in order that the paper will stretch evenly in this direction and not stretch in "pockets," as it would if the brush strokes were not all directed the same way.

After being pasted, the end paper is taken up with the left thumb and fingers at the center of the fore-edge, is brought over onto the cover, and is held firmly a little up from the cover board. It is then smoothed over the joint tautly with the right hand, and is let to fall in place on the cover. Without delay a piece of wastepaper is placed over the joint and the end paper is rubbed firmly along the joint with the forefinger and thumb. A piece of wastepaper is then placed over the end paper, which lies on the cover board and it is rubbed with a folder until it lies smoothly in place. After this is done the worker should again rub down over the joint with his forefinger and thumb. Frequently a joint requires a considerable amount of rubbing in order to make the paper adhere firmly, and a piece of wastepaper should cover the end paper over the joint while the rubbing is being done. After one end paper is pasted down the book is turned over with care not to disturb the joint, and the other paper is pasted down.

If the end paper has stretched so that the leather margins are not equal in width, the end paper should be compassed off with the dividers and cut so that the margins are made uniform. When removing the cutoff pieces of paper a little water should be applied to them with a small camel's-hair brush, and after the water has penetrated the cut strips they may be pulled off without injury to the surface of the leather.

After the end papers have been pasted down, a pressing board is removed from between the bookboards and is laid on a table. The book is placed on the board with the book boards left bent back and with the joint projecting a little beyond the pressing board so that the air may get to the joint as the end paper dries. A wad of paper of a size sufficient to support the upper bookboard and keep it level is put between the open boards (see Fig. 128). The book is turned over about every ten minutes for about a half

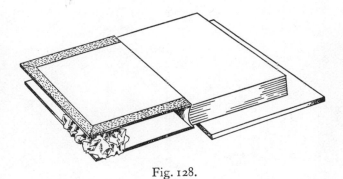

Fig. 128.

hour in order that the end papers may dry evenly. When dry, the boards are closed and covered tins are put inside and outside the boards just up to the joint. The book is put in the standing press with the back edges of the bookboards even with the edges of the pressing boards. The press is wrung down lightly so that the mere weight of the platen is on the book. Too much pressure put on a book after it has been covered will cause the leather over the backbone to wrinkle and be loosened.

Knowing just when to close a book after the end papers have been pasted down requires some judgment. If the book is closed too soon, the end papers will wrinkle over the joint. If the hinge is let to get too dry before closing the book covers, it will cause a swelling over the joint on the outside of the book. Should there be any doubt about closing a book at the end of a half hour, one

board of the book may be slightly pulled back, and if a swelling begins to show along the joint on the outside, the book is ready to be closed. A small amount of swelling will be smoothed out in pressing.

End papers are usually pasted back after the book has been tooled and polished.

CHAPTER XVI

FORWARDING

Leather Hinges. Doublures. Flyleaves

LEATHER HINGES

SEWED WITH THE BOOK. All leather hinges are put in place before the margins are cut and the filling in is done. Leather hinges sewed with the book are already attached to it and have only to be cut before being pasted down. The protective casing and the protection sheets are removed from the book, and the joint is cleaned out and freed from any glue or pieces of paper. The book is placed with its covers as for filling in (see Fig. 125) and the two corners of the board next to the joint are bisected and

Fig. 129.

are marked by a line with the point of a folder. The division line should not come from the point of the corner, but should start somewhat down from it along the joint, at a point even with the edges of the book (see Fig. 129). Otherwise, the leather would be mitered so that it would have to be cut away at the extreme end of the board and thus weakened where strength is essential. After being marked, the leather on the board is beveled off along

the division line at the corners with a sharp paring knife, the beveling starting just beyond the line. The pieces of leather cut off are removed from the board with a knife, and the leather hinge is then mitered and beveled at each end to fit over the mitered edges of the leather on the board.

After the hinges have been mitered, they are pasted down in place. The hinge is laid back over the book, and with a piece of wastepaper under it, is thoroughly pasted with a fairly thick, smooth paste. Then a little full-strength commercial paste is rubbed into the joint. The joint must be thoroughly coated, though no excess paste should be left in it. The hinge is then repasted and put in place, with care to set the mitered corners neatly. It is rubbed down over the joint with the forefinger and thumb, is smoothed out and is rubbed down over the bookboard. This rubbing is always done with paper over the hinge. The whole operation of pasting down a leather hinge is exactly like that of pasting back an end paper, except that the leather hinge must be allowed to dry somewhat longer than an end paper. Detailed directions for proceeding with the rubbing down, placing aside to dry, and putting in the press will be found on p. 226.

PASTED IN AFTER COVERING. Hinges which are put in after the book is covered are mitered like the sewed-in hinges. Before being mitered, they are cut off. The hinge will stretch after being pasted and must therefore be cut shorter than the distance between the two longest points of the bevels already cut on the margins, that is, between A and B, as shown in Fig. 129. The longer the hinge, of course, the greater the stretch will be, and the most accurate way of determining the length to cut the hinge is to put it in place and observe how much it stretches when pulled firmly from one mitered corner to the other. For an octavo volume with leather of average stretching quality, it will be somewhat more than one-eighth of an inch. After being cut, the

hinge is mitered and beveled to complement the bevel already made on the margin. The beveled edges on the hinge should be cut to lap just over the other edges. The second hinge is cut in the same manner. For directions for paring leather hinges, see p. 204.

After being pared, they should have been marked on the underside with a line indicating the part that is to go over the joint, as this portion of the hinge has been pared considerably thinner than that which rests on the board (see p. 204). When the hinges are ready to be put into the book, one of them is pasted with starch paste and is folded over and left while some commercial paste is rubbed into the joint. The hinge is repasted and is put in place with the marked line exactly on the back edge of the board. The leather is worked down sharply over the joint, and the surplus width is smoothed out over the end paper. The joint is rubbed, and then the leather on the cover board is put in place, first at one corner and then at the other. It is smoothed down and rubbed until it adheres firmly. The joint is then rubbed down again, and the work is finished as just described for sewed-in hinges.

When the hinge is sewed with the book, it will not be necessary to add any extra thickness of paper at the joint to allow for the thickness of the hinge, as the leather hinge was made a part of the end paper and was backed with the book. But when the hinge is to be put in after the book has been covered, allowance for the added thickness of leather should be made, and an extra piece of paper is folded around the end papers before sewing and is removed just before pasting in the hinge.

DOUBLURES

Books with leather or silk doublures are filled in with paper instead of newsboard in order that the doublure will be sunk into the leather frame of the margins. After the hinges have dried,

the margins are measured off, and if leather doublures are to be used, the margin leather is cut on a short, even bevel which slants toward the center of the board. The filling-in paper is then cut to fit the framework it is intended to fill, and a piece is cut off its length, the amount depending on how much the boards should be warped.

Most cover boards need to be made to curl inward, as heat and atmospheric changes have a tendency to make them curl away from the book. When end papers are pasted down they serve this warping purpose, but doublures that are merely "tipped in" have no warping value, and for this reason it is always necessary to line down under them a warping paper that will curve the board perceptibly. Leather doublures, on the other hand, are pasted in overall, and they therefore warp a board to some extent, though since they cover only the central part of the board, their warping value is not as great as that of an end paper, and a little extra warping is called for before these doublures are put in place.

The thinner the paper the greater its warping quality, providing it is of firm texture. For example, a thin linen-bond paper will warp a board to a greater degree than a thicker bond paper of like quality or than a piece of sturdy wrapping paper. This is understandable, for it is easier to stretch a thin material than a thicker one of the same texture. Bearing this in mind, the binder should select a warping paper with due consideration to the amount of warp needed on the board.

Paper suitable for the purpose having been chosen, it should be cut as wide as the leather framework between the margins and as much shorter than the length of the framework as is necessary to effect the required warping of the board when stretched. It is dampened on both sides and then, after being pasted, is put in place at one end and stretched to its utmost. If it stretches beyond the margin, it should be cut off even with it. The book is then stood up to dry with the boards open as for filling in (see Fig.

126), so that they will warp. After about a half hour, the boards are closed, and the book is put aside with a weight on it and with papers between the boards and end papers. It is well to do this filling in before beginning to prepare the doublures, so as to allow plenty of time for drying.

Very frequently one hears bibliophiles complain of a bad binding job because the boards of a book curve in and will not lie flat. It is quite possible that the binder, in his zeal for guarding against "yawning boards," warped his boards too much, but more frequently the complained-of curved boards are due to the fact that the bibliophile carelessly left his book without pressure before the boards had time to "season." If he only realized the facts, this amateur (in the French sense) of books and bookbinding would be grateful to his binder for the insurance provided by him against "yawning bookboards," and in nine cases out of ten he could readily correct the curving tendency of the boards by keeping the book weighted.

LEATHER DOUBLURES. Leather doublures should be pared to equal in thickness that of the leather margins (see p. 205). After the margins have been cut, it will be a simple matter to judge the thickness required for the leather doublure.

Having been pared, the doublure is cut to fit into the frame made by the cut-leather margins and hinge. The leather is placed on a cutting tin, and a straight line is first cut along one long edge of it. An end is cut square to this edge, with the aid of a transparent celluloid square. It is well to bevel these two edges on the underside before cutting the width and length of the doublure, for if the first beveling is somewhat faulty, plenty of leather should be left to "play with," so that the edges may be recut and opportunity given for perfecting at least two bevels on the doublure. When these bevels are satisfactorily finished, the length and then the width of the doublure are cut. To measure for the

length, the squared corner is put in place, and the leather is gently but firmly stretched along the length of the margin, in order to find out how much it will probably be elongated when pasted. It is marked where it is to be cut and is then cut on the tin with a very sharp knife, guided by a celluloid square. A measure is taken of the width between the margins, it is marked on the leather, and the leather is squared. This will leave two edges of the doublure to be beveled, and the beveling should be done very carefully, to produce a bevel the same depth and width as the one on the margins into which the leather is to fit.

Before the doublure is cut, the framework of the margins should be tested for squareness. If it is appreciably out of square — a fact that would denote very careless workmanship — the margins should be recut. Any slight deviation from squareness will not need to be compensated for in the cutting, as the leather may be stretched sufficiently to make it join properly with the margins.

It may have been observed that leather or paper, when cut to fill in a space, is always made smaller on either the length or the width, but never on both. This is because material is pasted in one direction only, in order to avoid its being pulled out of shape, and it will stretch only in the direction in which it is pasted. This is a very important principle to observe in handling materials, and if observed, it will prevent many a failure. The more fragile the material to be pasted, the more care must be taken to direct the strokes of the paste brush in the same direction.

When leather doublures are put in place, they are thoroughly pasted with a rather heavy starch paste from end to end and are doubled over so that the paste may sink into the pores of the skin. This first pasting of a material is always for the purpose of filling the pores, and the paste acts as a size to the material, sealing it up. The leather is unfolded after a few minutes and is repasted. One side and one end of it are then put in place and made secure, and

the doublure is drawn out so that it fits into the hollow that it is intended to fill. The beveled edges are made to overlap the edges of the margins nicely, and the doublure is rubbed down and adjusted until it conforms exactly to its proper position. When the doublure is finished, the covers of the book should be closed, and the book should be put away for about half an hour to dry, with papers between the boards and the end papers and with a heavy weight on it. It should then be looked at to see that the doublures have not "crawled" away from their positions, for in drying, a doublure is likely to shrink. After any necessary adjustments are made, the book is put away as before and is left until the doublures are thoroughly dry. A help in placing the edge of the doublure will be found if straight lines are drawn with a folder and a straightedge along the beveled edges of the margins. These should, of course, be drawn at right angles to each other.

The word "doublure" is very evidently of French origin, and so far as I know, no other word has been substituted for it in English. The word was doubtless derived from the Italian "duplicare," signifying a double fold. It was borrowed from the French and has evidently not as yet been Anglicized. It signifies a "lining" in French and means a doubling of a material. Usage in English has not yet determined whether it should be spelled "doublure," as in French, or "dublure," as it appears in some English texts. Since it is apparently a word of French coinage, it would appear to be rightfully spelled "doublure" until English usage establishes a different spelling. The meaning, in any case, remains the same.

SILK AND OTHER WOVEN FABRIC DOUBLURES. Doublures of silk or of other woven fabric are usually made by attaching the fabric onto the underside of a paper cut to a size that fills in the framework of leather on the board, and then tipping this fabric-covered paper into place.

Fabrics may be completely lined down on paper and used as doublures, but then fraying edges will probably have to be coped with, and the uncovered edges of the paper are unsightly even when tinted. Lining down fabrics will be discussed under flyleaves, and I shall now indicate how to make a doublure which is "tipped on."

Before the doublure is prepared presumably the leather margins have been cut out and the filling-in paper has been put in place. A piece of any good handmade laid paper is chosen and is cut smaller than the size of the space inside the framework of the leather, the amount smaller dependent on the thickness of the fabric to be used. If the fabric is very thin, the paper is cut not perceptibly smaller than the space, for there need be then practically no allowance made for the thickness of the material as it turns over the edge of the paper. Each paper and board should be marked so as to identify the placement of the doublure in the framework for which it was cut. The grain of the paper should run counter to its length, and the silk should be cut with the grain running with its length. This principle of having the grain of paper and the grain of fabric run opposite to each other is very important if a wrinkled doublure is to be avoided, for the opposing grains serve to keep the fabric taut. This is one of the two cardinal factors necessary to produce a smooth-lying doublure that does not cockle. The paper lining having been cut, the fabric is then cut one-quarter of an inch larger all round than the paper, with the grain running lengthwise. The two doublures for the book are made together, as one may be worked on while the other is drying, and thus time is saved.

Two pieces of binder's board are cut out, each about one inch larger all round than the cut pieces of fabric. On top of the boards, pieces of unprinted news are laid, and then on each of the paper-covered boards a piece of fabric is placed, with the right side down. The lining papers are laid on top of the fabric, with

identification marks uppermost. The papers are centered, thus leaving one-quarter of an inch projection of material beyond the paper on all four sides, and a weight is put on each to hold the material in place. At one end (not side) of the fabric, the two corners are cut off on a line running diagonally to them and extending not more than enough beyond the corner to allow the fabric to be turned over and mitered without leaving an edge of

Fig. 130.

the paper exposed. This amount should be less than one-sixteenth of an inch when a medium grade of moiré silk is used for the doublure. It aids in estimating the amount of material to be cut off if the position of the paper on the fabric is outlined in pencil at the corners. Excellent weights for such purposes as this are blocks of monotype or linotype metal (see Fig. 130). The lower faces of the blocks may be covered with a piece of split leather to keep the metal from sliding or marking the material.

When all is in readiness, one board is placed so that the cut corners of the fabric are farthest from the worker, and a piece of clean unprinted news is slipped under the fabric on the end with the cut corners. Some commercial paste is rubbed with the finger into the projecting edge of the fabric way up past the corners, with care not to allow the paste to go quite to the edge of the fabric. The wastepaper is removed and the fabric is turned over onto the lining paper with a small folder, with the edges kept even. At each corner, the tiny piece of fabric is folded over on itself at a slight angle. After the turnover has been finished, a narrow strip of binder's board is put over it, and the board is weighted all along. This doublure is put aside to dry while one end of the second doublure is turned over. That is likewise put aside and weighted. Then the board holding the first doublure is turned so that the fixed end is next the worker. The lining paper is pushed back evenly toward the fixed end, forming a slight hollow underneath it, and a weight is put on the side of the hollow near the unturned end of the fabric (see Fig. 130). The edge of the paper is marked and some of the projecting material may be cut off. Then the corners farthest from the worker are cut, and the fabric at the farther end is pasted and turned over onto the paper. A strip of board and weights are put on it, and it is put aside until the second doublure has its second edge turned over. The object of pushing the lining paper back is to give it a spring in order to stretch the fabric lengthwise, so that it will remain smooth indefinitely. This and the principle of having the fabric and lining paper cut so that their grains run opposite to each other constitute the two important factors in preventing doublures from cockling. The amount necessary to pull the lining paper back differs with different fabrics. The paper should be pulled back only enough so that it will be allowed to lie flat and not be shortened after the fabric ends have been pasted down. With a firm fabric this amount is trifling.

By the time both ends have been turned over on the two dou-
blures, the doublure first worked on will be dry enough so that
the weights may be removed from it. After the weights have been
removed, the lining paper is pressed down and is straightened
out. If it refuses to lie perfectly flat, it will have been pushed back
in the making farther than enough to take up the stretch in the
fabric, and it would better be unfastened at one end and redone
before proceeding with the side turnovers. The side turnovers
are pasted one at a time and are turned over on a line with the
threads of the fabric. The corners are patted with a folder so that
they are kept square and neat. When silk or other fabric dou-
blures are finished, they should be put away between clean cov-
ered boards and left under a heavy weight until quite dry. If cal-
culation has been accurately made about the filling-in paper, the
doublures should sink down into their leather frames when put
in place, but it is best not to put them in place until after the book
has been tooled. A piece of newsboard is cut and tipped into the
framework to protect the edges until the binder is ready to put in
the doublures. Some binders use glue for making doublures, but
I prefer paste because it admits of a nicer adjustment when turn-
ing over the edges. Glue dries so quickly that it fixes a piece of
material in place directly that material comes in contact with an-
other.

Putting in a doublure is a simple procedure. The finished dou-
blure is held in the hand or is placed on the bench on a clean piece
of paper, and the turned-over fabric edges are permeated with a
good strong commercial paste. Some speed is required in doing
the job, lest the paste dry before the doublure is ready to put in
place. A small brush or the finger may be used for the pasting.
When pasted all round, the doublure is set into its frame of leather
with due attention to how it is to be placed, and it is rubbed down,
with a paper over it, until all four edges appear to be firmly ad-
hered. For this operation glue may be used, but again I prefer

paste, on account of the opportunity it gives for adjustment of the doublure. Then, too, glue will permit the doublure to peel off, whereas paste makes a closer union with two fabrics because of its slow-drying quality, which allows it to permeate more deeply than glue, and two fabrics held by it do not often peel away from each other. They may become loosened in spots, but they will not peel in toto.

Application of the principle involved in making a smooth-lying doublure may be applied to other bookbinding processes. When any woven material is to be held in place by its turned-over edges, in order to make it lie smooth and flat, it should first be fastened at one end, then pulled tightly against that end and fastened at the opposite end. Finally, one side is smoothed out and fastened, and the other side is held taut and is fastened; but material must not be pulled in opposite directions while being fastened, for then the grain is pulled out of line, with resulting pockets in the fabric. The binder would do well to observe these rules in putting a protective cover on his workbench, and armed with this information, he might even invade his domestic household and cover tables with oilcloth *et al*. with gratifying success.

FLYLEAVES

A flyleaf is a blank page at the beginning and end of a book. When the word "flyleaf" is used instead of "end paper," it some-how carries with it the suggestion that the blank page is not an ordinary white end-paper sheet, but is a special leaf of different character. For instance, we do not generally speak of leather or silk end papers, but of leather or silk flyleaves.

When a binding has leather hinges and a doublure of leather or silk, it is usually thought more in keeping to put leather or silk flyleaves in the book than to have plain or figured end papers, but I question the taste or practicality of using silk for doublures or flyleaves. Silk does not seem to me a material suitable to combine

with leather and paper, and even a very good quality of silk fly-leaf will be split and worn when the leather cover and the paper text are still in perfect condition. Leather and vellum, on the other hand, are sturdy materials, and when used for flyleaves, they harmonize with the character of the bound volume. However, since silk flyleaves are in demand, a binder should know how to make them.

LINED-DOWN SILK FLYLEAVES. I have already described in detail, under End Papers (see p. 83), the making of silk lined-down flyleaves when they are to be used with leather hinges and concertina end papers, for the flyleaves should then be incorporated with the end papers as they are being made. The same procedure is followed in making the lined-down flyleaf when it is used with a leather hinge that is put in after the book is covered. After the silk has been lined down and let to dry, one edge is cut cleanly along its length, and a coating of heavy starch paste is worked along the edge with a finger, in order to seal it and keep it from fraying. Any clear size may be used instead of paste for this purpose. The leaf is then trimmed down, if necessary, so that it is very little larger than the text, for it is easier to handle, after being glued, when it does not extend too much beyond the text.

On that part of the leather hinge which is pasted over the joint onto the end paper, one point is marked at each end of the book to indicate how far the silk flyleaf is to come up toward the joint. These two marks should be put about one-eighth of an inch out from the joint. A wastepaper is then slipped under the first end-paper sheet, to which the silk flyleaf is to be attached, the back of the flyleaf is glued with thin glue, and it is put in place on the end paper with its straight edge just up to the two marks made on the leather. Where the flyleaf joins the leather it is rubbed firmly. Then the white end paper on which the flyleaf is to be lined down is glued over with a thin glue up to where the back of

the flyleaf has been attached to it and the flyleaf is let to fall over the glued paper. After it is lightly smoothed out overall with the palm of the hand, a tin is put between it and the cover board. With a sharp knife and straightedge, the three projecting edges of the flyleaf are cut even with the end paper. The book has, of course, been turned over so that the underside of the end-paper sheet is uppermost, in order that it may be used as a guide for cutting. The book is then turned with the flyleaf uppermost, and with a fresh wastepaper under it, it is well rubbed down with a folder through a piece of clean paper. The best position for the book in placing the glued flyleaf is with the fore-edge toward the worker.

After the second flyleaf has been glued in, thin covered tins are put under the freshly glued leaves, the book is closed, and covering tins are inserted between the covers and the flyleaves. The book is put aside between two boards and is weighted with a lithographic stone and left until the flyleaves are thoroughly set. Then some thick starch paste is carefully put on the three exposed edges of the flyleaves, and if the head of the book has been gilded, a little shell gold may be painted on the edges at the head of the book.

Any other fabric may be lined down and used as a flyleaf in this manner, but no flyleaves should be put in as an afterthought. They should be planned for while the book is being constructed, and provision should be made for their thickness by stuffing the joint of the book with paper before it is backed. The stuffing paper is pulled out before the flyleaf is put in place.

The method of lining down materials varies with the character of the material. When a material is loosely woven, paste or glue should never be applied to it directly; the lining paper should be glued lightly with thin glue, and the material applied to it and rubbed down. In most instances when glue is used, it should be applied to the paper and not to the material.

To line up a closely woven fabric like airplane linen, paste is best used, for it is less a surface fixative than glue in that it penetrates more deeply. With a tightly woven material, some penetration is desirable to prevent its peeling off. A thin bond paper or a heavy Japanese tissue paper is chosen for the lining. The linen and the paper are cut with the grain running the same way, in order to make the lined material more supple. The paper is dampened very slightly, so that it will contract and dry with a smooth surface. It is then pasted with a thin paste and is placed on the linen and rubbed down thoroughly with a folder, through a piece of paper. It is put away to dry between binder's boards, with a weight on it. After being lined up, a material of this kind may be cut successfully in a cutting machine.

Tipped-on Flyleaves. The making of silk and other woven material doublures has already been described. Flyleaves that are tipped on are made in the same way. Finding the measurement for the lining paper involves acute calculation and judgment, in order to produce a flyleaf that will not extend too evidently beyond the end paper to which it is fastened.

To measure for the lining paper of a flyleaf, first two marks are made on the leather that extends over onto the end papers; and they are placed at each end of the book about one-eighth of an inch out from the joint, as for lined-down flyleaves. Then, for the lining paper, a piece of rather thin handmade laid paper, with the grain running with its width, is cut a little larger than the end paper. A tin is put under the end paper to support it, and the lining paper is placed over the tin and under the end paper, with one straight edge coming on a line with the two marks made near the joint on the leather. A weight is put on the end paper, and pencil marks are made on the three sides of the lining paper extending beyond the end papers, to indicate their edges. The underside of this lining paper is marked with a letter or a cipher

next to where it rests along the joint, and the same mark is put on the upperside of the end paper near the joint, to indicate how the flyleaf is to be placed when it is glued onto the end paper. The lining paper is then placed on a tin and, with a knife, is cut on three sides just within the marks made. Unless the fabric to be used is quite heavy, no appreciable amount should be cut off to allow for its thickness when it is turned over the edges of the paper. The paper should be tested for size before it is used, and then the flyleaf is made up in the same way as a silk doublure.

To put the flyleaf in place, a tin not much larger than the end paper is inserted under the end paper, and the book is turned so that the back is toward the worker. The flyleaf is then glued with thin glue, and with care taken to turn it so that the two marks will coincide, it is placed on the end paper from the fore-edge. That is, the fore-edges of the flyleaf and the end paper are put together first, and the flyleaf is let to fall in place toward the joint. If the measurements are correct, it will fall about on the line indicated by the two marks on the leather next the joint. It is rubbed in place with a folder over a piece of paper, first on the upper and then on the underside of the flyleaf. After the two flyleaves are put in, a thin covered tin is placed under and over each of them, and the book is put aside under a lithographic block.

LEATHER FLYLEAVES. In order to use leather flyleaves, there must be a leather hinge in the book. The leather for the flyleaf is pared very thin, and it must be pared evenly. When it is reduced to the desired thinness, one straight edge is cut along its length. It is trimmed down until it is only a very little larger than the end paper on which it is to be glued, and its edges are all thinned out. The straight edge is beveled off evenly to a paper thinness all along its length. A piece of wastepaper is put under the end paper, and the end paper is glued almost up to the joint. The straight edge of the leather, which comes next to the joint, is

placed on a paper and is glued lightly but thoroughly for about one-eighth of an inch deep on its underside. The waste paper is then pulled from under the end paper and the glued edge of the leather is placed almost up to the joint and is let down onto the end paper. It is first smoothed out with the hand, and then, with a paper over it, is rubbed down thoroughly with a folder. It is left to dry with protection papers on each side of it, while the second flyleaf is put in place. Before the leather is cut even with the edges of the end papers, it is well to put the book aside under a weight after both flyleaves have been put in place, for the leather is apt to "crawl," while damp, unless it is well weighted. When the flyleaves are well set, the leather edges beyond the end paper are cut as described for lined-down flyleaves, and then the book should be kept under pressure with proper protection against dampness for several hours, at least. It will improve the appearance of the flyleaf at the head if a little shell gold is painted over the edge.

Vellum flyleaves are best made by being folded around a concertina end paper and sewed in with the section. Directions for making them are given in Chapter VI under "End Papers."

CHAPTER XVII

FORWARDING

*Half Bindings. Books of Reference. Library Binding.
Books of Music and Albums*

HALF BINDINGS

THE processes in binding a book in half leather are the same as for a full leather binding up to the point of cutting out the leather cover. I have already described in Chapter XIV the manner in which leather for half bindings is cut and pared.

After being pared, the leather is pasted and is put on the back of the book as for whole bindings. It is brought over onto the sides of the boards and is rubbed into place. Then the book is put aside to dry. Later, the four leather corners, which have been marked with the corner pattern and cut off so that a neat corner may be turned in, are thoroughly pasted with starch paste and are put together in pairs with their pasted sides inward. After they are allowed to remain together in this manner for a few minutes so that the pores of the skin may be filled with paste, two corners at a time are repasted and are put in place on the book, each in turn, tucked in and mitered as for corners of a full leather binding. The other two corners are now put in place, and the book is put aside to dry for at least an hour. Celluloid sheets are inserted under the covers of the book, to prevent any moisture from penetrating the text.

The leather coming over the sides of the book and along the diagonal edges of the corners will be somewhat uneven and must be trimmed. To trim the leather sides, wing dividers are used to find the shortest width of the leather, measured from the joint of the book. This width is marked on the leather near both the head and tail with one point of the dividers, and the leather is cut through the points with a sharp knife, a straightedge serving as a

guide. To cut the corner leather, the corner pattern is put in place over the leather, which is cut with a knife along the diagonal line of the pattern. The surplus leather is then removed from all the leather edges.

The leather edges on the sides of the book will now be straight and even (see Fig. 131), and a piece of material must be cut to fill in between the thickness of the leather coming over from the back of the book and the leather corners. For this purpose a piece of cartridge paper is used if obtainable, or newsboard may be used. A piece of filling-in paper or board is chosen of a thickness equal to that of the leather. It is cut a little larger than the space to be filled in, with one clean, straight edge along its length, and

Fig. 131.

it is then squared at one end. The long, cleanly cut edge is put in place against the side of the leather, and the squared end is placed even with one edge of the length of the bookboard. The length and width of the bookboard are then marked on the filling-in board, and it is cut to size. It must now be cut off to fit into the corner leathers. In order to do this, the filling-in board is put in place on the outside of the book, and when it is raised slightly at the corners and held firmly in place, the outline of each corner may be noted, and the board is marked to denote the size of the corners. The board is then cut off on a tin with a knife and straightedge on the indicated marks. It is well to leave a generous allowance for the board and recut it if necessary, for this mode of measuring is of the trial-and-error variety which is a manner of

measuring not often used in hand bookbinding. Each filling-in board should be marked on the inside to correspond with the mark put upon the cover board opposite it, so that it may be identified for placing. Otherwise it may not fit, for handwork at best is not one hundred per cent accurate. When finally cut to fit between the corners and leather side, each filling-in board is glued with a thin glue and is put in place and rubbed down.

The next procedure is to cut the material for the sides of the book. Marbled paper, block paper, linen, or a variety of materials may be used for this purpose, providing they are not too delicate in texture. The material is cut about three-quarters of an inch wider than the distance between the edge of the bookboard and the edge of the leather on the side, and about one and one-half inches longer than the bookboard. Two marks are made with the folder near each end of the book and about one-sixteenth of an inch inside the edge of the leather on the side. Two marks are likewise put the same distance inside of the edges of the leather corners — one near each end. The straight edge of the filling-in material is placed up to the marks on the leather along the back of the book, a weight is put on to hold it firmly, and the material is creased sharply at head, tail, and fore-edge along the broad edges.

With the back of the book toward the worker, the material is folded back wrong side out at each corner on a line corresponding with the two marks previously made, and is creased sharply back on this line and down over the two edges of the book. It will then have creasings made as shown by the lines in Fig. 132. Line A is cut on a tin with a knife and straightedge up to point L. Line B is cut to point M, line C to point N, line D to point O. Then the lines between points L and M and between N and O are cut, and the pattern of the material will be like that shown in Fig. 133.

This cut material is then glued with a very thin glue and is put in place on the sides of the book up to the marks indicated along

the leather at the back. It will fall properly in place on the corners, and it is rubbed down quickly with the palm of the hand and is turned over the edges and smoothed out on the inside of the board. A piece of paper is placed without delay over the out-

Fig. 132.

side, and the material is rubbed down with a folder, care being taken to see that the edges along the leather are sticking firmly.

The book is now ready to have a filling-in paper put on the inside of the board. Stout wrapping paper is better used than news-

Fig. 133.

board for filling in half bindings. The process of cutting and pasting in the filling-in paper is the same as described for filling in full leather covers (see p. 222), except that the paper is dampened on both sides with a sponge before being pasted. After being filled in, the book is stood up to dry (see Fig. 126), and after

about one-half hour it is put aside under pressure and is left overnight. The following day the end papers may be cut and pasted back as for a full leather binding (see p. 224), though not much more than one-quarter of an inch is allowed for the margins on the leather and paper turnovers. Before the filling-in papers and the end papers are cut, it is important to note how far the end papers will extend over the board at the fore-edge.

Fig. 134.

When a half binding is made without the usual leather corners and paper sides or when sides made of some material of delicate texture are used, there should be corners of vellum, leather or binder's cover cloth put on the book before the sides are glued on. These corners may be allowed to show, as in Fig. 134, or they may

Fig. 135.

be put on after the French method, so that they do not show on the sides of the book, but are visible on the board edge at the corners and on the inside of the bookboard. The inside pattern of the French corner is shown in Fig. 135.

If vellum or leather is used for a small corner on the outside of a cover, the material is cut in miniature size like regular leather corners and is pasted and put in place before the filling-in pro-

cess has been completed and the cover sides are glued on. When the French type of corner is used, the material is usually binder's cloth of a shade matching as nearly as possible the color of the leather used on the back and sides of the book. Leather or vellum is not advisable for this purpose, as leather will not stand the wear on a corner that book cloth of best quality will endure, and vellum is too refractory to be turned over easily and neatly when so small a piece has to be manipulated.

The cloth for these hidden corners is put on before the filling-in boards are glued in place. It is cut into strips about one inch long and one-half inch wide. The pieces are thoroughly pasted

Fig. 136.

with a heavy paste and are put in place and turned over the board edges onto the inside of the cover as for large leather corners. The filling-in board is glued in place after the corners have been put on. This board is not cut out at the corners, but is cut flush with the cover board at the edges. The paper sides are also cut differently from those used on a regular half binding. Instead of being cut off diagonally to fit the leather corners, they are left with squared edges extending beyond the cover board at head, tail, and fore-edge. When cut, they are glued and are placed over the edge of the leather which extends along the sides of the book (see Fig. 136). The book is then turned over so that the freshly glued paper rests on the workbench. A circular pencil mark, which just touches the corner of the board, is made on the paper,

as shown in Fig. 137. The paper is cut with the shears at each corner along this mark, and the edges of the paper are then turned over onto the inside of the board and are smoothed down.

This type of corner leaves a small V-shaped pattern of the cloth at the corners on the inside margin (see Fig. 135), and since the paper is cut up to the board corner, the cloth will also appear on the board edges, where it is intended to be exposed in order to take the wear which paper or other delicate material would not withstand. It will be found that this type of corner is the most successful model to employ when a large-figured material is used on the sides of a book, for the cover would suffer in artistic effect, if the paper were cut off at the corners.

Fig. 137.

There is no particular reason why the traditional triangular leather corners should be used on a half binding. Square or oblong corners may be used quite as well, and they often lend themselves to the scheme of decoration designed for a binding. A strip of leather may also be used along the fore-edge of a book, often with good effect, in which case shaped corners are not needed.

BOOKS OF REFERENCE

Heavy books of reference or other large tomes that must stand much wear and should open freely for the convenience of the reader are best not sewed "flexible," or over cords. All the sections of this type of book should be made sound, and whipstitching, or overcasting, is to be avoided, for this prevents the pages from

opening all the way to the back and makes for a very stiff-paged book.

End papers should be of strong, handmade paper and are best made with an accordion pleat (see Figs. 45 A, 45 B). If extra strength is called for where the board hinges to the book, a piece of fine, thin cambric should be pasted under the upper fold of the end paper to reinforce it over the joint.

The book should be sewed over strong, unbleached tapes, and every fifth section should be catch-stitched as the sewing progresses (see Fig. 69 C). After being sewed, the book is rounded and backed as previously described, and in order to make for flexibility, double or split boards are used for covers. They are attached to the book by inserting the ends of the tapes between them instead of by lacing the tapes through them. This is necessitated by the fact that the boards are left out from the joint of the book to form what is known as a "French joint." This joint allows a freer opening than an ordinary joint used with laced-in boards.

To make a pair of split boards, a thin binder's board is glued to a thinner board or to a piece of strawboard. Pieces of the two thicknesses of board are cut out large enough to make two cover-boards. Down the center of the thinner board and across its width, a strip of heavy chipboard, about four inches wide, is placed, and the board is then well glued. The chipboard is removed, the thicker board is laid on the glued board, and the two boards are then nipped up in the press. At first the nipping pressure should not be heavy or sudden, for fear of forcing the glue out between the boards. After a few moments the pressure is increased and the boards are left to dry in the press.

When dry, the double board is cut through the center, and thus two boards are made of it. These boards will be glued together except for a space about two inches wide on one long side. If the boards required for the book need to be very large, it may be

more convenient to make each board separately, gluing it so that an unglued space will be left on one long side.

The head of the book is cut in the guillotine cutter after the book is glued up, but before it is backed.

The ends of the tapes are cut to a length of about three-quarters of an inch, and they are glued down on the protection sheet. The protection sheet is then folded over the glued-down tapes at a distance about one and a quarter inches from the joint of the book and is cut off on a line with the joint. The underpart of the folded paper is glued and is lined down over the tapes. At each

Fig. 138.

end, it is cut off at an angle as shown in Fig. 138, so that it may be more easily slipped between the double boards.

The length of the boards is then cut square to the size required for the book, and the usual eighth-of-an-inch overhang is left for squares at head and tail. The width of the boards is cut a trifle more than one eighth of an inch shorter than the width of the text, the measure being made from the joint. This will allow the split board to be placed a little more than one-eighth of an inch out from the joint and still project one-eighth of an inch over the fore-edge to form the book-square as shown in Fig. 139.

To put the boards in place, one split board at a time is opened at the back, or unglued, edge and glue is inserted between the opened boards. The glued-down tape-piece is slipped between the freshly glued boards and is adjusted so that all three book-

squares are even. Then the boards are pressed together. After the
second board is placed properly, the book is nipped up in the
press and is left until the boards are firmly glued together at the
back.

Headbands may now be woven onto the book at head and tail,
if time and expense allow, or they may be dispensed with and a
piece of cord may be stuck in under the leather turn-ins at head
and tail when the book is being covered. This sort of headband
serves its practical purpose very well, though the decorative value
of a woven headband is sacrificed. The back of the book is now

Fig. 139.

lined up as for a regular flexibly sewed binding, and the book
is ready to be covered.

The leather is pared as previously outlined, whether for half or
full binding, though it may be left full thickness over the joint,
and the book is covered in the usual way. After being covered, a
piece of cord is tied around the book over the joints, and the book
is nipped in the press. The joints may be more definitely defined
by running the blunt end or the side of a folder along them.

When a book is bound in half leather after this fashion, the
corners should be protected with vellum or cloth, either partially
concealed, as in a French corner, or showing slightly on the sides

of the book. Both of these methods have been described in the foregoing directions for regular half bindings.

The forwarding of the book is finished in the usual manner, but when the end papers are pasted down, if a linen hinge has been used for reinforcement, the linen is pasted down on top of the end papers before they are lined down on the covers, and the pasted-down linen is pasted with the end papers when they are put back over the coverboard.

The type of binding just described is of English origin. The French use a similar method for binding books, which is known as a "Bradel" binding or a binding "en gist" (see p. 182).

Fig. 140.

LIBRARY BINDINGS

Library bindings would best be constructed in the manner just described, but the expense is prohibitive in this country for most public libraries. Specifications for library bindings will be found in books named in the Selected List of Books at the end of Volume I.

BOOKS OF MUSIC AND PHOTOGRAPH ALBUMS

Books of music or albums, if bound like books of reference, are strong and serviceable, but in binding music, the sheets should be hinged like a book composed of plates (see p. 49) in order to secure the most practical result. The only difference between guarding plates and sheets of music is that the paper, when cut along the back, need not be pared when the sheets are mounted, since the paper on which music is printed is not bulky. The pages

in photograph albums are mounted like plates, and around each fold a guard is folded in order to stuff the book at the back (see Fig. 140), so that when photographs are pasted in, the book will lie flat.

CHAPTER XVIII

FORWARDING

Limp Bindings. Pamphlets and Thin Books. Vellum Bindings.
Embroidered, Woven Material, and Velvet Bindings.
Casings. Portfolios

LIMP BINDINGS

LIMP bindings are usually not flexibly sewed, for they would better not have raised bands. When a book is to be bound in limp covers, it is best to sew it on tapes. The book is then backed with a very slight hinge, and the ends of the tapes are cut off to a length of about five-eighths of an inch and are pasted down on the outside of the last end-paper sheets. The book is headbanded, and the back is then lined up with super or with thin cambric, which should extend over the headbands and over the sides of the book about five-eighths of an inch. The back lining, after it has been glued on, is cut off even with the headbands and even with the text of the book where it extends over the sides. The two side extensions are cut off on both ends at an angle, as for books bound in double boards (see p. 254).

The back is then lined up with a piece of tough wrapping paper (see p. 177). Cover boards are cut out of "redboard" or "newsboard." Both of these materials are flexible and bend without breaking. The redboard is the more flexible and should be used for small books such as prayer books. A limp book is usually made with a narrow French joint, and the boards are cut like those for a book bound with double boards (see p. 254), except that only one-eighth of an inch, instead of one-quarter of an inch, is allowed for the joint. They are used unlined. A strip of redboard is cut the same length as the cover boards and the width of the back. To take the measure for the back width, a strip of paper is used, as a rounded surface cannot be accurately measured with a pair of dividers.

A paper pattern for the leather is then made. It is made like that for a full leather binding (see p. 187) except that in estimating for the allowance between the two boards there is added to the width of the back one-quarter inch, which represents the one-eighth inch taken up on the two sides of the book for the French joint. In other words, the whole width of the leather must be computed by adding the width of each board to the width of the back, plus one-quarter inch for French joints, plus about one and one-quarter inches for two turn-ins. The leather for each turn-in need be not more than five-eights of an inch. The height of the leather will be the length of the board plus one and one-quarter inches for the two turn-ins.

The leather is cut from the paper pattern and is marked up. To mark it up, one of the cut boards is placed about five-eighths of an inch from one end and is marked all round as described on p. 196. One-eighth of an inch from the line indicating the farther side of the board, another line is drawn parallel to it, using a straightedge. Beyond this line the width of the back is marked by a line, and then at another distance of one-eighth of an inch a line is marked to represent the boundary of the second French joint. A board is placed on the last line and on a line with the top of the marking for the first board. Its place is outlined by lines all round it (see Fig. 141).

The four turn-ins are pared quite thin so that they can be neatly turned over the thin boards. No other paring is done except to thin down the leather slightly with the French knife between the marks for the French joints. The leather is marked up again accurately after the paring is finished, indicating the width of the back, the French joints, and the outside boundary lines of the boards.

To make the cover, one board at a time is glued with thin glue and is put in place; the strip for the back is glued and is placed within the lines marking the back. The boards and backstrip

must be placed from the same end, with care to line them all up in a straight line. The boards having been placed, the cover is rubbed down on both sides with a folder. When the leather side

Fig. 141.

is being rubbed down, a piece of clean paper should be put over the leather. Then the turn-ins are cut at the corners like those of a regular binding (see Fig. 142). Or if rounded corners are used, as for a prayer book, the leather is not cut, but is turned over at

Fig. 142.

each corner after all the turn-ins have been turned. The leather turn-ins are pasted and turned over the board one at a time; the head and tail are turned first. The fore-edges are then turned over, and they are mitered when the boards have square corners

(see p. 197). If the corners have been rounded, a little paste is put on the inside of the leather and each corner is "fulled" over on the inside of the board with the point of a finishing folder by running the point down the leather diagonally from the corner to make very fine pleats or gatherings. After all the gatherings have been made even, the leather is pressed down firmly with a folder and made to lie smooth. To avoid too great thickness, the leather at the corners is thinned after the paring of the turn-ins is completed.

The cover is now finished and is put aside flat and weighted until needed, though it may be used at once. This cover is made exactly like a casing for a limp-covered book, and when done in this way the book will be a cased book. The backbone of the cover should be titled and tooled before it is put on the book. The sides of the cover may be tooled later.

When the book is ready for its covers it is pasted into them. The back of the casing should first be rounded by placing the book in the casing and shaping the backbone with a folder to conform to the contour of the back of the book. A piece of paper should be put over the leather when the back is being moulded into shape. A clean piece of wastepaper just a little larger than a page of the text is then put between the front end paper and the book, and the upper side of the end paper is pasted with very thin paste. First the super lying over on the side of the book is pasted down on the end paper, and then the whole end paper is pasted with strokes of the brush directed toward the fore-edge. The wastepaper is removed, and the book is set into the cover by placing the pasted side down exactly along the edge of the redboard backstrip, with even squares left at head and tail. The book is not let to fall until accurately placed. When it is placed, the end paper lying on the board is smoothed out with the hand. Then the second end paper is likewise pasted, and the uppermost cover is brought over onto the book with the left hand and is lined up with the lower cover. The book is taken up from the bench and is

adjusted so that the two cover fore-edges are even. The second end paper is smoothed out with the hand, the book is closed, and the edge along the side of a folder is run down the sides of the book between the back and the edges of the board, to outline the French joint. The front of the book is placed first, because the first-placed side is less likely to have a wrinkled end paper.

When finished, the book is put aside between boards without tins under the covers and is heavily weighted. It should be looked at after about a half hour to see that the end papers on the cover boards are smooth and are not sticking. If not smooth, they should have a piece of clean paper put over them and should be rubbed with a folder. If they stick to the end papers on the book, they are freed by running a folder under them and lifting them away from the boards.

PAMPHLETS AND THIN BOOKS

A book like a pamphlet, consisting of but one section, is best cased. It may be cased as a "saddleback" book, that is, with a rounded back, or as a square-back book.

If a book is cased with a square back, a piece of fine cambric is pasted along the back of the section, extending to within five-eights of an inch from each end of the book and about five-eights of an inch over each side of the book.

The section is then sewed by entering a threaded needle from the inside at about its center. The needle pierces the cambric, and the thread is drawn through the back, leaving a short end inside of the section. The needle is then brought back through the section at a point about three-quarters of an inch from one end of the book, and the thread is drawn through the book. The needle is again inserted through the first hole made in the center of the section, the thread is pulled through to the back, and the needle is inserted from the outside about three-quarters of an inch from the second end. The thread is drawn through into the inside of

the section and is tied twice in a hard knot to the end of the thread left in the fold of the section. Then two folded end papers are cut to the size of the text, and one is pasted on each side of the book (see p. 73) under the cambric and up to the line of the back. A casing is made like that for a limp-covered book, except that the backbone board is cut from heavy chipboard or a Number 50 cloth board, and the side boards are made of the same material. The side boards are cut to extend just short of the back of the book, as it is not possible to make a French joint successfully on a book of a single section. Before using the boards to make the casing they should be sandpapered off along their back edges, and the backstrip should be sandpapered along its side edges. The book is then cased as for a limp-covered book.

If a saddleback, one-section book is to be cased, one sheet of white paper and one of colored paper, or two sheets of white paper, are folded around the section after being cut to the height of the book. The fore-edges are cut off after the book has been sewn. Then a strip of muslin is pasted onto the back as for a flat-back, one-section book, and the book is sewed and stitched through the muslin guard as just described. If the guard is not used, the book will crack on the inside along the joint. A casing is made, using a piece of supple redboard for the backstrip, and the book is cased as for a limp-covered book.

Very thin books composed of only two sections would best be sewed on tapes and treated in this way, as they cannot otherwise be backed and a joint be gotten on them. Thin books of more than two sections may be bound flexibly or sewed on tapes, depending upon the thickness of the sections. They are bound like a flexible binding.

VELLUM BINDINGS

It is advisable to bind a vellum-covered book in stiff boards, for vellum cockles in almost any climate and especially in the Ameri-

can climate, where atmospheric changes are both sudden and intense.

The book should be sewed on tapes, as a hollow back must be used. Vellum cannot be pasted directly to the back successfully, and if a tight back were used, the opening of the book would be too stiff. The book is bound like books of reference with split boards (see p. 252), except that the vellum is lined with a good quality white paper before covering. The boards should also be lined with white paper.

To line vellum, the paper is pasted and the vellum put down over it after the cover material has been cut for the binding. A rather heavy, smooth starch paste is used, and after it has been applied, the paper is "skinned" by putting another clean paper over it, rubbing it lightly with the hand, and removing it at once. This evens the paste and eliminates any brush marks that might show through the vellum. When the vellum has been lined it is put in the press between flesher-covered boards or between boards covered with pieces of blotting paper, and is nipped up tightly.

The vellum cover should be put on the book at once, while still damp. If it is found to be too stiff to turn over the boards it may be softened by dampening it with a little warm water.

After the book has been covered, as outlined for split-board books, a piece of cord is tied around the book over the joint and over the headcaps. The cord should be knotted at one end over the text to avoid marking the sides. Sheets of celluloid are then placed under the covers, and the book is sharply nipped in the press. It is then left to dry, heavily weighted, before having the end papers pasted down.

In spite of any extra warping papers pasted on the inside of the boards of a vellum-covered book, the covers tend to curl back in the American climate, and all books bound in vellum must always be kept stacked closely on shelves or weighted, when not in use.

EMBROIDERED WOVEN MATERIAL, AND VELVET BINDINGS

When books are to be covered with embroidery, silk or any woven material, the material should be lined like vellum. The back should be smooth, without bands, and the specifications for the binding are the same as for any split-board book.

In covering, glue is used instead of paste (except on the turn-ins), because the material is "set" at once with glue and there is no danger of stretching it. The back of the book is glued first. The glue should be used thin, and before it is applied it should be foamed up in the brush on a piece of paper. With the material marked up on the inside and lying on the workbench, the back of the book is glued with thin glue and put down in place. The material is turned in at once at the head and tail, with the back of the book resting on the bench. A piece of paper is placed over the back and is rubbed with a folder until the material adheres firmly to the book. As the rubbing is being done, the book should be placed first on one side and then on the other in order to rub down the material over the joints. After the back has been thoroughly rubbed down, one board at a time is glued, and the material is pulled over and rubbed into place. Finally, the turn-ins are mitered at the corners, and at head and tail each turn-in is given a light coating of heavy starch paste, preferably applied with a finger, and is turned over. Then very carefully a little paste is rubbed on the edges of the mitered fore-edge corners to keep them from fraying, and they are turned over. Paste is used for the turn-ins, as it is not so liable to soil the material as glue, and more time is allowed for the work, since paste dries more slowly than glue. Glue may be used instead of paste, but must be very carefuly applied.

If either glue or paste gets on the outside of the material, it may be removed by holding it over a steaming kettle of water. The

glue or paste is thus moistened and can be wiped off. If velvet is used, it should be steamed again after the glue or paste has been taken off. Books covered in embroidery should have the corners stitched with a fine buttonhole stitch. If well done, this adds to the finish of the corners.

When a padded effect is desired on the sides of the covers, they are not glued in place. Before the book is covered, a piece of cotton batting is cut to the size of each board. It is fastened to the outside of the board by putting a few dots of glue here and there on the board and laying the cotton in place. A piece of thin cheesecloth is cut for each board of the book, allowing one-half inch over the length of the board on each end and one-half inch on one side. It is laid over the cotton just up to the back edge of the board and is fastened by turning it over onto the inside of the board and pasting it down, as for mounting doublures (see p. 237). The turn-in at one end is pasted down first, the cheesecloth is drawn tightly, and the opposite end is pasted down. Then the fore-edge turn-in is pasted and turned over. The material is now glued onto the back, and without any further gluing it is brought over the sides of the cotton-covered boards, is turned over the board edges, and is pasted down on the inside as it is when the material is glued to the outside of the boards.

Velvet-covered books are bound in the same way, and their sides may be padded if desired. However, this material should not be rubbed heavily with a folder, for fear of matting the pile. It is best to press velvet down or, with a paper over it, to rub it with the hand. A thorough steaming after covering improves its appearance.

CASINGS

The word "casing" is the name given to a book cover that is not built up as a part of a binding during the process of forwarding, but is made separately and put onto a book after the book has been forwarded to a point where it must have a cover.

Casings may be made of almost any covering material. Cased books may be covered with whole cloth, with "full leather," or with "half leather" and cloth or paper sides.

A book to be cased is sewed on tapes and is forwarded to the point of covering, like a book with limp covers. Headbands may be worked on the book by hand, or they may be cut from a ready-made strip and glued on. If commercially made headbands are used, the super does not extend over the headbands but is cut to fit in between the endings of the headband strips glued on the back. Therefore these headbands do not need to be cut off at an angle where they extend over the sides of the book.

The back of a cased book may be round or flat. When flat, the book is not backed, and the backstrip in the cover, or casing, is made of cloth board that is a little thinner than the boards used for the sides. This prevents the cloth from breaking over the hinge. When the back is to be round, the book is backed like a book "bound flexible," and the backstrip of the casing is made of redboard.

HALF LEATHER CASINGS. If the book is to be cased in "half leather," the leather is pared as for a regular half leather binding. The width of the back and of the French joints and the length of the boards are marked on the pared leather. Then a line is drawn on each board at a distance from its back edge equal to the distance the leather is to project over on each side of the book. A piece of folded wastepaper is placed up to the line to cover the front of the board, and the exposed part of the board is glued, is put in place on the leather, and is rubbed down. The second board is glued in the same manner and is placed on the leather. Then the backstrip is glued and is put down between the two lines marked for the back. The turn-ins at head and tail are pasted and are turned over, and the casing is finished like a half binding without leather corners. After the leather is placed and

rubbed down, vellum or cloth tips are pasted over the four corners of the cover, the leather is then trimmed, the sides of the cover are filled in with newsboard, and the cloth or paper for the sides is put on and turned over (see p. 250).

Full Leather Casing. A full leather casing is made like a limp-covered book except for allowing one-quarter of an inch, instead of one-eighth of an inch, for each French joint.

Whole Cloth Casings. If the casing is to be covered in "whole cloth," the cloth is cut out with the grain running from fore-edge to fore-edge, and it is then marked up as for a limp leather binding with one-quarter of an inch allowed for each

Fig. 143.

French joint. The cloth is cut diagonally at the corners and is then glued all over with very thin glue. Each board is put in place on the glued cloth; then the backstrip is placed, the casing is turned over, and its entire surface is rubbed with a folder. The casing is turned again so that the inside is uppermost, and the turn-ins are turned over the edges of the boards. When the turn-ins are uneven or too wide, they are compassed off with dividers to the desired width and are cut even with a knife and straight-edge. Figure 142 shows the inside of a finished full cloth casing. Glue must be used very thin when gluing cloth, for otherwise the cloth will not lie smooth. It should also be used mediumly hot. When a cloth-gluing job results in a bumpy appearance of the cloth on the outside of the casing, the glue used was too thick. This also applies to paper put on with glue. A good quality glue may be thinned down until it runs from the brush almost like

water, and still retains sufficient adhesive strength to make cloth
or paper adhere firmly to a binder's board.

A casing may be used at once after being made, or, if put aside,
it must be heavily weighted. If the back of the book is round, the
backbone of the casing should be rounded by putting it in place
on the book and shaping it to conform to the back of the book,
before "casing-in." The book is "cased," or put into its covers, as
described for a limp binding, except that after the book has been
cased, it is put into the standing press between two "cloth
boards."

Cloth boards have a metal projection over their back edges,
and when the book is put between them it should first be squared
up and the back should be adjusted until it is perfectly symmetri-
cal. This can be done most satisfactorily by holding the book in
the left hand with the back uppermost and pressing its boards
down against the palm of the right hand. It is then put in the
press with care to place it so that the metal projections of the
boards fit into the French joints (see Fig. 143). It is well to out-
line the joints with a folder before pressing the book. No tins are
placed between the covers. When the book is properly adjusted
in the press, the press is wrung down sharply, and the book is left
for about ten or fifteen minutes. It is then taken out of the press
to see that the end papers are not stuck. If they are sticking to the
papers on the boards they are freed by carefully running a folder
under them and flipping them away from the boards. Sticking
end papers are generally caused by the use of too much paste or
by the penetration of thin paste through a lightly sized end paper.
After the end papers have been freed, the book is put back in the
press as before, under heavy pressure, and is left until the follow-
ing day. It is best left in the press for a week.

All casings should be titled and tooled on the back before cas-
ing-in. "Casing-in" is the term used to denote the operation of
pasting a book into its casing.

PORTFOLIOS

Portfolios are made like casings (see p. 268). After the material has been glued on the outside of a portfolio and has been turned over, a lining of paper or of some other material is glued on the inside, as a finish.

It is usually best to cut the lining material into three pieces. One piece for the back is cut wide enough to cover the backbone strip and extend about one-quarter of an inch over each board at the back, and long enough to cover the height of the board minus about one-quarter of an inch. The other two pieces are cut for lining the sides. Each should be about three-eighths of an inch narrower than the width of the boards and one-quarter of an inch shorter than their height.

The lining piece for the backbone of a portfolio is glued and put in place first. Then the pieces for each side are glued and placed just short of the back edges of the boards. They overlap the lining extending over the back. If the lining is put down in three pieces, instead of in one piece, the material is easier to handle and is likely to be smoother over the hinge.

If ties are to be put on a portfolio, holes are made with a knife through the boards from the outside after the cover material has been glued on and before the portfolio is lined. Through these holes tapes are usually inserted, and the ends are pasted down on the inside of the boards.

Glue is used, instead of paste, for all lining up in portfolio work, because it warps the boards less than paste. But its use necessitates rapid work, for it dries quickly, and a piece of material must be put in place at once after it has been glued.

When a portfolio is finished, it should be left flat on a table and weighted until it is thoroughly dry. If any difficulty is experienced in getting either the covering or the lining material smooth after gluing, the portfolio is put in the press, one board at

a time, and is pressed heavily just after the material is glued onto it. It is left in the press only for a few minutes, because if it is left longer the glue is likely to strike through the material.

CHAPTER XIX

MISCELLANEA

Slipcases. Solander Cases. Chemises

SLIPCASES

To make a slipcase, sometimes called a "thumb case," for an octavo book, a Number 30 cloth board is used for the sides, and the end- and backstrips. For a very small book, a thinner board may be used for the strips.

First, the two end strips and a backstrip are cut in width. To take the measure for the width of these strips, if a paper lining is to be used, the bound book is laid flat on the workbench, a straightedge is placed across the length of the book and let to extend over the ends of it, and the difference in thickness between the middle and the ends of the book is noted. The measure of the thickness of the book in the middle of the page, plus a very slight addition, will be the correct measure for the width of the strips. This is usually about a generous thirty-second of an inch larger than the thickness of the book at head or tail. A "proof strip" is then cut to this width. It should be tested for width by standing it along the back of the book. When one edge of a straightedge is lightly held down across the book from the fore-edge over the strip which lies against the back, if the strip can be drawn out from under the straightedge easily, it is the proper width. If it draws out with difficulty, it is too wide; if there is a gap between it and the straightedge it is too narrow. When the correct measure is found, the three strips are cut for width.

Next, two boards for the sides are squared to size. The length of the boards should be the length of the book, plus the thickness of the two end strips, plus one-eighth of an inch. The width should be the thickness of the backstrip, plus the width of the book cover from the fore-edge to the joint of the cover. After cut-

ting the length of these boards, the cutting-machine gauge should be left unchanged until after the length of the backstrip is cut, as this strip should be the exact length of the side boards.

The length of the backstrip is now cut. It is first squared off at one end and then cut in the machine to the size already set. Then the length of the two end strips is cut. To find this measure most accurately the backstrip is stood up on a side board with one long edge resting even with the edge of the length of the board so that the side of the backstrip lines up evenly with the board edge. One of the end strips is laid flat across the width of the board and at one end of it so that it touches the backstrip. The projecting end of the strip is then marked on a line with the front edge of the board. If the case is to be lined with a heavier material than paper, all these measurements must be augmented to allow for the extra thickness of the material.

The boards for the sides and the strips for the ends and back are now lined up. The lining material is usually paper, Canton flannel, chamois, or split skin. When the material has been cut a little larger all round than the boards and strips to be lined, each strip or board is glued, one at a time, placed on the lining material, rubbed down thoroughly, and then put in a press between covered tins. It is left for about fifteen minutes. After being taken out of the press, the overhanging material should be cut off on a tin with a knife. It must be cut even with the edges of the strips and boards.

If the case to be made is for a square-back book, the two side boards must now be cut out on the edges that will come on the front of the case. The book may then be conveniently pulled out of the case. The usual way of cutting the boards is shown in Fig. 144 A. In this model a thumb-shaped half-circle is cut out—hence the name "thumb case." A model which I think more convenient to use and which results in a more pleasing form is shown in Fig. 144 B. In both instances a pattern is cut out of paper, placed on

the board, and marked on it before cutting. The cutting is done on a tin with a sharp-pointed knife.

After the side boards are cut out they are beveled along the front edges. To bevel them, they are placed one at a time on the workbench. A sandpaper block is then used over the edges to

Fig. 144 A.

thin them down to about half their original thickness. When Model 144 B is used for the cutouts, the board is thinned only to points C and D. On Model 144 A they are beveled almost up to each end, and must be beveled to an even thickness.

Unless used at once, the lined sides and strips should be kept

Fig. 144 B.

in the press, but it is better to use them as soon as they are lined, for then warping has not begun and they are consequently easier to use.

To make the case, one side board is placed flat on the bench, and one long edge of the back board is glued with heavy glue. The work must be done quickly, and a generous amount of glue

should be used, though it should not be allowed to run over onto the sides of the strip. When glued, the strip is placed on the back of the board so that its side lines up with the edge of the board and its ends coincide with the ends of the board. The strip is pressed down and held in place firmly for a minute or two. The flat side of a folder is used to adjust the strip to line with the edge of the board. The end strips are then glued, one at a time, on one long edge and on one short edge. They are put down along the width of the board even with the board edge and with the short glued ends pressed tightly up against the backstrip. Each strip is held in place until it is firmly stuck. If cut correctly, these end strips, after being glued down, will be even with the front of the board.

When the strips have been glued down, the half-made case is held in the left hand and all the exposed edges are quickly and carefully glued. The case is then laid on the bench, and the second side is put in place over the glued strips so that its edges are on a line with the sides of the strips. After the second side has been lined up accurately, a board is laid at once on top of the case without disturbing it, and a heavy weight is placed on the board.

The backstrip always reaches the full length of the case and the end strips are glued so that they rest against it. This makes for greater strength than if the side strips overlap the back board, and it also does away with a pieced board on the back at head and tail.

When the glue has "set," the edges of the case are sandpapered off with a sandpaper block until they form an even surface. The case is then bound on the three solid edges with a piece of wrapping paper. The paper is cut into three pieces, each a little wider and a little longer than the edge to be bound. One at a time the pieces are glued, put on the edges of the case, and rubbed down firmly. After each piece is affixed to an end, the case is stood up on a tin, and with a knife the overlapping edges of the paper are

trimmed off all around, even with the edges of the boards. These strips strengthen the box, since they overlap the joining of the boards.

If the slipcase is to have a flat back, the covering material is now cut out. If the back is to be round, a rounded piece of wood is cut to size and is glued on the back. A binder should keep on hand strips of wood rounded on one side and flat on the other. These strips are of assorted widths and different degrees of roundness, and they have to be milled to order from patterns supplied by the binder. They should range from about one-half inch to two inches wide so that a case of any width may be fitted with them.

A wooden strip which is nearest in width to the width of the case should be chosen. It is cut square at each end to the exact measure of the length of the back of the case. Then it is glued up on its flat side with a light coating of thinnish glue and let to dry. When dry, it is given a coat of rather heavy glue, is put in place on the case, and is pressed down firmly with the hands until the glue is set. The wooden back is rarely the exact width of the back of the case, and after it has been fastened securely a carpenter's plane is run along its length until its edges are even with the sides of the case.

The rounded back may be left smooth, or if bands are desired, the back is compassed up for them and marked (see p. 110). A binder usually keeps on hand pieces of leather for faking bands on cases. They are made by pasting two strips of leather together. After being pasted to each other, they are nipped in the press and then kept under a weight till dry. Paste is used instead of glue in this instance, so that narrow strips may be cut off from the leather without the danger of having the two layers peel apart. The doubled leather is laid on a tin, and strips for the bands are cut from it with a knife. They should be cut somewhat longer than enough to reach over the back, and they may be any

width desired. One by one they are glued and placed on the marks indicated for the bands on the back of the case. After they are firmly fastened to the back they are cut off even with the sides of the case. The edges should be sloped so that they conform to the contour of the back.

When a round back is put on a case in this way, the joinings at the head and tail and on the sides cannot be perfect, and these joinings are filled in with cord cuttings and paste so that they may not be evident after the case is covered. The filling in is done as for backs and headbands (see p. 175).

Both the square-back and round-back cases are now ready to be covered. Slipcases may be covered in a variety of materials — in full cloth, in full leather, in half leather with cloth or paper sides, and in half cloth with paper sides. A case covered in full or half cloth may not have bands on the back, though it may have a round back.

FULL CLOTH CASES. When cases are covered in full cloth, a piece of cloth is cut long enough to reach from the front of one side of the case to the front of the opposite side, plus about three-quarters of an inch for turnovers. The width of the cloth should be equal to the whole length of the case, plus about three-eighths of an inch for turnovers. The cloth is cut so that its length runs with the selvage. It is then marked off on the underside along its length at a distance of three-sixteenths of an inch from the edge. Along its width, a line is marked three-eighths of an inch back from the edge (see Fig. 145 A). One side and the back of the case are then glued with thin glue, and the side is put down on the cloth with one corner of the front of the side placed exactly at the corner A formed by the two marked lines (see Fig. 145 B). The end and the front edge of the case should rest on the marked lines. The cloth is pulled up over the back, and both the back and side are immediately rubbed down with a folder until the cloth

is securely fastened to them. Then the second side of the case is glued, after which the cloth is pulled tightly over it and is rubbed down. When the back is being glued, the glue should be allowed to extend a trifle over the unglued side of the case.

Fig. 145 A.

The cloth protruding beyond the edges of the back at head and tail is then snipped at intervals to allow it to turn over smoothly. One at a time, the turnovers are pasted, are turned over the edges, and are pressed firmly in place with a folder. The corners of the

Fig. 145 B.

cloth on the sides of the case are cut off diagonally, leaving a liberal overhang. Each of the turnovers on the boards at head and tail of the case is pasted and then turned over the edge and rubbed

down. The turnovers on the front edges of the box are cut to follow the curved edges and are snipped at intervals along the curve. They are then separately pasted, turned over onto the inside of the case, and smoothed flat with a folder. At the corners the cloth is tucked around on the inside of the case so that it extends over the head and tail boards. In order to be turned over the front of the case smoothly, the turn-ins must be snipped frequently along their curved edges. The deeper the curve, the more frequently the snipping must be done.

Finally, two pieces of cloth are cut for the head and tail of the case. First, the strips are cut the exact width of the head and tail. One end of each strip is squared or rounded to the contour of the end of the back, if the back is round, and then the two strips are cut about three-eighths of an inch longer than the width of the case. Each strip is glued with thin glue and is put in place on one end of the case up to the edge of the back. Then the overhanging piece of cloth is turned over the front edge onto the inside of the case and is thoroughly rubbed down. Because the front edge turnovers have to be snipped, the finish on the inside of the case is not neat; therefore a continuous strip of cloth is pasted over the snipped cloth. To cut the strip the case is laid on the underside of a piece of cloth, and the shape of the front edges of the case is marked on the cloth. The cloth is cut with the shears on the line marked for each side, and it is cut into strips the length of the inside of the case and the width of the snipped, turned-over edges. After being pasted and put in place, it should be firmly rubbed down.

If a cloth-covered book has a round back, the front edges of the case need not be cut out. The width of the case should be somewhat less when the case is not cut out, if it is to be placed on the shelf with its back exposed. It should then be of a width which will allow the book to be grasped by the joint when it is being

pulled out of the case. Therefore the case should come not farther than the back edge of the bookboard, thus leaving the full joint exposed.

A flat-back case covered with cloth may be lettered directly on the cloth, but a "title piece," or leather label, pasted on the back of a book enhances its appearance. The label should be paste-washed before titling, and after titling, it should be varnished with a thin binder's varnish.

FULL LEATHER CASES. Full leather cases usually have rounded backs which bear the title of the book. In this instance the front of the case is cut out as shown in Fig. 144 A or 144 B. A full leather case implies that it contains a book of value; hence, in order to protect the back, a "chemise," or cover, is made for it before the case is made (see p. 294). The book must be covered with its chemise when the size of the case is being calculated.

The leather for the case is cut like the material for a full cloth case, but with a narrower margin allowed for the turnovers. It is pared like the leather for a limp binding (see p. 259). Except for the matter of the covering strips on the head and tail of the case, the same technique as that for making a full cloth case is used in making, covering, lining, and finishing.

The edges of the leather for these end strips should be pared to a featheredge wherever they meet the edges on the top and bottom of the case. Where the leather turns over onto the inside it should be pared like all other turnovers. After the leather has been turned over the edges at head and tail, the turnovers should be trimmed evenly all round with a knife and should be left not more than one-eighth of an inch wide. Then two pieces of thick paper or newsboard are cut to fill in the depressions left in the centers of the ends of the case. These pieces should be of a thickness equal to the thickness of the cut edges of the turnovers, and they should be cut to fit up close to them and to extend from the

back leather turnovers to the front edges of the case. They are put in place with paste.

The pared leather strips are now separately pasted, and each is rubbed down on an end of the case. Paste, and not glue, is used on the leather strips so that they may be slightly stretched, if necessary, to meet the edges of the case perfectly. The case is finished on the inside with pieces of thinly pared leather, which are cut to the shape of the front of the case and are then pasted in place and rubbed down.

HALF LEATHER CASES WITH CLOTH OR PAPER SIDES. Cases may be covered in half leather with either cloth or paper sides. They are constructed exactly like a full leather case. The back is usually round and may or may not have bands. The boards on the inside of the case are lined. The front edges of the case may be either cut out, as in Figs. 144 A and 144 B, or left straight. If left straight, the boards are measured as for a full cloth case with straight front edges. Whether straight or cut out, they are thinned at the front edges with a sandpaper block, as are all slipcases, however fashioned or covered.

The leather is cut like that for the back of a half leather binding (see p. 188), except that only one-quarter of an inch is allowed for turnovers. The turnovers are pared very thin, and no other paring is done on the leather other than beveling the edges on the sides, as for a half binding. After having been pared, the leather is pasted and is worked over the back and rubbed down. The back turnovers are then snipped and turned as for a full leather case, and the remaining turnovers are put in place. The case is set aside for an hour to dry, and then the leather on the sides is cut (see p. 246). The ends of the case are covered partly with leather and partly with paper. The leather extends the same distance over the ends of the case as over the sides, and the paper lines up with the paper on the sides.

Two pieces of leather are cut for the two ends. Each piece should be cut somewhat wider than the ends and a little longer than enough to extend beyond the line of the back and beyond the end of the leather turnovers on the end of the book. Each piece is pared at the back edge and on the side edges like that for a full leather case. On the front edge it is beveled off like the leather on the sides of the case. After being pared, each leather strip is cut to size, pasted, put in place, and adjusted with a folder to fit the edges of the case. When both strips have been fastened to the case they are left to dry and are then cut off on a line with the edges of the leather on the sides of the case.

The sides and ends of the case are filled in up to the leather. The material used for the filling in is usually newsboard. It must be the same thickness as the trimmed-leather edges. The pieces of filling-in material are cut a little larger all round than the spaces to be filled, with a clean, straight edge left on the sides which are to be next the leather. Each end piece is glued and rubbed in place. After a strip is affixed to the end, the case is rested on a tin, end down, and the overhanging edges of the material are cut with a knife even with the edges of the case. In like manner the side filling-in material is glued to the case and cut off.

Now the papers are cut for the sides. They should be one-half inch longer and three-quarters of an inch wider than the sides. Each is glued with very thin glue and is placed on the case with one long, straight edge overlapping the leather (see p. 251). It is then immediately rubbed down, and the side is finished like the side of a full cloth case. When both sides are finished, two end pieces are cut from material like that used on the sides. Their width should be the exact width of the end of the case. They should be long enough to reach just over the leather on a line with the side material and to turn over the front edge of the case, leaving about a quarter of an inch on the inside of the case. The inside of the case is finished like a full cloth or full leather case.

HALF CLOTH CASES. A case with half cloth back and paper sides, with or without a round back or cutout front edges, is usually made like the half leather cases just described.

Books that are not rare or of great value except only to the owner are not infrequently cased in half cloth and put in slipcases. By changing the manner of covering, a very trig cloth and paper case may be made, which is especially suitable for a thin book cased with a cloth back and paper sides (see Fig. 146).

We will suppose that a slipcase is to be made for a thin book of this sort that has been cased with a black cloth back and plain

Fig. 146.

écru paper sides. A plain paper soils easily, and either a chemise or a case should be made for a book covered with it, unless the paper is sized after the case is made.

A case for this book that will have special appeal is made with a flat back and front edges which are left straight. The front edges should be thinned down with a file or sandpaper block more than for a case with cutout edges. Its sides should be the same width as the boards of the book and should not be made to cover the joint of the book. This is in order that the book may be pulled from the case by taking hold of it over the joint (see Fig. 146).

The case having been made, a piece of black binder's cloth is cut one-half inch wider than the thickness of the case and long enough to extend in one continuous piece from the front of the case over the top, down the back, and then across the bottom of the case, with an additional one and one-half inches added for

Fig. 147 A.

turnovers. The strip should be cut with its length running parallel to the selvage of the cloth, in order that the cloth may be turned over the edge with the grain.

The back of the cloth strip is then marked with a pencil. One line is drawn one-quarter of an inch from one edge along the

Fig. 147 B.

whole length of the strip, and a second line is drawn across one end of the strip three-quarters of an inch from the edge. Then one end of the case is glued with thin glue. It is put down on the cloth strip with the front of the case on the line marked across the cloth and with one edge on the line running along the length of the cloth (see Fig. 147 A). The glued-down cloth is rubbed

thoroughly with a folder. The back of the case is now glued and is put in place on the line and rubbed down (Fig. 147 B). Finally, the second end of the case is glued, and the cloth is pulled over it tightly and rubbed down (Fig. 147 C). All the gluing should be done with the case held in the left hand. The glue must be thinly

Fig. 147 c.

and evenly spread and must extend to the very edges of the case.

The overhanging cloth is creased over the side of the case at each corner and is pinched up so as to form a fold that runs diagonally to the corner (see Fig. 148 A). Held in this position with the left hand, the cloth is cut off with a pair of shears, on lines running about a thirty-second of an inch above the side of

Fig. 148 A. Fig. 148 B.

the case (see Fig. 148 B). The cutting must stop just short of the corners of the case. This cutting miters the cloth at the corner so that it may be turned over smoothly. The pieces of cloth overhanging the front edges on the two ends of the case are cut off diagonally about a quarter of an inch from the corner (Fig. 148 B

—corner C-D). All the turnovers are then ready to be put in place. Each one is pasted, is folded over the side of the case, and is smoothed with a folder until the edge is left sharply defined. The overhanging cloth at the front is pasted and turned over onto the inside of the case.

Two straight strips of the black cloth are now cut to bind the front edges of the case. Each should be as long as the length of the

Fig. 149.

case and wide enough to cover the edge and turn over one-quarter of an inch inside and outside of the case.

The cloth turnovers pasted down on the side of the case are cut off on the four front corners so that the front binding strips may be mitered over these strips at the corners (see Fig. 149). It should be noted in consulting Fig. 149 that the diagonal cut is made from a point beyond the corner on the front edge. This is so that

Fig. 150.

the corner will remain well covered by the cloth, which will be overlapped by the front strip.

The two strips cut for the front binding are cut off on an angle, as shown in Fig. 150, and a line is drawn along each side of the case one-quarter of an inch back from the front edge. Each strip is then glued, and the mitered edge is placed on the line drawn along the front of the case. It is quickly rubbed into place with the hand, and then the strip is turned over the edge and onto the

inside of the case. Glue is used instead of paste, because material loses none of its stiffness when glued, as it does when pasted, and when stiff it is easier to place.

All turning of edges should be done first with the hand. Then the material should be pulled over tightly and smoothed out with a folder so that the edges are left sharply defined.

The case is now quickly finished by cutting out pieces of the écru paper to cover the sides and ends and then gluing them and putting them in place. Each piece of paper is cut one-eighth of an inch short of all four edges of the case. This allows the black edging to show all round. The book does not have a chemise, as it would interfere with being able to take hold of the book at the joint when removing it from the case. It is lettered on the spine, which is placed outward on the shelf.

SOLANDER CASES

A solander case is one into which a book is put from one end, and not slipped in from the side as when put into a slipcase. Unlike a slipcase, it is cut into two parts, one part of which serves as a cover. The cover, or top, of the case slides over a collar attached to the bottom (see Fig. 151).

The material used for making the body of the case is a hard-finished, thin board, similar to a newsboard. The lining material may be of Canton flannel, chamois, cloth, or paper, though flannel or chamois is preferable. The covering material should be of leather, preferably levant- or turkey-morocco.

Some binders make a form out of binder's board with a round wooden back to serve as a model over which to construct the case. However, this is quite a bit of work, for the form must be absolutely square and must be an exact replica of the book in size and shape. Instead of using a made form, the book itself may be used. Before it is employed for this purpose, it is covered by wrapping a piece of stout, thickish paper around it and tipping one edge of

the paper down with paste so that it overlaps the other edge on the fore-edge of the book.

The collar, over which the top of the box slips, is made first. For this, a strip of lining material and a strip of the thin board are cut the same size. These should be cut so that they will reach around the form with about one-quarter of an inch overlap.

Fig. 151.

Their width should be about one-quarter of an inch less than the full height of the book. Then each end of the lining material is glued on opposite sides, to a distance one-quarter of an inch back from the ends. It is drawn tightly around the form with one long edge even with the bottom of the book, and one glued end is rubbed in place over the other glued end. The lap should come on one side of the form. The board is then glued in the same way and is placed around the form over the lining with its edges over-

lapping at the fore-edge. The edge of the overlap is sandpapered off somewhat to reduce its thickness.

Now a strip of board is cut for the fore-edge the length of the width of the lining. In width it is cut the width of the fore-edge. The strip is glued and rubbed down over the fore-edge, and the fore-edge is placed on the bench and is squared up with the folder. If the strip projects beyond the sides, the edges are sandpapered off. A sandpaper block is also run lightly over the top edge of the box to take off its squareness, so that the collar of the case will look less clumsy after being covered. This completes the construction of the inside collar which partially lines the case, and the collar must now be covered with leather.

The leather may be of a contrasting color to that to be used on the outside of the case. For a small book it is cut about one-quarter of an inch wider than the height of the box just made and a little short of long enough to reach completely round the box. (This short cutting is to allow for stretching.) If the box is octavo size or larger, the leather may be cut only wide enough to cover the collar well, and the bottom of the box is then filled in up to the leather with newsboard. But great care must be taken to choose a filling-in board of just the right thickness, for otherwise the joining will show on the outside of the case.

Before the leather is pared, a line is marked one-quarter of an inch back from one edge along its length, and another line is marked one-eighth of an inch wide back from each end of the leather. One long side is pared quite thin, from the marked edge out. Each of the two end edges is pared on an even slant from the marked line out to a featheredge, so that they will form a smooth joining. The second long side is not pared. After the leather is pared, a line is again marked along the length of the leather to indicate where the paring for the turnover begins.

The leather should join on one edge of the fore-edge, and when it is being put on the inside box just made, the box must be

kept in place over the book. After the leather has been pared, it is first sponged on the outside with water and then pasted thoroughly. One end is placed just over the fore-edge, and the leather is worked on over the box while the mark denoting the pared line is kept even with the top of the collar. The leather is then mitered neatly at the corner of the fore-edge, and the turnovers are re-pasted if necessary and turned over the edge of the collar.

When the covered box, or collar, has dried for a few minutes, it should be removed from the form and then put back on the form from the opposite end. This is to smooth down the turn-ins

Fig. 152.

and to be sure they are securely stuck. The inside of the case is now completed.

To make the outside part of the case, two pieces of the thin board are cut about one-quarter inch wider than the height of the whole form, or book, and a little longer than enough to go around the two sides, and the back, and project beyond the edges of the sides of the box just made. Then a strip of lining material is cut the same size. The strip of board is now compassed up and marked on one edge for five bands (see Fig. 152). It is cut in two between the second and third bands, as shown by the dotted line in Fig. 152. The lining material is likewise cut into two parts.

The covered box is left on the form, and the whole form is covered with a piece of wrapping paper, which is put on tightly and joined with glue. The paper should be cut the exact height of the covered form and should be cut only long enough to make a small overlap. Each piece of lining material is glued at the ends on opposite sides, is put around the form right side down against the wrapping paper, drawn evenly tight, and then joined at the center of one side of the form.

To cover the fore-edge of the built-up form, a strip of board is now cut from a piece of heavy newsboard. It is cut the length of the two side boards that were compassed up for the bands. The width is found by placing the covered form flat on the bench, laying a straightedge flat across its width below the collar, and then measuring the distance between the underside of the straightedge and the top of the bench. While the dividers are set to this measure, a strip should be cut the same width and it should be long enough to cover both the top and bottom of the case, with something over. This strip will later be cut for length. The strip which will serve for the two ends of the case is lined with the lining material, and the overhanging edges are trimmed close to the strip all round.

One of the wider-cut strips of newsboard to go on the lower part of the case is glued and is then placed down over the lining on the sides and back of the form. After the first strip has been thoroughly rubbed down, the second wide strip is glued, placed over the first one, and rubbed down. The edges of both strips will project beyond the form at the front edge. The longer fore-edge strip is glued and is put in place over the lining between the two projecting side strips. After this strip has been firmly pressed down, the projecting edges of the sides are trimmed off even with the face of the front strip, and they are sandpapered down.

Now the top part of the case is made in like manner. First the lining is placed and secured around the form, then the board

strips are glued around the lining, the fore-edge strip is added, and the top of the case is finished like the bottom. In setting the fore-edge strip, the top should be put over the bottom part of the case and the two fore-edges are lined up together. A piece of un-printed newspaper is then glued over the fore-edge strip of the top and bottom of the case and lapped over onto each side of the case for about a sixteenth part of an inch. This is to keep the strips evenly lined up and securely fastened. When a large case is being made, a thin cambric is used instead of the unprinted newspaper. If necessary for strength, a second piece of board is glued on the fore-edge over the first strip. It is made to extend over the edges of the side boards and is cut off flush with them. This second strip should be lined up with paper or cambric. The strips lined up for the top and bottom of the case are now cut to length. The dimen-sions of each strip must be separately calculated and the strips are marked "top" or "bottom" after being cut. A trial-and-error method is followed in getting these measures, for the pieces are cut to fit inside the case. The strips have already been correctly cut for width. To cut the strip for length, it is first squared on one end; then the box is stood up, and the strip is placed inside the downward end of it. The squared end of the strip is pushed up against the squared end on the inside of the box. In this position, the curve of the back of the box is drawn on the end of the strip, and the strip is cut inside this line. How far it should be cut in-side the line may be judged by observing the thickness of the case at the back. A little extra trimming usually has to be done in order to get a perfect fit. The strip should be tested by putting it in place inside the case from the bottom. It is then marked for the end for which it was cut, and the second strip is cut.

One extra strip is glued on the top and the bottom of the case. Extra heavy newsboard is used for these strips. Two pieces are cut out a little larger all round than the top and bottom of the case. One of the strips is glued on one side, and the case is placed down

on it; all the edges of one of the inside strips are carefully tipped with glue, and the strip is put down, lined side upward, from the inside of the case onto the outside strip just glued on. It is pressed down and adjusted from the inside with a folder. When putting the inside strip in place it should be held with the edges on its length bent downward, and it should be tilted in width until it reaches the bottom of the case. Otherwise, its glued edges will smear the lining. After the inside strip has been worked in place, the outside strip is cut off flush with the edges of the case. The other end strips are glued on and are cut in the same way, and the cover is put in place. The edges of the top and bottom are finished off with a sandpaper block. The edges of the upper and lower part of the case are then sandpapered until they meet and fit perfectly.

The body of the case is now completed except for having false bands put on the back, if bands are desired. When this is to be done, the back is compassed up and marked so that three bands go on the upper part of the case and two bands on the lower part. The last band on the cover is put on the extreme edge of the case and is made to line up with the edge.

Then several long strips are cut for bands out of a thin, stiff board. The width depends upon the taste of the forwarder. From one of these strips a piece is cut long enough to project slightly on both sides over the back. This piece is glued, put in place on one of the marked lines, and rubbed down until it adheres firmly to the back. Another piece is cut, glued, placed on top of the first one, and rubbed firmly in place. If a high band is wanted, a third strip may be added. When all the bandstrips have been put in place, the case is laid on the edge of the bench with its back extending beyond the bench, so that the ends of the bands will not be disturbed. It is left to dry a few minutes, after which the ends are cut off. To cut them, the case is kept on its side with its bands off the bench, and each band is cut off with a sharp knife, on a

slant which slopes from the back to the edge of the side boards of the case. The case is then ready to be covered.

The leather is cut, pared, and put on the top part of the case as for a full leather slipcase, except that the side leather is turned over onto the front edge of the case. Hence a strip must be cut for the fore-edge, as for the ends of the case. The same is true of the bottom part of the case, but since the leather stops at the collar, it is pared to a paper thinness on the edge that joins the bottom of the collar. The leather at this point, when being put in place, must be moulded over the edge so that it melds with the leather of the collar.

A book that has a solander case should be covered with a chemise if the leather is delicate, and the chemise should be made and put on the book before the case is made.

After learning to construct a slip cover, and a solander case, one should be able to make any kind of case for a book. A flat case with a hinged cover is constructed of binder's board in a way similar to that used for making slipcases. The cover is hinged to the case with a leather hinge which is put on in the same way it is put on a book.

CHEMISES

Before a case is made for a book, a "chemise," or cover, should be made for it if it is bound in full leather and is elaborately tooled. A chemise should also be made for a valuable first edition when it is "boxed," however it may be covered, and one must always be made for a scarce item that is to be left in its paper cover or one which is in bad condition. This kind of loose protective covering is invaluable for preventing the covers of books from being worn.

There are several types of chemises. The simplest type is one made like a casing and then lined on the inside. It may have edges that hinge over the fore-edge of the book, or all its edges

may extend an infinitesimal amount beyond all the edges of the
book cover.

A heavy quality of newsboard is used for the cover boards, and
if the chemise is to turn over the fore-edges of the book, two nar-
row pieces of newsboard are cut out the length of the cover
boards. A strip of newsboard is cut for the back if the back of the
book is flat. If it is round, the strip should be cut from redboard.
All these boards are cut just long enough to cover the book gen-
erously.

Leather, cloth, or any other woven material may be used for

Fig. 153.

covering the chemise. The material is cut out and marked up as
for a casing (see p. 268), with an added mark at the fore-edge
when the fore-edge is to be covered. In making the chemise, each
board should be glued and put in place as when making a casing.
When the fore-edge is covered, the hinges at the fore-edge should
be about one-sixteenth of an inch wide, so that the fore-edge flaps
may be turned over sharply (see Fig. 153).

After the covering material is turned over onto the inside of
the cover, a lining of any chosen material is glued over the inside
of the chemise, as for a portfolio (see p. 270). The chemise is left
flat to dry under one or two lithographic blocks. When dry, it is

creased along the hinges and fitted to the book. When a chemise is made for a round-back book, the back of the chemise must be shaped to the back of the book, like a round-back casing (see p. 269).

CHAPTER XX

MISCELLANEA

Repairing old bindings. Cleaning, sizing, washing, and toning papers.
Binders' tricks

REPAIRING OLD BINDINGS

A BOOK that comes to the binder with the covers split at the joint and the sewing threads broken should be pulled and rebound, if it has a tight back. However, when the owner insists upon having the old covers retained, the book must be cased, not bound, for the cords cannot be laced through the old covers. In this instance, the covers are removed and repaired if necessary, and the book is taken through the processes of mending, sewing, backing, headbanding, and lining up, as for a casing (see p. 266). It is then pasted into its covers like a cased book, though it is seldom possible to case a book in the covers in which it was once bound and still have an ample "square" at the fore-edge. A better method of dealing with the book is to remove the covers and rebind the book in a leather as nearly as possible like that on the original binding. When this is done, the covering material is removed from the boards, the lining is scraped off the leather back, and the old sides and back are pasted down over the sides and back of the new binding. This method of restoring a binding can often be used so that almost none of the new leather shows, and that can be tinted to match the old leather. But when the old leather is disintegrated, this cannot be done, and there is no alternative to rebinding and redecorating the book.

When a leather-covered book with a hollow back has its covers split off along the joints, it can be repaired and retain both the old back and old covers, though the work takes much time, patience, and ingenuity. The back covering is first removed from the book, and the lining is moistened and taken off the leather. This must

be done with care. When the bare leather has been reached it is smoothed off with a piece of fine sandpaper. Then some matching leather is sought for. If it cannot be found, a near-matching color may be toned with a dye wash. If the color is a dark tan, a lighter tan may be darkened with coffee or with a permanganate of potash solution (see p. 304).

The leather is cut into two strips, each a little longer than the book and wide enough to extend a quarter of an inch under the back leather over the joints, and about one-quarter of an inch under the leather on the sides. It is pared to a suitable thickness all over and then thinned down quite thin where it goes under the back and side leather. The pieces of leather are pasted on the upper side to a depth of one-quarter of an inch, and one is affixed to the underpart of each side of the back. A piece of thin newsboard is cut just short of the width of the leather back and one-quarter of an inch shorter than its length. It is then glued down on the leather back; and a piece of fine cambric, cut the same length and wide enough to reach about one-half inch over each side of the book, is glued down over the newsboard. It is cut off on the sides at an angle (see p. 258). A piece of strong wrapping paper is then glued over the cambric.

The edges of the leather on one side of the book are carefully lifted with a thin folder or a dull knife. The back is put in place on the book, with care taken to see that the title is right side up, and the extension of thinly pared leather coming from under the back is marked for width. It must lap about a quarter of an inch over the board. The back is removed from the book, and the strip is cut off evenly and pared to a featheredge. It is then pasted on the underside, the back is put in place again, and the pasted strip is carefully tucked under the lifted leather and rubbed with the folder until it adheres to the book cover. The lifted leather is pasted on the underside, is put down in place, and with a paper over it, is rubbed down firmly.

The book, with its cover in place, should be weighted over the hinge and left undisturbed for at least a half hour. Then the other side is fastened to the cover in the same way, and the book is put aside under a heavy weight until it is dry. The leather should not be moistened with water, for fear of staining and darkening it.

When the cover is dry, it is removed from the book. A folded end paper is tipped along the edge up to the joint on each side of the book and is cut even with the edges of the text. A piece of fine cambric is cut and glued over the back of the book, with about one-half inch extending over each side. On top of the cambric a heavy paper is glued and rubbed down thoroughly, especially over the joints (see p. 177). If the book needs new headbands, they are worked on before the cambric is put on the back.

The book is now ready to be fastened into its covers. It is placed well up in the covers and held tightly in this position while it is being laid on the bench. Boards are built up to a height equal to the thickness of the book and are placed against the back. The top board of the book is opened and is let to fall back on the built-up boards. Then a piece of wastepaper is put under the cambric strip, which is cut off so that it does not extend beyond the edges of the text, and the cambric is glued lightly and is then rubbed down over the board like a leather hinge (see p. 220). The book is turned over without disturbing the position of the opened boards; the built-up boards are placed on top of the opened cover; and the closed cover is opened, and let to fall back over the pile of boards. With the book in this position, the second piece of overhanging cambric is glued down over the top board. A thin board is put under the text, the built-up boards are pulled out and removed, and a thick wad of paper is put between the covers to hold the upper one on a line with the book pages. (See directions for pasting back end papers, p. 224). The book is left for a half hour, and then the two end papers are cut and pasted back as de-

scribed on p. 225. After another half hour the book is closed and is put in the standing press (see p. 227).

CLEANING PAPER

The paper in old books often needs cleaning and resizing, but this can be done only by pulling the book apart, and unless an old book is very valuable, it would not be worth the time and trouble involved. Incunabula in original bindings should never be pulled apart, though if they have been rebound it is not a desecration to "pull" them, then wash and resize the text. Many stains can be removed by washing, and the surface of the spongy paper can be restored by sizing.

Printed books are often disfigured by pencil marks and other blemishes that can be removed without washing the sheets. For this work a good pencil eraser, a piece of hard rubber or a typist's eraser, a little powdered pumice, and some sheets of the finest sandpaper are employed. First the pencil marks and smudges are treated by rubbing them with a soft eraser. If the marks fail to respond to this treatment, the hard rubber or the typist's eraser is used on them. For inkstains, powdered pumice is taken up on a clean cotton tampon (see p. 340) and is rubbed over the ink trace, or the mark is rubbed over with a piece of fine sandpaper. When the paper is well sized, the inkstains will yield to this treatment, though when it is used on thin paper, care must be taken not to rub too hard. If the surface of the paper is soft, the ink will have penetrated so deeply that it cannot be removed in this way.

A grease stain, when it is fresh, can sometimes be removed by sprinkling powdered chalk over the spot, leaving it for half an hour, and then putting unprinted newspaper on each side of it and ironing the sheet with an iron sufficiently hot to draw the grease into the chalk. For removing older grease stains a solvent is used. The sheet is saturated with either gasoline or benzine, thin blotting paper is put on each side of it, and heat is applied

over the blotting paper as when using chalk for this purpose.

Nothing can be done with "art mat" paper, on which illustrations are often printed, for rubbing leaves a mark on its surface. Neither can it be treated by washing, since wetting destroys its surface and leaves a stain.

SIZING PAPER

The sheets of an old book may be sized when they have lost their original size and have become soft on the surface. Resizing will not only make paper stronger and restore its surface, but will tone down or remove any brown water stains.

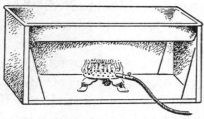

Fig. 154.

For sizing, a large low enamel pan similar to that used by a photographer is required. As the size bath has to be used hot, the pan should be set into some sort of frame constructed so that room is left under it for an alcohol lamp or an installed gas jet (see Fig. 154). Before sizing, the sheets should be dry-cleaned to remove any soil or pencil marks, for otherwise the size will "fix" them on the paper.

To make a size bath, an ounce of pure gelatin is soaked overnight in a little more than a quart of water. It is then slowly heated to a temperature of 120° F., at which temperature it should be kept while using. Then it is strained off through a fine sieve made by tacking a piece of large-meshed gray super over a small frame. When the size is of a proper strength, a slight stick-

iness is felt between the fingers if they are dipped into it; if too sticky, more water is added. Size will keep several days, if covered.

When the size is ready it is poured into the bath pan, under which a flame is kept while working. One sheet at a time is laid into the hot size and is gently pushed down flat with the blunt end of a folder. Other sheets are laid on top of the first sheet, and they may all be taken out almost immediately unless water stains are to be removed, when they should be left for about ten or fifteen minutes. If there are not more than a dozen sheets to be sized, they may be taken out of the pan, one by one, and placed between white blotting papers to dry. If the sheets are not dry in a day, the blotting paper should be changed. When an entire book is being sized, the sheets, as they are removed from the pan, are placed in a pile on a piece of clean, white paper. After the pile is completed, a white paper is put on top of it, and the sheets are put in the standing press between pressing boards and wrung down until most of the water has been squeezed out of them. They can then be more easily handled, and each one is spread out to dry on a table covered with clean paper. When they are nearly dry they are hung over lines of cord, which are covered with paper, each sheet slightly overlapping the other. Then, in order to keep them clean, paper is put over them. In hanging them up, they are more easily handled if they are held over a long folding stick or a papermaker's peel (see Glossary).

If the paper is very fragile, one sheet is sized at a time, and this is laid on a sheet of celluloid when being put into the size. Care must be taken not to let the celluloid come in contact with the flame, for celluloid is inflammable. As the size will not flow evenly over the underside of the sheet, the sheet should be turned. To turn it, another sheet of celluloid is placed on top of it, and the lower celluloid is removed. When taken out of the size, supported by the celluloid, the sheet is placed on a table. A piece of

unprinted newspaper is put over it and is gently rubbed to absorb some of the moisture. The sheet is then turned over with a fresh piece of "news" on it, the celluloid is removed, and the moisture is absorbed with another piece of unprinted news. It is then turned over onto a piece of blotting paper to dry.

When the sheets are dry they should be mended, folded, and gathered into sections. They are then pressed in the usual way, though with light pressure. Long and light pressing is necessary to flatten sections of hand-printed books, for heavy pressure will destroy the "punch" of the type.

WASHING PAPER

Many stains can be removed from paper by washing it in a bath of hot water with a little alum added, but inkstains and some other deep stains that cannot be removed in a size bath will need drastic treatment. This means using some bleaching chemical, a process which usually results in injury to the fibers of the paper and should not be resorted to when handling valuable books. However, when deep stains are to be taken out of paper, a bath of permanganate of potash is used. This turns the paper brown, and a sulphurous acid bath is then required to bleach the sheets white again. Finally, a solution of hyposulphate of soda should be used to neutralize the acid.

To make the first solution to be used, an ounce of permanganate of potash crystals is dissolved in a little less than a full quart of water and are warmed to a tepid temperature. The sheets of paper are put in this solution and are left for about two hours, or until they turn a deep brown. They are then taken out of the solution and are washed in running water. A purple color will run out of the sheets, and the washing should be continued until the water runs clear of color. They are then put into a bath of sulphurous acid, which is made up by adding one pint of water to one ounce of acid. This bleaches the sheets white again, and they

should be left until the stains disappear. Only a few sheets at a time should be put into this solution, and the stains should be watched and the sheets taken out of the solution as soon as they disappear. Uusually this requires only a few seconds. Then the sheets should be washed in clear, running water.

After coming out of the acid bath, the sheets are put into a bath of hyposulphate of soda. This is prepared by mixing one-half ounce of hyposulphate of soda to one-half gallon of water. This mixture is left until all the soda is dissolved. The sheets are soaked in the solution for about a half hour and are then put under running water for about an hour. Should any stains refuse to yield to this treatment, the process may be repeated. Sheets that have been put through this process must be sized. When it is necessary to do only a few sheets in a book, the sheets that have been freed of stains will have to be toned to match the rest of the book.

TONING PAPER

Various toning agents are used to get the shade necessary to match that on a given piece of paper. Coffee, tea, and permanganate of potash are most used in trying to approach the tone desired. Coffee produces a brownish hue that is somewhat opaque; tea, a rather limpid brown; and permanganate of potash, a yellowish brown. Any of these toning agents should be put in the size, and the color should be tested before the size is applied to the paper. Permanganate of potash should be used in a weak solution, for it is very powerful.

To test the shade of the toning size, a piece of unprinted newspaper should be dipped into it. The paper, after being dipped, should be allowed to dry thoroughly before the tone produced can be judged accurately. If the tone is too deep, more water should be added to the solution; if too pale, more of the coloring ingredient is added. Anyone with a good eye for color will soon

be able to decide what coloring agent should be used to match a sheet of paper.

BINDERS' TRICKS

Repairing Book Corners. Occasionally a corner of a book-board is injured during the process of binding. When a corner has been bent and crumpled before the book has been covered, it can often be successfully repaired. The layers of the board are separated with a knife at the damaged corner, and some paste is inserted between the layers. Then the corner is laid on a knock-ing-down iron and is tapped with a hammer on both sides. The tapping must be done gently so that all the paste will not be forced out. The book is left about fifteen minutes for the paste to take hold, and the corner is knocked on both sides with a few firm strokes until it is made solid.

The same treatment may be given to a broken corner after the book has been covered, but in order to do the work the leather has first to be cut on a bevel with a straight-edged paring knife, and then pulled back off the corner. After the repairing of the corner is finished, the leather is pasted and worked back again in place. This can be done by a skilled workman so that the repairing will not be noticed except on close inspection.

Peeling Leather. On some skins it is possible to peel off the surface of the leather for inlay purposes, and thus save time in paring. This is done by making a shallow, slanting cut on the leather with a sharp paring knife, then grasping the cut edge be-tween the fingers and thumb and peeling the top layer off the skin. As the leather is being peeled off, a knife is occasionally used under the layer to force it off the undersurface. Long strips can be peeled off of some leather in this way. Small thin pieces for patching purposes may be taken off from the upper side of the leather with a sharp paring knife, if the knife is held very flat.

Splitting Paper. To split a piece of paper into two parts, it is well pasted on both sides with a rather thick paste and is laid between two pieces of thin cambric. It is nipped in the press between pressing boards and left to dry. The cambric should overlap the paper all round. The cambric is then separated at one end, and it is carefully pulled off on the upper side of the sheet. If the paper has been well pasted and nipped, it will split, and one side will be left on each piece of cambric. The paper is removed from the cambric by soaking it in warm water. If left long enough in the water it will float off, but it should not be forced off. Unless the pasting and nipping have been done properly, there will be places where the cambric and paper are not securely joined together, and at these places the paper will tear.

Rejuvenating Cloth. When the color on a cloth-covered book is rubbed off, it can be restored quite successfully if a piece of the same cloth can be found. The top surface of a piece of the same cloth is moistened, and the color is scraped off with a knife. While still damp, it is spread smoothly over the spot which is to be patched, and left to dry. Then the surface of the spot is waxed with a piece of paraffin.

If the whole side of a cloth cover is stained and faded, the color may be restored by giving it an application of tinted size. The color is first mixed and then added to a little vellum size (see p. 327). The colored size is warmed, is strained through a piece of gauze, and is applied to the cloth with a small, fine sponge. A coat of clear size is finally applied over the color after it is dry.

Many cloth bindings may be cleaned and made bright by applying to them a dressing which is sold under the trade name of Leather Vita. Leather bindings also may be treated with this dressing, though it is not a substitute for the leather dressing previously recommended (see Vol. I, p. 192).

CLEANING VELLUM. Vellum may be dry-cleaned with pow-
dered chalk and bone dust. First powdered chalk is applied to the
vellum with a tampon, and it is then brushed off with a soft brush
and is wiped off with a soft cloth. If the chalk fails to clean the
vellum, a stronger abrasive is used. Chalk and finely ground bone
dust are mixed together in equal parts, and a dash of powdered
pumice is added. This preparation is applied and then removed
like the plain chalk. Sometimes powdered *sandarac* or *pounce* is
found to clean vellum when used on it like chalk.

FLATTENING VELLUM. It is difficult to flatten the sheets of a
book printed or written on vellum without taking the book apart.
Moisture must be used, but the sheets should not be washed for
fear of fading the ink or making it run, or of damaging an il-
lumination. Moisture has to be imparted to the vellum by means
of steam. This can be done by laying the book open in one end of
a long, high box that has a cover. A small electric disk is put in
the other end of the box, and on the disk is placed a steam kettle,
like that used for bronchitis patients. The spout of the kettle
should be pointing away from the book, and the cord leading
from the electric unit is run through a hole made in the box. The
lid of the box is closed almost tight, and the electric current is
turned on at the switch of the disk. The leaves of the book are
turned over from time to time as the steam penetrates them, and
they must be watched and not allowed to get too damp. After the
box is filled with steam, the cover may be closed tight and the
electric current turned off. If a little salt is added to the water in
the kettle, the water will boil more quickly. When the leaves of
the book are damp all over, the book is taken out of the box and
is interleaved with interleaving blotting paper, or if this cannot
be found, sheets of unsized paper may be used. The book is left
to dry heavily weighted, and as it dries, the interleaving sheets
should be changed frequently and the weight on the book should
be increased.

Unless a very long box can be found or made for this work, an empty cupboard or closet may be utilized for it. It takes some experience before a binder is capable of treating a book or manuscript in this way. He must be ever watchful to keep the steam content of the box or closet not too dense, but the density should be uniform throughout the treatment. Live steam must not be allowed to come in contact with the book. I strongly advise that some experimenting be done on a comparatively worthless vellum book before attempting to treat the leaves of a valuable book. Vellum books may be picked up for a few dollars each if old bookshops are searched.

When the leaves of a vellum book that has been taken apart are to be flattened, the process is simpler and usually more successful. The folded sheets are freed of any soil, and each one is spread out as flat as possible. Sheets of unprinted newspaper as large as the vellum sheets are dampened on both sides with a sponge. As many sheets of white blotting paper are cut as there are sheets of vellum, and every two pieces of blotting paper are interleaved with sheets of dampened newspaper and are put in a pile. The pile of interleaved blotting paper is put in the standing press between boards and is left under pressure for an hour, or until the blotting paper is evenly dampened. It is then removed from the press, one dampened sheet is placed on each sheet of vellum, and the pile of interleaved vellum is put in the standing press and left for half a day with merely the weight of the platen on it. It is removed from the press, and since the vellum sheets are damp, they can now be smoothed out. They are then put back in the press with dry sheets of blotting paper between them and are left under light pressure for another half day or overnight. When they are taken out of the press they are examined, and if they are not flat they must be redampened, but redampening is rarely necessary. They are kept in the press for several weeks, the blotting paper is changed every two or three days, and the pressure

is increased as the vellum dries, though it should never be so heavy that the printing or writing is harmed. The amount of time necessary for the sheets to dry is dependent upon the atmosphere, but unless kept under pressure until thoroughly dry, the vellum will cockle worse than when the flattening was begun. This is work that cannot be hurried. Vellum should never be ironed with a heated iron, even though it be covered with some material. Direct heat will cockle vellum badly.

CHAPTER XXI

MATERIALS

Leather. Paper. Gold Leaf. Glue. Paste

LEATHER

UNDER "Miscellanea" in Vol. I there will be found some general information about leather, and I am now adding some specific information that may be useful to a binder.

The leathers most used for covering books by the extra binder are levant, turkey-morocco, calfskin, pigskin, sealskin, oasis-goat, and niger. Vellum is less frequently used because of its tendency to curl. Persian-morocco and sheepskin (as it is now manufactured and called "roan" in the trade) are inferior leathers and are not suitable for extra binding. Split skins, or suède, sometimes used for limp bindings, have little strength and should not be used for covering books. There are other skins, such as sharkskin and alligatorskin, that may be used for covering, though they are thin and brittle and should be lined. Chamois, which is made from the underside of sheepskin, is used in bookbinding for lining purposes, but since it has a tendency to retain moisture, a better lining material is Canton flannel. Chamois skins should be kept well wrapped in a warm, dry place. All skins used for covering should be kept in a cool place, and they must be protected from dust and from drying out. If the storage place is heated, it is a good plan to keep them in a closed chest and occasionally put a few pieces of cut potato in the chest. The potato should not be left with the leather for more than a few days at a time, and it should not come in direct contact with it. The leather must be watched for fear of mildewing if this method of producing moisture in the chest is used. The ideal way of keeping leather is in an air-conditioned, cool room.

Real "levant," or "levant-morocco," is no longer obtainable. It was made from the skins of a large goat inhabiting the Levant, and it had a peculiar odor by which it could always be recognized. These Levant goats are now extinct, but goats similar to them are found in South Africa. They are known as "Cape goats," and their skins are very durable. Goatskins that are manufactured into leather come from the Swiss Alps, the Bavarian highlands, the Pyrenees, and other parts of the Continent. They also come from Turkey, the Cape of Good Hope, and other parts of Africa, as well as from South America.

The best "morocco" obtainable for use in bookbinding is manufactured from skins coming from Turkey. So-called "levant" is manufactured from the larger goats coming from the Cape. "Niger" is made from the skins of small goats found in Nigeria and along the Mediterranean coast of Africa. It is a superior skin for use in covering books. When native-dyed, niger usually has a pinkish-red color that is not found on any other leather. The finished skins often bear deep cuts made by crude methods of flaying (the process of removing the hair), and their color is not altogether even, because vegetable dyes are used and the skins are not cleared with acid. However, the nuance in color is pleasing and lends interest to the cover of a book.

Calfskins are no longer well prepared for use in covering books. They cut out quickly along the joints and show a tendency to dry-rot sooner than levant or morocco. Pigskin, when left undyed, is fairly durable. White pigskin is said to last well when it is prepared with lime. Sealskin was used in early times for covering books, but after that, it was not much used for this purpose until the beginning of this century. It is an oily skin, even after being well prepared for binding, and it is not favored by binders, because it is difficult to tool. It resembles oasis-goat in surface appearance. "Oasis-goat" is a name given to a leather that is made from skins coming from "the Cape." It is a smooth-surfaced

leather, and though it has a likeness to seal, it is less oily and has a harder surface.

Vellum is made from the membrane of calfskins (Vol. I, p. 11) and is not much used in America for covering books on account of its unruly tendency. It must be kept from light or it will grow dark and flake off on the surface. This is probably one of the reasons why vellum-covered books were kept on shelves with their backs inward for some time after books in general were placed on shelves with backs outward. In mediæval times vellum was stained a beautiful purple, and from the beginning of the sixteenth century it was stained green in England.

PAPER

It is necessary for a binder to be able to tell the grain of paper, for whenever he must use it folded, it should be folded with the grain, and not against it. This is especially important when making end papers, for if the paper is folded against the grain, a stiff opening of the cover will result. When paper is used to cover half bindings or portfolios, all the turnovers cannot be made to fold with the grain, and it is best to cut the paper in such a way that the long fore-edge turnovers fold over the edges with the grain.

"Laid" paper has a "wire mark," or "laid line," running across its width (see Vol. I, p. 182), and the grain of this type of paper, when handmade, always runs with the laid lines. In the case of a "wove" paper, the grain is often difficult to determine, and the paper must be tested. There are several ways of testing paper to find out which way the grain runs. On many papers this may be determined simply by holding the full sheet or piece of sheet lightly, with the two opposite ends placed against the palms of the hands, and moving it from both ends against the center so as to feel its resistance, then holding it from the other two ends in the same manner and comparing the resistance felt in one direction with that of the other. In the case of a sheet of heavy wrap-

ping paper, a grain can be told at once in this way. With lighter papers a further test usually has to be made. This is done by sharply creasing a piece of the paper in both directions and comparing the creasings. The crease following the grain will be smooth and tight, whereas the crease against the grain will be less smooth and flat. When this test fails to reveal the grain, a final test can be made that is certain to decide the matter. A piece of the paper is dampened with a sponge on both sides and is left to dry on the workbench. As it dries it will curl, and the direction in which it curls indicates the grain of the paper.

The effect of printing a book in such a manner that the greater number of folds in the section run against the grain, instead of with it, is ignored by many printers. When the "make-up" of a book is planned in this way, the pages will not lie flat and the opening will be stiff, whether the book is cased or bound.

Disregard of the grain in paper when printing a book is often due to economy, but it appears to be frequently due to lack of knowledge. I was amazed to read in a manual of bibliography the following sentence: "It does not matter which way a handmade sheet is folded in book making, the folds will have equal strength." This statement is only partly true. The folds will have about equal strength in a handmade paper whichever way it may be folded as the fibers cross each other, but it is not true that it does not matter which way the paper is folded in bookmaking. If in an octavo format the printing is so "imposed" that two of the three folds must be made against the grain, instead of with it, the section will be less supple than when two of the folds may be folded with the grain. For information about the manufacture of paper see Vol. I, p. 180.

GOLD LEAF

Binders often find difficulty in laying gold leaf when it is very dry. If kept for some time, gold leaf becomes friable, and when it

is cut on the gold cushion or pressed over a blinded-in design, it breaks up and cannot be laid solidly without great waste of time and material. It is best to buy gold leaf in small quantities and use it freshly beaten. It should be kept in a tin box with a tight cover.

When a stock of gold leaf gets old and begins to show signs of breaking up as it is being used, it can often be reconditioned by putting a piece of cut potato in the box in which it is kept. This creates moisture in the box, and the leaves become less brittle. But too much moisture should not be imparted to the gold in this way, as it affects its color and purity. This treatment, while not desirable, often makes gold usable when it could not otherwise be used. The manner in which gold is beaten into sheets is described on page 188 in Volume I.

GLUE

The glue generally used in bookbinding is made from animal hides, cartilage, or bones. The better glue is made from hides, and since it has the greater gell strength and viscosity, it is the best of the "animal glues." It is usually bought in whole sheets, in cakes, or in ground form.

The best glue is the cheapest in the long run, for it absorbs a greater amount of water than a poor glue when soaked and prepared for use, and thus produces a greater amount of liquid. It will absorb from two to three times as much water as a glue that costs half its price, and it has a greater adhesive quality than the poorer glue.

There is a glue called "flexible glue," also used by bookbinders, which is made by cooking animal glue with water and a softening agent, such as glycerin. This glue is used on the backs of books because of its flexible quality. I prefer to use flexible glue mixed with hard glue — one part of hard glue to three parts of flexible. This makes the glue less stringy and enables the binder to spread it more thinly and evenly.

There is a tendency among binders to glue up the back of a book with a thick coating of flexible glue and leave it on, in the belief that it will make the back more flexible. This belief is not well founded, for any binding material put on the back of a book constricts the back. When glue is properly applied to the back of a book it penetrates between the sections, and the amount of glue left between the sections after backing the book is sufficient to hold the sections together until they are later more firmly bound together with some material. The surplus glue should be cleaned off the back, after backing (see p. 142). However, when the sections are being glued up for backing they should be held firmly together so that the glue will not penetrate to a depth that will make it visible on the inside of the sections.

Glue is soaked in water before it is heated. Cake and sheet glue should be broken up before being soaked. The desired quantity is put into an earthen bowl, and water is poured over it. As the water is added, the glue is stirred, and as much water is added as it will absorb. Then about a half-inch of water is poured over the moistened mass, and the glue is allowed to stand overnight. The next day it will be swollen in quantity and like a stiff jelly, and it is put in a gluepot and heated slowly. A gluepot is of a double-boiler type, with a receptacle for the ingredients to be heated set into a receptacle to contain water. Glue should never be boiled, for boiling vitiates its strength. Also, if glue is reheated too often, its strength will be impaired. When a pot of fresh glue is to be made, the gluepot should be cleaned by boiling it in an open kettle of water until all the old glue can be removed. Glue that is evil smelling is either poor glue or glue that has been overheated or reheated too often.

Glue is thinned down by adding water to it after it has been heated. The thinning down should not be done until after the glue has been heated, because it will not be possible to judge ac-

curately the thickness of glue until it is liquid. It is a good practice to keep two gluepots going, one containing thin glue, which is suitable for use on paper or cloth, and the other containing heavier glue, which will be required for some other operation in binding.

Glue has advantages over paste for certain jobs in bookbinding. It dries more quickly than paste, and it should be used instead of paste when it is necessary for the work to "set" quickly. It warps material less than paste and should be used when warping is not desirable. On the other hand, a piece of glued material cannot be adjusted after it has been put in place as it almost immediately becomes a part of the material to which it is affixed. Glue must ordinarily be used quite hot, for it then penetrates the material to which it is applied and binds it more securely than when it is used too cool. It should be used cooler on paper than on cloth, as it takes longer to penetrate when cool and does not warp the paper so much. Cloth requires hotter glue, since it penetrates more quickly; and it prevents the cloth peeling off.

Because glue dries quickly, it must be applied without loss of time. A large brush should therefore be used for applying it. A large brush enables a worker to spread a greater surface than a small brush without redipping it into the glue. The brush should be freed from any surplus liquid as it is taken from the gluepot by drawing it over a wooden paddle kept in the pot or over a braided string arranged for the purpose across the top of the pot. Then the brush should be dipped again into the pot to take up the amount of glue necessary to be used. A glue brush should not be allowed to dry against a paddle in the gluepot, for its hairs will then be broken off when freeing it from the paddle after the glue is reheated.

Glue is said to have been used centuries before the Christian Era as an adhesive for joining pieces of wood.

PASTE

Paste is made from flour produced from grains, from the stalks and other parts of certain grain-producing plants, and from various other substances such as starches and dextrines. Commercially made paste serves well for some work in a bindery; it keeps in an unimpaired condition for a year or more, and since it is always ready for use it is convenient to have on hand. Preservatives are put into commercial paste which cause it to turn a grayish-cream color, and for extra binding it should therefore not be used next to the flesher surface of leather, or on paper used for guards or mending patches, the edges of which join another piece of paper. Paste can be bought in dry form and needs only to be stirred up with a little water to make it ready for use.

I have recommended the use of commercial paste on the backs of books when they are to be covered with leather, but the paste should not be put directly on the leather itself, for if used on the leather without the intervention of any medium, it may strike through the pores of the skin, and it will then take the bloom off the leather and may possibly stain it. If the leather is pasted with a paste containing no acids or other injurious substances before it comes in contact with commercial paste, the commercial paste put on the back of a book will not penetrate to the outside of the leather. The commercial paste is recommended for the back because it dries quickly and has a body that is lacking in most pastes made in a bindery.

Paste, instead of glue, is used for covering bound books, because, having a greater moisture content than glue, it softens the leather and makes it pliable so that a binder can mould it over the bands and the sides of a book. Another reason for preferring it to glue for covering bound books is that it dries more slowly than glue, allowing the binder more time to perform the operation of covering. However, glue is used for covering so-called

"limp bindings" because they are really casings, and since no opportunity is given the binder to "make" the grain in the leather of a casing, it is imperative that the grain be "set" at once as the leather comes in contact with the material to which it is affixed.

Rice flour, gluten flour, or any other flour may be used by the binder for making paste. To make it, some flour is put into a bowl, and cold water is added gradually until it is the consistency of thin cream. As the water is added, the mixture is stirred constantly until it is free of lumps. It is then transferred to a cooking vessel, and boiling water is added in the proportion of about one quart of water to four ounces of flour. The mixture is brought to a boil and is boiled for about three minutes, during which time it is constantly stirred. If it appears to be too thick when it is taken from the stove, hot water is added immediately until it is of the proper consistency. It will thicken as it cools, and allowance should be made for this thickening. Some binders add powdered alum to the flour as it is being mixed with water. This acts as a preservative, but paste made from flour takes little time and is cheap to make, so it is not an extravagance to throw away spoiled flour paste and make it fresh when necessary. Before the paste is used, it should be thinned to the proper consistency for the job to be done.

A whiter paste for mending paper may be made of rice flour than can be made of ordinary flour. Both pastes are made in the same way, but I prefer a paste made of starch for mending and for use on leather.

To make paste of starch in a quantity large enough to last a one- or two-man extra bindery for a few days, three heaping tablespoonsful of ordinary laundry starch are put in a mortar such as that used by a pharmacist. Cold water is gradually added while the mixture is stirred until it becomes the thickness of thin cream. Meanwhile, a kettle of water is brought to the boiling point and is let to boil for at least a minute. Then the mixture is

first set in motion with a large spoon, and the boiling water is rapidly poured into it while it is being constantly and vigorously stirred, until the mixture begins to thicken and appear glossy. The pouring is instantly stopped at this point, and the mixture is beaten rapidly until smooth. When finished, it should have a translucent, and not an opaque, appearance. If it looks like dough it will not be adhesive. If it has a live, glossy appearance it will have a good adhesive quality.

The reason for using a mortar is that a heavy vessel is needed for the operation, since one hand is being used for pouring water and the other for stirring, so there is no hand free for holding the vessel. It must be held in place by its own weight, or it will slide about and prevent the worker from stirring the mixture properly. The secret of making a good paste from starch is to have the water boiling hot as it touches the starch, to stir and pour simultaneously beyond the point where the mixture seems to grow thin and watery, until it begins to thicken again, and then to stop pouring instantly, and beat the paste vigorously for a moment.

For use on paper, paste should be thinner than for use on leather. The thinner the paste is used on paper, the less danger there will be of wrinkling; but if used too thin, the paste will strike through the paper and will not bind securely. With both glue and paste the tendency is to use too much and to use them too thick. A thin coat of either glue or paste ensures a better joining of material than does a heavy coat.

Sufficient starch paste for a day's work should be taken from the supply bowl and beaten to a smooth consistency. After being used for a given job, it should be covered with a dampened cloth, and the brush should be washed out. Starch paste forms a thickened covering when left to stand, and this should be removed on one side of the bowl far enough to uncover the paste to be taken from the bowl. The paste should not be dipped into here and there, but should be left in the supply bowl covered with its

thickened crust. Commercial paste should be taken from its container in such a way that its surface is left smooth.

I do not agree with those who advocate using a flat brush for applying paste for large surfaces. In my opinion a fairly large, round brush is the best brush for this purpose, if held and used as described on page 43. For very narrow surfaces, either a flat brush or a finger may be used to advantage, though when a binder has learned the trick of wielding a large brush expertly, he can neatly paste even the smallest surface. All paste brushes should be washed clean after using, and when not in use should be left soaking in sufficient water to cover the hairs where they are fixed into the end of the brush. The water should be changed frequently.

CHAPTER XXII

FINISHING

Finishing tools. Preparing leather for tooling. Tooling. Blinding-in.
Correcting tooling. Running lines

THE term "finishing" comprises all the work that must be done in binding after the forwarder has completed the covering and "filling in" of the cover. This includes preparing the leather for tooling, designing the decoration of the cover, tooling the design and title on the binding, and polishing the leather sides and back of the book.

FINISHING TOOLS

Tooling consists in impressing heated tools by hand on some surface such as leather, vellum, or cloth. The tools used for this

Fig. 155.

purpose are called "finishing tools." Each tool is made of metal which has a slender shank with an enlarged end on the face of which some device is cut (see Fig. 155). The device may be a

Fig. 156.

pictorial design, a dot, a short straight line, or any small engraved outline. These tools are used in combination with one another to form the designs. The straight lines are cut in different lengths and widths, and they may be single, double or triple. The pattern for a set of single straight lines is shown in Fig. 156.

For tooling long lines a "fillet," or "roll," is used (see Fig. 157). A fillet is a wheelike piece of metal on the edge of which one or more lines or a continuous design are cut. Several line fillets of different gauges are desirable to have in a bindery. The fillets with designs on their edges are not often used by extra binders. Their use makes it possible to speed up tooling, but the set de-

Fig. 157.

signs obviate the possibility of artistic freedom of expression. Building up a design with small tools offers a greater opportunity for diversity in the arrangement of decorative forms.

Curved lines are tooled with "gouges," which are curved line tools. They are made in sets, each set representing a series of segments of concentric circles, and each tool a single segment of one of the circles. Sets of gouges of various degrees of curved contours

Fig. 158.

are cut from patterns made by dividing concentric circles into different arcs (see Fig. 158).

For running lines across the backs of books, a "pallet" is used (see Fig. 159). A line pallet is a straight line tool of greater length and sturdiness than those in a set of straight lines. A length of about three inches will be found to be most satisfactory for a pallet, and for best results the contour of the line should not be curved. A long straight-surfaced pallet made of thick metal tapered to the width of the line has better balance than a shorter tool

constructed of lighter metal. The weight and length of such a tool aids in keeping a line straight when tooling over the rounded back of a book. Pallets with designs cut on their edges also are used for tooling over backs of books. They are usually made shorter than the line pallets. Because they have a wider tooling edge they are made of heavier metal than line pallets and conse-

Fig. 159.

quently are fairly well balanced when made shorter than pallets with a straight line. Their length is cut down as much as possible because they are expensive to have made and every added flower to be cut adds appreciably to the cost of the pallet. These pallets are not often used by the extra binder.

PREPARING LEATHER FOR TOOLING

POLISHING LEATHER WITH AN IRON TOOL. When a book comes to the finisher's bench, if it has been covered in a grained

Fig. 160 A.

leather such as morocco or levant, the leather is polished with a heated polishing iron. There are several models of polishing irons, three of which are here being illustrated. In Fig. 160 A a narrow iron is shown suitable for use on the back of small and medium-sized books and for inside margins. Figure 160 B illustrates a broader iron which is used on the edges and sides of books

and on the backs of large books. The rounded iron shown in Fig. 160 C is used only on the sides of books where a large surface is to be polished.

The polishing that is done before tooling is chiefly for the purpose of smoothing out the grain and irregularities of the leather

Fig. 160 B.

so that it may be more easily and successfully tooled. Hence no effort need be made to get a high polish on the leather. The polisher is heated on the tooling stove (**Fig. 15**) until it just sizzles lazily when a few drops of water are dropped on it. Great care must be taken to avoid having the tool too hot, for fear of scorching the leather. After being heated, the smooth face of the polisher is cleaned off with a piece of very fine emery paper (four

Fig. 160 c.

or five o), and it is best to rub the polisher on the flesher side of a piece of leather before using it on a book. When applied to the leather, it must be kept moving constantly to avoid leaving marks, and it should be passed across the leather from four directions with increasing pressure until sufficient polish is attained.

A pad made up by pasting a piece of split leather or a piece of any unsplit leather placed grain side down on a binder's board will be found useful for rubbing off both polishers and tools. A convenient size for the pad is about five by six inches. The fine emery paper, if mounted on a piece of thin cardboard about three by four inches in size, is more convenient to use for cleaning tools

than if left unmounted, and when applied to the face of a tool it is less likely to bevel off the edges or damage the design.

For testing the heat of polishing irons and finishing tools a large sponge is put in a shallow dish containing water. It is an advantage to use an oblong dish instead of a round one so that water can be taken up on the fingers without displacing the sponge. When a polisher or tool is too hot it is cooled by placing it on the wet sponge. Care must be taken not to let the face of a finishing tool come in contact with the sponge, for in so doing water is likely to be left in the design of a tool, and the moisture will blur the tooling. This applies equally to fillets, the tooling edges of which must be free of moisture when used on a leather cover.

TURNING GRAIN OF LEATHER. If a heavy-grained levant is used for covering a book, it is advisable to "turn" the grain preparatory to tooling rather than to polish the leather with a polishing iron. Many binders "crush" the grain of the leather on the sides of a book, but this is a practice of which I do not approve. When the sides of a leather-covered book are so treated they are dampened and are put into the standing press one at a time under tight pressure with a metal pressing plate over the leather. This actually crushes the natural grain and alters it. A method used by French binders for dealing with a heavy-grained leather so that it may be easily tooled leaves the pattern of the grain untouched, and I much prefer it to "crushing." The binder, when using this method, which the French speak of as "faire le grain," "turns" the grain instead of crushing it. That is, he "makes" the grain and does not destroy it.

To turn the grain of a leather binding, the leather over the sides and back is moistened with a small damp sponge. Moistening must be continued until the grain of the leather becomes supple. Then an agate or a bloodstone burnisher (see Fig. 54 A) is applied to the leather on the back and on one side of the book at

a time. The burnisher should be held with the handle in the armpit and with the hand on its shank. It is first moved over the surface of the leather with light pressure, and pressure is increased as needed for turning the grain. If the grain does not turn easily, the leather must be moistened until it is damp enough to yield to the pressure of the burnisher. When turning the grain, the burnisher is used with the pattern of the grain and must not be run over the surface of the leather in the opposite direction, or

Fig. 161.

against the grain. The grain on the back of the book is usually turned first, and the leather on each side must be kept moistened until its grain has been turned. When first attempting to turn the grain of leather the worker is likely to err in not having the leather sufficiently dampened. It requires some time before moisture penetrates the leather and it has to be dampened time and again before it is ready for turning the grain.

POLISHING LEATHER WITH A BONE TOOL. After the grain has been turned, the surface of the leather is polished with a piece of ivory or bone. Since ivory is expensive and not easily obtainable, a bone from some large quadruped may be used (see Fig. 161), or even a rib bone of a steer will be found satisfactory. If importuned, a butcher will supply a bone of this type. To prepare such bones for use they must be first boiled and made perfectly clean. Then the surface of the bone is smoothed by rubbing it with a "tampon" dipped in oil and powdered pumice. It should be rubbed vigorously with a clean piece of flannel cloth in order

to give it a high polish. An implement of this kind is lightly rubbed over the surface of a leather cover after the grain has been turned, in order to give the leather a polish. It should be applied to the leather with a circular motion.

PASTE-WASHING LEATHER. When leathers such as calf, sheep, or russia are used, they should be paste-washed before tooling, in order to fill up the many fine pores that otherwise would absorb the glaire preparation applied to the leather to make the gold adhere. If freshly dyed morocco or levant skins are used for covering they rarely need to be paste-washed or sized, but when these skins have dried out before they are put on a book or when covers are cut from the belly or flank of a skin, it is often necessary to paste-wash them. Otherwise it is difficult and often impossible to make the gold stick. I do not approve of paste-washing or sizing leather if it can be avoided, for this sort of treatment always takes away the luster of the leather, and a grayish cast over the leather is likely to result even when the work is carefully done. With nonporous leathers it is usually sufficient to wash them over before tooling with a solution of diluted acetic acid or with a pure mild vinegar. If vinegar is used, care must be taken to make sure it is of the best quality and is free of sulphuric acid.

To paste-wash a leather cover some starch paste is put into a receptacle and is beaten up until it is smooth and free of lumps. It is thinned down with water to a consistency of thin cream and is applied evenly with a small, clean sponge. Then the sponge is wrung out in clear water and is passed over the leather to even the paste and clear off any excess. The book is stood up and left to dry.

Calf and other very porous leathers require a heavier paste-wash than morocco or levant and should be sized after the paste wash is dry. The size may be made of vellum cuttings or of gelatin, and it is put on warm. To make a vellum size, cuttings of vellum are first soaked in water and are boiled up with water added

when necessary until the viscous properties are freed. The solution is then strained through a thin piece of muslin. It should be of a consistency easy to spread and it is applied while warm. To make size of gelatin, a pure gelatin must be used, preferably that which is in sheet form. About a quarter of an ounce of gelatin is dissolved in a half pint of water. It is then heated slowly, and when fluid it is strained through muslin and is reheated before being applied to the leather. Both gelatin and vellum sizes are best made in a double boiler to avoid scorching.

TOOLING

After the leather is prepared, a book is ready for tooling. Tooling may be either "in blind" or "in gold." In blind tooling, the impressions made on the leather remain as left by the hot tool, and the design stands out because the leather has been somewhat darkened in the process, whereas in gold tooling, after the first impressions are made they are covered with gold leaf and are re-tooled. This produces a design in brilliant contrast to the leather.

Tools used especially for blind tooling are usually cut intaglio like a die or seal. The design is sunk in the face of the tool and is brought out in relief when impressed on leather. Blind tooling may be done with tools cut for gold tooling, but the effect is not so rich as when die-sunk tools are used. For gold tooling the design is outlined on the surface of the metal, and all metal not a part of the design is cut away so that when the tool is impressed on leather the tracery of the design appears stamped in.

It is customary for a finisher to tool the back of a book first, though I prefer to leave the decorating and titling of the back until after the sides of a binding have been tooled. The back lies between the two sides when the covers of the book are opened, and the design from fore-edge to fore-edge should be considered as a whole. For this reason it would seem the logical thing to design the back before tooling the sides, but I find when I have done

this I frequently want to make changes in the design for the back after the sides have been tooled. There is a certain inspiration gained by seeing the design after it has been tooled on the sides of a book, and I am more successful in linking up the sides with the back after they have been tooled. Especially when scant decoration is put on the back, proportion is of great importance. The size and disposition of type for the title, how many or how few lines to use, whether to leave out or to place a decorative motif here or there to connect the decoration with the two sides — all these matters are often difficult to determine. With the leather back exposed to view between the two tooled sides I find the decision can be better made than when it is arrived at while working on a paper pattern before the values of the decoration for the covers have been brought out through tooling.

TOOLING THROUGH A PAPER PATTERN. Presuming that the leather on the back has been washed off with clear water and afterwards either with an acid solution or a paste wash, the design for the side of the book which has been accurately traced on paper is fastened in place by means of scotch tape. It should be adjusted perfectly and held securely. The book is then placed on the workbench with a board under it so that its position may be changed by moving the board without moving the book, with the danger of scuffing the leather. The board on which the book is placed should be lined on the upper side with a piece of flesher skin, and the underside should be smooth so that it may be turned easily. A revolving stand on which to lay a book for tooling has been invented in the bindery of Douglas Cockerell and Son (see Fig. 162). It is made by mounting a flat, round board, covered with a soft, smooth material, on another board. The lower board is stationary, and rests on six rubber knobs which are screwed into the bottom of the board to raise it and keep it from slipping. Ball bearings are placed between the two boards so that the top

one may be turned around easily, thus making it possible to shift the position of a book with the least effort. This tooling stand will be found especially useful when tooling the sides of large books.

The necessary tools and implements for tooling should be as-

SPACE
BETWEEN
BOARDS

Fig. 162.

sembled before beginning to tool a book. All the tools for impressing the design on the book should be collected and placed in a box so that their faces may be readily distinguished (see Fig. 163). Any fillets to be used should be chosen and laid out on the bench. A wooden rule, a finishing folder (see Fig. 164), a shallow

Fig. 163.

dish containing a large sponge and some clean water, a small soft sponge, a mounted piece of emery paper, a box for holding gold sweepings, and a flesher-covered pad for cleaning tools should all be in place on the workbench before beginning to work. When the finisher is ready for tooling, the tools are selected from the

box and are placed on the lighted stove in the order in which they are to be used. They should be watched and pulled back from the heating disk from time to time so they will not be overheated. Overheating takes the temper out of tools and renders them difficult to use. They require a much greater length of time to heat after the temper has been taken out, and they do not hold their heat. In fact, an overheated tool is sometimes unusable.

Before beginning to impress a design through a paper pattern, the finisher should arrange the height of his book so that the tools can be impressed accurately and without effort, sighting

Fig. 164.

them from the "heel" or the "head." The "heel" of a tool is at the lower end of the engraved figure. The opposite end is called the "head." Most tools should be sighted and "struck" from the heel, though occasionally, when the head of the tool is very pointed, it is advantageous to turn a book, in order to "sight" and place the tool from the head. "Sighting" means noting where the tool form begins. "Striking" a tool means placing it.

If the book seems too low for comfortable and efficient work, it can be raised by putting blocks of wood under it. If too high, the worker should lay a large wooden block on the floor and stand on it while working.

The heat of a tool to be impressed through a paper design varies with the leather. Some leathers take an impression readily, while others are difficult to impress, and one can only learn the degree of heat necessary for this operation after experience with different leathers. The object in impressing tools through the paper is to outline the design on the leather accurately with sufficient clearness so that it may be "blinded-in" or blind-tooled after the paper is removed. It is better to have a tool too cool than

too hot, for if a tool is heated so that it makes too deep an impression or leaves the impression burned in, the evenness of the tooling is unalterably destroyed, whereas, if the impression is too faint, the tool can later be accurately put in place by consulting the paper design. For most leathers a tool should be cooled down by laying the shank on the wet sponge until it just fails to sizzle when tested with a few drops of water. Only a faint impression is necessary to guide the finisher in blinding in his design after the paper is removed.

When a design is of a kind known as an "all-over" design, or is one which is made to cover the whole side of a book, the finisher must have a definite system in putting down his tools, or parts of the design will be overlooked. Each heated tool is impressed through the paper with only enough pressure to leave the tool form clearly outlined on the leather. If straight lines are a part of the design they should be marked at each end with a small heated straight line tool. These ends are joined, after the paper pattern has been removed from the book, by running them in with a finishing folder guided by a wooden straightedge.

In removing the paper pattern, one corner at a time should be lifted so that it may be observed whether all the tools have been impressed on the leather. In case any have been overlooked, since the pattern is held in place at one end it can be accurately fastened down again in order to add the missing impressions.

BLINDING-IN. After the paper pattern is removed the leather is slightly dampened with a small moist sponge, and the design is "blinded-in" if gold is to be used. Blinding-in is the process by which a design is made to stand out in crisp, evenly impressed outline. It is one of the most important operations in gold tooling. If properly done, it makes for greater ease in putting down tools through gold leaf, and it ensures greater perfection in a gold-tooled design.

When blinding-in, the tools are struck on the bare surface of the leather in the same manner as is used for striking them through the paper. They are heated only just enough to attain a clear, well-outlined impression. The amount of heat needed for this work varies with different leathers and can be determined only after striking a few tools and noting whether more or less heat is required. It is best to start with a fairly cool tool and increase the heat if necessary, as when working through paper, for otherwise the outline of a tool may be burned in and the whole design damaged, for burned-in impressions cannot be successfully hidden. The only possible way of concealing them is to inlay a piece of leather over the impression and retool the outline. If the leather has been so badly burned that it is cut through and shriveled up, a stuffing must be put over it to level it before the inlay is put in place. A satisfactory stuffing can be made by fraying out a piece of sewing cord, cutting it into very fine bits and mixing them with paste to form a rather heavy plastic material, which the French call a *pâte*. Scrapings from a piece of cover board mixed with paste may also be used for this purpose, but care must be taken to have the coverboard material well pulverized.

Finishers differ about how to strike or put down a tool most successfully, and each finisher develops a technique of his own. Generally speaking, a tool is best struck from either the head or the heel. That is, the tool is put down by placing the head or the heel into the impression and instantly bringing the whole tool into position. All parts of the face of the heated tool should meet the leather almost simultaneously, and no part of it should be allowed to linger in the impression. To facilitate the placing of a tool, the head, or top, of the tool design is indicated by a line cut across its shank. Even tools representing dots and squares or other nonfloral forms are thus marked so that they may always be struck with the same side uppermost when they must be put

down in an impression already made, for hand-cut tools are not mechanically perfect. Fillets and pallets have one side flat and the other side somewhat rounded. When they are used, the flat side should be kept to the left.

Fig. 165 A. Fig. 165 B.

When striking a tool it is held in the hand with the fingers and thumb wrapped around the handle as shown in Fig. 165 A, or if preferred, the thumb may be held on the top of the handle (Fig. 165 B). A leather finger and thumb cut out of a pair of heavy gloves are placed on the index finger and thumb of the left hand

Fig. 166.

to protect them from the heat. The fingers and the thumb of the left hand are rested on the surface of the book or on the table near the book, if the tool to be struck is on the edge of the book. As the heated tool is brought up with the right hand, the forefinger of the left hand is placed back of it well down on the shank of the tool and guides the tool into position (see Fig. 166).

Since the left hand is steadied by being anchored, as it were, to a solid surface, the tool can be more quickly and accurately placed with the aid of the steadied forefinger than it could be without some such guide.

After all the tool forms have been blinded-in, any lines in the design must be blinded-in with a fillet (see Fig. 157). When the fillet has been heated to the proper temperature it is grasped by the handle with the hand held down near the metal shank of the wheel, and the end of the handle is rested on the shoulder. To guide the fillet when it is being placed for running the line, the

Fig. 167.

left hand is rested on the book or the workbench and the metal wheel is grasped between the forefinger and thumb in the cutout space which interrupts the continuity of the line. Steadied in this manner the fillet is brought up to the line to be run, the end of the fillet line on the far side of the cutout metal is placed at the very beginning of the line indicated on the book (see Fig. 167), and the fillet is moved ahead by rolling it forward on the line until it reaches a distance of about a quarter of an inch from the end. To finish blinding-in the line, the fillet is then removed from the book and is grasped with the left hand just back of where the metal is cut out. It is placed back on the line so that when rolled forward the end made by cutting out the metal will just reach the end of

the line to be tooled (see Fig. 168). In finishing the line the fillet is held back a bit with the left hand while it is being rolled forward with the right hand and shoulder. This brake applied to the

Fig. 168.

motion of the fillet is for the purpose of preventing its being pushed too far, which would result in one of its points digging into the leather beyond the line. A wooden rest such as that shown in Fig. 169 may be used to rest the handle of a fillet on when it is on the tooling stove.

Fig. 169.

Until a worker's eye has been trained, it is best that he check all lines for straightness by laying a straightedge along their length. Any deviation from trueness will thus be shown up and the line should be corrected before it is gold-tooled.

CORRECTING TOOLING. There are various ways of correcting a crooked line or a badly placed tool, though none of them are altogether satisfactory. If the leather be levant or a grained turkey-morocco it should be dampened with a large camel's-hair brush saturated with water, and the water should be spread out beyond the immediate vicinity of the place where the correction is to be made, in order to avoid leaving a rim or watermark on the leather. Then a fine-pointed needle may be used to pick out the incorrect traces. On no account should the leather be rubbed with a folder or with the hand. After the picking out has been carefully done a cold tool should be impressed in the damp leather in the proper position. When a line is being corrected, a new trace is made with a folder run against a straightedge and the line is run in again on the dampened leather with a cold fillet. A heated tool should not be used on leather that is damp. Later, after the leather is dry, the heated tool or fillet is used to blind-in the correct trace crisply.

On calf, seal, or any other naturally flat-surfaced leather a needle should never be used. The most that can be done to remove incorrect impressions on these leathers is to dampen the leather several times, being careful to spread out the moisture over the whole side of the book, and then put the tool or fillet impression in correctly. Tools badly placed on a calfskin cover present an almost hopeless situation. On other ungrained skins the old traces can be fairly successfully eliminated with application of water, if the cold tool or fillet is applied at once after the leather has been thoroughly dampened.

RUNNING LINES. Running a perfectly straight line seems difficult when first attempted, but if a few things are kept in mind and put into practice, the art can be mastered without great difficulty. The first thing to remember when using a fillet is that both feet should be placed firmly on the floor, preferably some dis-

tance apart. A true, straight line cannot be run with certainty by a worker who has one foot stuck back of the other and who stands in a slouching position before the workbench. Firm stance and a proper position of the body are of great importance and a proper height of the book worked on is of equal importance.

The book should be higher for tooling lines with a fillet than for tooling with short-handled tools. For running lines it will be found best to bring the book up as high as it can be worked on and the far end of the line reached without effort. The finisher must keep the end of the handle of a fillet resting on his shoulder, and his grasp on the handle should be light but firm. As he rolls the wheel forward, his eye must be kept an inch or more ahead of the fillet, and he must not waver or be fearful, but should attack the job with confidence. This does not mean that he can be careless or overconfident or hurried. Just a steady, quiet, confident attitude is the one that wins out in running a good line. Another point of value is that as the binder rolls the fillet forward he should not hold his body stiff, but should let it follow the moving fillet and not depend entirely upon his hand to do the work. His hand must hold the fillet lightly and merely guide it; his body, not his arm, should provide through the shoulder most of the force for the operation.

Running a straight line on the side of a book is much like running a bicycle over a line marked out on the road. If the rider doesn't "hug the saddle," but sits with good balance and looks ahead of him with confidence instead of directly in front of him with bated breath, he can ride a very straight course. Good position, relaxed muscles, confidence, and keeping the eye ahead of the fillet when running a line on a book will win half the battle, and I have never known an expert finisher who didn't consciously or unconsciously incorporate these principles into his manner of working.

It is often a help when tooling the side of a book to put a cov-

ered weight on the book so that it will not slip when being worked on. The weight, however, must always be placed so that it does not cut off any light.

By adjusting the position of a book to the light the worker is aided in seeing the outline of a tool clearly or in distinguishing the definition of a line. In the case of tools, they are usually better defined to the eye if they are in a position perpendicular to the worker. In order that a line may be seen to the best advantage, a book should be turned so that the light strikes across it, not along it. Turning the book so that it is at a slight angle to the light is sufficient to make a line stand out clearly if the light comes from a window in front of the workbench.

CHAPTER XXIII

FINISHING

Gold tooling. Blind tooling. Tooling vellum, silk, and cloth.
Inlaying leather

GOLD TOOLING. Having blinded-in a design, the finisher is ready to tool the book in gold. To the tools assembled on the workbench for blinding-in, a gold-cleaning tool (Fig. 170) and a cotton tampon (Fig. 171) should be added. A cotton tampon is made by screwing up the ends of a piece of absorbent cotton and then twirling it around on the palm of the hand to give it a

Fig. 170.

flattened, firm surface. The best quality of cotton should be used, for otherwise fibers of the cotton will be pulled off and remain in the tooling when the gold is being rubbed off with the tampon. A gold cushion and knife will be needed (see Fig. 55 A), an-

Fig. 171.

other cotton tampon should be made ready, and a book of gold leaf should be laid out. The gold cushion should be shielded from draughts by a guard (see Fig. 55 B) and placed on the workbench in such a position that it will not cut off any light from the work. This guard may be made of heavy corrugated board. It is cut to the desired height and length, and then scored on the outside with a knife point in the two places where it is to

340

be folded. Each wing is then folded over the center strip and is bound first on the outside of the fold, while the guard is folded, and then on the inside with a piece of gummed paper. It is also bound on all outside edges. This makes a sturdy shield and one that can be put away flat over the gold cushion.

A little oil or grease should be put on the flattened surface of one tampon and then distributed evenly by rubbing the tampon with a circular motion over a piece of clean white paper. This oiled tampon should be kept near the gold cushion on a clean paper, for it must not be allowed to become soiled. Vaseline, coconut oil, and other oils are used for greasing the tampon. The more volatile the oil the better, and a pure almond oil will be

Fig. 172.

found most satisfactory. The least possible oil should be used on leather when tooling, for the traces are difficult to remove, and the luster of gold tooling is harmed by it.

A gold cushion should be brushed off and its surface freshly prepared periodically. To prepare a gold cushion so that gold leaf can be picked off it easily, a little powdered pumice is sprinkled on it and is spread over it with the gold knife. Then the cushion is beaten lightly with the knife until all excess pumice has been removed.

The gold knife should be kept on one side of the cushion, and its blade should never be touched with the hand, for all healthy human skin contains a certain amount of oil, which, imparted to a knife blade, would cause the blade to stick to the gold in the process of cutting it into strips.

For lifting the gold from the cushion a gold lifter such as that

shown in Fig. 172 is useful. This is merely a shaped piece of wood, with a piece of thin felt glued on its undersurface. The felt should be kept clean and free of grease.

When the book is ready for tooling, sheets of gold leaf are laid out on the gold cushion. Gold leaf comes to the binder in "books," each leaf of gold laid between sheets of thin paper. For most extra work it is used double. It is somewhat difficult to manage, and there are various ways of taking it from the book. The easiest way, I find, is to open the book and expose the leaf of gold to be taken out, then to bend half back the upper empty sheets of paper that cover it, so that part of the sheet of gold is uncovered. The book is held in the left hand by the papers that are turned partly back; it is turned over, and the uncovered gold leaf is let to fall on the cushion. The top of the book lying on the cushion is rubbed lightly to make the leaf of gold stay in place. The turned sheets are rolled open with the left thumb, allowing the rest of the gold leaf to come in contact with the cushion. It is freed from the book by rubbing the surface of the book which covers the whole leaf, and the book is removed. The gold leaf is lightly blown upon at the center to straighten it out flat, and another leaf is put down on top of it in the same way and is blown flat. This method sounds complicated when explained, but would appear quite simple if demonstrated.

If one prefers, the gold leaf may be taken out of the book with the gold knife, but this method requires greater dexterity, as the gold has to be handled in mid-air where the slightest movement of air makes it unmanageable. To remove a leaf of gold from the book, the book is placed on the gold cushion and the paper covering it is turned back. The gold knife is then carefully slipped under the center of the leaf and the leaf is lifted up and turned over onto the cushion. It is then blown flat with a light, quick breathing on it directed on the center of the leaf. When used double, another leaf is laid upon it, though this method of taking

out gold is not well adapted to laying one sheet of gold on another successfully.

When laid out on the cushion, the gold is cut into sizes suitable for laying over the part of the design to be tooled, by drawing the gold knife across the leaf. For laying over lines it is cut into long, narrow strips. For laying over an all-over design it is cut into as large pieces as can be easily handled A half sheet can be picked up on the gold lifter and put in place without difficulty.

Before laying gold, the tooled impressions must be painted with "glaire." Glaire for tooling is a preparation made of white of egg and vinegar, which acts as a binder between the gold leaf and the leather when a heated tool is pressed through the gold.

To make a small quantity of glaire the white of an egg is broken into a bowl, taking care to leave none of the yolk. Vinegar is added, the amount varying with the outside temperature and the size of the egg white. In hot summer weather almost a full teaspoonful of vinegar is the proper quantity to add to the white of a medium-sized egg. In wintertime this amount is shaded to about three-quarters of a teaspoonful, else the glaire will be too thin. This mixture is beaten with a common kitchen egg beater until it stands up stiffly. The bowl is then put aside until all the liquid in the foamy mass has been deposited in the bottom of the bowl. This requires several hours at least, though one is certain of getting the greatest quantity of glaire possible if it is made in the late afternoon and allowed to stand overnight. After standing a sufficient length of time, the bowl is tipped and the liquid glaire will run out from the stiffened foam.

Glaire should be kept in airtight bottles, preferably bottles with ground-glass stoppers (see Fig. 173). It will be more satisfactory if each batch of glaire is put into several such small containers and one at a time put into use, for exposure to the atmosphere causes glaire to deteriorate and frequent dipping into it may contaminate it.

Old, evil-smelling glaire is not fit for use, for it is bound to have deteriorated chemically. Many binders put a preservative into glaire, such as a small piece of camphor, but I think this practice is of doubtful value, and since the cost of glaire is so slight it does not seem worth while. Glaire will be found to be a better "binder" if allowed to stand a day after being made.

A certain amount of moisture should be present in leather when being gold-tooled, and if the leather has dried out, the moisture must be restored before beginning the work of tooling. This is made necessary if solidity of the gold is to be gotten in the

Fig. 173.

tooled impressions, because some slight steam or vapor is required to cause the albumen in the glaire to coagulate when the heated tool is applied over the gold leaf, in order to make it serve as a binder between the leather and the gold. Unless the albumen in the glaire coagulates as the heated tool is impressed, the gold will not stick firmly.

It will be fatal if the finisher attempts to supply the necessary moisture to make glaire clot by tooling over glaire not sufficiently dry, for this will cause the tooling to be burned in. The moisture for generating steam to induce coagulation of glaire when the heated tool is put down over the gold must be supplied by the freshness of the leather under and around the glaired surface, and not by glaire too wet.

To freshen leather before tooling, it should be washed off with either plain water or water and vinegar. The vinegar which is astringent, tends to close the pores of the skin.

Many of the older European finishers apply clear urine to leather in order to condition it for gold tooling. Urine when so used must be kept for some time and allowed to begin to ferment. When fermentation takes place, the urea in urine is changed into carbonate of ammonia, which makes it alkaline. The use of urine for this purpose originated with the manufacturers of leather. As a substitute for a urine wash on leather some finishers use a small amount of liquid ammonia in their glaire.

An old finisher in a London shop where I was once working gave me his "secret" for successful gold tooling. I pass it on for what it is worth: "First apply clear urine to the leather, then a weak solution of oxalic acid, finally a thin paste wash and two coats of glaire." The action of the urine has already been described as a sort of freshener of the leather; the oxalic acid clears the skin, but if used at all must be used in a very dilute solution and sparingly, as it has a bleaching tendency; the paste wash fills the open pores of the skin and prevents the glaire from running away through the pores; and the glaire supplies the adhesive agent necessary to effect a binder of leather and gold.

Glaire is best painted into the traces of a blinded-in impression with a small camel's-hair brush. Leather should be given two coatings of glaire to attain the best results. The first coating acts as a filler, or size, and may be applied the day before a binding is to be gold-tooled, but the final coat of glaire should be applied not long before the gold tooling is done. The glaire for the first coat should be flowed into the impressions until they are completely filled, though it should not be allowed to extend beyond the outlines of the tooled impressions, for it will leave a grayish film on the leather. The second coat of glaire should not be so generous — only enough should be used to coat the tracings

thinly. It must be painted on evenly and should be applied continuously.

Before laying the gold, the glaire should be dry enough so that it is not "tacky." That is, when tested with the finger it should not feel sticky. For some leathers, especially those dyed red, a fresher preparation of glaire is needed to produce solid gold tooling than is needed for other leathers. All dry leathers must be tooled while the glaire is quite fresh. As the tooling progresses, an experienced finisher will be able to determine whether to let his glaire dry more, or less, before laying the gold.

When the glaire is sufficiently dry, the oiled tampon is lightly passed over and a little beyond the tooled impressions, and pieces of gold (laid double) are taken up one by one on the gold lifter and are laid over the impression to be tooled. As each piece is freed from the gold lifter it is lightly pressed in place and made to lie flat with the clean tampon.

At least as many at a time as five or six lines running around the whole book cover may all be glaired, laid with gold, and tooled. Usually not more than a quarter of a whole solidly tooled surface of a book cover is prepared and tooled in gold at one time. How much one can prepare and tool to advantage will develop as the work progresses. It is sometimes possible to glaire and lay gold on the whole of a solidly tooled cover before beginning to tool it in gold, but no more work should be coated with glaire the second time and be laid with gold than can be tooled the same day.

Some French binders do not adhere to this rule. In fact, it has been a practice among some French extra binders to glaire, lay the gold, put a glass cover, or "cloche," over the book and leave it until the following day before tooling. They claim that a little dampness is created in this way that is advantageous for gold tooling. I have tried this method, but prefer to freshen the leather and gold-tool it the same day.

Flowered tools are sighted and struck through gold as for blinding-in a design. All gouges are sighted from the inside of the curve. The book must be placed at such height as to afford the worker an opportunity to impress the tools through the gold with sufficient force to outline them clearly. The larger the tool, the greater the force needed for striking it. Small tools must be struck very lightly, or the impressions will be too deep. All the impressions outlined in a design should be of equal depth. This is one test of perfect tooling.

A tool should not be allowed to hover over an impression before being struck, for this dries the glaire and results in broken tooling; nor should it linger in an impression too long after being struck, for that dulls the gold. A quick, decisive placing of the tools gives the best results. As it is put down at a given point, pressure is progressively put on it until the opposite side of the tool is reached. Then the tool is very slightly rocked from side to side. This motion is almost simultaneous with placing the tool and should not be exaggerated or it will blur the impression. The French have an expression in connection with placing tools that is very illuminating. Speaking of striking a tool or of meeting the leather with it, they say: *Il faut le saisir* (It is necessary to seize it).

When the same tool is struck in more than one impression without reheating, as it frequently is when tooling a "diaper" design, its position in the hand should not be changed. Shifting a tool in the hand when it is to be repeated slows up the work and increases the difficulty of placing it precisely.

The heat for gold tooling is greater than for blinding-in and depends upon the leather. The drier the leather, the greater the heat required. For most leathers the tool should be heated so that when a few drops of water are put on its shank to test for heat, they will produce a lively sizzle. Heat indicated by a lazy sizzle will be sufficient for tooling on thin, new skins. The cooler the

tool, the brighter the gold tooling will be, so that a finisher must find just how little a tool need be heated in order to make the gold stick, if brilliant tooling is to be achieved. This requires considerable experience.

After tooling a design through gold leaf, with a piece of absorbent cotton the surplus gold is rubbed off the book into a tin box. When the box is filled, the gold is sold to a goldbeater. The tooled impressions are then cleaned along the edges with the gold cleaner (Fig. 170) and the surface of the book is rubbed over with a piece of clean absorbent cotton to remove any residue of gold. It may be lightly cleaned with the gold cleaner, if necessary.

If the tooling is not solid, it must be redone or patched. One glairing is sufficient for patching. When the tooling is finally finished, the leather is washed off with a pure gasoline procured at a pharmacist's, and the book is stood up to dry before being put away. When put away it should always be kept weighted, as it should be when not being worked on during the process of tooling.

The cleaning of tools is even more important for gold tooling than for blinding-in. Bright gold tooling cannot be produced with dirty tools. Fine mounted emery paper must be used constantly to keep the face of tools clean, and an extra polishing on the flesher-covered pad is desirable.

Failure of the gold to stick may be due to various causes. The tool may not have been hot enough, the glaire may have been too dry or may not have been painted in with care to cover the traces, or the pressure used may not have been sufficient. After the finisher has tried a hotter tool or greater pressure and has made sure that his glairing is carefully done, if the gold still fails to stick, the cause may lie in the leather itself. When dried-out, old skins have been used, the finisher will find them difficult to tool, and he will have to resort to paste-washing them a second time if necessary.

For reconditioning dried-out leather, see page 310. For reconditioning gold leaf that has become too dry to use without breaking into pieces, see page 314.

Fig. 174.

When the back of a book is to be tooled or titled it is screwed up in a finishing press (see Fig. 14) between two pieces of cover board. For tooling lines along the length of the back, the book may be placed on the side of a finishing-press, as in Fig. 13, or on a block, such as that shown in Fig. 174.

Fig. 175.

The inside margins of a book are tooled with the cover open and resting on the tooling block (see Fig. 175). If the leather on the margins has been pared too thin, care must be taken in tooling not to cut through it.

Not only gold leaf but silver and other metals may be used for tooling. Different shades of gold are produced by alloying pure gold with other metals, such as copper to turn it red or silver to make it paler. Gold made with alloys tends to change in color and to tarnish, so that its use should be avoided. Aluminum leaf is generally now used in place of silver leaf because it does not tarnish. However, aluminum cannot be made so thin as either gold or silver and therefore requires much greater heat to make it stick to leather. In fact, it is very troublesome to use. A new leaf, called palladium, is a better substitute for silver than aluminum. It does not tarnish, is thinner than aluminum leaf, approaches silver more closely in color, and is less metallic in substance than aluminum.

Before gold-tooling a cover that is inlaid with colored leathers, the whole surface should be washed over with a fairly heavy paste wash, regardless of what leather the book may be covered with. It must be left to stand at least an hour before being glaired.

Blind Tooling. The technique of blind tooling is very different from that of gold tooling. After tracing the design through the paper pattern and removing the pattern, the finisher does not blind it in. If any impressions are left very faint, they are put in with a warm tool so that their outlines may be readily distinguished, but the leather should not be dampened for this work, and none of the impressions should be deeply tooled in when the design is being put on the leather preparatory to blind tooling.

The terms "blinding-in" and "blind tooling" should not be confused, for they represent two distinctly different techniques. For blinding-in, the leather is only slightly dampened, and the tool is heated so that it is almost at the sizzling point. For blind tooling, the leather is copiously dampened and the tool is used very slightly heated.

The first thing to be done when blind-tooling a cover, after the design has been impressed on the leather through paper, is to dampen it again and again as is done before turning the grain. The object of this is to have the leather damp enough to be able to "draw color" evenly with a warm tool when it is put down on the leather. The leather must be dampened thoroughly and kept damp while tooling in blind. Until it is dampened so that when a properly heated tool is put in place an evenly darkened impression results, it has not been dampened sufficiently. Once a tool is put down with a resulting uneven color, the trace can rarely be patched satisfactorily, for the tool has pressed the leather down so flat and smooth that water will not penetrate it. The whole secret of blind-tooling a design on leather with even color is bound up in the matter of having the leather dampened to the right degree for the work and using the tool only slightly heated.

A tool must be cooled down so that the metal can be taken hold of with the bare hand. A fillet must be so cool that the wheel can be held with the bare hand for an instant without too great discomfort. This means that it must be far short of the sizzling point as used for blinding-in.

When blind tooling, one small portion of the leather at a time must be redampened and brought to just the right state for tooling. As each section is redampened to condition it for immediate tooling, the rest of the leather that has not yet been tooled should be kept damp. Since the traces of the design are faint, the frequent wetting tends to obscure the outlines and the tools must be impressed again from time to time on the untooled part of the leather as the finisher works. They must be watched and kept visible.

After the impressions are blind-tooled they are polished by going into them several times with an almost cold tool. This should be done soon after the tool has been struck and before the leather under the tool has been allowed to dry out completely. To

polish lines, the fillet is pegged with a piece of wood to hold it from revolving, as in Fig. 176, or it may be held stationary with a cleaning tool (see Fig. 177). It is then pushed over the line a few

Fig. 176.

times with a "jiggering" motion, until the line is polished. The tools or fillet may be greased before polishing blind tooling, by rubbing them over a greased cloth. Any pure grease will answer for this purpose. This produces a high temporary polish to the

Fig. 177.

tooling, but the grease soon evaporates, and I prefer not to use it, for it is a dust catcher and eventually causes the tooling to be dulled.

Some finishers get a darkened effect in blind tooling either by putting their tools into a candle flame to get carbon on them be-

fore impressing them into the design or by painting the traces with black or brown ink after they are tooled in. This sort of blind tooling is, of course, far simpler to do, but the color is not permanent, as it is when "drawn" with a tool.

A leather cover must be kept so damp while being blind-tooled that it is liable to warp. To counteract the warping, the cover is polished with a round wooden form (see Fig. 178) placed between the inside of the cover and the text, with the rounded side uppermost. If this fails to get the cover flat, an extra lining paper

Fig. 178.

is pasted on the inside of the cover. The paper should be thin and tough, such as a bond paper. It must be dampened on both sides before being pasted and then it is stretched tightly after it is applied to the cover. Covers tooled with all-over designs in gold often have to be treated in the same way.

It may be readily surmised that blind tooling when done properly is quite as difficult as gold tooling. It is simple enough just to stamp the impressions in without color, but this does not bring out the design on the leather with a rich effect. It is not a simple matter, however, to judge the dampness of leather with respect to the heat of a tool that is expected to draw an even color when impressed into the leather. When blind-tooling, the finisher faces the possibility either of drawing the color unevenly or of burning in the design, until he has had considerable practice. For this reason it is necessary to work on leather-covered cards until the technique has been mastered. This is also advisable when learn-

ing the technique of gold tooling. When both gold and blind tooling are put on a book cover, the blind tooling should be done first, for otherwise the gold tooling would be damaged by the water used in the process of blind tooling.

After a book has been tooled, its end papers are pasted back, and it is pressed with tins between its covers (see p. 227). It is then polished and should be opened as suggested in Volume I, page 194, after which it should be lightly pressed again.

Some binders varnish their gold-tooled book covers in order to preserve the tooling. They use a very fine French varnish for this purpose, but I do not advocate varnishing leather-covered books. Whether gold-tooled or not, leather bindings should be fed with a "food dressing" periodically, if they are to last, and a film of varnish over their surfaces prevents an oily dressing from penetrating the pores of the skin. It is contended that the varnish protects the leather from moisture and heat, and doubtless it does retard drying out and may prevent mildew from attacking the leather, but eventually the leather underneath the varnish will lose its oily content and will be in need of oil, which cannot be fed to it through a coating of varnish. Mildew can be controlled by frequently wiping off leather bindings.

TOOLING VELLUM, SILK, AND CLOTH

TOOLING VELLUM. Vellum is very difficult to tool successfully, and the least possible tooling should be done on a vellum-covered book. Vellum has a surface which shows finger marks easily and it is very slippery, so that great care must be taken in placing tools on it.

Before tooling vellum it should be washed off with clean water to remove any marks, but not much water should be used on it nor should its surface be heavily rubbed, for water and rubbing tend to destroy its luster.

The surface of vellum is very hard, and requires no paste-

washing or other preparation before being tooled. The design is fastened to the book and is tooled in through a paper pattern as directed for tooling leather, though the tools must not be too hot, for vellum burns easily. Little heat and rather heavy pressure are best for tooling in the design through paper.

For gold tooling, the impressions are glaired twice, and gold is laid over them. It is better not to lay much gold at a time before tooling, as gold cannot be made to lie flat on vellum and stay in place as it does on tanned and dyed leathers. When the gold is laid, a slightly heated tool is used for the tooling.

Glaire stains vellum easily, and if allowed to go beyond the impressions of the design it will leave ugly marks, so great care must be taken in glairing.

Neither blind nor gold tooling is very successful on vellum. When blind-tooling, no water should be used, and the design is merely impressed on the vellum without attempting to draw color.

If a leather title piece is to be pasted on a vellum cover, the place where it is to go should first have the vellum surface scraped with a knife and slightly roughened. Nothing can be made to adhere to a vellum surface with paste unless it is so prepared. Before tooling on a leather title piece it should be given a paste wash. After being tooled, the title piece should be wiped off with gasoline and then given a coat of fine French varnish.

TOOLING SILK, VELVET, AND CLOTH. For tooling silk or velvet with gold, a powdered glaire should be used in place of liquid glaire, which will stain the material. The powdered preparation is now commercially manufactured and can be bought where binders' supplies are sold.

When using powdered glaire the design or lines are first blinded-in with a cool tool or fillet. Powder is then dusted over the tooled impressions, and the gold leaf is cut up into small

pieces, or in strips, if a line is to be run. The tool is heated just short of the sizzling point, and the face is lightly greased by applying it to a greased pad, so that gold will adhere to it. The tool is put down on a piece of gold cut to a suitable size, and it will lift the gold from the cushion. The gold is patted lightly with a cotton tampon to bend it over the sides of the tool in order to be able to sight the tool clearly when placing it. It is then impressed in the material with a fair amount of force. After all the tooling has been done, the surplus powder is brushed away. Tools must be used quite cool for this work.

Velvet has a deep pile, and therefore small tools disappear in it, so that it is better to use large tools and a fairly broad fillet or letters when tooling on velvet.

Cloth may be tooled in this same way by using a powdered glaire, though a liquid glaire may also be used on cloth. When a liquid glaire is used, the whole surface of the cloth should be sponged over with the glaire, for if it is applied with a brush just in the tooled traces it will run into the cloth and make unsightly marks around the tooling. Whether dry or liquid glaire is used for tooling on cloth, the gold should be picked up on the greased tools, and not laid over the material, as for tooling on leather.

INLAYING LEATHER

Colored leather of a different hue from that of a book cover may be either inlaid into a design on the cover or onlaid over it. To inlay, the edges forming the design blinded-in on a book cover are cut on a bevel, the leather within the tooled impression is removed, and a piece of pared, colored leather is fitted and pasted into the cavity. To onlay, a piece of pared, colored leather is cut to the form of the design tooled on the cover and is pasted over it. Onlaying is less difficult than inlaying, but it is a stronger method of introducing colored leather into a design and is the method most in use for this work. Regardless of whether the

colored leather is pasted into a cutout impression or whether it is pasted over the impression, the work is known as "inlaying," and the following directions are based on the second method of working, which, though called "inlaying," is actually "onlaying."

The leather used for inlaying is first pared very thin (see p. 204). When it is to be inlaid over a design impressed by a small tool or by several tools used to build up the design, the pared leather is moistened on both sides with a small sponge dampened with water, and is put over the design. The leather is pressed with the fingers into the design until the entire outline can be seen on it. It is then removed, and the leather is cut with a pair of small, curved scissors all along the outer edges forming the design. It should be cut in the middle of the lines defining the outer edges. For circles and small flowered tools which have a solid outline, punches to fit the design are made of steel. These are used to cut out the leather for small tool forms. The leather is placed on a piece of binders' board, the face of the punch is put down, and the handle is hit with a hammer. The edge of the leather used for inlaying the larger tool forms should be pared all round until they show none of the grayish tone on the edge of the inlay.

After inlaying leathers have been pared and fitted to a design, they are pasted and put in place. To paste the small-tool inlays, paste is spread over a slab of glass, and the inlays are put underside downward on the paste and rubbed with a paper over them. They are then taken up with the point of a folder and put in place on the design, and after the edges are adjusted, they are rubbed down firmly with a paper over them. The larger inlays are pasted individually with a brush and are put down and rubbed like the small inlays. The edges of an inlay must be worked over while freshly pasted, to make them conform to the outline and stick firmly. A pointed bone or ivory tool is used for this purpose (see Fig. 179).

When inlays are put in a border between lines they are usually

joined at the corners if the border is to go around a book. The leather should be cut a little wider and longer than needed for all the strips, and it is then pared. The pared leather is dampened, placed on each border segment, and defined as for small tools. To outline the lines more distinctly, the point of a folder is run along each trace. The leather is removed and is cut with a knife on a covered cutting tin. It should be cut in the middle of the traced line. The two longer strips are placed first. To measure for the proper length of each strip, one end of the strip is cut off

Fig. 179.

square, is then held at one end of the border to be inlaid, and is stretched somewhat. A mark is made on the strip where it reaches the end of the border opposite from that on which the squared end rests, and the strip is cut off square just short of this mark. Then the two short strips are measured in the same way, but they are cut on the marked line instead of short of it. Next, each strip is marked at each end with a line which miters the corner at a 45° angle, and the strips are cut off on the marks. The longer ones are beveled on the upper side of the leather along the mitered line. The bevel should not be deeper than one-thirty-second of an inch. The shorter strips are beveled in the same way, but on the inside of the leather. The strips are now ready to be put in place.

First one long strip and then the other is pasted on the under-side and left for a moment. The first strip is repasted and is stretched in place so that its two pared edges reach over onto the two short borders, in order that the short border strips will cover the beveled edges. The strip is adjusted and rubbed down, and the opposite border strip is pasted, placed, and rubbed down in like manner. Next the two short strips are put down and are

stretched to overlap the pared edges of the long strips. When the edges of the strips are beveled, each short strip should be beveled to fit over the longer one without showing a ridge on the upper side.

Panels are inlaid in a manner similar to the strips in borders, but the center of the leather does not need to be pared quite so thin as the edges. The panel has a richer effect if left somewhat thicker in the center.

When a large piece of leather is inlaid, a piece of paper is pasted on the grained side of the pared leather, and is left to dry under a weight. The pattern used for tooling the large design on the leather is put over the leather-lined inlay, and the design is tooled on the inlay through the pattern. The leather and paper are then cut out together, the edges of the leather are pared very thin, and the paper is removed after sponging it with a moist sponge. The large inlays are put in place and finished in the usual way. Borders may be inlaid in one whole piece by using this technique. In this way piecing at the corners is avoided, but mitered corners, if expertly done, rather add to the effect of the border.

After inlaying has been finished, the work should be covered and left to dry with a smooth pressing board and a heavy weight over it. Before the work is entirely dry, each cover may be put in the press between crushing plates and nipped. To put the book in the press for this work, a piece of heavy blotting paper is laid over a pressing board which is in place toward the top of the press, and the inside of one cover is laid over the blotting paper. A crushing plate is put over the outside of the cover, and boards are piled up over the plate. The book must be put in so that the back edge of the cover board is exactly even with the front of the board underneath it and even with the front of the crushing plate on top of it. The whole book, except for this one cover, will hang outside of the pile of pressing boards, and it must be supported (see Fig. 180). The press is then wrung down, and the book is

taken out almost immediately. This same method is used when the sides of books are crushed, though the book is left in until the leather has been highly polished. Crushing plates are made of steel and have a nickeled surface. It must not be forgotten that an inlaid book should be paste-washed before it is tooled.

For white inlays it is better to use a piece of Japanese paper than

Fig. 180.

leather, for most white leather is almost impossible to pare thin without wetting it, and this turns it a cream color. Furthermore, when pared very thin, white leather is not opaque, and the color of the leather on the book will show through it.

Vellum cannot be inlaid, and the introduction of color into a design tooled on a vellum-covered book must be made by painting the design with a stain. After the color has dried, a coat of size should be put over it.

CHAPTER XXIV

LETTERING

Lettering on back of book. Design and Pattern Making

LETTERING ON BACK OF BOOK

LETTERING may be done on the back of a book either with single letters, each put in a handle like small, flowered tools (see Fig. 155), or with type set in a typeholder, or pallet (see Fig. 181). Lettering may also be done by using straight lines and curves to form the letters.

Fig. 181.

Lettering that is done from a pattern made up of curves and lines in an original manner or with single letters cut on brass from a chosen model allows greater scope for artistic arrangement than that done with type set in a typeholder. Not a great deal of time is saved by tooling-in a title set up in a line and held in a typeholder, except when several books bearing the same title are to be lettered. The typeholder method is a method in which the French binders excel, whereas lettering with single letters is the method most used by English extra binders, and they have

mastered this technique so that an expert workman can tool forty titles in a ten-hour day. If books are to be lettered to harmonize with modern designs, the typeholder method is too rigid.

LETTERING WITH INDIVIDUAL LETTERS. When a book is to be titled with individual brass tools or with brass type, at least four or five sizes of letters should be in the binder's equipment for ordinary lettering. A model may also be chosen for special lettering, such as the Koch or Eve model or a lapidary model, and a third, or "antique," model may be added for the lettering of prayer books and missals. These special models cannot usually be afforded in more than two or three sizes, for hand-cut tools are very expensive. If a binder were well equipped with specially cut hand and typeholder letters, the expense would mount to between six hundred and one thousand dollars. All letter tools and type should be made of brass. Lead type is neither durable nor dependable, as it melts when put on the tooling stove in a typeholder, and it does not hold the heat as uniformly as brass.

Books that are to be kept on a shelf should always be lettered on the spine. If a book is too thin to allow for a title being put across the spine, the lettering may be run along the spine. The American custom is to run such titles to read from tail to head; the English binders have the convention of running them to read in the opposite direction. I think the American custom is preferable, for when a book is standing on a shelf, a title running from tail to head is more easily read than one running from head to tail.

Before a book is titled, a pattern for the lettering should be made on paper, when individual letter tools are used or when the letters are to be formed of straight lines and curves. For making the pattern, a strip of thin bond paper is cut the height of the panel to be lettered and wide enough to reach about two inches beyond each side of the back. The title and author should then be

written out exactly as they are printed on the full title page, and this copied title should be kept in view to work from as the title is being made up. The binder's memory should never be trusted, however familiar he may be with the title of a book.

Fig. 182.

If the written-out title and the pattern paper strip are consulted, the binder will be able to judge fairly accurately the number of lines and the size of the letters needed for the title. When these two matters have been decided, the binder estimates how far over each side of the spine he may allow the title to run. In order to determine this distance, the book is placed on the workbench with the spine up and perpendicular to the worker. It may then be noted that a shadow is cast on each side of the spine as the light strikes it where it curves toward the sides of the book. These shadows mark the limits of the space that should be tooled, for if gold tooling were to reach beyond these lines of shadow, the gold would crack after the book had been held open several times. The title would also be difficult to read. The book is marked on each side of the spine with the point of a folder where

the shadow lines occur (see Fig. 182) and the cut strip of paper is laid over the spine and is marked for width a distance equal to the width of the spine indicated by the folder marks. Lines are drawn through these marks at right angles to the length of the strip.

The next thing to be done is to space off the strip for the lines of lettering. If, for example, the book is "Art In Our Time," and this title is to be put on a rather thin octavo volume, it will be necessary to divide the title into four lines. A letter with a vertical stem or one that ends at top and bottom in straight lines like E, is chosen from the letters making up the title, the face of the letter is blackened in a candle flame and the letter is put down on paper. Spring dividers are set to the height of the letter, and this distance

Fig. 183 A. Fig. 183 B. Fig. 184.

is marked off four times on the width of the strip to determine how much space is needed for the four lines of the title. The balance left on the width of the strip represents the amount of space that is available for spaces between the lines of letters and for spaces above and below the title (see Fig. 183 A). This distance is divided up with a second pair of dividers according to the taste of the binder, though the spaces between the lines of letters must be even, and the space above the title should be a trifle smaller than that left below the title. It usually looks well to have the spaces between the lines of lettering equal to the height of the letters used. When the proper distances are found, the strip cut for the panel is compassed off and two parallel lines are marked with a hard pencil across the width of the strip for each of the four lines

of letters, leaving the desired spaces at top and bottom of the panel (see Fig. 183 B). The letters are then put down between these lines.

To put down the letters, the paper is first divided in the middle between the two side lines marked for the width of the title, and a line is drawn to indicate this division. Each tool face is blackened in the flame of a candle, and the tools are impressed on the strip so that the letters of the title are equidistant from each other — the longer words filling the width of the space and the shorter ones centering over them (see Fig. 184).

Spacing the letters in a line will be most easily accomplished if the number of letters in the line are counted, and the center letter of the line is put down first on the line marking the center of the strip, like "r" in "art" as shown in Fig. 184. From this center letter the other letters are then placed. Or if there are an even number of letters in a line, there will be no center letter, and one of the middle letters is just placed on one side of the middle line. This letter spacing is best worked out on one side of the strip before the letters are put down in the panel marked on the strip.

The author's name is compassed up for and is put down in the same manner as the title. An English title is usually placed in the second panel from the head of the book, and the author's name is placed in the panel below the title. A volume number is placed in the panel below the author's name, and the date of the edition is placed at the tail, when the edition is a valuable one. In lettering a French book the author's name is put above the title. Either both the author's name and the title are put in the second panel with a dash between the author's name and the line or lines of the title, or the author's name is put in the second panel and the title in the third one.

However, titles need not be tooled in a stereotyped fashion. Instead of putting down a title such as "Wordsworth's Poetical Works" with small letters, as in Fig. 185 A, larger letters may be

used, and the words may be broken up as shown in Fig. 185 B, or in some other way. In fact, the lettering of a book should be considered as a part of the whole design of the decoration used on the sides and back of a book, and the title should be planned to harmonize with the design. Unconventional titling of books is done to advantage by drawing the letters individually and then fitting the drawn letters with straight lines and curves, in order that they may be tooled on a book. This manner of lettering is especially suitable for books decorated in an unconventional manner.

Fig. 185 A. Fig. 185 B.

After a pattern has been made for a title to be put on the back of a book, the book is put in a finishing press with a piece of protecting binders' board on each side. The strip containing the title is put in place over the panel for which it was cut, and when it has been carefully centered it is fastened with scotch tape onto the protecting boards covering the sides of the book. The title is then tooled through the paper, and after the paper has been removed, the leather is slightly dampened and then the title is blinded-in clearly. It is then gold-tooled like the sides of a book. Or if the title is to be blind-tooled, deep blinding-in is omitted, and the work is done as already described.

LETTERING WITH TYPE. When type is used for a title, no paper pattern is made. The spacing for the lines of the title is estimated with regard for the width and height of the panel to be

lettered; then the type is put in the type pallet and is spaced according to the taste of the finisher.

There are two methods used in gold lettering done with type in a pallet. One is to impress the title on the leather with the type set in the pallet and slightly heated, after the spacing has been mapped out, then to glaire the tooled impressions, to lay gold over them when the glaire is dry, and to tool as for individual letters. The other method is to divide up the panel for the title, and indicate the divisions on a piece of paper for reference, then glaire over the whole panel with a small sponge, lay gold over it in the usual way after the glaire is dry, and mark lines for the lettering across the gold by drawing a piece of fine thread over it from side to side. The pallet is then heated and the letters are impressed over the gold.

It is no easy matter to run the type in a pallet over the round back of a book and make a straight line of the lettering. The French finisher places the book in the press at right angles to him, sights the line of type from the heel of the type, and runs the pallet across the back of the book on a line parallel with him from right to left. The English finisher usually places the back of the book parallel with him, sights the type from the line at the head of it, and guides the pallet across the back of the book. The American finishers usually use the French method. After a few trials at lettering with a pallet, a worker will soon find which of these ways is the easier for him to use.

Unfortunately, explanations are of little avail in helping a beginner to learn titling. He must learn this art through practice. The most valuable hint I can suggest for keeping a line of type straight across a book is that the worker must not bend over the work, but must stand erect before it, with both feet planted firmly on the floor some distance apart. Titling is an operation in which correct stance is of the utmost importance.

DESIGN AND PATTERN MAKING

Design is the arrangement of some form or forms within a given space. The empty spaces in a design often count for as much as the filled spaces, and the manner in which spaces are filled or left empty stamps the design as formal or informal, stereotyped or freely created.

A design to be tooled on a book cover must be of such a nature that it admits of reproduction on the cover by means of engraved tools, for this is the only way tooling can be done on a book. In consequence of this mechanical limitation, a very special type of design must be made for a tooled cover; the artist creating it is restricted and is unable to give his imagination such free scope as the artist who is designing a cut-leather cover for example. There is no such freedom possible in any type of book cover designing as there is in painting on canvas or etching on a copper plate. However, this does not mean that the artist making a design for a book cover must confine himself to the same symmetrical arrangement of repeated tool forms and produce cover designs like those of the traditional past.

Artistic arranging is not creative designing, and tool forms, however beautiful they may be, cannot be expected to do the work of the designer. They can merely work for him. The designer must conceive a design and utilize his tools to serve the purpose of carrying out a definite scheme of decoration that has been created through his imagination.

There are two general types of design for book covers —-symmetrical and unsymmetrical. Symmetrical designs may be built up with a repeat of tool forms at regular intervals, as in "diaper designs" (see Figs. 186, 187), or they may be created by drawing some symmetrical form and repeating small tools in conjunction with this form, in order to carry out a decorative scheme (see Fig. 188).

Fig. 186. Fig. 187.

A simple diaper design is the least creative of any type of design, but it serves well enough for decorating the covers of a prosaic book, when it is arranged as in Fig. 186. The type shown in Fig. 187 may be used on a leather doublure with good effect. The construction lines are shown in Fig. 186 by broken lines, and these lines are not reproduced on a book cover. However, in Fig. 187 the lines are utilized as a part of the design, as shown when they are made into solid lines.

To make the paper pattern for a symmetrical diaper pattern design, a piece of bond paper is squared to the exact size of the book cover and is then compassed up and divided equally in width and length after the desired width for a border has been marked off. Lines are drawn diagonally across the paper through the marks that divide it; thus diamond-shaped segments are made. A segment of the paper is decorated by arranging tool forms in it with tools blackened in a candle flame, the paper is folded in half and creased both in length and in width, and the same tool arrangement is repeated in each diamond on one quarter of the folded paper. The decorated quarter is then folded over, and the back of the paper on which the design has been marked is rubbed with a folder so that the imprint of the design is transferred to the opposite side of the paper. The indicated outlines are made clear by impressing blackened tools into them. The half-made design is folded over onto the other half of the paper and is transferred to it and made clear. A great variety of tool arrangements may be used for decorating the diamond-shaped units.

A paper pattern for symmetrical design such as that shown in Fig. 188 is made in a manner similar to that used for a diaper pattern. However, instead of decorating set spaces like diamonds and then repeating the motif, an outline is drawn freehand, the paper is folded into four parts, and after one-half of the paper pattern is decorated, the design is transferred and repeated on the other half of the paper.

In developing the design shown in Fig. 188, the procedure is first to decide the type of design and the tools that are to be used. Then a border is compassed off in a suitable proportion to the size of the cover, and a rough sketch of the decoration contemplated for the center panel is made on a separate paper. The paper pattern is folded into quarters, and the curved outline of half the design is drawn accurately on one side of the paper pattern. The paper is folded over, and the design is transferred onto the other side, in order to get the effect of the completed form. Changes are made until the desired outline is arrived at, and then the small joining curves are drawn.

When the tools are assembled, the designer begins to let his fancy play, and he creates the finished design by filling half the space to be decorated, with curves and tool forms, and then transferring that half to the other side of the paper pattern. He finally fills in, here and there, spottings of tools, in order to bring the whole design together. This design is made by using only three set tools, one a leaf, another an oblong solid tool used to form the bunches of grapes, and the third a spiral tool to finish the ends of curves. The design for the spiral tool has to be drawn by the designer and given to a tool cutter to cut. The lettering is afterwards blocked out on paper and is put down in the border with blackened tools.

Unsymmetrical designs are of the type in which set tool forms are generally dispensed with, and all the decorative forms in the design are drawn freehand (see Fig. 189). Symmetry is, of course, found in the component parts of the design, but balance is substituted for symmetry in the general scheme of decoration. For a design of this type a paper pattern of proper size is cut, and the finished drawing is drawn on the paper pattern with a pencil.

By using colored inlays and by using blind tooling with gold tooling, a variety of effects can be produced. If the same design were tooled in gold on a book cover, and then blinded-in and in-

laid in color on another cover of the same size and color, it would appear like a different design on the second cover, unless it were closely inspected.

Extra binders design most of their own tools (except period tools) and have them cut for their special use. All flowers and other forms must be conventionalized, because otherwise they give a restive appearance to the design when they are often repeated. It is well to have the same tool forms cut in different sizes. The drawing for a tool must be made quite large in ink; the tool cutter will reduce the drawing and cut the tool in any sizes specified. Some of the tools cut in outline should have punches made for them so that they may be inlaid. The tool cutter will make these upon request.

An extra binder should have training in the art of design. Unless he has learned to draw and has been steeped in the underlying principles of design, he cannot hope to produce decorated books of artistic merit. A basic training in this art is an absolute requisite for the expression of ideas or fanciful conceptions in a manner suitable for decorating book covers.

Fig. 188.

Fig. 189. *Design by Arthur Rackham on Midsummer Night's Dream manuscript.*

Courtesy of the Spencer Collection, The New York Public Library, New York, N. Y.

GLOSSARY

GLOSSARY

[Please note: A separate glossary follows the text of the first volume.]

All-over design. A design planned as a decoration to cover an entire side of binding, in distinction to a cover, center or border design, whether made up of a single motif, different motifs or a repeated motif.

Anchored. A head or tailband is said to be anchored when it is fastened to a book by a thread conducted from the front to the back of a section.

Armenian bole. A red chalklike mineral substance used in preparing edges for gilding.

Arming press. Another name for blocking press. A press used for stamping designs on book covers. The name was derived from its use in impressing armorial bearings on the sides of books.

Art mat paper. A kind of highly glossed paper used mostly for printing illustrations from half-tone plates.

Backbone. Same as Spine.

Backing. The process of shaping the back of a book and forming a joint on each side of the back after the sections have been glued together.

Backing a board. Cutting a straight edge along its length.

Backing board. Wedge-shaped board beveled at the top edge used to form a joint when a book is being backed.

Backing hammer. A hammer used for rounding and backing books.

Band nippers. A metal implement used for nipping up leather over the bands of a book when covering it.

Bands. The covered cords or other material across the spine of a book which divide it into segments.

Bandstick. A stick used over the back of a book during the process of covering for the purpose of smoothing down the leather between the bands.

Bandstrip. A strip of material which forms the basis of a head or tailband.

Basil. Tanned sheepskin used for cheap bindings.

Bead. The twisted stitch formed in headbanding.

Beating hammer. A short handled hammer used for beating the text of a book.

Beating stone. A stone or slab of iron set in a frame filled with sand, on which books are beaten.

Bench-made. Any work done on the workbench by hand.

Bench shears. A species of large shears used for cutting bookboards, sometimes fastened to a workbench.

Binder's board. A composition cover board.

Binding "en gist." A Bradel binding.

Bleeding. Cutting into the print of a book.

Blinded-in. A design is said to be blinded-in, when it has been impressed on a book cover with heated tools.

Blind tooling. Impressing heated tools on leather by hand, without the use of gold. Sometimes referred to as antique.

Block book. A book printed from blocks of wood having the letters or figures cut on them in relief.

Block papers. Papers printed from blocks of wood or metal on which a design has been cut or engraved.

Blocking. The process of stamping book covers. Same as Stamping.

Blocking press. Another term for arming press.

Boards.

 1. Wooden or composition pasteboard covers used on the sides of books.

 2. A general term used by binders for various stiff lining and mounting materials.

Bole. A reddish mineral used as a base on book-edges preparatory to gilding them.

Bolt. The folds in the sheets of a book at head and fore-edge.

Book covers.

 1. A term applied to the covered sides of a book.

 2. Protective covers of soft leather, like doeskin, sewed fast to a leather covered book. A custom in use during the Middle Ages and early Renaissance.

Bookmarker. A ribbon fastened to a book to be utilized for marking a place when reading. Usually put in prayer books or books of devotion, by a binder.

Book-square. The projection of the book board over the edges of the text.

Books in sheets. Books which come from the printer in unfolded sections.

Bound book. A covered book the sections of which have been sewn around cords or some other material, the ends of which are laced through the cover boards.

Bound flexible. A book is said to be "bound flexible" when its sections are sewed around cords which are laced into its cover boards.

Boxed book. A book is said to be boxed when it is in a covered case or book box.

Bradel binding. A type of temporary binding said to have originated in Germany, and first adopted in France by a binder named Bradel. Known in France as "cartonnage à la Bradel."

Brochure. A sewed book with a paper cover.

Burnisher. An agate or bloodstone set in a handle for burnishing leather.

Burnishing. The act of applying a burnisher to a surface in order to polish it.

Burr. A term used in bookbinding with reference to a knife to signify a turned-over edge.

Canceling. Cutting out a leaf of a book and substituting another leaf in order to correct a misprint or to make an alteration.

Cancels. Pages printed to substitute for pages in a book which contain errors or require alterations.

Carton bleu. A species of French cover board.

Cased book. A book which is held to its covers, or casing, only by means of pasted down end papers, which are sometimes reinforced.

Casing. Cover of a book made separately and pasted to the book by means of end papers.

Casing-in. Pasting a book into its casing.

Catch stitch. A stitch made to fasten one section to another when a book is being sewed. Also called chain stitch.

Catchword. A word printed at the bottom of a page to denote the first word on the following page.

Chain lines. The narrow numerous lines in a sheet of paper made by wires in the "mould."

Chain marks. Same as chain lines.

Chain stitch. Same as catch stitch.

Chemise. A cover or jacket used to protect a binding.

Chipboard. A thin hard-surfaced grayish board used in bookbinding mostly as a lining board.

Cloth board.

1. A pressing board having a metal flange on its edge used to define a French joint when casing-in.
2. A binders' board.

Collate. To examine the signatures after a volume has been folded to ascertain whether the pages are in proper sequence.

Colophon. A paragraph put at the end of a written or printed book, con-

taining information as to the identity of the scribe or printer, place of origin, date of printing, and sometimes other related matter. In extensive use until after about 1570. Sometimes referred to as an imprint.

Commercial binder. A term used to denote a binder who turns out publishers' editions in "casings," using machinery for the work. Better termed a machine binder.

Concertina fold. An accordion-pleated fold.

Cords. The material around which the sections of a book are sewed.

Corner knife. A specially shaped knife used for cutting leather at the corners of a book cover during the process of covering a book.

Cover boards. Same as "Boards" 1.

Cropped. A book is said to be cropped when its margins have been injured in cutting.

Cropping. Cutting the edges of a book beyond the shortest, or proof, sheet.

Crushed grain. Grain of leather that has been flattened with pressure between metal plates.

Crushing plates. Nickeled metal plates used for crushing the leather sides of books.

Cut-edge book. A book the edges of which have been cut off smoothly.

Cut in-boards. When the edges of a book are cut after the boards are laced on, the book is said to be cut in-boards.

Cut open. A finishing tool is said to be "cut open" when the design on its face is defined by lines.

Cut solid. A term applied to finishing tools the faces of which are of solid metal, sometimes with line veinings, in distinction to tools cut with the designs formed by lines, or cut open.

Cutting board.
1. A board (usually of hard wood) on which cutting is done.
2. A wedge-shaped board used when cutting the edges of a book.

Cutting press. An implement used for cutting book boards or the edges of books by hand.

Deckle edge. The rough or irregular edge produced on a sheet of paper when in process of being made. Especially characteristic of handmade paper.

Diaper design. A design in which a motif is frequently repeated at regular intervals, usually in lozenge forms.

Dividers. A steel instrument having two adjustable prongs used for dividing spaces.

Divinity calf. Dark-brown calf used on religious books and tooled in blind.

Doubled tool. A tool is doubled when in placing it a second or third time it is not placed exactly in the first impression.

Doublure. The lining of silk, leather or other material on the inside of book covers.

Drawing color. A term used in blind tooling when the color of the leather binding is darkened by an impressed tool.

Dummies. False or trial objects made up in models of real objects.

Duodecimo. A term used in reference to a book made up of twelve leaves to a section. Same as "12mo."

Edge-rolled. When the board edges of a leather-covered book are tooled with an engraved roll they are said to be edge-rolled.

Edging knife. A knife used to pare the edges of paper or leather.

End papers. The extra unprinted papers placed at the beginning and the end of a text, a sheet of which is pasted down on the inside of the front and the back book covers.

Extra binder. A hand binder who uses the best materials and employes the soundest methods of construction and who usually decorates each binding with a design especially made for it.

Extra binding. A term used to denote a binding done by hand with especial care.

Face. The face of a tool is on the end of the tool on which the design has been cut.

False back. A hollow back.

Fanning out. Manipulating a pile of book sections, sheets of paper, or boards so that each unit is exposed under the other a short distance along one edge.

Fanning over. Same as fanning out.

Fillet. A cylindrical revolving metal finishing tool mounted in a wooden handle and used for running lines or designs on a book cover. Sometimes called a roulette or a roll.

Filling in. The process of leveling surfaces by affixing a material of suitable thickness between them.

Filling-in boards. Any thin paste boards used to make surfaces level.

Finishing. All the work done on a binding after it has been covered in leather. The workman who does this work is called a "finisher."

Finishing press. A small lying press used for holding a book while it is being tooled, and for some other operations in bookbinding.

Finishing tools. Tools engraved with a design on their faces, used for tooling designs on book covers.

Flesher leather. The cutoff part of a split skin.

Flexible glue. Glue made by cooking animal glue with water and glycerin or some other softening agent.

Flyleaves. All the free leaves of an end-paper section; but when used in the singular, the term denotes the uppermost free leaf of the section next to the cover board.

Folder. A shaped piece of bone used in the process of folding sheets and for other binding processes.

Folding stick. A long thin polished piece of wood with rounded ends and sides, used for folding "books in sheets."

Folio. A book made up of sheets folded only once.

Fore-edge. The edge of a book opposite the folds of the sections.

Forel. An inferior kind of parchment prepared from split sheepskins.

Format. In bibliographical parlance, a term used to indicate the number of times the original sheets have been folded to form the sections of a book.

Forwarding. The branch of bookbinding that takes the book after it is sewed, and completes the binding through the covering process. The workman is called a "forwarder."

Foxed. A sheet of paper is said to be foxed when small brown spots appear upon it. The spots are called "foxing."

French chalk. A species of soft chalk (used by binders for removing grease spots).

French corner. A type of covered corner on a half binding fashioned in such a manner as to protect the corner without being visible on the side of the binding.

French joint. A joint formed by hinging the cover board a short distance away from the back of the book in order to permit it to swing freely.

Frottoir. The French name for a wooden stick with a concave end used to clean glue off the backs of books. No English equivalent.

Full-bound. When the entire back and sides of a book are covered with leather the book is said to be full-bound.

Full cloth. A full cloth book is one entirely covered with cloth.

Full gilt. A term applied to books with all edges gilded.

Full title page. The page bearing the complete title of a book (sometimes amplified), the author, usually the place of origin, publisher, date, and

often the printer's name and address constitutes the full title page of a book printed in recent times.

Gathering.
1. A section or signature of a book.
2. Collecting the sheets when folded and placing the sections in sequence.

Gauffered edge. A book-edge decorated with a design tooled in over the gilded edge, and frequently colored.

Giggering a tool. A term used to describe a back-and-forth motion of a tool in the process of blind tooling.

Gilder. The workman who gilds the edges of books.

Gilder's tip. An implement for lifting gold leaf, which has a grouping of soft hairs laid flat along one of its edges.

Gilding. The process of burnishing gold leaf on the edges of books.

Gilding boards. Boards similar to cutting boards which are used when gilding the edges of books.

Gilding press. A screw press used for holding a book when in the process of gilding.

Gilt all round. When all three edges of a book have been gilded, the book is said to be "gilt all round."

Glaire. A liquid deposited from the beating up of white of egg and vinegar or water used to size tooled impressions before laying on gold leaf for gold tooling, and for sizing book-edges before gilding.

Glairing. Painting in glaire over a blinded-in design preparatory to tooling the design "in gold."

Gluing up. A term applied to the process of gluing the sections of a book together preparatory to backing.

Gold cleaner. An implement for removing the surplus gold which extends beyond a gold-tooled impression.

Gold cushion. A cushion on which gold leaf is laid out for use in gold tooling.

Gold knife. A knife for cutting gold leaf.

Gold leaf. A thin leaf of gold beaten out of a block of gold.

Gouge. A finisher's tool that forms a segment of a circle.

Graining boards. Wooden boards with an artificial grain cut on their surface, used for producing a grained pattern on smooth leather such as calf.

Graining plates. Metal plates used in place of graining boards.

Grain of paper. The grain of paper is constituted by the main direction taken by its fibers.

Grooved boards.

 1. Cover boards with grooved edges, peculiar to Greek bindings.

 2. Cover boards that are cut out to receive the slips of a book.

Guarding. The process of pasting strips of paper over the folds of the leaves of a book.

Guards. Strips of paper on which plates are mounted or with which sections are mended. Also, narrow strips of paper sewed with a book to compensate for the thickness of inserted plates.

Guillotine cutter. A paper and book cutting machine built and operated like a guillotine.

Guinea edge. A style of tooled book-edge, made with a fillet which has an engraved pattern similar to the edge of an old guinea coin.

Half binding. A book covered over the back and partly on the sides with leather, and with some other material on the sides, is said to be a half binding.

Half title, or bastard title. An abbreviated title which precedes the full title page of a book.

Hand letters. Letters used by a binder individually, as opposed to letters used together in a typeholder.

Hard-sized paper. Paper liberally sized.

Head. The head of a written or printed book is that part above the first line of writing or printing.

Headband. A silk-, linen- or cotton-covered band stretching across the head edge of a book and resting along the contour of the back of the book.

Headcap. The shaped folded piece of leather that covers the headband.

Heel.

 1. A term applied to the end of a knife blade which is opposite the point.

 2. As applied to a finishing tool, the term signifies the lower end of an engraved figure or design.

Hinge. The material that is used to fasten the text of a book to its board covers.

Holing-out. A term used to signify the process of punching holes through the board covers of a book to receive the sewing cords.

Holing-out block. A lead block placed under bookboards when holes or slits are being punched through them.

Hollow back. A type of false back of hollow construction affixed to the back of an uncovered book.

Imposed. Type set up in page form is said to be imposed when it is arranged according to some specified scheme on an imposing stone, and is locked up in a chase or frame.

Incunabula. In bibliography, books printed in the infancy of the art, or "cradle books." The term is confined to books printed before 1500.

Inlays. Pieces of colored leather or other material set into a figured pattern, a border or panel. Now used interchangeably with "onlays."

Inlaying a plate. A plate is said to be inlaid when its beveled edges are fitted and pasted to the beveled edges of a piece of paper or cardboard cut out to its size.

Inset. The pages cut off a sheet in folding, and placed in the middle of the folded sheet.

Inserts. Maps and other similar matter inserted in a printed text.

Interleaving blotting paper. Blotting paper as thin as a medium-heavy sheet of paper.

Jaconet. A kind of material similar to cambric used by English binders to line up the backs of books.

Job binder. A binder who does mostly hand binding for the trade.

Joint. The groove formed along the back of a book to hold the cover board.

Justification. A word used to signify the act of checking the pages of a book to see that the printing is "in register."

Kettle stitch. The same as catch stitch.

Knocking-down iron. An iron block on which tapping or striking with a hammer is done in the process of binding a book.

Knocking up. A term applied to the operation of squaring the back of the sections of a book to the head of the book.

Koch letters. A model of letters designed by Rudolph or Paul Koch of Germany.

Kraft paper. A trade name for a special kind of heavy brownish paper.

Lacing-in. The operation of drawing the frayed cords, or slips of a book through the bookboards in order to fasten them to the book.

Laid lines. The broad lines seen through a sheet of paper running across its width, made by the heavy wires in the bottom of the "mould."

Laid on. Gold leaf is said to be "laid on" when it has been applied over a surface to be tooled.

Laid paper. Paper made in a mould in the bottom of which heavy lines of wire are fastened.

Lapidary letters. A model of letters taken from inscriptions on stone.

Law calf. Uncolored calfskin usually used for binding lawbooks.

Lay cords. The cord loops on the bar of a sewing frame to which the sewing cords are fastened.

Laying gold. Applying gold leaf over a surface.

Letter tools. Tools on the faces of which letters are engraved.

Library binding. A special type of binding for books in a public library, constructed to endure hard wear.

Limp binding. A binding the covers of which are flexible.

Lined-down end paper. An end paper the first leaf of which has had a piece of material entirely affixed to it.

Lining papers.

 1. End papers that are pasted down on cover boards.

 2. Papers used for lining purposes.

Lining up. Affixing one surface to another.

Lithographic block. A block of a special variety of stone used in lithography.

Lying press. A large, horizontally lying screw press used for holding a book for backing, edge gilding, and other bookbinding operations.

Make-up. A term loosely used to denote the format of a book, as well as to refer to the arrangement of the printed matter on a page.

Marbled paper. Paper that has had a colored pattern put on one surface by the process of marbling.

Marbling. The art of veining a surface by floating colors on size in a design and transferring the colored design to leather, paper, or book-edges.

Margins.

 1. The unprinted spaces around the written or printed text of a book.

 2. The turned-over leather or other covering material on the inside of book boards.

Millboard. A species of brownish cover board made in England from rope or cordage.

Moulding saw. A saw used by carpenters for cutting joints. Sometimes called a tenon saw.

Mount. A piece of material on which anything is mounted, or affixed.

Mounted plate. A plate that has been affixed to a sheet of paper or to some other material.

Mounting. Affixing an entire surface of a plate or similar object to some material, or one material to another.

Newsboard. A thin gray board used in bookbinding mostly as a lining board.

Nicking corners. A term applied to cutting the corners of a bookboard which rest near the ends of the head and tailbands.

Nipping. A pressing of only momentary duration.

Nipping press. A small iron screw press used for light and quick pressing.

Nipping up. Compressing the leather over the cords of a book with band nippers to form the bands.

Oasis-goat. A term used to designate a leather made from a goat inhabiting the region of the Cape of Good Hope.

Offset. The printing in a book is said to have offset when the ink on one page leaves a mark on the opposite page. Same as setoff.

Ogee tool. A double-curved finishing tool sometimes in floral outline.

Onlays. Pieces of thin colored leather or other material pasted over an outlined tool form, border or panel. Usually referred to as "inlays."

Overcasting. An operation in sewing, by which the leaves of a section are bound together by thread. Sometimes called "whipping" or "whipstitching."

Oversewing. The same as overcasting.

Pagination. The numbering of the pages of a book.

Paging. Going through the text of a book, and inserting any missing page numbers.

Palladium. An amalgam leaf resembling silver leaf, used in tooling bindings.

Pallet. A brass or steel tool used to make lines or designs across the back of a book. Also, another name for a binder's typeholder.

Pamphlet. A term applied to a book of a single section, issued in paper covers.

Panel. The space on the back or side of a book bounded by joined lines.

Paring. Thinning down leather or paper with a paring knife.

Paring knife. A knife used for paring leather or paper.

Paring stone. The lithographic stone block on which leather is pared.

Paste wash. Paste thinned with water used for sizing leather.

Peel. A thin stick with a handle used by papermakers for hanging up sheets of paper to dry.

Pencil. A small camel's-hair brush used by a binder for glairing.

Plain binding. The type of binding usually turned out by a job binder, with little or no decoration.

Platen. A large flat surface in the top of a press that is brought down by a device above it to effect pressure is called a platen.

Plough. The wooden implement equipped with a knife used by hand binders for cutting edges of books in a lying press.

Plough knife. A knife fastened into the base of a cutting plough for cutting boards and edges of books.

Polisher. A steel implement used to polish the leather covers of books.

Press. A term applied to several types of implements used in bookbinding for their holding or pressing capacity.

Press cheeks. The tops of the two wooden blocks of a press.

Press jaws. The facing edges of the two blocks of a press.

Press pin. A small iron bar used for manipulating the screws of a lying press.

Pressing board. A wooden board used for pressing books.

Proof. The leaves of a book left uncut by a bookbinder which prove that the margins of the book have not been cut deeper than one or more uncut pages. Formerly called "witness."

Protection sheet. A sheet fastened to the end papers of books, during the process of forwarding, to protect them.

Pulled. A book is said to be "pulled" when it has been cut away from its covering and all its sections have been freed from each other.

Punch. The indentation of the type on a printed page.

Quarto. A book made up of groups of four leaves, or eight pages.

Quire. A word formerly used in bookbinding to denote a "gathering" or a "section."

Redboard. An unsized, thin, supple board colored red and having a quality similar to blotting paper.

Register.
　　1. A list of the signature numbers or letters in a book. Usually placed at the end of the book.
　　2. In a printed book when the lines of print do not fall directly over each other the printing is said to be "out of register."

Register in truth. In perfect register.

Register ribbon. Same as bookmarker.

Repeat design. A design made up of a repeated motif.

Roan. A trade name for sheepskin tanned in sumach.

Roll. Same as fillet. Called by French binders "roulette."

Rolling machine. A machine with revolving cylinders used to flatten the printed text of a book.

Rough-gilt. A book is said to be "rough-gilt" when its edges have been gilded before the book is sewed.

Roulette. Same as fillet or roll.

Rounding a book. A term applied to a process which consists in forming the back of a book into a convex shape.

Russia leather. A leather tanned with willow bark, dyed with sandalwood, and soaked in birch oil.

Saddleback. A rounded back.

Sandpaper blocks. Blocks of wood to which sandpaper is affixed.

Sawn-in. A book is sawn-in when the back of the sections are sawed through for sinking the cords in sewing.

Seasoned boards. Bookboards that have been lined up with paper and kept under a heavy weight until they are thoroughly dry.

Secondary bevel. A narrow extra bevel put on the cutting edge of a knife.

Section. A term applied to each unit of folded leaves comprising a book.

Semis, or Semée. A term meaning sprinkled, borrowed from heraldry by the bookbinder to denote a type of design in which small tool forms are placed over a surface at regular intervals.

Setoff. Same as offset.

Setting a headband. Gluing it to the edges of a book.

Setting the squares of a book cover. Adjusting them to an even width.

Sewed all-along. A book is said to be sewed "all-along" when the sewing thread runs through each section from one kettle stitch to the other.

Sewed two-on. When a book is sewed in such a manner that each section is fastened to another with the sewing thread running through the sections at every second cord, the book is sewed "two-on."

Sewing bench. A wooden appliance composed of a large flat board, called a "bed," and two upright screws connected by a bar, used for sewing a book by hand. Sometimes termed a sewing frame.

Sewing cords. A term applied to the cords, tapes or other material around which the sections of a book are sewed.

Sewing frame. Same as sewing bench.

Sewing keys. Metal pronged instruments used to secure the cords, or other material around which the sections of a book are sewed, to the bottom of the sewing frame.

Sewing stick. A weighted stick of wood used to knock the sections of a book down firmly when they are being sewed together.

Sheet. The full size of paper on which written or printed pages have been imposed, which when folded becomes a section.

Signature. The letters or figures placed under the foot line of the first page of each section of a book to indicate the sequence of the sections. The word is also used synonymously with section.

Signet. The French binder's term for register ribbon.

16mo, or sextodecimo. This term is applied to a book made up of folded sheets containing sixteen leaves or thirty-two pages, to a section.

Size. A name given to any coating preparation that tends to make a surface impervious to penetrating agents.

Sized paper. Paper that has had a coating of size put on its surface or in the pulp of which it was made.

Skinned. A skinned surface is a pasted surface on which the paste has been equalized by being rubbed over through a piece of paper.

Skiver. A split sheepskin.

Slipcase. A bookcase with open front edges. Also called a slip cover.

Slip cover. Same as slipcase.

Slippery book. A book the sections of which are not held together firmly.

Slips. The frayed ends of the cords over which the sections of a book are sewed.

Smooth-gilt. A term applied to the edges of a book that have been gilded after the book is cut in boards.

Soft-finished paper. Paper made with an unpolished surface.

Solander case. A closed bookcase with a removable top into which a book is placed from tail to head.

Spine. A term used to designate the covered back of a book on which the title is usually lettered. Sometimes called the backbone.

Split-board book. A book with cover boards made of two boards glued together.

Split skin. A skin that has had a part of its undersurface split off.

Spring dividers. Dividers the two prongs of which are connected by a threaded rod on which a threaded nut operates for opening or closing the prongs.

Sprinkled edge. A book-edge that has been covered with a sprinkling of color or colors.

Squares. The portions of the boards of a book that project beyond the edges of the text.

Stabbed binding. A binding that is held together by cord laced through holes stabbed along its back edge.

Stamp. In mediæval times, a piece of metal engraved intaglio, used cold, for impressing a design on a surface either by hand or by means of a press. At the present time, a piece of metal with a design cut either intaglio or in surface outline, and impressed heated, by means of an arming or blocking press.

Stamping. In mediæval times, impressing an unheated, engraved stamp on a surface either by hand or by means of a press. In modern times, impressing a heated, engraved stamp on a surface by means of an arming or blocking press.

Standing press. A heavy, fixed press worked by means of a cogwheel, lever or by some other means, used for pressing books.

Started. When the leaves of a book push out beyond the others because of too loose sewing or too rough usage they are said to have started.

Straightedge. A metal ruler.

Straight-grain leather. A leather that has been dampened and rolled, or "boarded," to make the grain run in straight lines. An innovation accredited to Roger Payne.

Stringing up. A term applied to fastening cords or their substitutes to a sewing frame.

Super. A kind of meshed material used to line the backs of books.

Tacky. A term used in bookbinding to mean sticky.

Tail. The tail of a book is the end opposite the head.

Tailband. A band on the tail edge of a book woven over with silk or linen thread by which it is fastened to the book.

Tampon. As used in bookbinding the word signifies a piece of absorbent cotton or cloth screwed up at one end and made flat at the opposite end.

32mo. A book made up of sheets of paper folded in thirty-two equal parts is said to be made up in a 32mo format, and is commonly designated as a 32mo edition.

Three-quarter binding. A binding similar to a half binding with a greater proportion of leather on its sides.

Thrown out. A page or map is said to be "thrown out" when it is guarded so that it may be pulled out to lie outside of the fore-edge line of the text.

Thumb case. A bookcase the open sides of which are cut out in a small thumb-shaped curve.

Tipping, or Tipping on. A term to denote the fastening of one material to another by pasting the material only at one edge.

Title piece. A colored leather label, usually pasted on the back of a binding, on which the lettering of a book is done.

Toe. The toe of a knife is the pointed end of the blade.

Tooling. The art of impressing a design on leather or some other material by hand, with heated tools.

Tools. The name applied in a specific sense to the engraved metal bookbinder's tools with wooden handles which are used by hand, heated, to impress a design on a surface.

Tooth burnisher. A curved-surface burnisher used by illuminators and edge gilders.

Top centered. Placed above a center vertically, and centered horizontally.

Tranchfille chapiteau. A type of double headband of French origin.

Trimmed-edge book. A book the edges of which have been here and there cut off to make them less irregular.

Trimming. Cutting off only a little.

Trimming board. A board on which the pages of books are cut to a desired size.

Trindles. Metal bifurcated plates used in cutting the fore-edge of a book with a plough.

Try square. A mechanically perfected instrument used for squaring edges.

Turn-in. The leather that is turned over the edges of a cover from the outside to the inside.

Turned grain. Leather that has been dampened and has had its grain turned over with an agate polisher is said to have a turned grain.

Turnover. Same as turn-in.

12mo. The same as duodecimo.

Tying-up boards. Boards used to tie up a binding when the leather on the spine fails to adhere firmly.

Typeholder. A metal implement for holding type, used in tooling titles on books. Sometimes called a type pallet.

Type pallet. Same as typeholder.

Utility knife. A name given to a knife used for various purposes in bookbinding.

Vellum. A calfskin prepared with lime, and not tanned like leather.

Vellum binder. A term used in England to denote a binder of account books, notebooks, and office stationery, etc.

Warping. A process in bookbinding, usually applied to a cover board, which turns it from a flat to a convex or concave form.

Warping paper. A paper pasted to a surface usually for the purpose of counterwarping it.

Waste.

1. Fragments of old books or spoiled and excess sheets of new books, frequently utilized by binders for lining purposes.

2. The extra sheets supplied to a binder to substitute in the event of spoilage.

3. Excess pieces of paper cut off by a binder.

Watermark. A device, or design, in a sheet of paper, which is made during the process of forming the sheet, representing a sort of trademark of the maker.

Well. The open box under a cutting press utilized for catching waste.

Whipping, or Whipstitching. Same as overcasting.

Whole binding. A binding with spine and sides entirely covered with leather.

Wing dividers. Dividers the two prongs of which are held together and operated by a winglike curved bar.

Wire marks. The lines made in a sheet of paper, while it is being formed, by the wires in the bottom of the "mould."

Wringing down. As applied to a press — the act of bringing the two jaws or platens closer to each other.

Wove paper. Paper made in a mould which has a bottom of woven wire screening similar to woven cloth fabric.

Yawning boards. Cover boards that curl away from the text of a book.

INDEX

INDEX

[Please note: A separate index follows the text of the first volume.]

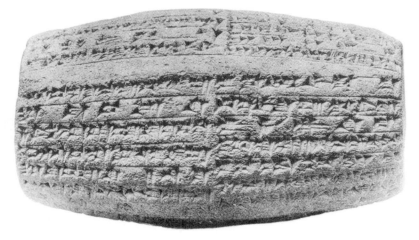

PLATE I. *Babylonian Clay Cylinder* (CA. 2200 B.C.).

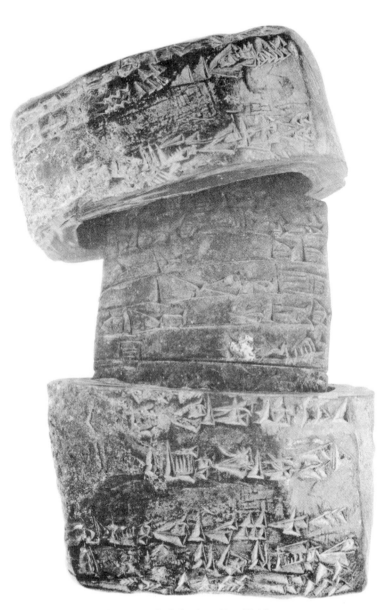

PLATE 2. *Babylonian Clay Tablet.*

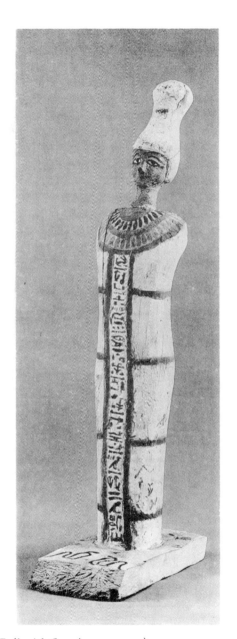

PLATE 3. *Papyrus Roll with Case* (ca. 1025 B.C.).

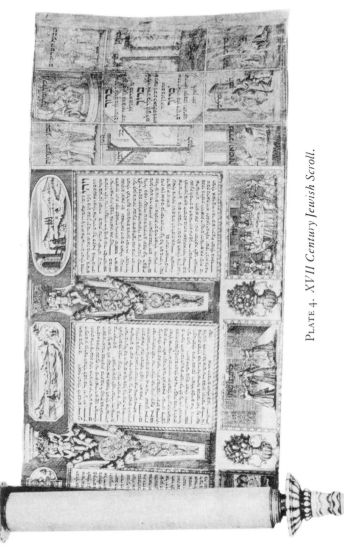

PLATE 4. *XVII Century Jewish Scroll.*

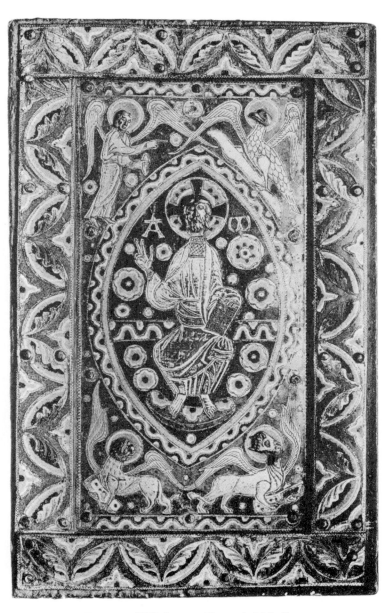

PLATE 5. *XIII Century Enameled Binding.*

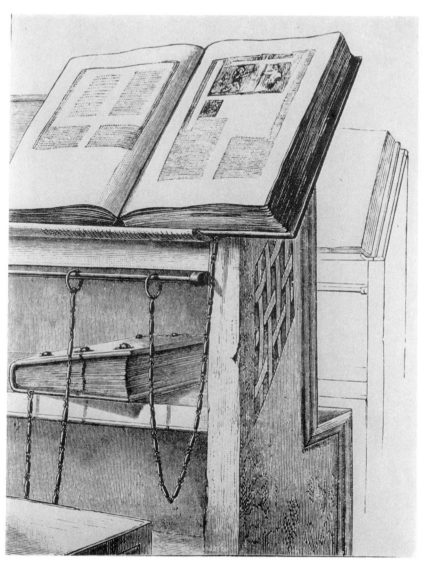

PLATE 6. *Book Chained to Reading Desk.*

PLATE 7. *Laurentian Library.*

PLATE 8. *Hereford Cathedral Chained Library.*

PLATE 9. *XV Century German Stamped Binding.*

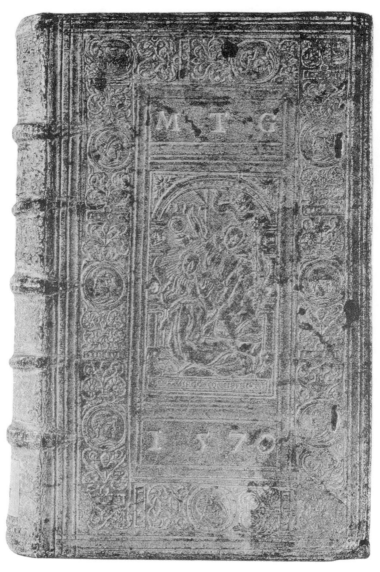

PLATE 10. *XVI Century Panel-stamped Binding.*

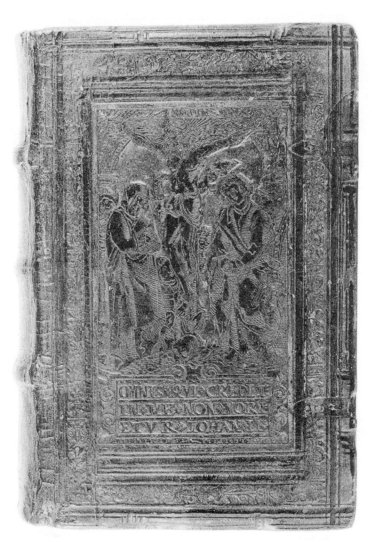

PLATE 11. *XVI Century German Panel-stamped Binding.*

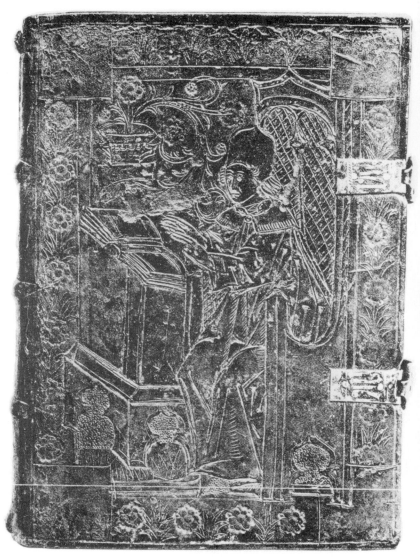

PLATE 12. *Cuir-ciselé Binding by Mair Jaffe.*

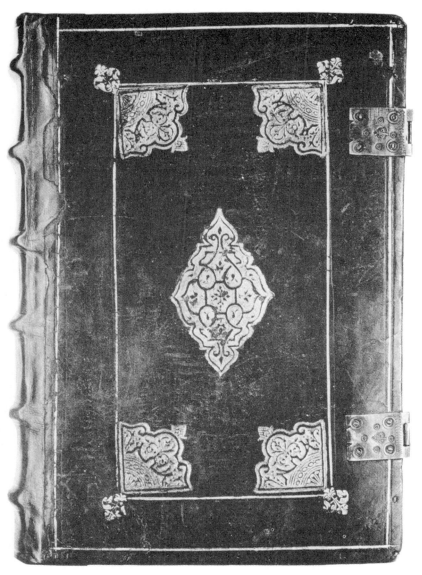

PLATE 13. *English "Trade Binding."*

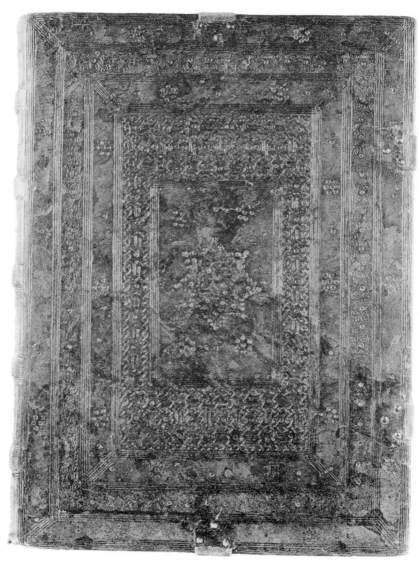

PLATE 14. *XV Century Italian Binding.*

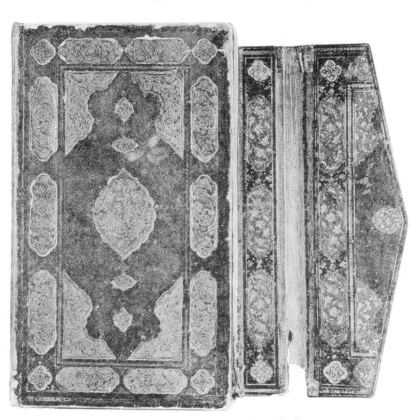

PLATE 15. *XVII Century Persian Binding.*

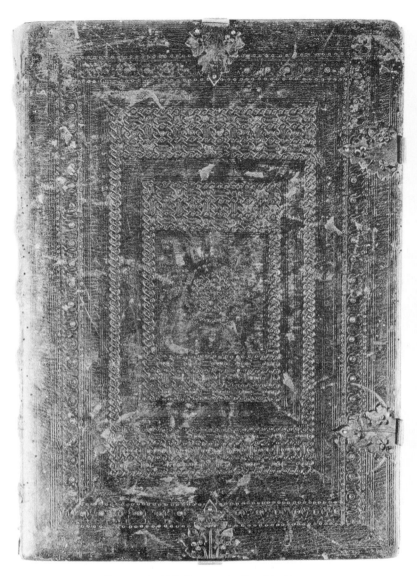

PLATE 16. *XV Century Italian Binding.*

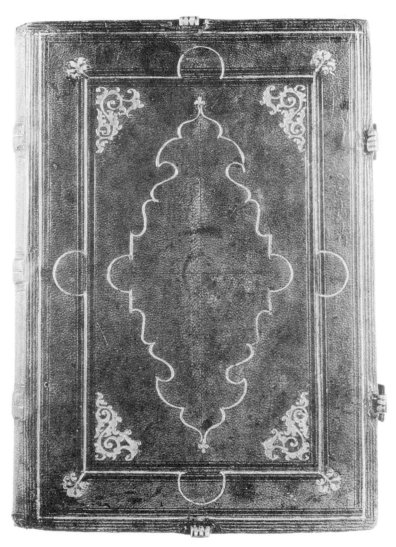

PLATE 17. *XVI Century Venetian Binding.*

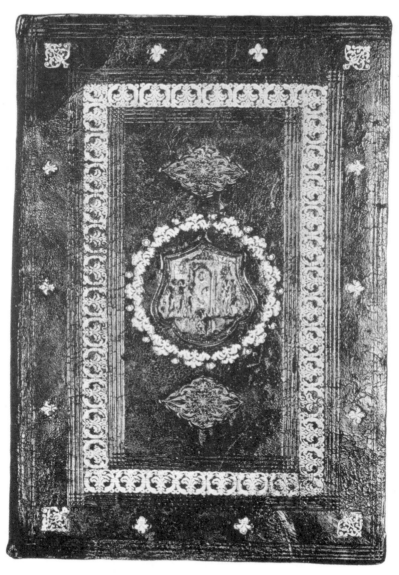

PLATE 18. *Grolier Plaquette Binding.*

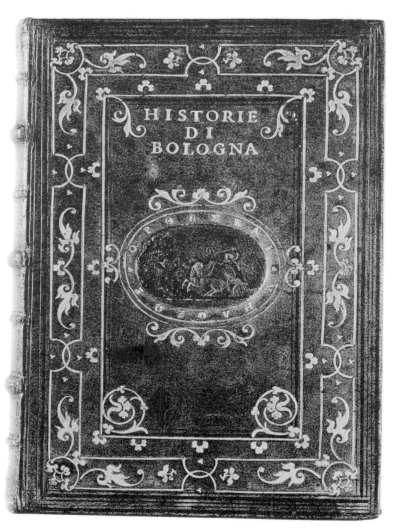

PLATE 19. *"Demetrio Canevari" Binding.*

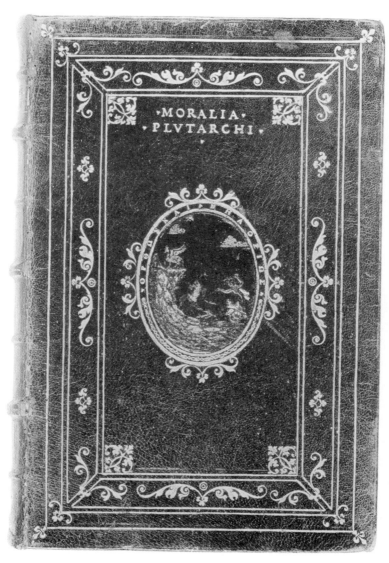

PLATE 20. *XVI Century Plaquette Binding.*

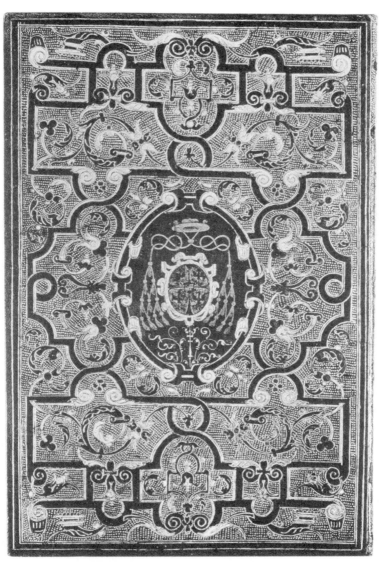

PLATE 21. *Italian Renaissance Binding.*

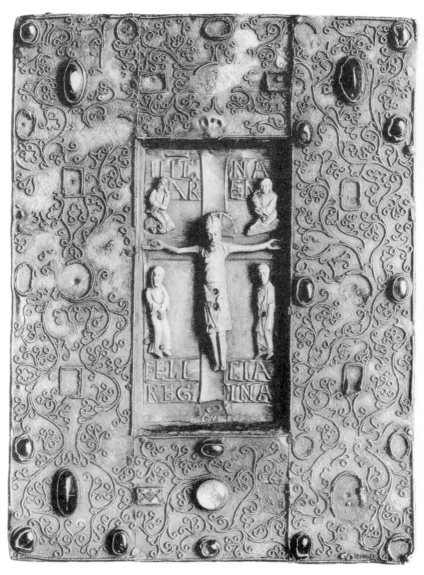

PLATE 22. *Spanish XI Century Book Cover.*

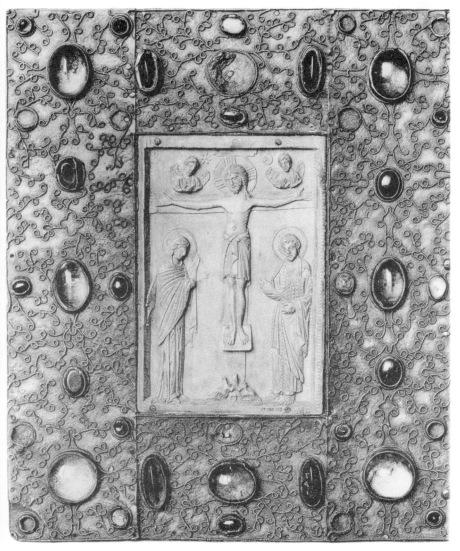

PLATE 23. *Spanish XI Century Book Cover.*

PLATE 24. *Spanish XVI Century Binding.*

PLATE 25. *XVI Century Mudéjar Binding.*

PLATE 26. *XVI Century Mudéjar Binding.*

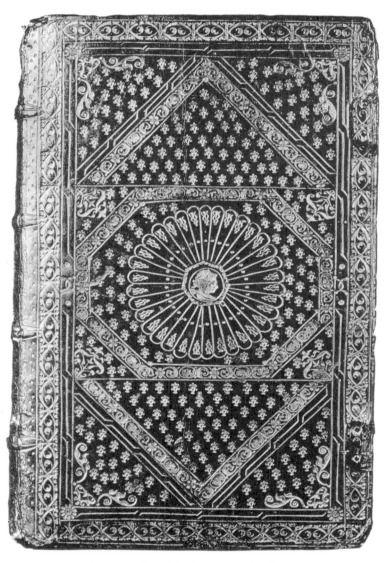

PLATE 27. *Spanish Renaissance Binding.*

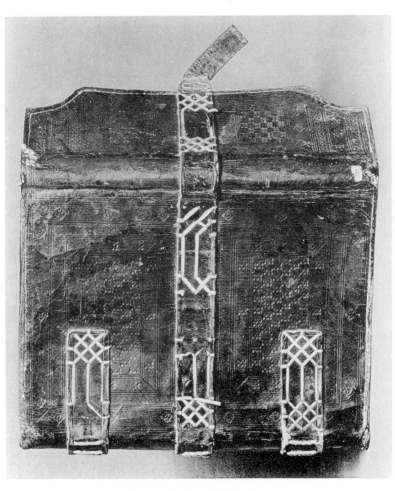

PLATE 28. *Spanish Binding.*

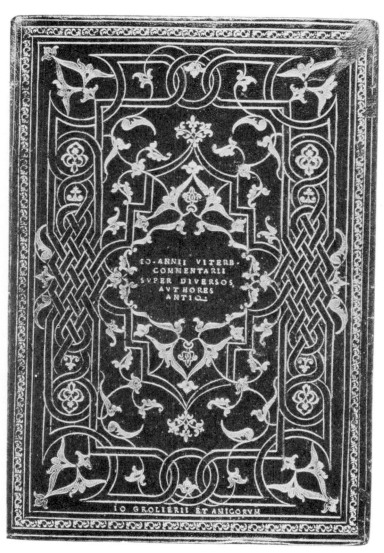

PLATE 29. *Grolier Binding.*

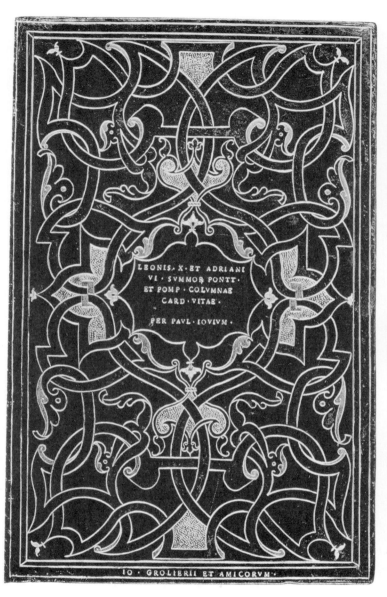

LEONIS · X · ET · ADRIANI
VI · SVMMOR PONTT ·
ET · POMP · COLVMNAE ·
CARD · VITAE ·

PER PAVL · IOVIVM ·

IO · GROLIERII ET AMICORVM ·

PLATE 30. *Grolier Binding.*

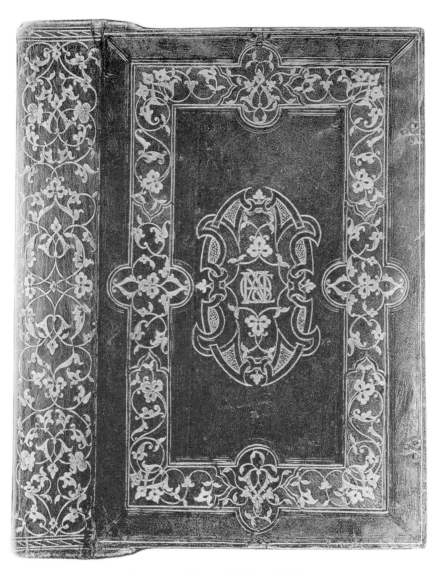

PLATE 31. *Thomas Mahieu Binding.*

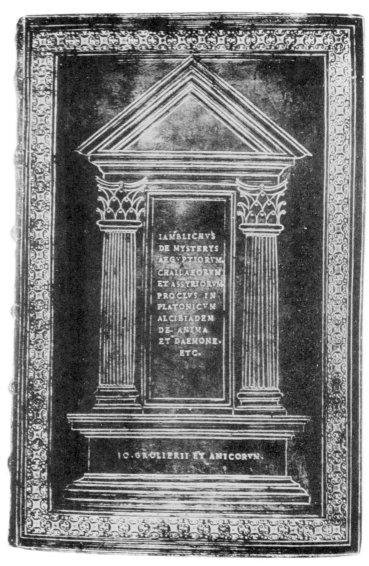

IANBLICHVS
DE MYSTERYS
AEGVPTIORVM.
CHALDAEORVM.
ET ASSYRIORVM.
PROCLVS IN
PLATONICVM
ALCIBIADEN
DE ANIMA
ET DAEMONE.
ETC.

IO. GROLIERII ET AMICORVM.

PLATE 32. *Italian Portico Binding.*

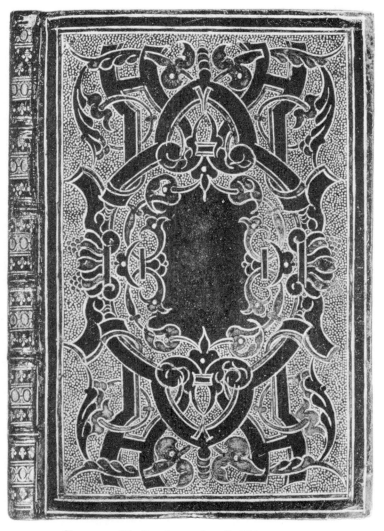

PLATE 33. *Binding in a style called "Lyonnaise."*

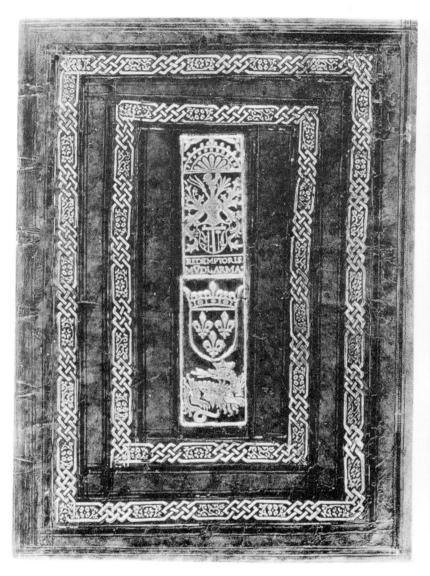

PLATE 34. *François I Binding.*

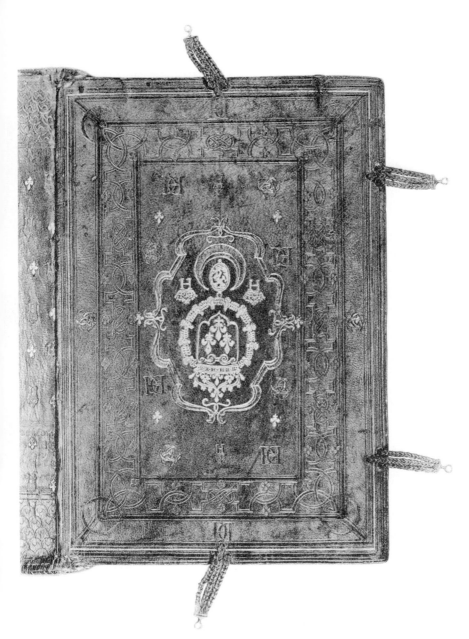

PLATE 35. *Henri II Binding.*

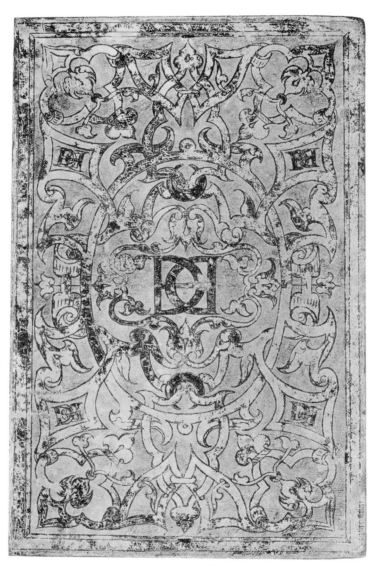

PLATE 36. *Diane de Poitiers Binding.*

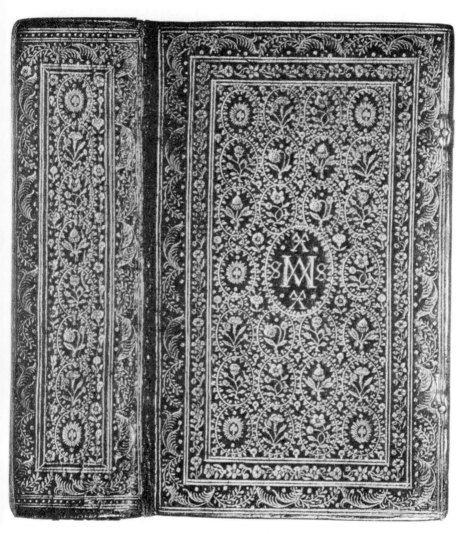

PLATE 37. *Binding by Clovis Eve.*

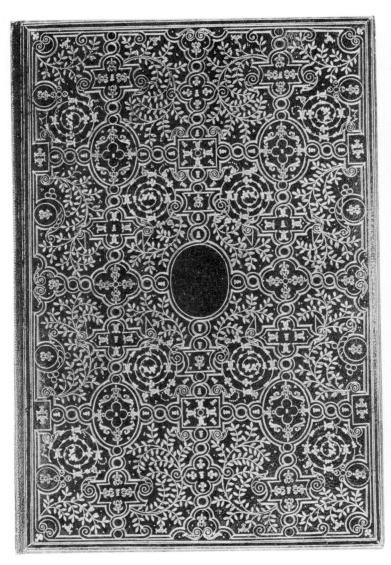

PLATE 38. *Binding by Nicholas Eve.*

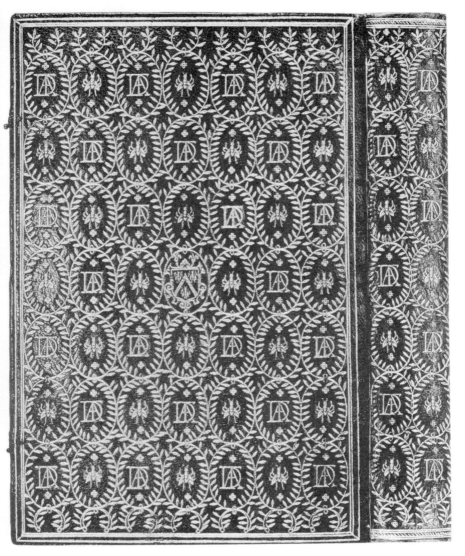

PLATE 39. *Binding by Clovis Eve.*

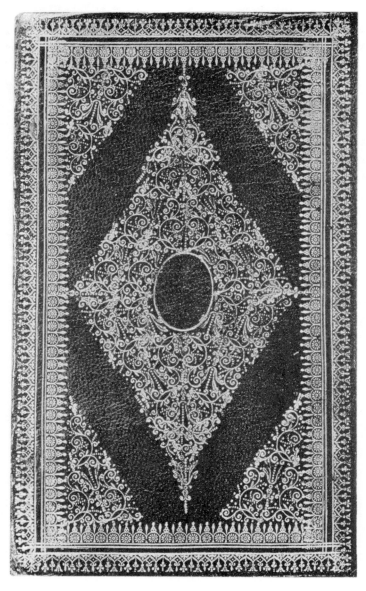

PLATE 40. *"Le Gascon" Binding.*

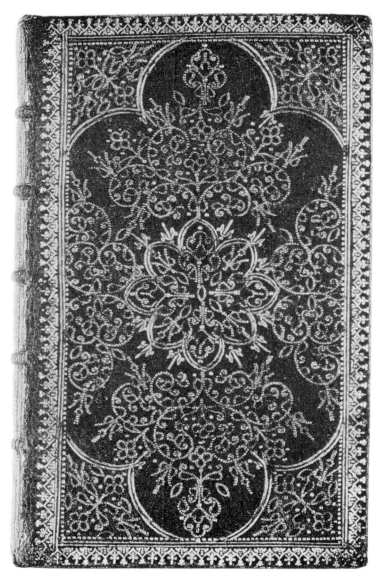

PLATE 41. *"Le Gascon" Binding.*

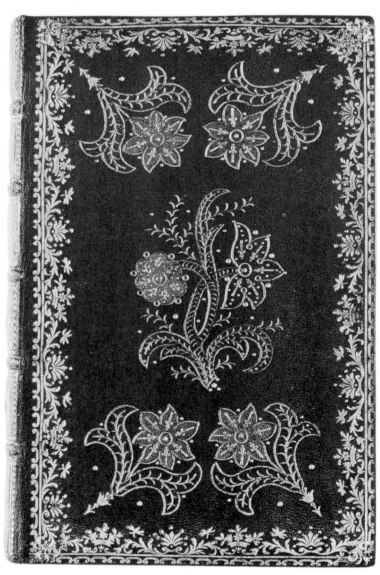

Plate 42. *Padeloup Binding.*

PLATE 43. *Padeloup Binding.*

PLATE 44. *Binding by Derome le jeune.*

PLATE 45. *Binding by Thouvenin.*

PLATE 46. *Binding by Trautz-Bauzonnet.*

PLATE 47. *Binding by Pierre Legrain.*

PLATE 48. *Binding by Paul Bonet.*

PLATE 49. *Binding by John Reynes.*

PLATE 50. *Binding Executed for Robert Dudley, Earl of Leicester.*

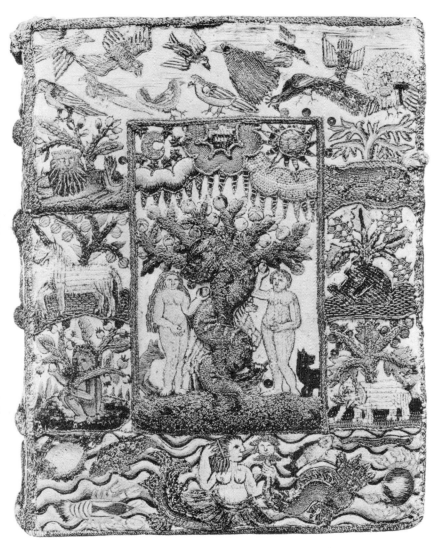

PLATE 51. *XVII Century English Embroidered Binding.*

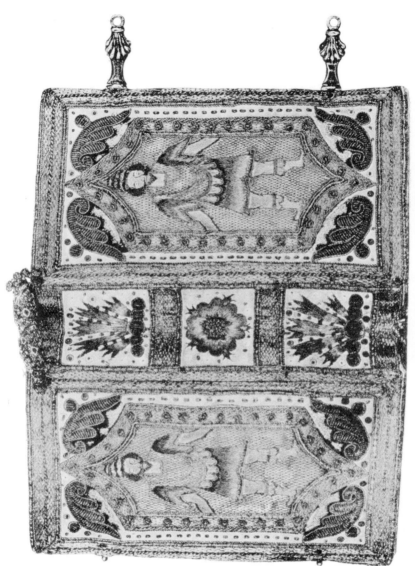

PLATE 52. *XVII Century English Embroidered Binding.*

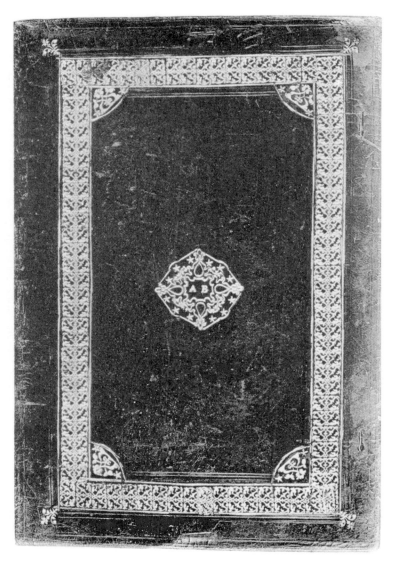

PLATE 53. *Binding Attributed to Thomas Berthelet.*

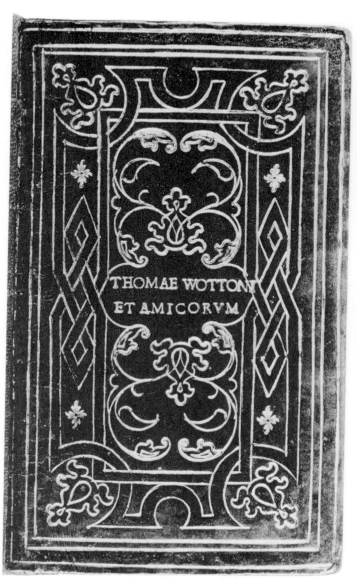

PLATE 54. *Thomas Wotton Binding.*

PLATE 55. *Binding Executed for Mary II, Queen of England.*

PLATE 56. *"Mearne Binding" in Cottage Style.*

PLATE 57. *Binding by the "Mearne Binder."*

PLATE 58. *"Mearne Binding" with Gauffered Edge.*

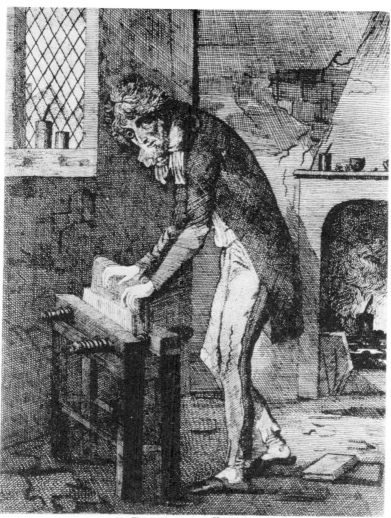

ROGERUS PAYNE.
Natus Vindesor MDCCXXXIX, denatus Londini MDCCLXXXVII.
Effigiem hanc graphicam solertis BIBLIOPEGI Μνημόσυνον meritis BIBLIOPOLA dedit.
Scalptibus Thomæ Pinx.

Etcht & Published by S. Harding Nº 127 Pall Mall March 1 1800

PLATE 59. *Etching of Roger Payne.*

PLATE 60. *Binding by Roger Payne.*

PLATE 61. *Doublure by Roger Payne.*

PLATE 62. *Binding by Cobden-Sanderson.*

PLATE 63. *Binding and Decorated Fore-edge by Douglas Cockerell.*

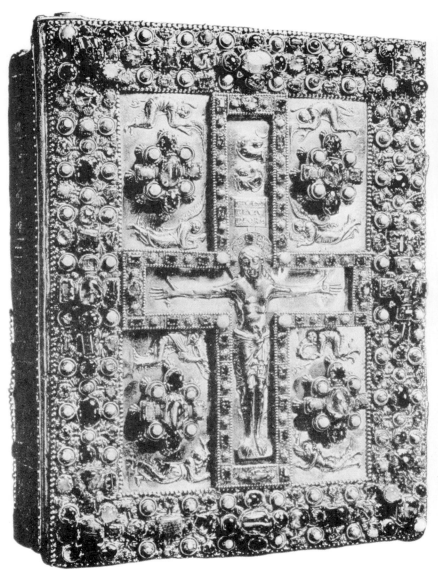

PLATE 64. *Upper Cover of the "Lindau Gospel," IX Century.*

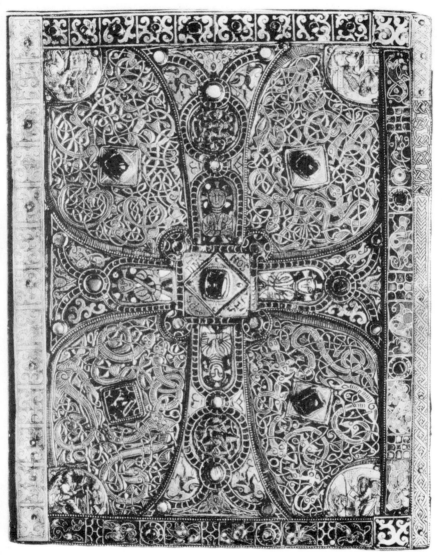

PLATE 65. *Lower Cover of the "Lindau Gospel," IX Century.*

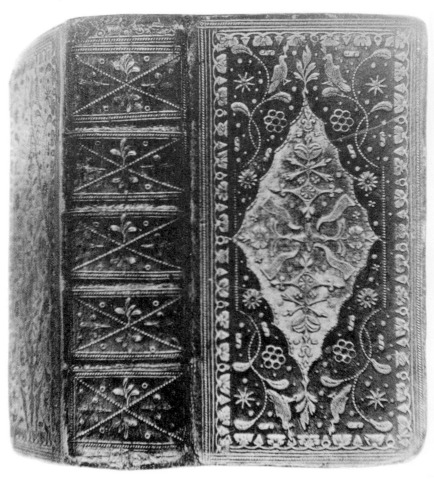

PLATE 66. *XVIII Century Irish Binding.*

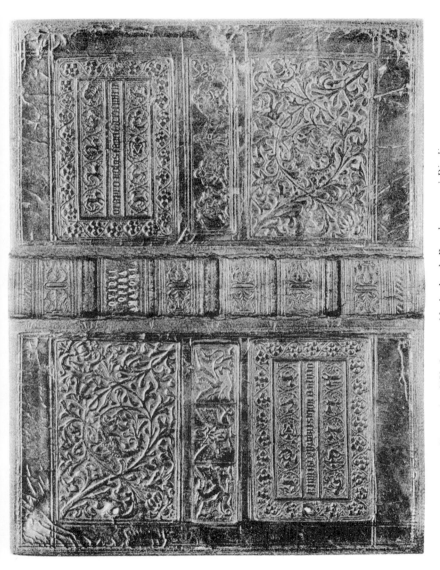

PLATE 67. *XIV Century Netherlands Panel-stamped Binding.*

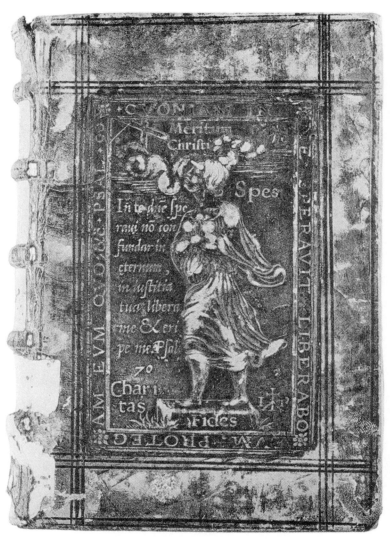

PLATE 68. *XVI Century Louvain Stamped Binding.*

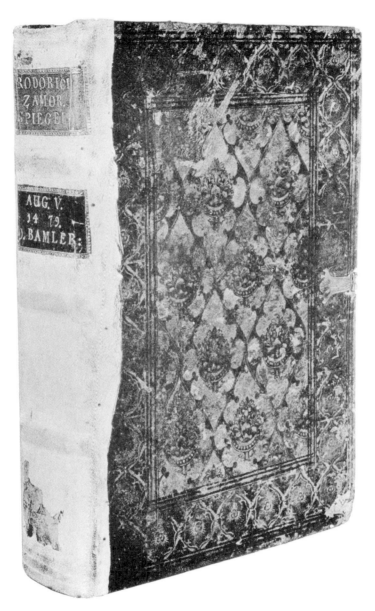

PLATE 69. *XV Century German Stamped Binding.*

PLATE 70. *XV Century German Stamped Binding.*

PLATE 71. *XV Century German Binding, Front Cover.*

PLATE 72. *Back Cover of Binding, Plate 71.*

PLATE 73. *Binding Executed by Johannes Rychenbach.*

PLATE 74. *Binding Executed by Johannes Fogel.*

PLATE 75. *Binding Executed by Johannes Hagmayr.*

PLATE 76. *XVI Century German Binding, with Hunting Scene.*

PLATE 77. *XVI Century German Parchment Binding.*

PLATE 78. *XVI Century German Stamped Binding.*

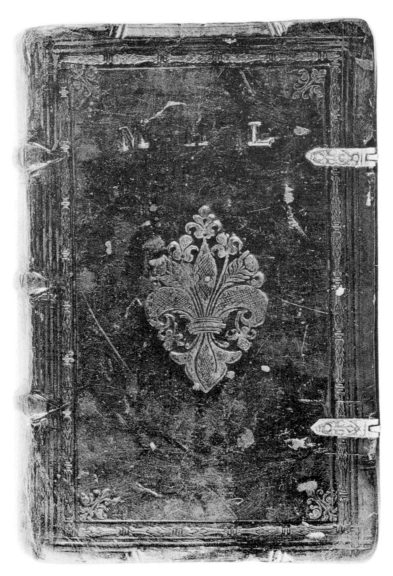

PLATE 79. *XVI Century German Binding.*

PLATE 80. *XVII Century German Binding.*

PLATE 81. *Binding by Ignatz Wiemler.*

PLATE 82. *American Colonial Binding.*

PLATE 83. *XVIII Century American Binding.*

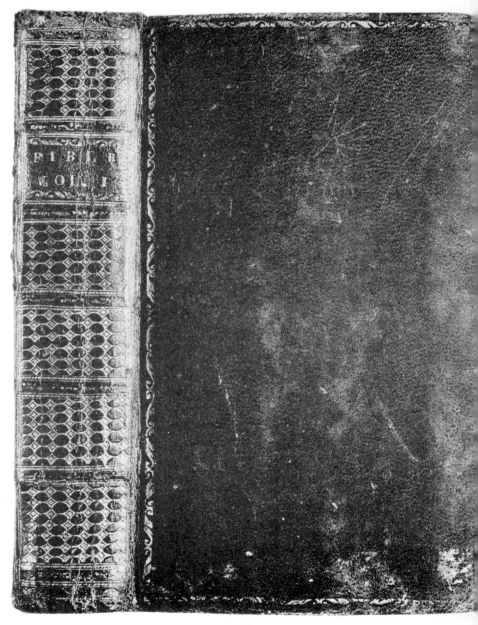

PLATE 84. *XVIII Century American Binding, Attributed to Robert Aitken.*

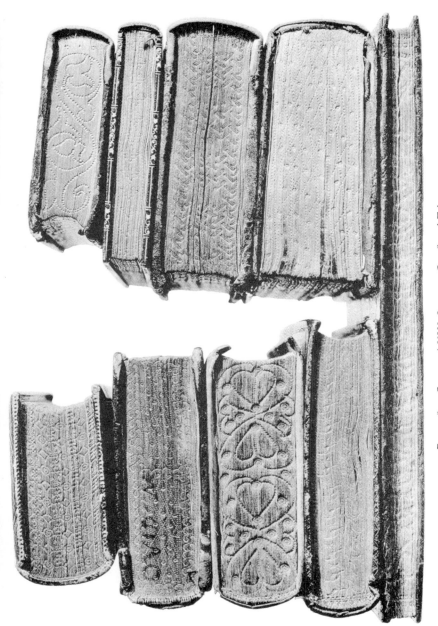

PLATE 85. *Group of XVI Century Gauffered Edges.*

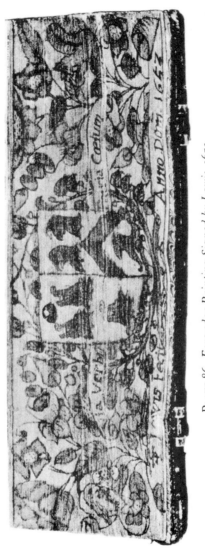

PLATE 86. *Fore-edge Painting Signed by Lewis*, 1653.

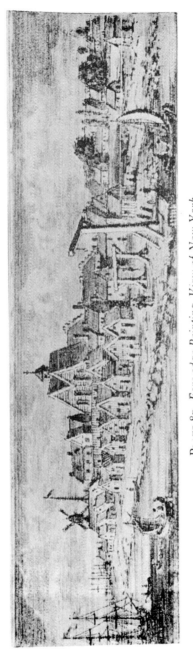

PLATE 87. *Fore-edge Painting, View of New York.*

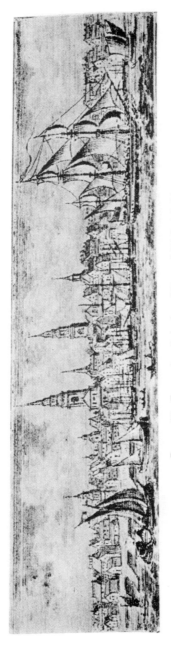

PLATE 88. *Fore-edge Painting, View of Philadelphia.*

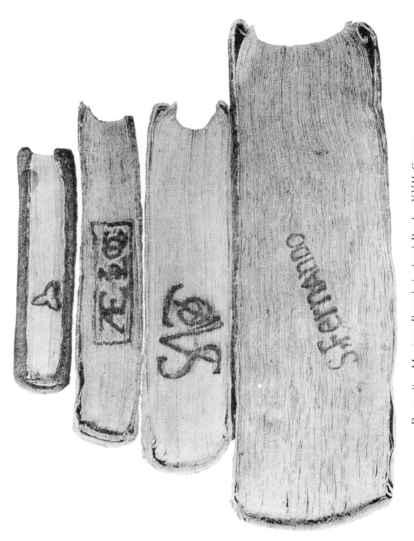

PLATE 89. *Mexican Branded-edged Books, XVII Century.*

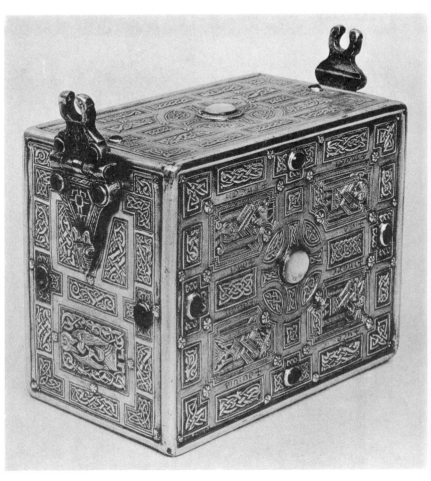

PLATE 90. *Cumdach of the Gospel of St. Molaise.*

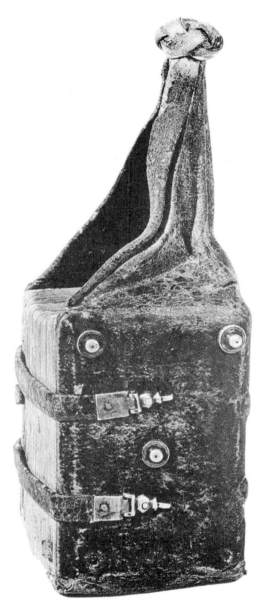

PLATE 91. *German Girdle Book, XV Century.*